Viewing
Renaissance Art

Renaissance Art Reconsidered

Volume 3

Viewing Renaissance Art

Edited by Kim W. Woods, Carol M. Richardson and Angeliki Lymberopoulou

Yale University Press, New Haven and London
in association with The Open University

Yale University Press
47 Bedford Square
London
WC1B 3DP

The Open University
Walton Hall
Milton Keynes
MK7 6AA

First published 2007 by Yale University Press in association with The Open University.

Edited, designed and typeset by The Open University.

Printed in the UK by The Westdale Press Limited.

This book forms part of an Open University course AA315 *Renaissance Art Reconsidered*. Details of this and other Open University courses can be obtained from the Student Registration and Enquiry Service, The Open University, PO Box 197, Milton Keynes, MK7 6BJ, United Kingdom: tel. +44 (0)870 333 4340, email general-enquiries@open.ac.uk, http://www.open.ac.uk

Library of Congress Cataloging-in-Publication Data

Woods, Kim
 Viewing Renaissance Art/Kim W. Woods, Carol M. Richardson and
Angeliki Lymberopoulou.
 p. cm.
 Includes bibliographical references and index.
 ISBN 978-0-300-12343-2 (cl : alk. paper)
 1. Art, Renaissance. 2. Art and Society–Europe. I. Richardson, Carol M.
 II. Lymberopoulou, Angeliki. III. Title.
 N6370.W655 2007
 709.02'4–dc22
 2007002351

ISBN-10: 0-300-12343-4
ISBN-13: 978-0-300-12343-2

1.1

Contents

List of plates

Preface

This book on viewing Renaissance art is the third of a series of three volumes that form the core of a Level 3 Open University course entitled *Renaissance Art Reconsidered* (AA315). The other two volumes are *Making Renaissance Art* and *Locating Renaissance Art*, also published by Yale.

These three books aim to familiarise readers with art produced in the fifteenth and early sixteenth centuries, a historical period conventionally associated with the Italian Renaissance and with Florence in particular. In line with contemporary art-historical study, this series reconsiders the traditional bias towards Italian centres of production and its exclusive focus on the so-called 'fine arts' of painting, sculpture and architecture. Hence, although some chapters deal exclusively with Italian art, others broaden the boundaries by considering the art of Italy alongside that produced in northern Europe or focus exclusively on the Netherlands, England, France or Crete. The so-called 'crafts' of printmaking, tapestry weaving and manuscript illumination are also explored.

Each of the three volumes of the series takes a different approach towards Renaissance art. The first volume examines the theory and practice of making art. Beginning around the year 1400, it explores the processes of drawing, painting, sculpture, architecture and printmaking in relation to themes traditionally associated with the Renaissance, including perspective, the gradual assimilation of the literary and artistic revival of classical antiquity, the illusion of life, the status of the artist, and theoretical and biographical writing on art. The second volume, on locating Renaissance art, looks at some of the differing geographical models for the production and distribution of European Renaissance art from around 1450, and considers issues of cultural exchange and the transmission and assimilation of ideas or motifs. This third volume deals with issues surrounding the viewing of Renaissance art, introducing varying patterns of commissioning, marketing and consuming works of art across the social classes and in the period leading up to the Reformation.

This volume includes chapters written by members of the Art History department of The Open University and by consultant authors based at other academic institutions. It is also the result of less visible but nonetheless important contributors. In particular, we would like to thank Mike Franklin (Course Manager) and Sheila Page (Project Manager). Nancy Marten, the Production Editor, has worked tirelessly to bring everything together. It stands as a testament to her thoroughness. Liam Baldwin conducted the picture research with patience and professionalism. The Tutor Assessors, Vicky Ley and Lyn Rodley, have provided invaluable feedback and advice. Caroline Elam, our external adviser, has generously lent us her experience and considerable expertise throughout.

The course to which this book belongs forms part of the Open University's humanities degree programme. For readers interested in the Renaissance or in pursuing their study of art history, other relevant Open University books are available also published by Yale, including the six volumes of the Level 2 course *Art and its Histories* (A216), the four volumes of the Level 3 course *Art of the Twentieth Century* (AA318), and the three volumes of the Level 3 course *The Renaissance in Europe* (AA305).

Introduction

Kim W. Woods

For some art historians, starting with Vasari, viewing Renaissance art traditionally centred on the formal qualities for which it was later prized, such as evidence of renewed interest in antique art, the primacy of drawing (*disegno*) in Florentine art as against the colour associated with Venetian art, the use of mathematical perspective, and the development of complex yet coherent narrative compositions. According to this model of viewing, invention and innovation were the province of the artist alone, and the patron was cast in the role of either enlightened paymaster or philistine. The skill of the artist was certainly important to Renaissance patrons: writing in the 1970s, Michael Baxandall showed that during the fifteenth century the prestige of a work of art shifted to depend increasingly on artistic skill rather than cost and material value.[1] That Renaissance patrons viewed works of art with a competitive eye for skill is clear from the discrimination with which they placed their commissions. The innovation in manuscript illumination by the Vienna Master of Mary of Burgundy examined in Alixe Bovey's chapter is just one example of such discriminating patronage in practice.

Carol Richardson's chapter, 'Art and death', demonstrates another crucial aspect of viewing: Renaissance works of art were not designed for visual delectation alone. Rather, their formal qualities and content alike were intended to serve a whole raft of social or religious functions that are no longer always obvious to viewers today. Renaissance art historians have long recognised that patrons were not just admiring bystanders providing the wherewithal for talented artists to flourish, but clients who had particular wishes and motives in placing a commission that they expected to be met. If the original viewing experience may be reconstructed at all, a complex web of assumptions, aspirations, permissions, obligations and limitations must be deciphered. Signifiers of wealth, status, piety or authority that would have been obvious at the time might pass the modern viewer by entirely.

Building on the foundations laid by cultural historians such as Jacob Burckhardt, Aby Warburg and Johan Huizinger, recently developed approaches to the task of viewing works of art have transformed the nature of the question. Using the concept of the 'period eye', Michael Baxandall explored the ways in which the prevailing visual habits and categories of a society might impinge on the style in which works of art were made.[2] Richard Goldthwaite pioneered the exploration of art as consumer objects in the material consumption associated with the burgeoning economic prosperity of fifteenth- and sixteenth-century Europe.[3] Hence, viewing Renaissance works of art today brings with it an obligation to consider their original social and cultural significance. Rembrandt Duits's opening chapter in this book takes into account recent methods of scholarship associated with the study of material culture. Other chapters explore the theme of viewing in terms of patronage, meaning and context. The overriding premise is that Renaissance art is not a neutral matter of stylistic taste on the part of a patron, artist or society, but an aspect of material production in which values were invested; uncovering the viewing habits of fifteenth- and early sixteenth-century patrons and viewers necessarily entails uncovering some of these values, whether they be of a religious, cultural, social or political nature. Viewing Renaissance art also demands an understanding of the social 'rules' by which art was constrained, and which were occasionally defied.

1 Renaissance art, prestige and social class

When Charles VIII, King of France from 1483 to 1498, rejected a Netherlandish altarpiece on the grounds that it was suitable only for merchants, he betrayed a very firm outlook on the connotations art might bear.[4] Despite the fact that arguably the most famous early Netherlandish painter of all, Jan van Eyck, was employed by Philip the Good, Duke of Burgundy and the Netherlands (ruled 1419–67), Netherlandish painting had in Charles's

eyes become so associated with the merchant classes that it no longer conveyed a prestige appropriate to his own status – if, indeed, it ever had. Painting was a relatively humble medium, less fitting for a royal family than tapestries, metalwork like the reliquary donated by Charles the Bold (ruled 1467–77) to Liège Cathedral (see Chapter 1, Plate 1.20), and tomb sculpture cast in bronze (see Chapter 6, Plate 6.30). For a king like Charles VIII, the choice of art form – and the use to which that art was put – was a matter of what was deemed appropriate for rulers in comparison with other social classes.

As Jill Burke shows in Chapter 2, the ancient Greek philosopher Aristotle offered a sort of social code of expenditure which he called 'magnificence'. According to his *Nicomachean Ethics*, magnificence constituted public-spirited expenditure on projects of benefit to the community, such as public events or buildings, at levels that were lavish yet appropriate to the social class of the donor and the nobility of the project.[5] Spending on private homes, conversely, was governed by propriety and the levels of a person's wealth. Overexpenditure was censured as vulgar and an ostentatious attempt to curry admiration rather than a noble or generous action. Whether directly inspired by Aristotle or a matter of social expediency, the concept of magnificence is a crucial tool in understanding the way in which Renaissance art was viewed.

Of all the social classes, rulers were least at risk of overstepping the mark where magnificence was concerned. Indeed, in Chapter 4 Thomas Tolley argues that Louis XI, King of France from 1461 to 1483, underestimated the importance of magnificence, not simply as a device to overawe but for its capacity to create or reinforce an image. Philip the Good reputedly upstaged Louis XI in his lavish, triumphal entry to Paris in 1461.[6] Although only a duke and a vassal of the king, Philip used magnificence to show that he was nevertheless a ruler to envy and respect. As Thomas Tolley shows, art such as tapestries and goldsmiths' work was essential to Philip's display of magnificence on this occasion. A second such occasion was the marriage of Philip's son Charles to Margaret of York in 1468, just the sort of public event that Aristotle had judged appropriate for a display of magnificence. Englishman John Paston described the wedding in awesome terms: 'I have never heard of such plenty as there is here … Of the Duke's court,

I never heard of one like it for lords, ladies and gentlemen, knights, squires and gentlemen, except for King Arthur's court. Indeed, I have not the wit or memory to write to you of half the noble events here …'[7] The long list of artists documented to have been employed to produce temporary works of art for this occasion has been mined to discover or confirm the names of the respected Netherlandish artists of the time and the rates of pay they could command, but it also provides an insight into their vital role in the creation of magnificent ephemeral display appropriate for a duke aspiring to be a monarch on such a prestigious occasion.[8] Artists, it seems, could play an essential part in the creation of a royal image of wealth and power.

So impressive was the glitter of the fabulously wealthy Burgundian court that other European rulers aspired to imitate it, and this extended to securing the services of Netherlandish artists. Hence Jean Hey, who probably trained in the Low Countries, was employed by the Bourbon court in France (see Chapter 4, Plate 4.18), though he adapted his approach to suit his French patrons, while Edward IV of England (ruled 1461–70, 1471–83) collected Netherlandish illuminated manuscripts (see Chapter 3, Plate 3.13). Thomas Tolley shows how the ruling elite of France resorted increasingly to the Italian Renaissance to enhance their prestige. Ideals of magnificence descended through the social scale to the wealthy bankers and merchants of Florence, as Jill Burke shows in Chapter 2, but considerations of decorum also came into play. Even a ruling family like the Medici of Florence were obliged to keep public display within acceptable limits, and according to Vasari, Cosimo rejected a design by Brunelleschi for their new palace on the grounds that it was too lavish, choosing instead a more modest design by Michelozzo, built over 20 years beginning in 1444 (Plate 0.1).[9] The 1492 inventory of the Medici palace on the death of Lorenzo 'the Magnificent' reveals the true extent to which the Medici family accumulated art and artefacts in private as one aspect of their lavish lifestyle (see Chapter 1). There was clearly a distinction between what was regarded as appropriate behaviour in public and in private.

In contrast to the cautious public display of the Medici family, the splendid tomb of Richard Beauchamp, made 1447–50, comes perilously close to defying the rules of social decorum, for

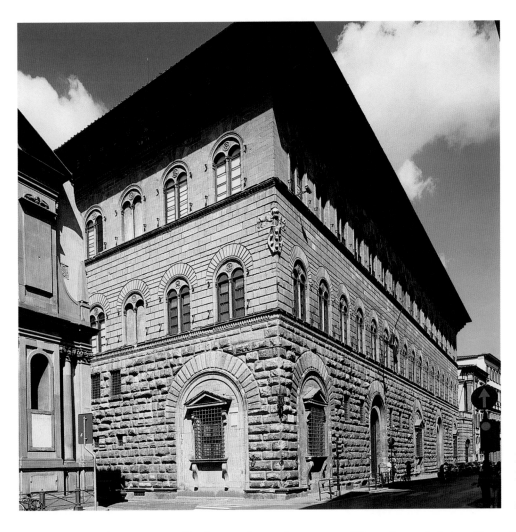

Plate 0.1 The Medici palace, Florence, begun 1444. Photo: © 1998 Scala, Florence.

gilt-bronze tombs were usually the province of the English royal family (Plate 0.2). Although Lieutenant General and a former personal governor and tutor of Henry VI (ruled 1422–61, 1470–1), Beauchamp was only the Earl of Warwick. This is in fact the only such surviving tomb in England of a man who was not royal. Later, in the first decade of the sixteenth century, Lord Stanley is also known to have had a bronze tomb, but his status as husband of Margaret Beaufort and hence stepfather of Henry VII (ruled 1485–1509) – as well as crucial ally in the battle of Bosworth – makes it easier to justify.[10] Beauchamp's costly tomb was placed in a lavishly built and decorated private family chapel in Saint Mary's Church, Warwick. Bronze statues of Beauchamp's relatives, replete with coats of arms, surround the Purbeck marble tomb chest, leaving the viewer in no doubt about his social pedigree.[11] For all that he is represented in prayer facing the altar, Beauchamp's tomb and chapel show that using art to enhance reputation and prestige was by no means restricted to

fifteenth- and sixteenth-century rulers. Indeed, an element of social emulation might even be involved, whereby individuals lower down the social scale might aspire to the practices of their social superiors. In Chapter 6, Carol Richardson shows that tombs may be viewed not just as pious monuments but as monuments to an individual's or institution's reputation and prestige.

Although the social codes restricting the levels of display of the Medici family were largely tacit, in many European countries what was deemed to be the appropriate costume and indicators of wealth of the various social classes were formalised in so-called 'sumptuary laws', and these had a bearing on art. According to the 1510 sumptuary regulations in England, only knights of the Garter were entitled to wear crimson or blue velvet; only dukes, earls and viscounts were allowed to wear cloth of gold, though barons might wear it in doublets; only those of knightly status or higher were permitted to wear foreign fur, while gold chains were the privilege of barons, knights and

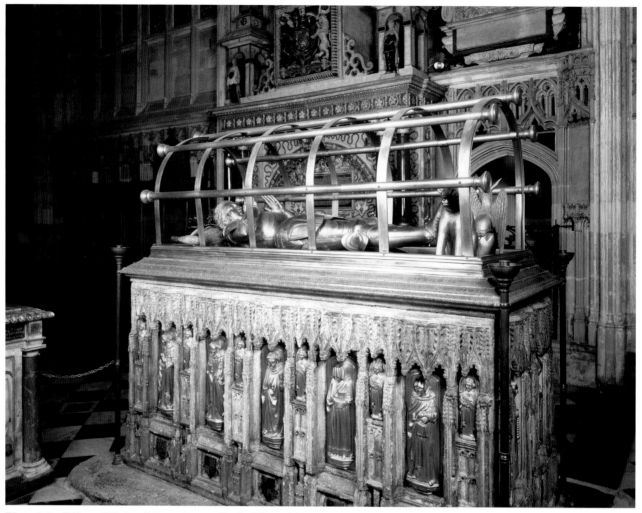

Plate 0.2 Effigy of Richard Beauchamp, Earl of Warwick, 1447–50, gilt-bronze, figure length 183 cm, tomb chest 257 × 111 × 139 cm, Beauchamp Chapel, collegiate church of Saint Mary, Warwick. Courtesy of the collegiate church of Saint Mary, Warwick. Photo: V&A Images/Victoria and Albert Museum.

those with an annual income of over £200.[12] Such restrictions and privileges informed the dress worn by English sitters in portraits by Hans Holbein (see Chapter 7); thus, portraiture could serve as a very clear indicator of social class for those conversant with the sumptuary laws. In Italy, sumptuary laws were, if anything, more strict than in England, aiming to guard against the vainglory and presumption of the few. They could only be enforced in public, however. Illuminated manuscripts were luxury items replete with heraldry and even portraiture that were not subject to public scrutiny or censorship, as Alixe Bovey shows in Chapter 3. Such manuscripts might be secular, reinforcing the owner's scholarly aspirations or pretensions, or religious, reinforcing their piety.

2 Viewing religious art in the Renaissance period

Religious concerns pervaded the visual habits of Europeans. Even apparently secular portraits, like those Holbein painted of merchants of the German Steelyard in London or of scholars and clerics in Switzerland, might have connotations of mortality. Likewise, for all the social radicalism of the *danse macabre* series, painted on cloister walls or published in printed form, in which death is the great leveller assailing rich and poor, powerful and insignificant alike, the prevailing message is a religious one, reminding viewers that they might meet their maker at any time. As Carol Richardson shows in Chapter 6, fear of purgatory was a

powerful motive for commissioning works of art, both to prompt intercession for the deceased and as an offering meriting remission of the donor's sins.

Richard Goldthwaite used the memorable phrase 'privatisation of the church' to describe the increasing expenditure of lay people on religious commissions during the fifteenth and early sixteenth centuries.[13] Individuals or lay institutions such as confraternities might endow altars with altarpieces, establish chantries at particular altars (the provision of a priest specifically charged to pray for the donor and his family), build private chapels onto existing parochial or collegiate foundations as did Alice de la Pole at Ewelme (see Chapter 6), or commission religious works of art for display within their own homes. Alixe Bovey shows how Books of Hours enabled pious lay individuals to participate in the canonical hours of worship observed by those who took religious vows. The lavish miniatures illustrating them served both as a visual aid and as a consumer luxury appropriate to those who had the wealth and leisure, as well as the piety, for such a lifestyle. Individuals might colonise the chancel of a church otherwise reserved for the clergy by commissioning a tomb overlooking the high altar, usually in return for welcome financial contributions to the church. In the same way, families might colonise the church itself, deemed a respectable career choice for a younger son who did not stand to inherit, and hence blur the distinction between dynastic and ecclesiastical interests. In this sense, viewing religious art during the Renaissance crosses the boundaries of private and public, sacred and secular.

It would be a mistake, however, to suppose that religious art in the Renaissance was the province of the wealthy alone, or indeed that the only viewing option for poorer classes was in terms of an education for the illiterate, one of the traditional functions associated with religious art. As Rembrandt Duits shows in the first chapter, even the poor might purchase modest religious artefacts such as pilgrims' badges or souvenir woodcuts at centres of pilgrimage. Jill Burke reveals that by combining their meagre financial resources, even the poorest of confraternities in Florence, the Biliemme, could commission a public work of art as thanksgiving for deliverance from the plague. Many other commissions were parish or civic affairs which might be owned on some level

by the whole community, and in which secular and religious concerns are again inextricable.

Just as decorum and magnificence were important in the selection of an art form and the manner in which it was used, so these concepts were relevant in the dispute over images during the Protestant Reformation. According to the Protestant reformers, the sort of magnificence traditionally accorded to God in the western Catholic tradition through lavish works of art in precious materials was inappropriate, and the cost involved excessive. As such, for reformers art was a symptom of vested interests and luxury from which the Church needed to be purged. In Chapter 2 Jill Burke shows that in Catholic Florence Girolamo Savonarola took much the same stance, at the cost of many works of art and ultimately of his own life. When Hieronymus Emser defended the use of images in the western Catholic Church against the reformers in 1522, he nonetheless recommended a return to the use of the simpler images of the past, which he claimed were more effective in turning the viewer's contemplation from the image to the saint represented than the more modern and 'artful' images.[14] It is possible that this helps to explain the appeal of icons in the West. The vigorous market for icons in Europe explored by Angeliki Lymberopoulou in Chapter 5 shows that many western Catholics were attracted to these images despite the fact that they represented the worship and beliefs of a different tradition. The fall of Constantinople to the Turks in 1453 may have contributed to their popularity. Icons also seem to have been sought after for their spiritual and miraculous power: whenever the city of Venice was in danger, the Venetians appealed for help to the *Virgin Nikopoios* icon that they had brought from Constantinople after the sack of the city in 1204.[15]

It is a moot point to what extent western iconoclasm (the destruction of images) was a theological dispute over the deceptive power of images, or a social protest about misspent money and the role of art in bolstering the authority and doctrines of an allegedly corrupt Church. Both were undoubtedly important to the reformers. Ulrich Zwingli in Zurich and Andreas von Karlstadt in Wittenberg both emphasised that the sums of money lavished on works of art might be better spent on the poor. It was the initial intention to sell the images removed from Basle churches for their

materials in order to raise money for the poor, and only institutional disorganisation led to their being publicly burnt instead. Hans Holbein the Younger was caught up in the Reformation first in Basle and then again in England, and he experienced at first hand the consequences for art (see Chapter 7).

The way that art was viewed shifted fundamentally over the Reformation period. While in the western Catholic and Greek Orthodox traditions images might have been viewed sometimes as miracle-working objects of veneration, in the western Protestant tradition they were demoted to mere wood and paint and considered to deflect worship from its true object, God himself. Whereas the image of the Virgin was central to Cretan icons and western Catholic religious imagery alike, according to the Protestant tradition veneration of or intercession to the Virgin was superstitious and unbiblical. Western Catholic churches had been filled with images, but Protestant churches were largely empty apart from tombs, where the concerns of politics, social status, wealth and dynasty continued to overlap with religious concerns for the afterlife.

3 Conclusion

The aims of this book are to bring to our own modern-day viewing of Renaissance art the interests of prestige, social class and devotion of Renaissance patrons and consumers of art, whether in terms of a specific commission with particular demands, the tacit 'rules' of status and value that an art work needed to observe, or the level of material wealth that might afford one work of art but not another. Inevitably a gulf remains between the viewing habits of fifteenth- and early sixteenth-century patrons and observers and those of our own day, but this book presents a bold attempt to bridge the gulf.

Chapter 1
introduction

Who viewed Renaissance art? What did they see? What, perhaps, were they intended to see? And how can we, centuries later, understand the viewing process of the Renaissance period? There are many ways to approach this difficult issue. An art historian like Erwin Panofsky might begin with individual patrons, investing works of art with complex content emanating from the intellectual and religious culture of the day. We are choosing to begin this book with an entirely different approach in which works of art are examined not as inventive, meaningful objects to be deciphered, but as commodities that were bought and owned just as a piece of furniture or a garment of clothing might be bought and owned: in other words, as part of the material culture of the day.

Material culture, conspicuous consumption and self-fashioning have now become fashionable concepts in the academic discipline of Renaissance art history. In this chapter, Rembrandt Duits gives a clear demonstration of what they mean in practice. Exploring the entire social range of European society beginning with the humblest, he examines the level of material culture accessible to particular classes of people, and with it the kinds of art works that the different classes might own. In this analysis, works of art form both a source of information on cultural and social habits and specific commodities to be owned and consumed. Hence a portrait reveals details about a sitter's standard of living and how he wished his status in society to be conveyed, and also constitutes a possession in itself.

This chapter, and Jill Burke's chapter that follows, explode the myth that art was the province only of the very wealthy, and explore its value not only in monetary terms but in terms of prestige. Although painting has long enjoyed a high status in our own culture, arguably the highest of all the arts, Rembrandt Duits stresses anew that this scale of values differs significantly from that of the Renaissance. In the fifteenth century an item of clothing might routinely cost more than a work of art – sometimes much more – and a princely patron like Charles the Bold still favoured items with high monetary as well as artistic value above the humble painting. This was not backward philistinism, to be corrected eventually by the 'enlightenment' brought by the dissemination of Italian Renaissance values, but simply a reflection of the material culture proper to the most elevated social class of all. This chapter serves as a reminder that there is much more to Renaissance art than painting.

The author's appendix on currency rates in Renaissance Europe (p.56) is an invaluable resource not just for this chapter but for the study of Renaissance art in general.

Kim W. Woods

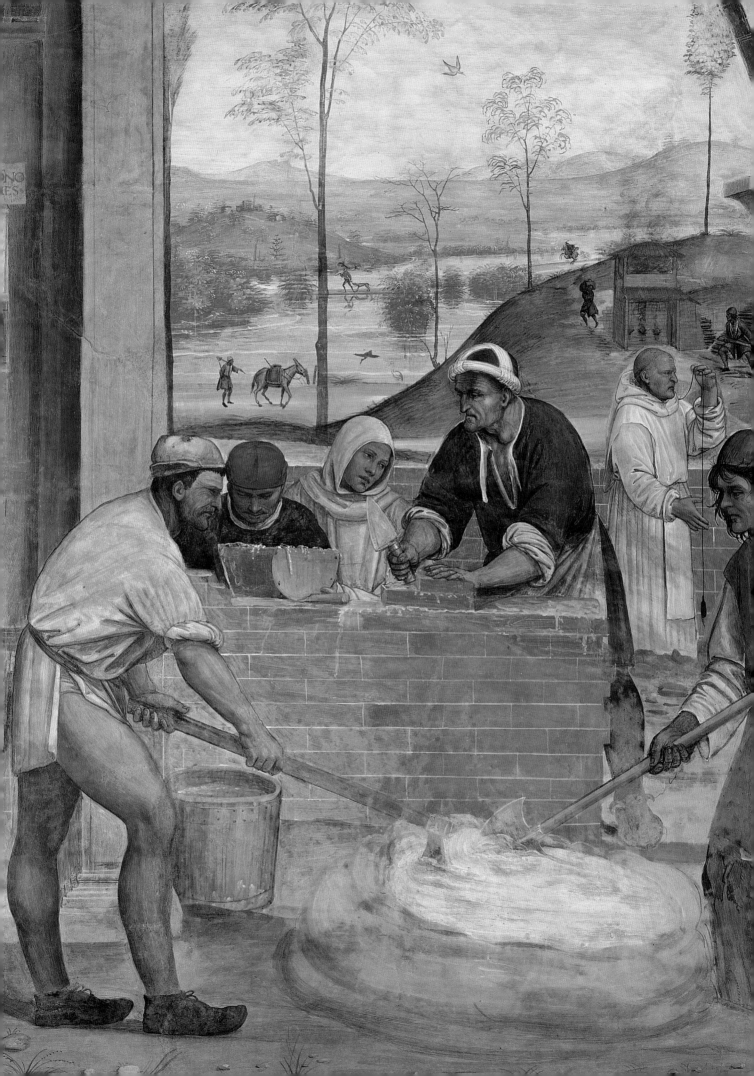

Chapter 1

Art, class and wealth

Rembrandt Duits

There are few greater pleasures in life than an early summer morning visit to the Villa Farnesina in Rome. Situated on the western bank of the River Tiber, its quiet formal gardens cover part of the once much larger grounds that extended right down to the water's edge. The house, built between 1506 and 1510 and designed by the architect Baldassare Peruzzi (1481–1537), defies the common tendency of Roman architecture towards the monumental.[1] Its flights of rooms and loggias are on a human scale, their walls and ceilings adorned with frescoes by great painters. The decorations playfully relate to the former functions of the spaces they embellish. The loggia that used to overlook the river, for example, is home to the mother of all marine mythologies, painted by Raphael (1483–1520) between 1511 and 1514 (Plate 1.2).[2] The fresco shows the classical sea-nymph Galatea surfing the waves on a giant scallop shell drawn by dolphins to taunt her hapless admirer, the ungainly Cyclops Polyphemus.

The villa was long owned by the illustrious Farnese family (hence its name: the small Farnese residence, to be distinguished from their large palace on the Piazza Farnese), but it was built originally for Agostino Chigi (1465–1520).[3] A merchant-banker from Siena, Agostino made his fortune in the service of three successive popes. Alexander VI (reigned 1492–1503) put him in charge of the papal alum mines at Tolfa in 1500, a concession that was subsequently renewed by Julius II (reigned 1503–13) and Leo X (reigned 1513–21). Alum was a mineral widely used as a mordant for dyeing fabrics (the 'glue' that makes

the dye stick to the fibre), so the mines were a lucrative proposition, which Agostino exploited to the best of his abilities. With equal cunning, he managed his own reputation for being fabulously rich. An anecdote recorded from the society circles of his day narrates how, during one of the lavish garden parties held at his Roman villa in the summer of 1518, he had the table silver thrown into the Tiber after use by his guests.[4] It was a well-kept family secret, revealed only by Agostino's seventeenth-century biographer Fabio Chigi, that the silverware was actually caught in a net below the water surface and retrieved the next day.

Table silver at a Renaissance formal dinner consisted of vessels installed on a dresser or *credenza* – a buffet table with several tiers, constructed to give the attending servants quick access to the dinnerware, but also functioning as a display cabinet for ceramics and precious metals that allowed the host to flaunt his wealth.[5] A painting by Sandro Botticelli (1445–1510) shows a *credenza* in the context of an outdoor banquet (Plate 1.3).[6] The panel is the last of a series of four which the artist produced for the Florentine entrepreneur Antonio Pucci, who commissioned them as a wedding gift for the marriage of his son Gianozzo to Lucrezia Bini in 1483 (the Pucci and Bini coats of arms can be seen at the top of the outer columns of the loggia depicted by Botticelli, flanking the arms of the Medici, who had acted as mediators between the two families). The paintings were made to be part of the panelling of a room. They illustrate a story from Boccaccio's *Decamaron*,

Plate 1.1 (Facing page) Sodoma, *Labourers at Work*, detail from *Saint Benedict Appears in the Dream of Two Monks and Gives Them the Plan for a New Monastery* (Plate 1.4).

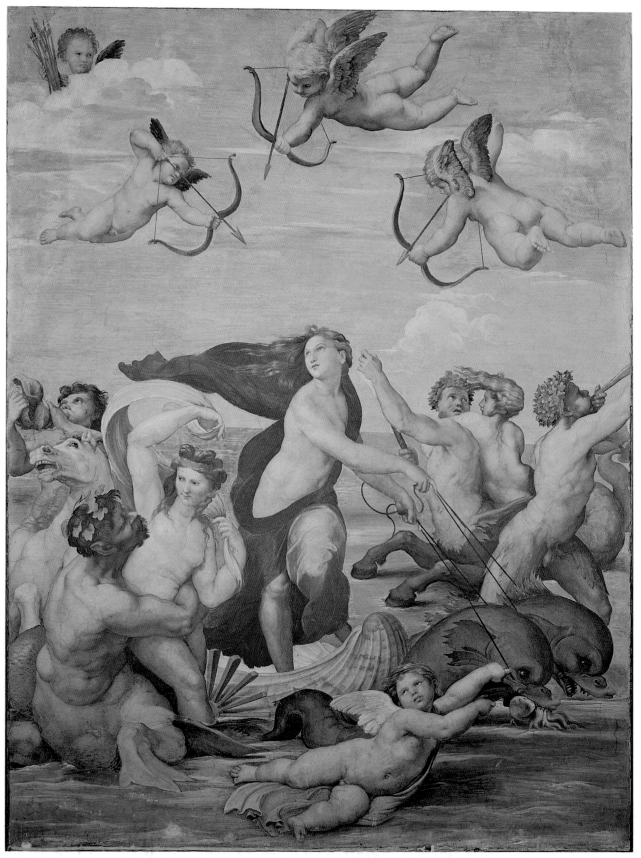

Plate 1.2 Raphael, *The Triumph of Galatea*, 1511–14, fresco, 295 × 225 cm, Villa Farnesina, Rome. Photo: © 1990 Scala, Florence.

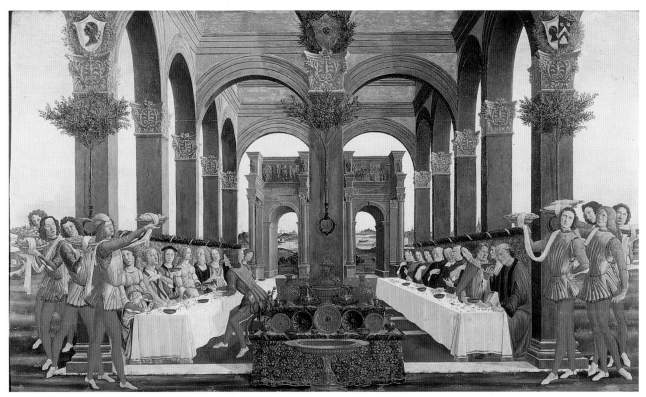

Plate 1.3 Sandro Botticelli, *The Wedding Banquet of Nastagio degli Onesti*, 1483, tempera on panel, 83 × 142 cm, private collection. Photo: Bridgeman Art Library, London.

which ends with a happy marriage feast that is represented in the fourth panel.

The scene shows the wedding guests gathered in an open loggia. The long tables at which they are seated are very sparsely laid by modern standards, attesting to the fact that the art of table setting, one of the lesser known Renaissance contributions to modern culture, had only just begun to develop in Italy around this time.[7] The *credenza* is standing in the middle, its position almost making it the central subject of the painting. Most prominent among its contents are the silver and silver-gilt water pitchers and wash basins for the guests to rinse their hands between courses. In real life, such pitchers and basins were often spectacular objects with figurative ornaments designed by prominent artists. Raphael, for instance, is documented to have designed two basins for Agostino Chigi in 1510.[8] It must have made a deep impression to see vessels of this kind so casually discarded into the murky waters of the Tiber. Yet the performance staged by Agostino Chigi on the river bank that summer evening, though eccentric, was perhaps less unusual than it may appear. Taking a favourite piece of Renaissance lore as its point

of departure, this chapter will show how such calculated gestures to manifest wealth and social status, whether genuine or simulated, were an integral part of the interaction between patrons, artists and their audience in Renaissance art.

1 Catch-phrases or concepts?

Students of Renaissance art browsing through conference programmes or recent bibliographies these days can easily find themselves confounded by a range of suggestive phrases, such as 'conspicuous consumption', 'material culture' and 'self-fashioning'. Some appear to take such expressions overly seriously; others see them as vacuous slogans. Given this state of affairs, it is worth taking a brief look at their theoretical background. The phrase 'conspicuous consumption', for example, is often used light-heartedly to refer to the purchase of expensive commodities for the sole purpose of demonstrating the buyer's wealth. Not all of its users may be aware that they are quoting from a late nineteenth-century work of social philosophy. The American economist Thorstein Veblen, a follower of Karl Marx, published his

masterpiece, *The Theory of the Leisure Class*, in 1899.[9] The book is a half-serious, half-satirical analysis of the strategies developed by the industrial upper middle class to manifest and maintain their social superiority. The essence of these strategies was a deliberately excessive use of resources – time, labour, money, goods – both to signify wealth beyond the bare necessities of life and to keep others from gaining access to the same resources. Agostino Chigi's (simulated) disposal of silverware into the Tiber was a Renaissance example of such a strategy, one that Veblen would have classified as 'conspicuous waste'.

Veblen similarly coined the phrase 'conspicuous consumption' for the acquisition of commodities beyond the purchaser's elementary needs. Chigi's construction of a pleasure villa would come under this heading, as would his use of silver rather than pewter or ceramic vessels for the entertainment of his guests. Veblen's theory, however, was about taste as much as economics. He argued that the members of the so-called leisure class cultivated a certain fastidiousness regarding the luxury goods they invested in. They made an effort (and spent money!) to educate their kind in the distinction between 'right' and 'wrong' in the display of wealth and social status: adhere to the established pattern and you manifest a sense of class, deviate from it and you expose yourself as a parvenu with money but no taste. The fact that Chigi decorated his villa with frescoes depicting scenes from classical mythology in a quasi-antique style reflects a set of aesthetic preferences resulting from a contemporary (humanist) education.

Unlike 'conspicuous consumption', the phrase 'material culture' cannot be traced to a single source. It originates in the field of anthropology, where it has existed since at least the early twentieth century. For anthropologists, it simply stands for all material aspects of human civilisation, functional as well as decorative, from flint axes to cathedrals: both the silver Agostino Chigi cast into the Tiber and the net in which it was caught. The first outsiders to adopt this concept, around the middle of the twentieth century, were archaeologists, for whom the reconstruction of lost cultures on the basis of their material remains is an important part of their work. More recently, art historians have begun to incorporate the phrase into their vocabulary as

well. Historians of Renaissance art appear to find it particularly appealing, mainly because it helps to circumvent questions of the artistic status of artefacts raised by the way we view art in our own time. Nowadays we are quite used to distinguish between 'Art with a capital A' and the 'decorative' or 'applied' arts – the former a profound emotional and intellectual medium for communication, the latter a category of functional objects with added aesthetic qualities. The art of painting, in particular, is treated reverentially, with entire museums devoted to it exclusively. A fresco by Raphael in Chigi's villa qualifies as Art, his table silver as ornate accessories.

The roots of this aesthetic hierarchy go back to the Renaissance. It was Giorgio Vasari (1511–74) who singled out painting, sculpture and architecture from the other forms of craftsmanship of his day in his famous book of artists' biographies, *Lives of the Painters, Sculptors and Architects* (first edition 1550; second edition 1568).[10] Vasari claimed his three arts deserved their special status because all other artisans depended on them for designs.[11] This claim is partially true, as painters, for instance, regularly supplied designs for silverware and tapestries. However, Vasari's book was also a work of propaganda for the very arts it described. His choice of artists and works of art is not representative of the artisan population and the artistic production of Renaissance Italy, let alone Europe; his views on art may reflect the tastes of Renaissance patrons with regard to painting, sculpture and architecture, but not to other media. Art forms such as goldsmiths' work, embroidery and silk weaving were much more expensive than paintings, and were favoured by the wealthiest and most prestigious patrons. To describe the collective arts of the Renaissance as part of the material culture of the period provides a neutral umbrella term and indicates that works of art had social functions as well as aesthetic properties.

The phrase 'self-fashioning' is the least venerable of the three cited at the beginning of this section. It has its roots in sociology, specifically the theory that identity is not merely a combination of accidental character traits, but a construct crafted by individuals in interaction with the rules and patterns of the society in which they live. The idea of 'self-fashioning' was first introduced into Renaissance studies by historians of literature

attempting to analyse the various images authors gave of themselves through their written works.[12] In the context of art history, the expression has come to be applied to patrons rather than to artists in a way that deviates from its original meaning. It has become shorthand for patrons using art (or, for that matter, material culture) to project an identity to the outside world, almost as a work of art in its own right.[13] The implicit danger of this approach is that one single aspect of Renaissance art – patronage – is promoted to its guiding principle. None the less, works of art carried social messages about the people who bought or commissioned them, and these messages formed part of how art was viewed.[14]

This chapter will discuss issues of identity that contemporaries would have observed in art. It will show how all ranks of Renaissance society used art forms to distinguish themselves socially, conveying messages about their status and the amount of surplus wealth they had to spend. These art forms included everything from lead pilgrims' badges to goldsmiths' work; painting, sculpture and architecture as well as silverware, maiolica, armour, textiles, costume and interior decoration; both public commissions and objects from private households. The chapter started with a Sienese banker active in Rome; other examples will be equally international. The most information regarding the social function of Renaissance art, however, is available from the city of Florence, making it inevitable that Florence will function as an anchor point. One Florentine document, in particular, will be a constant source of reference. The 1492 inventory of the possessions of Lorenzo 'the Magnificent' de' Medici (1449–92) not only lists an exceptional array of worldly goods, but also includes a financial appraisal of almost every single item.[15] It gives an idea of the monetary value various artefacts represented for Renaissance viewers.

2 The working classes

In the early sixteenth century, the Italian painter known as Sodoma (1477–1549) completed a large fresco cycle begun about a decade earlier by his older colleague Luca Signorelli (1450–1523), decorating the great cloister of the Benedictine Abbey of Monte Oliveto in Tuscany (south of

Siena).[16] One of the frescoes shows, on the left, how the founder of the Benedictine Order, Saint Benedict, appears to two of his followers in their dream, presenting them with a scale model of a new monastery he instructs them to build (Plate 1.4). The picture gives an insight into the interior decoration of a monk's cell in the Renaissance. The furnishing is predictably sparse, but the two monks share a comfortable bed on an elevation (*predella*) with built-in storage chests (note the little key protruding from the keyhole in the foreground).[17] Their ceiling beams are decorated with gaudy colours. They have a dried apple for a fresh smell, a brass candlestick, and a small painting of the Virgin and Child on the ledge above their bed. Interestingly, there is a plaque inscribed with a secular epigram by the Latin poet Martial on their wall: 'sit nox cum somno, sit sine lite dies' (the night with sleep, the day without a quarrel).[18]

The right half of the fresco depicts the new monastery under construction. Two monks (the same?) act as overseers on the site. Two journeymen are mixing mortar in the foreground, while a mason (*muratore*) and his assistant are laying bricks. Sodoma's depiction of the building works is rare in its realistic rendering of the appearance of labourers. Lavish miniatures from deluxe manuscripts such as the *Très Riches Heures* of the Duc de Berry (see Plates 3.2–3.3), not to mention twentieth-century Hollywood films which eagerly drew on such visually attractive sources, have created an image of the working classes of this period as going about their business in brightly coloured attire. Renaissance Europe, however, was still a developing country by today's standards. During the fifteenth century, a Tuscan bricklayer earned between 10 and 20 silver soldi per day working on short-term contracts (see the appendix for details about the currency).[19] The working year consisted of 250 days after deduction of Sundays and liturgical holidays, but it was unlikely a bricklayer would have been fully employed for that length of time. His top annual salary might have been equivalent to 30 gold florins, the price of one single gown of purple wool lined with marten as could be found in the wardrobe of Lorenzo de' Medici in 1492.[20]

The only materials a bricklayer could afford for clothes were, by contrast, linen and cotton. In the

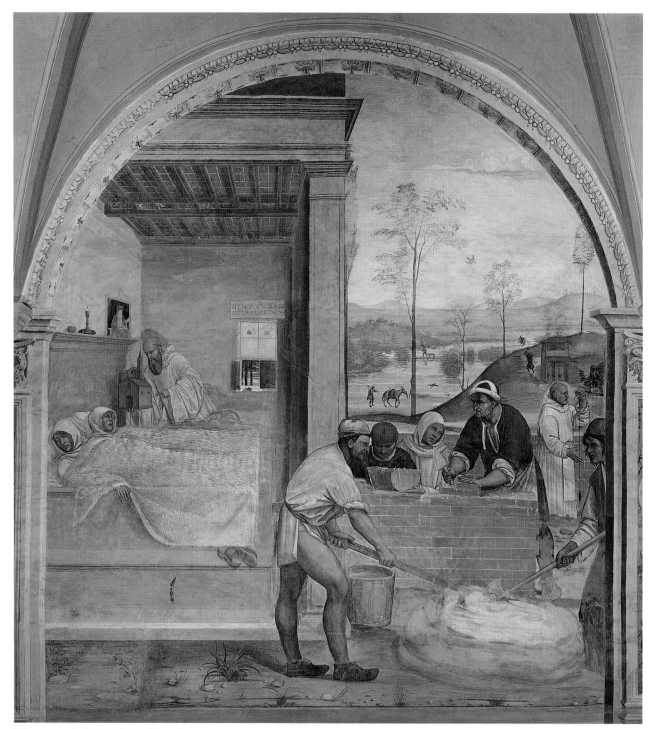

Plate 1.4 Sodoma, *Saint Benedict Appears in the Dream of Two Monks and Gives Them the Plan for a New Monastery*, 1505–8, fresco with added tempera, 420 × *c.*265 cm, great cloister, Abbey of Monte Oliveto Maggiore. Used with the permission of the Ministero Beni e Attività Culturali. Photo: © 2004 Scala, Florence.

1492 Medici inventory, fine linen (but not the finest quality imported from Rheims) was appraised at about 0.16 florins per braccio (58.4 cm for most types of cloth in Florence; in the case of linen the fabric was probably woven at a width of 2 braccia), while wool was expensive even in a cheap quality,

with prices of up to half a gold florin per braccio.[21] The grubby, threadbare outfits worn by the men in Sodoma's fresco are probably what Renaissance builders actually dressed in when at work. Of the two journeymen in front, whose wages would have been much lower still than those of a trained

mason, the one on the left has nothing but a cap with a prominent hole in it, a smudged cotton or coarse linen shirt (*camiccia*) and briefs (*mutande*); his bare legs constitute perhaps the fifteenth-century counterpart of the modern builder's cleavage. His colleague on the right has a similar shirt under a sleeveless tunic with a large hole at the knee. The mason holding the small cement trough behind the wall wears some colour, which indicates he is the only skilled (and therefore somewhat better paid) worker on the site. The hues are subdued, however, and the fabrics appear to be thin – once more linen or cotton.

At least 95 per cent of the population of Renaissance Europe must have been dressed in such a fashion.[22] It is against the backdrop of this vast economic underclass that the efforts to stand out socially of the remaining 5 per cent of people have to be seen. Yet, the proletariat, too, had its own modest forms of conspicuous consumption. One of the most important status markers for the poor was perhaps the pilgrim's badge. The road of pilgrimage was open to all ranks, as inns and convents provided pilgrims en route with free accommodation.[23] A pilgrimage was officially undertaken to fulfil a religious vow. By 1500, though, visits to renowned relics and miraculous images had become a form of tourism. Paupers could even earn money by making the sacred journey on behalf of a rich person. Among the most popular destinations were the sepulchre of the apostle Saint James in Santiago da Compostela in Spain and the Veronica in St Peter's in the Vatican – the veil Saint Veronica used to wipe Christ's face on the way to Calvary, leaving an imprint of his face on the fabric.

Pilgrims' badges were, in their simplest guise, cheap tokens cast in lead or pewter, or stamped in tin or brass foil, which were sold as souvenirs at the holy sites.[24] They took the shape of an image or symbol associated with the shrine at which they were issued, such as the familiar scallop shells from Santiago da Compostela, or medallions with the vernicle: the stark frontal image of the face of Christ as it appears on the Veronica (Plate 1.5).[25] Pilgrims returning from these sites wore the badges pinned to their hats. An early sixteenth-century engraving by the Netherlandish artist Lucas van Leyden (*c*.1494–1533), for example, shows a pilgrim couple sitting down for a small picnic along the way. Their characteristic headwear

Plate 1.5 Unknown craftsman, *The Vernicle, or the Veil of Saint Veronica* (pilgrim's badge), 1475–1525, stamped brass, diameter 3 cm, Museum of London. Photo: © Museum of London.

bears scallop shells – possibly but not necessarily obtained in Santiago da Compostela – and badges of the Veronica (Plate 1.6).

The badges were believed to protect the wearer against evil. At a price range that was roughly equivalent to one-tenth to one-third of the daily wages of a Florentine mason for a dozen badges, they were also among the very few luxury goods marketed specifically for consumers with a very small purse (although much more glamorous versions in gold and silver existed).[26] With sales figures running into the hundreds of thousands, the Church can claim to be the first to have successfully exploited the economic potential of mass consumption. Their large-scale manufacture and unpretentious execution mean pilgrims' badges belong to an area of material culture that is not normally included in art-historical surveys. Yet, for the great majority of the population, they were a form of craftsmanship more familiar and accessible than many of the works of Renaissance art admired today. A pilgrim's badge was a simple type of jewellery; it signified, moreover, that its owner had travelled far and seen exotic places. It offered those who were otherwise condemned to a fairly colourless existence an opportunity to shape a more interesting identity for themselves.

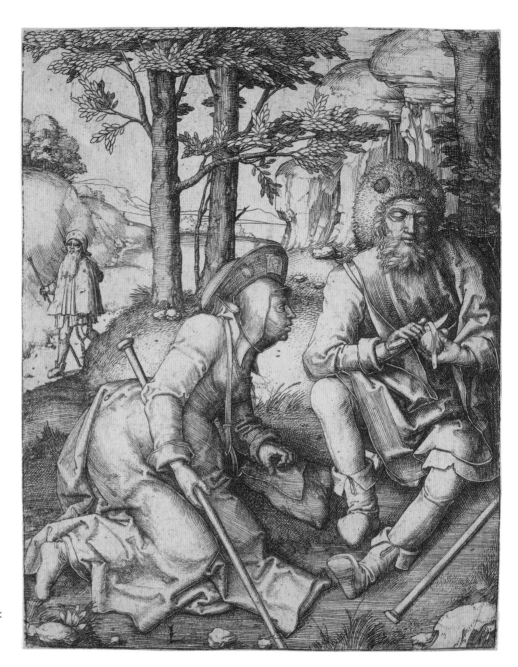

Plate 1.6 Lucas van Leyden, *The Pilgrims*, 1508, engraving, 15 × 12 cm, British Museum, London. Photo: © The Trustees of the British Museum.

3 Artisans

A gifted member of the working classes could achieve social mobility by training to become a specialised craftsman. This brought greater responsibilities, as a master had to run a workshop and to take care of apprentices and assistants who lived as dependents in his household, but the payment was considerably better.[27] The manufacture of an altarpiece, for instance, would have constituted only part of the annual activities of a successful master painter, but he was likely to earn more from it than a mason made in a good year. An example is Botticelli's Bardi altarpiece of 1484, a standard-size Florentine altarpiece of the period showing the Virgin and Child and two saints, painted in tempera on panel with an ornamental frame, made for the family chapel of the Florentine merchant Giovanni d'Agnolo Bardi in the church of Santo Spirito (Plate 1.7).[28] Detailed information concerning the payments for the work has been preserved. The total cost of the painting amounted to almost 100 gold florins, about three times the top annual salary of a bricklayer, which was a competitive price for Florentine altarpieces at the time. The price can be broken down into three main components: slightly over 24 florins for the panel and frame; 40 florins for materials, mostly ultramarine blue and gold leaf; and 35

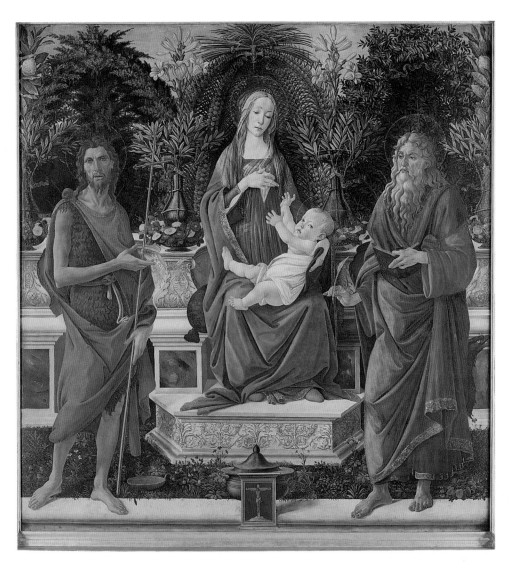

Plate 1.7 Sandro Botticelli, *Virgin and Child Enthroned between Saints John the Baptist and John the Evangelist*, known as the Bardi altarpiece, 1484, tempera on panel, 180 × 185 cm, Gemäldegalerie, Staatliche Museen, Berlin. Photo: © 2007 bpk/Staatliche Museen zu Berlin/Jörg P. Anders.

florins to the painter 'pel suo pennello', literally for his brush.

The most lucrative position for an artisan was to be appointed court artist by a grand prince. In 1425, Jan van Eyck (*c*.1395–1441) enjoyed the status of *valet-de-chambre* (a title given to middle-bracket court functionaries) at the court of Philip the Good, Duke of Burgundy. In this capacity, he received an annual pension of 100 pounds of Tours, the equivalent of 50–55 Florentine florins at the time.[29] This sum was a guaranteed annual salary that came on top of van Eyck's income from individual commissions. The artist also had the rent of his house in Bruges paid. By 1434, his pension had risen to an astonishing 360 pounds of 40 groat, the equivalent of a similar sum in Florentine florins, or 12 times the income of a Florentine bricklayer.

The earnings of painters were by no means exceptional among craftsmen. A Florentine brocade weaver, for instance, had an annual salary of 170 florins, nearly six times as much as a bricklayer, and five times what Botticelli received 'pel suo penello' when he produced an altarpiece.[30] Gerard Loyet, a goldsmith working for the Burgundian court in the second half of the fifteenth century, received an annual pension of 160 pounds of 40 groat (*c*.150–170 florins), plus income from commissions, which ranged from 30 pounds for a small statuette to no less than 830 pounds for the making of two tomb effigies and two busts for Duke Charles the Bold in 1477.[31]

All these artisans made their living from the conspicuous consumption of the rich. Some took pride in their illustrious clientele, as is evident from the 1449 portrait of a southern Netherlandish goldsmith by Petrus Christus (*c*.1410–75/6) (Plate 1.8). Long thought to be Saint Eligius, the patron saint of goldsmiths, the protagonist of this

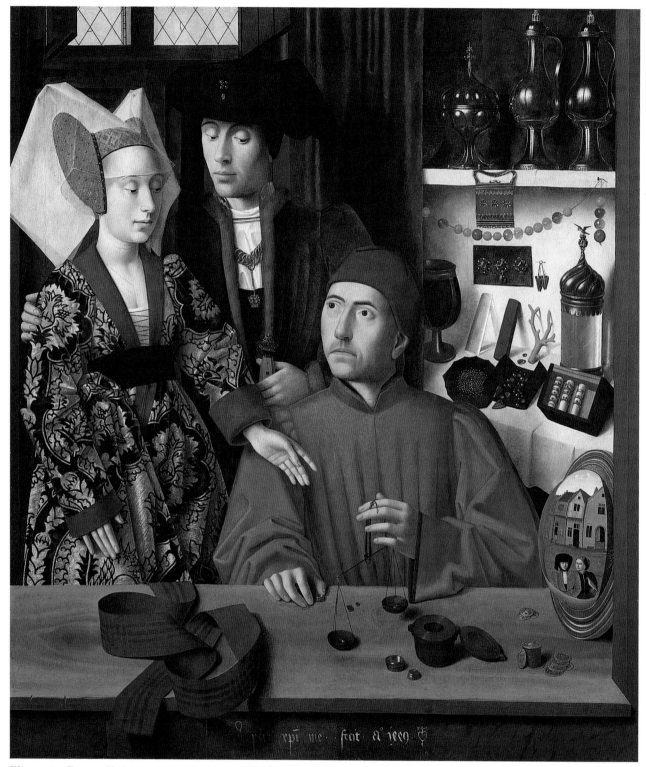

Plate 1.8 Petrus Christus, *Portrait of a Goldsmith* (Willem van Vlueten?), 1449, oil on panel, 98 × 85 cm, Metropolitan Museum of Art, New York. Robert Lehman Collection, 1975 (1975.1.110). Photo: © 1993 The Metropolitan Museum of Art.

painting has recently been convincingly identified as the Bruges goldsmith Willem van Vlueten.[32] The master has been depicted in his workshop, establishing the weight of a set of wedding bands with a little balance. The reflection in the mirror on the right, which shows a street scene with a passing nobleman and his falconer, suggests he is seated at an open shop window. He is visited by a female client, possibly Mary of Guelders, who placed an order for jewellery for her wedding to

James II of Scotland (ruled 1437–60) with van Vlueten in the year the picture was made. The lady is undoubtedly a noblewoman, and the cloth-of-gold gown she is wearing suggests wedding attire. The man accompanying her is probably a male chaperone: he wears a pendant with the coat of arms of the Duchy of Guelders (two lions rampant) on the gold chain around his neck.

The wealth generated by the production of luxury goods also allowed artisans an extended, if still rather modest, range of material culture of their own. A small sample can be seen in the 1496 double portrait of the artist and his wife by the Master of Frankfurt (1460–c.1518), a painter whose style was first defined on the basis of two paintings in Frankfurt but who worked, in fact, in Antwerp (Plate 1.9).[33] The sitters are shown behind a table on which a small still life is exhibited, consisting, among other things, of a pewter jug, a tin plate with berries, a knife with an inlaid wooden handle, two drinking glasses, and a little ceramic vase with flowers. Such items may well have been found in the painter's actual household. The master and his wife are stylishly though not ostentatiously dressed. Their clothes appear to be made of woollen fabrics, with a fur lining on the artist's gown and fine linen for his wife's veil. His wife is also holding a rosary with coral beads.

By comparison, the costume of Petrus Christus's goldsmith is much richer. He is wearing a scarlet woollen gown lined with fine fur, perhaps miniver (squirrel). Scarlet was a red dye made from the secretion of insects.[34] It was imported from Asia in small quantities and formed the most expensive dyestuff for textiles in the Renaissance. Flemish weavers used it exclusively for their finest woollen fabrics, which bore the name *schaarlaken* (possibly translating as shorn cloth), a term that was subsequently transferred to the colour in which these fabrics were dyed. In the Italian silk industry, the same red dye was known as crimson, or *chermisi*, a term derived from the Arabic word *kermes*, which indicated the insects on whose red secretion the dyestuff was based.[35] The value of the goldsmith's gown may well have been similar to that of the fur-lined purple woollen gown appraised at 30 florins in the 1492 Medici inventory.[36] The possibility that a goldsmith with a flourishing shop actually possessed such a garment for a Sunday

suit cannot be excluded, but it is also conceivable that the painter flattered his client by dressing him up as a rich burgher rather than as an artisan.

An equally expensive object that was definitely purchased by this goldsmith was the painting itself. It was probably not uncommon for members of the artisan class to own small devotional paintings. In the 1492 Medici inventory, a small panel of the Virgin and Child by Fra Angelico was valued at the modest sum of 5 florins. A small triptych by the Florentine painter Neri di Bicci made for a nun cost as little as 4 florins in 1462 (see Plate 1.29).[37] A large portrait by the renowned master Petrus Christus, however, must have stood out in a craftsman's house. It is likely that the intended audience for this painting as well as the Master of Frankfurt's double portrait included the artists' rich customers. Both works present the viewer with a calculated image (the phrase 'self-fashioning' might apply here in its original meaning) of professional prowess. Petrus Christus's goldsmith is sitting in front of a cabinet with a collection of his materials – gems, pearls, a branch of coral – and samples of his work, including silver-gilt vessels, a coconut cup and pieces of jewellery. The painting by the Master of Frankfurt is itself a display case of the artist's skills. Two painted flies deceptively appear to be crawling on the picture surface, showing his talent for mimicking reality. The still life further demonstrated his ability to handle a range of different textures and light reflections.

The material culture depicted in the paintings (clothing and household objects) projected a picture of professional success translated into relative personal prosperity. The Master of Frankfurt also emphasised his corporate status. A painted extension of the picture frame above the sitters' heads bears a coat of arms held by a winged ox, the attribute of Saint Luke the Evangelist, who, according to the legend, painted a portrait of the Virgin. The coat of arms belonged to the Antwerp guild of painters, the guild of Saint Luke, of which the master was a member.[38] A guild was, of course, primarily a corporation for the protection and regulation of trade, but it also formed a collective through which its members could wield power well beyond their individual financial means (as discussed in the next chapter by Jill Burke).

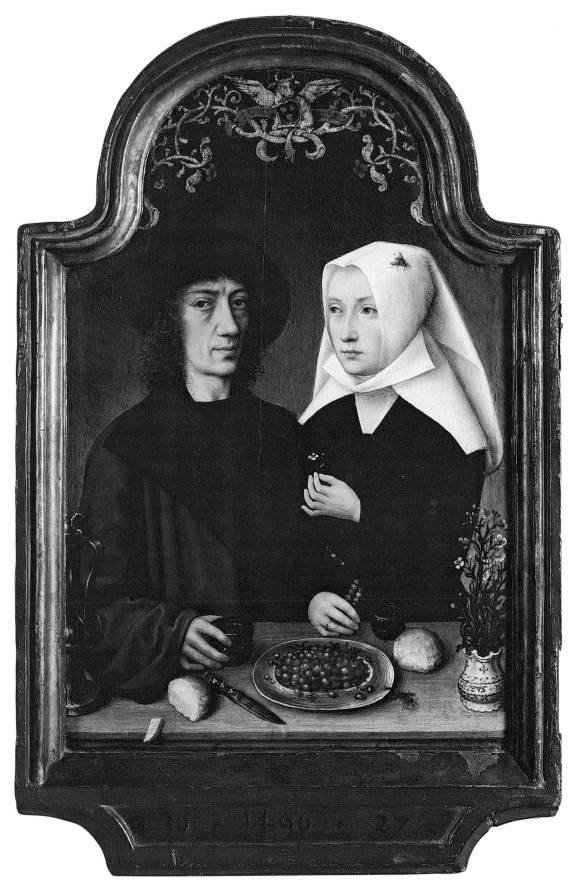

Plate 1.9 Master of Frankfurt, *Portrait of the Artist and his Wife*, 1496, oil on panel, 38 × 24 cm, Koninklijk Museum voor Schone Kunsten, Antwerp.

4 Doctors

Artisans earned enough to allow their intellectually talented offspring further education, which was generally a guarantee for them to make another step up the social scale. In 1427, for instance, Matteolo Mattioli, the son of a Perugian painter called Baldassare Mattioli (active 1416–23), became a lecturer in philosophy in his native city.[39] Five years later, Matteolo completed his doctorate in medicine at the University of Padua, where he was subsequently appointed as a lecturer in 1437. His father specialised in decorating furniture and painting coats of arms, which must have made him a decent living. None the less, his income probably paled to insignificance next to the stipendium of 330 florins a year his son was awarded upon his return to Perugia, where he taught medicine at the university from 1454 onwards. Matteolo's income was a normal fee for a lecturer in medicine, comparable to what was being paid at the University of Pisa, for example.[40] Salaries at the prestigious University of Padua were even higher, ranging from 400 to 600 florins a year for senior staff. Studying medicine was also a good way to mingle with the higher social classes.[41]

The considerable wealth of doctors and others with an academic training (lawyers, in particular) was expressed through various forms of conspicuous consumption in the domestic sphere, as is evident from the 1484 inventory of the household of a physician from Siena, Master Bartolo di Tura (1391–1477).[42] Bartolo was the owner of a sizeable town house with two storeys, a basement and a loft. An inventory of its furnishings was made up at the death of Bartolo's son Bandino and his wife in 1483.[43]

Rich houses in Renaissance Italy usually contained one or more clusters of rooms for various family units: the *pater familias* with his wife and underage children; an adult son with his wife and children, etc. The centre of each cluster was the *camera grande* or grand chamber, which combined several functions usually divided between the master bedroom and the living room today.[44] In Bartolo's house, the most prestigious room was the *camera grande* on the first floor. It contained, among other things, two small devotional paintings: a Virgin and Child with two angels; and a panel with Saint Cosmas and Saint Damian, the patron saints of medics.[45] The room was dominated,

Plate 1.10 Vittore Carpaccio, *The Dream of Saint Ursula*, 1495, oil on canvas, 274 × 267 cm, Gallerie dell'Accademia, Venice. Used with the permission of the Ministero Beni e Attività Culturali. Photo: © 1990 Scala, Florence.

however, by what the inventory describes as 'a large bed, decorated with painted gold brocade, enclosed by four posts Venetian style'.[46] An artist's impression of such a Venetian-style four-poster can be found in a contemporary painting of *The Dream of Saint Ursula* by Vittore Carpaccio (c.1460/6–1525/6) (Plate 1.10).[47] Saint Ursula's bed is mounted on a *predella* like the bed of Sodoma's Benedictine monks (Plate 1.4), but with an added canopy on four slender posts.

Whereas the *predella* in the painting is decorated with *intarsie* (wood inlays), Bartolo's bed was embellished with a painted imitation of gold brocade. What this may have looked like can be seen on a surviving piece of Italian Renaissance furniture: a *cassone*, or wedding chest, which has painted gold-brocade hangings on its *spalliera*, the raised panel with a cornice at the back (Plate 1.11).[48] Gold brocade, a generic term used for silk fabrics woven with additional patterns in gold thread, was by far the most expensive textile known in the Renaissance. A fifteenth-century Florentine silk-weaving treatise puts its production price alone at between 1 and 16 florins per square braccio (one-third of a square metre), depending on the amount of gold thread used.[49] During the fifteenth century, this gold thread usually consisted

Plate 1.11 Zanobi di Domenico (construction) with Biagio d'Antonio and Jacopo del Sellaio (painted decorations), wedding chest (*cassone*), 1472 (part nineteenth-century reconstruction, e.g. the feet), poplar decorated in tempera and gold leaf, 206 × 193 × 66 cm, Courtauld Institute of Art Gallery, London.

of a silk core wrapped in a foil of silver-gilt. Its precious metal content was the defining ingredient for the price of the fabric. The brocades listed in the Florentine treatise suggest a range of textiles with between one-twelfth and two-thirds of their surface covered in gold thread. The very richest form of gold brocade, also known as cloth of gold, is worn by the noble lady visiting the goldsmith in his studio in Petrus Christus's painting discussed above (Plate 1.8).

In Bartolo di Tura's household, actual gold brocade was found only in the form of one headscarf and one pair of sleeves for a woman's dress (in fifteenth-century fashion, sleeves came as separate garments that could be attached to a dress or gown by means of laces or ribbons).[50] Bedcovers with merely decorative borders made of gold brocade were appraised at 100 florins each in other Renaissance inventories – the equivalent of three times the annual income of a Florentine mason, and between one-sixth and one-third of the annual income of a physician.[51] Master Bartolo probably could not afford actual gold-brocade drapes on his

bed. Instead, he opted for simulation, as his later compatriot Agostino Chigi did more flagrantly in his party trick with silverware.

Some of the further material culture with which doctors surrounded themselves can be seen in a 1515 double portrait by Lorenzo Lotto (c.1480–1556) (Plate 1.12).[52] The sitters are Giovanni Agostino della Torre and his son Nicolò, two generations of physicians from the northern Italian town of Bergamo. Their appearance looks modest enough at first glance, but there are a number of subtle status markers a contemporary viewer would undoubtedly have noted. Giovanni Agostino's attire is a relatively inconspicuous blue-grey fur-lined woollen gown appropriate for his advanced age (the sitter was 80 years old when his likeness was captured). His true wealth is betrayed, however, by the prominent gold ring with a stone on his left index finger and the golden clasp and ornaments on his belt – finery with which not even Petrus Christus's goldsmith had himself depicted. Gold rings with stones are valued at 10 to 30 florins in the 1492 Medici inventory.[53]

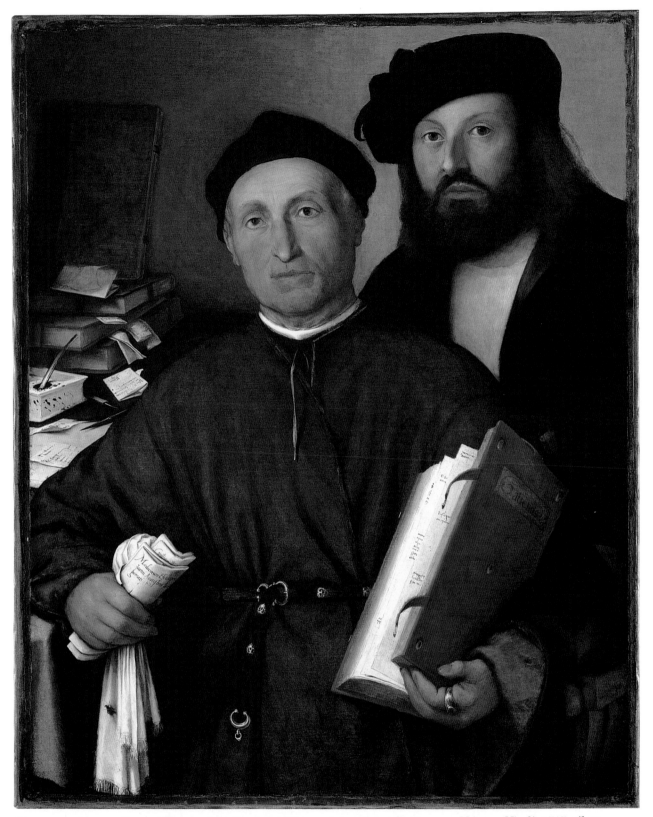

Plate 1.12 Lorenzo Lotto, *Portrait of the Physician Giovanni Agostino della Torre and his son Nicolò*, 1515, oil on canvas, 84 × 68 cm, National Gallery, London. Photo: © National Gallery, London.

Plate 1.13 Christoph Weiditz, portrait medal of the physician Ambrosius Jung (obverse) (reverse: Jung's coat of arms and motto), 1528, bronze, diameter 7 cm, National Gallery of Art, Washington, DC, Samuel H. Kress Collection. Photo: © 2005 Board of Trustees, National Gallery of Art, Washington, DC.

The paint of Nicolò's costume is unfortunately damaged, but what is left of it suggests the latest Venetian male fashion of the day. The books Giovanni Agostino is consulting were tools of his trade (the one he holds bears the name of Galen, the ancient Greek father of the medical discipline), but they were also fairly expensive commodities in their own right. In fifteenth-century Venice, for example, the majority of books had prices of up to 5 gold ducats (roughly equivalent to the same amount in Florentine florins): not a huge sum but still expensive compared to the income of a labourer.[54] Moreover, collectively, the five books depicted in Lotto's painting might have represented a value of as much as 25 ducats. Even the fact that the doctor is sitting on a chair singles him out as an affluent man, as chairs were relatively rare and exclusive pieces of furniture at the time. Interestingly, the artist has also smuggled in a small advertisement for his own skills in the shape of the illusionistic fly sitting on Giovanni Agostino's otherwise spotless white handkerchief.

The sense of identity Renaissance viewers may have detected in portraits of physicians is one reflecting the social class of the sitters, wedged in between the stratum of specialised craftsmen and the higher echelons of rich merchants and minor nobility. Lotto's portrait of Giovanni Agostino della Torre, not unlike that of a craftsman, emphasises the sitter's occupation, the composition giving the impression that he has been interrupted while writing prescriptions at his desk. The double portrait of the medic and his son also expresses pride in the continuation of a family lineage within the same profession and social rank. A much more pretentious form of representation is the bronze portrait medal the Augsburg doctor Ambrosius Jung commissioned from Christoph Weiditz (1500–59) in 1528 (Plate 1.13).[55] Ambrosius Jung had studied in Padua and was city physician of Augsburg at the time the medal was made. The front depicts the sitter in profile, dressed in a gown with a broad fur collar and the typical hat of a scholar, with attached ear warmers that enabled the wearer to spend hours immobile in a poorly heated study.

Jung was also the son of the personal physician of the Holy Roman Emperor Maximilian I. In 1520, he was knighted by Maximilian's successor, Charles V, as a posthumous reward for his father's services. The back of the medal contains the coat of arms Jung adopted, crested with a helmet to indicate his title. Jung was a staunch Protestant, and both the arms and the crest show Christ as a judge of souls, the accompanying motto reading 'Iustitia nostra Christus' (our justice is Christ). The medal itself was equally a token of Jung's

noble status. Bronze was an expensive material, much more so than paint on panel or canvas. A small gilt bronze plaque of the Virgin and Child by Donatello was valued at 25 florins in the 1492 Medici inventory, against 5 florins for a small panel painting by Fra Angelico.[56] Bronze medals had been a favourite medium for portraiture among princes and patricians since the moment of their invention in Italy in the fifteenth century.[57]

5 Entrepreneurs

Those who had accumulated a small capital could make the gamble of investing it in a private business venture. Over time (often a few generations) and with luck and skill, this could lead to a substantial fortune. The Florentine entrepreneur Andrea Banchi (1372–1462) was the son of a silk shop owner.[58] Starting with about 1,000 florins, he invested in a silk manufacturing firm, through which he managed to increase his assets to 18,000 florins, about 600 times the annual income of a Florentine mason, by the time of his death. Once it was up and running, the firm

guaranteed him an income of around 750 florins a year from its profits. Banchi occasionally also withdrew larger sums from his steadily accruing business capital for such projects as the building of a villa in the countryside outside Florence, which cost him 1,500 florins. Banchi was rich but by no means exceptionally so among the urban middle classes of Renaissance Europe. In Florence, other silk manufacturers, such as Gino di Neri Capponi (1423–87), did equally well.[59] The Ghent patrician Joos Vijd (d.1439), the donor of Jan van Eyck's Ghent altarpiece, must have had an income in the same bracket as Banchi's judging from the amount of taxes he paid.[60] The Venetian cotton merchant Andrea Barbarigo left an estate worth around 12,000 ducats at his death in 1449, which was increased to slightly over 27,000 ducats in the hands of his son Nicolò in 1500.[61]

The numbers of these entrepreneurs were small (perhaps 2 per cent of the population), but their extensive material culture included many of what are nowadays considered to be the highlights of Renaissance art.[62] Such is clear, for instance, from the 1498 inventory of the household of

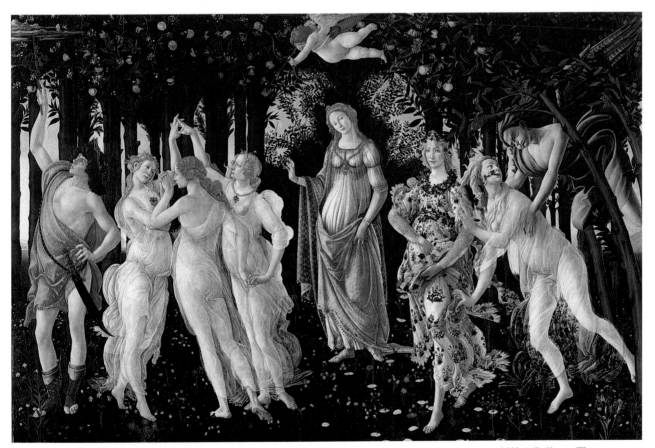

Plate 1.14 Sandro Botticelli, *Primavera*, c.1481–2 (or later), tempera on panel, 203 × 314 cm, Uffizi Gallery, Florence. Used with the permission of the Ministero Beni e Attività Culturali. Photo: © 1991 Scala, Florence.

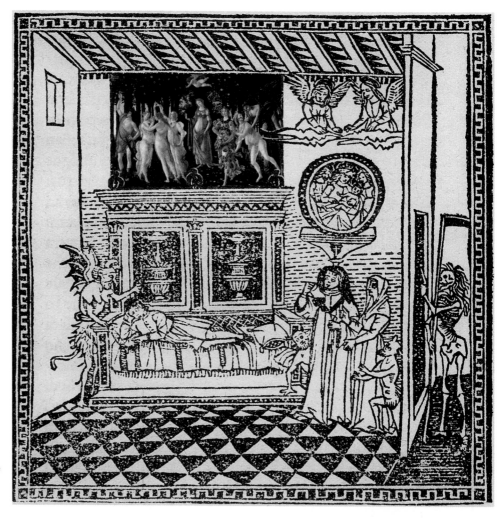

Plate 1.15
Reconstruction of
Botticelli's *Primavera*
mounted on the wall
above a *letuccio*, based on
a woodcut from Girolamo
Savonarola, *Predica
dell'arte del ben morire*,
Florence, 1496. Photo:
(*Primavera* only – detail
of reconstruction): © 1991
Scala, Florence. Used
with the permission of the
Ministero Beni e Attività
Culturali.

Lorenzo di Pierfrancesco de' Medici and his late
brother Giovanni, second cousins of Lorenzo the
Magnificent from the slightly less fabulously
rich branch of the Medici family.[63] Lorenzo di
Pierfrancesco was, among other things, the proud
owner of Botticelli's *Primavera*, that glorious but
enigmatic allegory of spring (Plate 1.14).[64] The
painting could be found in Lorenzo's chamber in his
town house in Florence. All around the chamber,
the lower part of the walls was wainscotted with
a *spalliera* 40 braccia long in total (23.36 metres).
Gilt Spanish leather was applied as wallpaper on
the upper section of the walls. The *Primavera* was
attached above a *letuccio*, a day bed with a raised
panel, also called *spalliera*, at the back.

A reconstruction of what the painting may have
looked like *in situ* in Lorenzo's chamber can be
based on a woodcut from a published sermon by the
notorious preacher Girolamo Savonarola (1452–98);
the text addresses the macabre theme of how to die
in a dignified Christian manner, and the woodcut

shows the figure of Death knocking at the door of a
man who is approaching his last hour languishing
on his *letuccio*, with devils and angels waiting
to collect his soul (Plate 1.15). Interestingly, the
Primavera is valued at a relatively modest sum
of slightly over 16 florins in the inventory, which
indicates it was not as exclusive an item of the
decoration of the room as its current artistic
status might suggest. The *letuccio* underneath it
was valued at 14 florins; the strips of gilt leather
covering the walls at a total of 30 florins; and the 40
braccia of wainscotting at a whopping 240 florins.
This valuation is consistent with the one found in
the 1492 inventory of Lorenzo the Magnificent,
where the *spalliera* of Lorenzo's chamber, including
a series of six large paintings affixed above it,
was valued at 300 florins in total.[65] This series of
paintings included the famous *Rout of San Romano*
panels by Paolo Uccello (*c*.1397–1475), now divided
between the National Gallery in London, the
Louvre in Paris, and the Uffizi in Florence.

The members of the mercantile class also erected public monuments in their own memory through furnishing private chapels in churches. Surviving examples can be admired for their aesthetic qualities and studied for their function in religious culture (see Chapter 6); in the eyes of contemporary viewers, however, they must have been overt manifestations of wealth as well. The Sassetti Chapel in the church of Santa Trinita in Florence gives an idea of what a typical – albeit rather prestigious – project involved (Plate 1.16).[66] Francesco Sassetti (1420–90) made his fortune under the broad umbrella of the business empire of the Medici, of which he became the general manager in 1469. For his chapel in Santa Trinita, he commissioned a fresco cycle and an altarpiece from the leading fresco painter of the day, Domenico Ghirlandaio (c.1448–94), in 1480. Two marble sarcophagi for Francesco and his wife may have been the work of the sculptor Giuliano da Sangallo (c.1443–1516).[67]

This ensemble alone represented a massive expenditure. Ghirlandaio's much larger fresco cycle in the Tornabuoni Chapel in Santa Maria Novella cost 1,200 florins, so Sassetti is likely to have paid at least 600 florins for his.[68] The price of the altarpiece, slightly smaller than Botticelli's Bardi altarpiece (Plate 1.7), must have been around 100 florins. The marble sarcophagi in their sculpted stone niches may well have added another 200–300 florins to the tally.[69] Equipping a funerary chapel also meant buying liturgical vestments and utensils for the clerics who had to say masses for the dead at the chapel altar (and leaving money for a stipend to pay their wages). The Florentine entrepreneur Giovanni Rucellai boasted in his memoirs that he had spent 1,000 florins on gold-brocaded liturgical vestments for his funerary chapel in the church of San Pancrazio.[70] Sassetti may not have been as generous as Rucellai, but he may easily have spent another 500 florins on vestments, altar cloths and silver vessels. The total cost of the chapel is likely to have amounted to 1,500 florins, which makes it clear that no member of a social class below that of the successful entrepreneur could have engaged in such conspicuous consumption.

Ghirlandaio's frescoes in the Sassetti Chapel have long drawn attention for the inclusion of a large series of portraits and views of contemporary Florence in the religious scenes.[71] *The Confirmation of the Rule of Saint Francis*, for example, shows

Plate 1.16 The Sassetti Chapel in Santa Trinita, Florence: fresco decorations (scenes from the life of Saint Francis and donor portraits) and an altarpiece (*The Adoration of the Shepherds*) by Domenico Ghirlandaio, sarcophagi attributed to Giuliano da Sangallo (or Bertoldo di Giovanni), 1480–5, fresco (walls), tempera and oil on panel (altarpiece), black marble and *pietra serena* (sarcophagi and sculpted niches), chapel 371 cm deep and 523 cm wide, altarpiece 167 × 167 cm, height of wainscotting with tomb niches 313 cm. Photo: © Alinari Archives, Florence.

Pope Honorius III granting official status to the Franciscan Order in 1223, but this historical event has been relegated to the middle ground (Plate 1.17). The background offers a view not of the Vatican but of the political heart of Florence, the Piazza della Signoria with the governmental palace and the Loggia dei Lanzi, the prominent vaulted portico on the right. The foreground is occupied by a number of portraits. On the far right, the donor, Francesco Sassetti, is depicted with his youngest son, Federigo. Beside him stand his boss, Lorenzo the Magnificent, and the father-in-law of his daughter, Angelo Pucci. Sassetti's adult sons, Galeazzo, Teodoro and Cosimo, are depicted on the far left. Coming up the stairs in the middle are Lorenzo the Magnificent's three sons, Giuliano, Piero and Giovanni, with their tutor Angelo Poliziano.

Plate 1.17 Domenico Ghirlandaio, *The Confirmation of the Rule of Saint Francis*, 1480–5, fresco, width 523 cm, Sassetti Chapel, Santa Trinita, Florence. Photo: Bridgeman Art Library, London/Alinari Archives, Florence.

The fresco can be interpreted as a representation of the complex identity of the donor. It associates him, like the rest of the chapel, with his patron saint, Francis, whose protection and intercession he probably invoked both during his life and for his afterlife in purgatory (see Chapter 6 for a discussion of purgatory and its importance at this time). The background presents him as a Florentine, an aspect of his identity he may have learned to cherish during his long years abroad managing various foreign branches of the Medici bank. The portraits emphasise his family lineage as well as his all-important affiliation with the godfather of Florentine politics, Lorenzo the Magnificent. Sassetti's wealth is demonstrated through his long gown of scarlet wool, the fifteenth-century equivalent of a hand-tailored suit from Savile Row.[72] His son Federigo and his boss have similar gowns in a darker colour, possibly the purple shade called *pagonazzo*, or peacock-colour, which was based on the scarlet dye. Angelo Pucci has a more modest blue-grey woollen gown,

probably similar in price to the one worn by the doctor, Agostino della Torre, in Lorenzo Lotto's painting (Plate 1.12).

6 Women

The mercantile upper middle class was the first level of society at which independent portraits of women were commissioned. Lower-class women, like lower-class men, were sometimes depicted as social types instead of individuals, as in Lucas van Leyden's *The Pilgrims* (Plate 1.6). At the level of artisans, painters occasionally made portraits of their wives, as in the double portrait by the Master of Frankfurt (Plate 1.9). The wives and daughters of merchants, however, sat for portraits that were paid for by patrons, as is attested by numerous works from Italy as well as Germany and the Low Countries, the notable exception being Venice, where portraits of women were rare during the fifteenth and early sixteenth centuries. A famous example is the posthumous profile

Plate 1.18 Domenico Ghirlandaio, *Portrait of Giovanna degli Albizzi Tornabuoni*, 1488, tempera and oil on panel, 77 × 49 cm, Collection Thyssen-Bornemisza, Madrid. Photo: Bridgeman Art Library, London.

portrait Ghirlandaio made of Giovanna di Maso degli Albizzi (1468–86), the late wife of Lorenzo Tornabuoni, in 1488 (Plate 1.18).[73]

This commemorative work must have been made for Lorenzo or his father Giovanni, the patriarch

of the Tornabuoni clan, but it was probably no exception as a female portrait that was commissioned by a man. Men also fashioned the identity of the women portrayed. Significantly, the Latin inscription on Giovanna's portrait reads: 'If

only art could render virtue and spirit, this would be the most beautiful painting on earth' (adopted from another Martial epigram – the original, ironically, is about an old man).[74] This praise of the virtue of the sitter in compliment to her physical beauty shown in the panel was most likely the expression of a male ideal of womanhood as much as a realistic assessment of Giovanna's character. The material culture by which Giovanna is surrounded – jewellery, a small prayer book, coral rosary beads – consists of objects that women were given as part of their trousseaus when they entered into marriage. They are traditional feminine attributes related to the concepts of beauty and virtue and may tell us little about Giovanna's personal tastes. On the other hand, women may not have been the purely passive recipients of such gifts. Little is known about their freedom of choice regarding the items included in their trousseaus. In general, women are likely to have been involved with commissions for goldsmiths' work, manuscript illumination and textiles much more than with those for painting, sculpture and architecture. Together with the 'gendered' approach of traditional art history, which has dealt almost exclusively with the interests of male patrons, this predilection for the 'minor arts' may be the reason why women's patronage has received relatively little scholarly attention so far.

The women of Giovanna degli Albizzi's class were financially only semi-independent at best. Their money was managed by their male relations: fathers, husbands or brothers. Viewed through the eyes of these men, women were objects of conspicuous consumption. When a woman married, her father provided her with a dowry to guarantee her financial security. The size of the dowry was a matter of negotiation between the two families involved; it reflected the wealth of the family of the bride as well as the success of the family of the groom in establishing social connections. The above-mentioned trousseau of sumptuous garments and jewellery was part of the dowry; in Florence, the groom also made his bride a gift of rich clothing or finery.[75] The sleeveless gown, or *gamurra*, worn by Giovanna in Ghirlandaio's portrait is of a type typical for such bridal provisions. It is made of satin with a pattern in velvet pile, a combination also known as voided velvet. This fabric (if it was not dyed with the expensive crimson dyestuff) was produced at a cost price of 1.6 florins per square

braccio.[76] Making a *gamurra* required 10–15 braccia, a quantity worth one-half to three-quarters of what a Florentine mason earned during a good working year.[77] The ochre colour of the groundwork of Giovanna's *gamurra* hints perhaps suggestively at even more costly textiles such as cloth of gold. Such attire formed a direct indication of the economic value a woman represented as a wife or a prospective marriage partner.

7 Bankers and collections

To become really rich in the Renaissance, one did well to combine mercantile activities with banking. The owner of sufficient capital could, next to investing money directly into industry and trade, use part of his funds for loans to third parties and charge interest on the repayments. The Florentine family to exploit this strategy to its greatest success were the legendary Medici.[78] Giovanni di Averado de' Medici (1360–1429) laid the foundation for their fortune and his son Cosimo (1389–1464), later designated 'Cosimo the Elder' and also 'Pater Patriae', consolidated it. By 1433, Cosimo's wealth and influence were such that the leading Albizzi family (a different branch from the one that produced the Giovanna of Ghirlandaio's portrait) had him exiled from the city. However, when the Albizzi lost their own grip on power during the next year, Cosimo returned triumphantly, soon to emerge as the most important player on the Florentine political scene.

At the peak of the family's economic success around the middle of the fifteenth century, Cosimo and his nephew Pierfrancesco (the forebear of Lorenzo, the owner of Botticelli's *Primavera*) jointly ruled over a business empire that comprised large-scale wool and silk manufacturing operations as well as a bank. They declared total assets of 122,669 florins for their tax return of 1457 – seven times as much as the capital of the silk entrepreneur Andrea Banchi, and about 4,000 times the annual salary of a Florentine mason.[79] These assets guaranteed them an income of around 8,500 florins a year, but their unofficial earnings were probably closer to the 10,000 florin mark. Yet their financial status was not quite as exceptional as the popular association of the Medici name with spectacular riches might suggest. Agostino Chigi's capital, for instance, was reputedly of a similar size, and at his death in 1476 the Venetian Doge Andrea Vendramin left an

estate worth 160,000 ducats, almost a third more than the Medici put on their tax return of 1457.[80]

The extensive material culture of such magnates included not only vast arrays of luxurious household goods, clothing and domestic decorations, but also, increasingly, collections of ornate artefacts that served no particular purpose at all – the precursors of private art collections in the modern sense.[81] A classic example of a work of art these men viewed as a coveted collector's item is the *Tazza Farnese*, a Hellenistic ceremonial dish carved from a single piece of sardonyx, the differently coloured layers of the stone used craftily to create a contrast between figures and background in the allegorical scene sculpted on the inside (Plate 1.19).[82] Having passed through the hands of several ecclesiastical dignitaries in the fifteenth century, the *Tazza* was obtained by Lorenzo the Magnificent, Cosimo de' Medici's grandson, in 1471. If art is a medium for conspicuous consumption, then art collecting raises the stakes of this social game, because competition

between collectors vying for the same artefacts usually drives up the prices. The *Tazza* especially would have been viewed as a token of wealth. In the Medici inventory of 1492, it was listed among the contents of Lorenzo's private study, or *scrittoio* (a term interchangeable with the more commonly used *studiolo*).[83] It was valued at a staggering 10,000 florins: more than 330 times the annual income of a Florentine mason; 100 times the price of a Botticelli altarpiece, and approximately one-quarter of the building costs of the grand town palace the Medici had erected for themselves under Cosimo (of which Lorenzo's *scrittoio* formed part).[84]

An art collection also made a much more pronounced statement about its owner's tastes and identity than any individual art object could. In the Medici household, the *Tazza* would not have been viewed just by itself but in the context of other valuables in Lorenzo's quarters. The *scrittoio* was home to more antiquities (all cameos and not the marble statues more commonly thought of in connection with the Renaissance admiration for

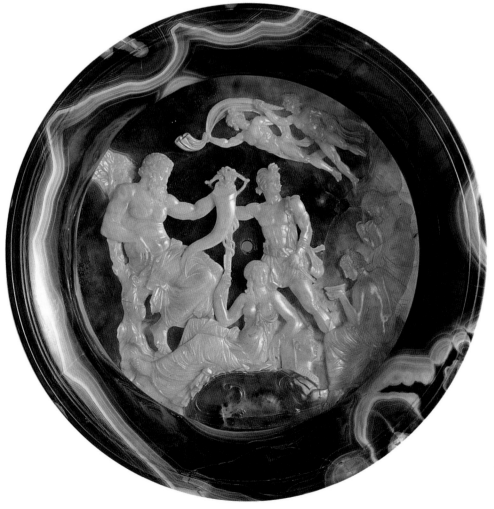

Plate 1.19 *Tazza Farnese*, libation dish probably depicting the fertility of the Nile, made in Alexandria, first century BCE, sardonyx, diameter 20 cm, Museo Archeologico Nazionale, Naples. Photo: Bridgeman Art Library, London.

43

classical art), vases made of (semi-) precious stones, goldsmiths' work and jewellery.[85] Objects in the remainder of the rooms included an array of small panel paintings, two of which were attributed to Jan van Eyck and Petrus Christus, respectively; pieces of bronze and marble sculpture; and, perhaps surprisingly, a number of Byzantine miniature mosaics.[86] All these items shared a common aesthetic, with a venerable provenance, refined craftsmanship and precious materials as its main parameters. Together, they suggested that Lorenzo was sensual yet refined, and had a healthy respect for history and heritage. As befitted a statement of identity so carefully assembled, many items from the collection were passed on carefully as heirlooms from generation to generation, and can still be seen in Florentine museums among the art the last Medici heir, Gian-Gastone, Grand Duke of Tuscany (ruled 1723–37), left behind at his death. The *Tazza* left the family only through inheritance via the female line during the sixteenth century, to end up in the possession of the Farnese (the same that procured Agostino Chigi's villa in Rome).

8 Princes

Renaissance bankers such as the Medici and Agostino Chigi may have been the richest members of the mercantile upper middle class, but their wealth was still quite limited next to that of the grand courts of Europe. The princes whose finances have been studied in the greatest detail are the Valois Dukes of Burgundy, the rulers of the Duchy of Burgundy in France and, by the second half of the fifteenth century, most of the Low Countries.[87] During the first half of the fifteenth century, the annual revenues from taxes levied in the Burgundian territories amounted to 300,000 pounds of Tours.[88] A contemporary calculated that the ducal family could safely use half of these revenues for their personal expenses, a sum that was equivalent to 90,000–95,000 Florentine florins – about 3,000 times the annual income of a Florentine mason, almost the entire family capital of the Medici, and eight or nine times their annual income at the height of their success as bankers. The fourth and last Valois Duke of Burgundy, Charles the Bold (ruled 1467–77), raised the tax revenues to 700,000 pounds to fund his many military campaigns. Their spending power put the Dukes of Burgundy in a minute percentage of the population whose assets exceeded those of practically everyone else put together. Princely wealth of this kind is comparable only to the budgets of nation states in today's terms, with the difference that the ruler in charge was free to use the national budget for his or her personal ostentation.

The dukes and their peers also held the crown of conspicuous consumption in their day, as an example from their public patronage makes clear. In 1467 and 1468, the Burgundian army was twice called in to suppress successive uprisings by the inhabitants of the city of Liège against their unpopular overlord, Prince-Bishop Louis of Bourbon, who was a close political ally of Duke Charles the Bold. It can be surmised that on the occasion of these military expeditions, Duke Charles vowed to make an offering to the patron saint of Liège, Lambert, if his troops were to prevail against the rebellious citizens. The resulting votive gift (a donation made to fulfil a religious vow) can still be admired in the modern Liège Cathedral, and is one of the few surviving pieces of what was once a flourishing art, fifteenth-century Burgundian goldsmiths' work. The goldsmith Gerard Loyet, already briefly introduced as one of the court artists of Charles the Bold, made a statuette of pure gold, with parts in *en ronde bosse* (three-dimensional) enamel, on a base of gilded silver (Plate 1.20).[89] It depicts the duke in a kneeling position holding a small reliquary, and recommended by Saint George, whose appearance and pose are based on a painting by Jan van Eyck, the *Madonna of Canon van der Paele* of 1436.[90]

The statuette was presented to the shrine of Saint Lambert in the old Liège Cathedral (demolished in the eighteenth century, when the statuette was transferred to its present location). The reliquary held by the figure of the duke allegedly contains Saint Lambert's finger, presumably a missing piece from the set of the saint's relics in this shrine. The ducal accounts state that the mere cost price of the materials for the statuette was 1,200 pounds of 40 groat, which was roughly equivalent to the same amount in Florentine florins – about 40 times the annual income of a Florentine mason, the price of a very large fresco cycle by Ghirlandaio, and about twice the sum of 500 guilders the southern Netherlandish painter Dirk Bouts accepted for making four large panel paintings and a *Last Judgement* triptych for the town hall of Louvain

Plate 1.20 Gerard Loyet, votive image of Charles the Bold, 1467–71, gold and enamel on a base of gilded silver, 53 × 32 × 18 cm, Treasury of the Cathedral of Saint Paul, Liège. © IRPA-KIK, Brussels. Photo: Jean-Luc Elias.

in 1480 (a sum that covered both labour and materials).[91] Votive gifts, even ones as expensive as the Liège statuette, were generally put on display around the shrine to which they had been donated. The unfortunate inhabitants of Liège must have viewed it as a stark warning that further resistance was futile given the sheer size of the ducal coffers. For the duke himself, however, the Liège statuette was merely one of numerous gold-enamel figurines he donated to churches in his domains (all melted down to retrieve the gold in later centuries).

The duke's choice to donate a gold-enamel statuette rather than, for instance, a painting reflected the exclusive tastes his class had cultivated for several centuries.[92] More evidence of these tastes could be found in Charles the Bold's private chapel – a term that denotes, in this context, not a physical space but rather the complete set of furnishings the duke had for liturgical ceremony and private devotion at his court. It was a veritable treasure house of liturgical vestments, embroideries, statuettes, reliquaries, crosses and tabernacles, which can be reconstructed on the basis of an extensive inventory taken in 1468 at the time of Charles's accession.[93] The contents of the chapel greatly exceeded the practical requirements for liturgy and devotion, and sources suggest the dukes sometimes treated them more as an art collection which they would show to visitors.[94] It is even possible that the art collection of the Medici, though more secular in nature, was modelled on such princely examples.

Judging from the 1468 inventory, the ducal court, with immense funds at its disposal, developed not only a large material culture but also a culture of materials. The works of art in the chapel were all made of materials with a high intrinsic value – a direct translation of the ducal wealth. Craftsmen had worked with these materials in ways that emphasised their physical qualities and advertised their abundance through a maximum variety in texture, sheen, colour and reflection: hard polished metal; soft vellum; supple silks, their surfaces varying from satin to velvet; crisp gold thread; and cut gems refracting the light. Many of the objects they manufactured were intended not just to be seen but also to be handled, and viewing such courtly art must have been a tactile experience as well as a visual one.

One of the few works of art from the chapel that still exists today is the golden cross used to swear in new members of the Order of the Golden Fleece, a chivalric order founded by Duke Philip the Good (ruled 1419–67) in 1430, with the idealistic (and never realised) aim of launching a crusade against the Ottoman Turks (Plate 1.21).[95] The object is described in the 1468 inventory as 'a golden cross weighing, including the base, two marks two ounces and five sterlings [*c.*560 grams], decorated with five balas rubies, 20 sapphires [actually 21], four groups of pearls of three pearls each and … three pearls on each arm. There is a fragment of

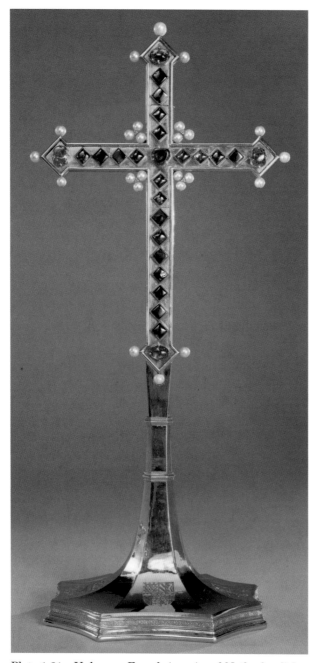

Plate 1.21 Unknown French (cross) and Netherlandish (base) craftsmen, cross for taking the oath of the Order of the Golden Fleece, c.1400 (cross) and 1453–67 (base), gold, pearls, rubies and sapphires, height 36 cm, Kunsthistorisches Museum, Vienna (on loan from the Order of the Golden Fleece).

the true cross in the centre, and it is marked with the arms of Monsieur the Duke ...'[96]

Not surviving, unfortunately, are any of the spectacular items described as *tables d'autel*, or altarpieces. Contrary to what we might expect, these were not paintings. It is significant for the princely tastes of the time that no painted

altarpieces were present at a court where no less a painter than Jan van Eyck had been employed for many years. In fact, only a mere eight items in the ducal inventory are identifiable as paintings, five small panels for private devotion, and – remarkably – three Byzantine icons. These icons must have been among the ducal possessions either because Duke John the Fearless had brought them back from the failed crusade he led against the Ottomans at Nicopolis in 1396, or because many icons were held in special veneration as sacred pictures.[97]

Rather than to paintings, the descriptions of *tables d'autel* refer to elaborate pieces of embroidery, such as the 'altarpiece ... embroidered and in three parts, of which the central part ... shows the story of the three Magi, the second part the story of King David, sitting on a throne with several figures kneeling before him, and the third part, the story of Solomon sitting on a throne and the Queen of Sheba kneeling before him'.[98] Embroidery was a far more expensive medium than painting, especially if it involved great amounts of gold thread. The Medici inventory of 1492, for example, includes a single embroidered altarcloth, 5 braccia long (c.275 cm), made with gold thread and silk, and valued at 300 florins, the same amount as the above-mentioned *spalliera* with six large panel paintings in Lorenzo's chamber, which included Paolo Uccello's famous *Rout of San Romano* series.[99] The lost splendour of the embroidered altarpieces of the Dukes of Burgundy can be reconstructed only by approximation. An altarpiece in Sens Cathedral in France, for instance, can give us an indirect impression of what they may have looked like (Plate 1.22).[100] The Sens altarpiece is a woven tapestry and does not contain needlework, but it is as rich in colour and gold thread as the Burgundian embroidered altarpieces must have been. As in the altarpiece described in the ducal inventory, it consists of three narrative panels, each with a typically 'regal' theme: the three kings adoring Christ flanked by two Old Testament monarchs in the ducal altarpiece; the *Coronation of the Virgin* in between two Old Testament queens (Esther and the Queen of Sheba) in Sens.

Duke Charles the Bold was not to enjoy his treasures for long. In a political move that changed the map of Europe, he died on the battlefield of Nancy in 1477, the victim of one too many military adventures. His sole heir was his daughter, Mary of Burgundy (ruled 1477–82), who saw her rights

Plate 1.22 Unknown workshop, possibly from Tournai, *Coronation of the Virgin with the Coronation of Esther and Solomon Receiving the Queen of Sheba*, third quarter of the fifteenth century, wool, silk and gold thread tapestry, 165 × 318 cm, Treasury of Sens Cathedral. Photo: Cl. Musées de Sens (France)/E. Berry.

to the ducal titles instantly challenged by King Louis XI of France (the Dukes of Burgundy, though operating as independent rulers, were officially vassals of the King of France). Mary solved her predicament through a combination of cunning diplomacy and a strategic marriage with Maximilian of Habsburg, Archduke of Austria and later Holy Roman Emperor Maximilian I (ruled 1493–1519).[101] The Burgundian heritage was settled with the Treaty of Arras in 1483, when the original Duchy of Burgundy in France passed to the French Crown and the extensive Netherlandish territories the dukes had acquired over the years were given to the Habsburgs. By then, the latter were already the most powerful family in Europe, having secured the originally non-hereditary title of Holy Roman Emperor for their lineage.

The intricacies of lineage may be a dull subject of history, but it was all-important to the identity of princes in a feudal system based on heritable wealth and titles to land. A striking example of how this aspect of princely identity was promoted through art is a painting by the German artist Bernhard Strigel (Plate 1.23).[102] This unobtrusive panel encapsulates the largest concentration of power in Europe in the early sixteenth century. The man on the left is the Holy Roman Emperor Maximilian I, his profile outlined against a

damask cloth of estate (a panel of precious fabric suspended behind a person of noble blood to mark their status). The woman on the right is none other than Mary of Burgundy. Mary had in fact died in 1482, long before the painting was made; Maximilian was by now remarried to Bianca Maria Sforza. Behind Mary stands the son she had with Maximilian, Philip, who had grown up to become King of Spain (ruled 1504–6) through marriage to Joanna of Aragon, but had also died before the painting was made. The central position in the family group has been allocated to Philip's eldest son, a boy with a severely deformed jaw – nature's way of disagreeing with dynastic policies to preserve wealth and status for the same small group of families by constant intermarriage. Charles was not to be pitied, however. He succeeded his grandfather Maximilian as the Holy Roman Emperor Charles V (ruled 1519–58) and became one of the most powerful rulers of world history, governing the vast array of territories the Habsburgs had brought under their control, from the German Empire and the Netherlands to northern Italy, Spain and the Spanish colonies in the Americas.[103]

The male figures in Strigel's painting are depicted in contemporary German costumes, with all the trappings of power. The emperor is dressed in a

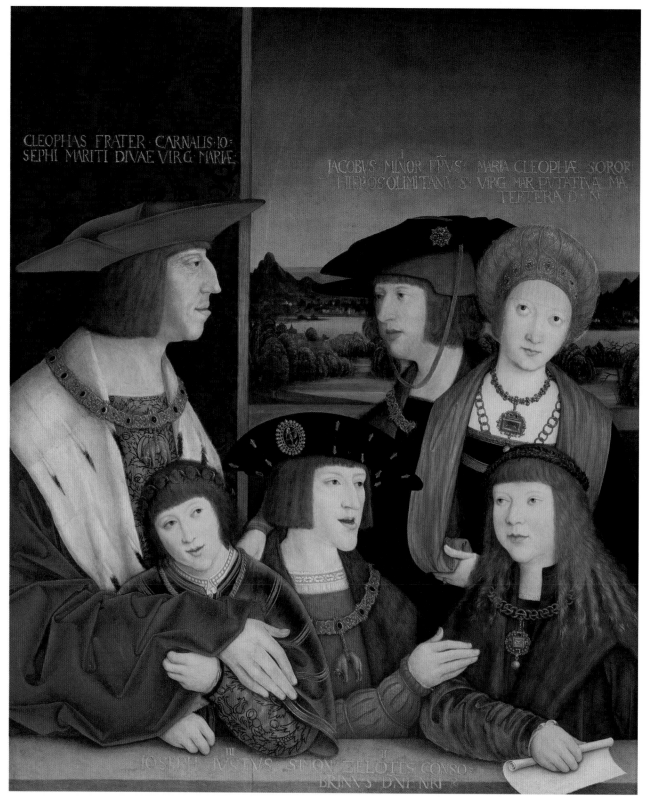

Plate 1.23 Bernhard Strigel, *The Habsburg Lineage: Emperor Maximilian I with his first wife Mary of Burgundy, their son Philip, their grandchildren Ferdinand and Charles, and the Emperor's adopted son Louis*, 1516 (possibly 1520), oil on panel, 73 × 60 cm, Kunsthistorisches Museum, Vienna.

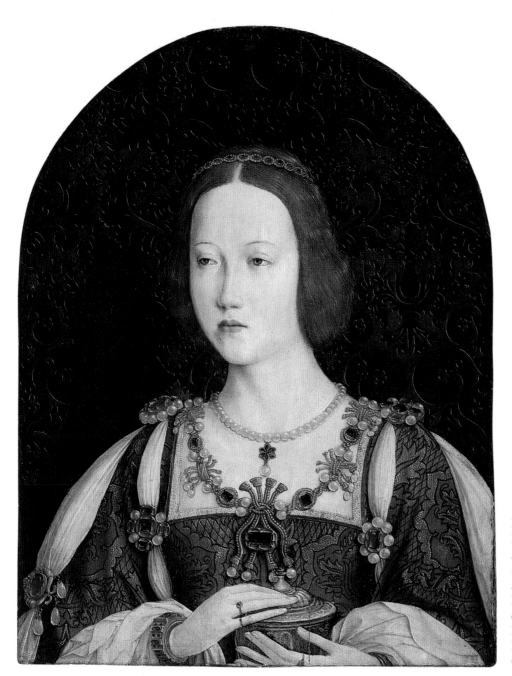

Plate 1.24 Unknown Netherlandish artist, *Portrait of a Lady in the Guise of Saint Mary Magdalene* (Beatriz of Portugal?), *c.*1520, oil on panel, 41 × 32 cm, National Gallery, London. Photo: © National Gallery, London.

crimson velvet mantle lined with ermine. Velvet was a silk textile at this time and was made in a laborious procedure. After the warp threads had been mounted on the loom, a number of thin metal rods were woven into the fabric along with the ordinary weft threads. A knife was then drawn over these metal rods, cutting those warp threads that ran over them and leaving their severed ends as small tufts on the fabric surface to form the velvet pile. Velvet dyed with the exclusive crimson dyestuff was produced at a cost price of 2 florins per square braccio in Florence.[104] A large mantle like the emperor's required 25 braccia of fabric, a quantity worth more than one-and-a-half times

what a Florentine mason earned in a good year. The emperor's doublet, visible under the mantle, is made of that very richest of Renaissance fabrics, cloth of gold. Both the Emperor Maximilian and his grandson Charles wear the golden chain of the by then venerable Burgundian Order of the Golden Fleece, recognisable from the pendant in the shape of a ram's fleece. Young Charles also has a prominent gold-enamel hat badge, a secular and very exclusive counterpart of a pilgrim's badge, showing the figure of Fortuna.[105]

Strigel's painting captures many aspects of feudal lineage in a nutshell. It graphically demonstrates

the one-sided emphasis on the male family line. Neither Maximilian's second wife nor the late Philip's wife, both of whom were still alive, has been depicted. The inscriptions in gold leaf add an extra dimension. They were probably included on the instigation of the humanist scholar and protégé of Maximilian, Johannes Cuspinian (1473–1529), who owned the panel after the emperor's death in 1520. They draw a parallel between the House of Habsburg and the family of Christ. Mary of Burgundy, for example, is identified with Maria Cleophas, the reputed half-sister of the Virgin, while Maximilian appears in the role of her husband Cleophas, who in his turn was a brother of the Virgin's husband, Joseph. Mary's son Philip and her grandsons Ferdinand and Charles are equated to Mary Cleophas's three sons, James, Joseph and Simon, two of whom became apostles known as James the Less and Simon the Zealot, respectively. Thus, the very concept of lineage is strengthened and legitimised by a reference to scripture.

Interestingly, only Mary of Burgundy is represented dressed in a way that might refer to her identification with a historical figure. Her attire is loosely based on early sixteenth-century German fashion (quite different from the Burgundian fashion of the 1470s Mary would have worn during her lifetime), but with fantastic touches. The exotic looking headdress, for instance, is reminiscent of the headwear given to female saints and biblical figures in contemporary religious paintings. Dressing up and assuming an alternative identity was a favourite pastime among princes. The Emperor Maximilian himself, for instance, is recorded to have appeared dressed as an Italian peasant at the Carnival of Innsbruck in 1502 – albeit with a peasant costume made out of cloth of gold.[106] There was a certain tendency for role-play in portraits as well, which was perhaps more pronounced among female than among male sitters at this time. A Netherlandish painting of c.1520 shows a lady, possibly Beatriz of Portugal, sister-in-law of Emperor Charles V, in the guise of Saint Mary Magdalene, identifiable from the saint's traditional attribute, the ointment jar (Plate 1.24).[107]

Princely identities were not only conveyed through portraiture, however. An important attribute of male identity among princes was armour. The Liège statuette (Plate 1.20) depicted Charles the Bold wearing a suit of armour, an unintentionally

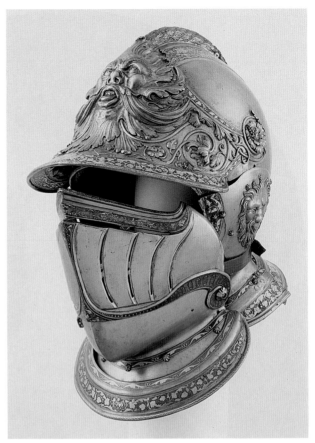

Plate 1.25 Filippo Negroli and brothers, burgonet belonging to the masks garniture (parade armour) of the Holy Roman Emperor Charles V, 1539, plate steel and silver-gilt, weight of the suit of armour 14.49 kg, Real Armería, Patrimonio Nacional, Madrid. Photo: © Patrimonio Nacional.

ironic touch in the light of his untimely demise at Nancy. The design of Charles the Bold's armour in the statuette may have been based on an actual suit of armour from Milan, the most famous city of armourers in Europe in the fifteenth and sixteenth centuries.[108] Armour, apart from offering protection on the battlefield, was also a symbol of military might. Charles the Bold, for instance, had himself depicted as the subduer of Liège. Moreover, a full suit of armour was an expensive commodity, especially if it was richly decorated. The practical purpose of armour diminished with the advance of firearms in warfare from the early sixteenth century onwards, but its role as a princely status symbol increased as designs, ornaments and materials became ever more lavish and elaborate. A typical showpiece is the helmet (burgonet) belonging to a suit of parade armour made for Emperor Charles V in the renowned Milanese workshop of Filippo Negroli in 1539 (Plate 1.25).[109]

The plate steel, decorated with a leaf mask and foliage in front and lions' masks on the sides, is now brightly polished, but it was originally almost black, providing a sharp contrast for the borders with silver-gilt patterns in slight relief (a process known as damascening).

9 Institutions

The only way in which members of the urban middle class could offer serious competition to the politics and patronage of princes was through co-operation. Some of their co-operative structures, such as religious confraternities, guilds and the governmental bodies of city-states, are discussed at greater length by Jill Burke in Chapter 2. Here, it is sufficient to remark that although Renaissance studies usually focus on Italian examples, civic organisations and institutions were no less well established in the rest of Europe. The communal spirit of a northern city, for instance, is expressed in a standard made for the city of Ghent in 1482 (Plate 1.26).[110] This standard is a rare surviving piece of what must have been a widespread form of material culture at the time, but it is even rarer as a work of art known to be the product of a named female artist. The triangular banner, made of silk with fringes embroidered along its edges and a painted heraldic image, was the work of Agnes van den Bossche (a local woman of unknown origin and dates). It should be viewed as a statement of the identity of Ghent, showing a gilt Gothic letter G combined with the city's emblem of a maiden and a lion rampant. The pride of the citizens who united under this banner is conveyed through a (simulated) form of conspicuous consumption, as the city maiden has been depicted dressed like a princess, wearing cloth of gold lined with ermine.

The two major non-civilian institutions of Renaissance Europe, the military and the Church, each had a social structure and an economy of their own. Noblemen as well as city-states regularly kept small standing armies, supplemented with extra recruits and mercenaries in times of war.[111] The costs could be considerable. For the Republic of Florence, for instance, the mere maintenance of territorial garrisons combined with the payment of a number of mercenary bands could amount to more than 130,000 florins per year in peacetime.[112] A disproportionate amount of this money went to the commanding officers, who were invariably selected from the higher echelons of society. Ordinary foot-soldiers were unlikely to rise in rank and were not paid well. The annual wages of a foot-soldier in Italy appear to have been of the same order as those of a Florentine mason.[113] Mercenaries were slightly better paid but had to buy their own weapons and equipment. Bonuses were given for certain dangerous activities such as scaling the walls of a city during a siege, and for invading armies there was always the promise of plunder.

Despite their meagre earnings, soldiers managed to create a distinctive material culture and even

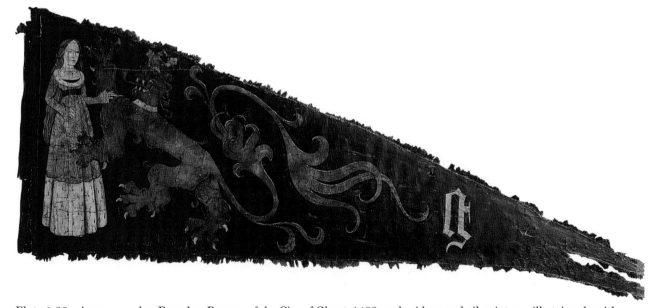

Plate 1.26 Agnes van den Bossche, *Banner of the City of Ghent*, 1482, embroidery and oil paint on silk, triangle with a height of 100 and a base of 265 cm, Bijlokemuseum, Ghent. Photo: Paul Maeyaert/Bridgeman Art Library, London.

a form of conspicuous consumption compared to those with whom they shared their stratum of society. They were often given part of their pay in cuts of cloth, which allowed them to define a specific identity for themselves by wearing striking and colourful uniforms. None more so, perhaps, than the fearsome German *Landsknechte*, professional soldiers of fortune who sold their considerable combat skills to the highest bidder and who established the trademark image of the Renaissance soldier. They developed a flamboyant fashion with plumed hats, rather dramatic codpieces to bring out their manhood, and garments marked by prominent slashes – an outfit so outrageous that it became a favourite spectacle with Renaissance viewers, represented in popular print series by contemporary artists (Plate 1.27).[114]

The only people who genuinely made money out of soldiering were the Italian *condottieri*, captains-for-hire with their own troops who did the dirty work in the countless petty feuds between Italian fiefdoms and states. In 1471, the illustrious Federico da Montefeltro, Duke of Urbino (1422–82), served the Florentine Republic as a *condottiere* heading a cavalry unit of 400. He was paid 18,000 florins, an income of several thousand florins even after deduction of the wages of his men and the expenses for taking care of his animals.[115] Fighting on commission earned Federico enough to enable him to spend no less than 200,000 ducats on the raising of a magnificent ducal palace in Urbino (Plate 1.28).[116] Whether intentionally or not, the style of the palace appears to reflect

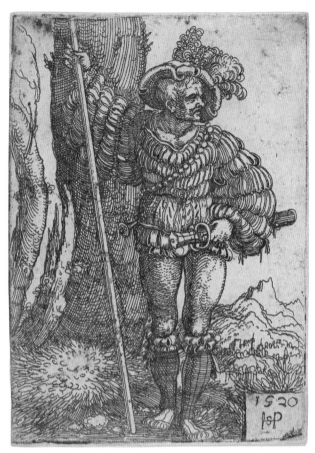

Plate 1.27 Hans Sebald Beham, *Landsknecht*, 1520, etching on iron, 9 × 6 cm, British Museum, London. Photo: © The Trustees of the British Museum.

Federico's dual identity as a military man and a refined Renaissance prince. It has typical Italian Renaissance features on the inside, such as an elegant colonnaded courtyard with classical-

Plate 1.28 Lorenzo Laurana and others, Palazzo Ducale, seen from the west, with the 'facciata dei torricini' in the centre, first main building phase (under Laurana) 1464–72, Urbino. Photo: Alinari Archive, Florence.

style columns and pilasters, and a private study or *studiolo* (comparable in function to Lorenzo the Magnificent's *scrittoio*). At the same time, its location on a hilltop and its austere façade commanding the view of the surrounding valley give it the character of a rocca or mountain fortress, and even the famous 'facciata dei torricini' or twin-tower façade has something of a bastion about it in the lower parts.

To enter the Church was, even more than joining the army, to step out of the regular structure of society and to assume a new identity. This identity came with duties and restrictions but also with rights and privileges. Among those who profited from the latter may well have been women. The lives of nuns have recently become the subject of academic interest, and it has been shown that convents made substantial contributions to Renaissance culture.[117] As private persons, too, nuns seem to have had a greater freedom to engage actively in artistic patronage than most secular women. A small triptych by Neri di Bicci (1418–92), a minor but in his day very successful painter, was commissioned by a nun from the Florentine convent of San Salvatore e Santa Brigida, also known as Il Paradiso, in 1462 (Plate 1.29).[118] Its

price was a mere 4 florins, which indicates the pious patroness may have been of relatively modest means. The triptych must have served as an aid for her private devotions. Its iconography appears to have been tailored to her specific religious identity. It shows her membership of a religious order, her personal piety, her attachment to her city, and perhaps even her conventual name.

The nuns from Il Paradiso belonged to the Order of Saint Bridget of Sweden, who appears with her daughter Saint Catherine of Sweden in the central panel on the right. Saint Bridget had a special devotion for the Virgin Mary, of whom she had many visions. Her Florentine sister probably shared her passion, as the three panels contain three key moments from the life of the Virgin, which each confirm her divine nature: the annunciation of the birth of Christ (in the top halves of the wings); the nativity (the birth itself, in the lower half of the left wing); and the assumption, with the added legend of the Virgin's girdle, which she dropped into the hands of the always sceptical Saint Thomas as proof that she was truly bodily raised up to heaven (central panel). The lower half of the right wing depicts Saint John the Baptist praying in the wilderness; he was the patron saint

Plate 1.29 Neri di Bicci, triptych, left wing: *The Angel of the Annunciation and the Nativity*; central panel: *The Assumption of the Virgin with Saints Jerome, Margaret, Bridget and Catharina of Sweden*; right wing: *The Virgin of the Annunciation and Saint John the Baptist in the Wilderness*, 1462, tempera and gold leaf on panel, 51 × 59 cm, private collection. Photo: © Christie's Images Ltd, 2002.

of Florence and his intense devotional exercises may have had a special appeal to this nun. The central panel, finally, also contains images of Saint Jerome and Saint Margaret, which may have been a more personal choice: it is tempting to postulate Saint Margaret as a potential name saint.

The Church, although effectively a conglomerate of individual parishes, bishoprics, convents and monasteries, was none the less the only international institution of Renaissance Europe and also the only one with an internal professional hierarchy that spanned all ranks of society. A career in the Church provided a fast track for social mobility, circumventing the laborious process of climbing the steps of the economic ladder. An example from English soil is Richard Fox (c.1448–1528), a man of obscure origins who rose to become Bishop of Winchester, the richest see in England with an annual stipend of 4,000 pounds sterling – the equivalent of some 11,000 Florentine florins – in 1501.[119] It was probably in this capacity that Fox commissioned a splendid episcopal crosier of silver-gilt (Plate 1.30).

In the crook of the staff is an image of Saint Peter, to whom Winchester Cathedral was dedicated. Just below the crook, there is a protrusion with an emblematic representation of a pelican. According to the lore of medieval bestiaries, this bird fed its young with its own blood by pecking itself in the breast in a self-sacrificial manner. The pelican feeding its young was often used as a reference to Christ, who gave his blood to wash away the sins of humanity. Bishop Fox adopted it as a personal device. Its presence on the crosier demonstrates that this object was a personal item of conspicuous consumption as well as a traditional attribute of episcopal rank. Its refined goldsmiths' work, still visible despite a somewhat bland nineteenth-century regilding, had a courtly ring to it. The Gothic pinnacles, however, were conservative. They belonged to the court art of the preceding century rather than to the new classicist Italian style of ornament that was soon to be introduced. It is known that, as a theologian, Bishop Fox favoured recent developments in Italian humanist scholarship, but he was obviously more cautious when it came to the image he projected of himself through material culture – betraying perhaps the insecurity of a man who had only recently become part of the establishment and chose safe tradition over daring innovation when it came to matters of taste.

Plate 1.30 Unknown English goldsmith, Bishop Fox's crosier, after 1501, silver-gilt and enamel, height 181 cm, Corpus Christi College, Oxford. Reproduced with the permission of the President and Fellows of Corpus Christi College, Oxford.

10 Conclusion

This chapter has attempted to show that Renaissance art, when viewed through contemporary eyes, was a much wider ranging concept than it is often given credit for, despite, or perhaps because of, the general intense admiration for a selected group of painters, sculptors and architects from the period. In viewing this art, issues of conspicuous consumption and social identity, though neither was strictly of an artistic nature, played an important role. They guided the choices of patrons and artists regarding materials, expenditures, preferred forms of craftsmanship, and even style. All these factors came together in a superlative form in one of the greatest of all Renaissance artistic enterprises, begun at the outset of the sixteenth century. Its discussion requires a return to Rome, the city where this chapter started. There, in 1505, a few miles to the north of the site where Agostino Chigi was to raise his villa, construction was begun on what is arguably the largest single item of material culture realised in the Renaissance, when Pope Julius II took the initiative for the rebuilding of the venerable basilica that marked the grave of the apostle, St Peter's (Plate 1.31).[120]

Practically from the earliest conception by its first architect, Donato Bramante (c.1443/4–1514), it was clear that patron and artist envisaged a landmark to make architectural history, both in terms of engineering, with a central dome that was to be the largest since antiquity, and in terms of style, with a centralised groundplan that was a notable deviation from the elongated rectangular shape of the existing basilica and all other major European churches. It was to be a statement of institutional identity comparable, to some extent, to the dramatic constructions marking the corporate headquarters of certain modern multinationals. The projected building costs were phenomenal. When Raphael succeeded Bramante as architect of St Peter's in 1514, he sent an enthusiastic letter to his uncle Simone in Urbino, writing that 'this is the greatest building work ever seen', which would require total expenditures of 'more than a million in gold [ducats], and know that the pope has assigned a budget of 60,000 ducats per year to this project'.[121] The collateral damage caused by this lavish papal spending was totally unforeseen, however. It was the sale of indulgences (vouchers through which sinners could reduce the length of their stay in purgatory after death) to finance the construction of new St Peter's that incited the wrath of Martin Luther and sparked off the Reformation in Germany, leading Europe into centuries of fierce theological debate and civil strife that would leave a permanent cultural divide across the continent. The giant dome as it was eventually realised by Michelangelo may be a beautiful and spectacular monument; it also marks quite possibly the most influential and expensive project of conspicuous consumption devised by man.

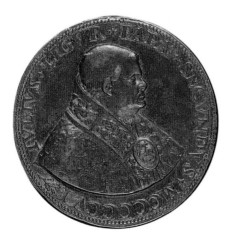

Plate 1.31 Cristoforo Caradosso Foppa, foundation medal of the new basilica of St Peter's, Rome (obverse: portrait of Pope Julius II; reverse: view of the new basilica based on the design by Bramante), 1506, bronze, diameter 5.6 cm, National Gallery of Art, Washington, DC, Samuel H. Kress Collection. Photo: Philip A. Charles.

Appendix: Types of money and exchange rates

During the Renaissance, most European cities and regions had their own currencies. The most renowned was perhaps the Florentine florin, one of the first gold coins to be issued in Europe (since 1252), and one of the most widely used currencies due to the extent of the Florentine trade network. International transactions aside, however, there were, in general, at least three different currencies in use in one place at the same time, i.e. silver coinage, gold coinage, and money of account.[122] Silver coinage, e.g. the Florentine silver lira, or lira di piccioli, was the money of daily life. Labourers' wages were paid and prices of food were calculated in silver. Gold coinage, e.g. the Florentine gold florin, or fiorino d'oro, was the money of big business. Prices of luxury goods, including most works of art, were expressed in gold. Money of account, e.g. the Florentine fiorino di suggello or the Florentine fiorino largo, was a currency that existed only on paper for the purpose of financial transactions. It often had the same denomination as the local gold coinage, but unlike the latter it represented a fixed weight in metal. In practice, this meant that any money of account usually had a slightly different value from the coinage from which its name was derived (in today's terms: a pound in one's bank account would be of a different value from a pound coin in one's pocket).

Most types of currency, in most places of Europe, broke down according to a ratio of 1:20:240. One Florentine lira di piccioli, for instance, was worth 20 silver soldi. Each silver soldo in its turn was worth 12 silver denari, resulting in a total of 240 silver denari per lira di piccioli. Consequently, an amount that we would write as £1.50 was written as £1.10.- or £1 s10 d- (1 lira, 10 soldi, and 0 denari) in fifteenth-century Florence; and an amount that we would write as £1.67 was written as £1.12.8 or £1 s12 d8 (1 lira, 12 soldi, and 8 denari – the exact equivalent of 1⅔, unlike the modern decimal approximation). There were also currencies that broke down according to different ratios. In Flanders, for example, two frequently used moneys of account were the pound of forty groat and the pound groat Flemish. The pound of forty groat broke down according to a ratio of 1:40, one pound being the equivalent of 40 groats. The pound groat Flemish was a very large currency: one pound groat Flemish was worth 6 pounds of forty groat, or 240 groats.

Everywhere in Europe, the local gold and silver coinage had fluctuating mutual exchange rates depending on the changing prices of gold and silver (unlike modern coins, Renaissance coins were literally worth their weight in precious metal).[123] Exchange rates between the gold coinage of different cities and regions also varied owing to slight changes in the weight of the gold coins.[124] Being an accountant was a challenging profession in the Renaissance, particularly in the service of such transregional overlords as the Dukes of Burgundy, whose transactions were concluded in a whole range of different currencies, e.g. the French franc, ecu and salut d'or; and the Flemish pound of Tours and pound of 40 groat.[125] The accountants of the ducal treasury often facilitated their own tasks by including exchange rates between currencies in their records of particular payments.

Because of the complex situation regarding currencies, prices of goods found in documents such as inventories, contracts and account books have to be treated with a certain amount of caution. It is important to be aware of the exact denomination in which a price was expressed, and whether the figure given referred to money of account or to actual coinage. Even so, the mere citation of its price does not say anything about the value of an object. Prices acquire significance only in the context of other prices and salary scales. The most common type of comparison is with the price of staples such as wheat, which gives an indication of living conditions and the amount of money needed for subsistence, and with the pay of skilled labourers such as builders, which is usually the lowest income level to be relatively stable. Such comparisons, too, are impossible without an understanding of historical currencies and their constantly changing relations to each other.

Chapter 2 introduction

Florentine Renaissance art is often studied in relation to elite patronage, and the degree to which rich patrons dictated the programme and content of the art they commissioned, whether intended for the public or private sphere. In the previous chapter, Rembrandt Duits took an alternative view, and Jill Burke takes up the baton from him here. She examines the patronage of the wealthy in relation to the concept of magnificence originating in the writings of Aristotle and developed and propagated by humanists during the fifteenth century. The author shows that when rich families like the Medici financed artistic projects, they did so both for the honour of their own families and, in theory at least, for the benefit of the city as a whole. Even an apparently private project might have a civic, public face. Although apparently accepted by many, this concept of magnificence met with a certain scepticism among ordinary Florentines like the apothecary Luca Landucci, and was opposed fundamentally by the Dominican friar Savonarola.

It was not only wealthy individuals who commissioned works of art for the public good. Equally important were corporate bodies such as guilds and confraternities, the *opere*, or public committees overseeing the construction, modification or renovation of key Florentine churches like the baptistery, and civic commissions like Michelangelo's famous marble *David*, which remained in situ in the Piazza della Signoria until the nineteenth century. Many such works of art were accessible to people of all social echelons. This chapter shows, however, that the actual commissioning of art involved a much wider social spectrum than has usually been recognised. The less wealthy might afford a religious painting from a painter such as Neri di Bicci, whose work was inexpensive. Confraternities of manual workers like the wool-cleaners (*purgatori*), and even associations of those at the very bottom of the social scale, the *potenze*, might raise enough money to commission significant works of art for their own religious purposes and also the edification of a more general public.

Kim W. Woods

Chapter 2

Florentine art and the public good

Jill Burke

In the opening paragraph to the life of
Michelangelo from the 1550 edition of his *Lives*,
Giorgio Vasari claimed that God had good reasons
for favouring Florence:

> In the practice of these disciplines and singular arts,
> that is painting, sculpture and architecture, the Tuscan
> genius has always been exalted and raised high above
> all others, being far more devoted to the labours and
> studies of every skill than any other people of Italy.
> Thus Florence, the most worthy of all cities, was
> Michelangelo's birthplace, so that through one of her
> citizens all her virtues could reach perfection, having
> already shown a wondrous and most great beginning in
> Cimabue, in Giotto, in Donatello, in Filippo Brunelleschi
> and in Leonardo da Vinci. Through these men one
> could not but believe that with time there would have
> to emerge a genius that shows us perfectly, thanks to
> [God's] goodness, the infinity of the ultimate.[1]

This chapter will investigate the tradition of
Florentine pride in the visual arts that influenced
Vasari's collection of artists' biographies. It will
suggest that while the *Lives* are very firmly based
in this tradition, Vasari's presentation of patronage
in fifteenth- and early sixteenth-century republican
Florence is distorted because it was written after
a significant shift in the understanding of 'art' and
the 'art patron'. Writing in the milieu of the Medici
duchy, Vasari sought to promote an idea of 'art' as
an essentially elite activity. Throughout the *Lives*
he emphasised the importance of great individual
patrons, especially members of the Medici family,
the ancestors of his main employer. The resulting
impression is that Florentine artistic supremacy
was based on the generosity and perspicacity of
great and wealthy individuals.[2]

Vasari's assertion that visual art is the preserve
of the upper classes is anachronistic when applied
to the guild-based republic of fifteenth-century
Florence. First of all, the classification of painting,
sculpture and architecture as liberal as opposed to
mechanical arts (i.e. 'art' as opposed to 'craft') was
still a new idea and far from generally accepted
in the fifteenth century. For most Florentines
these activities would have been more naturally
considered as part of the broader visual and
material production that served the day-to-day life
of the city-state. This included the creation of all
types of ecclesiastical and domestic furnishings,
making fine cloth and tapestries, providing designs
for festivities, painting processional banners and so
on. Indeed, many Florentine workshops produced a
wide range of such objects alongside painting and
sculpture. The Verrocchio workshop, for example,
produced luxury bronze goods such as candlesticks
in addition to painting and sculpture, and this
diversity of practice was common in Florence.[3]
Moreover, justifications for spending money on
the visual arts and architecture in the fifteenth
and early sixteenth centuries were very much
bound up with the idea that festivities, buildings,
paintings and other visual arts were of benefit to
a much wider range of people than merely those
who paid for them. The idea was that those of low
social status – the viewers of these objects and
buildings – would also benefit from living in a
beautiful and honourably maintained city. Group

Plate 2.1 (Facing page) Domenico Ghirlandaio, detail from *Annunciation to Zachariah* (Plate 2.16).

patronage – such as that of the government, guilds, confraternities and others – was tremendously important in the development of the visual arts in Florence. Participation in these groups, as we shall see, allowed even quite poor Florentines to make a mark on their city's fabric.

1 'Firenze bella'

From at least the fourteenth century, civic identity and pride had been bound up with the idea that Florence was particularly beautiful (see Plate 2.2). Thus, in 1403–4, in his *Laudatio Florentinae urbis* or *Panegyric to the City of Florence*, the humanist (and later chancellor of the city) Leonardo Bruni exclaimed, 'And what can I say of the multitude of inhabitants, of the splendid buildings, of the richly decorated churches, of the incredible wealth of the whole city? Everything here, by Jove, is astonishingly beautiful,' before going on to annotate Florence's grand buildings.[4] Similarly, in the historian Benedetto Dei's listing of the adornments of his native city in 1472, almost every line is prefaced with the words 'Firenze bella': 'Beautiful Florence has preserved its liberty

since its founding 1,545 years ago … Beautiful Florence rules over 406 walled towns … Beautiful Florence has an annual revenue of 360,000 florins … Beautiful Florence has a total of thirty square miles of land' and so on, ending triumphantly with the challenge: 'Venetian, Milanese, Genoese, Neapolitan, Sienese, try to compare your cities with this one!'[5] Florentine scholar Ugolino Verino in his *De illustratione urbis Florentiae* or *Description of the City of Florence* of c.1500 claimed, 'Every traveller arriving in the city of the flower admires the marble houses and the churches textured against the sky, swearing that there is no place more beautiful in all the world.'[6]

It does seem that visitors to the city were, indeed, impressed. In 1473 Ludovico Carbone, a Ferrarese orator on a diplomatic mission to Florence, praised the city as 'the splendour and ornament of all Italy' from which have arisen 'the most prudent doctors, the most respected lawyers, the most famous poets and orators, the most noble painters'; Pope Pius II, from Siena, noted, 'The admirers of Florence call attention not only to her illustrious citizens, but the size of the city (which is surpassed in all Italy by Rome alone), the lofty and extraordinarily thick

Plate 2.2 View of Florence from Piazzale Michelangelo. Photo: J. Malone/jonarnold.com.

walls which encircle it, the elegance of the streets and squares which are not only wide but straight, the magnificent churches, and the splendid towering palaces, both public and private.'[7]

For Florentines, the beauty of their city was important because it represented deeper civic virtues: the success of the social and political institutions of the republic and, above all, the ability of the city's inhabitants to co-operate for the common good, to the extent that one commentator has described beauty in Florence as 'a kind of visual politics'.[8] As with many other medieval communes, in the thirteenth century the skyline of Florence was dominated by clan towers, just as the Tuscan town of San Gimignano remains today (Plate 2.3). Remnants of these towers can still be seen in Florence (Plate 2.4), and are artefacts of a history of in-fighting between the city's great families, who jostled for political power. The spread of wealth among a relatively broad section of the Florentine ruling class meant that despotic regimes of individuals or single families were never able to flourish in medieval Florence, but this was achieved at the price of much civic turmoil. The poet Dante believed that the citizens of his native Florence were particularly prone to faction and civic discord, and his *Divine Comedy* (begun *c.*1307)

is redolent with references to the city being 'torn by hate'.[9]

After a period of protracted governmental instability, a new guild-based regime was first established in Florence in the late thirteenth century – starting in 1282 with the priors of the seven major guilds taking supreme office, and culminating in 1292–3 with the Ordinances of Justice, which banned all land-owning magnates from participation in office.[10] Further reforms in 1343 created a governmental system that was fundamentally retained until the end of the fifteenth century. Seats in government were restricted to members of the 21 guilds, and dominated by the seven major guilds. Unskilled labourers, those with no property and magnates were not eligible for office. The state was ruled by a body of nine men called the Signoria, made up of eight priors, two each from the quarters of the city, and the official head of state, the Gonfaloniere di Giustizia. The Signoria was advised by two other bodies – the Dodici Buonuomini (literally,

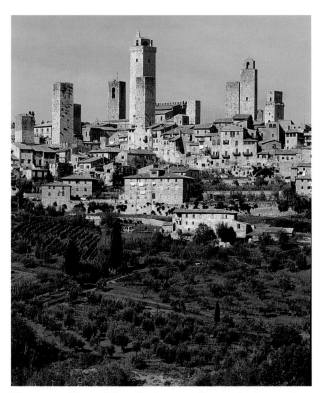

Plate 2.3 View of San Gimignano. Photo: akg-images/ Erich Lessing.

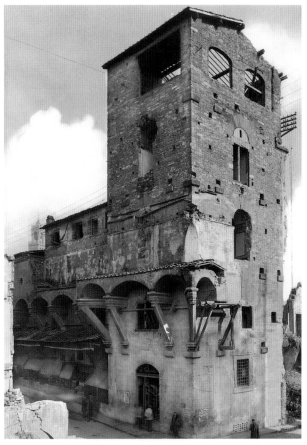

Plate 2.4 Manelli tower on Borgo San Jacopo, Florence, early thirteenth century. Photo: Alinari Archives, Florence. This archive photograph shows World War II damage.

Twelve Good Men) and the Sedici Gonfalonieri di Compagnia (Sixteen Flagbearers of the Urban Militia). There were also two bodies that voted on legislation, the Council of the People and the Council of the Commune, the first with 300 members and the second 250. Like other medieval Italian communes, all these bodies had very short tenures of office, from two months for the Signoria to six months for the two councils. Eligible men were chosen for office by lot – their names were, quite literally, picked out of a bag.[11] What might seem today to be a bizarre system of government was, in effect, an attempt at keeping the ambitions of individual families in check. The idea was that no one family or individual could dominate government for any length of time, and that all eligible citizens would participate in ruling the commune – or, at least, feel that they had the chance of doing so.

As successive regimes sought to assert a permanent mode of peaceful governance over the city's factions, they emphasised the solidity of communal government through changing the appearance of the city. The period of the establishment of the guild regime in the later thirteenth century saw an unprecedented investment in public building programmes that were to shape fundamentally the urban fabric of Florence. These included the third circuit of city walls (begun 1299), the construction of the mendicant churches of Santa Maria Novella and Santa Croce (1283 and 1295), the foundation of the new cathedral (1299), and the beginning of the government palace, now called the Palazzo Vecchio (begun 1299, Plate 2.5).[12]

Already by 1250, the first merchant-led government of Florence, the 'primo popolo', had sought to limit the height of individual clan towers, decreeing they could be no more than 50 braccia (c.29 metres) high. This provision was to be confirmed in 1325. Effectively it meant that the towers of the government palaces – first the Bargello, then the Palazzo dei Priori (Palazzo Vecchio) – were to be the highest secular buildings in the city, dominating the landscape, while the towers of several large clans had to be shortened.[13] Individual family interests were thus visibly suppressed for the good of the commune as a whole. The Palazzo Vecchio was not merely a practical response to defend and house the new government but a grand statement, much bigger than necessary for its function. From its inception, according to

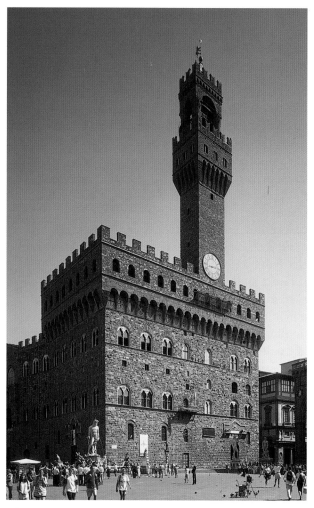

Plate 2.5 Palazzo Vecchio, Florence, begun 1299. Photo: © 1998 Scala, Florence.

Marvin Trachtenberg, the palace was a bid for 'civic magnificence' on the part of the republic, a visual claim of 'status, legitimacy and authority'.[14] The grand new building and the large paved piazza that accompanied it were architectural expressions of the ideals of harmony, order and virtue that were meant to characterise the new communal government.

The communal ethos that characterised Florentine government persisted in infusing large-scale Florentine architectural and sculptural projects that continued, or were initiated, in the fifteenth century. As in most other Italian communes, the building of the cathedral was funded by public taxation. The ambition of the cathedral project in Florence, in direct competition with Siena and Pisa, led to the building of Brunelleschi's enormous dome – construction of the dome itself lasted from 1420 to 1436, though the copper ball at the top of its lantern was only finally completed in 1471.[15]

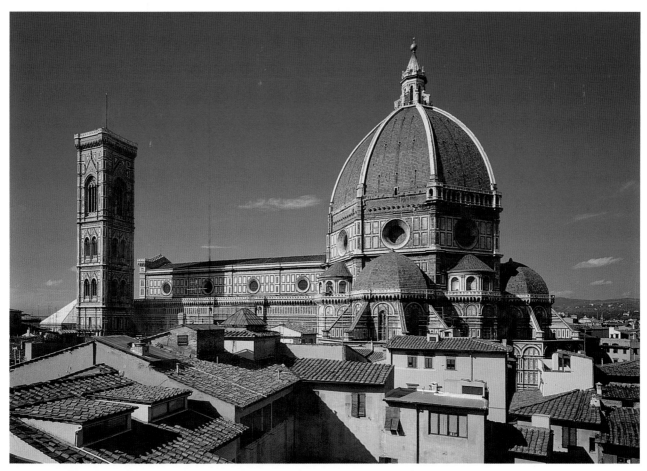

Plate 2.6 Side view of Florence Cathedral. Photo: Bencini/Alinari Archives, Florence.

The dome still dominates the Florentine skyline and was the focus for much civic pride (Plate 2.6). Ugolino Verino claimed, 'Nothing is superior to this dome, not even the seven wonders of the world.'[16] An indication of the importance of the cathedral in Florence and beyond is indicated by one commentator asserting that 200,000 people attended its consecration in March 1436. Although this is no doubt an exaggeration – the population of Florence was then around 37,000 – it does give an indication of the great excitement generated by the building project in the city and beyond.[17]

Public subsidies were also put towards the building and maintenance of other major ecclesiastical buildings, including Santa Maria Novella and Santa Croce, and later the new church of Santo Spirito (from 1397 but with many delays) and the upkeep of Santa Maria del Carmine (in the mid-fifteenth century).[18] In their petition to the government for funds, these last two institutions expressed the relationship between the honourable appearance of the city and the good of the Florentine people in the eyes of God that formed

a key justification for spending on ecclesiastical buildings:

> it would be so pleasing to both God and to his holy mother to adorn and complete their most sacred temples, and, in addition to the praise and honour that would follow for the city, we should hope that our Lord God, through his clemency, and through the intercession of his most glorious mother, will concede to us peace, tranquillity, and well-being, both to the community and to each person who gives favour to [the churches].[19]

These large-scale projects were often overseen by committees dominated by prominent Florentine citizens. These *opere*, or boards of works, were key institutions in building programmes in Renaissance Florence. They tended to be elected bodies of anything from three to 15 men – run either through guilds, confraternities or the chapter of churches, or sometimes elected by the men of a parish.[20] Their powers could be extensive. They were in charge of organising finances for building work and also dispensing these funds, which typically gave them a large degree of control over the fabric of the building and its decoration.

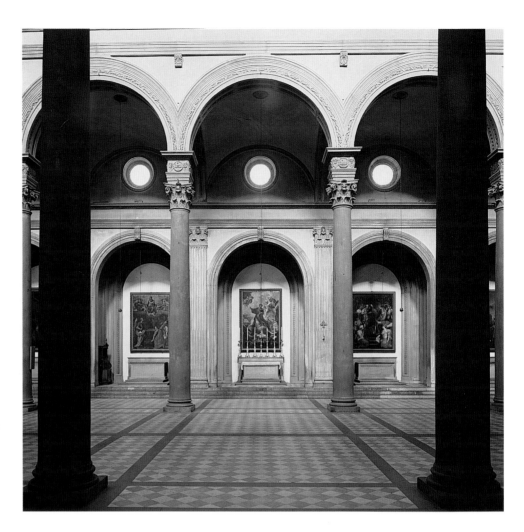

Plate 2.7 Filippo Brunelleschi, interior of San Lorenzo, Florence, initial scheme *c.*1421, building work 1434–*c.*1460. Photo: © 1990 Scala, Florence.

The *opere* allocated contracts to masters and laid down programmes for chapel sizes, altar and altarpiece types, and so on. Many of the major public buildings in the centre of Florence were overseen by *opere*, often related to particular guilds. Thus the *opera* of the Arte di Calimala (the cloth merchants' guild) was charged with the upkeep of the baptistery, including the baptistery doors; the *opera* of the Arte della Lana (the wool merchants' guild) was in charge of the cathedral.[21] Families or individuals who purchased chapels in several churches – including the Innocenti church, Santo Spirito and San Lorenzo (Plate 2.7) – had to negotiate their individual decorative wishes in the light of the needs of the entire church, a process that was often overseen by *opere*.[22] The desired result was a harmoniously decorated church, in which the wealthy chapel patrons could be seen to work together to produce a visually satisfying whole.

2 Magnificence and the Medici

Although Florence was officially a republic until 1537, during the fifteenth century the Medici family grew in political importance and became the leading citizens of the commune. Particularly towards the end of the century the Medici became surrounded by an increasingly courtly ethos, but the family were always careful to respect republican forms of government, even if in practice they used their wealth and patronage to pack the lists of eligible men with their political allies.[23] Despite sometimes significant opposition from other prominent Florentines, three generations of the family – Cosimo, Piero and Lorenzo – managed to maintain their role as first among equals, through asserting that their activities in promoting their own family were also good for the republic.

This balancing act was demonstrated in their commissions, notably in two sculptures by

Donatello that originally appeared in the courtyard and garden of the Medici palace, both areas that would have been accessible to petitioners and visitors, of which there seem to have been a constant stream.[24] Donatello's *David* (Plate 2.8) and *Judith and Holofernes* (Plate 2.9) both take up the subject of heroic Old Testament tyrant killers. Judith saved her city of Bethulia from the siege of the Assyrian general, Holofernes, by beheading him after a banquet when he was in a drunken stupor. David, the youthful hero who, with God's aid, slayed the tyrant Goliath against

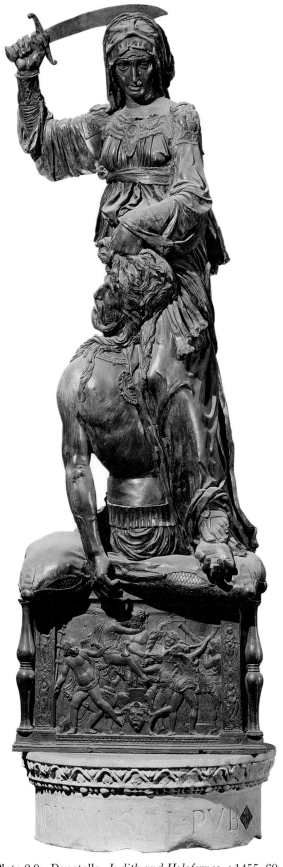

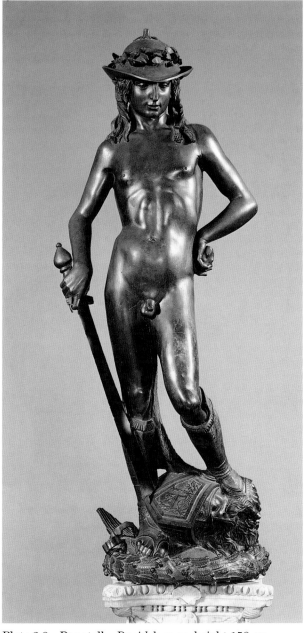

Plate 2.8 Donatello, *David*, bronze, height 158 cm, Bargello, Florence. Used with the permission of the Ministero Beni e Attività Culturali. Photo: © 1990 Scala, Florence.

Plate 2.9 Donatello, *Judith and Holofernes*, c.1455–60, bronze, height 236 cm, Palazzo Vecchio, Florence. Photo: © 2001 Scala, Florence.

all the odds, had long been an important symbol of Florentine republicanism.[25] The subject of the *David* replicated that of the marble sculpture Donatello (*c.*1386–1466) had previously made for the Palazzo della Signoria (1408–9, Plate 2.10), and

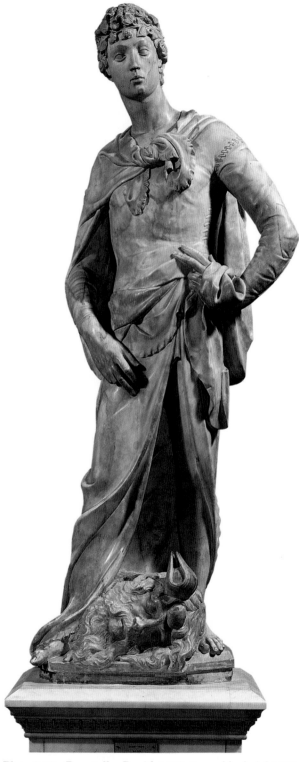

Plate 2.10 Donatello, *David*, 1408–9, marble, height 191 cm, Bargello, Florence. Used with the permission of the Ministero Beni e Attività Culturali. Photo: © 1990 Scala, Florence.

thus visually linked the power base of the Medici with the seat of the republic. This sculpture was one of the earliest free-standing bronze sculptures since antiquity, and the hero's naked form was clearly inspired by classical sculptures such as the *Spinario* (Plate 2.11).[26] Thus in its form it implicitly flattered the discernment and education of its owners and perhaps viewers in their knowledge of classical works. At the same time, the use of the expensive and relatively new medium of bronze linked these sculptures to publicly funded works such as some of the guild sculptures on Orsanmichele and the baptistery doors. The fact that a private family was able to fund such a novel technique also suggested that they were furthering the development of sculpture in a city renowned for its skill in the visual arts.[27]

That the Medici sought to argue they were protecting, rather than eroding, republican virtues was not only suggested in the subject of these

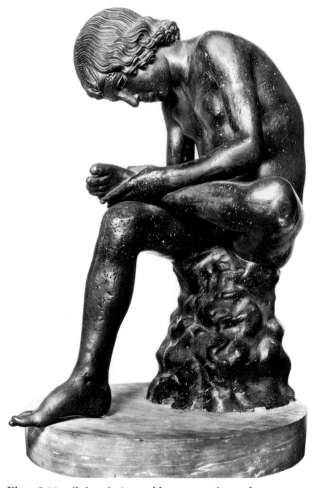

Plate 2.11 *Spinario* (seated boy extracting a thorn from his left foot), first century BCE, bronze, Palazzo dei Conservatori, Capitoline Museums, Rome. Photo: Alinari Archives – Anderson Archive, Florence.

sculptures, but driven home to a literate audience through inscriptions. The inscription on Donatello's *Judith and Holofernes* reads: 'The salvation of the state. Piero de' Medici son of Cosimo dedicated this statue of a woman both to liberty and to fortitude, whereby the citizens with unvanquished and constant heart might return to the republic' – with the additional reminder that 'Kingdoms fall through luxury, cities rise through virtues. Behold the neck of pride severed by the hand of humility.' The inscription on the *David* was: 'The victor is whoever defends the fatherland. God crushes the wrath of an enormous foe. Behold! A boy overcame a great tyrant. Conquer, o citizens!'[28]

Several recent studies have pointed out that, as the fifteenth century wore on, the Medici were also able to spread their artistic influence beyond their own commissions, as members of the family and their allies began to dominate the composition of many key *opere*. This is particularly true of Lorenzo 'the Magnificent'. His opinions on stylistic matters, and his recommendations for artists, were repeatedly sought for all kind of projects, and he

was often elected as an *operaio*, a member of the *opere*. Lorenzo and later his son Piero (1471–1503) were on the boards of works of the Parte Guelfa (Guelph party), the Mercanzia (discussed below), the cathedral, the important pilgrimage church of Santissima Annunziata, the Palazzo Vecchio and Santo Spirito, among others.[29]

As an *operaio* of the Mercanzia, the judicial body that oversaw commerce and the guilds, Lorenzo had an important influence in the commission for its statue to be placed on the guild church of Orsanmichele (Plate 2.12). In the late 1450s, the Guelph party decided to sell its niche on Orsanmichele to the Mercanzia, and removed its sculpture, Donatello's *Saint Louis of Toulouse* (completed 1423, Plate 2.13), to the church of Santa Croce around that time.[30] This niche was the central one on the side of the church that faced onto the main thoroughfare between the cathedral and the Piazza della Signoria (now Via Calzaiuoli), a very prominent and honourable position. The Mercanzia also had to replace a very lavish sculpture. *Saint Louis of Toulouse* was the

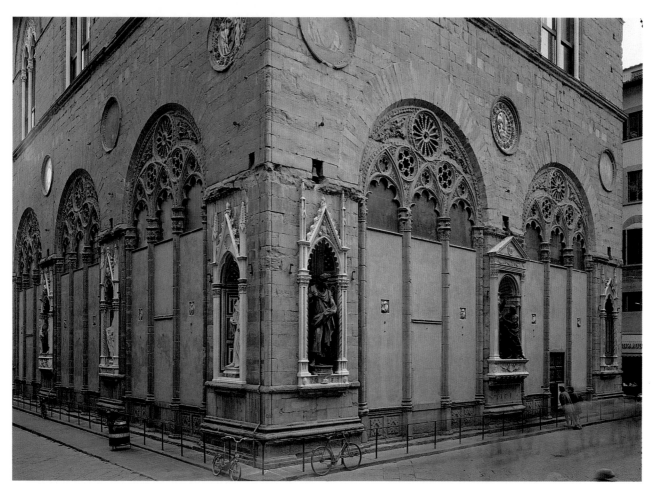

Plate 2.12 View of Orsanmichele, Florence, showing sculpture niches. Photo: Alinari Archives, Florence.

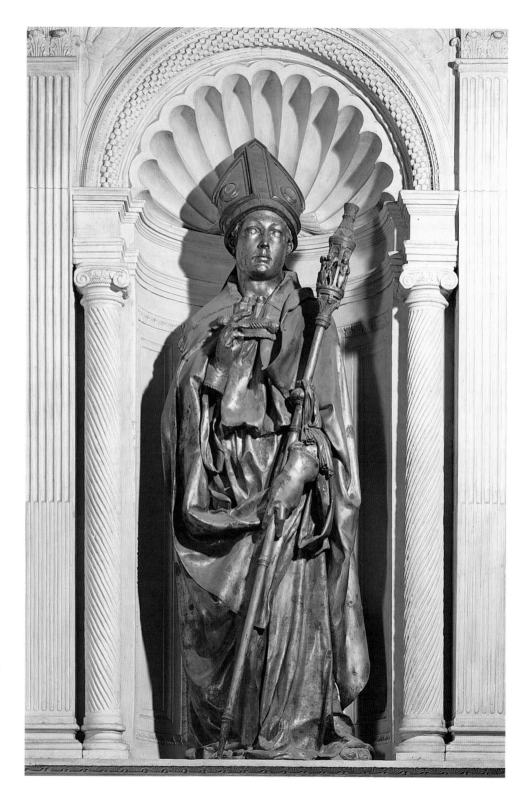

Plate 2.13 Donatello, *Saint Louis of Toulouse*, completed 1423, gilded bronze, height 266 cm, Santa Croce, Florence. Photo: © 1990 Scala, Florence/Fondo Edifici di Culto – Ministero dell'Interno.

only bronze sculpture on the building that was also gilded, and must have been an impressive and opulent sight to passers-by, appearing to be of solid gold.

Chosen for the execution of this important new commission was Andrea del Verrocchio (1435–88), a sculptor who had worked with the Medici previously, including the important commission of the tomb of Lorenzo's grandfather Cosimo (commissioned 1465–7 by Lorenzo's father Piero). The figures decided upon were Christ and Saint Thomas. The choice of a narrative subject necessitated a new type of composition for Orsanmichele. All but one of the guild niches

contained one figure, the patron saint of the guild staring straight out at the viewer. The only exception was the niche of the wood and stoneworkers' guild, which included its four patron saints, the *Four Crowned Saints* (c.1415–17, Plate 2.14) by Nanni di Banco (d.1421). Despite a suggestion of interaction between these figures, their bodies remain standing straight and facing frontally, causing a rather static effect.

Verrocchio's *Christ and Saint Thomas* (1467–83, Plate 2.15) overturned this tradition by emphasising the physical and psychological

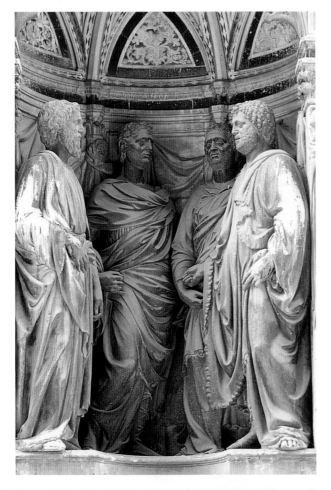

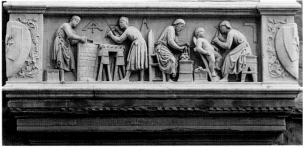

Plate 2.14 Nanni di Banco, *Four Crowned Saints*, c.1415–17, marble, height c.183 cm, Orsanmichele, Florence. Photo: Bridgeman Art Library, London.

relationship between the two figures. The Gospel passage (John 20:26) discusses how the risen Christ appeared to the disciples for the second time, emerging through shut doors before asking Thomas to thrust his finger into his wounds to prove the truth of Christ's bodily Resurrection. John Shearman has pointed out that Verrocchio probably intended the niche to represent the doors that Christ has just appeared through. We see Thomas stepping into the niche, his right foot resting on the edge of the frame, just about to touch Christ's chest wound. Christ's words to Thomas, 'Because you have seen me, Thomas, you have believed; blessed are those who did not see and believed,' are inscribed on the hem of his cloak, while Thomas's reply is on his clothing: 'My Lord and My God.' Thus the viewer of this sculpture is implicitly witnessing the biblical event as if in suspended motion, notionally taking the place of one of the apostles who also witnessed this event, and were often portrayed alongside Thomas in medieval and Renaissance paintings of this subject.[31]

This sculpture seems to have been immediately impressive. Luca Landucci, an apothecary who kept a diary from 1450 to 1516, said that it was 'the most beautiful thing and the most beautiful head of Christ ever made'.[32] The reasons for the choice of subject that prompted such startling and innovative compositional solutions by Verrocchio are significant. As Andrew Butterfield has explained, the story of Christ and Saint Thomas was a favourite subject for the decoration of judicial courts in Tuscany, as Saint Thomas looks for the evidence of Christ's Crucifixion. On Orsanmichele it would have acted as a reminder of the Mercanzia's judicial primacy over the guilds who were represented by their sculptures around the building. Thomas was also a saint associated with the Medici family, the main patron of the nearby church of San Tommaso Apostolo. In the 1470s and 1480s Lorenzo particularly sought to associate himself with good, just and legitimate rule, so this iconography of the just law-giver would have been particularly suitable for him.[33] Lorenzo's influence over the Mercanzia niche at Orsanmichele was not an isolated event. Several historians have discussed how Lorenzo had a key influence in many other public projects of the late fifteenth century, including the decoration of the Sala dei Gigli in the Palazzo della Signoria and the cathedral façade.[34]

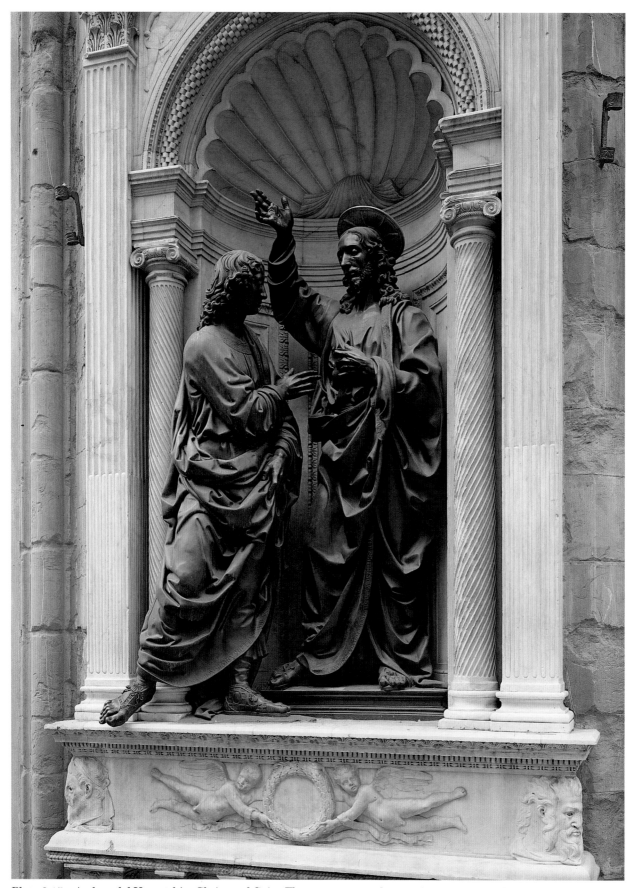

Plate 2.15 Andrea del Verrocchio, *Christ and Saint Thomas*, 1467–83, bronze, height 231 cm, Orsanmichele, Florence. Photo: Alinari Archives, Florence.

Lorenzo's interest in patronage of the visual arts should be seen against the backdrop of a conceptual framework for the funding of buildings, festivities, paintings and sculpture which became increasingly prominent in Florence during the fifteenth century – the virtue of 'magnificence'. This concept associated abundant spending for the beautification of the city with individual, rather than collective, virtue. The doctrine of magnificence was a political tool that the Medici and the circle of rich families in Florence's ruling oligarchy could employ to rationalise the vast disparities in property ownership at this time; research into tax (*catasto*) records from 1427 has shown that the richest 1 per cent of households owned more than a quarter of the city's wealth.[35] Adapted originally from Aristotle's *Nicomachean Ethics*, the Renaissance concept of magnificence exhorted the wealthy to spend their money wisely in praise of God and for the common good.[36] Virtuous projects could include church and chapel building, palace construction, rich clothing and festive entertainments. The appending of family coats of arms or other personal symbols to these buildings so that everyone knew who funded them was essential for the recognition of magnificence, as it encouraged other wealthy people to follow the benefactor's example. In the case of churches and chapels, it encouraged worshippers to pray for the patron's soul. Magnificence justified a few citizens being vastly more wealthy than the majority, as long as those citizens used their wealth in the essentially charitable and patriotic act of enhancing the grandeur and beauty of the city.[37]

One of the earliest and most comprehensive defences of Renaissance magnificence was about the building work of Cosimo de' Medici in a document by an Augustinian canon, Timoteo Maffei, in the mid-1450s. For Maffei, magnificent spending was a duty: 'if [Cosimo] were not going to look ungrateful it was necessary that he should appear … more distinguished than the other people in the town in the same proportion as he received benefits from it greater than theirs'.[38] Cosimo soon became a model for magnificence throughout Italy – thus the Neapolitan humanist Giovanni Pontano argued in his tract *On Magnificence* of 1494: 'In our days Cosimo the Florentine imitated the magnificence of the ancients through constructing temples and villas and through founding libraries. He was not content, it seems to me, to imitate

them, but he was the first to revive the custom of dedicating private wealth to the public welfare and to the embellishment of the fatherland.'[39] This idea that wealthy men not only could, but also should, spend large sums on grand building projects such as palaces and churches to justify their wealth and give back to their cities was taken up by several humanists from the mid-fifteenth century. Though later attached particularly to members of the Medici family, the epithet 'Magnifico' – the Magnificent – was a common title applied to many rich Florentine men in the mid- to late fifteenth century.[40] Thus, justifications for spending on the visual arts and architecture even by wealthy individuals were not predicated on the idea of art for art's sake, but rather on the idea that they would benefit the entire populace and please God.

There is ample evidence that the rich Florentines who undertook such enormous building projects assimilated these justifications. Often in contracts and diaries, these men discuss their building projects in terms of the glory of God, the good of a church or convent, the furtherance of their lineage and the beautification of the city. It was sometimes explicitly linked to other charitable and public-spirited acts. Lorenzo de' Medici explained his family's spending of the enormous sum of 663,755 florins on alms, buildings and taxes from 1434 to 1471: 'I do not regret this, for though many would consider it better to have a part of that sum in their purse, I consider that it gave great honour to our State, and I think the money was well expended, and am well pleased.'[41] Giovanni Rucellai echoed these sentiments when discussing the building of his house, family loggia, tomb in San Pancrazio and façade of Santa Maria Novella, among others: 'All the above-mentioned things have given and give me the greatest satisfaction and pleasure, because in part they serve the honour of God as well as the honour of the city and the commemoration of myself.'[42]

The mingling of personal and community benefit was also stressed in the contract between Domenico Ghirlandaio and Giovanni Tornabuoni for the latter's chapel in Santa Maria Novella (painted 1486–90), with the attestation that Giovanni was acting 'as an act of piety and love of God, the exaltation of his house and family and the enhancement of the said church and chapel'.[43] Visual testimony of Giovanni's eagerness to associate the success of his flourishing family

Plate 2.16 Domenico Ghirlandaio, *Annunciation to Zachariah*, 1486–90, fresco, width *c.*450 cm, Tornabuoni Chapel, Santa Maria Novella, Florence. Photo: © 1990 Scala, Florence.

with wider civic pride can be found in the fresco of the *Annunciation to Zachariah* in the chapel (Plate 2.16). This painting is the first in a series of the life of Saint John the Baptist, Florence's patron saint and Giovanni's name saint. The biblical story recounts how John the Baptist's father, Zachariah, is officiating in the temple when an angel appears to him and tells him that his elderly (and previously thought to be barren) wife Elizabeth is to bear a son. Set against a classicising backdrop of coloured marbles and military reliefs, the biblical narrative takes up a small part of the centre of the image. Standing at either side of the temple are men in contemporary Florentine dress – most wearing the long red cloak and soft cap (*cappuccio*) that were restricted to the holders of high office. These are members of the Tornabuoni family, their friends and allies, with (in a rather peculiar hole in the lower-left corner) some of Florence's most renowned intellectuals – Marsilio Ficino, Cristoforo Landino, Demetrius the Greek and Angelo Poliziano. At the right-hand background of the painting, clustered beneath an arch, are some women of the Tornabuoni family, peering onto the

civic space that was largely closed to them (see Plate 2.1). Above their heads is a Latin inscription: 'In the year of 1490, when the brilliant city, famed for its wealth, history, vitality and its architecture, was living in peace and prosperity.'[44]

This fresco might stand as a painted manifesto for magnificence. The Tornabuoni family's wealth and success were matched through their virtuous involvement in the government of the commune, amply attested to by the number of red cloaks. Their money was used wisely and paid not only for intellectual study, represented by the four scholars, but also for the beautification of the city through architecture and, implicitly, the chapel itself. Their judicious use of their wealth was of benefit to everyone and so aided the maintenance of peace in the city and beyond. It was also pleasing to God to create such an honourably adorned chapel, and would bring his favour upon the family, the church and Florence as a whole.

The value of private citizens' spending lavishly on display objects was also often appreciated by those with less money. Luca Landucci kept careful

note in his diary of the grand new buildings and other projects that were going up around the city. Of the Tornabuoni Chapel, he exclaimed excitedly that 'the painting cost 1,000 florins alone'. He also mentioned favourably how the 'estimable Messer Jacopo Manegli' spent 500 florins on the setting for the relics of Saint Jerome, a setting the whole city could enjoy when the relics were processed annually through the city.[45] Similarly, a coppersmith, Bartolommeo Masi, described the beauty and riches of the festive group of wealthy young Florentines led by Giuliano de' Medici in the 1470s with pride and awe, and described excitedly the contribution of private citizens to the celebrations in Florence after the election of the Medici pope, Leo X, in 1513: 'they made on this day much magnificence at the houses of some citizens', especially the Salviati and the Rucellai, wearing grand clothes and giving out food and drink to all, 'which was such a great act of magnificence that it seemed all of Florence had been driven crazy by happiness'.[46] Masi's use of the term 'magnificence' indicates how diffused this concept had become by the early sixteenth century.

The ethos of communal co-operation in the name of magnificent display was graphically demonstrated in the lavish festivals for John the Baptist, the patron saint of Florence, which took place for three or four days each June. A traditional point in the year to display new public sculptures (both Verrocchio's *Christ and Saint Thomas* and Michelangelo's *David* were revealed as part of the San Giovanni celebrations),[47] the visual riches of Florence and the inventive skill of its artisans in designing temporary festive apparatus and floats were key parts of these civic celebrations. All Florentines were expected – and in some cases coerced – to stop work in order to participate, with fines for those who kept their shops open.[48] On the first day of the festivities all the workshops in the city brought out their most prized goods and displayed them on the streets, a traditional event also described by Piero Cennini in 1475: 'they ostentatiously show their things in the more frequented places of the city. For almost all the artisans and those with warehouses who do business in such places put whatever precious things they have outside.'[49] This was an annual opportunity for Florence's artisans to participate directly in making the city magnificent, an attestation of both Florence's material wealth and the wealth of skills possessed by its inhabitants.

The rhetoric of magnificence, though created by humanists whose interests were served by lavish elite spending, appears in many ways, then, to have fulfilled its function – the evidence above suggests that even those people who were excluded from this particular virtue through their relative poverty seemed to appreciate the lavish spending of their more wealthy compatriots. Niccolò Machiavelli in his *Florentine Histories* (1525) noted that Lorenzo de' Medici's aims were to 'maintain abundance in the city, to keep the people united and the nobility honoured'.[50] His magnificent spending went some way towards attaining these aims.

3 Magnificence contested

However, it was a difficult balancing act. Although the Medici family eventually did become the hereditary rulers of Florence, their position was always on sufferance in the republican era. There were repeated attempts to get rid of them, all of which actually had a consolidating effect on their power base. The more notable attempts include Cosimo's exile of 1433–4, the plot against Piero's life in 1466, and the attempted assassination of Lorenzo in the Pazzi conspiracy of 1478, when his brother Giuliano was murdered. Nevertheless, in 1494, two years after Lorenzo's death, the entire family were expelled from the city, only to return in 1512 with the help of troops of the Holy Roman Empire. They were then expelled again in 1527, and only allowed back in Florence after a siege lasting almost a year. To create a hereditary duchy, the Medici literally had to starve the Florentine population into submission. Even then, the first Medici duke, Alessandro, was universally disliked and assassinated by a relative in 1537.[51] His murderer's justification was one that would have been familiar to Florentines 100, or even 200, years previously: 'men ought not to desire anything more than they desire civic life, that is, a life lived in liberty, since good civic order is rarer and less enduring in any other regime than it is in a republic'.[52] It was only with the shrewd and lengthy rule from 1537 to 1574 of Duke Cosimo de' Medici (1519–74) that the family succession was secured.

Not surprisingly, then, there was a constant thread of opposition in Florence to the Medici and the policy of magnificence that became increasingly associated with the family.[53] Some historians – notably Lauro Martines – have suggested

that the humanists who promulgated the idea of magnificence were doing so because they, too, benefited from the generous patronage of wealthy families.[54] Martines's argument is supported by a strand of suspicion towards this new style of conspicuous consumption that was voiced from the mid-fifteenth century on. Not all wealthy patrons were friends of the Medici, yet this type of spending was often equated with the family's regime by their opponents. The Florentine patrician Marco Parenti, for example, while admitting that 'Florence had not seen such prosperity in a long time' and discussing the great sums of money people spent on festivities, clothing and buildings, argued that many citizens still felt they had lost the republican liberty that was their birthright: 'Their possessions and comfortable lifestyle notwithstanding, they longed more for liberty than for anything else.'[55]

Many Florentines suspected that the motivations of these magnificent patrons were more selfish than public-spirited. There is little evidence from poorer members of the community about how the building boom affected their lives, but it is worthwhile remembering that the building of magnificent palaces by the Florentine elite often meant the destruction of many more humble dwellings and the displacement of their inhabitants.[56] The Strozzi palace, for example (Plate 2.17), was the biggest private building in Florence. Its construction involved the demolition of no fewer than 13 different houses and shops, and neighbours complained to the commune in 1489 that the palace was encroaching on public space, violating communal legislation.[57] Luca Landucci's apothecary shop was opposite this building site, and though Landucci had been happy to see money spent by private citizens on churches or ambassadorial missions, he was less impressed by the grandiose palace that was growing before his eyes. On Filippo Strozzi's death in 1491, Landucci came near to gloating:

> That Filippo who was building the above mentioned palace died; and he did not see it carried up even as far as the lanterns. He only saw it carried up to the *campanelle* [iron rings where horses were fastened]. One sees how vain are the hopes of transitory things! It appears as if we were master of them, but in reality it is the other way about; they are master of us. This palace will last almost eternally: has not this palace mastered him then? And how many others! We are not masters, but only dispensers, in so far as it pleases the goodness of God. All lies in God's hands, and happens as is meet for His universe. Therefore I pray that God may pardon Filippo Strozzi his sins.[58]

The suspicion of lavish display reached its height in the sermons of Girolamo Savonarola, a Dominican friar whose influence in Florence after the expulsion of the Medici in 1494 led many Florentines to believe that their city was to be at the centre of a renewed world order, a

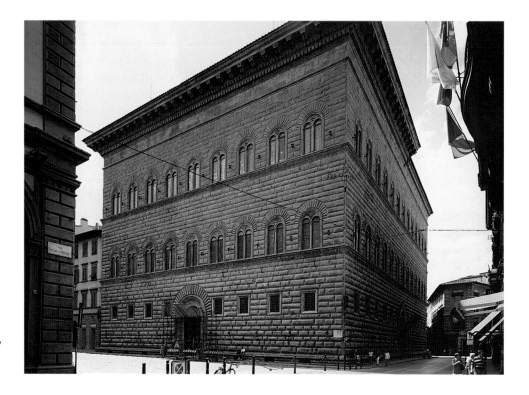

Plate 2.17 View of the Strozzi palace, Florence, built 1489–1539. Photo: © 1998 Scala, Florence.

new Jerusalem.[59] Savonarola explicitly attacked the supporters of magnificence in his sermons. Thundering that grand palaces were built 'with the blood of the poor', he built on the by now familiar argument that patrician palaces were directly displacing poorer habitations.[60] He also argued that Florentines had become so caught up in the appearance of things that they had forgotten the importance of interior spirituality: 'If I said to you, "Give me ten ducats to give to a poor man," you wouldn't do it. Yet if I say to you, "Spend 100 ducats on a chapel here in San Marco," you would do it so that you could put your arms on it, and you would do it for your own honour, not in honour of God.'[61]

For Savonarola, magnificent spending was a symptom of a spiritual malaise that was rife in Florence and that could be seen through an obsession with exterior display at the price of true piety: 'Today, anyone who is not full of pomp is reputed by everyone to be poor or mad,' he thundered from the pulpit in April 1495.[62] His opponents, he had just explained, 'seem to know everything and know nothing. They have their hearts in their eyes and they don't have their eyes in their hearts, they love only those things that one can see on the outside, and exterior things, and the honours and pomp, however trifling, of this world.'[63] Savonarola's arguments against all types of 'pomp' resonate through his sermons. He repeatedly objected to palace, church and chapel building (and particularly coats of arms within an ecclesiastical setting), wearing rich clothes, an interest in classical philosophy, new types of religious music, and the paintings and sculptures that filled Florentine churches. Aligned with this were the potential dangers in the artistic skill that was now displayed in religious painting: 'Look at the figures they nowadays make for churches, which are done with such craftsmanship, and are so ornate and elaborate, that they obscure the light of God and true contemplation, and people do not consider God, but only the craft within the image.'[64]

A great many Florentines disagreed with Savonarola's message – a Signoria made up of his opponents eventually helped to bring about his execution for false prophecy in 1498 – but many inhabitants of the city, of all social ranks, became his followers, including many palace and chapel builders. The four years of Savonarola's prominence, coupled with economic and political problems, had profound effects on the way the visual arts were viewed and understood, effects that scholars are still seeking to understand.[65]

4 Communal patronage in the service of the republic

The early years of the sixteenth century – between Savonarola's execution and the return of the Medici in 1512 – saw a self-conscious resurgence in communal and guild patronage. The revived republican regime immediately sought to appropriate and transform Medici magnificence. The family's goods were confiscated, and some of their grandest sculptures and paintings transferred to the Palazzo della Signoria in 1495. This included three large canvases of the Labours of Hercules[66] by the Pollaiuolo brothers (now lost), and the two sculptures by Donatello – the *David* and *Judith and Holofernes* (Plates 2.8–2.9) – previously in the courtyard and garden of the Medici palace. The *Judith* was set up next to the entrance of the Palazzo della Signoria and the inscription slightly changed – Piero de' Medici's name was replaced with the word 'cives', citizens. With the new inscription and placement, the Medici and all opponents to the new Florentine republic were cast as tyrants. The commune adopted its traditional iconography as the vanquisher of tyrants aided by God.[67]

The first great new public commission was the building of the Sala del Gran Consiglio or Great Council Hall adjoined to the Palazzo della Signoria. Transformed by Vasari in the 1560s into the Sala dei Cinquecento (Plate 2.18), the Great Council Hall was built to house the new, more broadly based legislative body inaugurated late in 1494. It was built incredibly quickly and was greatly praised when finished.[68] Its impact on those who saw it was described by Landucci after the incoming Medici government ruined the hall by billeting troops there: 'It was of great reputation, and it was an honour to the city to have such a beautiful residence. When an embassy came to visit the Signoria, its members were lost in admiration at what they saw on their entrance to such a magnificent place and into the presence of such an impressive council of citizens.'[69]

This hall was to be richly decorated. Early commissions, certainly influenced by Savonarola and his followers, included a bust of Christ by

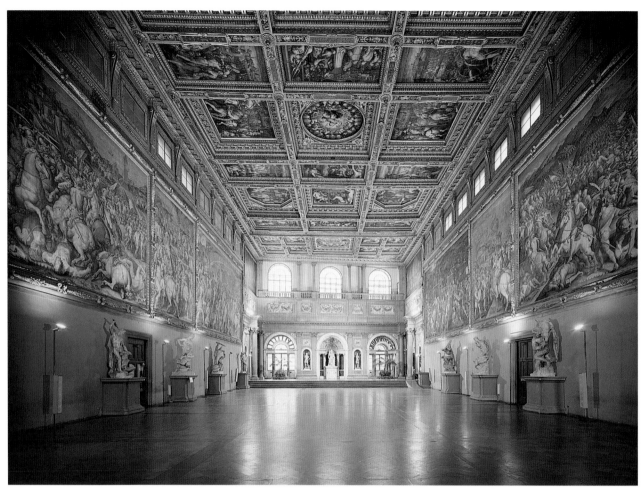

Plate 2.18　Sala dei Cinquecento, Palazzo Vecchio, Florence. Photo: © 1990 Scala, Florence.

Andrea Sansovino, which seems never to have been completed, and an altarpiece originally commissioned from Filippino Lippi, but then given to Fra Bartolommeo after his death, and also left incomplete (now in the Museo di San Marco in Florence). In 1503, Leonardo da Vinci was commissioned for a wall painting of a famous Florentine victory at Anghiari, and in 1504 Michelangelo was commissioned for its companion painting, *The Battle of Cascina*.[70] Although Leonardo started to paint his work, the traces of his composition are now covered by Vasari's additions to the hall, and Michelangelo's painting only got as far as the cartoon stage (Plates 2.19 and 2.20 are copies of these lost works). The importance of these designs for later painters, however, is near legendary – Vasari described Michelangelo's *Cascina* cartoon as 'a school for artists'.[71] The failure in bringing any of these projects to completion is largely due to Florence's political struggles. Because of their superior political and diplomatic power, when patrons like the pope (in Michelangelo's case) or the French king (in

Leonardo's) asked these artists to work for them, the republic of Florence had little choice but to let them go.

The guilds, like the commune, responded to the new political circumstances by taking up old civic projects once again. An insight into the way that Florentines perceived their duties to maintain the city's reputation, and the consciousness of the tradition of corporate patronage in Florence, can be seen in the deliberations of the consuls of the Arte di Calimala over the commissioning in 1506 of three new sculptures of John the Baptist preaching from Giovanfrancesco Rustici (1474–1554) to be placed over the north doors of the baptistery (Plate 2.21).[72] They had already commissioned from Andrea Sansovino in 1502 a sculpture of the *Baptism of Christ* to be placed over the east doors of the baptistery, and this new commission was conceived of in terms of stimulating excellence through competition, like Ghiberti's baptistery doors and the sculptures on Orsanmichele. The document starts by considering their forerunners

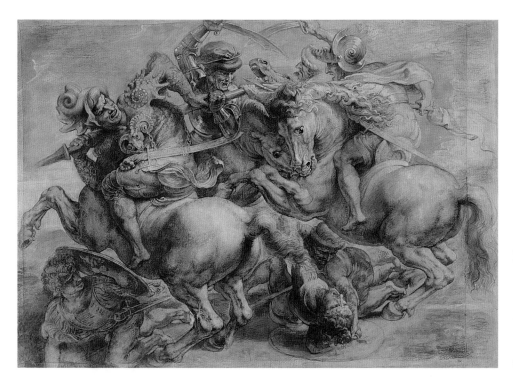

Plate 2.19 Peter Paul Rubens, after Leonardo da Vinci, *Study after the Battle of Anghiari*, 1600–8, black chalk, pen and ink and white paint, 45 × 64 cm, DAG, Louvre (inv. 20271). Photo: © RMN/Michèle Bellot.

in the guild who had commissioned so many beautiful works to decorate the baptistery. The consuls are at pains to point out that the decorous undertaking of religious services is their prime concern in relation to the upkeep of the building, but then go on to say that a new adornment to the baptistery would be suitable as 'one does not find another [church] more beautiful, or as beautiful, not only in Italy but in the entire world. And all this increases the fame, honour and reputation of your city and, particularly, of your guild.' They decided to commission three works to replace some

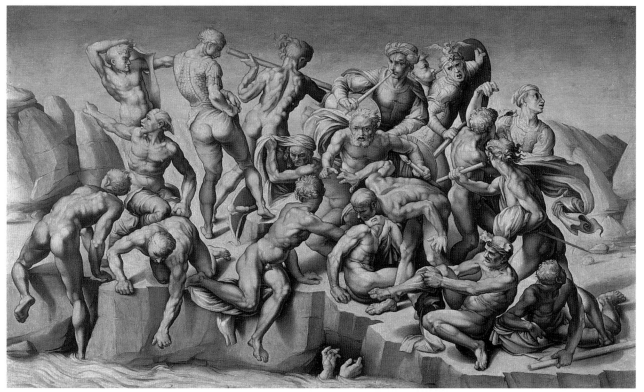

Plate 2.20 Aristotile da Sangallo, after Michelangelo, *The Battle of Cascina*, 1542, oil on panel, 76 × 130 cm, Holkham Hall, Norfolk. Photo: © collection of the Earl of Leicester/Bridgeman Art Library, London.

Plate 2.21 Giovanfrancesco Rustici, *John the Baptist Preaching to a Levite and Pharisee*, 1506–11, bronze, height 265 cm (with base), above north doors, Baptistery, Florence. Photo: © 1990 Scala, Florence.

'ugly' marble figures that stood above the north doors, and to make them of bronze as a deliberate reminder of the doors by Lorenzo Ghiberti from the previous century and Andrea Pisano from the fourteenth century.

Here we see a self-conscious harking back to the traditional basis of Florentine corporate patronage, in the days before magnificence and the Medici made such an impact on the civic scene. The final appearance of the sculptures, too, shows an interest in evoking memories of other civic projects in the mind of the viewer. The three sculptures, which still stand above the north doors of the baptistery, show John the Baptist in the centre with a Levite and a Pharisee at either side, illustrating the biblical passage John 1:15–28, where John explains that he foretells the coming of Christ. John is framed by Corinthian columns with a pediment above, his right finger pointing upwards to illustrate his point, while the Pharisee tugs his beard and the bald Levite points to himself, as if

considering John's words. Each statue is separately placed on its own plinth, complete with a Hebrew inscription, and all are positioned roughly in line with the coloured marble blind arches of the baptistery building. There is no interest in the close physical intertwining of figures that is such an important feature of much of the art of this period, particularly in the work of Leonardo – especially significant here as Leonardo may have had a hand in designing this group, since he was living with Rustici at this time. Perhaps the most obvious bronze sculptural precedent for this would have been Andrea del Verrocchio's *Christ and Saint Thomas* (Plate 2.15). Rustici, who probably trained in the Verrocchio workshop, eschewed these recent references, however, and took as a model earlier sculptural groups, notably Donatello's series of prophets for the cathedral bell tower just round the corner. In fact, the Pharisee is reminiscent of Donatello's *Bearded Prophet* (Plate 2.22) and the Levite of his *Prophet Habakkuk* (Plate 2.23),

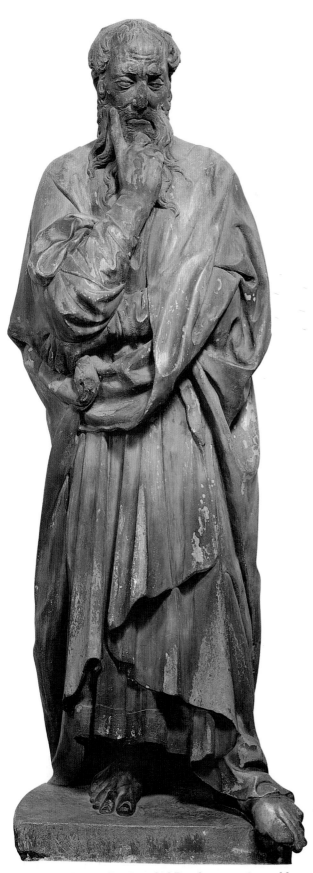

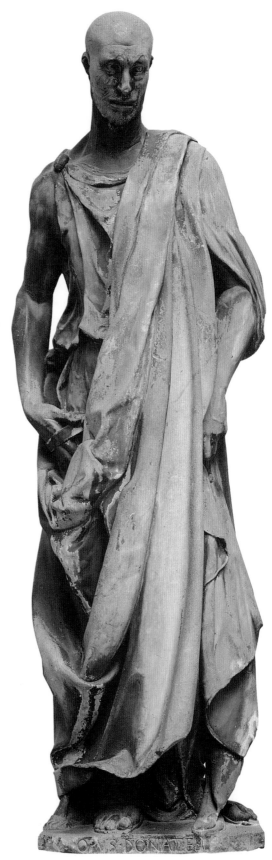

Plate 2.22 Donatello, *Bearded Prophet*, *c.*1418, marble, height 194 cm, Museo del Opera del Duomo, Florence. Photo: © 1990 Scala, Florence.

Plate 2.23 Donatello, *Prophet Habakkuk*, 1427–36, marble, height 196 cm, Museo del Opera del Duomo, Florence. Photo: Alinari Archives, Florence.

familiarly known in Florence as 'pumpkin head' (*zuccone*). The formal echoes of prophets make theological sense here in a sculptural ensemble about the prophecy of the coming of Christ, but also carry political overtones. In their form they deny a sculptural type associated with the era of Lorenzo de' Medici in favour of a tradition associated with civic patronage.

Tellingly, Vasari makes his account of this commission into a cautionary tale about working with corporate patrons, especially if, like Rustici, you come from a high-born family:

> while engaged upon [the baptistery group], Rustici became tired of being obliged to ask money from the consuls or their masters every day, as they were not always the same persons and are generally men who have little esteem for ability ... In spite of his labour and expense he was but ill-rewarded by the consuls and his fellow-citizens ... Thus what should have brought Rustici honour turned to his prejudice, and whereas he should have been esteemed at once as a noble citizen and a man of genius, his skill as an artist prejudiced his nobility in the eyes of the ignorant and foolish.

> Rustici called in Michelangelo to value the work for him, and the magistrates ... called in Baccio d'Agnolo [who designed the celebrated woodwork for the Palazzo della Signoria, was employed extensively by the Opera del Duomo, and also became a noted architect]. Rustici complained, telling the magistrates that it was strange to call in a wood-carver to value the work of a sculptor, intimating that they were a herd of oxen ... But, worse still, a work which did not deserve less than two thousand crowns was valued by the magistrates at five hundred, and only four hundred of them were paid, through the intervention of Cardinal Giulio de' Medici. In despair at such malignity, Rustico determined never again to work for the magistrates, but only for individuals.[73]

So, for Vasari, this story provides proof that well-born creative artists should never work with committees, and certainly not have their work assessed by a lowly-born artisan without even a family name. Luckily, who should come to the rescue but a beneficent aristocrat, one of the Medici family, to help salvage the situation.

There were indeed problems over payments, though these were neither rare nor surprising given the social and political disruption of the period, but Rustici was eventually paid a total of 1,150 florins for his work, a considerable sum.[74] Neither was it unusual to have wood-carvers or

painters assessing the price of a sculpture – in 1509 Rustici himself chose the painter Lorenzo di Credi to assess a fair price for another piece of work.[75] Vasari uses Rustici's difficulties, however, to argue against a type of patronage that had been crucial for the development of the visual arts in Florence over the last 200 years. His belittling of committees indicates how profoundly ideas about art and social status had changed by the mid-sixteenth century. Significantly, in 1547, Michelangelo (1475–1564) suggested that the relative ignorance of Florentine committees could allow a large degree of artistic autonomy if they admitted their lack of knowledge. Frustrated by what he saw as the meddling of the works committee of St Peter's in Rome, he compared their interference unfavourably with the *operai* of Santa Maria del Fiore: 'some were wool merchants and some had other occupations ... and they did not understand architecture or building, and for these reasons they deferred in absolutely everything to messer Michelangelo,' trusting him to spend hundreds of thousands of scudi.[76]

Whatever the rhetorical distortions of Michelangelo's account of his relationship with the *operai* of Florence Cathedral, it seems certain that Vasari also misrepresented the history of his most famous Florentine commission, the marble *David* (completed 1504, Plate 2.24). The impulse for the commission, Vasari claims, came from Michelangelo himself, who remembered that an enormous block of badly carved marble was languishing in the cathedral workshop. The cathedral warden and Piero Soderini, who was to be made the Florentine head of state (Gonfaloniere di Giustizia) for life in 1502, 'gave it to him as worthless, thinking that anything he might do would be better than its present useless condition'.[77] This is pure fantasy. A document of July 1501, before Soderini came to power, shows that the *operai* of the wool merchants' guild decided to revive a long dormant commission and actively seek possible sculptors, a couple of months later entrusting the task to Michelangelo.[78] In fact, Michelangelo's *David* is possibly the epitome of co-operation in Florentine corporate commissions.

As the famous – and true – story tells, there had been a large marble block languishing for some time in the Opera del Duomo, left unfinished because a former sculptor had started the work badly. In 1501 Michelangelo was contracted to restart this block, which according to

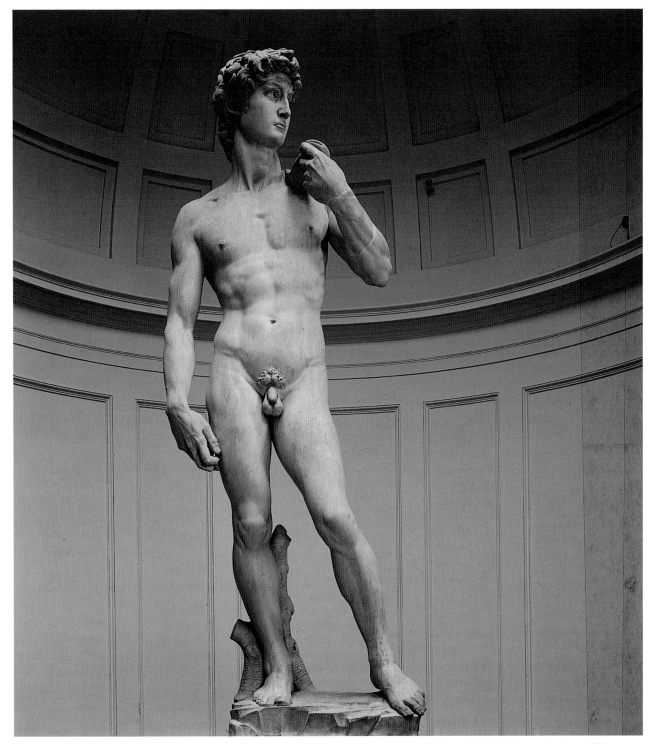

Plate 2.24 Michelangelo, *David*, 1501–4, marble, height 517 cm, Accademia, Florence. Photo: Alinari Archives, Florence.

documentation was originally intended to be 'put up on high' somewhere on the cathedral.[79] For some reason, plans for the location were changed – perhaps because of logistical worries about the sculpture's weight or because of a wish to make the *David* more easily visible – and a committee of various experts was brought together in January 1504 to consider where the statue should go.[80]

The advisory meeting (or *pratica*) was common in Florentine government and traditional for important decisions in the cathedral works, but in this case was prompted by an extraordinary sculpture. Always referred to as 'the Giant' by contemporaries, Michelangelo's *David* is mentioned in every chronicle of this era, its movement from the cathedral to the Piazza della Signoria being a

public spectacle.[81] It eventually replaced Donatello's *Judith and Holofernes*, a sculpture that many chroniclers, like Messer Francesco the Herald in the 1504 meeting, believed to have been erected under inauspicious astrological conditions, leading to the loss of the important Florentine possession of Pisa.[82] With the 'decent ornament' that Leonardo said was necessary – the statue's genitals were covered with a garland of leaves – it was finally revealed to the public in June 1504.[83]

The *David* is the embodiment of Florentine public sculpture, celebrating many facets of the city's republican identity. Originally commissioned to be placed on one of the buttresses at the eastern end of the cathedral as a corporately funded project, its extraordinary size and artistic quality led it eventually to be placed next to the Palazzo della Signoria, where it could more clearly evoke the ideals of the new republic. As Charles Seymour has pointed out, Michelangelo, with the difficult task of making a colossus out of an enormous and badly blocked-out piece of marble, identified with David's struggles against his own sculptural Goliath.[84] As he was also making a copy of Donatello's bronze *David* (Plate 2.8) for the French government at this time, Michelangelo must have been keenly aware of the implicit competition between himself and the most renowned Florentine sculptor of the previous century.

As we have seen, the Florentine people had a long tradition of looking to the story of David for inspiration against tyranny. The realities of the new European political scene made David's example ever more relevant as the small city-state found itself caught up in conflict between greater powers such as France, the Holy Roman Empire and the papacy. The new sculpture's size and ambition represented the skill of Florentine craftsmen to evoke and surpass classical antiquity, but more than this, it represented a new hope that the Florentine republic would prevail against overwhelming odds.

5 Artisans and workers

Many Florentines contributed through taxation and guild fees towards the great civic projects of the early sixteenth century, but there were more direct ways in which average inhabitants of the city could become involved in artistic culture. As Rembrandt Duits points out in Chapter 1, the poor were unable to afford the kind of luxury goods that art historians study today. There is little source material to tell us about the decoration of the dwellings of artisans and labourers. What is certain, however, is that it was not just the super-rich 1 per cent of families that bought paintings and sculpture. There is much evidence that minor guildsmen – craftsmen and shopkeepers – bought and commissioned objects for churches and their own homes. Bartolommeo Masi, for example, recounted how his father bought a tomb for the family at the church of Santissima Annunziata in 1515, complete with the family coat of arms and the inscription: 'Bernardo di Piero Masi calderaio [coppersmith] et suorum'. Masi proudly exclaimed: 'And these verses are in Latin!' He also carefully recorded the price – 6 lire (pounds) and 10 soldi (shillings).[85] The account books of the painter Neri di Bicci, which run from 1453 to 1475, reveal several artisans among his clients, including a cooper, leatherworker, ropemaker, stationer, stoneworker, tailor, barbers, coachmen, goldbeaters and hosemakers. Neri specialised in religious imagery in gesso and on panel, and his prices varied between 140 lire for an altarpiece for the confraternity of San Giorgio, commissioned by Damiano the leatherworker and presumably paid for by the confraternity as a whole, to a tabernacle of the Virgin Mary bought by Giovanni the barber for his house for 3 lire, 6 soldi.[86] To put these prices in perspective, Richard Goldthwaite has estimated that unskilled construction workers would earn around 10 soldi a day in the 1460s, and skilled labourers about 17.[87] So when Giuliano Sandrini, a skilled stoneworker, bought a painting of the Virgin Mary for his son's room from Neri in 1473, he spent 15 lire (equivalent to 300 soldi), approximately 17½ days' work.[88] An unskilled colleague would have had to work for 30 days to earn this kind of money. This painting is lost, but may have been something like another *Virgin and Child* by Neri di Bicci (Plate 2.25). To give a rough sense of proportion of income in comparison with earnings today, equivalent British workers, according to the Building and Allied Trades Joint Industrial Council, should earn £52.04 a day for unskilled work, £72.15 skilled, so proportionally Sandrini's 17½ days' work would be worth around £1,300.[89]

This is a far cry from the 1,000 florins (in 1490 no less than 650 days' work for an unskilled construction worker, equivalent to around £34,500) that Landucci reported Giovanni Tornabuoni had paid for the painting of his chapel in Santa

Plate 2.25 Neri di Bicci, *Virgin and Child with Saints James and John the Baptist, c.* early 1470s, tempera on panel, Museo Bandini, Fiesole. Photo: © 1995 Scala, Florence.

Plate 2.26 Unknown Italian, *Saint Dominic*, fifteenth century, coloured woodcut, National Gallery of Art, Washington, DC, Rosenwald Collection 1963.11.7. © 2006 Board of Trustees, National Gallery of Art, Washington, DC. Photo: Dean Beasom.

Maria Novella.[90] Nevertheless, it does represent a considerable sum of money, and the fact that these artisans were willing to save up for these objects suggests their importance for personal devotion, and a readiness to spend a significant proportion of one's income on high-quality objects of this type. This has to have been for reasons of piety and status as much as, if not more than, aesthetics. Paintings were not, of course, the only kind of religious imagery available – Rembrandt Duits discusses pilgrim badges as a relatively accessible form of religious display for the poor – and in the later part of the fifteenth century religious prints were also available for those who could not afford painting or sculpture. The 1525 inventory of the print seller and stationer Alessandro Rosselli gives an insight into prices. Although complex engravings were valued as high as 1 lire, more

simple woodcuts could be as little as 2 denari, a small fraction of a day's income even for an unskilled worker – less than 90 pence to continue the comparison with building workers today.[91] Sometimes these images were then coloured by hand, as with one now in the National Gallery of Art in Washington, DC (Plate 2.26).[92] It seems likely, therefore, that all but the near-destitute would have been able to afford some type of religious imagery.[93]

6 Confraternaties and the visual arts

If, individually, Florentine workers could afford only relatively humble works for their homes and local churches, collectively they could make a much greater impact on the city. There was an understanding in Renaissance Florence that the beautification of the city was of benefit to all who lived there, and the commissioning of buildings, sculptures and paintings by groups of people rather than individuals was common. There was, therefore, an entrenched conceptual model for corporate commissions in the visual arts.

Aside from guilds and government bodies, the most important corporate groups were confraternities. This type of organisation of lay people was common throughout Europe from the later thirteenth century. John Henderson has identified five types of confraternities active in Florence in the fifteenth century. The two most important types were the *laudesi*, who sang songs of praise to the Virgin and the saints, and the *disciplinati*, penitent organisations whose members flagellated themselves at meetings. A third type was the charitable organisation which distributed poor relief, and the last two types were defined by their membership – youth confraternities and artisan companies, which drew their members from a single occupational group and met under the control of a guild.[94] These last, as we shall see below, also often played key roles in poor relief and other charitable activities, such as supplying dowries for members' daughters, visiting the sick, burying members in confraternal graves and saying masses for the souls of their deceased brethren. As well as commissioning altarpieces and other pieces of liturgical equipment for chapels and meeting houses, many confraternities were also responsible for festivities, processions and sacred plays, both on the day of the confraternity's patron saint, and, as discussed above, as part of bigger civic festivities such as the annual celebrations for Saint John the Baptist.

Like the idealised commune, the confraternities preached to their membership a suppression of individual desires in favour of the creation of a pious community that worked for the benefit of everyone involved. This was celebrated ritually on Maundy Thursday, the Thursday before Easter when the Last Supper took place and Christ washed the disciples' feet, a ritual that was often repeated in confraternities by the officials washing the feet of the other members, the ceremony ending with a communal meal.[95] The aim of this was explained in a sermon of 1476 given to the youth confraternity of the Nativity: 'let us turn to each other with hearts warmed by the virtue of charity and her companion, humility; let us forgive one another our injuries, let us forget the hatreds that exist between us, let us do away with our mutual envies, let us lower our heads, imitating our Lord Jesus.'[96]

There were several confraternities that, in the mid-fifteenth century, were famous for the *sacre rappresentazioni*, sacred plays staged in their local churches, which could be absolutely spectacular and which, as much as altarpieces and domestic religious imagery, formed a key part of devotional visual culture for most Florentines.[97] An example is the confraternity of Sant'Agnese, which met in the church of Santa Maria del Carmine and each year staged the play of the Ascension of Christ in that church. Sant'Agnese was a very old *laudesi* company dating from the mid-thirteenth century.[98] Its membership derived from the *gonfalone* (district) called Drago Verde (Green Dragon) in Santo Spirito, an area that encompassed some of the grandest Florentine families, such as the Soderini, as well as some of the poorest streets in the city. The confraternity offered an arena where these social classes could mix, a regular reminder of the equality of all people before God.[99] Neri di Bicci acted on behalf of this confraternity in the 1460s, and in 1467 he made an inventory for his fellow 'property masters' – like Neri, skilled artisans (a shoemaker, squirrel-furrier and goldsmith).[100] The full inventory lists a vast panoply of items. Some of these are for regular use: the 'large pall [coffin cloth] of rich red brocade with white figures of Jesus and other figures … a pillow for use with the above pall' and 'a pair of large torches' for burying the dead; 'a wheelable lectern', 'a cloth for the lectern of black taffeta', 'a small wooden crucifix' and several books of rhymes and music for singing the lauds; seats, desks, tables and an altarpiece for their meeting place; a large star with angels that they erected on various feasts in the church; and fittings for the altar including an altarpiece, a frontal, various cloths, lamps, torches and a bell. Many, however, are dedicated to the Ascension play, including a 'big cloud in

which Christ goes' when he ascends to heaven, with several ropes to pull him into the ceiling, 600 glass ampoules, somehow attached to the 'heaven' that was made in the church, cords and ropes to raise and lower scenery, 'an iron frame on which the angels come down' and various wigs, masks and costumes for Jesus, God, angels and various saints. These objects were bought by an entire community of people for an annual celebration that wowed the entire city as well as many foreign visitors.[101] Through their membership of this confraternity, the badly off and the poor could have access to a world of material culture that would have been closed to them as individuals.

All confraternities also commissioned items of liturgical equipment – chalices, candles, priestly clothing and altarpieces – in order to celebrate Mass at an altar dedicated to their patron saint. An examination of these altarpieces can give an insight into the social networks engendered by these religious groups, and the jostling for local prominence within them. For example, the company of Sant'Andrea commissioned its altarpiece from Cosimo Rosselli (1439–1507) around 1478 (Plate 2.27).[102] This company, founded in 1455, was based not on locality but on occupation. Membership was restricted to wool-cleaners (*purgatori*) and carders, the semi-skilled workers who cleaned the wool cloth before it went on to be dyed, and its regulations were overseen and ratified by the wool guild.[103] The revised statutes of 1466 and 1515 reveal the scope of the confraternity's activities – it paid alms to maintain a hospital with two beds for old and ill brothers, and it had a feast each year at the church of Santa Candida, just outside Florence's walls at Porta alla Croce. This included a Mass at the confraternity's altar of Sant'Andrea there – with a 5 soldi fine for not showing up. The company met every first and third Sunday of the month in its hospital and maintained a chaplain there. When any of the brethren died, they were processed with torches to the tomb of the company at the foot of the altar in Santa Candida, and all members of the confraternity were obliged to pray for them. Everyone was also obliged to go for a pilgrimage once a year to the Marian shrine of Santa Maria Impruneta, just outside Florence. To fund these activities, every wool-cleaner and carder in Florence was obliged to become a member, at the price of a hefty fine. Every master of a wool-

cleaner's shop paid a fee according to the amount of cloth that went through the workshop, whereas his workers paid 4 denari for every lire they earned: thus membership fees were based on an ability to pay.[104]

The altarpiece was the focal point of much company ceremonial and, along with its coat of arms – a carding tool on a red background – was a permanent display of corporate identity, an indication of the fruits of mutual support in the name of God. It shows the Virgin and Child on a raised throne at the centre of the image. Standing on a tiled marbled floor at either side are Saints John the Baptist, Andrew, Bartholomew and Zenobius. Inscriptions with the names of saints and the date are on the bottom step, while further steps lead up to the Virgin's throne with a Latin inscription reading: 'Joy to thee, O Queen of heaven! Alleluia! He whom it was thine to bear; Alleluia!', the first two lines of the antiphon[105] in praise of Mary sung by Catholics during the Easter season, and intended to be sung, like the other Marian antiphons, by the entire congregation. The date on the bottom step, although much altered, probably read 28 November 1478. Falling just before Saint Andrew's day, on 30 November, it perhaps records the date of the dedication of the altar, just before the first confraternal celebration.[106]

Both inscriptions contextualise the altarpiece at the centre of the confraternity's major feast days. The antiphon of the Virgin, some Latin with which these workers would almost certainly be familiar, would evoke the Easter period of confraternal rituals culminating in the washing of feet on Maundy Thursday. The date on the lower step would remind the brothers of the original commission of the altarpiece in honour of their patron saint and the continuous activities of their company, particularly the feast on Saint Andrew's day when most of the brethren would see the altarpiece. The two outer saints on the panel were respectively patrons of the city of Florence and the wool guild. Their presence would remind the confraternity of their duties and contribution to each of these grander institutions.

We are lucky enough to have documentary evidence to explain the presence of the fourth saint, Bartholomew, the only one who looks directly at the viewer. Messer Bartolomeo di Matteo, prior of Santa Candida, was instrumental in drawing

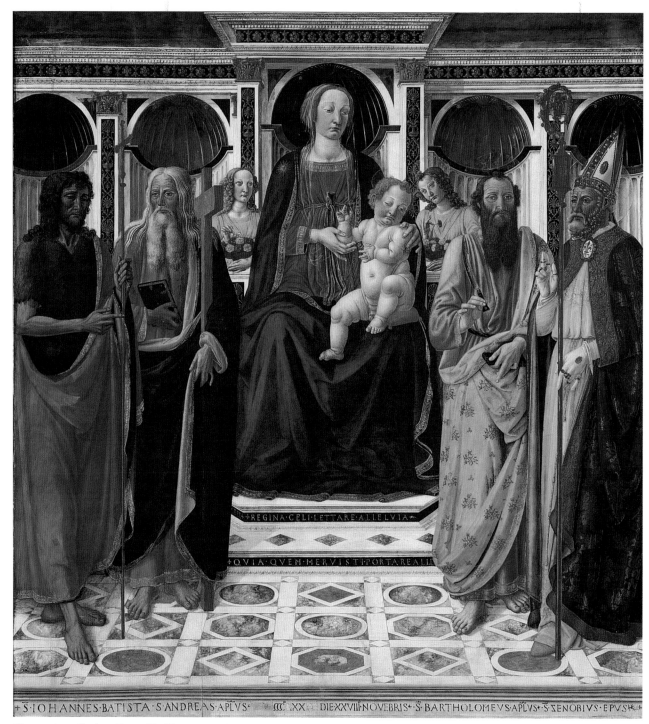

Plate 2.27 Cosimo Rosselli, *Virgin and Child Enthroned with Saints John the Baptist, Andrew, Bartholomew and Zenobius*, 1478, tempera on panel, 191 × 175 cm, Fitzwilliam Museum, Cambridge. Photo: © Fitzwilliam Museum, Cambridge.

up the company's constitutions in 1466. In this document his role in refounding the company is emphasised: 'Because you could say that this was started first by God and then by him … [Messer Bartolomeo] is confirmed that without further election of confirmation during his life he will be our corrector and chaplain.'[107] By placing his name saint on its altarpiece – Anna Padoa Rizzo even

suggests that this is a portrait – the confraternity ensures that it will remember its early benefactor, and that his soul will continue to oversee the brethren even after death.[108] Notably, Bartholomew is the only saint who looks directly out of the altarpiece, and his right hand, though holding an instrument of martyrdom, the flaying knife, could also be interpreted as being in a gesture of blessing.

7 Corporate patronage and empowerment

The confraternity of Sant'Andrea was made up solely of artisans and workers, but most of these organisations were open to all levels of society. There was, however, one type of group that was exclusively the preserve of the lower classes. The *potenze* (literally, the powers) existed in many cities under different names throughout early modern Europe, and staged festivities, processions and ceremonial fights during various holiday periods.

Formerly shadowy presences on the civic stage, the nature of the *potenze* and their importance for lower-class male sociability is now becoming clearer, thanks to the work of David Rosenthal.[109] Often allied to, but not exactly the same as, confraternities, these groups were made up of artisans and lower-class men who each 'ruled over' a zone of the city. Each group – and there were about 45 by the mid-sixteenth century – had a meeting place (often a tavern), crowned a 'king' to rule over them, and participated in public festivities. There remain in Florence today several boundary markers to show these divisions, such as the kingdom of the Red City marker on the church of Sant'Ambrogio (Plate 2.28) and the kingdom of the Apple at the Canto della Mela (Corner of the Apple) near Santa Croce (Plate 2.29). Rosenthal's work has shown that, far from being confined to festivals, membership of these groups provided often illiterate working men with permanent social networks through which they could attain access to people who could write letters of supplication to the governing authorities on their behalf, and the importance of these groups in providing unofficial mediating organisations between workers and the government lasted well beyond festive time.[110]

The biggest street tabernacle in Florence was commissioned by one of the *potenze*. The tabernacle of the *Fonticine* (little fountains), made in 1522 by Giovanni della Robbia (1469–*c*.1530, great-nephew of Luca della Robbia), still stands today where Via Nazionale meets Via Ariento, near the church of San Lorenzo (Plate 2.30). The colourful glazed terracotta, typical of Giovanni della Robbia, shows the Virgin and Child enthroned, with the infant John the Baptist praying at their feet, and Saints James and Laurence just behind the Virgin's throne. At either side, at an oblique angle to the main panel, are two female saints labelled Barbara and Caterina. On the top of this inner frame God the Father leans over the main scene with open arms while angels carry a crown to the Virgin, topped by the Holy Spirit in the form of a dove. The entire ensemble is framed by garlands of flowers and leaves interspersed with heads of various saints – an unusual device that echoes the frame of the east doors of Florence Baptistery (Plate 2.31). At the bottom of the frame are small niches with two standing saints, Sebastian and Roch, at either side. Underneath the main panel are two inscriptions. The first, in Latin, reads: 'Hail the Virgin, the ruling mother of the earth! Hail the hope, grace, life, salvation of man!'[111] The second, in Italian, says: 'The men of the kingdom of Bethlehem [Biliemme] made this pious tabernacle, placed in Via Santa Caterina, 1522.'[112]

Plate 2.29 Apple marker at Canto della Mela, Via Ghibellina, Florence. Photo: David Rosenthal.

Plate 2.28 Red City marker on church of Sant'Ambrogio, Florence. Photo: David Rosenthal.

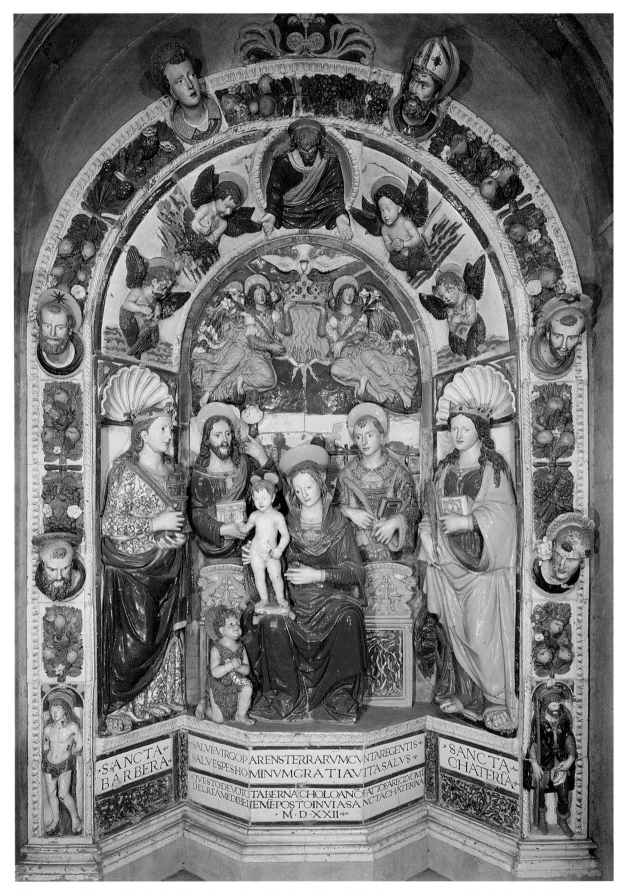

Plate 2.30 Giovanni della Robbia, tabernacle of the *Fonticine*, 1522, glazed terracotta, Via Nazionale, Florence.
Used with the permission of the Ministero Beni e Attività Culturali. Photo: © 1990 Scala, Florence.

Plate 2.31 Lorenzo Ghiberti, detail from frame of east doors, c.1447–8, fire-gilded bronze, Baptistery, Florence. Photo: © 1990 Scala, Florence.

The *potenza* kingdom of Bethlehem was centred on a tavern, the Cella di Ciardo on Via Ariento, a short walk to the tabernacle. This area, near the church of San Barnaba, was largely inhabited by wool-weavers of German and Flemish extraction, who also found corporate identity in two confraternities – those of Saint Catherine and Saint Barbara, who had a chapel in the church of the Annunziata.[113]

There is no documentary evidence for the cost of making this tabernacle, but we can gain an idea of how much the men of Bethlehem spent by comparing prices with a similar work Giovanni della Robbia made a few years previously. The altarpiece of the Assumption of the Virgin made for the parish church of San Marco at Calcesana in 1518 cost a total of 44 florins, or 6,160 soldi – 352 days' work for a skilled worker.[114] It may be that Giovanni, whose workshop was nearby and thus was a subject of the Bethlehem king, would have given the men a discount or accepted payment in kind, but nevertheless such a large and complex altarpiece would have represented a considerable expense for these artisans.

A number of factors came together in this monumental assertion of kingdom and territory, though in the first instance the tabernacle was probably linked to the plague.[115] Both the small standing saints that flank the frame, Sebastian and Roch, were commonly invoked in times of pestilence. In August 1522, five officials were appointed to bring in measures to protect Florence from an epidemic that was raging in the countryside around the city, mainly by forbidding entrance to anyone from a disease-affected area.[116] Despite their attempts, according to the chronicler Bartolommeo Cerretani, an 'unknown German' managed to enter in early November of that year and went straight to the 'marmeruchole', a street now known as Via Chiara, where many other Germans lived, just around the corner from the tabernacle. The German was then carried to the hospital of Santa Maria Nuova, where he died. The Florentine authorities' response was to close off entirely this area of the city, a square of two or three streets; the tabernacle is near the centre of this square. In the next few weeks around 40 people in the German community were killed by the plague, very few casualties compared to the 25,000 that Cerretani says died in Rome, and for the rest of 1522 Florence was spared further casualties, 'which seemed miraculous' according to another commentator.[117] Also as a response to the threat of the plague, popular preaching was banned and saints' days at churches were not allowed to be celebrated, including the festivities of Saint Catherine on 25 November and those of Saint Barbara on 4 December. The chronicler Giovanni Cambi says this was a grave mistake, which the common people did not like, as if the Florentine government 'did not want the help of male or female saints'.[118]

This tabernacle demonstrates, therefore, an attempt by the poor men, many of German or Flemish extraction, to give thanks to the Virgin and their patron saints for sparing them the worst ravages of disease. Moreover, by including their images on the tabernacle, they provided a permanent monument of thanks that replaced their temporary inability to gather together to honour Catherine and Barbara on their saint's days. Perhaps one can also see in the building of such a grand tabernacle a wish to expatiate the sins of a fellow German for bringing the plague

into Florence in the first place and a bid to assert the community's permanent contribution to civic life. Although German saints are prominent, local Florentine saints – John the Baptist and Laurence (the patron of the parish church) – occupy pride of place, and the evocation of the baptistery doors through the form of the frame of the tabernacle would remind the Florentine onlooker of a monument central to civic identity, the place where all those born in the city were baptised. Though prevented from celebrating the feasts of their saintly patrons by their social superiors, the weavers of the Biliemme gave their heavenly advocates a permanent and public celebration through commissioning their grand tabernacle. Their kingdom, the kingdom of Bethlehem, was overseen by God-fearing men, whatever the state of the city's government as a whole.

8 Conclusion

What Vasari does in the *Lives* is to marginalise activity that does not conform to his view of an archetypal art patron – which one could call the 'Lorenzo de' Medici type' – by denying the effectiveness and innovations of Florentine group patronage. More than this, however, through making the historical and theoretical case for 'art', with objects such as painting and sculpture primarily vessels for the expression of the skill and imagination of an 'artist', facilitated by an understanding and educated patron, he obscures the function of these objects as hubs for broader social identities, shaping the way contemporaries understood power relationships within the Renaissance city. Objects such as the Biliemme tabernacle were not chiefly created as art works, but acted as a permanent means of asserting the importance of an essentially disenfranchised group before their fellow citizens and God. Michelangelo's *David* came to encapsulate the hopes and fears of a republic under external and internal strain. Through making this sculpture primarily an expression of an individual's genius, Vasari effectively, and no doubt deliberately, depoliticised its message and denied the power it held for many Florentines in the difficult days of the end of the republic.

The examples discussed here are designed to suggest that our understanding of the visual production of the Renaissance in Florence can be enhanced if we consider how Florentines conceived the motivations behind the production and purchase of painting, sculpture and other objects and buildings. Most fifteenth- and early sixteenth-century Florentines looking at what we call 'art' primarily saw not the expression of an individual's creative genius, but a potential instrument for the public good.

Chapter 3 introduction

Illuminated manuscripts constituted a sought-after luxury commodity particularly apt for the social and cultural aspirations of Europe's elite. Their expense put them beyond the reach of almost all but rulers and the nobility, and the extraordinary invention of some of the illuminators added artistic prestige to financial value. Coats of arms and even portraits included within a manuscript celebrated the status and lineage of its owner. A tiny prayer book like the Sforza Hours was designed to be viewed as an exclusive aid to devotion by the patron alone. Conversely, Edward IV's copy of the *Deeds and Sayings of Noble Men* by Valerius Maximus, at 50 centimetres high, was probably big enough when placed on a lectern to have been viewed by more than one courtier at once while it was read aloud at the English court. In theory at least, illuminated manuscripts were bespoke commissions designed to meet the requirements of a single, elite patron. In practice, manuscripts might be purchased ready-made or second-hand, inherited or acquired as gifts. Like the *Très Riches Heures* with which this chapter begins, they were frequently left unfinished and passed from owner to owner and illuminator to illuminator. The French illuminator Jean Colombe completed the *Très Riches Heures* c.1485–6 in a markedly different style decades after the death of the de Limbourg brothers in 1416, and at the behest of an entirely different owner, Duke Charles I of Savoy.

For all that they might be viewed as part of the paraphernalia of prestige of a particular elite class, Alixe Bovey shows that illuminated manuscripts were far from being simply collectors' items. The revival of interest in Italy in the literature and culture of ancient Greece and Rome stimulated a demand for antique texts from scholars or those with scholarly aspirations, together with a new 'humanist' way of presenting those texts. The same demand for scholarly books, for devotional literature and for histories, romances and didactic secular literature that fuelled the production of illuminated manuscripts also fuelled the printing industry that eventually eclipsed hand-made books. Generally illustrated by woodcuts rather than hand-painted miniatures, printed books produced in multiple copies were designed for a much wider viewing public. The first printed edition of Valerius Maximus' book appeared before 1477, and hence slightly earlier than the lavish bespoke manuscript version produced for Edward IV – and like Edward's copy, it incorporated hand-painted illuminations. Although the ultimate demise of the hand-produced, illuminated book was inevitable, until at least 1530 printed and hand-produced books existed alongside each other, and patrons like Federigo da Montefeltro continued to favour the bespoke manuscript above the inevitably more modest printed version.

Kim W. Woods

Chapter 3

Renaissance bibliomania

Alixe Bovey

A picture of Jean, Duc de Berry seated at a banquet table surrounded by his servants, guests, pets and sumptuous furnishings is the first image in one of the most celebrated of all illuminated manuscripts, a book known as the *Très Riches Heures* (Plate 3.2). The firescreen behind Berry encircles his head like a halo, setting his jowly profile apart from the other figures in the crowded composition. A steward stands beside Berry, with the beckoning words 'aproche, aproche' inscribed in gold above his head. Several of Berry's guests – and two cheeky little Pomeranians – help themselves to the delicacies laid out across the table on glittering golden dishes, while others converse and sip wine from precious cups. A canopy bearing Berry's emblems – bears, wounded swans and gold fleurs-de-lis on a blue ground – decorates the chimney. The feast takes place in a grand hall festooned with tapestries showing battle scenes from the Trojan War.[1] This image of a splendid winter party asserts the magnificence of Berry's court, his generous hospitality, and his identity as the patron of the book in which it is included.

The *Très Riches Heures* (literally, *Very Rich Hours*), so-called after its description in the inventory of Berry's goods made after his death in 1416, is an extraordinary example of a type of book that had become immensely popular by the later Middle Ages: the Book of Hours. These prayer books provided their owners with the texts – and often the images – they required for their daily devotions. Books of Hours were composed of standard elements, including calendars of saints'

days; the Hours of the Virgin, a cycle of prayers to be said at the eight canonical hours of the day;[2] prayers for the dead; the Penitential Psalms;[3] and Suffrages of the Saints.[4] These components could be adapted, rearranged and otherwise modified through the addition of miniatures and other textual material. In common with all books made before the advent of print in the mid-fifteenth century, every Book of Hours was made by hand, with its text copied by scribes. For those who could afford it, illuminators could enrich the pages of these books with decorations ranging from simple flourishes and ornaments to sophisticated full-page miniatures.

The *January* miniature of the *Très Riches Heures* is an apposite starting point for an exploration of the place of illuminated manuscripts in Renaissance culture. Like Janus, the double-faced Roman god from whom the month of January takes its name, this miniature looks back to the past and ahead to the future. It is saturated with allusions to antiquity, the Trojan War tapestry a backdrop for the guests' revelries. Above the banquet scene, rising up from the coved ceiling of the dining hall and picking up the intense blue of the tapestry's background, the January sky forms a zodiacal calendar, through which the Roman sun god Apollo drives his chariot.[5] The references to antiquity in the *January* miniature are a precocious indicator of a cultural current that gathered force during the fifteenth century. During this period, intellectuals, princes and princesses, statesmen, aristocrats and artists across Europe increasingly sought

Plate 3.1 (Facing page) Attributed to Francesco d'Antonio del Chierico, detail from opening page of Pliny the Elder's *Historia naturalis* (Plate 3.8).

Plate 3.2 Pol, Hermann and Jean de Limbourg, *January*, from the *Très Riches Heures*, before 1416, parchment manuscript, folio 24 × 18 cm, Musée Condé, Chantilly, MS 65, fol.1v. Photo: Giraudon/ Bridgeman Art Library, London.

inspiration in the literary and artistic legacy of the past, and especially the ancient world.

The *Très Riches Heures* could be said to play a role in fostering this trend, yet the audience for a precious book like this was extremely small compared to works of art fashioned for public display (such as tapestry, sculpture or painting). On a scale essentially suited for an audience of one or two people, and intended to serve as the focus for prayer, one can imagine that the duke might have shown a book like the *Très Riches Heures* to members of his inner circle (a group including, perhaps, the guests depicted in the *January* miniature). Unlike other, more visible forms of patronage, illuminated manuscripts could be considered a form of inconspicuous consumption, designed to be seen by an exclusive and influential audience. The duke may have had a number of

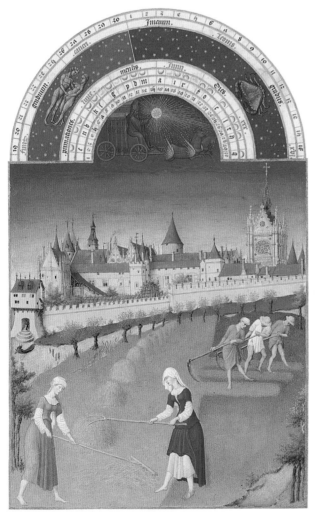

Plate 3.3 Pol, Hermann and Jean de Limbourg, *June*, from the *Très Riches Heures*, before 1416, parchment manuscript, folio 24 × 18 cm, Musée Condé, Chantilly, MS 65, fol.6v. Photo: Giraudon/Bridgeman Art Library, London.

ambitions for the *Très Riches Heures*. Primarily a work of devotion, it was undoubtedly intended as an expression of and focus for piety. Its ambitious and extraordinarily beautiful illuminations, executed by the duke's court painters, the brothers Pol, Hermann and Jean de Limbourg (active early fifteenth century), would at once have given pleasure and indicated the duke's unequalled taste and patronal status. Many of its miniatures include representations of castles and other places that would have been well known to him and his retinue. *June*, for example, includes a view of medieval Paris (Plate 3.3). Women rake hay in the foreground as men reap behind them; the River Seine divides the composition, and the towers of the old royal palace and the Sainte-Chapelle soar above the walls of the Ile de la Cité.[6] Such miniatures could have given the book special resonance for the duke and his inner circle. It is impossible, however, that he ever used this manuscript for prayer and unlikely that he showed it to his friends, for work on the book was cut short by the deaths of the Duc de Berry and at least two of the Limbourg brothers in 1416. Nearly 70 years later, after at least two intervening campaigns,[7] in c.1485–6 its cycle was completed by the illuminator Jean Colombe under the aegis of a later owner, Charles I, Duke of Savoy (ruled 1482–90).

In this chapter, I look at many different types of illuminated manuscript, including copies of ancient texts, works of devotion, histories and poetry. What can the images in these books tell us about the way that people read and thought about the adjacent texts? Manuscript miniatures offer contemporary interpretations of and responses to the text, insights into the function of the book, and an indication of its status as a physical object. Moreover, deluxe illuminated manuscripts like the *Très Riches Heures* very often contain evidence of their first owners. This can take the form of inscriptions, heraldry and even images of the owner. In many cases, these marks of ownership reveal not only the identities of their patrons, but also something of how these men and women wanted to be thought about and remembered. The books considered in this chapter include some of the most splendid illuminated manuscripts ever made, most (if not all) of which were owned by Europe's most privileged, unusual and influential men and women.

A high-quality bespoke illuminated manuscript represented a considerable financial investment.

Skilled scribes copied texts onto parchment made from carefully prepared animal skins, and illuminators enriched their pages with painted decoration executed in expensive pigments, such as gold and lapis lazuli. Producing such a book was a time-consuming, labour-intensive and highly skilled undertaking. This is attested to by many ambitious projects that were, like the *Très Riches Heures*, left unfinished due (among other things) to the death, disinterest or destitution of their patrons. The resulting manuscripts, however splendid, were inevitably imperfect: scribes copied textual errors from their exemplars into new books, at the same time contributing new idiosyncrasies. The individuality of the manuscript book was at once its unique selling point and, ultimately, its fatal disadvantage.

The fifteenth century was a period of widespread bibliomania among Europe's elites. Princes, dukes, duchesses, bankers, merchants and scholars spent considerable sums to assemble libraries. Courts gathered to hear histories and romances read aloud. Illuminated prayer books were the focus of the private devotions of wealthy aristocrats. Scholars and their patrons sought out reliable copies of esteemed texts, which they copied, read, discussed and debated. The culture of bookishness fostered by Europe's elite – who read, collected, commissioned and discussed manuscripts and, later in the century, printed books – is a defining feature of the fifteenth century. Bibliophiles, who assembled their libraries by a variety of means including inheritance, purchase and patronage, prized their books not merely for the texts they contained, but also for the visual context in which they were presented. Through scale, script, page layout, decoration and even the colour of their pages, illuminated manuscripts could convey a complex series of messages about their owners' attitude to the past, piety, intellectual attainment, social status, wealth and aesthetic sophistication. Medium and message are inextricably linked in illuminated manuscripts.

The printing press, devised *c.*1450 by Johan Gutenberg (*c.*1394/9–1468), rapidly transformed the literary culture of Europe. For the first time in European history, identical copies of texts could be reproduced relatively quickly and affordably. Yet despite its demonstrable advantages, the printing press did not immediately render the illuminated manuscript obsolete, any more than digital technology instantaneously brought about the extinction of analog. On the contrary, deluxe manuscripts continued to play an important, if gradually diminishing, role in the literary and devotional lives of their elite patrons well into the sixteenth century. In these, some of the leading artists of the period demonstrated their powers of invention and painterly virtuosity. At the end of this chapter, I will reflect on some of the reasons why the illuminated manuscript endured long after the dawn of the age of print.

1 Illumination in Italy

A manuscript known as the Albi Strabo provides an example of the multiple roles that an illuminated manuscript could play, for this copy of Strabo's *Geographia* or *Geography* was at once a text, a work of art, a diplomatic gift, a mark of friendship, and a symbol of an intellectual community. It represents collaboration between translator, patron, scribe and illuminator. Jacopo Antonio Marcello gave this translation of the ancient treatise on geography by Strabo (64 BCE – after 20 CE) to René of Anjou *c.*1459. Marcello (*c.*1400–64), a noble Venetian military commander and associate of the flourishing circle of Paduan humanists, had for many years supported René (1409–80) in his unsuccessful claim to the Kingdom of Naples.[8] The translation of Strabo's *Geography* from Greek (which relatively few westerners could read in the 1450s) into Latin had only recently been completed under Marcello's patronage. An artist in Venice, perhaps Giovanni Bellini (*c.*1431–1516), undertook its illumination.[9] The Albi Strabo contains a remarkable visual record of its own history and status. One of its opening miniatures shows Marcello kneeling humbly before René, handing him a large book handsomely bound in gilt red leather (Plate 3.4).[10] About 58 years old at the time of the image, Marcello's earnest face is framed by wavy white hair. René sits on a marble throne draped in scarlet cloth, and places his hand on Marcello's shoulder as he accepts the book. A group of courtiers stand nearby, observing the presentation. Marcello and René's relative status is mirrored by the image on René's throne, showing a timid rabbit crouching before a mighty lion. This miniature reveals that, for Marcello, this was much more than a geography book. It was a way of expressing – and reinforcing – his ties to René, of demonstrating his erudition and taste, and of asserting his membership in a group of elite bibliophiles.

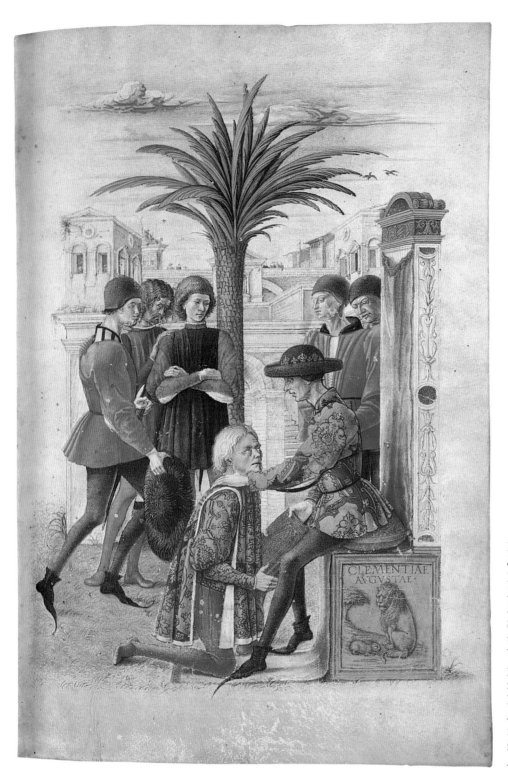

Plate 3.4 Circle of Jacopo Bellini (Giovanni Bellini?), *Jacopo Antonio Marcello Presenting the Book to King René*, from Strabo's *Geographia*, translated by Guarino da Verona, Venice, 1458–9, parchment manuscript, folio 37 × 25 cm, Médiathèque Pierre Amalric et bibliothèques municipales, Albi, MS 77, fol.4r. Photo: Alain Noel, Albi.

The deluxe treatment of Strabo's ancient geographical treatise in the Albi manuscript is indicative of the high esteem placed on classical literature by Marcello, René and the community of intellectuals and statesmen to which they belonged. The resurgent interest in Latin and Greek literature in this period is closely associated with humanism, a scholarly movement that took shape in fourteenth-century Italy. Named after the *studia humanitatis* – the academic curriculum they followed – humanists recovered, studied and emulated ancient Greek and Latin rhetoric, grammar, poetry, history and philosophy. During this period of literary renewal, the visual arts also underwent a profound transformation, and the two phenomena – the revival of Latin and Greek, on

the one hand, and the development of Renaissance art, on the other – are often seen as causally linked. Sounding a sceptical note, Charles Hope and Elizabeth McGrath have observed, 'Historians have often supposed that the two were closely related, yet it is not immediately obvious why this should be so.'[11] They go on to demonstrate that humanists and artists would have had relatively few opportunities for interaction, and then examine the contexts in which collaboration and exchange did occur. Although Hope and McGrath mention libraries and printed books, illuminated manuscripts do not feature in their argument. Yet if one is searching for the integration of these two aspects of Renaissance culture, then one could do worse than to look at the pages of illuminated manuscripts made for humanists and their patrons. As we shall see, their literary priorities and the artistic preoccupations evident in the visual arts are inextricably entwined in illuminated manuscripts.

The story of humanism in Renaissance Italy is, to its core, a tale of bibliographic adventure. The texts preserved in manuscripts were the central focus of the humanists' obsession with antique literature, philosophy, history and art. The humanists' search for antiquity involved archaeological excavations, with expeditions in Padua, Rome and other Italian cities unearthing ancient artefacts and buildings. At the heart of this quest was their campaign to locate and copy ancient texts. Supported by affluent bibliophiles, such as the Chancellor of Florence, Coluccio Salutati (1331–1406), humanists searched out manuscripts of ancient authors in libraries throughout Europe. The avowed intention of these expeditions was to emancipate ancient texts from monastic libraries, making them accessible to a widening readership of humanists and their educated patrons. An account of an expedition to the Swiss monastery of Saint Gall in 1416 relates the appalling conditions in which the manuscripts were kept, and triumphantly lists the texts 'liberated' from this monastic prison.[12]

Of necessity, the humanists viewed antiquity through the lens of the intervening millennium, for the antique texts that they sought were almost invariably preserved in medieval copies.[13] Interest in and knowledge of antiquity had waxed and waned throughout the Middle Ages, but its literature and art had never vanished. In the ninth century and again in the twelfth, an intense

revival of interest in antique learning resulted in campaigns to produce reliable copies of ancient texts. From a textual perspective, the fifteenth-century revival of antique literature and learning can be seen as a continuation of a movement of renewal. The humanists themselves were aware of their reliance on the Middle Ages, as is manifest in their illuminated manuscripts. Indeed, their acknowledgement of this debt is expressed most forcefully through visual means. Yet through the appearance of their books, especially their script and decoration, they contrived to set themselves apart from the high Middle Ages, preferring instead to borrow aspects of the aesthetic of earlier books, notably those produced in the twelfth century. One example of this is the distinctive script in which many humanist manuscripts are written, which was almost certainly invented in Florence by the young humanist Poggio Bracciolini (1380–1459) around the year 1400 (Plate 3.5; see also Plates 3.7–3.10).[14] This script

Plate 3.5 Cicero's *Epistolae ad Atticum ...*, copied and signed by Poggio Bracciolini, Florence, 1408, parchment manuscript, Staatsbibliothek Preussischer Kulturbesitz, Berlin, MS Hamilton 166, fol.96. Photo: © 2007 bpk/ Handschriftenabteilung, Staatsbibliothek zu Berlin – Preussischer Kulturbesitz.

was derived from a style of writing developed in the ninth century known as Caroline minuscule, which was itself based on the handwriting of late antique Rome. Poggio's script adapted a form of Caroline minuscule preserved in twelfth-century manuscripts. Despite its newness, this script became known as *littera antiqua* (literally, antique letters) in contrast to the contemporary Gothic script known as *littera moderna*, and it was used especially to copy classical texts.[15] The script caught on quickly, with Poggio training professional scribes to use it and scholars adopting it to make their own copies of texts.

Classical decorative motifs and visual references were not reserved for classical texts alone, nor exclusively for writing in Latin or Greek. Copies of works by humanist authors sometimes merited this

distinguished treatment. Among these authors, Francesco Petrarch (1304–74) is the supreme example. A contemporary of Dante and Boccaccio, Petrarch was regarded as the pre-eminent father of humanism. His elevated status is expressed in a copy of his collection of poetry made in the Veneto *c.*1463–4. Using several visual strategies, this copy of Petrarch's poetry is overlaid with references to antiquity. Inspired by the example of late antique and Carolingian manuscripts, the title page to the *Trionfi* is a leaf of stained purple parchment. On this leaf, Cupid, riding victorious in a chariot followed by a parade of his enchained captives, takes aim with a flaming arrow (Plate 3.6). The opposite page, attributed to Francesco di Giovanni de' Russi (active 1453–82), is enclosed in a border made up of classical architectural motifs including

Plate 3.6 Unknown artist (fol.149v) and attributed to Francesco di Giovanni de' Russi (fol.150), opening pages of Petrarch's *Trionfi*, copied by Bartolomeo Sanvito, Venice or Padua, probably *c.*1463–4, parchment manuscript, folio 23 × 14 cm, Victoria and Albert Museum, London, L. 101–1947, fols 149v–150. Photo: V&A Images/Victoria and Albert Museum.

pillars and reliefs. The text, copied by the eminent Paduan scribe Bartolomeo Sanvito, is written in epigraphic capitals (that is, initials which imitate letters inscribed in stone) in emulation of a late antique script. The coat of arms underneath a cardinal's hat on folio 9 verso is blank, making it difficult to establish its first owner, but this manuscript could be the one mentioned in the inventory of the estate of Cardinal Francesco Gonzaga (1444–83), which describes a Petrarch bound in green silk: fragments of green silk have been found under the manuscript's sixteenth-century binding.[16]

The manuscripts owned by the humanists themselves were generally not treated to extensive decoration, for their scholarly owners were not wealthy princes for the most part, but rather earned a living through their scribal, scholarly and pedagogical activities. A modestly decorated page from a manuscript of Cicero's letters copied by Poggio in Florence in 1408 serves as an example both of the new humanist handwriting and also of the nascent vine-stem initials which grew increasingly elaborate in later humanistic manuscripts (Plate 3.5).[17] It also provides an example of the value placed on humanist books by princely bibliophiles, for by 1425 this manuscript had probably entered the library of Cosimo 'il Vecchio' de' Medici (1389–1464), the Florentine oligarch who consolidated his family's position as Europe's pre-eminent bankers.[18] Patrons like Cosimo could afford to embellish their manuscripts with illumination commensurate with their wealth and status.

According to the Florentine bookseller and biographer Vespasiano da Bisticci, Cosimo 'had a knowledge of Latin which would scarcely have been looked for in one occupying the station of a leading citizen engrossed with affairs'.[19] He describes how, as a young man, Cosimo devoted six months to reading Saint Gregory the Great's *Moralia in Job*, a sixth-century Latin commentary on the Old Testament Book of Job. The contents of Cosimo's library can be reconstructed, at least in part, from an inventory of his father's house in 1417–18 and from surviving books which bear marks of his ownership.[20] On his shelves were copies of many ancient authors, including Valerius Maximus, Sallust, Eusebius, Cicero and Boethius. Dante, Petrarch and Boccaccio were represented in his collection, along with devotional works and copies of recently rediscovered texts

copied by his great friend, the humanist Niccolò Niccoli, and others.[21] Cosimo's library was not distinctive for its texts alone: many of his books were beautifully illuminated, and they helped to establish conventions for humanistic manuscripts. For example, his 1435 copy of the early Christian *Institutiones divinae* or *Divine Institutions* of Lactantius (260–340 CE) opens with an early example of the type of heraldic border of white vine stems that came to be favoured by humanist patrons (Plate 3.7).[22] The initial 'M' is entangled in an elaborate framework of intertwined white vine stems infilled with intense hues. Colourful birds and putti perch on the stemwork framing the page, and Cosimo's arms occupy a prominent position in the lower border.[23]

Cosimo de' Medici's books were inherited by his son Piero (1416–69), who was also actively engaged for much of his life in commissioning new manuscripts. A particularly splendid copy of

Plate 3.7 Attributed to Filippo di Matteo Torelli, opening page of Lactantius' *Institutiones divinae*, Florence, 1435, parchment manuscript, Biblioteca Medicea Laurenziana, Florence, 21, 5, fol.1r. Used with the permission of the Ministero Beni e Attività Culturali. Further reproduction forbidden by any means.

Pliny the Elder's *Historia naturalis* or *Natural History* probably made for Piero is a witness to the merging of humanistic textual concerns with princely taste (Plate 3.8). Pliny's encyclopaedic work, written before 70 CE, was one of the most important Roman texts for the humanists. Piero's text begins with the title written in capitals in burnished gold, and continues in the clear, regular humanistic minuscule script invented more than 50 years earlier by Poggio Bracciolini. The initial 'L' is decorated with white vine scrolls, putti, animals and the three rings that were one of the Medici's devices (see Plate 3.1). The sumptuous border consists of white vine scrolls infilled with pink and pale green, outlined in blue, and illuminated with flashes of burnished gold leaf. Animals, monsters, putti and portrait busts are entwined in the winding vine. At the bottom of the border, putti and cupids support the arms of the Medici family.

This illumination has been attributed to Francesco d'Antonio del Chierico (1433–84). On this page, the aesthetic of magnificence that was cultivated by the Medici is infused with allusions to ancient art.

Piero's reverence for antiquity manifested itself in the splendid illumination of many of his copies of ancient texts. The first page of Piero's copy of Cicero's speeches opens with a sumptuously decorated border consisting of white vine-stem decoration, animals, medallions containing putti, portraits and personifications, and his arms (Plate 3.9).[24] The miniature showing a bearded man holding a book and raising his hand in a gesture of speech is almost certainly meant to be Cicero. The ancient author stands on a plinth in a niche as if he is a sculpture, but his colourful clothing and lively gesture are more suggestive of living flesh than lifeless stone: perhaps this miniature is meant to suggest that through his speeches Cicero remains alive.

Plate 3.8 Attributed to Francesco d'Antonio del Chierico, opening page of Pliny the Elder's *Historia naturalis*, Florence, 1458, parchment manuscript, folio 42 × 28 cm, Biblioteca Medicea Laurenziana, Florence, 82, 3, fol.4r. Used with the permission of the Ministero Beni e Attività Culturali. Further reproduction forbidden by any means.

Plate 3.9 Attributed to Ser Ricciardo di Nanni, opening page of Cicero's *Orationes*, Florence, probably before 1459–60, parchment manuscript, folio 36 × 26 cm, Biblioteca Medicea Laurenziana, Florence, 48, 8, fol.2r. Used with the permission of the Ministero Beni e Attività Culturali. Further reproduction forbidden by any means.

Plate 3.10 Attributed to Francesco Rosselli, opening page of Aristotle's *Physica, Metaphysica ...*, copied by Gonsalvo Fernandez de Heredia, Florence, *c.*1473–8, parchment manuscript, folio 38 × 27 cm, Biblioteca Medicea Laurenziana, Florence, 84, 1, fol.2r. Used with the permission of the Ministero Beni e Attività Culturali. Further reproduction forbidden by any means.

In many deluxe illuminated manuscripts made in fifteenth-century Italy, imagery was ingeniously deployed in order to assert links between antiquity and the present, simultaneously presenting a text in historical and contemporary terms. A copy of a selection of Aristotle's writings almost certainly commissioned by Lorenzo 'the Magnificent' de' Medici around 1473–8 is a remarkable example of the complex ways in which painted decoration could situate a text in these terms. Lorenzo's

copy of Aristotle is in the Latin translation of Janos Argyropoulos, a portrait of whom fills a roundel in the intial 'I' that marks the beginning of the first text's dedication (Plate 3.10).[25] Three of Argyropoulos's translations in the manuscript are dedicated to Cosimo, Lorenzo's grandfather, and the others to his father Piero. The decoration of the border draws on a broad range of classical motifs, including cameos (like those collected by the Medici), putti, griffins and gems. But this

border is not simply looking back to antiquity: its focus is also on the Medici's dynastic tradition as bibliophiles. The decoration of the manuscript's major border expresses Lorenzo's filial piety through representations of his father and grandfather. In the right margin is a portrait of Cosimo, and in the bottom Piero is portrayed as if on a gold medal. The form of the Medici arms in the upper border was adopted in 1465, the year after Cosimo's death. The juxtaposition of these images of Lorenzo's father and grandfather with Aristotelian texts may have had particular resonance for him, especially regarding his grandfather, for Cosimo seems to have taken particular consolation in Aristotle. Vespasiano records that for about a year before Cosimo died, 'his humour was to have Aristotle's *Ethics* read to him' by his old friend Bartolomeo Scala (1430–97), a humanist and Chancellor of Florence from 1465.[26]

2 Illumination in the north

The evocation of antiquity through the script and decoration of the Medicean manuscripts considered here is suggestive of the way that classical antiquity was approached within the sphere of humanist influence. By rejecting Gothic scripts and decorative styles and adopting those of a more distant (though not necessarily antique) past, humanist manuscript patrons aspired to create books that evoked classical antiquity. Perhaps inevitably, though, this desire for an antique visual vocabulary succeeded not in replicating antique books but rather in establishing an entirely new aesthetic. Contemporary illuminated manuscripts made in northern Europe reveal a dramatically different set of priorities on the part of their patrons and makers. Like their Italian counterparts, many of these bibliophiles were interested in history, philosophy and antique literature; however, they did not (for the most part) share their desire for a self-consciously antiquarian aesthetic. The differences between these two elite cultures of bibliophilia reveal common interests but different approaches.

The literary preferences of Philip the Good, Duke of Burgundy (1396–1467), were described in similar terms to Vespasiano's account of Philip's Florentine contemporary, Cosimo de' Medici. Philip's secretary, David Aubert, described how he

has since long ago been accustomed to have old histories read before him every day; and to be provided with a library beyond all others he has since his youth had in his employ several translators, great clerks, master orators, historians and writers, and in various countries a great number diligently working; so much so that today he of all Christian princes, without a single exception, is the best provided with an authentic and rich library.[27]

Philip's son Charles the Bold (1433–77) also enjoyed listening to books read aloud, showing particular enthusiasm for ancient history in French translation. The chronicler and poet Oliver de la Marche described how Charles 'never went to bed without having someone read before him for two hours … and he used to have read in those days the high histories of Rome and took very great pleasure in the deeds of the Romans'.[28] That both Philip and Charles preferred to hear history read in French (rather than Latin) suggests a key difference in emphasis between the Burgundian courts and Medicean circles, in which Latin literature was a particular interest. Furthermore, whereas Medicean manuscripts use script and decoration to establish a connection with the distant past, the aesthetics of Burgundian manuscripts show greater concern for the present. Characteristically copied in a script known as 'Burgundian letters', their text makes no visual allusion to antique writing, and the rich decoration of their manuscripts betrays none of the preoccupation with antique art that is such a feature of the manuscripts commissioned by their Italian counterparts. The profusion of classically inspired motifs – putti, candelabras, white vine scrolls, epigraphic capitals and humanistic script – so conspicuous in Italian Renaissance manuscripts is more or less absent in contemporary northern books. Instead of emphasising the connection between their books and the ancient world, the illuminated manuscripts commissioned by the elites of northern Europe reveal an enthusiasm for narrative illustration and pictorial invention that interpreted the past in contemporary terms.

One of Philip's most splendid manuscripts, a three-volume history of Hainaut (one of his territorial possessions), exemplifies these points. The text is a French translation commissioned by Philip of a fourteenth-century Latin chronicle of the history of Hainaut. Its preface outlines Philip's descent from a line of rulers from the fall of Troy, thereby

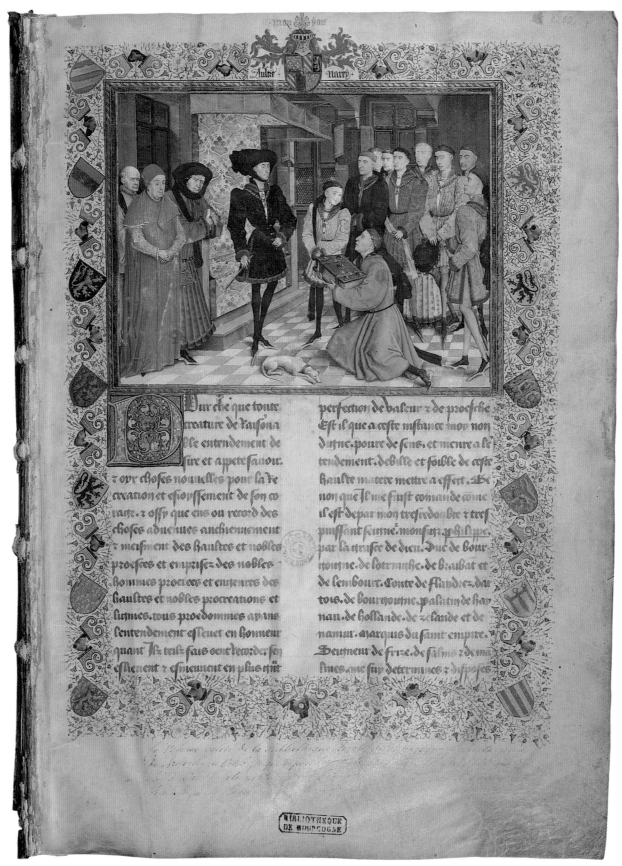

Plate 3.11 Attributed to Rogier van der Weyden, frontispiece to volume 1 of the *Chroniques de Hainaut*, Mons, Brussels or Tournai, 1447–8, parchment manuscript, folio 44 × 32 cm, Bibliothèque royale de Belgique, Brussels, MS 9242, fol.1r. Photo: © Bibliothèque royale de Belgique, Brussels.

Plate 3.12 Willem Vrelant, frontispiece to volume 2 of the *Chroniques de Hainaut*, Mons, Brussels or Tournai, 1468, parchment manuscript, Bibliothèque royale de Belgique, Brussels, MS 9243, fol.1r. Photo: © Bibliothèque royale de Belgique, Brussels.

asserting his legitimacy as ruler in historical terms. The first volume opens with the only miniature that is attributed to one of the greatest painters of the period, Rogier van der Weyden (*c.*1399–1464).[29] This miniature shows Philip standing under a rich textile canopy as Jean Waquelin, the translator, kneels before him presenting a large book: the *Chroniques de Hainaut* (Plate 3.11). Philip's adolescent son Charles and his courtiers observe the presentation respectfully. Rogier's miniature

evokes the solemn ritual, and perhaps some of the psychology, of this courtly ceremony. Chancellor Nicolas Rolin (in blue), standing behind Philip and therefore outside his line of vision, leans heavily on the arm of Philip's throne. One of the courtiers seems to be fiddling with his sash, and another (dressed in green) walks forward, or perhaps shifts his weight from one foot to another. Oblivious to the dignified ritual going on around him, a little dog takes a nap. The seeming spontaneity of this

image belies the care and forethought that must have gone into it, for it is ingeniously constructed so that each sitter's physiognomy, signs of rank and costume are integrated seamlessly into the composition. The image appears to reinforce the idea expressed in the adjacent text that Philip is the culmination of the history contained in the pictured book.

Rogier's frontispiece to the *Chroniques* is undoubtedly the most splendid miniature in the set of volumes, but it could be argued that the remaining miniatures make up in quantity what they lack in quality: the first volume alone has a further 40 miniatures.[30] The Netherlandish illuminator Willem Vrelant (active 1449–81) was paid for executing 60 miniatures in the second volume in 1468.[31] If Rogier's miniature is an evocation of the presentation of the book to Philip, then Vrelant's frontispiece miniature to the second volume reveals something more about how the book might have been used at court (Plate 3.12). Philip listens as the book is read aloud in the company of his son Charles (who stands on the left, next to his father's chair) and the court. Evidently not everyone in attendance shares Charles's enthusiasm for history: one courtier throws a backward glance to the listeners as he slips out of the door to join his friends in the busy street outside. Rogier's frontispiece expresses the book's status as a symbol of the political power and cultural sophistication of its patron and his court. The second miniature shows the manuscript in action: once again it is the focus of attention for Philip's court.

Some of these differences in approach between northern and southern patrons can be observed by comparing copies of the *Deeds and Sayings of Noble Men* made c.1480, one in Bruges and the other in Rome. Written in the first century CE by the Roman historian Valerius Maximus, this anthology of historical anecdotes arranged thematically was one of the most popular texts in the fifteenth century. Although these books demonstrate a common interest in this text, the scale, language, script and decoration are dramatically different.

In 1479, Edward IV, King of England (ruled 1461–70, 1471–83), commissioned a magnificent two-volume copy to be made in Bruges.[32] The opening miniature of the first volume, attributed to an anonymous illuminator known as the Master

Plate 3.13 Attributed to the Master of the White Inscriptions, opening miniature of volume 1 of Valerius Maximus' *Faits et dits mémorables des romains*, translated by Simon de Hesdin and Nicholas de Gonesse, Bruges, 1479, parchment manuscript, folio 47 × 33 cm, British Library, London, Royal MS 18 E iii, fol.24. Photo: by permission of the British Library.

of the White Inscriptions, pictures one of the two translators (Simon de Hesdin and Nicholas de Gonesse) who rendered the Latin text into French in the fourteenth century. The motto 'Je suis bien toudis joieulx' (I am truly merry always) and the date 1479 are inscribed on the back wall of the chamber like elegant graffiti (Plate 3.13).[33] This is the sort of white inscription from which the manuscript's illuminator takes his name. A border of acanthus scrolls, flowers and twisting vines interspersed with Edward's heraldic devices frames the miniature and the two columns of text, which is written in a Gothic script. Eight of the nine miniatures in this volume are attributed to the Master of the White Inscriptions. These are grand, imposing volumes, standing almost 50 centimetres tall and containing between them a total of 668 folios.[34]

A Valerius Maximus made in Rome in the early 1480s is no less sumptuous than Edward IV's richly illuminated copy.[35] Commissioned by Cardinal Giovanni d'Aragona (1456–85) and later owned by King Ferdinand I of Naples (d.1494), it too has a distinguished royal provenance. But the similarities between these books are less conspicuous than the differences. The most obvious discrepancy between them is their size: d'Aragona's copy is just over 30 centimetres tall (nearly 20 centimetres shorter than Edward IV's copy), and it is a single volume of 197 folios (compared to the heft of Edward's two volumes). Whereas Edward's copy is in French, d'Aragona's is in Latin. Unlike Edward's Valerius Maximus, which has nine large miniatures, the first page of the Roman copy is the most richly decorated one in the book. It is framed with an elaborate decorative border, replete with classical motifs including coins and medallions of the four Virtues (Plate 3.14). The initial letter of the text is contained within a miniature showing Valerius Maximus writing at a desk, with a stack of books beside him and a landscape of ancient ruins behind. Rustic capitals, a script of ancient derivation, are used for the title, and the main text is written in a humanistic hand also evoking antique script.

Both manuscripts begin with images of writers, but interestingly they represent different authors: d'Aragona's manuscript opens with a historiated initial (that is, a letter containing a scene or figures) showing the author, Valerius Maximus, while Edward IV's copy represents the process of the text's translation into French. That one of its translators rather than the ancient author is depicted suggests the divergent priorities of the patrons of these manuscripts. Through the profusion of classical imagery on the opening pages of his manuscript and the portrait of Valerius Maximus, d'Aragona's copy pays homage to antiquity. By contrast, Edward IV's manuscript seems to reveal a much greater concern with the recent history of the text, and specifically the French translation initiated by Charles V, King of France (ruled 1364–80). Further, the programme of large miniatures in Edward IV's two-volume copy demonstrates a much greater appetite for narrative illustration compared to the relatively restrained programme of decoration in the Roman copy, in which each of the ten books is introduced simply with painted and decorated initials.

The different approaches taken to Valerius Maximus represented in these manuscripts reveal some of the ways that a text can be transformed through script, language and decorative embellishment. Edward IV and Giovanni d'Aragona both valued Valerius Maximus enough to commission deluxe copies for themselves, but their books show that the emphasis of this common interest fell in different places. Arguably, d'Aragona was pursuing an ideal of historical authenticity, evoking antiquity through its language, script and decoration. For Edward IV, this seems to have been much less important than transforming the text into something of explicitly contemporary value and relevance.

The books discussed so far have been chosen to illustrate, in one way or another, some major trends in secular book production in this period. One of the hazards of this approach is the implication that there are 'rules' one can observe in the history of illuminated manuscripts, which are then somehow proven by 'exceptions'. In reality, all illuminated manuscripts are exceptional to a greater or lesser degree: each book is the unique product of particular circumstances. With this in mind, let us turn to a book that takes advantage of the illuminated manuscript's capacity for uniqueness.

Around 1500, Pierre Sala gave a book to his mistress Marguerite Bullioud.[36] Sala (before 1457–1529) was a courtier to three successive kings of France (Charles VIII, Louis XII and Francis I) and a man of letters, and Marguerite was the wife of the royal silversmith.[37] The small book contained Sala's own poems, probably copied by Sala himself in gold ink onto purple-stained parchment.[38] The verses are inscribed on the left side of each opening, with a miniature on the opposite page. In a lengthy preface, Sala professes his enduring love for Marguerite, praises her as the most perfect woman in the world, and explains, 'I am sending you this little book containing pictures and words which are the two ways by which we can enter the house of memory.'[39] The final miniature in the book is an extraordinary portrait of Sala himself, attributed to the renowned artist Jean Perréal (?1450/60–1530), and opposite, written in mirror writing, are the words: 'Look in pity on your faithful friend who loves you constantly and unrequitedly' (Plate 3.15).[40] The manuscript's elaborate case survives, decorated with flower tendrils entwined

Plate 3.14 Attributed to Gaspare da Padova, opening page of Valerius Maximus' *Facta et dicta memorabilia*, Rome, *c.*1480–5, ink and pigment on vellum, 34 × 23 cm, New York Public Library, Spencer Collection, Astor, Lenox and Tilden Foundation, Spencer MS 20, fol.1r.

with Marguerite's and Pierre's initials, 'M' and 'P'. The small rings on the box indicate that the book could be worn as an accessory from the belt. This manuscript was evidently a slow-acting but effective love token: more than ten years after the death of her first husband, Pierre and Marguerite were married.

Sala's little book could be interpreted as a valentine not just for Marguerite but for the manuscript book itself. With invention and erudition, Sala exploits the potential of the manuscript as a one-of-a-kind object. As a work of creative literature probably in its author's own hand, Sala's manuscript is unlike those considered so far, all of which are copies of

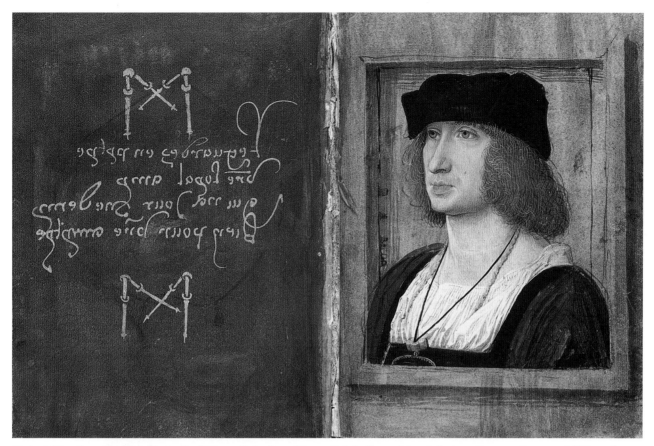

Plate 3.15 Jean Perréal, *Portrait of Pierre Sala*, from Pierre Sala's *Ensembles et devises d'amour*, Lyons, *c.*1500, each folio 13 × 10 cm, British Library, London, Stowe MS 955, fols 16v–17. Photo: by permission of the British Library.

canonical works (sometimes in new translations, as in the Albi Strabo or Philip the Good's *Chroniques de Hainaut*) by professional scribes. Made some 50 years after the invention of the printing press, Sala seems to turn his back on print: according to Yves Giraud, for Sala 'the manuscript retained all its prestige while the printed word enjoyed hardly any'.[41] A sign of Sala's esteem for the manuscript is its opulent purple pages, which allude to deluxe manuscripts made in antiquity and the early Middle Ages, and their Renaissance emulators.

3 Visions of devotion

The scale and format of the illuminated book mean it is essentially a private art form, suited to reading and viewing in solitude or in small groups. This is perhaps especially true of books designed for prayer and contemplation, in which devotional texts and images are generally conceived on an intimate scale. The patrons who commissioned bespoke prayer books instead of buying ready-made

volumes (handmade or printed) must have valued the individuality of the illuminated manuscript over the conformity of the mass-produced book. Devotional books could be constructed for the private, intimate use of their patron or intended owner, and also to express something about their owner's piety and status to others, including peers and subjects, as well as to posterity. For modern viewers, decoding these personal messages is one of the most fascinating challenges presented by devotional books, but interpreting their images often raises frustratingly unanswerable questions about their intended and actual functions, and the creative genesis for their pictorial schemes. With unambiguous evidence a rarity, establishing the role played by artist, patron, intermediaries and advisers in the creation of a programme normally remains a matter for informed speculation. Even so, the images in deluxe devotional manuscripts lend insights into the piety of their patrons, and demonstrate the sophistication with which illuminators used images to evoke profound emotion.

Plate 3.16 Vienna Master of Mary of Burgundy, *Mary of Burgundy (?) Reading*, from the Hours of Mary of Burgundy, Ghent, Antwerp, Valenciennes and Bruges (?), *c.*1470–5, parchment manuscript, folio 23 × 16 cm, Österreischische Nationalbibliothek, Vienna, Codex Vindobonensis 1857, fol.14v. Photo: Austrian National Library, picture archives, Vienna.

Plate 3.17 Vienna Master of Mary of Burgundy, *Christ Nailed to the Cross*, from the Hours of Mary of Burgundy, Ghent, Antwerp, Valenciennes and Bruges (?), *c.*1470–5, parchment manuscript, folio 23 × 16 cm, Österreischische Nationalbibliothek, Vienna, Codex Vindobonensis 1857, fol.43v. Photo: Austrian National Library, picture archives, Vienna.

The work of an anonymous Netherlandish artist known as the Vienna Master of Mary of Burgundy offers a remarkable example of the ways in which the pages of a manuscript could be transformed into windows to a spiritual plane. This artist takes his name from the Book of Hours probably made for Mary of Burgundy (1457–82), the daughter of Charles the Bold, Duke of Burgundy. The Hours associated with her was illuminated by a team of artists c.1470–5, and the miniatures contributed by the Vienna Master to the manuscript are among the most astonishingly inventive compositions of the period: they were unprecedented and without imitators. The first full-page miniature in the manuscript shows a woman – Mary of Burgundy herself? – seated with a little dog in her lap, reading a book cradled in the folds of a green chemise binding (Plate 3.16). Jewellery, a couple of buds of dianthus, and a crystal vase of towering irises rest on the windowsill. This intimate, domestic scene frames a dramatic vision that takes place through the open window: the Virgin and Child seated in front of an altar under the soaring vaults of a Gothic church, surrounded by four angels holding golden candlesticks. On the left, wearing a blue and gold brocade gown, a woman kneels with her hands clasped in prayer, gazing at the Virgin and infant Christ. A retinue of ladies accompany her. In posture and the style of her dress, the kneeling woman in the vision echoes the reader in the foreground, whose Book of Hours is open to a page with a large blue initial 'O'. This can be interpreted as the beginning of one of two prayers to the Virgin that were commonly included in Books of Hours (and indeed are in the Hours of Mary of Burgundy, on folios 20 and 24 respectively), the *O intemerata* or the *Obsecro te*.[42] The image, then, shows Mary being spiritually transported from a mundane domestic setting to a sacred dimension through the text of a hymn to the Virgin. Yet despite this apparent interest in the power of reading, this image is arguably more concerned with the visual than with the textual: the pictured Mary might be reading a text, but her spiritual experience is articulated in visual terms. Cradling the Hours in her hands just like her portrait, she would have been engaged in a slightly different contemplative act than the one portrayed, for, instead of reading, she would have been looking at an image.

Later in the book, another miniature by the Vienna Master takes the book-as-window metaphor one step further. Here, a window frames a miniature, this time showing Christ being nailed to the Cross (Plate 3.17). As in the previous miniature, precious objects surround the windowsill, but it would appear that the reading seat has suddenly been abandoned: a book lies open, the lid of a jewel box is gaping, a rosary necklace lies on the cushion. The manuscript is open to a full-page miniature of the Crucifixion, and through the window we see crowds gathered to witness the Crucifixion. It is a moment of drama: Saint John grasps the Virgin as she reaches desperately towards Christ, who is being fastened to the Cross. In the foreground of the picture is a crowd of exotically dressed ladies and gentlemen. These figures stand with their backs to the open window, except one woman, who glances over her shoulder. Her backward glance is expressive and conspiratorial: she seems to be looking back through the window to the viewer, inviting (or perhaps challenging) us to make the same spiritual journey to the foot of the Cross.

The Vienna Master uses what would have been, for someone like Mary of Burgundy, everyday devotional tools (books, rosary beads, prayer cushions) and settings (private, quiet spaces) to frame images of the Virgin and Christ, thereby using the intended viewer's personal experience to heighten a sense of emotional proximity. A rather different approach can be found in a Book of Hours that was probably made for Bonaparte Ghisleri (d.1541), a senator from Bologna. His initials and arms appear in the manuscript (folios 16, 74 verso), and his father Virgilio (d.1523) is probably the subject of a portrait in the calendar (folio 7).[43] This manuscript reflects a rather different set of devotional concerns from the Hours of Mary of Burgundy, but like the Netherlandish manuscript its illuminators also used a range of ingenious pictorial devices to draw the viewer into a contemplative mindset.

Every aspect of this manuscript, from its extraordinarily elaborate binding to its script to its illumination, affirms that no expense was spared in its production.[44] Its illumination was executed by at least three artists, Amico Aspertini (1474/5–1552), Perugino (Pietro di Cristoforo Vannucci, c.1450–1524), and Matteo da Milano (active c.1492–1523). Aspertini and Perugino, both well-known painters (rather than illuminators), contributed signed miniatures to the manuscript. Perugino's *Martyrdom of Saint Sebastian*, the

only miniature known to have been executed by this prolific artist, shows the saint naked but for the transparent purple cloth around his hips, conversing with angels as archers prepare to shoot him (Plate 3.18). If not a triumph of technique (commentators have noted that Perugino does not seem to have completely mastered the unfamiliar medium of miniature painting), this is certainly a compositional masterpiece, expressing in miniature formal ideas to which Perugino returned in later monumental representations of Saint Sebastian.[45] As Mark Evans has suggested, the inclusion of these miniatures by prominent artists may suggest that Ghislieri had the ambitions of a collector, conceiving of his opulent Hours as a portable gallery.[46]

Aspertini's *Adoration of the Shepherds* is a telling reflection of the ways in which fascination with the antique could be harnessed to a devotional

Plate 3.18 Perugino, *Martyrdom of Saint Sebastian*, from the Hours of Bonaparte Ghislieri, Bologna, early sixteenth century, parchment manuscript, folio 19 × 14 cm, British Library, London, Yates Thompson MS 29, fol.132v. Photo: by permission of the British Library.

programme of images (Plate 3.19). Sometime between 1500 and 1503, Aspertini had visited Rome where he filled a sketchbook with drawings of ancient Roman monuments, including the Domus Aurea (Golden House), the imperial palace built by Nero in the first century CE. In the 1480s, part of this palace had been discovered in the Roman hills, and its elaborate stuccowork and painted decoration had quickly become a source of artistic inspiration.[47] Aspertini drew on his Roman sketchbooks for the border of the *Adoration of the Shepherds*, which is dense with putti, gemstones, masks, animals, figures, armour and trophies dramatically set on a black ground. The wispy, impressionistic style of the border is a compelling evocation of the antique decoration of the Domus Aurea. Although this virtuoso border clearly points to Aspertini's (and also Ghislieri's) fascination with antique painting, it would be a mistake to see it merely as the expression of a taste for archaeologically inspired decoration, for in several respects its content relates closely to the scene that it frames. Nero (37–68 CE) built the Domus Aurea after 64 CE, about 30 years after the Crucifixion. It may be that Aspertini's framing of the Nativity with imagery inspired by the Domus Aurea was motivated by a historical approach to the New Testament, which could be seen to simulate historical authenticity by pairing the Nativity with an approximately contemporary aesthetic. The juxtaposition of border and miniature also operates on a symbolic level: the pagan rite taking place in the lower border, with two kneeling figures making an offering before an idol in a splendid temple, mirrors the adoration of the shepherds above. The broken column that lies at Joseph's feet is perhaps by implication a ruin of the pagan temple in the border below, symbolising how Christ swept away the pagan idols, and contrasting the humility of Christ with the amoral splendour of the pagans below. Aspertini's signature ('Amicus Bononiensis') is on a plaque in the middle of the right side of the border.

The Hours of Mary of Burgundy and Bonaparte Ghislieri are both exceptional examples of a type of book – the Book of Hours – that had by the close of the Middle Ages become commonplace. As such, they demonstrate how a standard set of texts could be transformed to suit its patrons' requirements through illumination. Illuminators contributing to Books of Hours could work within,

Plate 3.19 Amico Aspertini, *Adoration of the Shepherds*, from the Hours of Bonaparte Ghislieri, Bologna, early sixteenth century, parchment manuscript, folio 21 × 15 cm, British Library, London, Yates Thompson MS 29, fol.15v. Photo: by permission of the British Library.

and sometimes (like the Vienna Master) cleverly subvert, the established conventions of the genre. Not all books provided the illuminator with traditions on which to draw, and so presented a different sort of challenge: instead of innovating within a tradition, sometimes the task was to do so without benefit of one. The library of Margaret of York (1446–1503) – sister of two kings of England

(Edward IV and Richard III), wife of Charles the Bold, Duke of Burgundy, and stepmother to Mary of Burgundy – contains several books that match this description. Her library was relatively modest in scale, consisting of about two dozen books, but was sophisticated in its textual and visual content. Most of her books were of a devotional or religious character.[48] Some of these texts were standard

Plate 3.20 Attributed to the Master of Guillebert de Lannoy, *Margaret of York Performing the Seven Acts of Mercy and in Prayer*, frontispiece to Nicholas Finet's *Benois seront les miséricordieux*, Brussels, between 1468 and 1477, parchment manuscript, folio 37 × 27 cm, Bibliothèque royale, Brussels, MS 9296, fol.1. Photo: © Bibliothèque royale de Belgique, Brussels.

works, but others were more unusual, and images play an important role in a large proportion of them.

Margaret of York's illuminated manuscripts reflect her spiritual priorities, and indeed her own piety is sometimes the subject of miniatures in her books. The frontispiece to one of her manuscripts, Nicholas Finet's *Beniot seront les miséricordieux* or *Blessed are the Merciful* is a series of images showing Christ watching Margaret as she prays and performs seven acts of mercy: feeding the hungry, giving drink to the thirsty, clothing the naked, sheltering the poor and pilgrims, visiting prisoners, burying the dead and, finally, in prayer with her namesake, Saint Margaret, behind her (Plate 3.20).[49] Another of her manuscripts, Finet's *Dialogue de la duchesse de Bourgogne à Jésus Christ* or *Dialogue between the Duchess of Burgundy and Jesus Christ* shows Christ appearing to Margaret in her bedchamber (Plate 3.21).[50] Like the images in the Hours associated with her stepdaughter Mary of Burgundy, Margaret of York would have

meditated on images of herself in acts of piety and prayer, which could have spurred her on to enact the activities portrayed. Manuscript patrons, especially those (like Margaret) who came from book-collecting families, knew that libraries usually outlived their founders, and so she may also have conceived of these images of piety as a memorial to her good works. After the untimely death of her battle-obsessed husband, Margaret's patronage of illuminated manuscripts seems to have lost its momentum. Instead, her focus turned to charitable works, founding convents and benefiting the poor: perhaps this is an example of life imitating art.[51]

One of Margaret's books, a copy of a French translation of a twelfth-century text known as the *Visions of Tondal*, indicates the exceptional qualities of her illuminated manuscripts. A forerunner to Dante's *Divine Comedy*, it tells the story of a knight's vision of hell, purgatory and heaven, beginning with the knight Tondal having a seizure at a banquet. While unconscious, an angel shows him the torments of hell and purgatory and the delights of paradise. The *Visions of Tondal* was

Plate 3.21 Attributed to the Master of Guillebert de Lannoy, *Christ Appearing to Margaret of York*, from Nicholas Finet's *Dialogue de la duchesse de Bourgogne à Jésus Christ*, Brussels, shortly after 1468, parchment manuscript, folio 20 × 14 cm, British Library, London, Add. MS 7970, fols 1v–2. Photo: by permission of the British Library.

popular in the later Middle Ages, circulating in its original Latin and in vernacular translations, but of all the surviving manuscripts, only Margaret of York's includes a narrative cycle of images. Its artist, the painter Simon Marmion (c.1425–89), seems to have devised its programme based on a careful reading of the text, following many of its details very closely.[52] One of the most dramatic images in the manuscript reveals Marmion's narrative skill and mastery of light effects. Tondal's soul, shown as a naked figure, is being led past the beast Acheron, who devours sinners guilty of avarice (Plate 3.22). He sees a fiery spectacle looming out of the darkness. The text describes how '[t]his horrible beast had in its jaws two big devils. One of them had his head forced into the upper teeth and onto the lower teeth were affixed his feet; and the other devil was in the opposite direction.'[53] Marmion's illustration matches this narrative very closely, showing two figures – one right side up, the other upside-down – wedged in Acheron's mouth.

Marmion's illustrations follow the twelfth-century text, but they also use details of costume and architecture to place the story within a contemporary setting: just as the text has been translated into French, so too the images transport the story into fifteenth-century Burgundy. In the miniature illustrating the torments of the 'bad but not very bad', the damned are depicted frozen in the niches of a late Gothic wall, dressed in the finery of contemporary Burgundian fashion (Plate 3.23). The text describes how '[e]nsconced in the wall was a great multitude of men and women who, night and day, were exposed to wind and rain and felt great pain, especially from hunger and thirst'. Tondal asks, 'Who are these people who live in this place without undergoing torments?' The angel explains, 'They are those who, while in the world, did not commit great evil, and who behaved honestly. But the worldly goods that God had lent them to give to the poor, they did not share as faithfully as they should have.'[54]

Plate 3.22 Simon Marmion, *The Beast Acheron, Devourer of the Avaricious*, from *Les Visions du chevalier Tondal*, Valenciennes and Ghent, 1475, tempera, gold leaf, gold paint and ink on parchment, J. Paul Getty Museum, Los Angeles, MS 30, fol.17. Photo: © The J. Paul Getty Museum.

Plate 3.23 Simon Marmion, *The Bad but not Very Bad*, from *Les Visions du chevalier Tondal*, Valenciennes and Ghent, 1475, tempera, gold leaf, gold paint and ink on parchment, folio 36 × 26 cm, J. Paul Getty Museum, Los Angeles, MS 30, fol.33v. Photo: © The J. Paul Getty Museum.

Plate 3.24 Giovanni di Paolo, *Dante and Beatrice Ascend from the Earthly Paradise*, from Dante Alighieri's *Divina commedia* (*Paradiso*, Canto I), Siena, 1442–50, parchment manuscript, folio 37 × 26, British Library, London, Yates Thompson MS 36, fol.130. Photo: by permission of the British Library.

The programme of illumination in Margaret's *Visions of Tondal* is unique, but the idea to illustrate the poem might have been inspired by another visionary poem about hell, purgatory and heaven, the *Divina commedia* or *Divine Comedy* of Dante Alighieri (1265–1321). Despite the pictorial challenges presented by this complex text, numerous copies with a miniature at the beginning of each of its sections (known as cantos) were produced in the fourteenth and fifteenth centuries.[55] Images played multiple roles in these books. On a practical level, they helped the reader find their way through the text by marking major divisions and identifying the subject of each canto. But, as in Margaret's *Visions of Tondal*, they also offered an interpretation of the adjacent text.

One particularly splendid copy was made in Siena in the 1440s for Alfonso V of Aragon, King of Naples, and includes 115 miniatures. Giovanni di Paolo (*c*.1399–1482), one of the greatest painters of his generation, contributed the illustrations for *Paradiso* (Plate 3.24).[56] Dante is guided through paradise by Beatrice, the poet's muse, and as they move through the circles of heaven towards God, she explains what they see. Giovanni di Paolo's miniatures do more than simply illustrate the text: they offer sophisticated visual interpretations of Dante's vision. For example, the illustration for Canto I of *Paradiso* does double service by incorporating diagrams of the concepts contained

in the text into a depiction of the key narrative moments in the canto. Giovanni di Paolo's miniature shows Beatrice and Dante as they hover above the great sea of being. In the poem, Dante describes the peculiar sensation of flying upwards by likening himself to the fisherman Glaucus (described in Ovid's *Metamorphoses*), who was changed into a sea god.[57] Glaucus is represented on the left of the miniature, perhaps as a way of helping the reader who missed the literary reference. In the poem, Beatrice explains the order of the universe to the bewildered Dante (and, by extension, to the reader), and this is pictured in the centre with the nine rings of heaven with Love at the centre. Dante's reference to the position of the sun in the sky is illustrated with a diagram of the cosmos on the left, consisting of four concentric circles with three crosses surrounding the sun.

The images examined in this section demonstrate how manuscript illuminations could operate in ways that augmented, or indeed even took priority over, the texts they accompany. Visions of biblical figures and events, and of heaven, hell and purgatory, could provide moral instruction and a focus for prayer. They could also serve as a memorial to the piety of their owners long after they were gone. Further, as in the *Divine Comedy*, they could help the reader to understand the adjacent text.

4 The case of the Sforza Hours

So far in this chapter, we have jumped from Italy to the north, comparing the choices made by artists and patrons north and south of the Alps. While reflecting the broad differences in deluxe book production between the two regions, this approach risks implying that the Alps acted as a boundary rather than as a thoroughfare. In fact, the movement of people and the exchange of goods and ideas around Europe, over land and by water, was a crucial feature of the period. As an example of this, we can consider the Sforza Hours, a manuscript initiated in Milan and completed 40 years later in the Netherlands. An astonishing amount is known about the history of this book and its patronage by successive noblewomen, and as such it allows a glimpse into the way that these women thought about and valued their books. Interpreted as a response to the Italian part of the manuscript, the choices made by its Netherlandish patron and artist in completing it offer insights into the way that one illuminator viewed the work of his predecessor. And, despite all that is known about the Sfroza Hours, unanswered questions demonstrate the interpretative problems confronting the modern viewer.

In about 1490, an illuminator and priest, Giovanni Pietro Birago (active 1471–1513), wrote a letter complaining about the theft of some pages from an unfinished illuminated manuscript. He explained that the incomplete Book of Hours recently given to the letter's unknown recipient (identified only as 'your Excellency') had been stolen from him by a friar called Fra Johanne Jacopo. The book, he says, 'is that which Duchess Bona had made'. Fra Jacopo, a friar of San Marco in Milan, had evidently made off with a clutch of illuminated pages, estimated by Birago to be worth 'more than 500 ducats'. The thief had been caught and, as Birago explains, thrown into jail. The letter includes a plea that 'your Excellency not permit the said Fra Johane Jacopo to be released until he has paid for the said book of hours'.[58] There is undoubtedly a certain irony in the fact that this Book of Hours, a small prayer book designed for the daily devotions of its owner, could have inspired criminality in a mendicant committed (at least in theory) to a life of service to God. Unfortunately, we do not know what became of the thieving Fra Jacopo, but remarkably we do know what happened to Bona's unfinished manuscript, and even to some of its stolen pages.

Known today as the Sforza Hours, the manuscript commissioned by Bona Sforza (d.1503) from Birago is one of the British Library's greatest treasures. The story of this book takes us from Milan of the 1490s to the Netherlands of the 1520s, into a Madrid hotel room in 1871 and to a satisfying epilogue in 2004. Its tale reveals much about the place of illuminated manuscripts in Renaissance culture in Italy and the north, the ways in which illuminators responded to one another, and the capacity for pictorial and stylistic invention within the conventions of an established form like the Book of Hours. It also provides evidence of the lasting value of an illuminated manuscript from the time it was initiated to the twenty-first century.

The Sforza Hours is, by any standard, a miniature masterpiece. With pages measuring about 13 x 9 centimetres, it would originally have rested comfortably in its owner's hands as she used it for her devotions. One of the most richly illuminated manuscripts of its period, many of its text pages are framed with elaborate borders, and the divisions in its texts are marked with full-page miniatures. It includes 64 full-page miniatures and 140 text pages with decorated borders and small miniatures. This diminutive manuscript is a compendium of the texts suited to Bona's devotions throughout the calendar year, including a liturgical calendar, biblical extracts, the Hours of the Virgin, and other cycles of prayers to be said at the eight canonical hours of the day. Judging from its present contents, we can surmise that a substantial proportion of its pages were stolen from Birago, including the manuscript's entire calendar and folios from the Gospel lessons, the Hours of the Cross, the Hours of the Holy Spirit, the Hours of the Virgin, the Passion according to Saint Luke, three prayers to the Virgin (*Salve Regina*, *Obsecro te* and *O intemerata*), and the Suffrages of the Saints.

Mark Evans has drawn attention to Birago's astonishingly high valuation of the stolen portion of the Sforza Hours, observing that the 500 ducats claimed by Birago is 'five times Leonardo da Vinci's own estimate in 1504–06 of the *Virgin of the Rocks*'.[59] Close inspection of just one of its miniatures reveals why Birago (and his patron) might have valued these miniatures so highly. The final one in the sequence of seven images

accompanying the Passion according to Saint Luke is a complex composition illustrating three distinct narrative moments (Plate 3.25). In the foreground, the dead body of Christ lies across the lap of the Virgin, who stretches out her arms in a dramatic gesture of despair. She is surrounded by other figures, including Mary Magdalene (who holds the crown of thorns), John the Evangelist (behind Mary), Joseph of Arimathea and Nicodemus. Two further episodes are depicted in the landscape behind this group. On the right, three demons are silhouetted against the sky as Christ liberates souls from limbo.[60] On the left, the resurrected Christ stands triumphant on his tomb, surrounded by sleeping guards. The gnarled, seemingly lifeless trees on the left offer a metaphor for the Resurrection: although apparently dead, the trees will return to life in spring just as Christ rose from the dead. Its saturated colours – dominated by jewel-like reds, blues, yellows and greens – are typical of Birago's palette. The first words of the Passion of Saint Luke – 'ET ECCE' (and behold) – are written in gold capitals on a red scroll at

the bottom of the page. The narrative density, emotional intensity and iconographic sophistication of this miniature are sustained in each of the full-page miniatures that survive of Birago's contribution to the Sforza Hours.

By the time she commissioned this Book of Hours *c*.1490, Bona Sforza had been a widow for 14 years. Her husband Galeazzo Sforza, the Duke of Milan, had been assassinated in 1476, leaving Bona and their seven-year-old son Gian Galeazzo Maria (1469–94). In 1494, after her son's death, the French invasion of Italy, and the collapse of her position, Bona returned to her native Savoy to live under the protection of her nephew Phillibert of Savoy. By then, she had evidently given up on completing the Hours. She died in Savoy in 1503, leaving the fragmentary (but nevertheless magnificent) manuscript to Phillibert, who died the following year. It then became the property of his widow Margaret of Austria (1480–1530). In 1507, Margaret returned to the Netherlands to serve as the Governor of the Burgundian Netherlands, and later (from 1509) Regent of the Netherlands for

Plate 3.25 Giovanni Pietro Birago, *Pieta*, from the Sforza Hours, Milan, *c*.1490, parchment manuscript, folio 13 × 9 cm, British Library, London, Add. MS 34294, fol.165. Photo: by permission of the British Library.

Plate 3.26 Muzio Attendolo Master, *Saint Matthew*, Milan, *c*.1490, parchment manuscript, folio 13 × 9 cm, British Library, London, Add. MS 34294, fol.7. Photo: by permission of the British Library.

her seven-year-old nephew Charles V, taking the Sforza Hours with her.

In 1517, almost 30 years after the manuscript was first commissioned, Margaret of Austria set about completing the Sforza Hours, employing the French scribe Etienne de Lale to replace its missing text pages. Instead of writing in a northern script, de Lale's pages are written in a rather shaky imitation of the book's original round Italian Gothic hand. Soon after, Margaret engaged the illuminator Gerard Horenbout (before 1465–*c*.1541) to replace the missing images and to add to the programme of miniatures to accompany the suffrages. Horenbout, from 1515 Margaret of Austria's court painter and *valet de chambre*, was one of the most inventive and successful illuminators of his day, running a busy workshop that seems to have included three of his children.[61] As part of the same project, she commissioned Horenbout to paint 16 miniatures and two borders. Horenbout's contribution to the Sforza Hours can be viewed as a considered, sophisticated response to Birago's style. Presumably acting on the specifications of

Plate 3.27 Gerard (or perhaps Lucas) Horenbout, *Saint Mark*, southern Netherlands, *c*.1519–20, parchment manuscript, folio 13 × 9 cm, British Library, London, Add. MS 34294, fol.10v. Photo: by permission of the British Library.

his patron, Horenbout clearly sought to emphasise the unity of the book: instead of painting in his own accustomed style, he cleverly adapted his established practices so that his miniatures would fit in with Birago's portion of the manuscript. Yet within the manuscript's conventions of form, palette and style established by Birago, Horenbout nevertheless retained his own distinctive techniques and northern aesthetic.

The ways in which he achieved this can be examined through a comparison of the Saint Matthew miniature executed by one of Birago's assistants, an artist known as the Muzio Attendolo Master, and Horenbout's Saint Mark.[62] The Attendolo Master shows Matthew seated at a desk in a richly decorated barrel-vaulted interior, with an undulating verdant landscape visible through the open doorway (Plate 3.26). Matthew turns away from his writing to read a book held by an angel. Scholarly clutter surrounds him, his desk crowded with a pen, ink pots and books, and a half-spent candle is positioned to allow him to work into the night. Horenbout's portrait of Saint Mark takes up many of the same features present in the Saint Matthew miniature (Plate 3.27). Like Matthew, Mark sits at a desk in a vaulted chamber, its decoration evoking contemporary Italian Renaissance architecture. The blue columns are decorated with golden stuccowork, similar in its classicising motifs to Aspertini's contribution to the Ghislieri Hours (Plate 3.19). A view of a townscape – perhaps an urban square – is visible through the double arches of the doorway. A finely bound book with golden clasps sits precariously close to the edge of his table, its gleaming goffered edges a testament to Horenbout's technical virtuosity. A lion, Saint Mark's symbol, sits on the rug at his feet. In both miniatures, the opening words of the Gospel extract are inscribed on illusionistic parchment scrolls. Perhaps trying to outdo the Attendolo Master's rectilinear scroll with its dense shadow, Horenbout's illusionistic parchment strip twists and curls dynamically, and its artfully attenuated shadow is cast by the same light source as the other objects in the miniature's foreground.

According to Mark Evans, to Margaret and her court 'the 30-year old Milanese miniatures in the Sforza Hours seemed eminently fashionable and the book a desirable subject for imitation and completion'.[63] It is difficult to square this view of the Sforza Hours' second campaign with what we

know of Margaret of Austria's tastes as an art collector and patron, and Horenbout's superlative ability as a painter. Is Horenbout's contribution merely imitative, and were Margaret's tastes as backward as Evans seems to imply? Clearly, Horenbout analysed Birago's miniatures and chose to adopt elements of them, such as the intense palette and the Italianate architecture. The multicoloured pebbles around the feet of Elizabeth and the Virgin in Horenbout's *Visitation* miniature (see Plate 3.29), for example, take up the same device in Birago's miniatures.[64] But Horenbout rejected other aspects of Birago's technique that, given his manifest skill, he could easily have mimicked if that had been his, or his patron's, desire. Birago's blocky, monumental figures; his reliance on line to define form; and his dense compositions are not mirrored in Horenbout's miniatures. These choices suggest that the notion of 'imitation' is misapplied here: working within a brief to maintain a coherent aesthetic within the book, Horenbout retained some of Birago's design and style but rejected others. One of the most significant features of this book is the glimpse it affords of the dialogue between its two illuminators.

Taking up Evans's point about the appeal of the Sforza Hours to Margaret, it is worth asking whether Margaret and her court really were so backward that Birago's 30-year-old illuminations seemed avant-garde. Margaret's art collection included extraordinary treasures acquired by gift and inheritance and through her own activities as a patron. This remarkably diverse collection was richly endowed with Netherlandish art (such as Jan van Eyck's *Arnolfini Portrait*),[65] and included works made in Germany and France as well as Italy; she also acquired exotic objects from the New World. Given the range of her goods, it is hard to see her as a collector dominated by the appeal of Italian art. Undoubtedly, Margaret must have admired the Sforza Hours' Italian miniatures, but it seems doubtful that her perception of it as fashionable was a primary motivation for its completion. The context in which Margaret initiated the campaign to complete the Sforza Hours reveals that a range of considerations beyond those of fashion may have been at work.

The hypothesis that Margaret gave the Sforza Hours to Charles V on the occasion of his coronation in 1520 as Holy Roman Emperor is widely accepted; indeed, it has recently been expressed as a point of fact rather than conjecture.[66] However, the evidence for this is limited to an image of Charles inscribed with the date 1520. The absence of the Sforza Hours from the 1523 inventory of Margaret's library could be taken to add a bit of weight to this supposition, though the case remains inconclusive.[67] This circumstantial evidence, while suggestive, does not prove that Margaret gave the manuscript to Charles at the time of his coronation, or indeed that he ever acquired it by gift or inheritance. All we can be sure of is that the manuscript was in Spain by *c*.1600 (some prayers were added to the end of the book about this time), a provenance that would be consistent with, but not proof of, Charles's ownership. These points might seem like mere quibbles: does it make any difference whether Margaret intended the book for Charles? I will return to this question shortly.

Margaret instigated the refashioning of the manuscript in 1517 with the replacement of lost text pages. Even if she had anticipated Charles V's coronation at this point, she might not have initiated the project with this in mind. Indeed, the insertion of the page containing Charles's portrait on folio 213 recto, juxtaposed to the beginning of the Penitential Psalms, could have been something of an afterthought; alternatively, Margaret could have specifically wished the image of her nephew to be situated in this location (Plate 3.28). This page is Horenbout's replacement for one of the Italian pages of the book, but it is not clear that the page it replaces was among those stolen from Birago's workshop. The scribe is not Etienne de Lale, whose tremulous script is easy to identify, but rather a second (rather better) scribe who collaborated closely with Horenbout on a few leaves. This scribe's hand is much closer than de Lale's to the original Italian script. Perhaps Margaret instructed Horenbout and the second scribe to excise an existing Italian page and replace it with one including the image of Charles. Horenbout imitated Birago's border style on three sides, and in the lower register painted an oval portrait medallion showing Charles wearing the Order of the Golden Fleece, the chivalric order founded by Philip the Good in 1430, around his neck. Charles's monogram 'K' (for Karolus, or Charles) surrounds the medallion,[68] and a lidded crystal vase is placed on either side.[69]

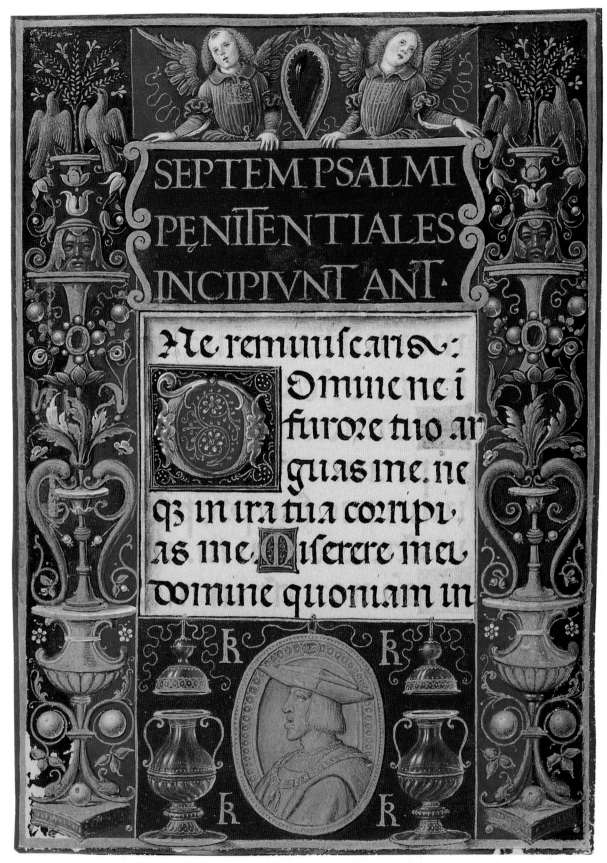

Plate 3.28 Gerard Horenbout, *The Penitential Psalms with a Medallion of Charles V*, from the Sforza Hours, southern Netherlands, *c.*1519–20, parchment manuscript, folio 13 × 9 cm, British Library, London, Add. MS 34294, fol.213r. Photo: by permission of the British Library.

The fact that Margaret inserted the image of Charles into the Sforza Hours does not in itself prove that she intended to give him the book. Indeed, if Margaret intended the refurbished Sforza Hours for Charles from the outset, it seems strange that the manuscript's connection to him is restricted to one image situated at the beginning of the Penitential Psalms. This relatively inconspicuous image contrasts sharply with the prayer book Margaret gave him in 1516, in which he is depicted in a large miniature wearing the Order of the Golden Fleece and the Spanish crown. Margaret inscribed this book: 'Never will I be content / If you do not see me as your humble aunt / Margaret.'[70]

Not only does the Sforza Hours lack an analogous dedication, but also the placement of the image of Charles strikes an ambiguous note if the emperor was the manuscript's intended recipient. His portrait appears opposite a full-page miniature showing King David in penitence, which sends a rather different message from the dedicatory text and image of the earlier prayer book. The juxtaposition of King David and Charles is superficially flattering, insofar as it asserts a parallel between the young emperor and the Old Testament king. Yet this comparison does not emphasise David's heroic qualities as the slayer of Goliath but rather his moral weakness, for he is shown in a posture of atonement (he had committed adultery with Bathsheba, then had her husband Uriah killed). The juxtaposition of Charles's portrait with the words of the first Penitential Psalm also seems loaded. The text above the portrait medallion begins with a plea for divine mercy: 'Lord rebuke me not in thy fury: nor chastise me in thy wrath. Have mercy on me because …' The happenstance of word spacing means that the next (most potentially reproachful) words, 'I am weak', are on the following page (Psalm 6:1–2).[71] One might wonder whether Margaret would have wanted this declaration of moral frailty directly above the new emperor's head if he was to be its principal audience.

Another scenario is plausible. If we reject the interpretation of this image as evidence that the book was refurbished as a gift for Charles, and consider that Margaret herself may have wished to be reminded of her nephew as she said the Penitential Psalms, then the image ceases to be admonitory. Instead, the image of Charles could have functioned as a trigger for Margaret to pray for her nephew, and also perhaps to appeal not just for divine mercy but for the mercy of her nephew (on whom her status depended). This reading of the image fits with Margaret's enthusiasm for portraits of her family, of which she had approximately 100 in her collection.[72]

The possibility that Margaret of Austria refurbished the Sforza Hours for herself, rather than for Charles V, has implications for the interpretation of one of the most remarkable additions to the manuscript. In Horenbout's miniature depicting *The Visitation*, the meeting between the Virgin (pregnant with Christ) and her cousin Saint Elizabeth (pregnant with Saint John the Baptist) described in Luke 1:39–56, Elizabeth is a portrait of Margaret (Plate 3.29). According to Luke, Elizabeth had been barren and miraculously conceived Saint John 'in her old age' (Luke 1:36). In the miniature, the two women greet one another tenderly, with Elizabeth placing her hands on the Virgin's round belly. Margaret's portrait seems like a comparatively subtle assertion of her identity. Since there are no inscriptions explaining that Elizabeth is Margaret, the viewer would have to know what Margaret looked like in order to realise the personal nature of the representation of Elizabeth. Indeed, it is only through comparison with other surviving portraits of Margaret (notably those by the workshop of Bernard van Orley, on which the Sforza Hours' image must have been based) that Elizabeth has been recognised as a portrait.[73]

What might Margaret's intentions have been for this *Visitation* portrait, and how might it have functioned? Dagmar Eichberger has suggested that the image might relate to Margaret's role as surrogate parent to her dead brother's children.[74] But did Margaret intend this image to be a statement about herself for somebody else (Charles), or did she want it for her own use, as a focus for her private thoughts and prayers? Gazing at this image, Margaret would have been face to face with the Virgin, both as a viewer of the image and also as a subject within it. The image seems to convey Margaret's devotion to the Virgin as much as her spiritual connection to Elizabeth, with whom she may have particularly identified. When she initiated the completion of the Sforza Hours, Margaret was twice-widowed, childless and approaching 40. By having herself cast in the role

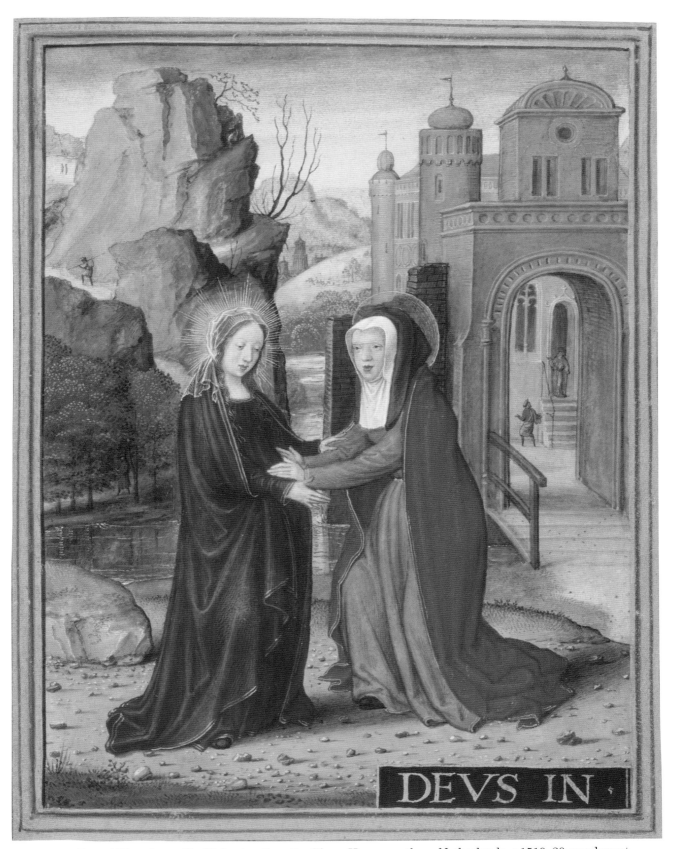

Plate 3.29 Gerard Horenbout, *The Visitation*, from the Sforza Hours, southern Netherlands, *c.*1519–20, parchment manuscript, folio 13 × 9 cm, British Library, London, Add. MS 34294, fol.61. Photo: by permission of the British Library.

of Elizabeth (it is hard to imagine the illuminator taking such a daring initiative unprompted), Margaret may have addressed whatever regrets she fostered about her own childlessness. Given the weakness of the evidence that Margaret gave the Sforza Hours to Charles, it may make more sense to read this miniature as a highly personal image intended for Margaret herself rather than as a contorted allegory about her role as an aunt aimed at Charles.

The inspiration to incorporate an image of herself within her Book of Hours may have been sparked by one of the manuscripts we have already considered: the Hours of Mary of Burgundy. Margaret could have possessed, known or known about the Hours associated with her mother, which also includes a patronal portrait within a visionary encounter with the Virgin (Plate 3.16).[75] Margaret of Austria was only three years old when Mary of Burgundy died, but Margaret of York, Mary's stepmother, was Margaret of Austria's godmother (and namesake), and the two women spent a great deal of time together at Mechelen. If the Hours of Mary of Burgundy was at Mechelen with either Margaret of York or Margaret of Austria, then this might explain the apparent debt owed by Horenbout's *Christ Nailed to the Cross* (folio 12 verso) to the Vienna Master's treatment of the same scene in Mary of Burgundy's Hours (Plate 3.17). In both manuscripts, this scene marks the beginning of the Hours of the Cross. Common to both miniatures is the dramatically foreshortened figure of Christ, lying supine as he is nailed to the Cross; figures converse and glance towards the viewer in the foreground, and crowds mill around in the middle distance. Some minor details, such as a 'T'-shaped wrench, appear in both images. Could Horenbout's miniature, which is sometimes likened to a small panel by the Bruges artist Gerard David (National Gallery, London), instead have been deliberately conceived as an allusion to the image it more closely resembles in Margaret's mother's manuscript?[76]

The case of the Sforza Hours, while hardly typical, highlights many of the issues affecting the interpretation of deluxe Renaissance books by modern scholars. Among these is the question of agency: to whom do we attribute the ideas and innovations in these books? How can we determine the extent to which a book reflects a patron's wishes as opposed to its artist's? Even

in the case of the Sforza Hours, about which so much is known (especially in comparison to most contemporary manuscripts), ultimately we cannot uncover the motivations and intentions of its patrons, Bona Sforza and Margaret of Austria. This does not, however, mean that we should not try. By considering the context in which the book was first made and later refurbished, and assessing the details of its textual and visual contents, it is possible to offer some informed speculations on how the book might have been viewed by its original audiences. Additionally, the Sforza Hours offers an opportunity to consider an artist not just as a maker of images but as a viewer also, for in this book we are presented with Horenbout's skilful response to the work of his predecessor, Birago. The Sforza Hours also serves as an example of ways in which a splendid book might be valued as a luxury object: Birago's ambitious and accomplished programme, twinned with his estimated value of the stolen portion, are witnesses to the high priority given to the small book by Bona Sforza. The fact that Margaret initiated a campaign to complete it, and engaged the services of a skilled scribe and her own court painter to do so, similarly affirm its material value. The modern epilogue to the story of the Sforza Hours demonstrates that the book held its value over the centuries.

What happened to the Sforza Hours after it was completed? It remains a possibility that Margaret could have given the book to Charles around the time of his coronation in 1520, or he might have inherited it upon her death ten years later in 1530. Charles lived on to 1558. By about 1600 the manuscript was in Spain, but from this date until 1871 it disappears from view. In this year, against the backdrop of the Franco-Prussian war, the renowned museum curator, collector and connoisseur J.C. Robinson (1824–1913) made his way to Spain, where he hoped to take advantage of the disruptions to the art market caused by war. The dealers, he wrote later, 'were only too eager to welcome any clients who might present themselves in such a time of depression'.[77] A few days after arriving in Madrid, Robinson's hotelier, an Italian named Don José Fallola, told him that some months before, a wonderful illuminated manuscript had been brought to him by a priest acting as agent for a distinguished person who wished to remain anonymous. Don José had decided to buy the book himself for the enormous price of 20,000 pesetas

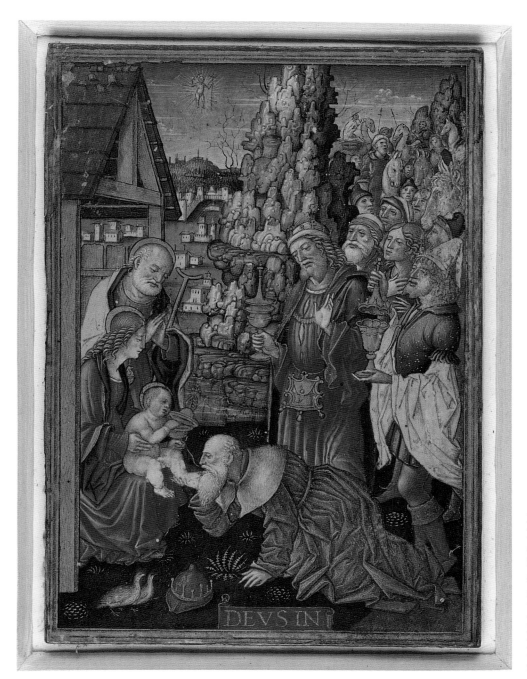

Plate 3.30 Giovanni Pietro Birago, *Adoration of the Magi*, from the Sforza Hours, Milan, *c.*1490, parchment manuscript, folio 13 × 9 cm, British Library, London, Add. MS 45722 (single leaf). Photo: by permission of the British Library.

(the 1871 equivalent of 800 pounds sterling), and had gone to the priest's residence with the cash in his pocket. Finding nobody home, the hotelier returned to his hotel and, forgetting the fortune in his pocket, hung his cloak in the hallway. By the time he prepared to go again to the priest later that day, the money was gone. 'This story excited me not a little,' Robinson recalled.[78] Accordingly, he arranged to see the manuscript for himself. That evening, the priest brought it to his hotel room and 'with much ceremony the little corpulent velvet-covered volume' was placed in his hands. Opening

the book, Robinson was immediately 'struck dumb with admiration', and 'when every page of the book … was revealed equally enriched, the only thought was that it should not leave my hands; and literally it did not, for luckily I had provided the funds in anticipation and so the bargain was instantly concluded.'[79] On his return to England, Robinson tried unsuccessfully to sell the manuscript to the British Museum, and so sold it to the collector John Malcolm of Poltalloch; in 1893 Malcolm presented the manuscript to the British Museum, the library of which is now the British Library.

This gift was not the last twist in the tale of the Sforza Hours: several of the leaves stolen from Birago in the 1490s have surfaced and been reunited, one at a time, with the Sforza Hours in the British Library's collections. One of these, Birago's *Adoration of the Magi* (Plate 3.30), was given anonymously to the library in 1941; another, the calendar miniature for May, was acquired in 1984; and in 2004 it purchased Birago's calendar miniature for October.[80] No further Sforza miniatures are known, though we can hope that others might appear.

5 Conclusion

In his memoirs, Vespasiano da Bisticci recalled the library of one of his greatest clients, Federigo da Montefeltro, Duke of Urbino (Plate 3.31):

> In this library all the books are superlatively good, and written with the pen, and had there been one printed volume it would have been ashamed in such company. They were beautifully illuminated and written on parchment.[81]

By the time of Federigo's death in 1482, the printing press had only been around for about 30 years. Even within this short time it had transformed European literary culture, certainly enough for Vespasiano to think that Federigo's refusal to acquire printed books was worthy of mention. Within the first 50 years of print, an estimated two million books were printed. Yet, as Federigo's library attests, print did not instantly render the illuminated manuscript obsolete. On the contrary, deluxe illuminated manuscripts continued to be made in significant numbers well into the sixteenth century, and have been prized ever since. Federigo may have been unusual in his wholesale rejection of print, but he was certainly not alone in his enthusiasm for the handmade, hand-painted book. Encouraged by wealthy patrons, magnificent illuminated manuscripts continued to flourish for more than a century after the dawn of the age of print. These manuscripts preserve some of the finest paintings of their age, often demonstrating astonishing pictorial invention and artistic skill.

What was it about the illuminated manuscript that ensured its continuing survival? Why did Federigo and other bibliophiles continue to commission and collect illuminated manuscripts even after print offered them more affordable and, from the point of view of textual consistency, more reliable books? Whatever the advantages of print, the manuscript – and perhaps especially the illuminated manuscript – could do things that the printed book did not.

Traditionally, histories of Renaissance art have tended to cast illuminated manuscripts in a supporting role, with the spotlight firmly fixed on painting, architecture and sculpture. Given the importance of the complex relationship between art, humanism and the wider literary culture of the fifteenth century, it might perhaps seem perverse that illuminated manuscripts have been sidelined in this way. After all, where might one find a clearer indication of the nature of the relationship between art and ideas than on the pages of a book where text and paintings are juxtaposed? Illuminated manuscripts are invaluable witnesses to the intellectual, aesthetic, literary, moral, historical and devotional priorities of their makers and owners. The imagery in these books – including (but not limited to) miniatures, borders framing blocks of text, and historiated initials – can be interpreted not just as commentaries on the adjacent text, but in many cases as an index of the patron's ambitions as a bibliophile. Images in manuscripts can reveal not just what, but how and sometimes even why, their owners read, as well as how they saw themselves and wanted to be remembered.

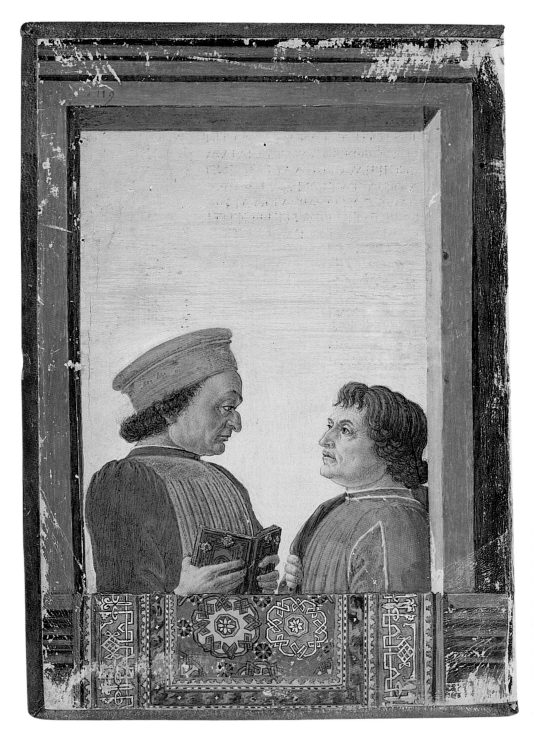

Plate 3.31 Attributed to Francesco d'Antonio del Chierico, *Federigo da Montefeltro with an Unidentified Companion*, miniature pasted into the front cover of the binding, *c.*1472, parchment manuscript, Biblioteca Apostolica Vaticana, Vatican, Urb. Lat. 508. Photo: © Biblioteca Apostolica Vaticana.

Chapter 4
introduction

Traditionally, French art before the arrival of Leonardo da Vinci in France was viewed as of little significance. In this chapter Thomas Tolley uncovers a different history of French art that has only recently been assembled and is still in progress. He shows that French Renaissance art did not begin with the arrival of Leonardo in 1516 but had much earlier roots. From the reign of Louis XI onwards, renewed stability and prosperity in France created favourable conditions for artistic production for the first time since the end of the Hundred Years War between France and England. A range of artistic strategies were developed, both distinctively French and Italian Renaissance in character.

Louis XI fostered a devotional art that continued into the next reign under artists like Jean Bourdichon. After the death of Louis, the artistic focus shifted to the Bourbon court of his daughter, Anne of France, during the minority of her brother, Charles VIII. As well as employing an important artist probably of Netherlandish origin called Jean Hey, the Bourbons attracted officials also devoted to the arts who encouraged the production of illuminated books. Although the inheritor of this artistic tradition, Charles VIII encountered a very different style of art in Italy during his Italian campaigns; and during his reign, an enthusiasm for Italian Renaissance art developed. French traditions were not eclipsed, however, but continued alongside the new style. Under his successors Louis XII and Francis I, art was used increasingly deliberately to enhance the image of the monarchy. It is a measure of how important art had become in establishing and maintaining the reputation of rulers that Francis I invited Leonardo da Vinci, arguably the most famous artist of the day, to work for him in France.

The dissemination of Italian Renaissance art into France did not constitute an eradication of the French artistic tradition; still less did it constitute the beginning of French art. In charting the development of French art from the reign of Louis XI onwards, Thomas Tolley shows a shift in patterns of patronage from devotional art and portraiture to art as propaganda. Its importance grew not so much because of the inspiration of the Italian Renaissance, but because once again French monarchs had money to spend and realised afresh the potential of art for enhancing royal authority.

Kim W. Woods

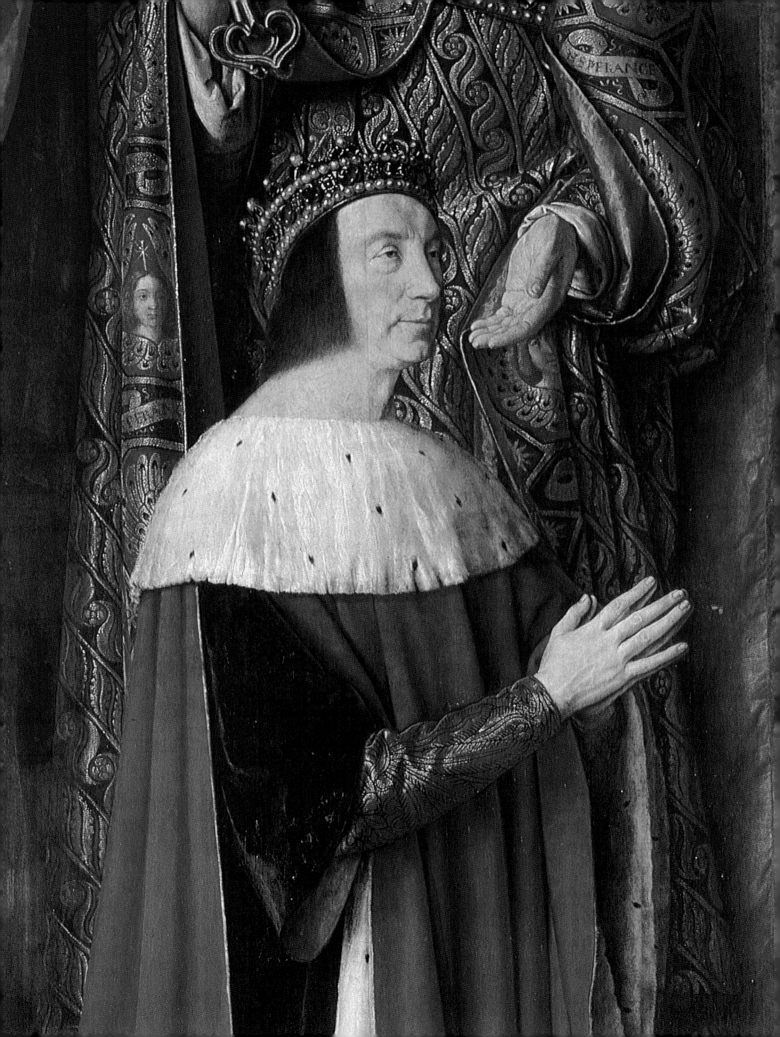

Chapter 4

Monarchy and prestige in France

Thomas Tolley

1 Restoring reputations

Mantegna, Perugino, Leonardo, Michelangelo, van der Goes, Cranach and Dürer – these are the names of some of the most celebrated artists active in Italy, the Netherlands and Germany around 1500. For those interested in the history of art, they have long been considered key figures in any appreciation of what we call the Renaissance. They also feature in a list of 24 artists mentioned in the introduction to a treatise on perspective written in 1521 by a French scholar and diplomat, Jean Pélerin (c.1445–1524).[1] Also on his roll of artistic excellence – he called them 'ornaments' of France, Germany and Italy, worthy of Zeuxis and Apelles[2] – Pélerin included several French artists whose names fail to strike the same chord. What are we to make, for example, of Colin d'Amiens or Jean Poyer? As a patriot, Pélerin naturally hoped France could hold its own with other countries in artistic celebrity. But did he really think that Colin, Poyer and others ranked alongside the luminaries mentioned above?

Until recently, so little was known about French artists at this time that it was easy to dismiss Pélerin's appraisals. Most attempts to write the history of French art during this period reveal a preoccupation with identifiable connections with other countries, especially Italy, where most innovation was assumed to originate. The tendency to presuppose that anything worthy of discussion always had behind it some Italian inspiration explains why the only French painter on Pélerin's list to have had a series of monographs

devoted to him is Jean Fouquet (c.1415/20–before November 1481), who visited Italy in the 1440s.[3] Classicising or Italianate details reflecting works of art seen during this trip often feature in paintings created in Fouquet's workshop and by his followers, suggesting a growing appreciation in France for the visual trappings of ancient Roman civilisation. An illumination painted by a follower of Fouquet (Plate 4.2), perhaps one of his sons, reinterprets ancient monuments – Trajan's Column and monuments in the Roman Forum were obvious sources of inspiration – to recreate a setting appropriate to an episode from Roman history.[4] Fouquet's Italian experience secured for him mention in the first edition of Vasari's *Lives* (1550), then the most authoritative account of the history of the visual arts, read as avidly in France as elsewhere. Vasari was primarily concerned with presenting the arts as they had developed in Italy, and he largely ignored artists active abroad. However, Pélerin's list, written 30 years earlier, reflects a different view of the decades around 1500, one in which French artists held their own in a pan-European context.

Consider, for example, Colin d'Amiens (active c.1450–c.1495). Scholarship has now restored to him a leading position in artistic production in Paris in the later fifteenth century. Like his father and sons, Colin was a painter, illuminator and designer of artistic programmes in several media. One work that can be associated with him unequivocally is a monumental *Entombment* (Plate 4.3), commissioned by Louis Malet de Graville

Plate 4.1 (Facing page) Attributed to Jean Hey, detail from *Saint Peter presenting Pierre, Duke of Bourbon* (Plate 4.18).

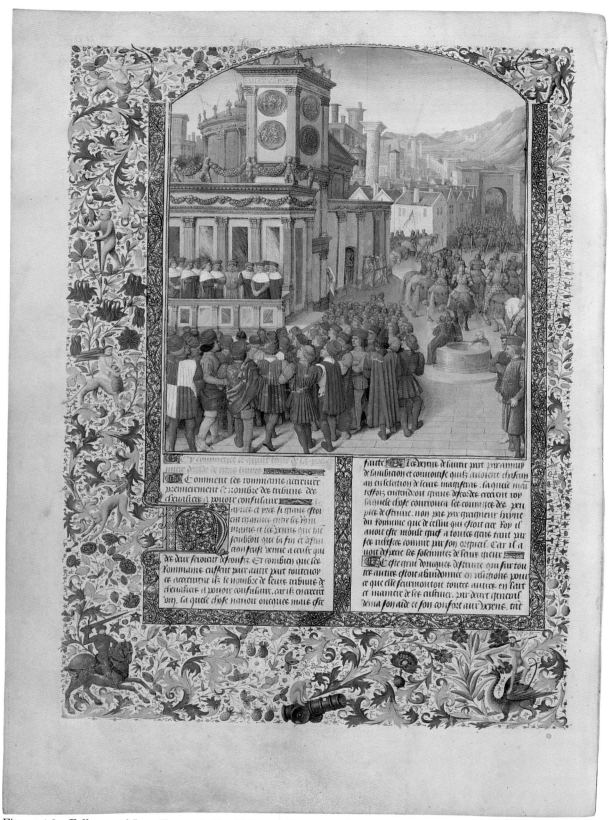

Figure 4.2 Follower of Jean Fouquet, *The Tribunes Harangue the Romans over the War with the Veii*, illustration to Book 5 of Livy's *Roman History*, 1470s (border decoration *c*.1450), parchment manuscript, folio *c*.60 × 43 cm, Bibliothèque nationale de France, Paris, MS fr. 20071, fol.98v. Photo: Bibliothèque nationale de France.

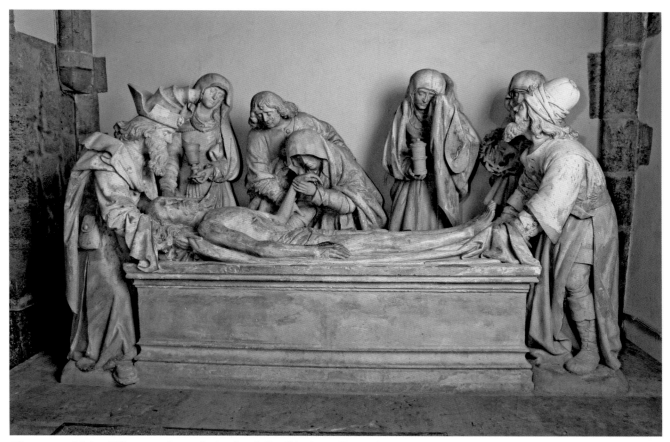

Plate 4.3 Adrien Wincart, after a design by Colin d'Amiens, *Entombment*, 1495–6, stone, parish church of Saint-Martin, Malesherbes (with twentieth-century restorations). Photo: Photo Benoit, Malesherbes.

(d.1516), admiral of France.[5] Colin did not carve the life-size figures of this spectacular group himself, so this cannot be taken as evidence for his personal style, but he did provide their design. Unlike Fouquet, Colin owes nothing to Italian precedent. Monumental Entombments were popular in all regions of France in the fifteenth century.[6] But whereas many of these feature stiff, rather inexpressive figures, the one designed by Colin breathes life into his characters. The participants command attention through their emotional credibility. The composition balances the spiritual dignity of a sacred drama with the dynamism of an actual event. Life-like details, such as the tear-stained faces and intricacies of clothing, underline this group as a work of intensity and creativity, supporting Pélerin's assertion that Colin was a major figure.[7]

The same applies to Jean Poyer (d. *c.*1502?), active – like Fouquet – in Tours (see the map of France, Plate 4.4). Although no documented work by Poyer has yet come to light, extensive circumstantial evidence has enabled an impressive corpus of illuminations, panel paintings and stained glass to be convincingly attributed to him.[8] Decades following his death, there is brief mention of him as having 'surpassed' Fouquet and his sons 'in perspective and the science of painting', evidence that his presumed contribution to the development of pictorial space earned him a lasting reputation.[9] Pélerin's inclusion of Poyer in his own treatise on perspective confirms that Poyer's standing rested on what contemporaries regarded as exceptional perspectival skills. The earliest dated work identified as Poyer's, an impressive altarpiece of 1485, shows an intriguing feature that corroborates his standing (Plate 4.5). The triptych's right wing includes a figure wearing a white habit, kneeling in the distance, behind a scene of the Entombment. The adjacent inscription 'F.I.B.' permits identification of this figure with Jean Béraud (Frater Iohannes Berandi), who in 1483 became prior at the Charterhouse of Le Liget, where the altarpiece was presumably intended. Generally in painted altarpieces of the fifteenth century, donor figures are placed in the foreground

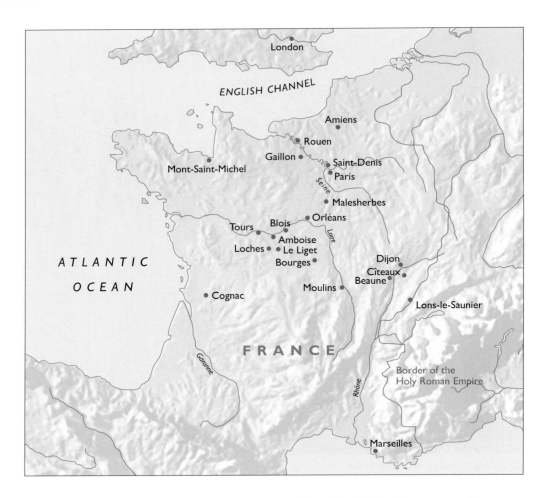

Plate 4.4 Key artistic sites in France from the reigns of Louis XI to Francis I.

to ensure that they stand out. The remote position of this Carthusian monk, convincingly depicted in the middle distance, implies some humility on his part. Poyer's subtle treatment of perspective perhaps appealed to Béraud because this aspect of his art, on which his subsequent reputation rested, was helpful in conveying a key monastic virtue by pictorial means. This is certainly praiseworthy.

Colin, Poyer and others working in France have not until now played any significant part in the history of Renaissance art. Scholars have only recently succeeded in reconstructing their careers and oeuvres. With few exceptions, their reputations were forgotten during the course of the sixteenth century as Vasari's *Lives* came to represent *the* history of the visual arts. Since Vasari had nothing to say about French artists, excepting those active in Italy, the impression was easily gained that there was little worth saying about earlier art in France. German and Netherlandish writers followed Vasari's example by recollecting the lives of major artists in their countries, but there was no equivalent for this in France.[10] When later

generations of French scholars became curious about the history of painting in their own country, the earliest reference many found was Vasari's account of Leonardo da Vinci coming to France at the invitation of Francis I (ruled 1515–47). This was understood as confirmation that the beginnings of meaningful painting in France had Italian origins. Subsequent accounts of painting in France therefore often began with Leonardo's arrival in France in 1517, while earlier artists were generally just ignored. André Felibien, a seventeenth-century member of the French academy of painting and sculpture, mentioned René of Anjou, who enjoyed an early reputation as a painter; but here it is reasonably clear that René's royal status was the main factor in presenting his artistic reputation.[11] While many nineteenth-century scholars took it for granted that French art had been reinvigorated through contacts with Italy around 1500, some French scholars later sought to extol their own national 'school', mounting a seminal exhibition of French 'primitives' in Paris in 1904. Although this brought before the public 'key' surviving works of art associated with France

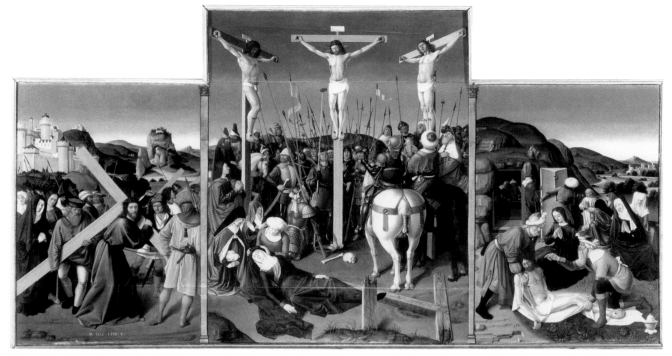

Plate 4.5 Jean Poyer, *Christ Carrying the Cross, the Crucifixion, and the Entombment*, 1485, oil on panel, 143 (central panel) × 283 cm (height of side panels 110 cm), le château, Loches. Photo et collection Villes de Loches.

dating from the later Middle Ages, the scholarship of the exhibition served to demonstrate how inadequate was the prevailing state of knowledge of French art before 1520.[12]

Rectifying this state of affairs was fraught with problems. Much monumental painting and sculpture from the period before Leonardo's arrival had either been destroyed or survived in fragmentary form, so it was hard to assess what once existed. Religious conflicts of the later sixteenth century and major changes in taste proved devastating.[13] Losses were also sustained during the French Revolution. Since all leading artists in the years around 1500 received commissions from the royal family, they suffered extensively during the revolutionary period when much associated with monarchy was vandalised. Antiquarians recorded a great deal before destruction, but for those interested in actual works of art, relying on written sources has obvious limitations.[14]

Studying the visual arts of this time in France is therefore problematic. While considerable progress is being made, it remains a challenge for scholars to re-establish the activities and reputations of French artists working between *c.*1480 and *c.*1520 (the period covered here) and view them in broader

contexts, as Pélerin did. This chapter explains how the monarchy conditioned the position of the visual arts in France during this period and provided a focus for their development. Colin, Poyer and others on Pélerin's list enjoyed extensive royal patronage, and each consequently had a role to play in shaping and promoting the form of monarchy then emerging in France. Although their contribution to European art has long been viewed as merely tangential, Pélerin's testimony indicates that this was not always so.

2 Unity and devotion: Louis XI's legacy

Between 1480 and 1520 France saw a considerable transformation in the circumstances of artistic patronage. Following decades of conflict during the Hundred Years' War between France and England, the English were finally ejected from France (except for Calais) by 1456. The achievement of Louis XI (ruled 1461–83) was to maintain peace and successfully address problems of finance and administration. The monarchy's impoverishment was an embarrassment. After Louis's coronation the Duke of Burgundy upstaged the king in Paris, using the occasion as an opportunity to display

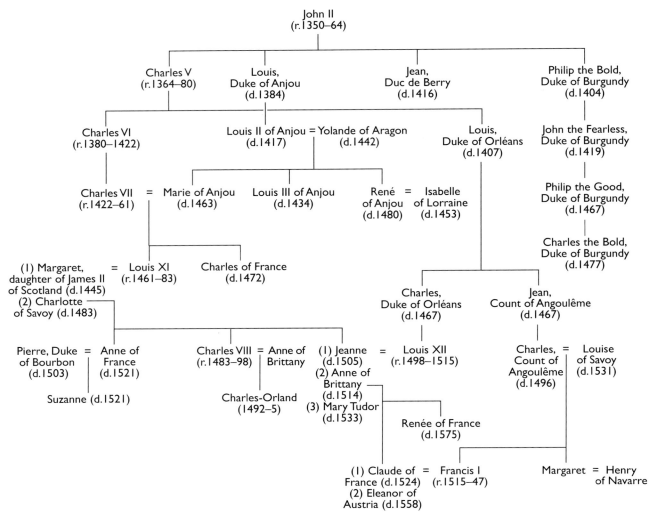

Plate 4.6 House of Valois family tree.

dazzling tapestries and examples of goldsmiths' work produced in the Burgundian Netherlands, purposefully flaunted before an astonished French audience.[15] Magnificence on this scale had not been seen in France since the days of Jean, Duc de Berry (d.1416). Furthermore, Paris had long lost the status it enjoyed at the start of the century as Europe's most refined centre for artistic production.[16] In restoring France to economic prosperity, Louis XI re-established conditions for dynamic patronage. By the reign of Francis I, who succeeded in 1515 (see Plate 4.6), it was the French court that now employed tactics of display and brilliance to impress foreign visitors and outshine rival courts.[17]

Royal authority was gradually reasserted through a process of unifying the fragmented kingdom that Louis inherited. Diplomacy regained several territories long governed independently. The most

important of these, French Burgundy and Picardy, were ruled until his death in 1477 by Charles the Bold, Duke of Burgundy. Several influential patrons previously loyal to the Burgundian administration – like Philippe Pot (d.1494), seneschal[18] of Burgundy – changed allegiance, effecting a more sumptuous style of patronage in France. The monument Pot commissioned c.1480 to his own memory (Plate 4.7), originally in the abbey at Cîteaux, is one of the grandest free-standing sculptural ensembles of the period and an example of an ambitious enterprise that French patrons had long failed to pursue. The sculptor is undocumented, but the monument has been reasonably attributed to Antoine le Moiturier (c.1425–after 1495), who previously worked at Dijon for the Duke of Burgundy.[19] Eight near-life-size hooded figures, each carrying a heraldic shield, bear on their shoulders a slab supporting

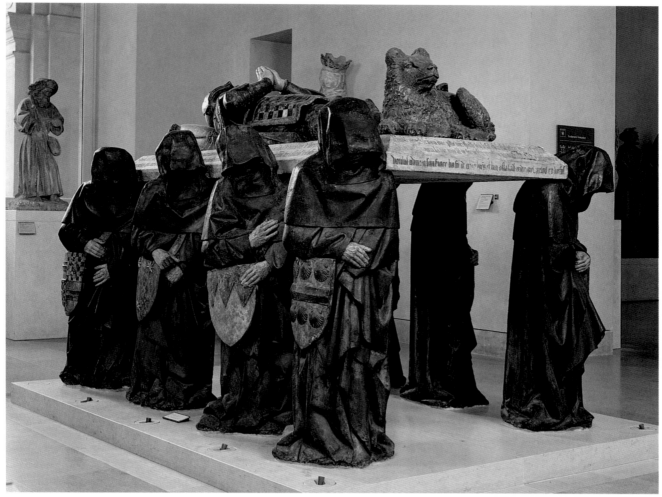

Plate 4.7 Attributed to Antoine le Moiturier, tomb of Philippe Pot from Cîteaux, *c.*1480, limestone with polychromy, 181 × 260 × 167 cm, Louvre, Paris. Photo: © RMN/rights reserved.

Pot's effigy, his hands clasped in prayer. The use of hooded figures, implying grief without describing it, and the notion of a funeral procession, lending the group a sense of momentum, connect the tomb with a tradition of sculpture based in Dijon, and in particular with the tombs of former Dukes of Burgundy, to which Le Moiturier contributed.[20] However, the concept of the figures carrying the bier and its monumental scale are a new departure, pointing the way forwards to still grander conceptions for funerary monuments in succeeding reigns.

The tomb that Louis XI commissioned for himself, in which he took an uncharacteristic interest, is possibly a reflection of the stimulus men like Pot provided, though one carefully crafted to meet Louis's particular needs. The king chose to be interred not at Saint-Denis, the traditional mausoleum of French kings, but in the pilgrimage church of Notre-Dame-de-Cléry, near Orléans, where he professed devotion to a miracle-working image of the Virgin Mary. Most of Louis's artistic patronage can be connected with his piety, and his tomb is no exception. But its form and materials show that he went out of his way to achieve a monument that distinguished him from his predecessors.

Louis first considered the matter in 1474, when two prominent artists were paid for making designs. While Fouquet supplied a working drawing, the sculptor Michel Colombe helpfully created a carved model of his proposal featuring the king's 'portrait and likeness'.[21] Neither design was approved by the king, who only revisited the issue in 1481, illness obliging him to delay no longer. A royal administrator, Jean Bourré, was charged with sending Louis's intentions to Colin d'Amiens, a rising star, requesting a new

design.[22] The monument itself was destroyed by French Protestants in 1562, but some idea of its effigy comes from a preliminary sketch illustrating the instructions Bourré sent to Colin (Plate 4.8). Below the figure of the king, someone – probably reflecting the king's opinion on the design – added comments correcting the form of the effigy: 'The nose aquiline. The hair longer behind. The collar slightly lower. …'[23] The effigy was not of the traditional recumbent type, as in Pot's tomb. Louis was shown instead kneeling in prayer, dressed like a hunter, a hunting horn on his back and a dog at his side.

Kneeling tomb effigies were rare and had never previously been used for monarchs, though this form of effigy was sometimes used for monuments to senior royal officials.[24] The king clearly wanted to make a contrast with earlier royal monuments. The kneeling format captured the deceased as though alive, which in 1481 was probably considered advantageous for effective commemoration. Since the statue was to face Cléry's miraculous image

Plate 4.8 Unknown artist, *Kneeling Portrait of Louis XI*, drawing sent to Colin d'Amiens by Jean Bourré illustrating detailed instructions for the effigy for the king's tomb, 1481, parchment manuscript, 28 × 20 cm, Bibliothèque nationale de France, Paris, MS fr. 20493, fol.5r. Photo: Bibliothèque nationale de France.

of the Virgin, it seems clear that Louis wished to associate himself unambiguously with devotion to her, the juxtaposition of image and effigy suggesting him petitioning the Virgin to intercede for him. Louis's intention was apparently to present himself to posterity by alluding to his two passions in life, hunting and devotion. The tomb was also unusual in France by being cast and engraved in bronze rather than sculpted in stone. This choice may have been influenced by a desire to compete with the lavish bronze tombs associated with the Dukes of Burgundy and also with the bronze tomb of Jean, Count of Dunois (d.1468), an illegitimate cousin of the king and one of the great heroes of the French during the English wars, which was likewise at Cléry.[25]

Apart from former Burgundian territories, the most significant regions Louis succeeded in regaining were Anjou and Provence. Their former ruler, René of Anjou (d.1480), was the most celebrated royal patron of his time, with the distinction of being a practising artist.[26] René's close involvement with the visual arts provided an incentive for later generations of the royal family to become more closely engaged in the creative aspects of visual culture, seeking new dimensions for patronage beyond the devotional. Among René's enthusiasms was the design of lavish tournaments, a subject on which he wrote a kind of guide, the *Traictié de la forme et devis d'ung tournoy* or *Treatise on the Form and Devising of a Tournament*. Several opulent illustrated manuscripts of this text survive, mostly dating from the last decades of the fifteenth century, a clear indication of the continuing impact René's highly developed sense of visual spectacle had on his royal and noble successors. The earliest of these, which provided a model for the illustrations in the others, is reasonably attributed to René's leading painter, Barthélemy d'Eyck (d. c.1470), another artist whose reputation was acknowledged by Pélerin.[27] René was also among the first patrons in France to commission portrait medals in the Italian style, a fashion that subsequently proved hugely popular in France. One of the artists René employed for this, Francesco Laurana (d. c.1500), also made a medal of Louis XI and, in the years around 1480, was responsible for probably the earliest structure on French soil employing classicising forms and decoration, the monument to Saint Lazare at the church of the Major in Marseilles.[28] Louis also employed another

of René's former artists praised by Pélerin, Copin Delf (d. *c.*1488), as his 'master painter'.[29]

Louis's preoccupation with restoring his kingdom meant that it was left to his heirs to instigate substantial artistic projects capable of reflecting the monarchy's renewed standing. Louis's instinct was for frugality, a consequence of the impoverished financial situation he inherited. Even at his favourite residence, Plessis-lès-Tours, where he spent increasing time in the contemplation of sacred objects brought to him with a view to improving his health, he opted for austerity, showing his preference for inexpensive wooden devotional images.[30] Although construction mixing brick and stone subsequently proved popular in royal buildings, Louis probably chose this combination of building materials for Plessis as much for economic as aesthetic reasons. In 1517 Antonio de Beatis, secretary to a visiting Italian cardinal, noted that Plessis was a 'palace of great renown, but in reality does not seem deserving of such praise'.[31] The interior was dominated by a series of painted scrolls with pious inscriptions reflecting on eternity, further evidence of Louis's obsessions with the hereafter and decorative simplicity.[32]

Only at the end of his life did Louis's devotions, and the patronage associated with them, transcend the conventional and make a lasting impact. In 1482 he arranged for a renowned holy man, the hermit Francis of Paola, to visit Plessis from Calabria. The founder of an order of Franciscan friars called the Minims (the least of the servants of God), Francis comforted the king in his last days, choosing to remain in France until the end of his own life, a source of pious inspiration for the whole royal family. When Francis died in 1507, Anne of Brittany, Queen of France (ruled 1491–8, 1499–1514), petitioned the pope to obtain his canonisation. The testimony of a painter, Jean Bourdichon (d.1521), at the ensuing inquiry bears witness to the air of religious fervour that infected the French court after Francis's arrival in France, which had major repercussions for the development of Bourdichon's art.[33] A pupil of Fouquet, Bourdichon was appointed 'king's painter' under Louis XI, for whom he painted those scrolls decorating Plessis. He remained a royal favourite for almost four decades.[34] According to his own evidence, Bourdichon took a death mask of Francis soon after death – a practice in France

generally reserved for monarchs and their wives – and a second mould to ensure the most accurate likeness when the saint's body was reburied in a more suitable grave a few days later. Although no original survives, Bourdichon painted several representations of Francis, clearly in connection with the saint's veneration. One portrait, for the Minims' church at Tours, was especially revered since it was painted on the board on which Francis died. De Beatis, who saw this painting in 1517, carefully noted that it was painted 'from life': 'He had a great white beard, was very thin and had a grave and most pious countenance, as may be partially appreciated from the print placed and fastened here.'[35] The print de Beatis sewed into his journal (Plate 4.9), presumably purchased at Plessis, was evidently modelled on the lost portrait. It shows how even sophisticated foreign visitors, in the right circumstances, could be susceptible to the simple standards of devotion advocated by Louis XI and moved by relatively crude images.

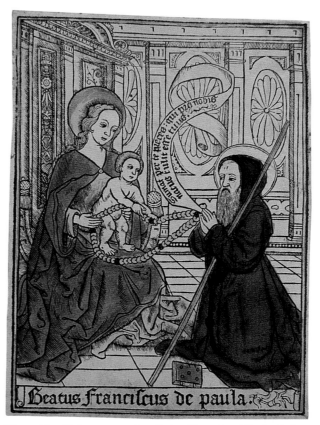

Plate 4.9 Unknown artist, *Saint Francis of Paola before the Virgin and Child*, print inserted in the travel journal of Antonio de Beatis, before 1517, Biblioteca nazionale Vittorio Emanuele III, Naples, MS.x.F.28, fol.75v. Photo: Massimo Velo.

The physiognomical accuracy Bourdichon went to such lengths to guarantee was evidently part of the effectiveness of these portraits. Bourdichon's abilities as a portrait painter were long appreciated, as commissions for a portrait of Francis I 'from life' and for several others ordered by the king in 1516 indicate. But it was as an illuminator that he was most admired. In 1507 an authorisation from Queen Anne of Brittany for payment to 'our dear and well-loved Jean Bourdichon' for a 'richly and sumptuously historiated and illuminated' 'large Book of Hours for our use' shows that the artist devoted four years to this book, for which he was owed the extraordinarily large sum of 600 crowns, though he actually received it only in 1517.[36] This lavish manuscript is the only work documented as Bourdichon's to survive. The distinctive approach to the decoration of this book, however, enables several royal commissions to Bourdichon to be

identified, including a Book of Hours for Louis XII datable to 1498.[37] The illuminations in the Hours of Anne of Brittany, in particular, reveal a style calculated to elicit a devotional response from its audience. The main miniatures, set in simple gold illusionistic frames, are conceived like small devotional panel paintings. Scenes such as *The Flight into Egypt* (Plate 4.10) make use of soft modelling, exaggerated colour schemes, and tender – almost insipid – facial expressions to encourage a spiritual frame of mind in the viewer.

Complementing the miniatures, Bourdichon devised a programme of decoration for text pages consisting of 337 depictions of individual plants, most with considerable botanical accuracy.[38] The borders of manuscripts illuminated in the Netherlands often featured naturalistic flowers. What distinguishes the series in Queen Anne's manuscript is that the plants all have identifying

Plate 4.10 Jean Bourdichon, *The Flight into Egypt* (with thistles in the margins of the folio opposite), from the Hours of Anne of Brittany, *c*.1503–7, parchment manuscript, each folio 30 × 20 cm, Bibliothèque nationale de France, Paris, MS lat. 9474, fols 76v–77. Photo: Bibliothèque nationale de France.

inscriptions in both Latin and French. Opposite *The Flight into Egypt*, for instance, he depicted a kind of thistle, labelled 'Species Cardo' and 'Chardons', enlivened by the addition of several insects (see Plate 4.10). The choice of naturalistic flora as decoration was possibly calculated to appeal to a queen interested in horticulture, and was imitated in later devotional manuscripts destined for members of her family. The labels betray a new scientific awareness of the classification of flora that stems in part from the old tradition of illustrated herbals.

One such text, the *Book of Simple Medicines*, written in the thirteenth century by Matthaeus Platearius, enjoyed a revival in French translation (as the *Livre des simples medicines*) during the later fifteenth century not so much for its dubious information on the medicinal uses of plants but

because its text lent itself to attractive illustrations, which enabled the species to be readily identified and their religious significance contemplated. An illuminated Platearius bearing the arms of a royal couple, Louise of Savoy and her husband Charles d'Angoulême (ruled 1467–96), parents of the future Francis I, shows this tradition at its most impressive.[39] The page depicting a gallica rose and Solomon's seal is turned into an eye-catching composition by the addition of a magnificent moth, identifiable as *Saturnia pyri*, a relative of the emperor moth (Plate 4.11). Both plants had associations with the Virgin Mary: 'Rose without thorns' is one of Mary's common designations, and Solomon's seal was also known as *Sigillum Sanctae Mariae* (seal of the Blessed Virgin), the name used on this page.[40] Although the precise significance of the moth remains unclear, its exceptional size and brilliance were presumably intended to complement the Marian references in the choice of plants.

The artist of this manuscript is identifiable as Robinet Testard, who by 1484 was working for Charles d'Angoulême in Cognac, the capital city of Charles's domain, and is last mentioned in accounts connected with Francis I in 1531. Like Bourdichon, Testard attracted extended loyalty from his patrons, notwithstanding his failure to keep abreast of the latest stylistic trends. Conceivably some respected knowledge of the visual arts and personal qualities endeared him to the family he served. A hint that this may have been the case comes from the Book of Hours he executed for Charles d'Angoulême in the early 1480s. Testard's approach to decorating this book intriguingly shows the artist saving time by basing his work on prints made in the Netherlands.[41] Sixteen engravings of the Passion by Israhel van Meckenem (*c.*1440/5–1503) were introduced into the manuscript, overpainted to make them appear like miniatures. Other compositions were derived from a large stock of engravings and woodcuts. Such derivations seem an unlikely qualification for guaranteeing appreciative clients, but his imaginative adaptations of the prints and their range point to a sense of humour and the eye of a collector.

The miniatures illustrating calendar pages for August and September (Plate 4.12) were inspired respectively by popular prints depicting *A Woman Pushed in a Wheelbarrow* by the so-called Master

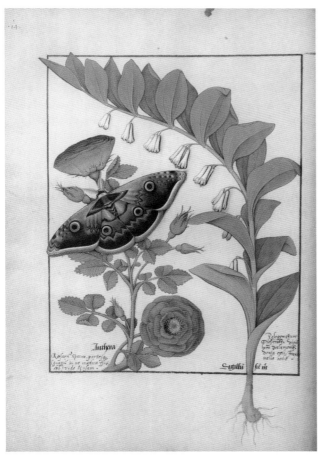

Plate 4.11 Attributed to Robinet Testard, *Rose (Anthera), Solomon's Seal (Sigillum Sanctae Mariae) and Moth (Saturnia pyri)*, from Matthaeus Platearius, *Book of Simple Medicines*, probably *c.*1487–96, parchment manuscript, folio 36 × 26 cm, St Petersburg, National Library of Russia, MS Fr.F.v.VI.1, fol.115v. Photo: National Library of Russia.

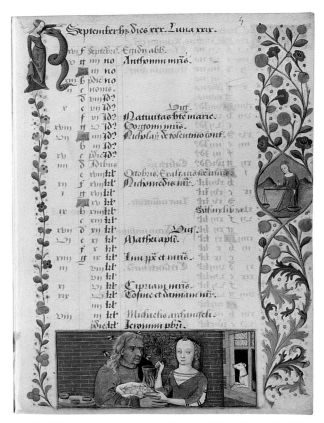

Plate 4.12 Robinet Testard, *A Woman Pushed in a Wheelbarrow* (with Virgo in margin) and *Unequal Couple* (with Libra in margin), calendar pages for August and September, from the Hours of Charles d'Angoulême, early 1480s, parchment manuscript, each folio 22 × 16 cm, Bibliothèque nationale de France, Paris, MS lat. 1173, fols 4v–5. Photo: Bibliothèque nationale de France.

bxg and an *Unequal Couple* by the Housebook Master, both originally dating from *c*.1475–80, though the Housebook Master's design had been used by other engravers. The latter features a coy young woman and a lecherous old man who embraces her, offering a bag of coins.[42] In Testard's adaptation of this second print, the money becomes instead a bag of fruits, and the woman now holds a vine branch. These changes allude to the time of year, wine-making being the customary activity represented in calendar cycles for September. But suggestively, Testard's old man holds an empty glass below the woman's vine. The flies around his head presumably draw attention to another kind of emptiness: his idle thoughts. Testard here subverts a moralising image by turning it into a joke. A traditional image associated with September, the zodiac sign of Libra, here personified in the right margin of the same page, serves to underline the imbalance in the couple through the balances she holds, her attribute. Perhaps the subject matter on this page was intended to amuse the manuscript's young patron, unmarried at the time

the manuscript was made. Since Testard did not use prints elsewhere in his oeuvre, the inspiration for adapting them may have come from his patron, who probably owned the prints in question and encouraged Testard to do something new with them. This inventive use of images, like the flowers in the Platearius, suggests a search for visual novelty, probably consciously responding to the limitations of Louis XI's patronage.

3 The *mode française* and the 'antique' style

The quest for novelty also extended to an appreciation of stylistic diversity. Around 1500, this is best illustrated through the recurrent juxtaposition in France of traditional French styles with those derived from classical antiquity, as this section will demonstrate.

After French forces occupied his kingdom in 1501, Frederick III, King of Naples (d.1504), was exiled to Tours, where he commissioned a Book of

Hours.[43] Bourdichon executed the miniatures, but the surrounding decoration is by Frederick's own illuminator, Giovanni Todeschino (active c.1487–c.1504), who accompanied his master to France. The collaboration resulted in an aesthetic strikingly different from manuscripts where Bourdichon was responsible for the entire effect, like the Hours of Anne of Brittany (Plate 4.10). On folio 198 of Frederick's prayer book, for example, Bourdichon painted the main miniature showing a *Descent from the Cross*, but Todeschino completed the remainder of the page (Plate 4.13). By painting an altar below Bourdichon's miniature and angels on either side of it holding back curtains to permit the readers of the book a privileged view of the image, Todeschino ingeniously contributed an illusionistic element to the decoration, whereby Bourdichon's picture becomes an altarpiece in a chapel. Here Italian artfulness seemingly pays tribute to a distinguished French artist. Todeschino includes a further illusionistic dimension by painting the scene as though it were viewed through a gap in the page. The ambiguity between the real and the invented was extended by painting a series of holes in the parchment, thereby confounding the viewer's sense of reality. Trompe-l'oeil effects are not uncommon in earlier French illumination, but Todeschino's virtuosity set a new standard.

Illusionism like Todeschino's is known to have been much admired in painters in classical antiquity. The kind of detailed naturalism that enabled viewers to identify species of plants, as in the Hours of Anne of Brittany, had also been held in high esteem. It seems likely that knowledge of ancient criteria for assessing what was desirable in painting was having an effect on choices in royal patronage by c.1500. The classical heritage also determined the choice of architectural and decorative elements in Todeschino's borders, which became popular in most of the visual arts in France during the last two decades of the fifteenth century. Since the forms involved – garlands, candelabra, sirens, putti and classicising architecture – were not readily to be seen on French soil, their availability to local artists stemmed either from foreign artists bringing them to France or from travelling to Italy, where the best survivals of ancient classical civilisation were to be found. Each of the three monarchs who succeeded Louis pursued dynastic claims to territories within the Italian peninsula. A sequence of invasions

(beginning in 1494) in turn resulted in parts of Italy at times falling under temporary French control. These occupations had cultural as well as political consequences. Many French patrons became receptive to aspects of Italian art, especially in the regions they occupied, promoting what they regarded as desirable about Italian visual culture in France.

The responses to Italy of Charles VIII (ruled 1483–98), the first French monarch to enter the peninsula in pursuit of French claims, and his companions suggest how overwhelming the experience might be for some French patrons.[44] Seeing the work of Donatello in Florence was especially overpowering. Abortive attempts to purchase this sculptor's *David* sparked a chain of events eventually culminating in a bronze *David* by Michelangelo reaching France in 1508. Commissioned by the Florentine authorities as a gift to the French General Pierre de Rohan but received by Florimond Robertet, royal treasurer, after Rohan's disgrace, the statue is now lost. In Rome, chroniclers recorded the king's fascination with monuments such as Hadrian's tomb. But seeing Naples made the greatest impact.[45] Capturing the city added lustre to the monarchy, as contemporary correspondence reveals. Poggio Reale, the royal residence outside Naples, was considered such 'a pleasure house' compared to Plessis that neither poet nor writer nor 'the brush of Fouquet could describe' it. The king wrote to his brother-in-law:

> you cannot believe what exquisite gardens there are in this city. So wonderful is their beauty that it seems, I assure you, as if only Adam and Eve were necessary to turn them into an earthly paradise … I have also found here some skilful painters, and will send some of them to you; they will also paint you the most beautiful ceilings. The ceilings … in France hardly compare in beauty and richness with ones here; so I shall engage some of these artists, and take them to work at Amboise.[46]

Charles arranged for vast quantities of booty to be sent from Naples to the château he was constructing for himself at Amboise, including stained glass, porphyry and marble for decorating the gardens, 130 tapestries, 172 carpets, and numerous other items.[47] He also persuaded several artists to make the same journey. Pacello da Mercogliano, a garden designer, was needed to recreate effects Charles had admired in Naples.[48]

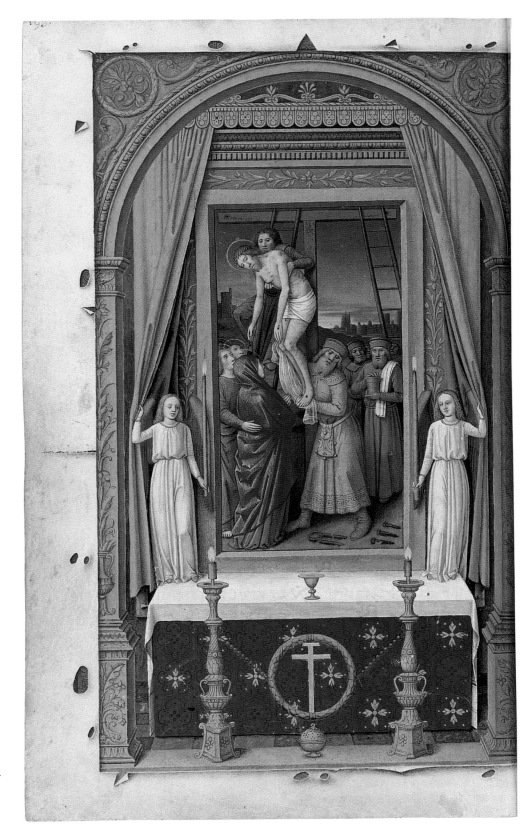

Plate 4.13 Jean Bourdichon and Giovanni Todeschino, *Descent from the Cross*, from the Hours of Frederick III, 1501–4, parchment manuscript, folio 25 × 15 cm, Bibliothèque nationale de France, Paris, MS lat. 10532, fol.198. Photo: Bibliothèque nationale de France.

The most famous artist attracted to France by Charles was Guido Mazzoni (?1450–1518), who received an exorbitant salary and a knighthood – unprecedented for an artist in France – as inducements to stay.[49] Today Mazzoni is best known for the uncompromising realism of his Italian sculpture, but the French records suggest he was most admired as a 'painter and illuminator', though few painterly projects have survived.[50] Notwithstanding the drawbacks of working in a foreign country, Mazzoni stayed in France until 1515, participating in numerous schemes, including the funerary chapel of Philippe de Commynes, the most distinguished chronicler of the period, fragments of which still exist (Louvre, Paris).[51] Even Anne of Brittany, who never set foot in Italy, was infected by her first husband's craze for things Italian. She learned how works by Italian artists whose reputations extended to France – like Lorenzo Costa (*c*.1460–1535) and Perugino – might be acquired through diplomatic haggling.[52]

Despite the enthusiasm for Italy and its artists, it would be misleading to infer from this that the French considered the achievement of Italy to be necessarily superior to that of France. It was a valid alternative. Responses to visual culture abroad were often conditioned by a French preoccupation with comparing their own culture to that of Italy – best documented in relation to literature, but also relevant to the visual arts – either to satisfy their patriotism or to draw attention to supposed deficiencies in French traditions which, once identified and overcome, would allow French creativity to surpass rival traditions. Even Italian artists drawn to France to work, like Mazzoni, found themselves compromising their working methods, either following local customs or collaborating with native artists. The tomb of Charles VIII, the major commission Mazzoni received in France (now destroyed), certainly did not conform to Italian conventions for funerary monuments. It followed a French model – the effigy of Charles evidently reflected the kneeling figure from his father's tomb.[53]

Bound up with these ambivalent attitudes to Italian art was the claim sometimes voiced that, as well as Italy, France also had a special relationship with the culture of classical antiquity. As early as 1408, a letter written by Nicolas de Clamanges (d.1437), one of a group of early French humanists,

advanced the notion of a 'rebirth of eloquence … long buried in France'. It reveals a desire to rival the standards of rhetoric practised in Italy, since France 'is hardly inferior to other regions in other achievements'.[54] These 'other achievements' are clarified later when Nicolas explains that eloquence, the classical art of letters he hopes to revive, reaches perfection in the same way as the visual arts: 'The arts generally originate with imperfect forms, but are improved gradually through use and expansion … The original inventor of the art of stone-carving sculpted in an archaic style, not with the same elegance of form as did Euphranor or Polyclitus.'[55] Nicolas's ideas concerning perfection in the arts and the association of the visual arts with rhetoric derive from readings of classical Latin authors, not from practical experience. But his argument indicates how well-informed French scholars were conscious of stylistic differences and, by analogy with literary arts, might choose to juxtapose them. On the one hand, there were styles in the visual arts rooted in traditional French culture (now labelled collectively 'Gothic'), which many in France considered French in origin and inspiration. These were potentially sources of national pride, especially in architecture, and thus required promotion. By the fifteenth century, French architects had developed a form of Gothic that largely depended for its effect on elaborate curving and twisting tracery forms resembling flames – hence the term 'flamboyant' to describe it.[56] Statues, sometimes with drapery forms echoing the tracery patterns, generally complement the architectural decoration of the flamboyant.

In its developed form, like the façade of Saint-Maclou at Rouen (Plate 4.14), the exuberant ornamentation forms a kind of mesh encasing the structure proper. Despite its expense, the monarchy favoured the ostentatious and intricate nature of flamboyant architecture and associated arts. The magnificence of this native style and its scope for elaboration particularly appealed to monarchs who valued spectacle and associated the well-being of the kingdom with it, such as Louis XII (ruled 1498–1515), whose taste for grandeur in civic ceremonial is well documented.[57] The monarchy found ways to encourage the construction of buildings of this type without having to fund them itself. Tax incentives were offered for individual projects across the realm; and indulgences were

Plate 4.14 Parish church of Saint-Maclou, Rouen, façade *c*.1500–14, tower after 1514 with nineteenth-century restorations, Conway Library, Courtauld Institute of Art Library, London. Photo: Wickham.

also sought, like that at Rouen allowing the devout to purchase an exemption during Lent for the consumption of dairy produce, which after 1487 funded the cathedral's impressive 'Butter Tower'. At Saint-Maclou the building accounts indicate that the architect was rather overenthusiastic about adding extra, unauthorised decorations to his church without considering the expense. When challenged for the increase in the height of the lantern tower (see Plate 4.14), he responded simply that it was 'for the sumptuousness and decoration of the church'.[58]

Accounts of architecture in France later in the sixteenth century show that the excesses of the flamboyant were understood as particularly attractive and were recognised as specifically French. In describing the complications and intricacies of late Gothic vaults, the architect Philibert de L'Orme (d.1570) noted that:

[They] were considered very beautiful, and one sees well-constructed ones employed in various places in the kingdom and especially in this city of Paris … Today [1568] those who have any knowledge at all of true architecture [classicising styles] do not follow this fashion of vaults, called by the workmen *la mode française* [in the French style]; nor in truth do I mean to despise them, but will rather confess that very good and difficult designs were planned and carried out.[59]

De L'Orme perhaps had in mind a vault like that in the chapel of the abbots of Cluny in the hôtel they built between 1485 and 1498 for use when visiting Paris, which is intricate and eye-catching (Plate 4.15).[60]

On the other side of the stylistic spectrum, artists had available to them features stemming from classical antiquity like those favoured by Fouquet and Todeschino. French patrons increasingly favoured the classicising mode. It was associated with perfection, as implied by Clamanges, and with virtues admired in the ancient world. It also suggested authority associated with the Roman Empire, a useful concept as the monarchs who succeeded Louis XI grappled with issues concerning their own authority in relation to their expansionist policies.

In France these two stylistic modes – the Gothic and the classicising – were increasingly used together. For example, accounts of the château built at Gaillon in the early sixteenth century by Cardinal d'Amboise, Louis XII's chief minister (1460–1510), distinguish between decorations in 'the modern manner' or 'in the French style [*à la mode française*]' (i.e. Gothic) and those 'in the ancient style' (i.e. classicising), sometimes (according to accounts) actually copied from antiquities.[61] Here both modes were equally desirable. The cardinal ensured that he employed experts trained in both traditions – working in Italy as well as in France – to ensure competence in all aspects of the decoration.

Only fragments of the château now survive.[62] However, descriptions by early visitors provide vivid indications of the combined magnificence achieved. Apart from the extensive tapestries and stained glass, everyone agreed that the most stunning aspects of the château were the expansive formal gardens with their range of fountains and topiary, outstripping what Charles VIII had achieved at Amboise. Something of this may be appreciated from the view of the grounds

Plate 4.15 View of vault of the chapel of the Hôtel de Cluny in Paris, probably between 1485 and 1498. Photo: akg-images/Joseph Martin, 2000.

by Androuet du Cerceau published in 1576 (Plate 4.16). Like Anne of Brittany, d'Amboise appreciated flora and its decorative uses. De Beatis, visiting Gaillon in the summer of 1518, was impressed by 'the royal arms and some *antique* lettering laid out most cunningly in a number of varieties of small plants'.[63] Inside the courtyard, he observed that 'the stone mouldings of windows and doors all have heads modelled after ancient marbles'.[64] Another Italian visitor, writing in 1510, noted that one of the façades of the main court was sculpted with reliefs depicting 'the Triumph of Caesar in the form that the famous Mantegna painted it'.[65] D'Amboise's interest in Mantegna is known from other sources.[66] However, using Mantegna's well-known series of *Triumphs*, then at Mantua (now at Hampton Court) but probably known through prints, as a source for creating a prominent sequence of sculptures in France – rather than other triumphal images – suggests a

particularly keen interest in the visual trappings of classical antiquity. Before these paintings, no artist had gone to such lengths to reconstruct the appearance of a Roman event by means of archaeological and literary investigation.[67]

While this was undoubtedly important for the cardinal, he made no attempt at Gaillon to match the standards of authenticity Mantegna set himself. As du Cerceau's view indicates, many of the architectural elements of the château, such as the upper windows, had conspicuous flamboyant decoration. The cardinal, it seems, actually went out of his way to juxtapose contrasting stylistic modes. In the chapel, for instance, there were paintings by the Lombard artist Andrea Solario (now lost) and an altarpiece commissioned from Michel Colombe (Louvre, Paris).[68] The surviving wood panelling from the chapel makes a still more striking contrast: one side is carved with flowing

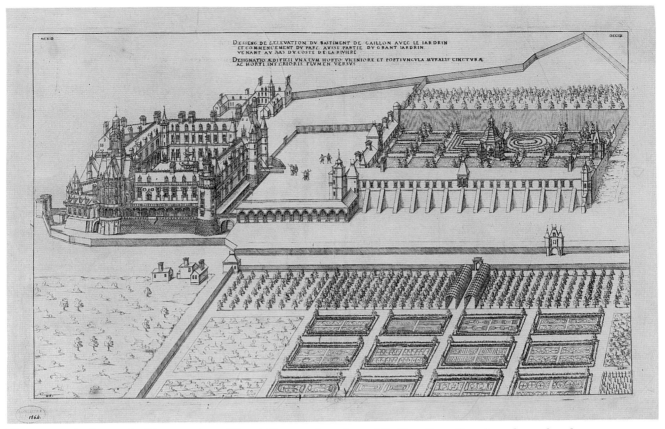

Plate 4.16 Androuet du Cerceau, view of the château and gardens of Gaillon, from *Premier volume des plus excellent bastiments de France*, Paris, 1576 (vol.I), engraving, 35 × 53 cm, Bibliothèque nationale de France, Paris, FRBNF30020375. Photo: Bibliothèque nationale de France.

tracery and statuettes, the other side with graceful classical foliage, putti and fabulous grotesques.[69] Early descriptions of Gaillon suggest that no one found anything incongruous about these contrasts. Even Italian visitors were charmed by what they saw. A Milanese visitor of about 1517 considered that for its size the château was 'the finest in France' and 'even in Italy there is nothing so fine'.[70] De Beatis, who was very well travelled, wrote that Gaillon is 'as fine and beautiful as any [palace] I have seen', and the visitor of 1510 thought there was 'such majesty and richness' that it would be hard to find anything 'more magnificent and superb' not only in France but throughout Europe.[71]

At Gaillon there is no sense from the early accounts that either the Gothic mode or the classicising was deemed superior to the other. Earlier clerics used to working in Rome such as Cardinal d'Estouteville (d.1483), d'Amboise's predecessor, had built up considerable expertise in commissioning works of art in Italy in classicising styles, but were equally comfortable ordering

structures in France in traditional French styles, as in the work d'Estouteville commissioned at Mont-Saint-Michel.[72] D'Amboise's achievement, which made a considerable impact throughout the realm – especially in royal building programmes like Blois, one of the favourite residences of Louis XII – was to bring the two modes together to create something entirely novel: distinctively French but receptive to new approaches. While some French patrons returned from Italy so overwhelmed by the experience that they only considered Italian artists for their monuments at home, most preferred to balance the classical and the Gothic, often encouraging elements of one to creep into the other.

Only later, as de L'Orme implies, did the classicising mode start to enjoy predominance with leading patrons. The parity shared by the two modes was still appreciated into the 1520s, however, in the series of paintings, or *puys*, commissioned by members of the confraternity of Our Lady in Amiens Cathedral.[73] Every year the confraternity's master devised a phrase (*palinod*)

Plate 4.17 Unknown artists, Amiens *puy* of 1518, oil on panel and carved wooden frame, 173 × 97 cm, Musèe de Picardie, Amiens. Photo: Hugo Maertens. *Puy* offered by Antoine Picquet in 1518 with the inscription: 'Au juste pois véritable balance' (At the right weight true balance [is found]).

in the Virgin's honour, from which competitors composed a poem. The winning verses, generally filled with thought-provoking sacred imagery, were used as the basis of a picture, each displayed annually as a votive offering. By the sixteenth century, these paintings were very elaborate indeed, featuring many portraits of confraternity members, their families and dignitaries. The example from 1518, probably by an émigré Antwerp painter, includes a portrait of Francis I and representations of a pope and an emperor within an intricate composition of symbolic images focusing on the depiction of a set of scales (Plate 4.17), which is very different from Testard's use of this motif (Plate 4.12).[74] The painting was furnished with a magnificent wooden frame decorated with an array of features and motifs, mostly classicising, including putti and Italianate grotesque ornament.[75] But the *puys* commissioned in succeeding years make much more conspicuous use of the alternative Gothic repertoire, despite originating in the same workshop.

4 The Bourbon court

Although Louis XI's conception of patronage reveals an outlook closer to a well-to-do merchant than a monarch, his successors recognised that, for the monarchy to benefit from his political successes, new approaches to the arts required cultivation. Charles VIII was too young to rule in his own right at his succession in 1483, aged 13. It was Charles's sister Anne of France (d.1521), together with her husband Pierre, Duke of Bourbon (d.1503), who initially rose to the challenge of Louis's legacy, first when they both played key roles in the governance of the country during Charles's minority, and later when they acted as regents for the kingdom during Charles VIII's invasion of Naples (1494–5). The patronage of Anne and Pierre shows the value they placed on the visual arts in promoting their personal concerns. In addition, during those periods when they represented the monarchy, both took advantage of their positions to promote understanding of the visual arts at court, especially with the young king and his prospective wives.

The capital of the Bourbon domain was Moulins in central France. During Anne and Pierre's greatest authority, when members of the nobility gravitated to Moulins, the city attracted not only court officials but also leading poets and artists. The foremost

painter to benefit from the patronage of the ducal couple and their circle, and whose work today best exemplifies this episode in French history, may be identified with the 'Jean Hey' who in 1494 signed a small panel painting depicting the scourged Christ, presented by Pontius Pilate to the Jews, a subject here labelled *Ecce Homo* (Behold the Man) (Musées Royaux, Brussels); it was made for Jean Cuillette, a royal official from Tours then in Moulins.[76] A significant corpus of portraits attributable to Hey survive, many of them fragments of larger devotional works associated with members of the Bourbon court.[77] The inscription on the *Ecce Homo* panel calls Hey 'Teutonicus', indicating that he was not himself French. Judging from his style and from features derived from paintings by Hugo van der Goes (d.1482), it seems clear that the putative Hey began his career in Ghent in the 1470s.[78] The only large-scale altarpiece attributable to Hey surviving intact, the sumptuous Moulins altarpiece (Plate 4.18), is a good example of Hugo's influence in its arrangement and in the spectacular effects of the central panel.[79] But Hey also adapted his style to French taste, turning to French models and developing a distinctive palette closer to Poyer than fifteenth-century painters from Ghent.[80] Decorative effects, such as details of costume or jewellery, are subordinated to clarity of form and simple, stylish elegance, which evidently appealed to Hey's ducal sponsors. His style is therefore distinguishable from most contemporary Netherlandish painting, which may have been unfashionable at court, perhaps because it was associated with the taste of merchants.[81]

Among the earliest surviving works attributable to Hey are a *Nativity* (Musée Rolin, Autun) painted for the elderly Cardinal Rolin (d.1483) and the portrait of another cardinal, Charles of Bourbon (d.1488), Pierre's brother. It was probably through Charles's intervention that the painter entered ducal service, remaining in Moulins until Pierre's death in 1503, when Hey probably moved to Paris. Pélerin, who includes Hey in his list of praiseworthy artists, probably came into contact with him during the Moulins period. One of the illustrations in Pélerin's treatise on perspective quotes part of the setting of an altarpiece Hey painted for Anne and Pierre c.1493 featuring portraits of the couple and their infant daughter Suzanne (b.1491), which survives in fragmentary form (Louvre, Paris). The wings of the Moulins

Plate 4.18 Attributed to Jean Hey, *Saint Peter Presenting Pierre, Duke of Bourbon, the Virgin and Child with Angels, Saint Anne presenting Anne of France, with Suzanne of Bourbon*, interior of the Moulins altarpiece, *c.*1498, oil on panel with original carved and gilded frames, *c.*159 × 267 cm, Moulins Cathedral. Photo: © Peter Willi – ARTOTHEK.

altarpiece include still more imposing portraits of Pierre, Anne and Suzanne, whose presumed age at the time it was painted – about seven – dates the altarpiece to *c.*1498. The iconography exemplifies Bourbon devotion to the Immaculate Conception, a dogma sanctioned by the Church in 1476, which refers to the miraculous conception of Mary in the womb of her elderly mother Anne. The doctrine helped to explain how Mary herself was born free of original sin. The choice of subject in part provided a devotional focus for the couple's desire for male offspring, since it suggests a parallel between Anne's predicament and that of Saint Anne.[82] The issue of succession was crucial to the royal family since French law prevented women from inheriting. Anne and Pierre confront the issue directly, commemorating themselves as confident, forceful individuals, their faith unswerving.

The surviving portraits of Suzanne show that she was painted from life at least twice, first when she was as young as two. Portraits taken from life of children this young are exceptional in the fifteenth century, since there was an understandable reluctance to involve sitters unlikely to keep still. The evidence in fifteenth-century Netherlandish altarpieces suggests that painters did not depict children from life until they reached the age of about 11, and although Habsburg patrons required naturalistic portraits of young children, the results are often contrived. Jean Hey, however, evidently had a talent for dealing with children, exploited by the Bourbons for dynastic and sentimental reasons. At an earlier stage in his career he depicted another child, Margaret of Austria, when she was betrothed to Charles VIII at the Bourbon court (Plate 4.19).[83] Margaret first came to France at the age of three as part of an agreement between the rulers of France and the Netherlands securing their borders. The portrait shows the princess, aged about nine, looking uncomfortable, perhaps a reflection of her actual circumstances. Charles repudiated her in 1491, favouring instead a more expedient marriage with Anne of Brittany at the end of that year. According to the writer Jean Lemaire de Belges and others, Margaret became proficient at drawing and painting during the period she spent in France – this pastime was probably deemed respectable for a young queen as a consequence of René of Anjou's artistic practices – and apparently continued into adulthood.[84] Margaret was probably taught these skills by Hey, the painter doubtless responsible for her portrait.

Plate 4.19 Attributed to Jean Hey, *Portrait of Margaret of Austria*, *c*.1490, oil on oak panel, 33 × 23 cm, Metropolitan Museum of Art, New York, Robert Lehman Collection, 1975 (1975.1.130). Photo: © 1981 The Metropolitan Museum of Art.

Anne of France probably instigated these activities. Her interest in the education of princesses is known through the manual on conduct she wrote for her own daughter, which touches on several visual interests.[85] The statue of her name saint commissioned for the ducal chapel at Chantelle, near Moulins, is a further token of Anne of France's educational enthusiasms: it represents Saint Anne teaching her daughter the Virgin Mary to read

(Plate 4.20).[86] The seriousness with which the duchess pursued this agenda influenced another of her charges, Anne of Brittany. Unusually for a fifteenth-century queen, Anne of Brittany commissioned a special prayer book for her personal use that doubled as a first devotional book, or primer, for the infant dauphin Charles-Orland (1492–5), probably in anticipation of helping the mother teach her son how to read; it

important the notion of the instruction of infants was for her, since it features an illumination showing Saint Anne's two other daughters witnessing the saint teaching the Virgin how to read, a subject that also appears in the primer for Charles-Orland. Anne of Brittany's commitment to the early education of children is further suggested by the primer she commissioned *c.*1505 for her daughter Claude (1499–1524), with miniatures attributable to Mazzoni of the queen and her daughter.[88]

Anne of France's understanding of how representations of the younger members of the royal family might play valuable roles in the well-being of the nation is further reflected in the portrait of Charles-Orland that Anne of Brittany arranged to be sent to her first husband Charles VIII in 1494, painted when staying with the Bourbons during the period of Charles VIII's Italian campaign (Plate 4.21).[89] This portrait, again attributable to Hey, is clearly a respectable likeness of the infant and was sent to show Charles what his heir looked like (presumably to encourage the king in his endeavours). In Italy this favourite possession was discovered in baggage containing Charles's most valuable artefacts abandoned after the battle of Fornovo.[90] As the inscription on the frame indicates, the child was only 26 months old at the time it was painted. As with portraits of Suzanne and Margaret, the one of Charles-Orland shows Hey evidently developing a rapport with a young sitter in order to achieve the desired results, something that, for this period, permits an unusual insight into a painter's temperament.

It seems likely that Hey, under instruction from Anne and Pierre, also developed a relationship with Charles VIII. In an illumination illustrating a copy of the statutes of the royal order of Saint Michael (founded by Louis XI in 1469) made in 1494, Hey portrayed Charles VIII.[91] Despite its diminutive scale, this is among the most credible surviving portraits of Charles. The manuscript was commissioned as a gift to the king by Pierre, whose portrait was included immediately behind that of Charles. This arrangement was an astute means of reminding the young monarch of his brother-in-law's support during the invasion of Naples.

Hey's success relied chiefly on his ability to portray his sitters with striking naturalism. This was observed by Jean Lemaire de Belges. In a poem entitled *La plainte du désiré* commemorating the

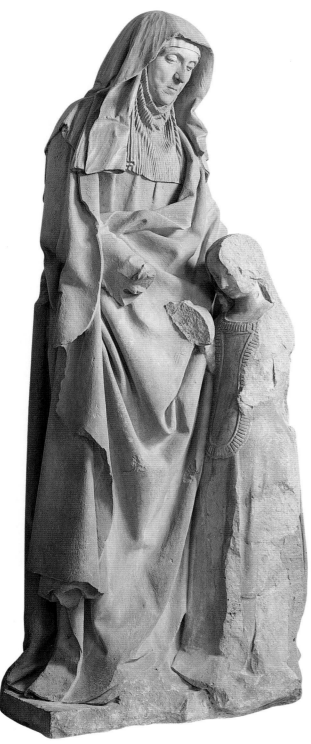

Plate 4.20 Jean Guilhomet, called Jean de Chartres, *Saint Anne Teaching the Virgin to Read*, *c.*1500–3, limestone with polychromy, 192 × 78 × 49 cm, Louvre, Paris. Photo: © RMN/Hervé Lewandowski.

was profusely illuminated by Poyer.[87] The Book of Hours that Anne of Brittany commissioned from Jean Bourdichon (see Plate 4.10) also indicates how

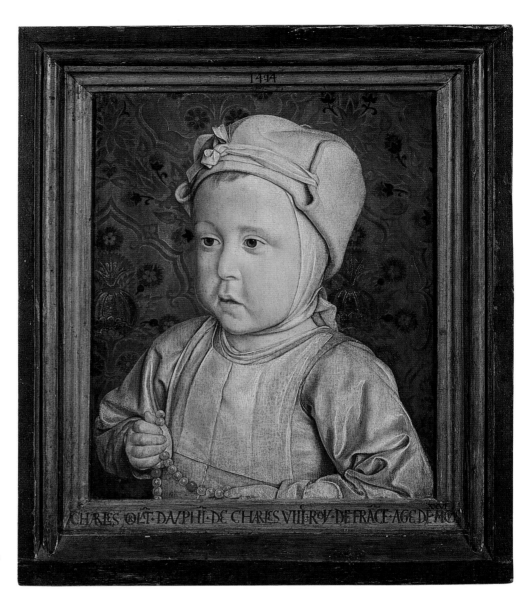

Plate 4.21 Attributed to Jean Hey, *Portrait of the Dauphin Charles-Orland*, with original inscribed frame, 1494, oil on panel, 28 × 23 cm, Louvre, Paris. Photo: © RMN/Michèle Bellot/Jean Schormans.

death in 1503 of Louis of Luxembourg, composed in the form of a debate between Painting and Rhetoric on which of them is best suited to honour Louis, Lemaire records the outstanding painters of the age.[92] Hey appears immediately before the French artist Jean Perréal, who, like Hey, is particularly associated with naturalism. Here the imitation of nature provides a standard by which to assess the most outstanding artists. Lemaire himself was a significant figure in French visual culture of the early sixteenth century, not as a practitioner (though he claimed practical experience) but as a writer consumed with the entire 'artistic scene'. His unprecedented personification of Painting invested the pictorial arts with a respectability previously reserved for the literary arts. Lemaire

was particularly fascinated by artistic techniques and provides a unique description of a painter's workshop in a second poem, the *Couronne Margaritique*.[93] Furthermore, he was among the first in France to develop 'antiquarian' interests, travelling to follow up leads on information about artists in order to record what might otherwise be lost.[94] Much of his poetry, like the lament composed for Pierre of Bourbon (*Le Temple d'Honneur et de Vertus*, 1503), is suffused with pictorial details, going well beyond the poetic conventions of his day and revealing sound artistic expertise.[95]

Apart from Lemaire, who began in Bourbon employment as a finance clerk and rose to become official poet and royal historiographer

to Anne of Brittany, Anne and Pierre shrewdly advanced other officials capable of providing an intellectual basis for appreciating arts necessary for establishing the worth of a court. One family in particular, the Robertets, supplied two generations of ducal officials, distinguishing themselves through their writings and patronage. Jean Robertet (d.1503), a patron of Fouquet and first secretary of the royal order of Saint Michael, is among the earliest French poets to treat painting as a subject of interest in its own right.[96] In verses entitled 'On a bad painting, made with poor colours, by the worst painter in the world', Jean mocks a 'masterpiece' by setting it alongside works by two well-known foreign painters, Rogier van der Weyden and Perugino, and by unnamed painters of René of Anjou – he probably had Barthélemy d'Eyck and Copin Delf in mind.[97] Jean's 'masterpiece' is in fact a work that passes itself off as competent but to perceptive eyes appears execrable, the efforts of someone trained but devoid of talent. The irony partly depends on the changing meaning of the term 'masterpiece'. Until the period when Robertet was writing, 'masterpiece' might denote a special work executed to demonstrate a young artist's grasp of the skills necessary to practise his art. Jean, however, implies something closer to the modern understanding of the term: a never-to-be-repeated achievement by a unique talent. Jean's Bourbon audience fancied they could recognise a masterpiece in this sense when they saw one.

Jean also encouraged more critical viewing habits by writing a guide to colour symbolism and devising iconographic programmes, mostly reconciling Christian and classical traditions. He wrote an adaptation of Petrarch's *Triumphs*, introducing to France the theme of man's immortality due to virtuous living, and another guide describing the twelve sibyls, pagan equivalents of the prophets who foretold the coming of Christ.[98] Both texts were inspired by Italian sources, but Robertet's versions popularised their themes in France. According to one early source, the Petrarch adaptation was intended specifically as a programme for painting or tapestry.[99] This is probably also true of the sibyls, who appear in many forms in the later fifteenth century. One of the most substantial prayer books illuminated

during this time, the Hours of Louis de Laval, executed partly by Jean Colombe (Michel's brother), includes them (Plate 4.22).[100] Colombe was the preferred illuminator of Queen Charlotte of Savoy, who recommended him to her brother and to her daughter Anne of France. Anne's enthusiasm was such that Louis bequeathed his Book of Hours to her.

Robertet's writings appear with illustrations in an impressive manuscript containing several other illustrated texts, partly written by his son François. This compendium, compiled over a prolonged period, provides a rare opportunity to view the emergence of new iconographic themes.[101] Among the earliest texts represented in the volume is a series of poems by the Moulins poet Henri Baude (d. after 1496), apparently conceived as commentaries on a set of tapestries.[102] In their illustrated form these respond to the desire at court for new iconographic themes, challenging the intellectual powers of viewers and giving visual expression to poetic themes for amusement and edification. The scene on folio 46 (Plate 4.23), for example, depicting two courtiers watching flies in a spider's web, can be understood as an allegory of injustice. Perhaps the nickname 'universal spider' given to the manipulative Louis XI inspired Baude's image.[103] Testard, as we have seen, also used flies to underline social issues (Plate 4.12). French court artists were evidently encouraged to develop themes highlighting social concerns, using imagery drawn from proverbs.[104] Interestingly the technique of the illustrations in this manuscript – refined pen drawings with wash – was apparently devised to match the new iconography. By the reign of Francis I, books of drawings, especially of portraits, had become popular at court.[105] Indeed, the present volume reflects this, its latest additions being copies of portrait medals, including one of Francis I.[106]

François Robertet is identifiable as the artist of some of these drawings. But in ducal service François's main responsibility was caring for Pierre of Bourbon's books. As was customary, he noted details of provenance. Occasionally he went further by supplying attributions, an indication that distinguishing artistic hands and recording this for posterity – a new preoccupation – was expected

Plate 4.22 Jean Colombe, *Cumean Sibyl*, from the Hours of Louis de Laval, c.1480–5, parchment manuscript, folio 25 × 17 cm, Bibliothèque nationale de France, Paris, MS lat. 920, fol.20v. Photo: Bibliothèque nationale de France.

of him. In a manuscript of Josephus' *Jewish Antiquities* begun in the 1410s for Jean, Duc de Berry but completed later for Jacques d'Armagnac, Duke of Nemours (d.1477), François observed that the first three miniatures in the volume were by '*the* illuminator of the Duc de Berry' and the nine others 'by the hand of Jean Fouquet'.[107] Pierre acquired this volume from d'Armagnac

after the latter was arrested for plotting against the Crown. It was evidently d'Armagnac, one of the great bibliophiles of the fifteenth century, who commissioned the miniatures Robertet attributed to Fouquet. One other leading illuminator who worked for d'Armagnac, Évrard d'Espinques (d.1494), was also taken up by Pierre.[108]

Plate 4.23 Unknown artist, *Un homme de court (A Courtier)*, poem XIV from Henri Baude's *Dictz moraulx pour faire tapisserie*, part of a compendium of poetic texts (*Recueil Robertet*) illustrated by pen drawings with wash, *c*.1495?, 30 × 22 cm, Bibliothèque nationale de France, Paris, MS fr. 24461, fol.46. Photo: Bibliothèque nationale de France.

5 'By command of the king'

This section explores the often fragmentary evidence showing how the monarchy built on the example set by the Bourbons in making use of the visual arts to project its own interests and enhance the prestige of the nation. Starting with Charles VIII, each king became increasingly confident in dealing with talented artists, coaxing the best out of them and creating appropriate conditions for artistic activity and innovation to flourish.

The prestige involved in collecting books illuminated by exceptional artists has already been mentioned. Under Charles VIII this interest extended to artists of the early fifteenth century, apparently regarded as a golden age of illumination, as Robertet's inscription in d'Armagnac's *Jewish Antiquities* implies. The

young Charles VIII certainly valued illuminated books of this period. The Duc de Berry's *Grandes Heures*, completed in 1409 by one of his leading artists, Jacquemart de Hesdin, appears four times in royal accounts of 1488 in connection with its rebinding, a sure sign that the king was looking at it.[109] The impetus to collect was such that soon whole libraries of illuminated books were sought in order to enhance the credentials of patrons connected with the Crown. The library of Frederick III was purchased by Cardinal d'Amboise and displayed at Gaillon, where it impressed de Beatis. Louis XII augmented his library by adding to it those of the former Dukes of Milan and Louis de Bruges, both exceptionally rich in illuminated treasures.[110] Viewing this was a highlight of de Beatis's visit to Blois in 1517.

With the period of the invasions of Italy (starting in 1494), political considerations reinforced the monarchy's seizure of whole collections. The scale of accumulation extended to items other than books, and particularly to objects capable of being seen by wider audiences. The scale of collections Charles VIII sent home from Italy has already been mentioned. This was emulated by his successor, Louis XII. For example, in 1499, having defeated Lombardy, Louis ordered a spectacular collection of portraits of bigwigs at the Milanese court to be sent to his wife Anne of Brittany in France. Louis perhaps valued these as much for their dynastic significance as for their aesthetic merit, though his artistic discrimination was certainly well developed. For Louis, however, the overriding issue in such acts of appropriation was probably the notion that significant accumulation of treasures had the power to express the Crown's extended authority. New territories brought under French control, like Lombardy, needed to be represented in royal collections as demonstrations to French audiences why foreign conquest was in France's interests. A further reflection of these aims may be seen in the numerous inventories drawn up in order to record the extent of accumulation. Since little survives, these inventories are important sources of information for modern art historians. The series of portraits Louis sent from Milan, for instance, is known today from an inventory compiled for Queen Anne in 1500, when the collection was displayed at Amboise. This is one of numerous royal inventories, evidence of how by the turn of the sixteenth century the scale of collecting matched the aspirations of a newly assertive monarchy. The inventories often indicate

how uncertainty existed between acquisitions of dynastic or devotional significance and those of artistic value.[111] The Milanese portraits joined a collection of 'têtes de Napples' that Charles VIII sent Anne from Naples.[112] In presenting these particularly to his wife, Louis was perhaps pandering to an interest in personalities known but never seen, an issue that preoccupied the queen, as we know from the portrait of Charles-Orland (Plate 4.21).

By the 1490s Paris had assumed the lead in France in the production of illustrated printed books. The royal family quickly recognised possibilities in this for them in terms of collecting illustrated books and in advancing the interests of the monarchy. Charles d'Angoulême, whose interest in printing has already been mentioned, was supplied by Antoine Vérard, the foremost publisher of illustrated books of the period.[113] Many of Vérard's productions were presented to members of the royal family in specially decorated volumes, perhaps as a means of ensuring their support for this new art form. A poem on the Passion of Christ illustrated with 12 engravings by Israhel van Meckenem, for instance, was probably presented to Charles's wife, Louise of Savoy.[114] In the prologue, Vérard explains why illustrations are so important to books, arguing that *signes* – pictures – are more successful than words in stirring the reader. Few understood this point of view better than Vérard's most notable client, Charles VIII. The king probably instigated some of Vérard's productions, including the printed *Grandes Heures Royales* in an edition containing devotions by the king's former tutor, the renowned scholar Guillaume Tardif.[115] This was an exceptionally large book. Charles VIII is likely to have understood the propaganda value for the monarchy in associating himself with a big Book of Hours – most were relatively small – from his formative experience (as mentioned earlier) of admiring the Duc de Berry's *Grandes Heures*, hitherto the largest prayer book produced in France, but only seen by limited audiences usually restricted to the king's immediate family. Vérard's productions, however, as Charles VIII recognised, were for broader dissemination, with the potential to reflect a positive and splendid view of monarchy. The *Grandes Heures Royales* opens with an introductory text explaining that it was begun 'by command of the king', and numerous marginal and special illustrations accompany Tardif's texts. Here, therefore, we have evidence of the monarch sponsoring a new iconographic programme for

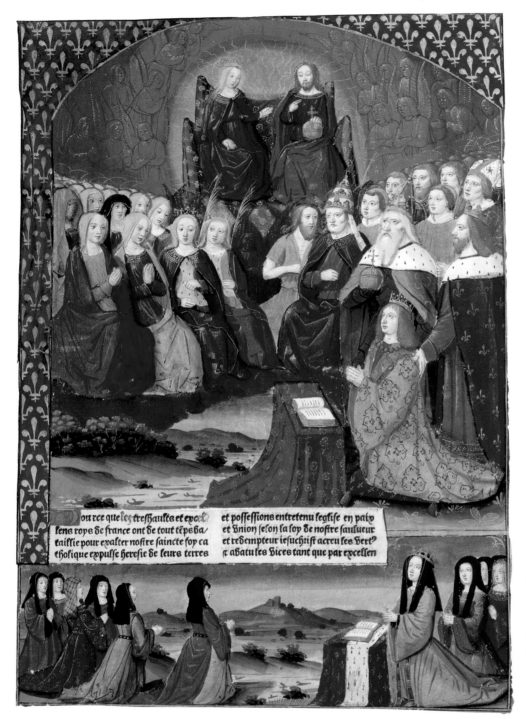

ou rce que les trefhaultss et epcol
lens rope de france ont de tout tépsba
taiffie pour epalter noftre faincte fop ca
tholique eppulfe herefie de feurs terres

et poffeffions entretenu feglife en paip
et bnion felon fa fop de noftre faulueur
et redempteur iefuchrift acreu fes bert?
e abatu les bices tant que par epcellen

Plate 4.24 Master of the Chronique Scandaleuse, *All Saints with Charles VIII Presented by Charlemagne and Saint Louis, with Queen Anne of Brittany and her Ladies Below*, 1493, printing and illumination on vellum, 35 × 24 cm, Bibliothèque nationale de France, Paris, Vélins 689, frontispiece. Photo: Bibliothèque nationale de France.

religious edification and placing it in the public domain. Unlike illuminated manuscripts, printed books were enjoyed by an increasing proportion of society. For books with royal associations, this was exactly what the king wanted.

In copies of other volumes specially prepared for presentation to Charles VIII, Vérard employed another leading Parisian illuminator, the Master of Jacques de Besançon.[116] It remained the expectation that privileged patrons, like the

king, would prefer the exclusive appearance of illuminated manuscripts to relatively inexpensive printed books, so the printed pictures were skilfully overpainted. Perhaps because many of its productions were destined for the king, the Master of Jacques de Besançon workshop, which created one of Charles's many Books of Hours, helped to develop a new view of monarchy.[117] In one miniature commissioned by Vérard from a contemporary Parisian artist (Plate 4.24), Charles

VIII is depicted in prayer, presented in heaven by Saint Louis and Charlemagne, the first Christian Roman emperor, who had long been associated with the French monarchy, while the queen and her ladies say their devotions below. Here the association with Charlemagne, who wears an emperor's crown, implies an imperial dimension to the monarchy. Such connections became increasingly important as French monarchs pursued their expansionist policies. The Sun of Justice (*Sol Iustitiae*), an emblem associated with another emperor, Constantine I the Great, was likewise adopted by Charles to bolster imperial pretensions.[118] Documentation shows that it was added to tapestries depicting the Trojan Wars displayed at Amboise. Part of this set of tapestries featuring the Sun of Justice, or another related set for Charles VIII, is still extant (Victoria and Albert Museum, London).[119] The original designs for these tapestries, which were reworked several times to satisfy the demands of various royal patrons across Europe, have been reasonably attributed to Colin d'Amiens, probably commissioned by an earlier royal patron.[120] But in adding the sun motif to his tapestries, Charles gave the story a topical twist, associating it with aspirations in Naples. Contemporary audiences would have recognised this. The Trojan Wars had long been understood in France as relevant to the development of the monarchy. Parts of the story were found useful as

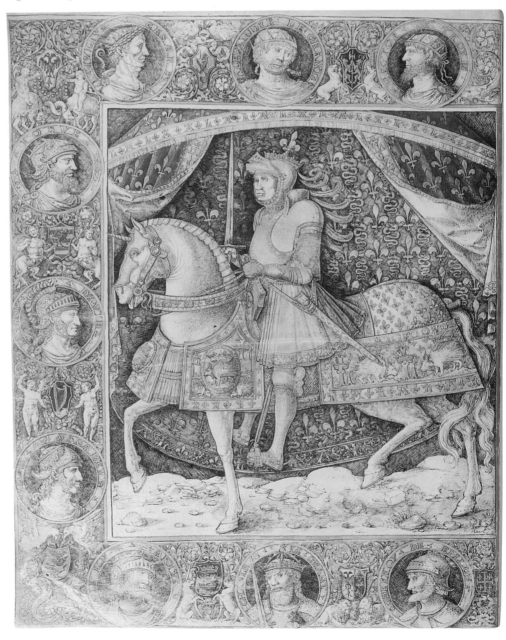

Plate 4.25 Master of the Rochechouart Monstrelet, *Louis XII on Horseback, with the Nine Worthies*, 1510, pen drawing with wash and some colour, 37 × 29 cm, Bibliothèque nationale de France, Paris, MS fr. 20360, fol.1v. Photo: Bibliothèque nationale de France.

models for events, as when Dunois used the Trojan horse strategy to capture Chartres during the wars with England.[121]

Following Charles VIII's premature death in 1498, the glorification of personal kingship by means of association continued under Louis XII. It appears at its most fundamental in manuscripts of French chronicles executed in 1510 for the French governor of Genoa. Although written in Italy, these were illustrated by an unidentified Netherlandish artist working in dazzling monochrome, colour applied only for heraldic detail.[122] Two volumes have large frontispieces depicting Louis, showing some respect for his physiognomy. Although these are unique

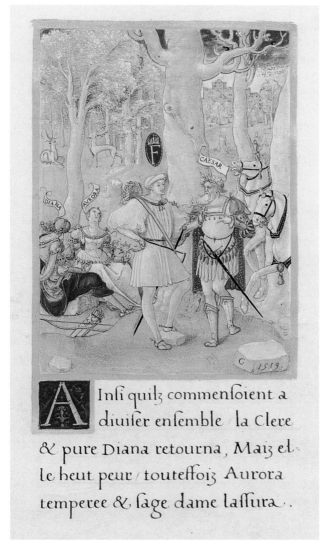

Plate 4.26 Godefroy le Batave, *Francis I with Julius Caesar in front of Diana and Aurora, in the Forest of Fontainbleau*, from *Commentaries on the Gallic Wars*, vol.2, 1519, parchment manuscript, folio 27 × 13 cm, Bibliothèque nationale de France, Paris, MS fr. 13429, fol.4v. Photo: Bibliothèque nationale de France.

portrayals of the monarch in a medium intended for viewing by privileged audiences, it seems likely that the essential iconographic elements were originally conceived for the larger audiences of monumental schemes, perhaps sculptural, in which form they would have made a valuable contribution to royal propaganda. The first frontispiece (Plate 4.25) shows Louis fully armed on horseback. The image is strewn with royal and personal devices, like the porcupine, used by Louis's immediate forebears as the ducal badge of the house of Orléans. This impressive representation of the king responds to a predilection for full-scale equestrian portraits decorating French châteaux around 1500, including Louis's own statue on horseback above the entrance to his château at Blois, probably designed by Mazzoni (now known only from a reconstruction). What distinguishes the miniature depicting Louis XII, however, is that the artist decorated the margin with classicising medallions of the famous Nine Worthies, a familiar subject in French art featuring popular heroes drawn from the Old Testament as well as classical and medieval sources, here used to imply that Louis, conqueror of northern Italy, is fit to enter their company – a tenth worthy.[123] In the second frontispiece, Louis appears enthroned, this time surrounded by medallions of nine illustrious Roman emperors. Again, by association, the artist implies an imperial status for the king who appears as the latest in a long illustrious lineage. In this manuscript Louis is presented in two complementary guises: one responds to traditional French values, *la mode française*; the second asserts a new order based on the authority of antiquity. Both approaches seem equally valid.

By the reign of Francis I, the second of these approaches was found to have the greater potential for dignifying the monarchy. Returning to France after Marignano, at which the king won a decisive victory over Italian adversaries, Francis became a kind of national hero in whom aspirations were fulfilled in the classical sense, in that he reminded his people of the greatest victories of the more successful generals of antiquity, like Alexander the Great and Julius Caesar, rather than as a medieval worthy, which embodied notions of prowess rather than triumph. In a set of volumes concerning Julius Caesar's Gallic Wars, the illuminator Godefroy le Batave (active in France *c*.1515–*c*.1526) created imaginary scenes of Caesar and Francis discussing their military tactics (Plate 4.26).[124]

Notwithstanding their diminutive scale, Francis is easily recognisable since the artist used the king's actual features throughout, whatever the situation – a distinctly new kind of portraiture. The association between a contemporary monarch and one of the greatest generals of antiquity is unambiguous. A second artist, identifiable as Jean Clouet, extended this parallel by decorating the volumes with portraits of French generals credited with Marignano's success. When the manuscript was originally made, these portraits were not labelled; their identities can be established by comparing the portraits with drawings of the same sitters, by the same artist, inscribed with their names. In the Caesar manuscript, however, these contemporary figures were actually given the names of celebrated Roman generals. The achievement of the present was here understood in terms of triumphs of the past. Although manuscripts like these were seen by relatively small numbers of viewers, the concepts associated with them probably reached larger audiences through Clouet's portraits of the same figures on panel, on which his subsequent reputation depended. Some of these were copied. Such portraits were probably displayed in chambers conceived to impress viewers.

6 Conclusion: 'an air of greatness'

The kind of association used by Clouet worked well because those represented were youthful and handsome. The young king in particular was praised for his looks and courtesy; there was, according to the Italian writer on courtly manners Baldassare Castiglione, 'an air of greatness about him'.[125] Although this impression derived from Francis I's personal appearance, it infected all kinds of perceptions about his standing and patronage. The contrast with his predecessors was conspicuous. Aversion to Charles VIII's ugliness – hooked nose and short stature (see Plate 4.24) – was offered as one explanation for his failures in Italy.[126] Although Louis XII's appearance was the first of a French monarch to become well known through coins, medals and other images, it unquestionably compared unfavourably with Francis's (see Plate 4.25). Early in his reign there is evidence that ordinary people recognised Francis, such was the dissemination of his likeness (in medals and drawings) and the renown of his

appearance, which helped him assert his authority. There is, for example, a good likeness of Francis in the Amiens *puy* of 1518 (Plate 4.17). Even the elderly Jean Bourdichon contributed to this dissemination.

The painter before Clouet who in France contributed most to the development of portraiture as a genre in its own right – in contrast to portraiture in the context of devotional works – was Jean Perréal (also known as Jean de Paris), 'king's painter' to three monarchs. Unlike Hey and Bourdichon, Perréal's standing as a portrait painter did not rest simply on his ability to capture a likeness. Commentators noted Perréal's skill in conveying something more transient – the sitter's beauty. This singular ability furthered the rise of a cult of good-looking appearance that culminated early in Francis I's reign. For example, an episode recorded by Francis I's sister, Margaret of Navarre, describes how Perréal was once sent to Germany to capture the looks of a singularly attractive woman.[127] In 1507 Louis XII, then in Italy, refers to this quality in Perréal's work, requesting that some of the painter's portraits be sent to him 'to show the ladies, for there is nothing [here in Italy] that can equal them', notwithstanding the existence of numerous portrait painters in Italy, as Louis certainly knew.[128] Since Perréal's career extended long into the reign of Francis I, he presumably continued working in the genre. Several portraits have been identified as Perréal's on the basis of a signed miniature representing an alchemist listening to Nature, who berates him for pursuing his art by false means (Plate 4.27). This painting was originally the frontispiece to a verse treatise on alchemy, the prologue to which reveals Perréal's name through an acrostic signature.[129] Although royalty is poorly represented in these surviving portraits, the elusive quality so admired is hinted at in the finest examples, like two panels representing a member of the Paris Parlement (Plate 4.28) and his wife painted in the 1490s.[130]

A form of portraiture that drew attention to the distinctive beauty of his court was naturally only one aspect of the more refined patronage promoted by Francis. Having established a glorious reputation at the outset of his reign, Francis needed to ensure that the scale of his sponsorship of the visual arts matched the 'greatness' recognised in him. His achievement at Marignano encouraged a desire in him to surround himself

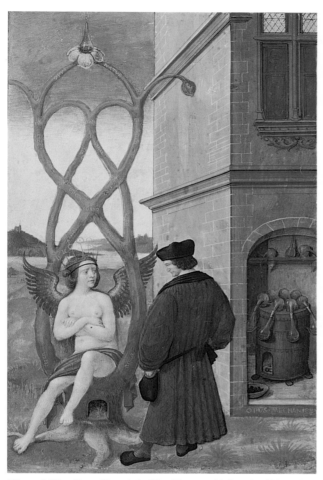

Plate 4.27 Jean Perréal, *The Errant Alchemist Listening to Nature*, c.1515, parchment manuscript, folio 18 × 13 cm, Musée Marmottan, Paris, Collection Wilderstein, inventory no. M6188. Photo: Musée Marmottan, Paris, France/Bridgeman Art Library, London.

Plate 4.28 Attributed to Jean Perréal, *Portrait of a Man*, c.1495?, oil on panel, 24 × 18 cm, Louvre, Paris. Photo: © RMN/Daniel Arnaudet.

with the best, developing a court rivalling anything in Europe in splendour. An important step in this direction was achieved in 1516 when he persuaded Leonardo da Vinci (already friendly with Perréal) that his future lay in France, where Leonardo spent the remainder of his life.

As early as 1507 Louis XII referred to 'our well-loved Leonard da Vincy, our painter and engineer', though exactly what Leonardo – then the most celebrated artist in Europe – achieved for Louis remains unclear.[131] 'Small paintings of Our Lady and others' were requested, but the only French patron to receive a picture from Leonardo in Louis's lifetime was his treasurer, Florimond Robertet (François's brother).[132] Already in 1501 Leonardo was reported to have been working on a painting for Robertet, the *Madonna of the Yarnwinder*.[133] Robertet's success is not surprising

since his correspondence shows him to have been a singularly determined collector, and as we have seen, it was he who secured Michelangelo's bronze *David* after the disgrace of Maréchal Rohan. Louis understood what made Leonardo special, but he had no way of turning this to the advantage of the monarchy. On viewing Leonardo's *Last Supper*, he is reported to have wanted it transported to France, a totally impractical objective. It was Francis I, who also stood in awe of the *Last Supper*, who found a solution by inviting the artist to France.

By the time Leonardo settled at Amboise, he was too infirm to paint, as de Beatis reported after visiting the artist in 1517. However, Leonardo brought with him many paintings, several of which Francis purchased in 1518, the foundation of a new royal collection.[134] So although there were limitations on what Leonardo could practically achieve for the king, his very presence in France was itself a tremendous achievement, a myth-making episode that helped to raise the monarchy's profile. Later generations considered this the moment when painting in France really began. Leonardo's importance to the French can be seen

Plate 4.29 Jean Poyer, *The Meal in the House of Simon the Pharisee*, central section from an altarpiece from Nozeroy, 1500–2, oil on panel, Conseil général du Jura, Lons-le-Saunier. Photo: Conseil général du Jura, Lons-le-Saunier.

in the way they responded to the *Last Supper*, for while the original could never cross the Alps, its composition, in various derivations, was often imitated in several media, notably for patrons close to the king. Among the earliest and most imaginative of these is part of an altarpiece by Poyer (Plate 4.29), which subsequently received much praise from a former secretary to Erasmus.[135] Pélerin's estimation of this painter was therefore not unusual. For Pélerin's French contemporaries, it indeed seemed as though he ranked alongside Leonardo. It was the king himself who recognised that Leonardo had to be placed in a different category to most artists. Francis understood that for Leonardo's kind of creativity to flourish, it was, for the most part, best to leave him to his own devices. Other artists in royal service needed to be given specific tasks, as they always had been in France. Bourdichon, for example, was among those artists paid for painting the pavilions at the famous Field of the Cloth of Gold in 1520, when Francis and Henry VIII set out to surpass each other in visual splendour. This may not have required a Leonardo, but it still reflected an assertive monarchy enjoying its success.

Since the end of the reign of Louis XI, the French had learned to place value on the business of looking, cultivating its possibilities, taking pleasure in spectacle. In the same year that Francis purchased his Leonardos, he and his mother Louise of Savoy visited Amiens, where they were struck by the long series of painted *puys* in the cathedral (see Plate 4.17). As a result of Louise's interest, a manuscript containing illuminated versions of these paintings was presented to her, a kind of embryo gallery in miniature, reminding her of the originals (Plate 4.30).[136] As with Leonardo's *Last Supper*, here was a solution to a problem of collecting something actually uncollectable. Francis I encouraged those around him to devise ever more imaginative ways of using the visual arts in the interests of the Crown. In this case, the manuscript not only extended the royal collections, it also encapsulated a whole era in recent French history. From Francis's point of view, there was no inconsistency in acquiring works by Leonardo one moment and showcasing the visual heritage of a leading city in his realm the next. Though they represented distinct traditions, both contributed to the prestige of a monarchy newly confident in utilising visual means to enhance its majesty, prestige that around 1480 could hardly have been imagined.

Plate 4.30 Jean Pichore, copy of the Amiens *puy* of 1511, *c.*1517, parchment manuscript, folio
56 × 38 cm, Bibliothèque nationale de France, Paris, MS fr. 145, fol.41v. Photo: Bibliothèque nationale
de France.

Chapter 5
introduction

Whether in the form of wall paintings decorating churches or icons decorating the iconostasis or hung privately in homes, religious art was essential to the Greek Orthodox Church. In this chapter Angeliki Lymberopoulou explains the relationship between art and the architecture of Greek Orthodox churches, the spiritual significance of icons, and how they were intended to be viewed. She also explores the intersection of this Greek Orthodox tradition with the West. Ruled by the Venetians yet resolutely Byzantine in character, the island of Crete was the ideal arena for this encounter. Following the fall of Constantinople to the Ottoman Turks in 1453, Crete became probably the most important centre for the production of icons. These icons were destined not just for the Greek Orthodox community but, more surprisingly, also for a western market which, from the evidence of contemporary documents, was startlingly large. As Angeliki Lymberopoulou shows, while traditional icons continued to be produced, a new hybrid form specifically geared towards a western market also emerged. Icon painters, she argues, were increasingly 'bilingual', able to produce work in both styles according to demand.

The fact that icons were sought after not just by the Venetian occupiers of Crete but as far afield as the Netherlands shows that the viewing habits of western Catholics ranged much wider than the imagery produced within their own traditions. Despite the gulf between the antique-inspired art of the Italian Renaissance with its illusion of reality and the non-realistic imagery of Cretan icons, Italian Renaissance art and Cretan icons were being introduced to northern Europe at much the same time. Vasari famously denigrated Byzantine art, but the western market evidently disagreed: the market for icons in the West shows that they were very far from being regarded as a superseded art form.

Kim W. Woods

Chapter 5

Audiences and markets for Cretan icons

Angeliki Lymberopoulou

Andreas Ritzos, a celebrated Cretan painter, lived and worked in its capital, Candia (now known as Herakleion), during the long period of Venetian domination of the island, which lasted from 1211 to 1669.[1] He was almost certainly trained in the workshop of the master painter Angelos Akotantos, the 'founder' of post-Byzantine art.[2] Ritzos (d. before 1503) was a prolific painter and a number of icons bearing his signature survive. Among those, one work, signed at the bottom right-hand corner 'ΧΕΙΡ ΑΝΔΡΕΟΥ ΡΙΤΖΟΥ' (by the hand of Andreas Ritzos), depicts a fascinating and unique iconographic subject (Plate 5.2). Its main feature is the stylised letters IHS, an abbreviation of the Latin *Jesus Hominum Salvator* (Jesus the Saviour of Men). Those familiar with the Catholic faith will probably recognise the emblem devised by Saint Bernard of Siena (1380–1444), which was adopted and promoted with great enthusiasm by the Franciscan Order during the fifteenth century.[3]

The letters are flanked by lozenges that contain the sun to the left and the moon to the right. Representations of the Crucifixion, the Harrowing of Hell and the Resurrection have been inserted into the three letters. The first two, I and H, host the Crucifixion. In the I, the Virgin Mary is depicted, identified with an abbreviation in Greek 'Μ(ὴτη)Ρ Θ(εο)Υ' (Mother of God). Above her hovers an angel with a chalice, collecting the

blood of Christ that springs from his side. The letter H contains the dead Christ on the Cross, his head leaning to the left. His eyes are closed and blood runs from his hands, pierced right side and feet. A very unusual detail (at least for Byzantine iconography) can be seen here, underneath the Cross, before the cave at the rock of Golgotha, where Christ's Cross was placed: Adam kneeling and with his hands in front of his chest in a gesture of prayer. Saint John the Evangelist appears in the second part of the letter, identified, like the Virgin, with Greek letters: 'Ὁ Α(γιος) ΙΩ(ἀννης)' (above his head) Ὁ ΘΕΟΛΟΓΟΣ' (to the left and right of the lower part of his halo). Another angel is depicted above John, averting his eyes from the painful spectacle of the dead Christ. The turning of John's and the angel's head to the right directs the eye to the final letter, S, the iconographic subjects of which are equally interesting. At the top part of the letter the Byzantine-style Anastasis or Harrowing of Hell is shown. Christ reaches into hell to draw out Adam – he is actually shown dragging Adam by his right hand – and Eve, who stands next to Adam with a red overmantle, as well as the rest of the group of righteous people. The remainder of this letter depicts a western-style image of the Resurrection with the triumphant Christ emerging from his tomb, having conquered death, an event which chronologically succeeds the Harrowing of Hell.[4] At the bottom of the tomb sits an angel, while three of the guards that kept watch outside are also shown here. In both scenes Christ holds a white

Plate 5.1 (Facing page) *Saint Eleutherios*, detail from *Saints Eleutherios, Francis, Anne and Catherine* (Plate 5.25).

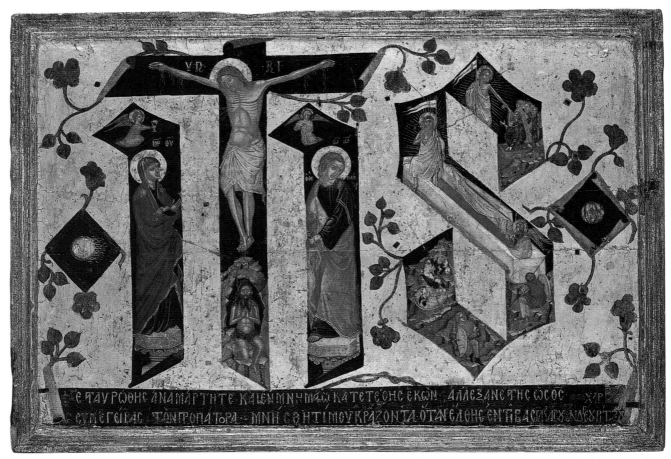

Plate 5.2 Andreas Ritzos, icon with the monogram IHS, second half of the fifteenth century, tempera and gold on panel, 45 × 64 cm, Byzantine and Christian Museum, Athens. Used with the permission of the Hellenic Republic Ministry of Culture.

banner with a red cross in it; this iconographic detail is 'correct' for a western Resurrection but 'wrong' for the Byzantine-style Anastasis, where Christ is customarily shown holding a cross.

The gold ground is filled with blossoming flowers that spring from the corners of the letters, as in a western manuscript illumination. The narrative scenes appear through the letters as though they were placed behind a veil or screen from which openings have been cut, a concept very similar to that entailed in the Byzantine iconostasis discussed below. A black band runs across the bottom part of the icon inscribed with Greek letters: 'ΕΣΤΑΥΡΩΘΗΣ ΑΝΑΜΑΡΤΗΤΕ ΚΑΙ ΕΝ ΜΝΗΜΕΙΩ ΚΑΤΕΤΕΘΗΣ ΕΚΩΝ. ΑΛΛ' ΕΞΑΝΕΣΤΗΣ ΩΣ ΘΕΟΣ ΣΥΝΕΓΕΙΡΑΣ ΤΟΝ ΠΡΟΠΑΤΟΡΑ. ΜΝΗΣΘΗΤΙ ΜΟΥ ΚΡΑΖΟΝΤΑ ΟΤΑΝ ΕΛΘΗΣ ΕΝ ΤΗ ΒΑΣΙΛΕΙΑ ΣΟΥ" (Thou without sin was crucified and placed willingly in the tomb. But thou arose as God, rousing the ancestor [i.e. Adam]. Remember me as I call upon thee when thou enterest upon thy kingdom.) This is a hymn from the *Parakletike* chanted during Sunday matins in the liturgy of the Greek Orthodox Church, which clearly refers to the events on the panel.[5] Thus the whole painting invites and encourages meditation on the redemption of humanity through Christ's Crucifixion, encapsulated in the meaning of his monogram.

What led Andreas Ritzos to create this unique composition? Did he devise this particular iconographic subject, or was it specifically requested by his patron? And who, in any case, was the recipient of this work: a Greek Orthodox or a western Catholic? Had this been the only surviving work from the painter's *oeuvre*, would we have guessed that his training was rooted in the Byzantine tradition? And can the painting actually be labelled as an icon? This inevitably leads to the question: what is an icon? These are the issues that I will explore in this chapter. I will examine other Cretan works and contemporary documents

to place artistic activity and production on Crete, to which this work by Ritzos belongs, into perspective.

On the basis of the monogram IHS, it is likely that the painting was destined either for a Franciscan church or monastery on Crete, or for an individual connected to this order, or for someone of mixed background (i.e. Greek Orthodox and Venetian Catholic) with a particular affiliation to the Franciscan Order.[6] The Greek inscription, which demonstrates the Greek education of the recipient and his appreciation of aspects of Byzantine imagery, suggests the last.[7] It is, furthermore, highly probable that this painting is the one mentioned in the will of Andreas Cornaros in 1611. Andreas was a member of an important Veneto-Cretan family, and a significant personality in the intellectual circles of his time.[8] His will describes an icon that bears the letters IHS with scenes, and says that he considered this work, which he kept in his bedroom, as a precious image for Greek painting. After his death, it was to be bequeathed to Alvize Tzortzis, an (apparently) important Venetian.[9]

With its mixture of western and eastern iconography, language and styles, Ritzos' painting – perhaps made for an ancestor of Andreas Cornaros or acquired by him as the work of an acclaimed Cretan artist – exemplifies a key theme of this chapter: the hybrid character of post-Byzantine Cretan art. First, however, is this work by Ritzos an icon – a question that can be asked about a number of the paintings under discussion – and, if so, why?

1 What is an icon?

The term 'icon' is derived from the Greek εἰκών (image). It covers a broad as well as a narrow field of definitions. In its broadest meaning, 'icon' refers to any representation of a sacred person or event in any medium – wooden panel, manuscript illumination, fresco, mosaic, ivory, enamel, etc. – and of any size, monumental as well as portable (Plates 5.3 and 5.4). In its narrowest meaning, it usually indicates a wooden painted devotional panel of variable dimensions (Plate 5.5). This latter meaning is the one more closely associated with the term within the congregation of the Orthodox Church. Orthodox Christians, up to the present day, prostrate themselves before icons, make the sign of the cross, kiss them, burn incense and light

candles in front of them, carry them in processions, and have them hanging in their homes not as decorative items but as protectors and 'watchful eyes'. Icons in their broadest sense form the core of Byzantine artistic production, while icons in their narrowest sense dominated the post-Byzantine period, when they were by far the most popular artistic and religious item.

The 'road', however, for the establishment of icons within the Byzantine (i.e. Greek Orthodox) Church was neither straightforward nor smooth. Early Christianity had an inbuilt resistance to all forms of images. This was partly because during the persecutions of their faith Christians had to sacrifice against their will to pagan idols – which could also, to a certain extent, account for the fact that the Byzantines more or less abolished sculpture.[10] In addition, the Old Testament takes a clear stand against any form of representation of the divine in Exodus 20:4–5: 'Thou shalt not make unto thee any graven image, or any likeness of any thing that is in heaven above, or that is in the earth beneath, or that is in the water under the earth: thou shalt not bow down thyself to them, nor serve them.' A similar sentiment is expressed in Leviticus 26:1 and Deuteronomy 5:8 and 27:15. Therefore, a number of early Christians, Church Fathers as well as laymen, questioned and even opposed the representation of Christ or any other holy person and event, while others defended it. This dispute marked and divided the early Christian world. During the eighth century it escalated into a serious controversy known as iconoclasm (from the Greek εἰκονοκλάστης or image destroyer): the anti-images faction obtained imperial support, and a ban was imposed on their use. The controversy had two phases; the first lasted from 726 to 787 and the second from 815 to 843.[11] Icons emerged triumphant from this hard test.[12]

The Byzantine Church took every precaution to avoid being accused of encouraging idolatrous worship of icons. Before the controversy started, early theologians had established that the icon serves as a channel of divine grace, one of the main arguments that iconophiles used in their defence. When Orthodox Christians venerate icons, they venerate the person depicted because, according to Saint Basil (c.329–79), 'the honour given to the icon passes to the prototype'.[13] In other words, the icon is a 'visual aid' to worship, not the object of worship. For Orthodox believers, an icon

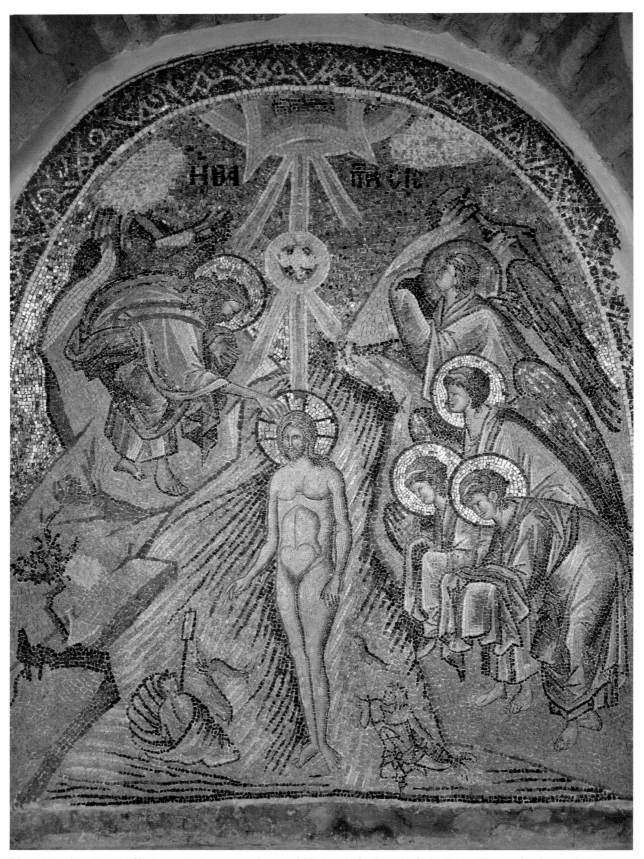

Plate 5.3 *Baptism of Christ, c.*1305–10, mosaic, *parekklesion* (side chapel), Saint Mary Pammakaristos (Fetiye Camii), Constantinople. Photo: Byzantine Photograph and Fieldwork Archives, Dumbarton Oaks, Washington, DC.

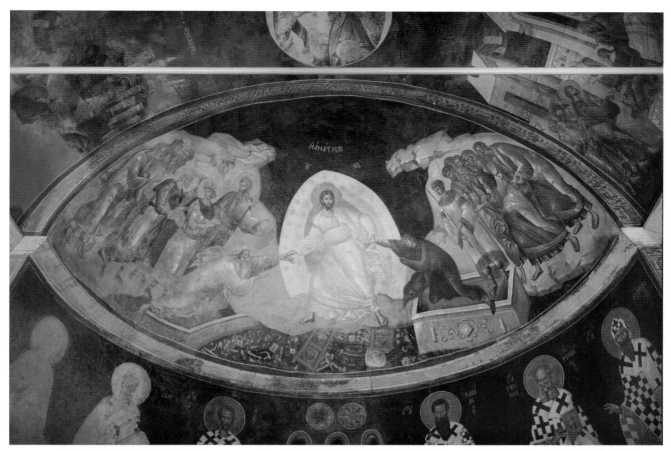

Plate 5.4 *Anastasis*, finished 1321, fresco, *parekklesion* (side chapel), Chora monastery (Kariye Camii), Constantinople. Photo: Byzantine Photograph and Fieldwork Archives, Dumbarton Oaks, Washington, DC.

representing Christ cannot be an idol; idols were images of false gods, while Christ was a true sacred person who walked on earth as divine and human at the same time. Because it represents a true prototype, an icon partakes of the holy nature of the sacred person depicted.[14] Standing in front of an icon of Christ, the Virgin or any other saint is equal to encountering the sacred persons face-to-face. Similarly, kissing an icon is equal to kissing the sacred persons depicted; physical involvement with icons was encouraged by Church Fathers, such as John of Damascus (*c*.675–*c*.749).[15] This view led some iconophiles to insist that broken or otherwise damaged icons should be destroyed.[16]

Furthermore, venerating the icon of Christ in particular was crucial because 'if anyone does not venerate the icon of Christ', as the Eighth Ecumenical Council (879–80) declared, 'they will not see his form in the Second Coming'.[17] In other words, icons are proof of identity for the sacred person depicted.[18] In many cases, the Byzantines

claimed their images were so 'lifelike' that there was no difference between standing in front of them and the saintly persons depicted – although what they actually meant when they called an icon 'lifelike' is open to interpretation, especially since it is highly doubtful the modern viewer would use this word to describe any form of Byzantine art.[19] Byzantine artists heavily relied on reproducing faithfully the specific identifying features of the sacred persons,[20] so there would be no doubt regarding their identity (this is one of the reasons Byzantine art has been accused of being repetitive and stagnant, an accusation that could not have been further from the truth). Patriarch Gregory Melissenos (reigned 1443–59, though he left Constantinople in 1450), who was in Italy for the Council of Ferrara-Florence in 1438 to negotiate the union of the Catholic and Orthodox Churches, did not recognise the way saints were depicted in the West: 'When I enter a Latin church, I can pray to none of the saints depicted there because I do not recognise them. Although I do recognise Christ, I

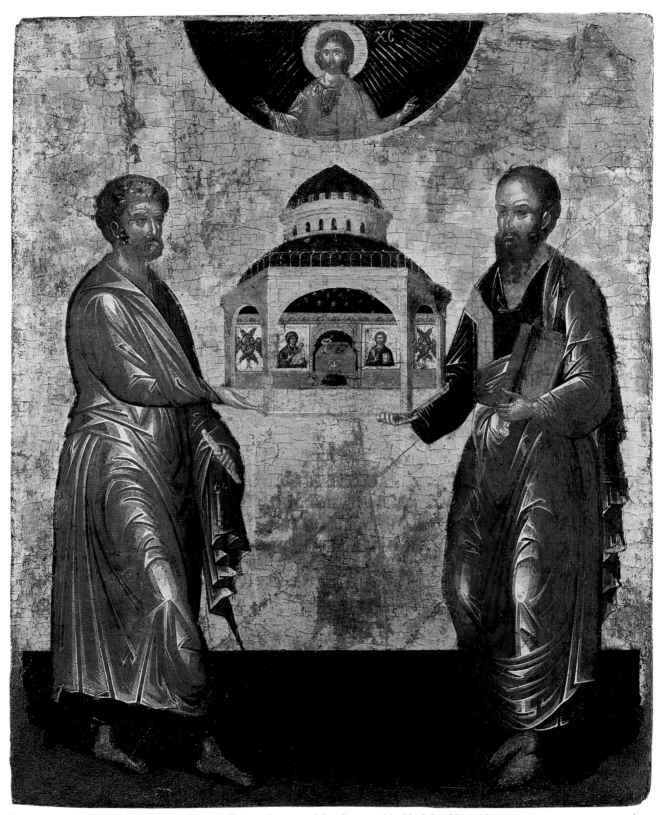

Plate 5.5 Attributed to Nikolaos Ritzos, *Saints Peter and Paul*, second half of the fifteenth century, tempera on panel, 53 × 41 cm, Accademia, Florence (no. 9382). Used with the permission of the Ministero Beni e Attività Culturali. Photo: © 1996 Scala, Florence.

Plate 5.6 Present-day *proskynetarion* in the church of Hagioi Anargyroi at Chania, Crete, with hanging votive offerings and an icon of the *Hagioi Anargyroi* (literally 'without silver', applied to all doctor saints who treated the poor without charging a fee). Photo: Diogenes Papadopoulos.

cannot even pray to him because I do not recognise the manner in which he is depicted.'[21]

Icons function as a door through which the faithful enter a sacred space and time. Therefore, the monumental decoration of an Orthodox church building along with the icon screen – known as the iconostasis or templon – and the *proskynetaria* – stands on which icons are placed for veneration (Plate 5.6) – are designed to invite the congregation to open this door and to be part of the 'heaven on earth'. According to Saint Germanus, Patriarch of Constantinople (reigned 715–30), 'the church is the earthly heaven in which the heavenly God dwells and moves'.[22] Even the wax of the candles that are lit in front of icons as a form of veneration 'is consumed as it burns and is transformed to smoke, which rises up to the heavens, transferring the gift to a higher physical plane'.[23]

The official end of iconoclasm in 843, which gave the veneration of icons the seal of approval, is commemorated by the Orthodox Church with the feast of the Restoration of Orthodoxy, held annually on the first Sunday in Lent. An icon now in the British Museum, dated *c.*1400, offers the earliest

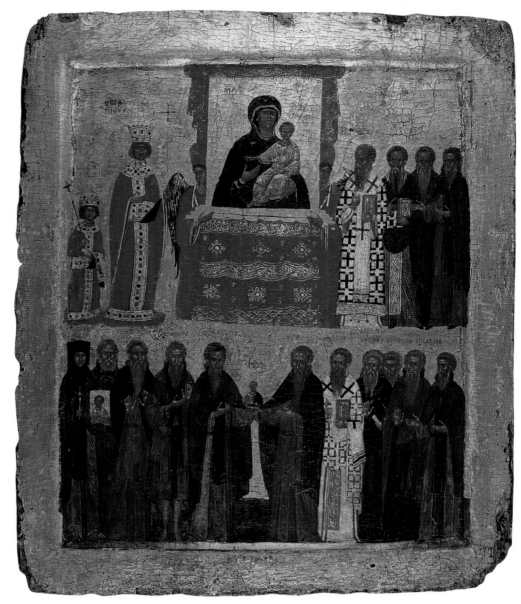

Plate 5.7 *The Triumph of Orthodoxy*, c.1400, tempera on panel, 39 × 31 cm, British Museum, London (National Icon Collection, no. 18). Photo: © The Trustees of the British Museum.

known example of the iconographic type inspired by this event (Plate 5.7).[24] Divided horizontally in two registers, it presents to the eyes of the faithful the essence of a historic landmark. The middle of the top row is occupied by the icon of the *Virgin Hodegetria* (who shows the way) attended by two winged figures.[25] Since the icon was claimed to have been painted by Saint Luke from life (as were a number of others), it makes an explicit statement about the sacredness of icons and their direct relation to real-life prototypes.[26] The Empress Theodora with her young son Emperor Michael III (ruled 842–67), the rulers of the empire at the end of the controversy in 843, are depicted to the left. The right part of the upper register and the

whole lower register are occupied with Church Fathers and saints who defended the veneration of icons during the iconoclasm. Thus, Theodosia, the only female saint present seen at the far left, and the two centrally placed male saints are depicted holding icons of Christ.

Those who defended the veneration of icons during its ban, either with their writings or with their lives, were sanctified. Such is the case of the monk Lazaros, who was tortured for refusing to give up the painting of icons during the iconoclasm. A miniature in the twelfth-century Ioannes Skylitzes chronicle, a unique manuscript for Byzantine historiography, shows him at the task that earned him his sanctification: painting

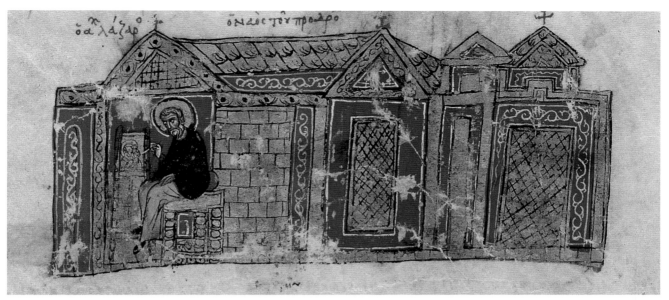

Plate 5.8 *Lazaros Painting an Icon in the Monastery of Saint John the Baptist,* twelfth century, parchment manuscript, folio 36 × 27 cm, chronicle of Ioannes Skylitzes (Skylitzes Martinensis, Codex Vitr. 26–2, fol.50r), National Library, Madrid. Photo: National Library, Madrid.

an icon of the Virgin and Child within a church (Plate 5.8).[27] It presents icon painting as a highly spiritual undertaking requiring contemplation and concentration, in accordance with hagiographic texts which often portray painters as 'inspired' and aided by divine guidance.[28]

2 The Orthodox church edifice and the icon in religious space

During the long life of the Byzantine Empire (330–1453), a number of architectural types were developed. Some periods showed preference for large-scale church buildings, while others favoured small-scale construction, especially during the late

Byzantine period (1261–1453), which sometimes has been associated with the declining economy of the empire. However, it is more likely that this was connected to social organisation: small towns or villages with a small congregation had no need of a large-scale construction, as is amply demonstrated on Crete. Size did not affect the symbolism embodied in the construction of an Orthodox church. A standard Byzantine church faces east (Plate 5.9). The edifice is fronted at the west end by a narthex, which represents the things that exist on earth. It is followed by the nave in the middle, which represents the things that exist in heaven, and finally the holy *bema* or sanctuary, which

(b)

(a)

Plate 5.9 Byzantine church plan (a) and diagram (b) of the 'cross-in-square' or 'inscribed cross' ((a) Kazhdan *et al.*, 1991, vol.1, p.460; (b) Krautheimer, 1986, p.520).

Plate 5.10 (Above and facing page) Mosaic diptych with cycle of the 12 feasts (*Dodekaorton*), 1300–50, miniature mosaic (coloured tesserae and gilt-copper rods embedded in wax and mastic) on wood panel; frame of standardised silver-gilt stampings and enamel plates; mosaics each 27 × 18 cm, Museo dell'Opera del Duomo, Florence. Photo: © 1990 Scala, Florence.

represents the things that exist above heaven. The latter is only accessible to the clergy and certainly off limits to any form of female presence, except images of the Virgin.[29]

According to the Byzantine scholar Otto Demus, 'a Byzantine building does not embody the structural energies of growth, as Gothic architecture does, or those of massive weight, as so often in Romanesque buildings, or yet the idea of perfect equilibrium forces, like the Greek temple. Byzantine architecture is essentially a "hanging" architecture; its vaults depend from above without any weight of their own.'[30] What Demus means here is that Byzantine architecture is conceived hierarchically from the top downwards, because in his view it embraces and reflects the hierarchical system that prevails in Byzantine religious thinking. The vaults and dome contribute to the concept of the church building as the earthly heaven, since, once inside, the boundary between the man-made structure and the sky (or rather the illusion of it) evaporates through this 'weightless hanging'. One may be justified, however, in wondering what happens to this idea in the simple, small-scale and more modest construction without a dome. In those cases, the symbolism of the dome and vaults is transferred to the vault of the sanctuary apse, and the very popular barrel-vaulted roof also contains this 'hanging' element, albeit to a lesser degree.

One of the most popular and standard forms in Byzantine architecture was the 'cross-in-square' or 'inscribed cross', evident from the ninth century onwards.[31] The core of the plan is a square made up of nine bays: four of these, usually barrel-vaulted, form an equal-armed cross around the central bay, where a dome is carried on four columns; four small corner bays complete the square outline. At the east end of the inscribed cross core are three apses, at the west end a narthex (see Plate 5.9 a and b).

The 'cross-in-square' type presented artists with a hierarchical construction with three zones which can be interpreted as corresponding to heaven (the cupolas and high vaults, including the conch of the apse – a semi-circular niche surmounted by a half-dome), paradise or the Holy Land (the squinches – niches formed below an arch that spans the corner of a square in order to support a dome; the pendentives – triangular segments of a sphere, bordered by arches; and the upper parts of the vaults), and the terrestrial world (the lower vaults and lower parts of the walls). The subjects

chosen to decorate the space of these three zones reflect the ordered hierarchy that prevails in the Byzantine church. In other words, the images were placed according to a kind of divine precedence with the most important figures given the most important spaces. It is highly probable, however, that this development was triggered by the arrival of the 'cross-in-square' type rather than the type being specifically invented in order to accommodate an existing hierarchical system. The highest zone hosts representations of the holiest persons – such as Christ Pantokrator (the 'all ruler'), the Virgin and angels – and of scenes that are associated with heaven such as the *Ascension* and the *Pentecost*.[32]

The second zone features scenes mainly from significant episodes in the life of Christ based primarily on the narrative of the New Testament (and sometimes Apocryphal texts), which is known in Byzantine art as a festival cycle. The liturgical calendar has a series of feasts, or particular celebrations, often of events described in Holy Scripture, and the corresponding images form part of the standard imagery of the Orthodox Church. A popular selection of scenes forming the so-called *Dodekaorton* (literally, 12 feasts) includes the *Annunciation*, the *Nativity*, the *Presentation of Christ in the Temple*, the *Baptism*, the *Transfiguration*, the *Raising of Lazarus*, the *Entry into Jerusalem*, the *Crucifixion*, the *Anastasis or Harrowing of Hell*,[33] and the *Komeisis (Dormition) of the Virgin*.[34] To these the *Ascension* and the *Pentecost* are added, regardless of their placement in the upper zone (Plate 5.10 shows these 12 scenes in the correct chronological sequence).[35] It should be noted, however, that the iconographic programme

Plate 5.11 Ioannes Pagomenos, *Saint Nicholas Goes to School* (left) and *Birth of Saint Nicholas* (right), 1325–6, fresco, church of Hagios Nikolaos at Maza, Apokoronas, prefecture of Chania, Crete. Photo: A. Lymberopoulou.

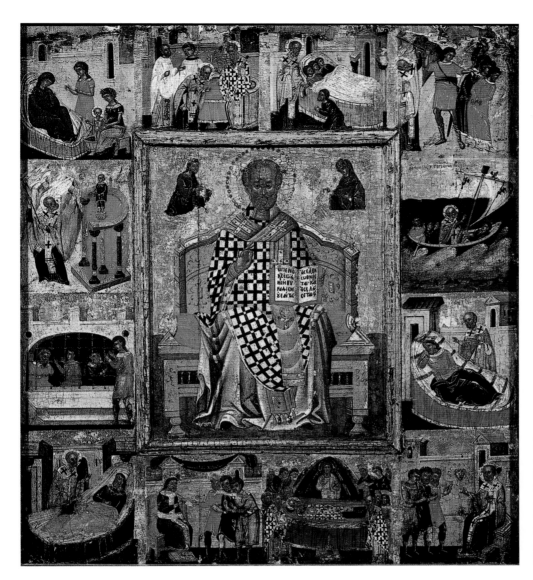

Plate 5.12 *Saint Nicholas with Scenes from his Life*, c.1500, tempera on panel, 41 × 36 cm, R. Andreadis Collection, Athens. © Byzantine Museum of Athens. Photo: M. Skiadaresis.

for Byzantine monumental decoration is by no means formed solely upon these scenes; countless variations to the *Dodekaorton* exist. The surface of large-scale churches with a narthex allows for more than 12 scenes as part of the decoration, but the conventional term *Dodekaorton* is applied to larger as well as smaller iconographic programmes. Therefore, other popular scenes such as the *Last Supper*, *Christ Washing the Disciples' Feet*, the *Betrayal of Judas*, the *Road to Calvary*, the *Descent from the Cross*, the *Threnos* (the *Lamentation* over Christ's dead body) and the *Entombment of Christ* also found their way frequently into Byzantine church decoration.

The selection of some scenes, such as the last two, also depended on the particular needs and requests of the donors. For example, if the church was their intended burial place, then usually the inclusion

of the scene of either the *Lamentation* or the *Entombment* (or sometimes both) was considered appropriate; the lament over a dead body, in particular, has been and still is an integral part of Greek culture. It should be noted that this second zone sometimes hosts scenes from the life of the patron saint of the church. For example, if a church is dedicated to Saint Nicholas, such as the one in the small village of Maza on Crete from 1325–6, we encounter scenes that narrate the life of the saint, including his birth, ordination as a priest and bishop, and the miracles he is supposed to have performed (Plates 5.11 and 5.12). The number depends on the availability of space, which in its turn dictates the selection of scenes – in a limited space it is more likely to find scenes from the saint's miracles, since these narratives underline the very important role of the saint as an intercessor for the salvation of humanity.

The arrangement of the *Dodekaorton* cycle within the nave of a Byzantine church would, in theory, be chronological, starting on the south-eastern side next to the sanctuary, and terminating on the north-eastern side, again next to the sanctuary, having worked its way clockwise around the church. However, this setting was not often observed. The chronological arrangement was, however, frequently observed on the *Dodekaorton* in panel painting, which also forms part of the decoration for the iconostasis or templon, a point to which I shall shortly return.

Finally, in the third and lowest zone, a gathering of individual male and female saintly figures are represented: martyrs, warrior saints, doctor saints, monks and sometimes prophets.[36] This well-orchestrated religious stage was completed by the careful use of colour and light – a combination of windows that allowed the natural light to illuminate the decorated surfaces as well as artificial lighting such as candles and oil lamps.[37] Similar principles of decoration can be observed in all Cretan Orthodox churches built during the Venetian domination, despite their small scale, as they generally lack a dome and a narthex.

In addition to the important role held by the embellishment of the walls in Byzantine churches in either mosaic or fresco (or, on occasions, in a combination of the two), an equally important role is given to panel paintings placed on the templon or iconostasis as well as on the *proskynetaria*. A templon is a screen (with doors), which separates the nave (main part) of an Orthodox church from the sanctuary or *bema*. It can be made of either stone or carved wood. A templon of wooden construction is also called an iconostasis.[38] The model church that Peter and Paul hold between them (Plate 5.5) depicts such a carved-wood templon. These templa prevailed during the post-Byzantine period. They have two parts, the lower and the upper. Depending on the size of the church, the lower part of the templon can have either one or three doors, such as the one that can be seen in the Stavronikita monastery (Plates 5.13 and 5.14).

3 The Stavronikita templon

Stavronikita is one of the Orthodox monasteries in the Holy Mountain of Athos, in the northern Greek province of Macedonia. Its monumental decoration as well as its templon icons were executed between 1545 and 1546. The templon is one of the best preserved of the post-Byzantine period to survive *in situ*. The painter, Theophanes Strelitzas (also surnamed Bathas), was a sixteenth-century Cretan artist who was called from his home island in order to decorate some of the most famous and prestigious monasteries in Athos, including the Stavronikita.[39] The journey must have been anything but straightforward, not least because the territories he had to travel through – most of modern-day mainland Greece – were under Ottoman rule at the time. Theophanes' selection for the task bears testimony to the great reputation that Cretan painters had acquired by the sixteenth century. Post-Byzantine Cretan painters, starting with the master Angelos, were keen to promote their talent. Just like the countless artefacts commissioned from the island, the work of Theophanes is part of the Cretan artistic trade. Furthermore, Theophanes raises another interesting point: even though on Crete there are presently around 845 surviving painted churches (representing different periods of artistic production on the island), post-Byzantine Cretan artistic activity is virtually synonymous with icon production. The reasons for this will become clear; however, it is obvious from Theophanes' example that Cretan painters (or at least some of them) did not abandon training in monumental decoration; otherwise he would not have been able to accept the highly prestigious Athos commissions, which primarily involved fresco decoration.

On the *bema* (or sanctuary) doors of the Stavronikita templon, the *Annunciation* is depicted – a common iconographic subject for their decoration. It is divided in two parts, with Gabriel seen to the left and the Virgin Mary to the right (Plate 5.13). To the left of these doors there is an icon of the *Virgin of the Passion*,[40] introduced into post-Byzantine painting by Andreas Ritzos.[41] Further to the left, largely concealed by the column before it, a *Saint John the Baptist with Wings* has been placed, three-quarter view to the right – the type introduced into post-Byzantine painting by Angelos.[42] The function of this particular type of the Baptist becomes clear within a church context, since originally it was developed for use in the templon and is often placed next to a Virgin and Child. The position of John, three-quarter view either to the right, as here, or to the left, is determined by its placement in the context

Plate 5.13 Theophanes Strelitzas (also surnamed Bathas), carved wood templon of the Stavronikita monastery, 1545–6, icons tempera on panel, Mount Athos, Greece. Photo: Kostas Paschalidis (Chatzidakis, 1986).

Plate 5.14 Theophanes Strelitzas (also surnamed Bathas), carved wood templon of the Stavronikita monastery, 1545–6, icons tempera on panel, Mount Athos, Greece. Photo: Kostas Paschalidis (Chatzidakis, 1986).

Plate 5.15 *Great Deesis*, iconostasis beam with pointed arches, *c*.1280s, tempera and golden wooden armature with linen and gesso foundation, 43 × 169 × 6 cm, part of an iconostasis, Holy Monastery of Saint Catherine, Sinai. © 2004 The Metropolitan Museum of Art. Photo: Bruce White. From left to right: Saints George, Luke, John the Evangelist, Peter, the Virgin Mary, Christ, Saints John the Baptist, Paul, Matthew, Mark, Prokopios.

provided by the templon. In other words, when John faces to the right, he is placed on the left side of the templon, and vice versa.

By contrast to the lower part of the templon, on the upper part – the beam or epistyle that surmounts it – smaller icons are usually placed. They depict either the 12 Apostles in the form of the 'Great Supplication' (*Great Deesis*) or the 12 conventional feasts, the *Dodekaorton*.[43] The Great Supplication comprises Christ in the middle with the Virgin to the left and Saint John the Baptist to the right and then the 12 Apostles, who are placed in groups of six on either side. If the templon is substantial in size, other saintly figures might be added to it. If the beam is shorter, then a selection of the Apostles with or without other accompanying saints are placed on it. An earlier example from Sinai shows six Apostles and two military saints (Plate 5.15).[44] The templon at Stavronikita depicts the *Dodekaorton* with 14 (rather than 12) scenes in total (Plates 5.13 and 5.14). They follow the chronological sequence of the events they represent, starting at the north (or left) side and moving to the south (or right) side. They are the *Nativity*, the *Presentation of Christ in the Temple* (concealed by the column), the *Baptism* (partly concealed by the column), the *Transfiguration*, the *Raising of Lazarus*, the *Entry into Jerusalem*, the *Crucifixion* – which, as you can see in Plates 5.13 and 5.14, has been placed directly below the big *Crucifixion* with the Virgin (to the left) and John the Evangelist (to the right) that crowns the templon at the top – the *Anastasis*, the *Holy Women at the Tomb or Myrrh-bearers*,[45] the *Noli me Tangere* or 'Touch Me Not',[46] the *Incredulity (or Doubting) of Thomas*, the *Ascension*, the *Pentecost* (the last two scenes are concealed by the column), and the *Dormition of the*

Virgin. (Note that the scene depicting the *Raising of Lazarus* – to the right of the *Transfiguration* – is hardly visible on Plate 5.13. For a better view of the *Entry into Jerusalem* and the *Crucifixion*, see Plate 5.14.)

4 Demand and supply (I): the icon in secular space

While the templon is the chief location for icons within a church, icons (in the narrow sense) hold an important position in the household of the Orthodox faithful. At least one room (usually the master bedroom) has an icon of either Christ or the Virgin and Child or the Crucifixion on the wall. Additional icons (of sacred persons or events) may be found in the remaining bedrooms and in the living room; the choice of the saintly person(s) is usually based on the protector saint(s) of the owner. In fact, icons can be placed in any part of an Orthodox household, except the bathroom. It is important to remember that their primary role is distinctly different from other paintings (e.g. landscapes) with which they may share space: their presence is linked to watching over and protecting the household and its members, and their decorative effect is secondary. This applies equally to plain ones as well as to those with more complex finishing, such as metal revetments (covers commonly made of silver and occasionally of gold) or elaborate frames (see, for example, Plate 5.17).[47] As noted above, for the early iconophiles, who maintained that a damaged icon should be destroyed, icons were not regarded as works of art to be admired and preserved; such a view did not arise until the sixteenth century.[48]

The possession of icons was not only the privilege of the Orthodox faithful. On Crete interaction between Orthodox and Catholic believers was not only very close and intense but also worked both ways. Therefore, the information provided by the Italian scholar Giuseppe Gerola in the second volume of his *Monumenti Veneti nell' Isola di Creta* that 'every Venetian family had an icon' hardly comes as a surprise.[49] This can certainly be applied to Venetian families living on the island, and is possibly true for a number of families living in Venice, where many Cretan painters lived and worked, especially after the founding of the Greek confraternity there in 1498. During the second half of the fifteenth century, Byzantine icons were, in fact, popular in the whole of the Italian peninsula as well as throughout Europe, made attractive partly by the legends that accompanied them – like the *acheiropoietes* icons, supposedly not made by 'ordinary' human hands, such as the *Virgin Hodegetria*.[50] In any case, Catholics were familiar with the concept of keeping devotional paintings in their bedrooms. A detail in a canvas by Vittore Carpaccio, depicting Saint Ursula talking to her father, illustrates this point: on the wall hangs a painting of the Virgin and Child resembling those produced in large quantities (due to their popularity) by the Bellini workshop in the fifteenth century (Plate 5.16).[51]

That icons were popular on Crete – and in any Orthodox context for that matter – is well established. That icons were also fashionable outside Crete around the turn of the sixteenth century is demonstrated by a number of surviving documents. These documents not only testify to an existing European market for icons during this period, but also show that they were probably among the popular exports of the island, along with wine, olive oil and honey. It is no wonder that Cretan artists were drawn to and excelled in panel painting, and that post-Byzantine Cretan artistic production has become synonymous with icon painting.

Two documents have become canonical texts in the study of post-Byzantine Cretan icon painting. Unfortunately, the only information available for the first is a summary in a publication with no further indication of or reference to its whereabouts, full context, number of icons or parties involved.[52] This summarised information makes it even more regrettable that more is

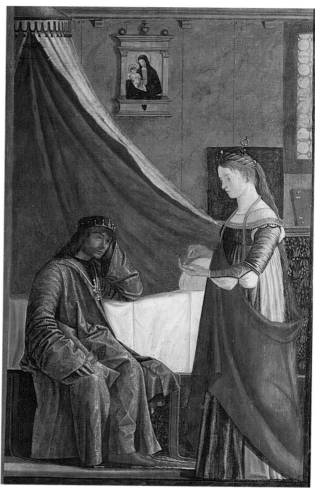

Plate 5.16 Vittore Carpaccio, *Saint Ursula Talking to her Father* (detail from *The Reception of the English Ambassadors*), mid-1490s, oil on canvas, Accademia, Venice. Used with the permission of the Ministero Beni e Attività Culturali. Photo: © 1990 Scala, Florence.

not known about it. In 1497 a Venetian dealer commissioned a large number of icons (total not given) from a Cretan painter. The targeted market for these icons was Flanders. This is not surprising since during this period Crete and Flanders maintained an active trading relationship. In Candia a number of items *alla fiamenga* (in the Flemish manner) were found in households, such as panel paintings, furniture and mirrors.[53] By 1498 the Venetian dealer had successfully disposed of half of the icons.

The second document is actually a set of three separate contracts, all dated 4 July 1499.[54] Two dealers named Giorgio Basejo from Venice and Petro Varsama from the Peloponnese commissioned a number of icons, all of the Virgin, from three different Cretan painters, all with the

same deadline for delivery, 15 August 1499. The first painter, Migiel Fuca (active 1493–1500, d. before 1504),[55] was asked to produce 200 icons. The first 100 had to be of 'a first type' (*prima sorta*), which was shown to the dealers by the painter. This term may possibly refer to either size/shape or quality (e.g. wood, colours, etc.), or both, or even perhaps an iconographic type (e.g. *Virgin Hodegetria, Eleousa*). Half of those 100 required the Virgin's garments to be deep blue with gold brocade, while the other half were to be purple with gold brocade; each icon was priced at 48 bezzi (a German coin). The remaining 100 icons had to be *in forma a la latina* (in the western, Italian manner). These were supposed to be of 'first, second and third type' (with unspecified numbers for each type) and were priced differently. Fuca received five gold ducats as an advance payment.

The second painter, Nicolò Gripioti (active 1491–1525),[56] was commissioned to make 300 icons, all *in forma a la latina* and painted in gold (i.e. with gold background). Again there were to be different types, which were also priced differently. What can be noted here is that although Fuca (painter of the first contract) was specifically asked to model his *in forma a la latina* types according to the shapes that Gripioti (painter of the second contract) was going to provide, Fuca was to receive 2 more bezzi for each icon of his first type than Gripioti (42 as opposed to Gripioti's 40). For the other two types, the painters were to receive the same sum of money per icon.[57] Gripioti also received five ducats in advance, and in addition he was given 600 leaves of gold for the icons.

The fact that Fuca was to receive 48 bezzi for his icons with gold brocade is understandable, since the application of gold brocade involved more work and there was no provision for gold leaves in his contract; furthermore, his *prima sorta* had nothing to do with Griptioti's types. It is not clear, however, why Fuca was to receive more money than Gripioti for what sound like identical types of icons. If they were indeed identical, then we could assume that the icons were to have gold backgrounds and the extra money would have been towards the expense of purchasing gold leaves. However, the contracts state the dealers' requests very clearly, and one would have expected a request for gold backgrounds to be specified in Fuca's contract as it is in Gripioti's. Another possibility could be that the 2 extra bezzi for this type were meant to make up

for the extra work involved in the icons with gold brocade.[58]

The third and final contract concerns Giorgio Miçoconstantin,[59] who was commissioned to produce 200 icons, half of them *a la forma greca* (in the Greek manner or style) and the rest *a la forma latina*. Like the others he had to provide the three different types, according to those he showed to the dealers. However, judging by the prices quoted in this contract, it seems likely that the first and second types provided by Miçoconstantin were different from those provided by the other two (all three painters were given the same sum for the third type). His advance payment was just over 14 ducats, probably because 170 of his icons had to be painted against a gold background and there was no provision of gold leaf here, as there was for Gripioti. It is worth noting that the advance payment is first quoted in hyperpyra, the Byzantine coin.[60]

Summarising the information that can be extracted from these contracts reveals the importance of this document. Even the two dealers, one Venetian and one Greek, reflect perfectly the hybrid situation on the island's society as well as its artistic production. The total number of icons commissioned is 700. All three contracts use the term 'icons' (*incone*), which should probably be understood here in the narrow sense of a painted panel, which is supported by the choice of the Virgin Mary for the iconographic subject. There are specific requirements regarding the style of the icons and, in some of them, the colours worn by the Virgin. The majority – 500 – had to be painted in the 'Italian fashion'. From the remaining 200, 100 had to be in the 'Greek fashion', while the last 100 only specified the colours on the Virgin's garments – half in deep blue with gold brocade and half in purple with gold brocade.

It has been suggested that the clause *a la forma latina* in such documents implies the highly popular and hybrid type of the *Madre della Consolazione* (Plates 5.17, 5.18).[61] This type was introduced into post-Byzantine art by Nikolaos Zafuris.[62] Because it combines both western (e.g. the decorative patterns on the Christ Child's shirt and the brooch that fastens the Virgin's *maphorion* in front of her chest, not seen in Byzantine Virgins) and Byzantine (e.g. Mary's aloofness, one of the most typical characteristics of a Byzantine Virgin) iconographic elements, it proved equally popular among Catholic and Orthodox Christians alike.

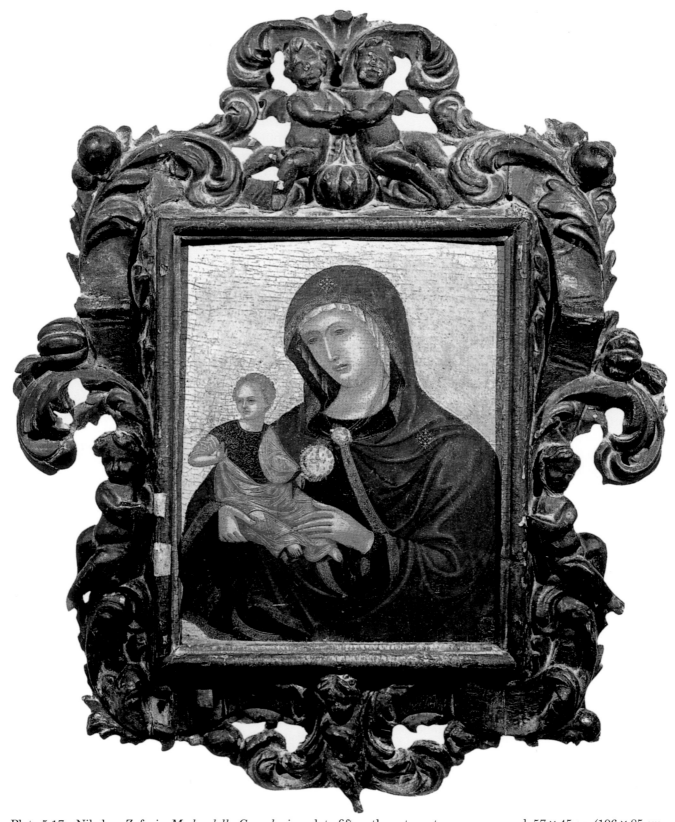

Plate 5.17 Nikolaos Zafuris, *Madre della Consolazione*, late fifteenth century, tempera on panel, 57 × 45 cm (106 × 85 cm with frame), P. Kanellopoulos Collection, Athens. © Byzantine Museum of Athens. Photo: M. Skiadaresis.

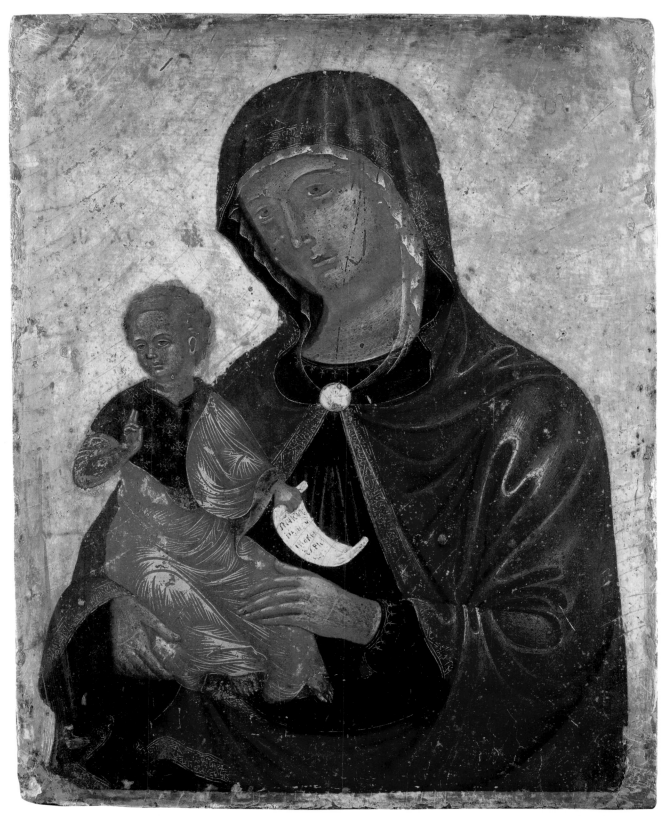

Plate 5.18 *Madre della Consolazione*, first half of the sixteenth century, tempera on panel, 35 × 27 cm, British Museum, London. Photo: © The Trustees of the British Museum.

Its wide use continued well into the seventeenth century. The vast numbers of surviving examples of the type in museums across the world, the majority of which are portable, testify to both its immense popularity and its exportability (Plate 5.18).

It is not known whether the three painters mentioned in the documents were aware of the terms and conditions of each other's contracts. One thing is clearly implied, however: co-operation between Cretan painters and their workshops. First, Fuca's contract states that he had to model his *a la latina* types according to those made by Gripioti. Second, co-operation is implied by the conditions stipulated in the contracts. The deadline for delivering these 700 icons is 42 days, excluding the day the contracts were drawn. It is explicitly stated in each contract that no concessions were to be made if the deadline was not met by any of the painters. In such a case, the dealers had the right to obtain their merchandise elsewhere without being liable for damages or loss of profit from any of the three painters. Even with the use of *anthibola*, the cartoons that Cretan artists used in order to reproduce a work quickly,[63] the time was just too short for three painters on their own to produce such a massive number of icons. Since the sizes are not given, it must be assumed that they were the popular rectangular shape, portable and without elaborate carved wooden frames. Given the detailed specifications, we would have expected that any requirements for elaborate frames also would have been explicitly stated. And although this does not imply that icons with frames were not exported, the 'plain' ones were certainly easier and less costly to transport. In addition, 470 required the application of gold leaf and 100 gold brocade, both delicate and time-consuming procedures. Fuca and Gripioti maintained workshops in Candia and had apprentices, but the size of the workshops is not known, nor the number of the apprentices they had at the time.[64] But, in my view, the three painters must have called upon other workshops in order to meet the deadline. Contracts exist that testify to the employment of painters by other workshops, and similar arrangements may have been made in this case.[65] Even if the painters had a ready-made stock of icons, given the particular specifications there still would have been a large number to be produced.

These contracts show that around 1500 the icon market was 'big business', which, at least to some extent, explains why post-Byzantine Cretan artistic production focused so much on the making of icons. At least one of the three contracted painters, Fuca, did not die a poor man: his widow was able to sell two large and four smaller houses.[66] The popularity of Cretan icons is confirmed further by the large number that survive, particularly of the Virgin and Child. Many of the surviving icons are currently in Italy, and were presumably made for the Italian market in the first place.[67]

5 Demand and supply (II): the 'hybrid' icon

The historical context of Venetian domination helps to explain why artistic production on Crete was so popular not only in Venice, but also in other parts of Europe.[68] In a society where by the late fifteenth and early sixteenth centuries a substantial number of families were mixed (through intermarriage between Catholic Venetians and Orthodox Cretans), it was only a matter of time before religious art followed: elements from both cultures were combined in order to create artefacts equally appealing to either. The demands of a hybrid and bilingual society led to the creation of hybrid and bilingual iconography. Some Candia workshops were even jointly owned by Cretans and Venetians, as in the case of the workshop run by Nikolaos Philanthropinos and Nicolò Storlado.[69] The specific demands of *a la forma greca* and *a la forma latina* that the dealers of the 1499 document placed upon the contracted painters clearly reflect this situation. This sort of demand further implies that Cretan painters were obliged to know how to paint skilfully in both styles. Published documents indicate that more than 125 painters were living and working in Candia during the sixteenth century.[70] The population of the Cretan capital around this time was roughly 15,000, which suggests that the painters' profession was highly competitive and therefore the ability to work in both styles was not merely a choice but rather a requirement and a matter of survival.[71] It further confirms that there must have been substantial demand for artistic production around that time. Seen in this context, the iconography of Ritzos' IHS icon (Plate 5.2), although unique, is no longer mysterious and perplexing. A number of other works, discussed below, fall into the same category. It is highly probable that their subjects were based

on collaboration between patron and artist rather than being the sole responsibility of the painter.

One of the many examples is offered by a triptych depicting the *Virgin and Child with Saints* (Plate 5.19). Commissions recorded in documents suggest that triptychs were very popular on Crete.[72] The work is attributed to either Andreas Ritzos or Nikolaos Zafuris – both trained in Angelos' workshop. The central panel shows the Virgin and Child in the type of Zafuris' popular *Madre della Consolazione* (see Plates 5.17 and 5.18). The combination of western and Byzantine elements, apparent in the *Madre della Consolazione* type itself,[73] is the main characteristic of this work. The left wing depicts the embracing of Peter and Paul painted in full length. Examples of this iconographic type are found in Angelos' art;[74] the pairing of the two saints was popular in post-Byzantine Cretan art (see Plate 5.5). Unlike the *Madre della Consolazione*, the two apostles are painted in a 'pure' Byzantine style. The subject, however, carries symbolism that made it popular among the Venetians, offspring of mixed marriages, as well as those Greeks with pro-Venetian sentiments.[75] Peter was the patron of Rome, and Paul took Christianity to the eastern Mediterranean sphere – their embrace could be interpreted as symbolism for the union of the Catholic and Orthodox Churches. Furthermore, the Venetians saw here the allusion of an embrace between their republic and beloved colony, since the patron saint of Venice, Mark, was a disciple of Peter while the patron saint of Crete, Titos, was a disciple of Paul.[76] On the right wing two deacon saints are depicted. They are beardless with short hair and tonsures, wear red, embroidered *sticharia* (dalmatics, long tunics with sleeves), and each holds a book in his left hand. The one to the right, who holds a labarum (a miniature ecclesiastical banner) in his right hand, is usually identified as Saint Daniel of Padua, a Catholic saint, who is not included in the Orthodox martyrology. The figure to the left, who holds a censer, is commonly identified as either Saint Stephen or Saint Lawrence. When the triptych is closed, on the outside of the left wing Saint George is shown, while the outside of the right is decorated with a cross on a stepped plinth. Floral scrolls fill the background.[77] Again, the hybrid iconography of the triptych, like Ritzos' icon (Plate 5.2), probably points to an owner of mixed background with knowledge and appreciation of both cultures.

Reflecting their popularity in western religious art, the presence of Saints Lawrence and Sebastian in hybrid Cretan icons was common (Sebastian was a protector against the plague, while Lawrence was the patron saint of the souls in purgatory).[78] Lawrence accompanies the Virgin and Child in another icon (Plate 5.20). He stands to the right and holds in his right hand the symbol of martyrs, a palm branch, and in his left hand the instrument of his martyrdom, a grill. The combination of the *Madre della Consolazione* type (or the variations on it, the development of which is not surprising given its popularity) with other saints on the same surface was as common as the triptych format. *The Virgin and Child with Saints John the Baptist and Sebastian* (Plate 5.21) shows Mary enthroned on a backless throne. Saint John occupies the left part, holding a cross and an open scroll in his left hand. Visible on the scroll is an inscription in Latin that reads 'ECCE AGNU[S] DEI' (Behold the Lamb of God), which unmistakably identifies Christ, to whom the Baptist is pointing with the index finger of his right hand. This inscription is very commonly found in the hands of John. With these words he bore witness to Christ during his Baptism according to the Gospel of John 1:36. The choice of Latin may imply a western patron. To the right Saint Sebastian is depicted as a martyr – wearing only a loincloth, naked from the waist up, with arrows stuck in his body and with his hands tied behind his back. This iconographic type of Sebastian was developed in western art and adopted by Cretan painters.[79] All figures bear halos with punched decoration.

An enthroned Virgin and Child of the *Galaktotrofousa* type (the Greek term for *lactans*, breast-feeding the Child) is similarly accompanied by two female saints, Catherine and Lucy (Plate 5.22). Saint Catherine, seen to the left, extends the index finger of her right hand in order to receive the ring that the Child is offering her, a visual reference to the 'mystic marriage' of the female saint, a popular theme in western art but not common in Byzantine iconography,[80] although Byzantine manuscript narratives of the life of the saint seem to have been familiar with it.[81] To the right, Saint Lucy holds a palm branch in her left hand, while in her right is a golden oval plaque with the symbols of her martyrdom, which entailed the plucking out of her eyes. This recalls votives, usually in relief, in either gold or silver that are

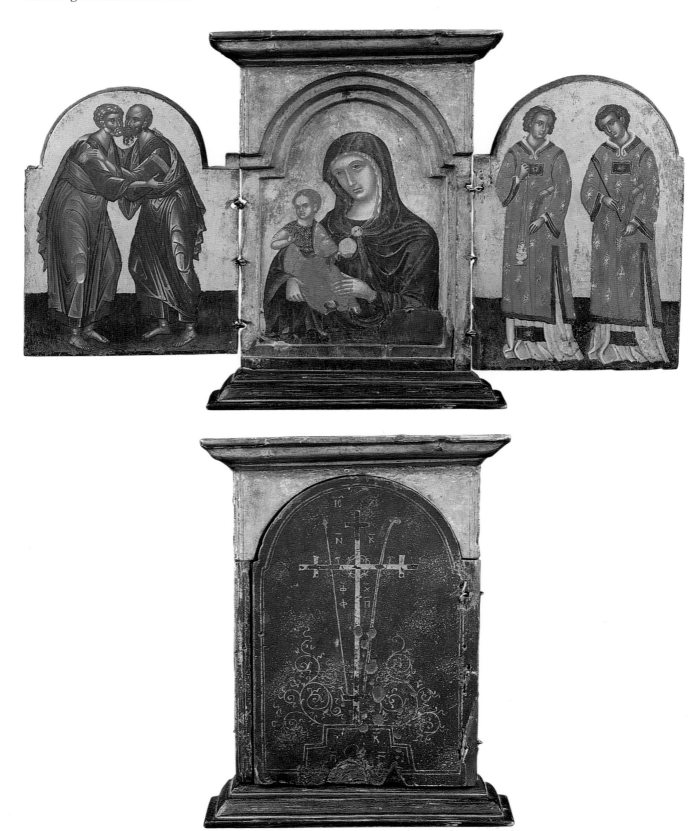

Plate 5.19 Attributed to Andreas Ritzos or Nikolaos Zafuris, *Virgin and Child with Saints*, late fifteenth century, tempera on panel, 25 × 44 cm (open), 25 × 25 cm (closed), private collection, London. © 2004 The Metropolitan Museum of Art. Photo: Bruce White.

Plate 5.20 *The Virgin and Child (Madre della Consolazione type) with Saint Lawrence*, first quarter of the sixteenth century, tempera on panel, 37 × 33 cm, Museo Nazionale, Ravenna (no. 4470). Used with the permission of the Ministero Beni e Attività Culturali.

Plate 5.21 *The Virgin and Child (Madre della Consolazione type) with Saints John the Baptist and Sebastian*, first quarter of the sixteenth century, tempera on panel, 39 × 48 cm, Pinacoteca, Vicenza (no. A-156).

Plate 5.22 *The Virgin and Child (Galaktotrophousa type) with Saints Catherine and Lucy*, first quarter of the sixteenth century, tempera on panel, 37 × 45 cm, Museo Nazionale, Ravenna (no. 4471). Used with the permission of the Ministero Beni e Attività Culturali.

placed on many icons, even to the present day. These votives represent suffering parts of the body (e.g. arms, legs, eyes) for which believers are asking for divine intervention to cure (see Plate 5.6).

One of the favourite saints for these hybrid icons was Francis, the popular saint of the Catholic Church who won the hearts of the Orthodox Christians on Crete.[82] Such is the case in the icon depicting a full-length Saint Francis to the left of a *Madre della Consolazione* (5.23). Unlike the examples examined so far, Francis is shown here

Plate 5.23 *Madre della Consolazione with Saint Francis*, late fifteenth century, tempera on panel, 60 × 52 cm, Byzantine Museum, Athens (T.233). Used with the permission of the Hellenic Republic Ministry of Culture.

Plate 5.24 *Saint Francis Receiving the Stigmata* (inside of the left wing of a triptych), second half of the fifteenth century, tempera on panel, 19 × 14 cm, Benaki Museum, Athens. Photo: © 2007 Benaki Museum, Athens.

in a much smaller scale. The saint holds a book in his right hand, a cross in his left, and bears visible red marks, his stigmata, on his right side and on both hands. It is believed that Francis received his stigmata from the wounds of the crucified Christ in a vision, a theme popular in Cretan icons (Plate 5.24). Since the saint holds a cross, it is possible that the symbolism of the miracle is suggested here, which reflects Christ's Passion. It is worth noting, however, that the cross in the hands of a saint is a common Byzantine symbol of martyrdom. Although Saint Francis was not a martyr in the sense of meeting a violent death and he certainly has a connection with the cross on the basis of the stigmata, it is tempting to suggest that the hybrid icon painter made creative use of traditional Byzantine iconography – both here and in another icon where Francis appears (see Plate 5.25). The three saintly persons depicted in the *Madre della Consolazione* meet neither the viewer's gaze nor each other's; they seem to dwell in a 'world of their own' so characteristic of Byzantine icons, especially for the Virgin. This work also offers an example of an icon which could

have been equally in the possession of a Greek or a Venetian or even a Franciscan church on the island. It is impossible to favour any one over another, and that sums up a large part of Cretan artistic production during this period. The same is clearly true also for Ritzos' IHS icon (Plate 5.2) and for the triptych (Plate 5.19).

As mentioned above, the symbolism of the miracle of the stigmata – as well as the possibility that the artist made use of traditional Byzantine iconography – are evident in a depiction of Saint Francis where he is accompanied by three other saints (Plate 5.25). The four saints are divided into two tiers according to gender: in the upper tier appear Saints Eleutherios (to the left – see also Plate 5.1) and Francis, while in the lower are Saints Anne (to the left) and Catherine. The combination is very interesting. The two females – Anne, the mother of the Virgin Mary, and Catherine – are major saints worshipped equally in both the Greek Orthodox and the Latin Catholic Churches. Eleutherios, on the other hand, is a popular Orthodox saint, one of the most frequently depicted bishops on the lateral walls of the lower zone of the sanctuary. Except for Francis, they are all shown frontally, in accordance with the tradition of Byzantine art. Francis is in three-quarter view to the left. It may be that the patron of the icon had a special affiliation to the saint and instructed the painter to 'single out' Francis from the rest, in which case the artist responded by changing the rigid frontality and symmetry that the icon would have presented in the 'pure' Byzantine tradition. Another possibility that could account for the positioning of the saint here would be that the artist used different prototypes, Byzantine for the Byzantine saints and western for Saint Francis; this does not exclude the possibility of 'singling out' Francis.[83]

Finally, Francis appears to the left in an icon which features Saint Peter in the middle and Saint Dominic to the right (Plate 5.26) and is attributed to the Greek painter Ioannes Permeniates (active 1523–8), who was a resident of Venice at least from 1523 onwards.[84] All three saints hold books and, in their right hands, attributes. Peter with his heavy keys is the only one who maintains his austere Byzantine frontality, while Francis with his cross and Dominic with his lily are depicted in three-quarter view. The Byzantine training of the painter is apparent in the way he handles the

Plate 5.25 *Saints Eleutherios, Francis, Anne and Catherine*, end of the fifteenth century, tempera on panel,
25 × 19 cm, Civici Musei di Storia ed Arte, Trieste (no. 675). Used with the permission of the Civici Musei di Storia
ed Arte di Trieste.

Plate 5.26 Attributed to Ioannes Permeniates, *Saints Peter, Francis and Dominic*, first decades of the sixteenth century, tempera on panel, 56 × 77 cm, Pinacoteca, Vicenza (A-172).

rendering of Peter's face with the dark undertones and the harsh, white highlights around the eyes and the forehead. In contrast, the faces of the other two saints are rendered in a much 'lighter' manner. The outlines of the drapery on Peter's and Francis's garments, like the former's facial characteristics, are equally harsh and rigid. What attracts our attention here, however, is the panoramic landscape that is revealed in the background and is in clear contrast with the rigidity of the saints – Peter in particular – in the foreground. Hills with castles, lakes and rich vegetation stretch into the far distance, while immediately behind the saints two shepherds with their dog and flock can be seen to the left, and a man wearing exotic garments and headdress, associated with Turkish costumes, and riding one of his two camels is visible to the right.[85]

Interest in an elaborate, detailed and often impressive background is one of the characteristics of Cretan icon painting at the turn of the sixteenth century. An example is offered by a painting with the rare iconographic subject (by Orthodox

standards) of *Christ and the Samaritan Woman* (Plate 5.27). The rendering of the colours and the attention that the painter has paid to the slightest of details (such as the person walking in the far background immediately to the right of the mountain complex) betray an extremely skilful artist. Since Zafuris is known for his interest in such careful rendering of details, it is possible that this icon could be attributed to this student of Angelos.[86] It has been suggested that the composition of the landscape in Cretan art was influenced by fourteenth- and fifteenth-century Italian painting, specifically by Ambrogio Lorenzetti (*c.*1290–1348) and Gentile da Fabriano (*c.*1385–1427).[87] It is more likely, however, that Giovanni Bellini (*c.*1431–1516) is the influence seen here, as well as in the previous work (Plate 5.26).[88] Regardless, the painter of this icon clearly demonstrates his Byzantine training: right in the middle of the scene at the back, serving as a distant framing 'curtain' for the main action on the foreground, he placed a mountain rendered

Plate 5.27 *Christ and the Samaritan Woman*, late fifteenth century, tempera on panel, 39 × 48 cm, Kanellopoulos Museum, Athens. © Byzantine Museum of Athens. Photo: M. Skiadaresis.

in typical Byzantine manner. The mountain dominates this impressive landscape, and could be interpreted as a signature of a Cretan artist. During the second half of the sixteenth century, one of the most celebrated artists of Cretan panel painting, Michael Damaskinos (*c*.1535–92/3), portrayed mountains in a similarly suggestive way.[89]

Similar elements of a detailed – and clearly popular – background are also found in another work, this time signed, by Permeniates (Plate 5.28), while displaying influences by Bellini and possibly Cima da Conegliano (*c*.1459–1517).[90] Here the *Virgin Galaktotrophousa* is depicted in the foreground in a way that has been argued to be 'un-Byzantine': full-length and enthroned.[91] This opinion could challenged by a number of full-length, enthroned Virgins that survive from the early, middle and late Byzantine periods.[92] The marble throne bears the signature of the painter in Latin, 'IOANNES

PERMENIATES P[inxit]', on a label on its base. Three angels can be seen above: the one in the middle crowns the Virgin – an 'un-Byzantine' iconographic detail – while the other two hold a cloth with gold embroidery behind her head. The fabric acts as a frame that emphasises and focuses the eye on the Virgin and Child. In other words, it underlines their importance and presents them to the viewer in a manner that confirms their regal (i.e. superior) status.[93] The Virgin and Child are flanked by Saints John the Baptist to the left and Augustine to the right. John the Baptist points at the Child with the index finger of his right hand, while in his left he holds a staff with a cross at the top and a banner with the Latin inscription 'ECCE AGNUS DEI' (also seen in Plate 5.21). Augustine wears a mitre decorated with precious and semi-precious stones, holds a book with both hands, and supports a staff with the inside of

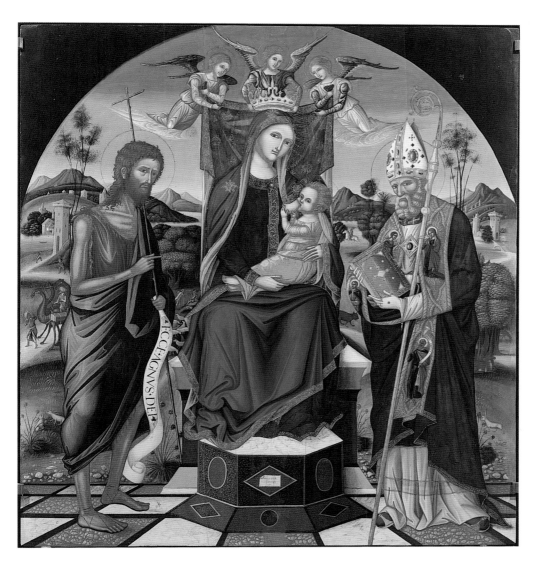

Plate 5.28 Ioannes Permeniates, *The Virgin and Child Enthroned with Saints John the Baptist and Augustine*, first decades of the sixteenth century, tempera on panel, 126 × 116 cm, Museo Correr, Venice (no. 214). Photo: Fotoflash Mario, Venice.

his left arm. His garments, much richer than the Baptist's plain clothing, include an elaborate cope, a long, narrow piece of cloth worn around the neck, which depicts the Annunciation on an embroidered border or 'frieze', with Gabriel to the left and the Virgin to the right and two prophets underneath, the one to the right being Isaiah, who prophesised about the Incarnation. The presence of Saint Augustine, whose features are very close to those of Saint Peter seen previously (Plate 5.26), implying a common model, may be explained from the original setting of the icon: an altarpiece that belonged to the Scuola dei Botteri (confraternity of the barrel makers) in Venice until 1840. Augustine, the patron saint of brewers, was probably also considered one of the confraternity's patron saints. Tradition has it that this icon came from Candia, which cannot be verified or rejected, since we do not know either its exact date or when Permeniates settled in Venice.[94] Since icons by him in a 'pure'

Byzantine style exist, it is obvious that in this painting the artist has moved a long way from his roots.[95] The same question posed at the beginning of the chapter regarding Ritzos is also valid here: if this were the only surviving example of the artist's work, would we have guessed that he was trained in the Byzantine manner?

6 Questions of identity

As noted above, the Greek confraternity was formed in Venice in 1498.[96] After this point Venetian artists started accepting not only the presence of Greek painters in their city, but also the fact that they were working on commissions. Moreover, the fame they enjoyed is suggested by the fact that many Cretan artists, regardless of where they were based and working, underlined their provenance by proudly placing next to their

signatures 'de Candia' (from Candia), which also may have served as a guarantee for the patron of the quality of the work they were receiving.[97] A similar reputation was established by Sienese artists in the painting of altarpieces.[98] At the same time, the example of Theophanes (discussed above) shows that this fame was equally sought after within the Greek world.

Venice, 'another Byzantium',[99] was doubtless the major artistic point of reference for Cretan painters after 1453, just as Constantinople had been until then. Permeniates offers one of countless examples of Cretan artists who emigrated to the republic. However, Crete – and Candia in particular – was the main centre of icon production. The contracts of 1499 confirm this, though this activity was also spread to the Ionian islands, the Adriatic coast (the Balkans in general) and even to Cyprus. As we have seen, the audience for this art included both Greek Orthodox and Catholics; the latter group probably included Venetians as well as other Italians and northern Europeans in general.

This situation presents a problem that on the surface might seem to be merely one of nomenclature. It is, however, one of identity: to what 'school' do these works, and the artists who produced them, belong: 'Creto-Venetian', 'Veneto-Cretan' (or 'Greco-Italian', 'Italo-Greek') or simply 'Cretan'? The answer to this question, if it exists at all, is anything but straightforward. The impact and influence of Venice in the emergence of hybrid Cretan artistic production cannot be denied. However, the 'seeds' for the generations of painters with the ability to paint equally in both manners were planted and cultivated on Crete, exactly because the 'soil' offered by its social circumstances was ideal. Therefore, the term 'Veneto-Cretan' might be inappropriate because it assigns to Venice the primary role it did not have.

If we opt for the term 'Cretan', which was used by the painters themselves as part of their signature, whom should we include? Surely, it must incorporate not only those with a Greek Orthodox background, but also painters of a mixed as well as Venetian background who were born and trained in Candia. Furthermore, Crete presented an attractive prospect for some painters who chose to go there in order to be trained in this bilingual art – it is known that immigrant Venetian painters were living in Candia from the fourteenth century onwards.[100] At the same time, we cannot forget that Venice must have been very appealing for ambitious Cretan artists, especially after the establishment of the Greek confraternity there in 1498. Apart from Permeniates, other acclaimed painters such as Michael Damaskinos and Domenikos Theotokopoulos, better known as El Greco (1541–1614) and certainly the best-known Cretan painter worldwide, made this journey. Permeniates settled in Venice permanently, while Damaskinos eventually returned to Candia. El Greco explored a different career path altogether. He moved to Toledo in Spain and took Byzantine and post-Byzantine art to a different level: the minimalistic rendering of form, the lack of preoccupation with the physical space, and the detached spirituality – characteristic elements of his later works – are all trademarks of 'pure' Byzantine art.

Could the term 'Cretan' also be applied to works produced by artists such as Permeniates, who chose to settle in Venice instead of just visiting and working there for a brief spell? Or should these artists be placed in a different category?[101] Compared to Candia, cross-cultural influences in Venice must have been somewhat diminished, while at the same time western influences must have been wider and more varied. For these artists, it might be wrong not to give credit to Venice and to omit the 'Veneto' prefix from the term; nevertheless, such works still retain a Cretan 'character'. But is it really a good idea to try to place a label on a 'school' which encompasses not only strong hybrid elements but also artists with a tendency to travel and to assimilate? Would it be better perhaps to accept that the social circumstances on Crete led to the emergence of a 'class' of painters with the capacity to paint in a bilingual manner? Crete provides the common ground for all these 'categories', and it enabled painters such as Pavias, Ritzos, Theophanes and El Greco to proudly state their place of origin – they were all Cretans. Almost certainly, both the painters and their clients regarded their works as such, regardless of whether or not they were produced on the island. In 2002–3, an exhibition was held at the Onassis Cultural Center in New York with the title 'Post-Byzantium: The Greek Renaissance'; post-Byzantium was hailed as 'an artistic heyday after a political collapse'.[102] The term 'Greek Renaissance' might, indeed, offer a solution that reflects the richness and diversity of post-Byzantine art. Although there are unquestionable differences between Italian Renaissance and post-Byzantine artistic

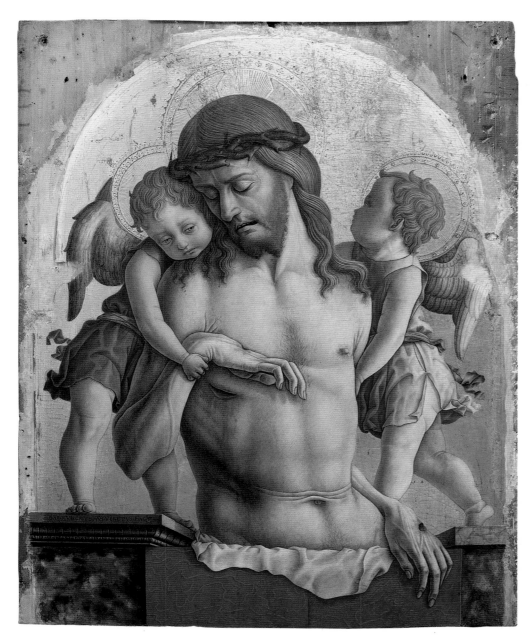

Plate 5.29 Carlo Crivelli, *The Dead Christ Supported by Two Angels* (*Man of Sorrows*), *c.*1470–5, tempera on panel, 72 × 55 cm, National Gallery, London. Photo: © The National Gallery, London.

production, there is a common denominator that characterises both: the emergence of a new era receptive to new influences and willing to adapt and expand its horizons. From this perspective, is it not time we viewed the Renaissance not just as an Italian 'miracle' but rather as a European 'phenomenon', the different manifestations of which are rooted in its multicultural contexts?

Although western influences were pivotal for post-Byzantine art, the latter may not have had a direct (or even indirect) impact on the majority of the artists who were working on prestigious projects in Siena, Florence and Rome during this period. It cannot be denied, however, that aspects of Byzantine art did influence Italian painters

working in Italy during the fifteenth century. Byzantine style and iconography are detectable in the work of the young Giovanni Bellini and Carlo Crivelli (*c.*1430–95). A comparison between Crivelli's *Dead Christ Supported by Two Angels* (Plate 5.29) with a twelfth-century Byzantine *Akra Tapeinosis* (Utmost Humiliation) (Plate 5.30) demonstrates this (the iconographic type of both panels is also known as *Man of Sorrows*).[103] Both artists unmistakably invite contemplation over the dead Christ and his suffering. Crivelli's Christ succeeds in displaying typical Byzantine characteristics such as dignity, solitariness and austerity. The Venetian painter uses hard outlines for the body of Christ, just like the icon. Christ's temporary 'surrender' to death is captured in both

Plate 5.30 *Akra Tapeinosis* (*Man of Sorrows*) (bilateral icon, painted on both sides with different iconographic subjects; on this icon the other side depicts a Virgin and Child of the Hodegetria type), second half of the twelfth century, tempera on panel, 115 × 78 cm, Byzantine Museum, Kastoria. Used with the permission of the Hellenic Republic Ministry of Culture.

works on his face, especially his mouth: Crivelli leaves it slightly open, while the anonymous Byzantine master shuts it firmly and frames it with the drooping moustache. In both works Christ's eyes are firmly shut and framed between strong eyebrows and dark lines underneath the eyes, his nose elongated with a prominent bulge on the visible left nostril – a typical stylistic feature in Byzantine art for Christ and the Virgin. In short, both works have succeded in presenting Christ at the peak of his humiliation, at his *Akra Tapeinosis* – this is truly a Man of Sorrows. Crivelli demonstrates here a strong stylistic affiliation with Byzantine art. If one takes into consideration that the Cretan painter Zafuris was influenced in his *Man of Sorrows* by Giovanni Bellini, is it not tempting to detect a network of influences from Byzantine to western (i.e. Italian) to post-Byzantine art?[104]

7 Conclusion

Having explored the characteristics of icons, I would suggest that all the hybrid works presented in this chapter fall into this category. The 1499 contracts refer to all the works as *incone*, a clear indication that the dealers both regarded them as icons and were planning to sell them as such. Although Andreas Cornaros did not fail to appreciate the artistic merit of Ritzos' IHS panel (Plate 5.2), the fact that he kept it in his bedroom is an indication that he was probably treating it as an icon. The hybrid icons are essentially based on icons. If a panel is copied from one or more icons (e.g. if it depicts more than one saintly person or event), its prototype(s) goes back to a 'life portrait' of the particular saintly person(s) depicted or to an event, and there can be no doubt that the new work is an icon, incorporating its spirituality.[105] This is certainly true for the countless panels depicting the Virgin, hybrid or not, since fundamentally they are all 'rooted' in the *Virgin Hodegetria*, which, according to legend, was painted by Saint Luke himself. This also offers an explanation of why Zafuris' *Madre della Consolazione* (Plate 5.17), for example, was perceived as an icon by its audiences, while a contemporary panel by Bellini with the same subject (e.g. similar to the one hanging in Saint Ursula's bedroom in the Carpaccio painting, Plate 5.16) would be classified as a 'devotional panel'. The *Madre della Consolazione* type was introduced into post-Byzantine art during the

fifteenth century and was by no means part of the 'old, traditional Byzantine school' of iconographic types. However, what assigns to it the quality of an icon is that its audiences viewed it and perceived it as one on the basis that it is closely connected to and rooted in a 'pure' iconographic type, such as the *Virgin Hodegetria*. Furthermore, it would be reasonable to accept, at least to a certain level, that a Greek environment or provenance, hybrid or not, is also closely connected to the concept of 'icon'.

However, the market appeal of the hybrid icons should not overshadow the fact that icons of a 'pure' Byzantine style continued to be produced on Crete during the post-Byzantine period, particularly for churches. *Saint John the Baptist with Wings*, the iconographic type created by Angelos, illustrates this point: the type was at first destined to be part of a templon, which is probably the reason why it never found its way into western iconography.[106] Thus post-Byzantine artists, while adapting for western appeal, did not forget their 'original' audience. They succeeded in making traditional Byzantine art more receptive to change and to new types, while at the same time keeping intact certain aspects of their cultural and religious identity.

Provided we are aware of the context that prevailed on Crete during its long Venetian occupation, there can be no doubt that even if only the two works survived from the *oeuvre* of Ritzos and Permeniates (Plates 5.2 and 5.28), we would have assumed they were trained as bilingual painters. In fact, the depiction of both the Byzantine Harrowing of Hell and the western Resurrection in Ritzos' work leaves no room for hesitation. The same assumption has been proven to be correct for Zafuris, for whom the belief that he was bilingually trained has only recently been verified with the discovery of a signed icon of 'pure' Byzantine style.[107]

While the evidence points to a peak in the icon market, two negative views on Byzantine style as a whole have disproportionately coloured western perceptions. Cennino Cennini, the fourteenth-century Florentine painter and treatise writer, said that medieval painting was associated with the recent Greek, that is to say Byzantine, style.[108] And had Vasari been responsible for the preservation of Byzantine art in the sixteenth century, we might not even have heard of it, so low was his opinion.[109] Subjective though these views may be, they reflect contemporary Florentine tastes. But such views

Plate 5.31 The *Virgin Hodegetria* set in an Italian painting by Gaspare Diziani; icon: beginning of the sixteenth century, tempera on panel, 40 × 31 cm; painting-frame: eighteenth century, oil on canvas, Museo Correr, Venice (no. 1904B). Photo: Fotoflash Mario, Venice.

are unavoidably subject to change. Today a number of scholars would defend the 'beauty' of Byzantine art, which, in part at least, is embedded in its spirituality. Furthermore, Cennini's and Vasari's opinions seem to be preoccupied with style rather than 'essence'. And the 'essence' of Byzantine art lies primarily in the spiritual message that it embodies and conveys, not in its 'naturalism' or decorative function. While many works of the Italian Renaissance had a highly decorative function (see, for example, Plates 1.14 and 1.15), this was not the primary role of post-Byzantine or even hybrid icon production. A lucid illustration of this point is provided by a painting by Gaspare Diziani (1689–1767) that acts as a frame for a sixteenth-century icon of the Virgin (Plate 5.31). The painting-frame with Saints Joseph (left) and John the Baptist (right) certainly clashes in technique, style and use of colour with the icon, but together they convey a clear message about the icon's spirituality. Therefore, I tend to disagree

– and so would the evidence of the 1497 and 1499 contracts – with Robert Maniura's statement concerning Rogier van der Weyden's *Saint Luke Drawing the Virgin*: 'The [Netherlandish] viewer no longer needs icons imported from the East or "not made by human hands": the images made in the viewer's own culture are a more than adequate focus for devotion.'[110] In any case, the influence of Byzantine images of the Virgin and Child on northern European artists has been acknowledged.[111] I believe it has been demonstrated that the adaptability of Byzantine art ensured its appeal, even in fifteenth- and sixteenth-century Florence, partly (or mainly) because its main asset – spirituality – was sought after by a multicultural clientele, but also because it is very hard to 'copy' works rooted in other cultural contexts. For the comprehension of the Renaissance as a pan-European phenomenon rather than an Italian miracle, the study of post-Byzantine icons is truly revealing.

Chapter 6 introduction

It is sometimes said that pre-Reformation Europe was obsessed with death. Whether this is accurate or not, it is certainly true that a high proportion of Renaissance works of art are connected with death in one way or another. At the most basic level, commissioning a religious work of art for a church, monastery or chapel constituted a 'good work' that accrued merit, and with it a remission of sins. This meant that the time an individual spent atoning for their sins in purgatory after death could be reduced. It was clearly in the interests of the living to reduce their sufferings after death in whatever manner possible. Indulgences – that is, documents granting a similar remission of sins – might also be acquired on payment of a fee, and these indulgences were sometimes issued to pay for specific artistic projects, most famously the rebuilding of St Peter's in Rome. Hence an individual's anxiety about death might pay for religious works of art in more ways than one. Both indulgences and the doctrine of purgatory came under attack during the Protestant Reformation, but up to the 1520s they retained their power for all except the most critical humanists and reformers.

In this chapter, Carol Richardson examines works of art more closely connected with the moment of death itself. Tombs commemorated more wealthy individuals in churches and burial chapels; altarpieces decorated the chapels in hospitals caring for the sick and dying. The *danse macabre*, popular in painted and printed form, and the blockbook or printed book entitled the *Ars moriendi* or *Art of Dying* reminded the viewer of death as the great leveller of social and religious status and of the need to be prepared for one's own demise. In addition, a wide range of art might serve as a 'memento mori' or reminder of death, from Mantegna's painting of the *Lamentation over the Dead Christ* (Plate 6.17) to Holbein's portraits, which recorded the transient likeness of an individual at a particular moment in time (discussed in Chapter 7).

Tombs and monuments (and once again Holbein's portraits) were also about preserving the memory of the dead and celebrating their dynastic connections, achievements and status. Maximilian I of Austria is probably the most extreme example of a ruler anxious to assert his dynastic and territorial assets: his tomb project was planned to include some 40 bronze statues of ancestors and family as well as a series of alabaster reliefs narrating significant events from his life around his tomb chest. In dying, his mortal remains would join this illustrious company of ancestors, except that ironically they never did, for his tomb project was completed by his grandson in the newly built Hofkirche in Innsbruck, while Maximilian's body remained interred in Wiener Neustadt.

Kim W. Woods

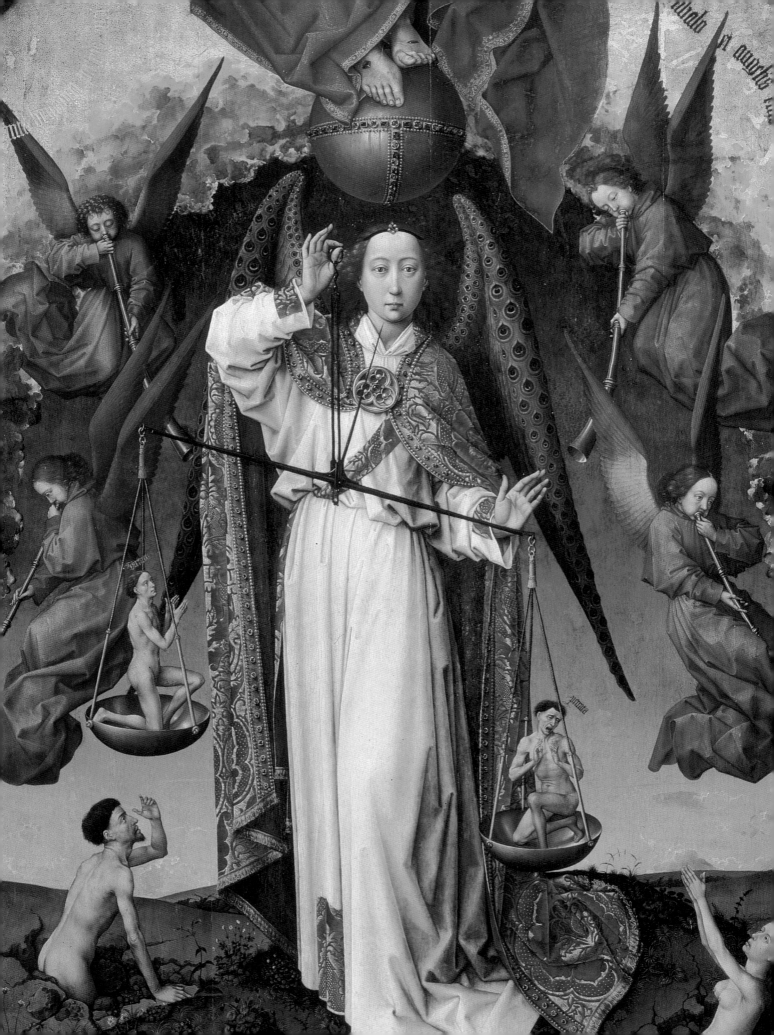

Chapter 6

Art and death

Carol M. Richardson

If the soul dies with the body, as Epicurus wrongly supposed, fame can advantage it nothing. If on the other hand the soul lives on after it is released from this corporeal frame, as Christians and the noblest philosophers tell us, it either suffers a wretched lot or joins the company of happy spirits … Why then do we so strive for the glory of a fair name? Do souls in Purgatory perhaps taste some sweetness from the reputation they left on earth? But let the argumentative think what they please about the dead, provided they do not deny that while men live they take pleasure in the glory of the present, which they hope will continue after death. It is this which sustains the most brilliant intellects and even more than the hope of a celestial life, which once begun shall never end, cheers and refreshes the heart of man.[1]

These opening lines of the *Commentaries* of Aeneas Sylvius Piccolomini (Pope Pius II) sum up the constant awareness in the fifteenth and early sixteenth centuries of death and dying as intrinsic to life and living. Rather surprisingly, perhaps, Pius does not focus exclusively on the question of heaven or hell after death. Instead he makes it clear that death raises another issue for the living: that of reputation, which, like the soul, lives on after death. This chapter explores a range of works of art – from monuments to manuscripts – that were commissioned with death in mind, and the aspiration to salvation in heaven and a lasting posthumous reputation on earth with which death was inextricably linked. They offer an important insight into the attitudes and beliefs that lay behind their creation, and how they, and that of so many other works of art from the same period, were viewed.

The most immediate danger associated with death, however, was not hell but purgatory, which no one could avoid in pre-Reformation western Christendom. Purgatory was understood as a kind of anteroom to heaven, where the saved were purged of any last vestiges of their sins through punishment appropriate for whichever of the seven deadly sins they had committed.[2] Wynkyn de Worde's *The Art or Craft to Live Well* (1505) describes how the proud, for example, were pinned to wheels with burning hooks so that they were constantly raised and lowered as it rotated – a fitting punishment for their sin. How long the process of purgatory took was largely up to the prayers of the living. There was concern that the faithful thought they could do what they liked during their lives just as long as they repented their sins on their deathbeds to avoid eternal damnation in hell. So writers such as Thomas More in England emphasised that it was living well and doing good deeds that shortened the tortures of purgatory. Good deeds included remembering one's dead ancestors by praying for them, giving charitably on their behalf and keeping their memory alive. Indeed, to be forgotten in death was to be left forever in a state of limbo. A huge effort, therefore, went into ensuring that one's memory was kept alive after death and paying due service to the memory of one's relatives.

Some were remarkably wily in ensuring that prayers were said in perpetuity for their souls without the need for spending large sums of money on altars and priests. One way to do this was to donate a chalice to a church with one's name or coat of arms on its side or base. Thus, when the chalice was raised by the priest during the Mass, he would look up and remember the name of the benefactor. An even cheaper way was to donate linen clothes to a church to be made into liturgical cloths.[3]

Plate 6.1 (Facing page) Rogier van der Weyden, detail from *Last Judgement* (open) (Plate 6.14).

These very personal items would be used during the Mass, thus locating the deceased individual at the very heart of the Church's most significant celebration.[4] Donatello's bronze floor tomb in Siena Cathedral for Giovanni Bartolomeo Pecci, Bishop of Grosseto, located his patron at the heart of the Mass in more literal terms. When the low relief is seen *in situ*, the corpse looks as though it is laid out within an oval bier complete with handles, the feet projecting forward (Plate 6.2). Although it has since been moved to a side chapel, the floor monument was originally in front of the high altar – the 'honourable location' Pecci requested in his will. In that location it would have been visible between the priests at the altar and the congregation in the nave when the priest turned to administer the sacrament and to give the blessing.[5] Therefore, while Pecci's choice of a floor tomb (rather than a wall monument) could be interpreted as a humble act, it enabled the tomb to be located where it was both visible and incorporated into one of the main liturgical celebrations in the cathedral, thus keeping the bishop's memory alive and helping his passage through purgatory.

Erwin Panofsky in his *Tomb Sculpture*, first published in 1964, characterised the Renaissance as a period of increasing secularisation. The living sought to hang onto their worldly trappings and celebrate their life's achievements, looking more to the past with regret than to the future with hope: 'a rejection of Christian concern for the future in favour of pagan glorification of the past'.[6] More recently, the arts of death have been studied in the context of popular belief structures and personal motivations for memorialisation, arriving at very different conclusions. Eamon Duffy, in his book about popular religion in England between 1400 and 1580, argues that tombs and memorials – an important part of the preparation for death – were not so much a 'reward' for life, and therefore an attempt to counteract the oblivion of death, but rather the result of a powerful sense of community between earth and heaven.[7] In Duffy's view, the formal and visible elements of dying and death – last wills and testaments, inventories, funerals and tombs – should be understood as evidence that the living wanted to count, celebrate and gather together their possessions, families and achievements as 'post-mortem fire insurance' to take them fully prepared into death.[8] While this was a concern for every member of society, this chapter focuses on wealthy patrons, who had

Plate 6.2 Donatello, tomb of Bishop Giovanni Pecci, *c*.1428, bronze, 247 × 88 cm, Siena Cathedral. Photo: © 2001 Opera Metropolitana Siena/Scala, Florence.

biblical incentive to spend their money on works of art to prove their worth: 'it is easier for a camel to go through the eye of a needle than for a rich man to enter the kingdom of God' (Mark 10:25).

1 Memorials, morals and the macabre

The governing statutes (*c*.1448) of the foundation at Ewelme in Oxfordshire explain the patrons' intentions behind the charitable institution:

Plate 6.3 Tomb of Alice de la Pole, *c.*1470, alabaster and stone, life-size, Saint Mary's Church, Ewelme. Photo: Malcolm Daisley, e-motif photography.

Because all Christian people, meekly and devoutly considering how, by the upholding and maintaining of Divine Service and by the exercise of works of mercy in the state of this deadly life, in the last dreadful day of Doom, with the mercy of Our Lord, [shall] take their part and portion of joy and bliss with them that shall be saved; [therefore all Christians] ought of reason [to] have a great and a fervent desire, and a busy charge in mind to uphold and maintain Divine Service, and to exercise, fulfil and do works of mercy before the end of their mortal life.[9]

The memorial of Alice de la Pole (1404–76) at Ewelme is part of an unusually complete survival of an extensive charitable institution founded in 1437. It was dedicated to doing good works on behalf of its wealthy founders and to keeping their memory alive, as John Goodall has demonstrated.[10] It included a chapel, school and almshouses endowed with the sum of £59 for the benefit of 13 poor men, who would have their spiritual and educational development looked after by two priests.[11] The bequest was not entirely without obligation on those in receipt of this charity, however. Living in a quasi-monastic arrangement, each with his own room round a cloister connected to the church by a stair and sharing meals in a common dining room, the men were obliged to take part in regular services throughout the day at the chapel of Saint John the Baptist adjoining the chancel of the church. Here they prayed for the souls of King Henry VI, William and Alice de la Pole and their parents, and all Christians.[12] Alice's tomb (Plate 6.3) is a feature of the chapel and a focus of the chantry itself, a private institution popular in England from the fourteenth century. Chantries did not always result in chapels or tombs, however: they consisted primarily of the provision of whatever was necessary for prayers and masses to be said for the souls of the patron and his or her family in purgatory.[13]

The chapel was started by Alice's father, Thomas Chaucer (son of the poet and courtier Geoffrey Chaucer), and added to the existing church of Saint Mary the Virgin at Ewelme. The complex of church, school and almshouses also included a large manor house frequented by Alice and her husband, William de la Pole, both of whom were important

Plate 6.4 Detail of effigy, tomb of Alice de la Pole, Saint Mary's Church, Ewelme. Photo: Malcolm Daisley, e-motif photography.

political players. Ewelme was a particularly important part of the couple's extensive estates because it was close to Windsor and the royal palace that was Henry VI's favourite. It was as a result of their loyalty to the Crown that Alice and William were made Duke and Duchess of Suffolk in 1448, which prompted the consolidation of their patronage at Ewelme and the establishment of the governing statutes the same year. But when William de la Pole died at sea in 1450, he was buried in Wingfield near Hull as he requested in his will, in the de la Pole chantry which his wife restored.[14] Left to exploit her considerable dynastic network on her own, Alice was able to commission her own monument, a relatively rare achievement for a woman.

Alice's tomb monument is carefully designed to preserve her noble memory for posterity while also conveying her humility and evoking prayer for the passage of her soul through purgatory. The tomb is set into an ornamented niche open to both the chapel and the church; the niche frames the tomb chest, which is embellished with shield-bearing

angels declaring her pedigree. Heraldic devices are repeated through the chapel itself. Alice's fine effigy wears a ducal coronet and the Garter on her left arm (as opposed to her upper leg, where men who were members of the Order of the Garter wore it) signifying her status as Duchess of Suffolk (Plate 6.4).[15] The long features and pronounced chin – as opposed to rounder, more idealised features usually reserved for effigies of women – may even betray elements of portraiture. The effigy is made of alabaster (gypsum), a particularly sought-after material by the middle of the fifteenth century.[16]

In addition to these signals of her status, with her hands together in perpetual prayer the effigy also represents Alice's piety, an attribute embodied in the whole donation to Ewelme. Although she is clearly a duchess, her dress is typical of that of both a widow and a vowess; around her belt, just visible under her tabard, which might also be interpreted as the scapula (a long narrow strip of fabric worn over the long tunic or habit) of a religious order, is a rosary. On her husband's death in 1450, Alice probably took the vows of a religious

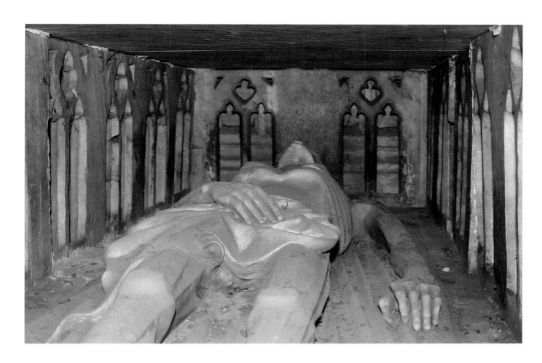

Plate 6.5 Cadaver effigy, tomb of Alice de la Pole, Saint Mary's Church, Ewelme. Photo: Malcolm Daisley, e-motif photography.

order, a pious act for a widow but also a shrewd move for a woman who wanted to protect her new-found independence since her vows would have committed her to a life of chastity and celibacy. Around the effigy is an inscription (restored in the nineteenth century) begging the viewer to 'Pray for the soul of the most serene princess, Alice, Duchess of Suffolk'.[17] This makes the purpose of the tomb clear: it was designed to keep her memory alive and to bear witness to her life's achievement so that those who prayed for her would help the passage of her soul through purgatory. Ambiguities in the tomb and effigy represent Alice's place between the living and the dead: the finely ornamented architectural canopy above her head and fall of the drapery suggest that the effigy is standing (particularly apparent if the photograph is turned 90 degrees). The cushion behind her head makes sense if she is recumbent, but the angels holding it seem to be clinging to the side of the bier with their large feet, again as though the effigy is in fact standing in a niche.

The humility of the donor is further emphasised by a second effigy representing Alice as a cadaver, this time just visible through biforate Gothic windows beneath the tomb chest – the only such effigy of a woman surviving in England (Plate 6.5). The eyes are slightly open as though contemplating the paintings on the underside of the tomb chest, which represent John the Baptist, patron of the chapel, Mary Magdalene and the annunciation. It would

not have been seemly to display the semi-naked body of a woman and a duchess, however dead, in too obvious a way – by putting it on top of the chest, for example. Alice's cadaver effigy should perhaps be interpreted more as evidence of the patron's humility – that she was not afraid of her own death despite her considerable status – than as a warning to the living.

The tomb of John Baret, a wealthy cloth merchant from Bury St Edmunds who was buried in the church of Saint Mary there, is a much more public cadaver tomb: here the corpse is in full view on top of the tomb chest (Plate 6.6). Baret commissioned his monument during the 1450s, more than a decade before his death in 1467, primarily as a public act of piety. Instead of Alice's alabaster, it is made of cheaper limestone, a material appropriate for representing the patron's humility. The tomb contributed to the spiritual welfare of those who visited the church, as it was designed to shock viewers into both taking stock of their own lives and praying for Baret himself. This intention is made clear in an inscription at the end of the tomb: 'He that will sadly behold me with his eye, may see his own morrow and learn for to die.'[18] But this 'macabre moralism' was combined with the ultimate hope of resurrection: while the body died, the soul lived on and would be reunited with the body at the Last Judgement. The cadaver effigy is a dramatic representation of the suffering that is an integral reality of life and death, but one that could

be replaced with the hope of a far more glorious afterlife, as long as the suffering was borne with grace and dignity.[19]

Pamela King suggests that the cadaver effigy was adopted in England among particular patrons because through it they could represent their political alliegance to the Lancastrians.[20] Originally a French innovation, the earliest cadaver effigies date from the second half of the fourteenth century and appear slightly later in England. The earliest surviving tomb in England that includes a cadaver effigy is that of Archbishop Henry Chichele in Canterbury Cathedral. Although Chichele did not die until 1443, his tomb was already in place by 1427; like Baret's, it was a public example of his readiness for death and a warning to the living to live well while there is time. Chichele was a favourite of Henry VI, who ruled 1428–61 and 1470–1 during the dynastic wrangling between the two sides of the Plantagenet family – the house of Lancaster and the house of York. Henry VI represented the ascendancy of the Lancastrian party, to which Alice Chaucer, the king's great-niece (on her mother's side), and her husband belonged. John Baret was also a Lancastrian, and

a distant relative of the Chaucers. Indeed, he left a spoon to Alice in his will. His tomb and the ceiling of the chantry are decorated with scrolls inscribed with the Lancastrian motto 'Grace me Gouerne' (God's grace guide me), and with collars of 'SS', the Lancastrian badge.[21] These blood ties between Alice and Baret, however distant, were therefore strengthened by political links displayed through artistic choices such as the cadaver effigies, according to King.

Alice de la Pole survived the death of her husband and the fall of the house of Lancaster to remain one of the wealthiest and most influential women in England in the middle of the fifteenth century. Even in 1461, when the Yorkist party was successful in gaining the throne for Edward IV, she rode the storm as she had managed to get her son John married to Elizabeth Plantagenet, the new king's sister. It was around 1470, the same year that the Lancastrian party briefly regained the throne, that Alice, by then in her late 60s, turned her attention to her own monument, which was probably in place at Ewelme by 1475.[22] She died in May 1476, about 71 years old. Taken together, as John Goodall explains, the foundation at Ewelme

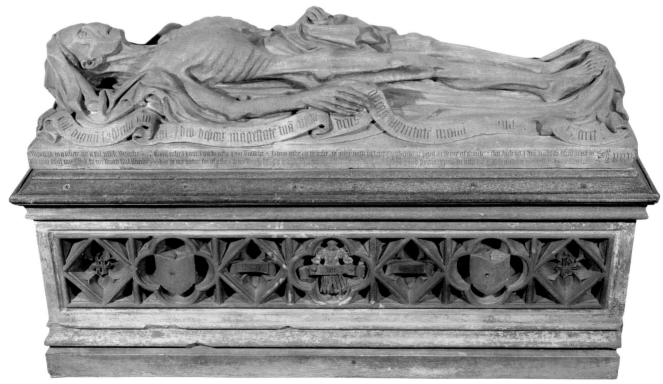

Plate 6.6 Cadaver effigy and tomb of John Baret, 1450s, limestone with traces of paint and Purbeck marble, 170 × 73 cm, Saint Mary's Church, Bury St Edmunds. Photo: V&A Images/Victoria and Albert Museum, with kind permission of Saint Mary's Church, Bury St Edmunds.

– the school, almshouses, chapel and Alice's tomb, together with that of her parents – combine to embrace 'concerns of piety, patronage and politics, which our contemporary world, with the sharp distinctions it has chosen to draw between them, find difficult to reconcile'.[23]

2 The fine arts of dying well

Ars moriendi

The task of preparing for death during life was an important one, and prints and paintings played their part in both the public and private sphere. One of the most popular manuscripts and early printed books was the *Ars moriendi* or *Art of Dying*, which appeared in numerous versions across western Christendom; many of these can be directly linked in terms of design. One of the earliest and most influential editions was the *Ars moriendi* by the Master ES dating from the 1440s or 1450s (Plate 6.7).[24] In the 1490s, a French edition was made, one in a long line of derivations

Plate 6.7 Master ES, *The Triumph over All Temptation in the Hour of Death*, from *Ars moriendi*, mid-fifteenth century, woodcut on paper, 10 × 7 cm, Ashmolean Museum, Oxford, Douce Collection 1863.

and a close replica of that by the Master ES. In 1505, this French edition was copied by Wynkyn de Worde (d.1535), a printmaker who had worked for William Caxton (1422–91), the printer who had the first press in Britain: all the illustrations are identical but reversed, evidence that they were traced from the French edition directly onto the woodblock. The prints follow the last minute temptations of a dying man who, having reconciled himself with his neighbours and received absolution from the priest by the end of the series, has his soul received into heaven by angels who appear behind him. At the foot of the bed, devils wail at their lost battle for his soul.

Danse macabre

While the *Ars moriendi* prepared the living for the moment of their death, perhaps the most vivid representation of the constant awareness of death by the living is the *danse macabre*. The original *danse macabre* (dated before 1425) was located in the cloister at the cemetery of Les Innocents in Paris. The version that was most often reproduced in prints and murals throughout Europe combined the verses and images of the original.[25] The series represents all of humanity in strict social hierarchy, lay people intermixed with clergy: the pope is followed by the Holy Roman Emperor, the king by a cardinal, an abbot by a member of the nobility, a monk by a wealthy merchant, a priest by a peasant, and so on. Death, the great leveller, is represented as a grinning cadaver, often dancing and playing a musical instrument, who meets princes and peasants alike, revealing to them what they soon will be. The images and text quickly spread throughout northern Europe. When John Lydgate (1371–*c*.1450), a Benedictine monk and poet, was in Paris in 1426, for example, he translated the verses at Les Innocents into English. These were used slightly later in the version of the *danse macabre* at old St Paul's Cathedral in London, dated around 1440 (destroyed in 1549). The St Paul's series was then copied. Of the many examples originally in the British Isles, very few survived the Reformation intact: those at Hexham Abbey in Northumberland and at the Markham Chantry Chapel in the church of Saint Mary Magdalene, Newark, both dated to the first decade of the sixteenth century, are rare examples.[26] The plethora of derivative copies and variations in manuscripts, engravings and paintings gives some idea of what the Paris and

Plate 6.8 Bernt Notke, *Danse Macabre*, 1460s, tempera on linen, 150 × 750 cm, church of Saint Nicholas, Tallinn. Photo: Art Museum of Estonia/Bridgeman Art Library, London.

St Paul's cycles were like. The version of the *danse macabre* by Bernt Notke (active 1467–1509) from the church of Saint Nicholas in Tallinn, Estonia (Plate 6.8) is remarkable not only for its size – some 30 metres long – but also because it is painted on cloth rather than on a wall, and includes scenes designed for women (the original version at Paris only included men).

Panels from Simon Marmion's Saint-Omer altarpiece offer some ideas of how these large-scale cycles were viewed (Plate 6.9). The altarpiece includes in the background a representation of the cycle that was painted on the cloister walls of the Benedictine Abbey of Saint-Bertin at Saint-Omer in northern France, which is thought to have been a copy of the original at Les Innocents.

Plate 6.9 Simon Marmion, detail from *Scenes from the Life of Saint Bertin*, known as the Saint-Omer altarpiece, 1453, oil on panel, 56 × 147 cm, originally in the Abbey of Saint-Bertin, now Gemäldegalerie, Staatliche Museen, Berlin. Photo: © 2007 bpk/Gemäldegalerie, Staatliche Museen zu Berlin/Jörg P. Anders.

Plate 6.10 Master of Phillipe de Gueldre, *The Queen*, from *Danse macabre des femmes*, c.1500–10, parchment manuscript, folio 31 × 20 cm, Bibliothèque nationale de France, Paris, MS fr. 995, fol.25r. Photo: Bibliothèque nationale de France.

Figures in the cloister are shown contemplating the scenes as they move slowly around the space or sit to consider their own inevitable destiny, each one repeating the same encounter between death and the living. As Mark Meadow memorably put it, 'The almost numbing repetition of scenes, each different and yet also identical, can only lead to the conclusion that Death does claim all.'[27]

More portable manuscript and printed versions entailed the same process of moving from one image to another (by turning the pages) towards the inevitable culmination of the series – and of life itself: the Last Judgement. From the middle of the fifteenth century, the accompanying verses and images began to appear appended to printed Books of Hours and were widely disseminated. The *danse macabre* of men first appeared as a printed edition in 1485, around the same time as a series designed for women appeared as a manuscript. Various twists to the original are offered by the many derivative versions which appeared as either series or single images in books: in the version printed by Matthias Huss in Lyons in 1499, the printers, typesetters and booksellers who made a living selling such popular books are themselves depicted being taken by Death, while in a book of sermons printed in 1514 in Strasburg, Death is shown hunting men who are out looking for prey, turning the hunters into Death's prey.[28]

A particularly fine example of the series featuring women, the *Danse macabre des femmes*, is preserved in a manuscript version that probably dates to the first years of the sixteenth century (Plate 6.10). No public version of the women's cycle on its own is known, betraying the private domain of its target audience. Through the rich detail and colouring of manuscript illumination, the earthy representations of the woodcut versions are made more sophisticated, suitable as a luxury object for a royal or noble patron.[29]

The *Danse macabre des femmes* begins with four corpses playing musical instruments to begin the dance. In the accompanying text they mock women for their vanity and their knack for fooling themselves. One by one, women in all walks of life – from queens and abbesses, theologians and merchants to girls, debutantes, brides and widows – are approached by Death. The duchess, for example, is reluctant to leave her riches, while the prioress goes more willingly:

The duchess
I am not yet thirty.
Alas, when I am just beginning
To know what a good time really is,
Death comes to take away my pleasure.
I have such important friends,
Delights, amusements, such fun people,
That's why death is so displeasing to me.
Wealthy people die thus, in mid life.[30]

The prioress
I was [at home] in my vocation;
My whole desire to serve God
Through devotion in the cloister,
Reciting my hours at my leisure.
Now death has come to take me.
I do not regret the world.
May God do with me as He pleases.
We must receive Death gratefully.[31]

Like the original *danse macabre* for men, that for women has as its main theme the absolute equality of death, regardless of one's station in life. However, the theme is not the hopelessness of death itself but the necessity of living better. All women are reminded to be prepared for their end and to change their lives while they can. Given the didactic message of the scenes and text, the book could also be used for teaching purposes, and indeed some of the lessons are taught not by Death but by the author, who is represented as a scholar speaking to his pupils. In the last illumination, he appears at the tomb of the queen and points to her rotting cadaver:

Mortal woman and thoughtful soul,
If you do not wish to be damned after death,
You must today, if only once,
At least think of your hideous end
To die well and to live long.[32]

Popular prints

In addition to printed books, relatively cheap and portable individual prints also helped to satisfy the needs of the living for works of art that served as a reminder of death and therefore living well. These prints were designed to be pinned to a wall in the home as a constant reminder of the transience of life. Such is a print by an unknown Netherlandish artist known as the Master IAM of Zwolle, the *Allegory of the Transience of Life* (c.1480–90), in which Moses holds the tablets of the Ten Commandments above a rapidly decaying corpse, a reminder that it is only through obeying

Plate 6.11 Master IAM of Zwolle, *Allegory of the Transience of Life*, c.1480–90, coloured engraving, 32 × 23 cm, British Museum, London. Photo: © the Trustees of The British Museum.

God's law that salvation might be secured and death transcended (Plate 6.11).[33] A scroll above the skeleton warns, 'Whoever looks upon me, let them see what they will be and reject evil.'[34] The fact that so few examples of this kind of print survive is testimony to their constant use – and therefore destruction – in a domestic context.

Albrecht Dürer (1471–1528) produced some of the most imaginative images that reflect similar concerns as the *danse macabre*.[35] Among them was the *Knight, Death and the Devil* (Plate 6.12), one of three remarkable engravings, all unusually large for prints. Known as the 'Master Engravings', they represent the height of his iconographic and technical skills. *Knight, Death and the Devil* was the first of the three, dated 1513, while *Saint Jerome in his Study* and *Melancholia I* followed in 1514. They have been related in the most general

terms through their subjects as examples of three different ways of life – the active and moral life of the knight, the contemplative spiritual life of the monk, and the intellectual life of the scholar.[36]

The knight in *Knight, Death and the Devil* stands as much for the Christian trying to live his life in a harsh world as for a soldier ready for battle – according to Paul's second letter to the Corinthians, 'we are not carrying on a worldly war'.[37] Behind the knight, riding an exhausted horse with its head bowed, is Death, face half rotted and hair entwined with worms and snakes. Following on behind is the devil, ready to take another soul. At the bottom left is a skull on the stump of a felled tree on which is propped the artist's distinctive monogram. But the knight and his horse are not distracted by any of these details and look straight ahead, accompanied by a running dog who looks up with a watchful eye, representing faith. At the same time, the print represents Dürer's response to some of the works of art he had encountered in Italy. He had visited Venice for a second time during his trip to Italy from 1505 to 1507, where he would have seen Andrea del Verrocchio's powerful equestrian statue at the Scuola di San Marco, erected in 1494 to the mercenary, Bartolomeo Colleoni. By the early 1500s Dürer was already displaying familiarity with studies of horses by Leonardo da Vinci (a pupil of Verrocchio), on which the print is almost certainly based.[38]

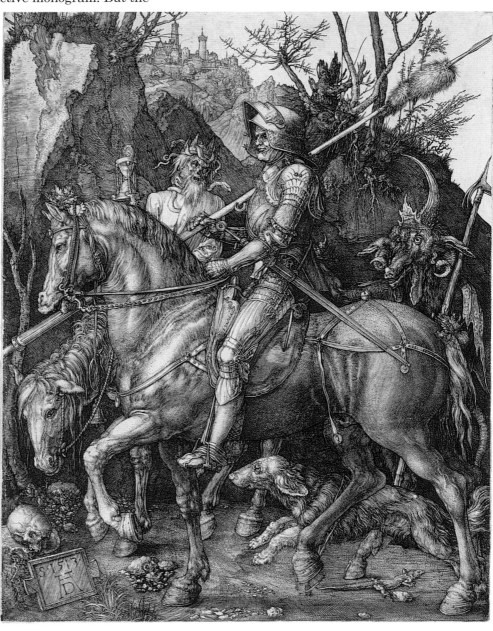

Plate 6.12 Albrecht Dürer, *Knight, Death and the Devil*, 1513, engraving, 25 × 19 cm, British Museum, London. Photo: © the Trustees of The British Museum.

Hospitals

If the living required visual reminders of the inevitability of death and the need to prepare for it, for those who were ill or at the point of death such visual messages were far more immediate. Those confined to hospitals were served by altarpieces that combined the moral duty of preparing the sick for a good death with the religious function of marking the altar. Caring for the sick by donating money to hospitals or even having new ones built was a particularly effective good deed for wealthy patrons to perform. In turn their charity could be celebrated in coats of arms and even portraits that would incorporate their own commemoration into the devotions of those who used the hospital. Like the chantry at Ewelme, those who enjoyed the services of the institution were expected to pray for their benefactors; thus, it was a mutually

beneficial relationship. Two of the most striking altarpieces created in Europe in the fifteenth and early sixteenth centuries served precisely these purposes: the polyptych of the *Last Judgement* by Rogier van de Weyden and the Isenheim altarpiece by Matthias Grünewald (*c.*1475/80–1528).

As Dirk de Vos puts it, 'the presence of death dominated the Hôtel-Dieu' at Beaune (see the map of key artistic sites in France, Plate 4.4). The hospital was a place for the sick and dying, while its convent and chapel were built to house the tomb of the patrons, Nicolas Rolin and his third wife Guigone de Salins, and preserve their memory. Beaune itself was particularly badly affected by the plague that swept Burgundy in the 1440s and was never far away. After 1422 when he became Chancellor of Burgundy, the most senior administrative position in the duchy, Rolin

Plate 6.13 Rogier van der Weyden, *Last Judgement* (closed), 1443–51, oil on panel, 220 × 273 cm, Musée de l'Hôtel-Dieu, Beaune. Photo: Hôtel-Dieu, Beaune, Paul Maeyart/Bridgeman Art Library, London.

Plate 6.14 Rogier van der Weyden, *Last Judgement* (open), 1443–51, oil on panel (6 of the 9 panels remounted on canvas), 220 × 548 cm, Musée de l'Hôtel-Dieu, Beaune. Photo: Hôtel-Dieu, Beaune, Paul Maeyart/Bridgeman Art Library, London.

amassed a huge fortune.[39] In 1440 at the age of about 64, he founded the Hôtel-Dieu at Beaune, a hospital for the sick served by a small community of nuns, which his wife joined when he eventually died in 1462. The hospice chapel was consecrated on 31 December 1451 by Rolin's son Jean, Cardinal and Bishop of Autun (d.1483). From 1459 two requiem masses a day were said in the chapel along with prayers for the donors' souls.

The altarpiece for the hospital's chapel was commissioned from Rogier van der Weyden sometime between 1443 and 1451. In its closed position it shows kneeling portraits of the patrons dressed in sombre clothes, long black coats lined with sable (Plate 6.13). They are praying before two painted representations of statues (grisailles) of the saints particularly associated with protection against the plague, Sebastian and Anthony Abbot. Above is a representation of the annunciation – the very moment when the possibility of salvation began. But, when open, the relevance of the altarpiece for the hospital and for the patrons is most obvious (Plate 6.14). The altarpiece depicts the Last Judgement in dramatic fashion: 'When the Son of Man comes in his glory, and all the angels with him, then he will sit on his glorious throne' (Matthew 25:31–46). Rolin and his wife would hope to be on the side of those to be saved because they had provided for the poor, sick and needy through their patronage of the Hôtel-Dieu, their benevolence clearly commemorated in the altarpiece.

Open, the nine panels that make up the *Last Judgement* line up to form an unusually long, narrow narrative. This serves to emphasise the enactment of Christ's judgement by the Archangel Michael, rather than Christ himself, who occupies a distinct zone above. The weighing of the souls by the Archangel is given centre stage as the dead are called to their fate by the angels' trumpets (see Plate 6.1), the ascent to heaven on the left-hand side and the descent to hell on the right. The placid faces of the saved are contrasted by the desperate expressions of the damned, some of them biting their hands with fear. Christ sits at the apex of a rainbow with a lily of peace and mercy on his right and the fiery sword of judgement at his left. At the ends of the rainbow sit the chief intercessors, Mary and John the Baptist. With Christ in the middle, these three figures form an arrangement known as the 'Deisis' (or 'Deesis', Greek for 'supplication', meaning prayer or intercession). Behind them are the 12 apostles (Paul in green on the right-hand side replacing Judas) and behind the apostles are male and female saints. Thirty of the most seriously ill patients would have been able to meditate this scene at length in a ward reserved for them that adjoined the chapel.[40]

The altarpiece designed for the church of the Antonite Order and the hospital it served at Isenheim near Colmar (in present-day Alsace) expresses a different and even more direct message for the sick.[41] The Isenheim altarpiece takes as its theme the transcendence of earthly suffering

Plate 6.15 Matthias Grünewald, Isenheim altarpiece (closed view), 1508–16, oil on panel, central panel 269 × 307 cm, side panels 232 × 77 cm, Musée d'Unterlinden, Colmar. © Musée d'Unterlinden, Colmar. Photo: Giraudon/Bridgeman Art Library, London.

through Christ's sacrifice – dying itself. In its closed state, the view it would have presented for most of the year, it displays the Crucifixion with the plague saints, Sebastian and Anthony, in separate panels on either side, and the dead Christ with the three Maries at the tomb in the predella (Plate 6.15). In the middle state, a much more reassuring image shows the Virgin and Child serenaded by an angelic concert with the Annunciation and Resurrection on the wings. These middle panels in turn open to reveal a carved altarpiece by Nikolaus Hagenauer (active 1493–c.1538) with Saint Anthony at the centre and Augustine (whose monastic rule the Antonites followed) and Jerome on either side; Christ and the 12 apostles are shown inside the predella (Plate 6.16). The meeting of Anthony with Paul and his temptation are the scenes painted on either wing. Beside Augustine kneels Johan d'Orliaco, preceptor (a teacher or instructor) at the monastery between 1460 and 1490 and the first patron of the altarpiece.[42] He probably left money to commission the carved altarpiece just before he died, which was then completed under the auspices of a second patron and Johan's successor as preceptor, Guido Guersi, who had the painted panels added by Matthias Grünewald between 1508 and 1516.

In the fifteenth and sixteenth centuries, and since the outbreak of the Black Death in 1348, the plague was a constant threat. Saints Sebastian and Anthony Abbot, who are included in both altarpieces, were traditionally associated with the disease because they were believed to protect against it. Sebastian, a Roman soldier who converted to Christianity, was tortured by being fired at with arrows, leaving wounds that were believed to resemble plague sores. A disease linked to the plague was 'Saint Anthony's fire', associated with him through the stories of healing in his hagiography. In the left foreground of Anthony's temptation a haunting figure lies slumped, tortured

Plate 6.16 Nikolaus Hagenauer and Matthias Grünewald, Isenheim altarpiece (open view of carved altarpiece and wings), *Saint Anthony with Saints Augustine and Jerome, The Last Supper*, painted wings: *The Meeting of Anthony and Paul* (left), *The Temptation of Saint Anthony* (right), 1505 and 1508–16, oil on panel, and polychromy and wood, central panel 269 × 307 cm, side panels 265 × 141 cm, Musée d'Unterlinden, Colmar. © Musée d'Unterlinden, Colmar. Photo: O. Zimmermann.

by his sick body – diseased skin, distended stomach and crippled arm. A particularly nasty disease, Saint Anthony's fire led to a painful death or an intolerable life for those who survived it. Sigebert de Gembloux described the disease as early as 1098: 'The intestines eaten up by the force of Saint Anthony's fire, with ravaged limbs, blackened like charcoal; either they die miserably, or they live more miserably seeing their feet and hands develop gangrene and separate from the rest of the body; and they suffer muscular spasms that deform them.'[43] It was not until 1597 that the cause of this terrible suffering was identified as ergot poisoning, a fungus that can contaminate rye and other cereal crops.

On the outer panels (the altarpiece's closed position) Christ's suffering is treated in as realistic and gruesome a way as possible (Plate 6.15). Contorted by pain, the fingers lift and claw from the wood of the Cross. Christ also bears the suffering of those in the hospital. His skin is marked by sores and disease. The possibility of gangrene and the loss of limbs is suggested in the break between the central panels on which the Crucifixion is depicted. Slightly off centre, when the panel was opened Christ's right arm would be cut off from the rest of his body. In a hospital no one could escape the reality of suffering in death, and Grünewald's altarpiece makes no attempt to do this. Instead, those suffering the most painful of ends could take comfort in Christ's suffering on the Cross and the possibility that a good death even in those desperate circumstances could lead eventually to salvation.

Both of these altarpieces are from the north of Europe and seem to be proof of the morbidity detected there by historians, most famously Johan Huizinga.[44] Such grim representations of death seem rare in Italy. Indeed, Ronald Lightbown in his monograph on Andrea Mantegna (c.1431–1506) does not try to reconcile the artist's dramatic *Lamentation over the Dead Christ* (Plate 6.17) with the wider artistic context: its pared-back details and austere colour 'would not have commended it to the average fifteenth century patron', he

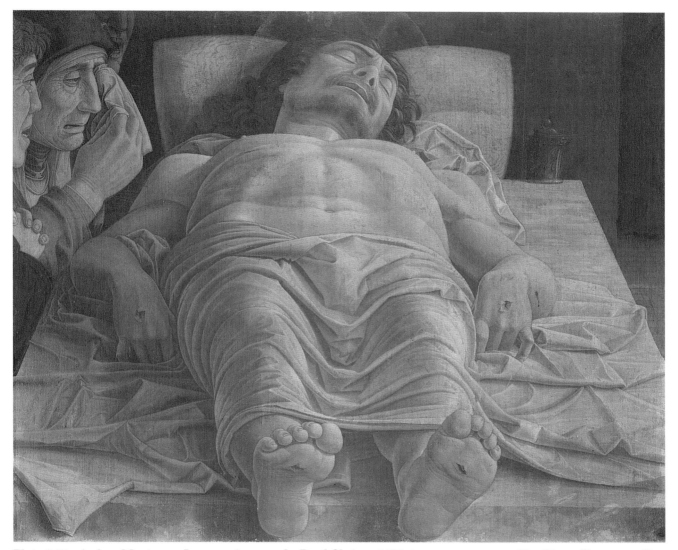

Plate 6.17 Andrea Mantegna, *Lamentation over the Dead Christ*, *c*.1490, tempera on canvas, 68 × 81 cm, Pinacoteca di Brera, Milan. Used with the permission of the Ministero Beni e Attività Culturali. Photo: © 1990 Scala, Florence.

suggests.[45] The stark representation of the body, feet and wounds projected forward into the viewer's space was almost certainly taken from life, as it is subtly different from a body conceived theoretically according to the rules of linear perspective: the head, for example, is slightly too big. Linear perspective is used, however, to establish the space of the tomb, though the vanishing point lies outside and above the picture, heightening its claustrophobic atmosphere. But the *Lamentation over the Dead Christ* does not seem so surprising an image for a painter such as Mantegna working in the north of Italy, where he may well have come across prints of such dramatic subjects from across the Alps.

Mantegna's painting was recorded in October 1506 as among the works of art that remained in his house in Mantua on his death, and it soon found a new home when Cardinal Sigismondo Gonzaga bought it.[46] Almost certainly dating to the 1490s when he was an elderly man, the painting was probably painted for the artist's own use. But Lightbown raises an important point – it is an unusually morbid image for an Italian artist. In the next section I will consider some Italian tombs and monuments and the way that the different circumstances in which they were created led to a different emphasis to the works of art created north of the Alps considered above.

3 The Italian triumph over death

Cardinals' monuments

Tombs of popes and cardinals epitomise an important feature of the Italian funerary monument in the fifteenth and early sixteenth centuries. Personal references – coats of arms, signs of office or narratives commemorating important achievements – are usually subsumed within more general associations. In the context of the communal ideals of the city-states, and in Rome the long continuity of the apostolic succession, achievement or virtue for the common good or in service of the papacy and Catholic Church was at least as important as the personal achievement and commemoration that characterise the monument of Alice de la Pole, for example. It was a subtle but important distinction that made for monuments celebrating the triumph of a person's fame, usually acquired through public office, over his death, presenting him as an example to be followed – and remembered, of course. Thus, a grand monument was not necessarily evidence of self-aggrandisement but a bigger and better celebration of the office. At the same time, the family left to organise a tomb for its relative could use the occasion to signal its own service to the city or Church – a contribution to the common good. The result was innovative and sometimes extraordinary monuments. Here I will consider a few of them.

When Cardinal Niccolò Forteguerri died on 21 December 1473 in Viterbo, he was commemorated with not one but two monuments. The cardinal's brothers, Pietro and Giovanni, had his body returned to Rome, where they commissioned a tomb for his titular church, Santa Cecilia in Trastevere, from Mino da Fiesole (1429–84), a Florentine sculptor.[47] At the same time, on 2 January 1474, the town council (Consiglio) of Pistoia agreed that the cardinal should be commemorated with a requiem mass (costing 30 florins) and a monument, also referred to as a tomb, in their cathedral (costing 300 florins). Forteguerri was born into a family of impoverished Pistoian nobility, and despite his success during his life he never forgot his home. Following a serious outbreak of plague in the 1460s, Forteguerri contributed to the city's recovery by setting up the Casa Pia di Sapienza, a school at which 12 gifted boys a year were prepared for university. Forteguerri himself owed his career to similar charity: in 1439 he had won a scholarship from the Opera di San Jacopo in Pistoia for his studies at the universities of Bologna and Siena.[48] The two monuments commemorate the cardinal in subtly different ways appropriate for their contexts of papal Rome and civic Pistoia.

In order to undertake the Forteguerri commission in 1474, Mino da Fiesole broke off from an existing contract to make a sculpted tomb for Count Hugo of Tuscany for the Badia in Florence, the Benedictine monastery and the oldest monastic foundation in the city, and moved with his workshop to Rome, where he went on to work on a series of monuments. Count Hugo's tomb was begun in 1469 to commemorate his foundation of the monastery 500 years earlier, and Mino returned to Florence to complete it in 1480. The count was a mythic figure in Florence whom Dante had called 'the great baron' and from whom the Florentine nobility believed they derived their pedigree. His remains were preserved at the monastery, but he had never had a monument until Mino was commissioned to provide one.[49]

While the Forteguerri tomb is closely related in its details to the tomb of Count Hugo – including the effigy and the now lost shield-bearing putti – it is worth making a brief comparison between them as this raises some important points about the different emphases of monuments, the tomb of the count with its display of civic virtue and that of the cardinal with its ecclesiastical overtones. In the panel above the count's tomb is a representation of Charity holding a child in one hand and a cornucopia in the other (Plate 6.18). The cardinal's tomb incorporates the Virgin and Child, Saints Cecilia (patron saint of the cardinal's titular church) and Nicholas (his name saint) (Plate 6.19).[50] While Mino da Fiesole adapted the triumphal arch motif of tombs by Bernardo Rossellino and Desiderio da Settignano in Santa Croce in Florence for his tomb of the count, his framing device for the cardinal's tomb is uniquely Roman. The canopied structure which makes the monument almost freestanding rather than fixed into the wall is close in form, if not style, to the Gothic tombs that had been common in the city since the twelfth century. Their structure also refers to the architectural *ciboria* over altars and niche chapels used in churches in Rome since at least the twelfth century. Many of the tombs actually incorporated altars. The differences between the two monuments can be explained

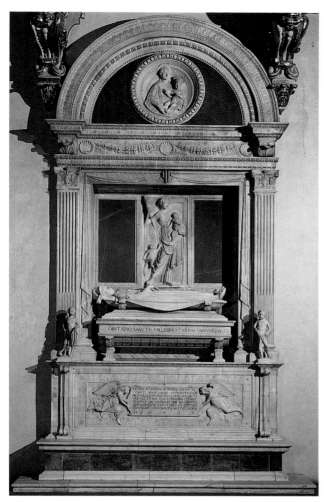

Plate 6.18 Mino da Fiesole, tomb of Count Hugo of Tuscany, 1469–74 and 1480–1, marble, life-size, Badia, Florence. Photo: © 1990 Scala, Florence.

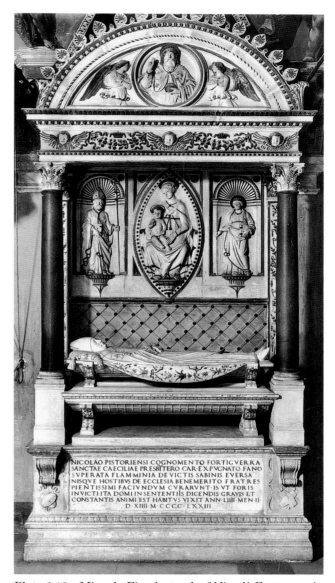

Plate 6.19 Mino da Fiesole, tomb of Niccolò Forteguerri, c.1474, gilded marble, life-size, Santa Cecilia, Rome. Photo: Archivio Brogi/Alinari Archives, Florence.

by their very different incumbents – a secular knight and a devout cardinal – but also by the very different cities in which they were erected. On the one hand, in the count's tomb in Florence, Charity is the main figure. She both refers to the count's generosity to the Badia and, being one of the theological virtues (Faith, Hope and Charity), was an essential value for citizens to uphold for the well-being of the city-state. On the other hand, the cardinal is commemorated in Rome in a monument in which continuity with past and future cardinals and his witness to the continued work and power of the Church are emphasised. While civic values were not ignored in Rome, they took second place to the wider ecclesiastical significance of the Catholic Church. Cardinals were called to Rome from all over western Christendom, and as a result were given titular churches to represent their new relationship with the city. In their different

ways, as Shelly Zuraw puts it, such monuments commemorate 'both a particular individual and, more broadly, the virtue his life exemplified'.[51] Indeed, the universal message of the two tombs is emphasised by the fact that the same features are given to each effigy: 'Mino's ideal, middle-aged man'.[52] Effigies were not portraits as they might be understood today, but reminders of the physical presence of the body in or near the monument. Even if they were not specific portraits, the link with the body was an important one, a perpetual prayer in stone for the soul in purgatory that had once been housed in it. The effigy included in both monuments is an indication of the high status of

227

each of the men commemorated. There was a strict hierarchy of what could be included in monuments – only senior ecclesiastics such as cardinals or bishops, or major benefactors to churches, were entitled to effigial wall monuments. Knights, nobles, university professors and important churchmen were sometimes entitled to wall tombs without effigies, but more commonly they had no more than floor slabs.[53]

Forteguerri's monument in Pistoia has also been called a tomb, even though his physical remains are in Rome. The Pistoia monument has a complex and therefore revealing history – some 50 records survive to document the intentions and process behind its problematic creation.[54] When in January 1474 the Consiglio decided to commemorate the cardinal, they chose to do it with 'an honorific *archa* or monument with an inscribed epitaph', and as a result the monument has been variously described as a cenotaph and as a tomb.[55] *Archa*, however, is a difficult word to translate into English. It describes a coffin or box within which the venerated relics of a saint were kept. In this case, because the cardinal's body was buried in Rome, the use of the word is more suggestive of the symbolic significance of the monument than its physical purpose: to preserve the precious memory of the cardinal in the minds of his compatriots, honouring his generosity to the city as an example to others. Andrea del Verrocchio, therefore, designed a memorial that includes a kneeling figure of the cardinal surrounded by the three theological virtues: Faith holding a chalice and cross, Hope with her arms crossed, and Charity above feeding a baby. Above is a vision of Christ in the mandorla of heaven supported by four angels. While the monument was radically reworked – and some would say ruined – it still exists in Pistoia Cathedral. The figures were mounted on a dark background in a heavy marble frame, and the cardinal's kneeling effigy replaced by a bust. Models for the original survive, however, which give a better impression of what Verrocchio must have intended (Plate 6.20).[56]

The commission was beset with problems and delays from the start, the result probably of rivalry between Pistoian factions and embezzlement of money (which was not unusual in such civic enterprise in the fifteenth century), but also tensions between Pistoia and Florence.[57] The cardinal, while he was alive, had not been afraid to stand up to the Florentines who had annexed

Pistoia in 1401, and as a result his monument seems to have caused political tensions between the two cities. The Consiglio del Popolo of Pistoia established a building committee or board of works, an *operai*, to organise the project, and it in turn held a competition to find the best design. In May 1476, from a total of five designs submitted, Verrocchio's was selected by the Commissari, a committee of four Florentines who oversaw Pistoian affairs. Probably towards the end of that same year, the *operai* met with the artist to discuss the project, whereupon the sculptor demanded 350 florins, not the 300 available. Having secured 380 florins from the Consiglio, the *operai* approached Piero Pollaiuolo from a rival firm of sculptors in Florence, who also happened to be working in Pistoia at the time. In March 1477 the *operai* wrote to Lorenzo de' Medici asking him to adjudicate and select the best design, probably in an imprudent attempt to override the Commissari, who wanted Verrocchio. The issue does not seem to have been the relative merit of the two artists but the authority of the Commissari, something that only gained the Pistoians Lorenzo's censure as he upheld the choice of Verrocchio.

By 1483 it was reported that the project was for the most part complete, but financial misdealings seem to have led Verrocchio to abandon it. In 1486 he went to Venice to work on the Colleoni monument and died in the summer of 1488. Even after 1488, when Lorenzo di Credi, who had been a member of Verrocchio's workshop, was commissioned to add the kneeling figure of the cardinal and of Charity, it was still not finished. By 1514 it had to be reworked: the monument had been framed in cheaper sandstone, not marble; Lorenzo di Credi's figures were thought inferior to Verrocchio's, and the background was stucco, not marble. Another sculptor was commissioned to 'improve' the monument, and then again in the 1660s and 1750s it was reworked. The terracotta model by Verrocchio of the entire monument provides a good idea of the original design. Although the Pistoian Consiglio originally asked for a tomb, the model is more suggestive of a sculpted altarpiece, albeit a particularly grand one. Each of the figures made by Verrocchio for the monument is life-size, which was unprecedented for a relief sculpture but not for an altarpiece, and no doubt permitted by the fact that it was a civic commission. No private individual would have been allowed such a grandiose monument in a city-state.

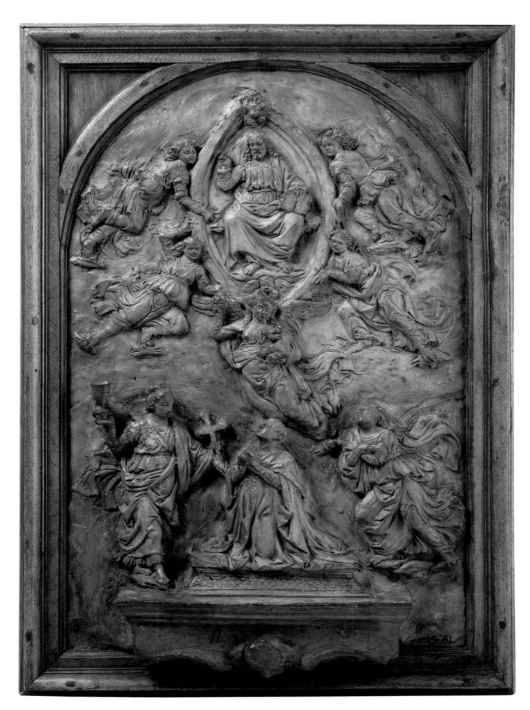

Plate 6.20 Andrea del Verrocchio, model for the Forteguerri monument, 1476, terracotta, 39 × 27 cm, Victoria and Albert Museum, London. Photo: V&A Images/ Victoria and Albert Museum, London.

Although Forteguerri left his commemoration to his family, it was not unusual for other cardinals to prepare their tombs during their lifetimes. This was not a morbid obsession with death but the pious preparation of the living facing life's realities – as well, perhaps, as the concern that one's relatives might not manage to do their duty. Francesco Todeschini Piccolomini (c.1440–1503), Cardinal of Siena, went to unusual lengths to prepare for his death, covering every eventuality in his will and in the monuments he commissioned. As an active diplomat used to travelling widely, he could not know where and when he would die. His first will was probably written in 1479, 24 years before he eventually died as Pope Pius III, and regularly updated thereafter. In it he refers to the parable of the Wise and Foolish Virgins, some of whom let their lamps go out, while others kept theirs ready to light with wicks trimmed and oil reservoirs filled up, 'for you know neither

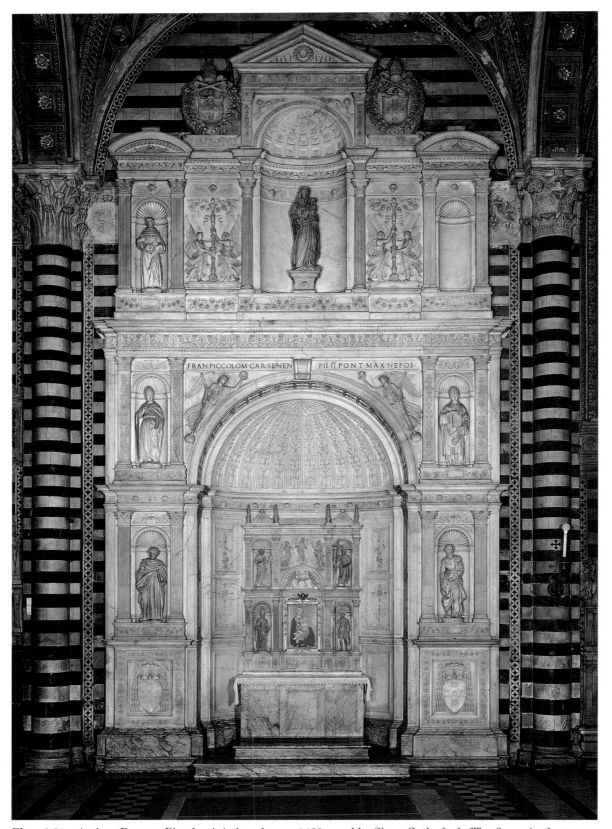

Plate 6.21 Andrea Bregno, Piccolomini altar, begun 1480, marble, Siena Cathedral. (The figure in the top left-hand niche is Pietro Torrigiano's *Saint Francis*, the *Virgin and Child* in the centre-top niche is from the workshop of Jacopo della Quercia, and the four figures in the lower niches are by Michelangelo and his workshop.) Photo: © 1990 Opera Metropolitana Siena/Scala, Florence.

the day nor the hour' (Matthew 25:2–13). If he died within a reasonable distance of Rome, then he asked that his body be taken there and buried with his uncle, Pope Pius II, in St Peter's basilica. But if he died closer to Siena or even outside the Italian peninsula, he requested burial in Siena Cathedral, where in 1480 he commissioned an altar from Andrea Bregno (1418–1503), the most prolific sculptor in Rome (Plate 6.21).[58] The ensemble includes on one of the steps below the altar an inscription describing how the cardinal had prepared the structure as his sepulchre during his lifetime.[59] Even then, he conceded in his will that he could not predict where he might die and that it may not even be possible to satisfy these detailed requirements. Except for the fact that it did not include an effigy, the altar resembles the conventional form of a cardinal's tomb in the late fifteenth century: an architectural surround embellished with sculpture framing an effigy and sometimes an altar.

The cardinal was perhaps wise to try to ensure as much of the work as possible was done in his own lifetime. While Andrea Bregno completed the frame and the figures for the inner altar, he never finished the statuary. In 1501 Pietro Torrigiano (1472–1528) was commissioned to make a life-size figure of the cardinal's name saint, Francis (now located in the top left-hand niche). Then, in 1503 Michelangelo signed a contract to provide 15 figures for the altar, agreeing to take on no other work, but the cardinal died in the same year (less than a month after being elected Pope Pius III). Working with Baccio da Montelupo (1469–1535), just four of the promised figures had been delivered by 1505, when Michelangelo went to Rome to work on the tomb monument for Pope Julius II.

Three exceptional tombs in Rome

The 'Julius tomb' represents a significant departure in tomb sculpture. Nothing like it had been considered before. Because the project seems to have changed conception quickly, there has been a great deal of confusion over the original design, something that led Ascanio Condivi to call it 'the tragedy of the tomb' and of Michelangelo's life, possibly repeating the artist's own description of it. Condivi's biography of Michelangelo was published in 1553 in part to refute the life written by Giorgio Vasari that had been published in 1550. In particular, Michelangelo seems to have wanted

to put his version of events on record, and the biography appears to have been written against the background of Michelangelo's own excitement with the initial idea followed by disappointment as the pope lost interest and the project was gradually reduced in scale, particularly following Julius's death in 1513. Condivi describes the monumental free-standing mausoleum enclosing a burial chamber for the pope's sarcophagus that may even have been intended as the centrepiece for Bramante's new choir and transept at St Peter's:[60]

> this tomb was to have had four faces: two of 36 feet, at the sides, and two of 24, front and back, so that it would have constituted a square and a half. All around the outside were to be niches, for statues … representing the Liberal Arts, as well as painting, sculpture and architecture … Above these would have run a cornice, binding all the work together, on the top of which were to be four large statues …

> So the work would have risen to end with another storey where there were to be two angels supporting a bier: one of them would have been smiling, as if to rejoice that the soul of the Pope had been received among the blessed spirits; the other weeping, as if to lament that the world had been deprived of such a man. The way into the sepulchre was to be at one end, where the entrance would lead to a small room like a temple, in the middle of which was to be a marble coffin, for the internment of the body of the Pope.[61]

The huge sculptural ensemble is perhaps best interpreted, in Marcia Hall's words, as a 'visual poem … upon life in death, and life after death'.[62] But while Michelangelo started gathering materials and making drawings, Julius quickly lost interest in the project, and by 1506 the pope's attention had turned to Bramante's plans for St Peter's itself. When the pope died in 1513, there was little to show for the tomb apart from some blocks of marble and sculptures at various stages of completion. Thereafter, in a series of contracts made between 1513 and 1542, the project was stripped of the elements that made it so unusual. When a wall monument to Julius II was finally erected in 1545, it was in Julius's titular church as a cardinal, San Pietro in Vincoli – not St Peter's basilica.

A drawing preserved in Berlin by a pupil of Michelangelo, a copy of one of the original *modelli* for the 1513 project, suggests a compromise at that stage between a free-standing monument and a tomb projecting from the wall (Plate 6.22).

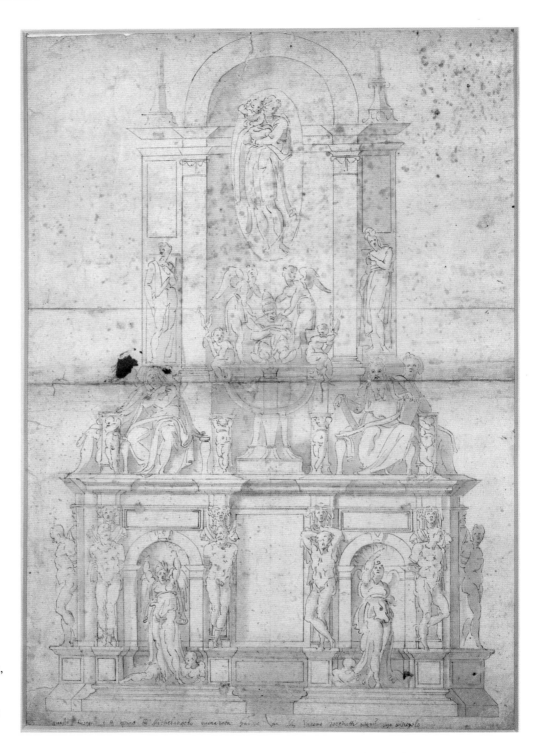

Plate 6.22 After Michelangelo (Giacomo Rocchetti?), design for the tomb of Pope Julius II, *c*.1530–50, 57 × 39 cm, Staatliche Museen, Berlin. Photo: © 2007 bpk/Kupferstichkabinett SMB/Jörg P. Anders.

Each of the levels was adorned with figures, from the Virgin and Child at the top to the pope's effigy, Moses and Paul at the middle level, and Michelangelo's unique contribution of the 'slaves' at the lower level. These 'slaves' were to be nude male figures that Vasari, in his 1568 version of the *Lives* (which relied heavily on Condivi's biography), interpreted as 'the provinces subjugated to that Pontiff and rendered obedient to the Apostolic Church'. Other figures, 'likewise bound', represented 'all the noble arts and sciences, which were thus shown to be subject to death no less than was the Pontiff, who made such honourable use of them'.[63] One of them, now known as the *Rebellious Slave*, was probably designed for a corner position because the contrapposto in the figure allows it to work from the sides as well as the front (Plate 6.23). The dramatic pose and

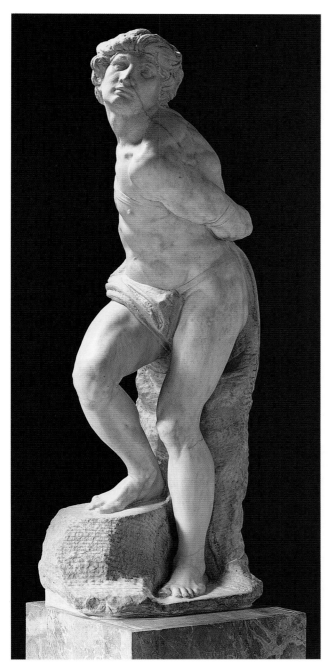

Plate 6.23 Michelangelo, *Rebellious Slave*, 1513–15, marble, height 215 cm, Louvre, Paris. Photo: © RMN/ René-Gabriel Ojéda.

tense and expressive musculature can be linked to two of the most influential classical statues that were excavated in Rome at the same time: the *Laocoön* (in 1506) and the *Belvedere Torso* (in 1507). Although Michelangelo's 'slaves' are his own innovation, captive slaves were common on the ancient triumphal arches of Rome, which were erected to celebrate successful military campaigns. Unusually for a pope, Julius II was renowned as a

soldier who spent much of his pontificate leading troops and trying to pacify the Papal States.

Julius II had already proved himself an innovative patron when, as a cardinal, he had been responsible for providing a monument for Sixtus IV (reigned 1471–84), his uncle (Plate 6.24). This was an important duty for the cardinal nephews, who were appointed to provide an instant and stable power base, because the next pope (their reigns were usually no more than five to ten years) would have more urgent responsibilities than providing a tomb for his predecessor. In the same way, Francesco Todeschini Piccolomini made sure that his uncle, Pius II (reigned 1458–64), was properly commemorated in St Peter's, though his was a much more conventional wall tomb. Whereas the tomb of Julius II was a one-off that was impossible to emulate, the tomb of Sixtus IV inspired a number of copies; some of the most important are in Spain and will be considered in the next section.

Sixtus's tomb was designed as the centrepiece of the chapel of the canons (the priests who ran the basilica), added by him to the southern aisle of the old basilica of St Peter. Inside, in a frescoed apse painted by Perugino, the pope knelt in front of the Virgin and Child with the Franciscan saints, Francis and Anthony of Padua, on one side and Peter and Paul on the other. These figures looked down on the bronze tomb below, set in a floor of maiolica tiles, each decorated with an oak tree, the device of the della Rovere family to which both Sixtus IV and Julius II belonged. Sixtus IV had started his ecclesiastical career as a Franciscan so he asked in his will to be buried below ground, not in a grandiose wall monument, a request that accorded with the humility expected of a Franciscan monk. On either side against the walls, probably explaining the need for a floor tomb (as opposed to the more usual wall monument), were wooden stalls for the canons, from which they would have had a good view over the pope's tomb, raised on its base of green serpentine marble.[64] As a result, Sixtus's monument was incorporated into the centre of the day-to-day activities in the basilica – and so was the artist. While a long inscription at his feet records the pope's achievements and the commission of the tomb by Cardinal Giuliano della Rovere, behind his head – where it would have been visible to anyone entering the chapel – an inscription records the name of Antonio Pollaiuolo, the Florentine sculptor 'famous in silver, gold,

Plate 6.24 Antonio Pollaiuolo, tomb of Pope Sixtus IV, 1484–93, bronze, 350 × 300 cm, Sacristy Museum of St Peter's, Rome (formerly Cappella del Canonico). Photo: © 1990 Scala, Florence.

painting and bronze' who completed the monument in 1493.[65]

Antonio Pollaiuolo (1432–98) went to Rome from Florence in 1484, the date of the pope's death. Trained as a goldsmith, he was well known for his skills and had provided designs for an altar frontal that Sixtus IV donated to San Francesco in Assisi, where Saint Francis was buried. The commission for the papal tomb may well have come through Lorenzo de' Medici, who used Tuscan artists to support his diplomatic activities.[66]

Casting anything so large as Sixtus IV's tomb and in the many pieces it must have taken would have demanded the highest levels of craftsmanship as well as project management. The dark patina of the bronze is polished to a high shine so that, combined with the abundance of figures and decorative details, the effect is of a glittering jewel. It soon acquired a reputation as one of the artistic marvels of Rome, compared to the ancient tomb of Alexander the Great.[67]

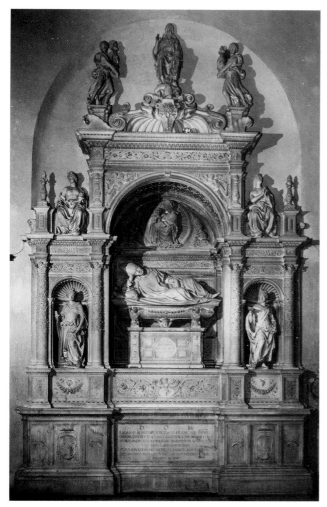

Plate 6.25 Andrea Sansovino, tomb of Cardinal Ascanio Sforza, 1505–9, marble, effigy life-size, Santa Maria del Popolo, Rome. Photo: Conway Library, Courtauld Institute of Art, London.

The monument itself – which was moved into the new St Peter's basilica in the seventeenth century, and from there to the treasury (now the Sacristy Museum) in the twentieth century – comprises an effigy raised on a low bier and surrounded by figures of virtues and personifications of the arts (Plate 6.24). It is one of very few bronze tomb monuments made in Italy in the fifteenth century, and it is by far the most complicated.[68] Fortunately, the virtues are identified by their attributes, and inscriptions help explain their significance. The theological virtues surround the head of the effigy, with Charity at the centre behind the pope's head so that she would have faced those entering the chapel. The liberal arts adorn the panels on the side. Rather than the traditional seven, there are ten arts which represent both Sixtus's patronage and his abilities as a writer and rhetorician: the

extra three are theology, philosophy and perspective. Although some of the sensuous, semi-naked bodies of the figures were criticised in the nineteenth century as inappropriate in such a monument, they should be seen as a deliberate attempt to capture the attention of the viewer – as in rhetoric an idea communicated in an attractive way was more likely to be understood than a simple, unmediated assertion.[69]

The remarkable monuments ordered by Giuliano della Rovere did not end there. Just after he had commissioned his own tomb from Michelangelo, Julius II summoned Andrea Sansovino (c.1467– 1529) to Rome from Florence in 1505 to make the tomb monument for Cardinal Ascanio Sforza (Plate 6.25). A longstanding rival of the pope, Sforza was a member of the important Milanese family. Luckily for Julius, who needed money to pay for his lavish projects – including the rebuilding of St Peter's – Ascanio Sforza died intestate. As was traditional in these cases, his estate was claimed by the pope, who spent some of the money on a tomb incorporated into Bramante's new choir behind the high altar at Santa Maria del Popolo, a church built by Sixtus IV, but most of it on St Peter's.[70] Even though Sansovino was already engaged on prestigious projects for the cathedral and the Palazzo della Signoria in Florence, the sculptor travelled to Rome, where he was to make one of the most original and influential monuments of the early sixteenth century, no doubt attracted by the international market of the papal court. In the Sforza tomb, Sansovino challenged the conventions of fifteenth-century tombs in Rome through his innovative combinations of sculptural and architectural elements. Semi-columns and entablature support a triumphal arch, the larger central arch over the effigy and two smaller arches framing two of the cardinal virtues – Justice and Prudence. Two of the theological virtues, Hope and Faith, appear above.

Sansovino had travelled widely and the monument reflects this. He had worked for extended periods in Portugal twice in the 1490s, where he probably saw monuments such as that of Martín Vázquez de Arca by Sebastián de Almonacid in Sigüenza Cathedral, which had recently been installed. His Iberian experience is reflected, in particular, in the innovation of the reclining effigy set back within the deep niche at the centre of the tomb. By propping up the effigy it assumes a position

more of sleep than of death, a vivid reminder of the nearness of the dead. This was what Panofsky called 'the activation of the effigy'.[71] Michelangelo was probably inspired by Sansovino's Sforza tomb to raise the effigy of Julius II above his tomb, no doubt in part to make it more visible to viewers standing below the enormous monument (Plate 6.22).

The tombs and monuments discussed in this section are among the most original made in the late fifteenth and early sixteenth centuries. They all include a variety of sculptural elements more or less subsumed by an architectural frame. But rather than a denial of death and an expression of the increasingly secular spirit of the Renaissance, as Panofsky suggested, these monuments emphasise the general over the specific – the virtues and achievements of the individual in a wider context. A pope, for example, is both an office and a person. Where personal details are included, these only serve to emphasise the contribution an individual made to the communal ideal of the city-state or the universal ideal of the Catholic Church. Conversely, the individual was rewarded with a memorial in a public place that made his personal memory as obvious as possible. These examples suggest that artists were rarely constrained by the strict conventions of funerary display and commemoration.

4 Dynastic monuments

Ferdinand and Isabella

Undoubtedly the most powerful weapon in the battle to be remembered was the family. Royal tombs were especially important symbols of political and dynastic ambitions and statements of lineage and pedigree. In common with the monuments of lesser mortals, they commemorated individuals in perpetual prayer for themselves and their families, joining the communities of the living and the dead – only they could do it on a much more grandiose scale.

Ferdinand II (1451–1516), King of Aragon and Sicily from 1479, and Isabella (1451–1504), Queen of Castile and León after 1474, together united a vast and powerful kingdom that became the basis of modern Spain.[72] The two were cousins who, after their marriage in 1469 and their ascent to their kingdoms, had access to huge resources, which even extended to the New World when Christopher Columbus went to the Americas in 1492 under their patronage. Through military success, political manoeuvring and artistic patronage, they positioned the institution of monarchy at the centre of ecclesiastical and political life in Spain. Their children, through canny marriage alliances, linked them with the major royal houses of Europe: Joanna married the Habsburg archduke, Philip the Handsome, son of Emperor Maximilian and Mary of Burgundy, and was mother to the future Holy Roman Emperor Charles V; Catherine was the ill-fated first wife of the English Tudor king, Henry VIII. The importance of their family was reflected in the care Ferdinand and Isabella took to see that their relatives were properly commemorated.

The double tomb for Isabella's parents, Juan II of Castile (d.1454) and Isabella of Portugal (d.1496), was commissioned by her as the centrepiece of the Capilla Mayor (main chapel or sanctuary) of the Charterhouse of Miraflores near Burgos (Plate 6.26). Isabella completed the monastery founded by her parents in 1441 on the site of a royal palace favoured by Henry III, Juan's father. In 1488 she began by having the vaults of the church completed. To make sure it was carried through, she left instructions in her will that the monuments should be finished if she died before completion.[73]

In 1486 Gil de Siloé (active 1486–1501), a goldsmith and sculptor who may have come to Spain from Flanders, received 1,340 maravedís (roughly the equivalent of two weeks' salary for the master of the ship in which Columbus sailed to the New World in 1492) for designing the tombs of Juan and Isabella as well as the tomb of the Infante Alfonso, Isabella's brother. The Infante had died prematurely in 1468, and his remains were brought from Arévalo to Miraflores to join his parents in 1492. The choice of sculptor probably reflects links with the Netherlands that were important to Ferdinand and Isabella at this time because they were negotiating the marriage of their daughter Joanna to Philip the Handsome. Philip had succeeded to the Burgundian possession on his mother's death in 1482. Joanna and Philip were eventually married in 1496.

The work of carving the monuments began in 1489 and was finished in 1493. The sculptor received the huge sum of 442,667 maravedís for the work and 158,252 maravedís for the alabaster.[74] The

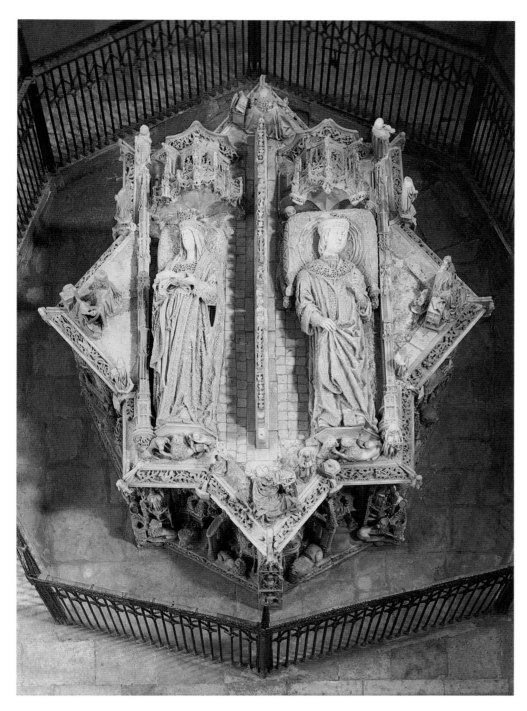

Plate 6.26 Gil de Siloé, tomb of Juan II of Castile and Isabella of Portugal, 1489–93, alabaster, effigies life-size, Carthusian monastery of Miraflores, near Burgos. Photo: © 1990 Scala, Florence.

double tomb he created for Isabella's parents is astonishing for its virtuosity and the exuberance of Gothic details that create a vivid expression of life and movement around the recumbent figures. A leading member of the 'inundating wave' of Flemish art and influence that swept through Spain in the second half of the fifteenth century, Gil's sculpture flies in the face of Italianate influence.[75] But essentially Spanish is its use of the star-shaped structure (created by the superimposition of two

squares) on which the effigies are displayed. This motif was common in *Mudéjar* architecture, a unique combination of Islamic and European forms that was the decorative style of the Moors in Spain. Once the tombs were complete, Isabella commissioned the ornamented screen (reredos) behind the high altar from Gil de Siloé, who was assisted by Diego de la Cruz (active 1475–1500), at a cost of 1,015,613 maravedís (Plate 6.27). In another dramatic scheme that relies on the

237

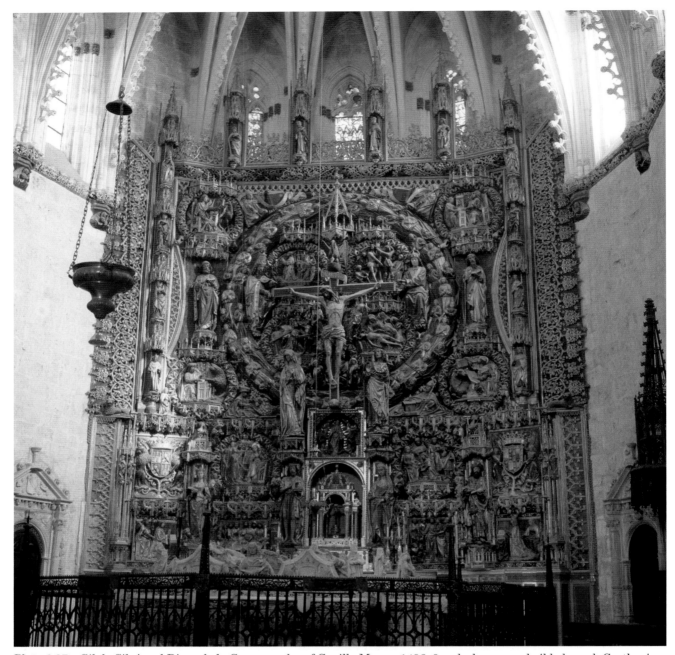

Plate 6.27 Gil de Siloé and Diego de la Cruz, reredos of Capilla Mayor, 1496–9, polychrome and gilded wood, Carthusian monastery of Miraflores, near Burgos. Photo: © Javier Calbet/COVER.

abstract geometry of local architectural decoration, executed this time in wood, the crucified Christ is framed by a circle of angels around which are scenes of the Passion, saints and at the bottom corners kneeling figures of Juan and Isabella. Diego de la Cruz was probably responsible for the polychromy and the gilding, which incorporated some of the gold brought back by Columbus from the New World. In addition to the tombs and reredos, Gil also added a screen to enclose the chapel (*reja*) that is no longer extant, possibly

lost in the Napoleonic Wars at the beginning of the nineteenth century. Overall it is a lavish monument to Isabella's parents that preserves their memory in as striking a way as possible.

Rather than using indigenous Spanish styles, in their own distinctly Italianate monument Ferdinand and Isabella aligned themselves with the international context to which their monarchy aspired. On 13 September 1504 they published their intention to make a burial chapel, prompted

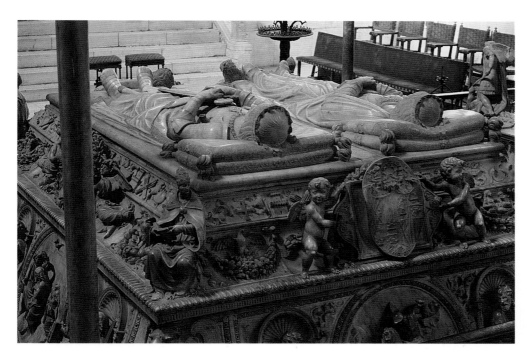

Plate 6.28 Domenico Fancelli, tomb of Ferdinand II of Aragon and Sicily and Isabella of Castile and León, 1514–17, marble, effigies life-size, Granada Cathedral. Photo: © 1990, Scala, Florence.

by the fact that the queen was dying.[76] In her will of 12 October 1504, made just before her death on 26 November, Isabella requested burial in the monastery of Saint Francis in the Alhambra of the city of Granada. Her body was to be dressed in the habit of a Franciscan and placed in a floor tomb. However, she requested that, if Ferdinand chose to be buried in a different monastery or church, her body be moved to join his.[77] This is exactly what happened. In his will of 1516, Ferdinand requested burial in the Capilla Real (royal chapel) he had commissioned for Granada Cathedral in Isabella's memory. When Ferdinand died, the chapel was not finished so his body was taken to join that of Isabella. On 10 November 1521 their remains were finally brought to the Capilla Real.

The location of the tomb in Granada Cathedral was especially significant. While at first the church of San Juan de los Reyes in Toledo was intended as the site of the monument of Ferdinand and Isabella, that soon changed on the successful annexation of Granada to their kingdom.[78] After a long campaign that lasted from 1481 to 1492, the Moors, who had held Granada in the south of the Iberian peninsula since the eighth century, were ousted. Ferdinand and Isabella made Granada their capital. The victory was celebrated not only as a local conquest but as a victory for the Christian Church, and extended their position among the ruling elite of western Christendom that recognised the spiritual authority of Rome and

the popes. Indeed, when the first gold was brought back from the New World, they sent part of it to gild the coffered ceiling of the major basilica of Santa Maria Maggiore in Rome. When their tombs were commissioned by Ferdinand, he emphasised these international links by moving away from the Gothic style of Gil de Siloé to the Italianate – Roman – style.

Between 1506 and 1521 the Capilla Real was added to Granada Cathedral as a royal mausoleum. Domenico Fancelli (1469–1519), who was commissioned to produce Ferdinand and Isabella's monument, had arrived in Spain from Florence around 1509 to supervise the installation of the tomb he had made of the Cardinal Archbishop of Seville, Diego Hurtado de Mendoza, a commission from the cardinal's brother Iñigo López de Mendoza, Count of Tendilla and ambassador in Rome at the papal court. In 1513 Fancelli completed a tomb for Ferdinand and Isabella's son, Prince Juan (1478–97). Rather than moving with his workshop to Spain, Fancelli is documented in Carrara in 1512 securing the fine white marble that his royal patrons expected for their Italianate monument; between 1514 and 1517 he was working on the tombs of Ferdinand and Isabella in a workshop at Genoa.[79]

For the monument of Isabella and Ferdinand (Plates 6.28 and 6.29), Fancelli's reliance on established Roman forms is clear: it is derived from the overgrown floor tomb of Sixtus IV (see

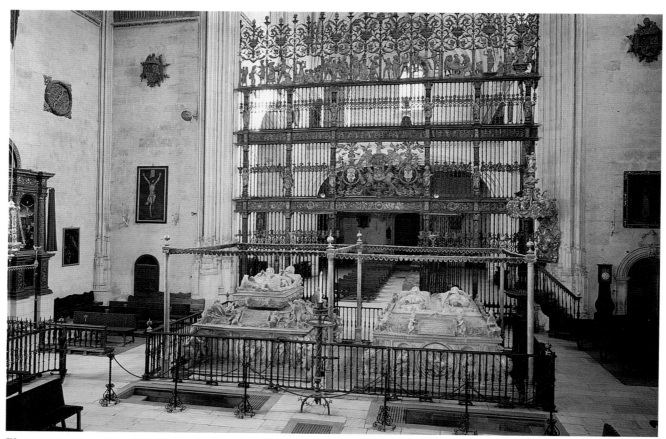

Plate 6.29 View of the Capilla Real, Granada Cathedral. Ferdinand and Isabella lie to the right-hand side; the monument of their daughter and son-in-law, Joanna and Philip, is on the left-hand side. Photo: © 1990 Scala, Florence.

Plate 6.24). This form suited the desire of the patrons to lie before the chapel's altar (and the congregation in the nave) in perpetual prayer, as Isabella's parents do at Miraflores (see Plates 6.26 and 6.27). The details of carved figures, swags and grotesque decorations are close to the standard fare of tomb monuments in Rome and particularly those by Andrea Bregno and his workshop, the major producer of sculptural monuments in Rome at the end of the fifteenth century.

The introduction of Italianate forms to Spain raises some important issues. Patrick Lenaghan has argued that the royal tombs did not represent innovation so much as the continuity with Rome that Fancelli and his workshop could offer both in terms of the Italian Carrara marble used and in the style of the monument and its sculptural details.[80] Traditionally this has been interpreted as a sign of the spread of the Renaissance, defined as rooted in Italy and influenced by classical antiquity, to Spain. However, this analysis implies that local forms were backward and in need of general modernisation or improvement, and overlooks the political motivation of the alignment of Spain

with the Church of Rome. When he died in 1519, Fancelli had already been commissioned to produce the tombs of Philip and Joanna to join those of Ferdinand and Isabella in the Capilla Real. He died in April before work was started, and on 1 May the commission was given to Bartolomé Ordóñez, a member of Fancelli's workshop who seems to have taken it over on the master's death. Ordóñez died only a year later in 1520, but in his will provision was made for the workshop to continue under Pietro Aprile, another Italian.[81] Thus, in the same way that Isabella employed a Flemish sculptor for her parents' tombs, Italianate forms were less about artistic innovation and more about the politics of style. They demonstrated the allegiances of royal and ecclesiastical patrons, all of whom had reason to display their links with Rome.

Maximilian I

The tombs of the monarchs in Spain mix a variety of styles and motifs to consciously display the lineage (Gothic), territorial expansion (*Mudéjar*) and international connections (Italian) of their

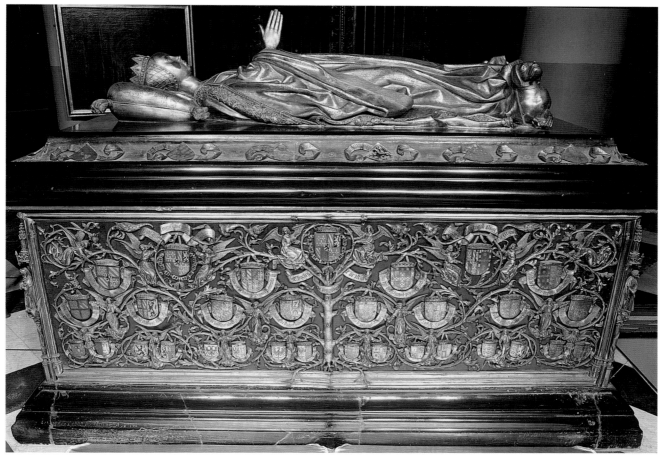

Plate 6.30 Jan Borman (model-maker) and Renier van Thienen (bronze-caster), tomb of Mary of Burgundy, 1488–1501, gilt-bronze effigy on black marble tomb-chest with enamel coats of arms, effigy life-size, chancel, Notre Dame, Bruges. Photo: Musea Brugge and H. Maertens, Bruges.

dynasty. When the Holy Roman Emperor Maximilian I planned his tomb, he took the established dynastic forms of the Valois dynasty to unique extremes. With the marriage in May 1477 of Mary of Burgundy and Maximilian of Austria (who became Holy Roman Emperor in 1493), the Valois and Habsburg dynasties were united – hence Ferdinand and Isabella's desire to marry their daughter Joanna into the family. Pedigree and dynastic display were especially important to the family because, as a woman, Mary's control of the Netherlandish territories was challenged by Louis XI of France, who took over Burgundy and Picardy in January 1477, as soon as her father died, and prepared to take over the rest of her inheritance. When Mary died in a hunting accident in 1482 at the age of 25, she was buried in Our Lady in Bruges within the disputed territories. Her tomb, which was commissioned in 1488 by Maximilian and Philip the Handsome, her son, is thought to be the work of Jan Borman

(active 1479–1520), who made the wooden models, and Renier van Thienen (active *c.*1465–98), who cast it in 1491.[82] When Philip died in 1506, he was commemorated with a monument next to that of Ferdinand and Isabella in Granada, but his heart was buried with his mother in Bruges. Mary's tomb was designed in the Gothic style to present the Valois lineage as a clear statement of her own and her husband's legitimate claim over the area, and it was installed by 1502. On each of the long sides of the tomb chest are family trees of Mary's parents and the family's links with the royal houses of England, Portugal and Spain (Plate 6.30).[83] Like the shield-bearing angels on the tomb of Alice de la Pole (see Plate 6.3), these dynastic displays were important for propaganda but also a potent reminder to the priest to say prayers for the whole family – and their ambitions.[84]

But no monument uses the family on the scale of the remarkable tomb of Maximilian I in the

241

Plate 6.31 Interior view of the Hofkirche, Innsbruck, 1553–63, with the tomb of Maximilian I, 1502–84. Photo: Bundesdenkmalamt, Vienna, and Ed. Beranck, Vienna.

Hofkirche in Innsbruck (Plate 6.31).[85] According to the plan of 1502, it was to include a sepulchre accompanied by 40 bronze over-life-size figures of his family holding candles, plus patron saints and busts of Roman emperors. When Maximilian died in 1519, he left instructions for the statues that had been completed to surround his tomb in the chapel of Saint George in the castle of Wiener Neustadt. The chapel, however, was too small for the huge number of figures so a new church was planned with an attached convent, although it was not built until the 1550s. It is not known for certain how Maximilian wanted the figures to be arranged, although those completed give a good idea of the monument's meaning.

The ambitious project demanded the collaboration of the group of artists and sculptors among whom the work was divided. A foundry was established in Innsbruck specially to cast the figures, and artists from Augsburg, Munich and Nuremberg moved there to undertake the work. The drawings for the models of the statues were mostly the work of Gilg Sesselschreiber and Jörg Kölderer, while Albrecht Dürer may have designed the mythical figures, King Arthur of England and Theodoric, King of the Ostrogoths. Unlike the rest, these

were cast in Nuremberg where Dürer was based. The full-size models that had to be made for casting were done by or under the supervision of founder Gilg Sesselschreiber, by Leonhart Magt, Hans Leinberger and others. The busts of Roman emperors were undertaken first, starting in 1509, but they were not incorporated in the Hofkirche (they are now in Augsburg). Twenty-eight of the ancestors were completed between 1513 and 1533, and 23 of the originally planned 100 saints and holy figures survive, designed by Kölderer and cast by the skilled bronze-founder, Stefan Godl, between 1514 and 1528. The sarcophagus, however, was only completed after 1560, but it is a cenotaph (an empty tomb) because Maximilian's remains were never taken there.

This emphasis on the family has led the monument to be called 'the culmination of the Burgundian tomb tradition' but on an unprecedented scale: the statue of Philip the Handsome, son of Maximilian and Mary of Burgundy who died in 1506, measures 272 centimetres rather than the more usual 30 to 40 centimetres for a subsidiary tomb figure or 'weeper'.[86] Although Maximilian married Bianca Maria Sforza, niece of the powerful regent of the Duchy of Milan, Ludovico 'il Moro', in 1493, his

Plate 6.32 Tomb of Maximilian I figures (from left to right): Zimburgis of Masovia (Gilg Sesselschreiber, 1516), Margaret of Austria (Stefan Godl, 1522), Bianca Maria Sforza (Stefan Godl, 1525) and Sigmund of Austria (Stefan Godl, 1523), Hofkirche, Innsbruck. Photo: Bundesdenkmalamt, Vienna, and Ed. Beranck, Vienna.

first wife's Valois ancestry is much more evident in his projects, representing the precedence of her children and therefore Maximilian's dynastic claims to Burgundy and her other territories. Significantly, Ferdinand II of Spain is not joined by his wife Isabella but by his daughter Joanna the Mad (1479–1555), whose marriage to Mary's son, Philip the Handsome, brought the Spanish kingdoms under Habsburg rule. Other figures include Maximilian's grandmother Zimburgis of Masovia (d.1429), his daughter Margaret of Austria

(1480–1530), and his second wife Bianca Maria Sforza (1472–1511), along with various mythical and actual figures, including Archduke Sigmund of Austria (1427–96), who tranferred his rule of the Tyrol to Maximilian in 1490 (Plate 6.32). Combined, the figures present Maximilian I as the culmination of so many dynasties – a true descendent of the Roman emperors.[87]

Maximilian's intentions behind much of his artistic patronage are revealed in his biography, written around 1512:

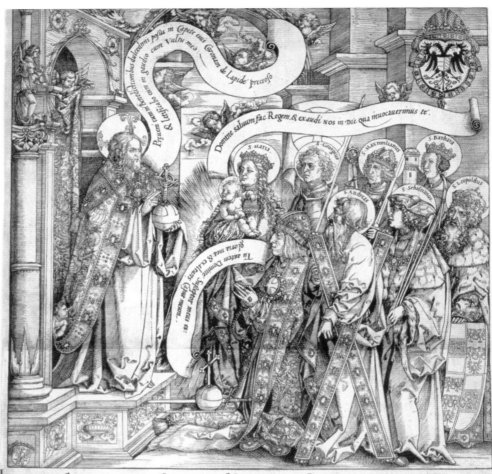

Plate 6.33 Hans Springinklee, *Emperor Maximilian I Presented by his Patron Saints to the Almighty*, 1519, woodcut, 53 × 38 cm, University of Michigan Museum of Art, Ann Arbor, museum purchase 1960/2.38.

Whoever prepares no memorial for himself during his lifetime has none after his death and is forgotten along with the sound of the bell that tolls his passing. Thus the money I spend for the perpetuation of my memory is not lost; in fact, in such a matter to be sparing of money is to suppress my future memory.[88]

During his life it was more often the graphic arts that Maximilian used to commemorate his achievements and satisfy his enthusiasm for complex dynastic allegory because of their flexibility and portability – although his ideas stretched the medium to the extreme. In 1512 in

Nuremberg, Albrecht Dürer oversaw the start of production of an enormous multi-page woodcut, the *Triumphal Arch*, decorated with scenes and texts representing the emperor's virtues, achievements and dynastic pedigree.[89] It took until 1518 for the 192 woodcuts to be printed because Maximilian could not resist making continual changes to the details of his family tree. The *Triumphal Procession* series was commissioned at the same time, with Dürer contributing the triumphal chariot itself, which shows the emperor in a carriage with his family around him: his first wife Mary of

Burgundy next to him and Philip the Handsome and Joanna the Mad in front.[90] In the front rows are Maximilian's six grandchildren, including the future emperors Charles V and Ferdinand I.

A woodcut by Dürer's pupil, Hans Springinklee (*c*.1495–1522), in which the emperor is presented to God in heaven by no fewer than six of his patron saints and the Virgin and Child, epitomises Maximilian's efforts to define and promote himself among his ancestors, relatives and patron saints (Plate 6.33).[91] Rather than a simple case of self-glorification, the tomb can be interpreted as representing the powerful associations Maximilian believed existed between himself, his ancestors, patron saints and the ancient emperors: his homage to them by gathering them all in one place and putting himself among them as a member of the same elevated group.[92]

This unity and continuity between the living and the dead, the past and the present, was not shared by Maximilian's successors who inherited the project, however. Indeed, the story of Maximilian's monument after his death is perhaps as revealing as its creation. Despite the fact that the completion of the monument was an explicit request in his wills of 1514 and 1518, Karl Schmid has suggested that Maximilian's grandsons, Ferdinand I and Charles V, did not share the same sense of continuity with the dead as their grandfather, and the project quickly became a burden. While a new site was found for the statues that had been completed, Maximilian's remains stayed at Wiener Neustadt.[93] What had changed was more fundamental than practicalities. Luther's protestations at the power of the Church of Rome in 1520 began a process in which fundamental belief structures were dismantled, among them the all-important continuity between the living and the dead that was the basis of Maximilian's vision.

5 Conclusion

Commemorative monuments, manuscripts and paintings reveal some of the complex beliefs and coping strategies adopted by the living to deal with the problem of death. They are among the most vivid examples of the different ways that works of art were viewed. They make it clear that the preparation of the living for death and the belief in an afterlife were an integral part of religious devotion. Through appropriate commemoration of relatives, ensuring the continuation of one's own memory and the demonstration of good deeds displayed in so many works of art, time in purgatory might even be curtailed.

All that quickly changed. Although at first he sought only to reform the concept of purgatory, by 1530 Martin Luther had completely rejected its existence. Intercession for souls in purgatory had taken over from the Mass, which Luther complained was 'held mostly for the dead, although it was given and instituted as a consolation only for living Christians'.[94] Luther instead envisaged death as sleep, a dream state in which the dead awaited the Last Judgement and where they could not be reached by the living.[95] John Frith in England argued that purgatory was no more than a way for the Church to exact money from the faithful: 'this their painful purgatory was but a vain imagination, and that it hath of long time but deceived the people, and milked them from their money'.[96] Whereas previously the funeral had served as only the beginning of a long process of prayer for the soul to aid its desperate plight through purgatory, by the middle of the sixteenth century north of the Alps the funeral had become the point at which the end of life was regretted, loss of the individual mourned and the corpse disposed of. It was a point of departure over which the living had no control or means of influence. Monuments commemorated life past; they did not remind the living to keep on remembering the dead. The commemorative arts of Protestant and Catholic Europe were set to follow separate paths.

Chapter 7 introduction

Hans Holbein's career was situated at a watershed in the production of painting. This watershed was the Protestant Reformation, which fundamentally changed the way that religious art was viewed in part, though by no means all, of Europe. Ecclesiastical art formed an essential element of the pre-Reformation Church and proliferated during the fifteenth century. Altarpieces served to mark the dedication of an altar, and to provide a suitably splendid backdrop to the Mass. Statues abounded and were used by the faithful as a focus for prayers of intercession. Epitaphs or memorial reliefs commemorated individuals in the context of a religious scene. Reliquaries, often in precious metals, were made to house revered relics owned by a church or monastic house. Cult statues or paintings thought to have miraculous powers invited pilgrimage. Commissioning a work of art for a church constituted a good work for which remission of time spent in purgatory might be earned, and indulgences offering further remission of sins might be associated with particular images. Hence religious art represented not only a financial but a spiritual investment for the pious lay donor. It also served a key role in the magnificence cultivated as much by the pre-Reformation Church as by the ruling elite in fifteenth- and early sixteenth-century Florence discussed in the second chapter of this book.

Holbein worked in two countries, Switzerland and England, in which the traditional use of religious art was eventually outlawed, its devotional and liturgical significance denied, and the whole visual culture of the pre-Reformation Church repudiated. It is fitting, therefore, that this book on viewing Renaissance art draws to a close with the end of religious art as it had hitherto been understood in these Protestant areas of Europe. Artists faced with the artistic desert of the Protestant Reformation needed strategies for survival. While Holbein began his career producing religious art, he ended it primarily though not exclusively producing portraits, which by virtue of their relatively neutral religious agenda remained an acceptable art form in Protestant countries.

Kim W. Woods

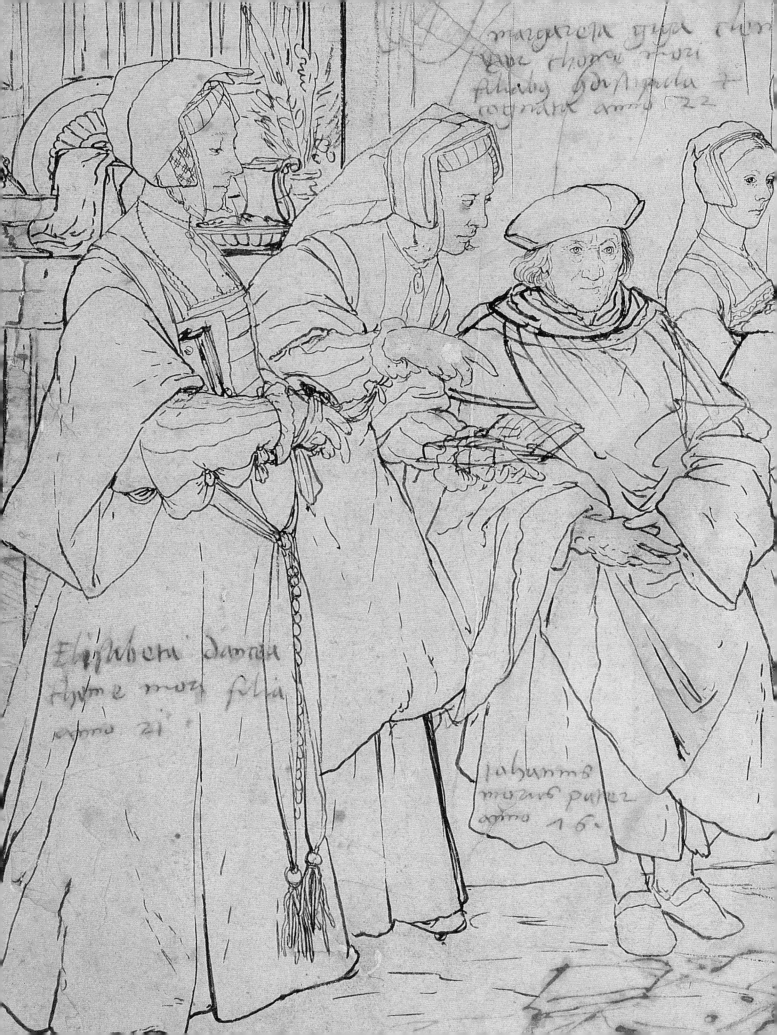

margarcta gijza vxon
vxor chome mori
filiabz adoptiuula +
cognata anno 1522

Elizabeta danua
thome mori filia
anno 21

Johannis
mozuc pater
anno 16

Chapter 7

Holbein and the reform of images

Kim W. Woods

During the first half of the sixteenth century huge changes occurred in Europe in the way that religious images were viewed. The Protestant Reformation was a complex movement that began well before 1517, when Martin Luther famously pasted his 95 'theses', or objections to the Roman Catholic practice of purchasing indulgences for the remission of sins, onto the door of the castle church in Wittenberg. This protest movement had serious implications for the Church and national politics, but it had consequences for art as well, and in Switzerland – very much in the vanguard of religious reform – this was apparent as early as the 1520s.

Whereas both painted and carved images were an essential part of the practice of the late medieval and Renaissance Catholic Church, Protestant reformers regarded religious art at best with great suspicion and at worst with outright hostility. The audience for religious art declined sharply in areas dominated by the Reformation, and many experienced bouts of iconoclasm: that is, the destruction of religious images. Other art forms such as portraiture profited by their relative religious neutrality, and survived and prospered during the Reformation period. The career of the artist Hans Holbein the Younger straddled two reformations: the Protestant Reformation in Basle in the 1520s and the beginnings of the Protestant Reformation in England in the 1530s and early 1540s. The commissions he received reflected the changing demand for art in these two countries. Although he is now renowned as one of the greatest portraitists of western European painting, this very reputation is predicated on a certain Protestant religious context that favoured some art forms and condemned others. In fact, his artistic practice extended far beyond portraiture, and his artistic talents were used in the production of both conventional Catholic religious art and propaganda images serving the cause of religious reform. This chapter examines the changing ways in which religious art was viewed in parts of northern Europe, and the impact those changes appear to have had on Holbein's career as an artist.

Hans Holbein the Younger (1497/8–1543) was born in Augsburg in southern Germany, the son of a painter of the same name. He left the city at the age of 17 or 18 and, together with his brother Ambrosius, arrived in Basle in Switzerland by 1515, becoming a member of the painters' guild in 1519. Augsburg was a cosmopolitan centre in prosperous southern Germany, one of Europe's three main industrial zones. The city was the home of a fabulously wealthy banking family, the Fuggers, and lay on one of the major trading arteries of western Europe. Augsburg promised good patronage opportunities though also, without doubt, a degree of artistic competition. A member of the Swiss Confederation from 1501, Basle also held considerable promise of work for a young artist. It lay on the River Rhine and hence boasted important trading links and all the associated crafts associated with a flourishing trading city; it had a cathedral and a university, founded in 1454. Crucially, it was also a centre of the book trade,

Plate 7.1 (Facing page) Hans Holbein the Younger, detail from a study for a portrait of Sir Thomas More and his family (Plate 7.22).

with 70 book printers established in the city by 1501. The Catholic humanist reformer Desiderius Erasmus (c.1466–1536) first settled in the city in 1514 because his Greek New Testament was to be published by Froben, one of the city's most eminent printer publishers; from 1521 he lived in the city more or less permanently.[1] Since Hans the Younger and his brother Ambrosius are known to have done designs for woodcut book illustrations, it could be that the lure of the book industry attracted them to the city as well.

By the mid-1520s, lucrative commissions for religious art were much more difficult to come by in both Augsburg and Basle. Augsburg was affected by reforming religious ideas and suffered iconoclasm from 1524. Although the city emerged from the religious turmoil resolutely Roman Catholic in persuasion, this did not happen until the late 1540s, after Holbein's death. Basle also became a hotbed for reform, and by the late 1520s, the Catholic Church and with it religious art were facing fundamental challenge from reformers. By 1532, when Holbein finally settled in England, religious art was a thing of the past in Basle. Within about two decades of his death, religious art had been all but eradicated in England as well.

1 The vanishing world of religious images

For centuries, much of the staple work of artists had been provided by the Church, either directly or from individuals, lay or clerical, commissioning work to donate to a church, chapel or monastery or for use in private worship. From the 1520s onwards, this market for art was severely threatened by the Reformation. Religious art was of necessity implicated in the particular religious mindsets of the patrons for which it was designed. Once this mindset was discredited, so too was the religious art associated with it. The more extreme reformers had fundamental objections to any religious imagery at all on the grounds that it was intrinsically idolatrous and offended against the second commandment, which forbade the making of 'graven images' (Exodus 20:4) (see also Chapter 5). Even moderate voices criticised the way in which art had been used. An examination of some different works of art connected either with Holbein's adopted country of Switzerland or with his father and the Augsburg area demonstrates

that religious art was anything but neutral in the reforming debates.

The Heilspiegel altarpiece

Roughly a contemporary of Jan van Eyck (c.1395–1441), Conrad Witz of Rottweil entered the painters' guild in Basle in 1434 and was dead by 1446. During these years he produced at least two monumental altarpieces, and may have been responsible for the *Dance of Death* series painted on the walls of the Dominican cemetery there. His Heilspiegel altarpiece, or altarpiece of the mirror of salvation, was broken up during the iconoclasm in Basle, but several painted panels from its movable shutters survive.[2] The use of oak panels and meticulous painting technique are among many elements of Witz's work that are strongly reminiscent of Netherlandish painting, though his training remains a mystery. The complicated and very unusual programme of the altarpiece is drawn from the *Speculum humanae salvationis* or *Mirror of Human Salvation*, a late medieval picture book dating from before 1324, available initially in manuscript form and later as an illustrated printed book. On each page, Old Testament, historical or legendary narratives were presented alongside New Testament events they were believed to anticipate. This form of comparison, or typology as it is called, regarded Christ's life and death as the high point in human history which significant prior events had unwittingly foreshadowed in a prophetic way, and it had a long history.

Since not all sections of the Heilspiegel altarpiece survive, its original layout, content and even shape can only be reconstructed hypothetically. On the outer face of the two shutters were representations of the Angel Gabriel and the Annunciate Virgin, personifications of church and synagogue, and standing figures of saints, placed in either two or three vertical tiers. Each inner face comprised four or perhaps five panels, on which were represented classical and Old Testament narratives that mirrored episodes in the redemption story. The rather obscure scene of Abisai, Sabothai and Benaja bringing water to David (2 Samuel 23:15–22; see Plates 7.2–7.3) was considered a type for the Adoration of the Magi.[3] Witz represents the three men offering vessels containing water in much the same way as the Magi are usually represented offering gifts to the Christ Child. Other surviving panels include the Roman Emperor Augustus

Plate 7.2 Conrad Witz, Heilspiegel altarpiece panel showing King David and Abisai, *c.*1435, oil on oak panel covered with cloth, 102 × 81 cm, Kunstmuseum, Basle. Photo: Kunstmuseum, Basle/Martin Bühler.

Plate 7.3 Conrad Witz, Heilspiegel altarpiece panel showing Sabothai and Benaja, *c.*1435, oil on oak panel covered with cloth, 98 × 70 cm, Kunstmuseum, Basle. Photo: Kunstmuseum, Basle/Martin Bühler.

receiving a vision of Christ through the Tiburtine sibyl (a type for the Nativity); Esther before Ahasuerus (Esther 5:1–8, a type for the Virgin interceding for humanity); the meeting of Solomon and Sheba (1 Kings 10:1–13, occasionally also a type for the Adoration of the Magi); Antipater showing his wounds to Caesar (a type for Christ showing his wounds to God); and Abraham meeting Melchisedek (Genesis 14:18, a type for the Eucharist). In each scene, Witz inscribes the characters' names on the fictive damask background to help the viewer identify what otherwise might in some cases be indecipherable narratives. Nothing is known of the lost central section, but it might have been an Adoration of the Magi and could have been carved rather than painted.

The precise history of the altarpiece remains unknown. One suggestion is that it might be the carved and painted altarpiece commissioned for the Augustinian church of Saint Leonard, for which Bern architect and sculptor Matthäus Ensinger sought final payment in 1450, though it had been

delivered some time before and hence probably in Witz's lifetime.[4] If so, Ensinger presumably supplied a carved central section and subcontracted the painted shutters to Witz.

With its highly programmatic typological approach, it is not difficult to imagine how antiquated and inappropriate this altarpiece might have appeared as the Protestant reformers introduced a more literal and straightforward approach to interpreting the Bible. Although works of art are often said to have instructed the illiterate, all but the simplest paintings also required prior knowledge of the narrative in order to make sense. Viewers could only have understood the complex didactic programme of the Heilspiegel altarpiece if they were already familiar with the *Speculum humanae salvationis*, or had been introduced to this sort of typology through sermons, for example. Its significance might otherwise have passed them by entirely. The inscriptions identifying the characters were useful only for those could read. Many Swiss reformers rejected the didactic function of images and instead stressed exclusively the spoken word of Scripture.

The *Large Einsiedeln Madonna*

The abbey church of Einsiedeln near Zurich was a centre of annual pilgrimage to celebrate the 'Engelweihe' (literally, angel consecration), the miraculous consecration of the initial church built on the site where Saint Meinrad was martyred in the ninth century. In 1466, 500 years after the papal bull granting indulgences to pilgrims to Einsiedeln, some 130,000 pilgrims made their way to the church, where they were served by 400 confessors.[5] Pilgrim shrines often sold souvenir woodcuts to visitors, but to celebrate the Einsiedeln anniversary a very much more sophisticated and without doubt more expensive souvenir engraving was commissioned from the accomplished Upper Rhenish printmaker Master ES (Plate 7.4). The upper part of the engraving shows Christ, to the left of God the Father and surrounded with the company of heaven, blessing the altar below with holy water taken from a bucket held by an angel. The prominent tiara and crossed keys – the insignia of the papacy – advertise the papal ratification of the Einsiedeln pilgrimages. The inscription in German around the arch through which the lower part of the scene is viewed suggests that the print was targeted at the more prosperous lay pilgrims visiting the shrine who might read German but not Latin. It says: 'This is the angel consecration of Our Lady of Einsiedeln hail [Mary] full of grace.'[6]

Central to the lower part of the print is an image of the Virgin and Child with Saint Benedict to one side and an angel to the other. All are set beneath architectural canopies as if they were carved statues within an altarpiece case, placed on an altar and protected by curtains to either side (as was the convention), yet the 'statues' appear alive rather than crafted. Gazing at these figures are lay pilgrims carrying their pilgrim staffs (which they would need for the 35 kilometre lakeside walk from Zurich to Einsiedeln). On one level this engraving appears to provide an insight into the devotional imagination of pilgrims venerating sacred images as surrogates for real holy people, but statues were sometimes rumoured to come to life more literally as well. Purportedly miraculous images that moved or wept stimulated pilgrimages in their own right, and were a valuable source of income for the Church. Inevitably there were a few much-publicised incidents of fraud, such as a statue of the Pietà in Bern alleged to weep tears of blood, but

exposed as a fake devised by a Dominican monk and trickster named Jetzler and his co-conspirators in 1507.[7] Miracles were also attributed to statues that did not move; indeed, Saint Meinrad, on whose place of martyrdom the Einsiedeln church was built, is reputed to have owned such a statue later installed there.[8]

The practice of pilgrimages, and the images associated with them, came in for criticism not just from Protestant reformers but from moderate Catholics: Erasmus was sharply critical of cult images associated with pilgrimage shrines, for example, and wrote a colloquy on the subject in 1526 while resident in Basle.[9] The famous Swiss reformer Ulrich (or Huldrych as he styled himself, meaning rich in grace) Zwingli (1484–1531) served as priest in the village of Einsiedeln from 1516 to 1518, and hence would have been well acquainted with the practice of pilgrimages. From 1518 he took up a post at Zurich Minster, where his reforming views rapidly crystalised and gained influence not just in Zurich but in other Swiss towns, including Holbein's Basle. As we shall see, the sorts of prints produced in support of Protestant reform in Switzerland to designs by Hans Holbein the Younger and others could not have differed more sharply from the devotional Einsiedeln engraving.

The Kaisheim altarpiece

Holbein's father Hans the Elder (*c.*1460/5–1524) was a respected Augsburg painter who depended for his livelihood primarily on the production of large-scale narrative altarpieces. Apparently in constant demand, he travelled widely to fulfil commissions. In 1493 he produced wings for a now destroyed carved altarpiece for the monastery of Weingarten by Ulm sculptor Michel Erhart (active 1469–1522). In 1501 Hans the Elder and his brother Sigmund completed the wings for an altarpiece commisioned by Johannes von Wilnau to decorate the high altar of the Dominican church in Frankfurt, the same church for which Jakob Heller commissioned Dürer to paint the *Assumption of the Virgin* altarpiece only a few years later.[10] In 1502 Hans the Elder signed and dated the painted shutters for an altarpiece for the Cistercian abbey of Kaisheim near Augsburg. This altarpiece had a carved central section with statues by Michel Erhart's son Gregor (active from 1494; d.1540) and a case by Gregor's brother-in-law Adolf Daucher (d.1524).

Plate 7.4
Master ES,
*Large Einsiedeln
Madonna*, 1466,
engraving,
21 × 13 cm,
Art Institute of
Chicago, Kate
S. Buckingham
Fund, 1972.1.
Photo: © The
Art Institute of
Chicago.

Plate 7.5 Gregor Erhart, *Virgin of Mercy*, *c*.1502, polychromed limewood, height 216 cm, formerly Deutsches Museum, Berlin (destroyed). Photo: Bildarchiv Foto Marburg.

The only statue to have survived from the Kaisheim altarpiece was destroyed in World War II but is known from photographs. The *Virgin of Mercy* (Plate 7.5) shows Cistercian monks sheltering beneath the robe of the Virgin, who holds a sprawling Christ Child. The moon at the Virgin's feet identifies her with the apocalyptic woman from the New Testament book of Revelation, 'clothed with the sun and with the moon under her feet' (12:1). The focus here is not so much on the Christ Child as on the Virgin and her protective powers. Such iconography, and indeed such beliefs, were absolutely standard in the fifteenth-century Catholic Church, but they were abhorrent to the Protestant reformers, who denied any biblical basis for the veneration of the Virgin Mary and rejected the idea of her mediation on behalf of humanity.

On the outer shutters of the altarpiece were 16 paintings narrating the Passion of Christ by Hans Holbein the Elder. Decorating the inner shutters was a narrative cycle of the life of the Virgin, each scene set under fictive tracery (Plate 7.6). Some of the themes were taken from apocryphal rather than biblical sources, like the *Death of the Virgin* (lower right side). The story of the death of the Virgin is found in the *Golden Legend*, written *c*.1260 by the Dominican Jacopo da Voragine. It was arguably the most-read devotional book in western Christendom, translated into every major European language and popularised through the printing press from the mid-fifteenth century.[11] According to the *Golden Legend*, the Virgin requested the presence of the Apostles at her deathbed, to which they were subsequently miraculously transported. In Hans the Elder's painting, Saint James is identified by the pilgrim shell in his hat, for example. From the mixed sources on which Voragine drew came some of the best-loved themes of the late Middle Ages. The Protestant reformers, however, advocated a return to scriptural authority, which firmly excluded apocryphal legends, however distinguished their pedigree in ecclesiastical tradition. Even apart from the problem of subject matter, altarpieces were condemned by the reformers as part of the trappings of the Mass. They were systematically dismantled and destroyed in many Protestant areas, and the altarpiece makers all but disappeared.

Plate 7.6 Hans Holbein the Elder,
right wing panel from the Kaisheim
altarpiece, 1502, oil on panel,
179 × 81 cm, Alte Pinakothek,
Munich. Photo: Blauel/Gnam
– Artothek.

255

The reliquary of Saint Sebastian

Some time prior to 1497, Hans the Elder was probably responsible for the sketched design of a reliquary for the Kaisheim monastery (Plate 7.7). Sebastian was a saint invoked against the plague, so he was a fitting subject for a reliquary commissioned during an outbreak of the disease. It had a companion reliquary of Saint Christopher, who was the patron saint of travellers. Setting eyes on an image of Saint Christopher was meant to protect the viewer from sudden death: hence representations of this saint were common in public places as well as in churches and monasteries. Hans the Elder's metalpoint drawing shows the saint as a real figure tied to an abbreviated but convincingly simulated tree. The final reliquary (Plate 7.8) is dated 1497 and bears the name of the abbot of the monastery, Georg Kastner, though a chronicle of the monastery suggested that Frederick the Wise, ruler of Saxony from 1486 to 1525, also contributed to the cost.[12] The tiny drawing was adapted somewhat – first in the tree but more importantly in the pose, for Saint

Sebastian appears to step off the base, indicating with his foot his own relics, which are stored behind glass in the base below. This base does not appear in the drawing. For all that it is fashioned in the rather artificial medium of gilded silver

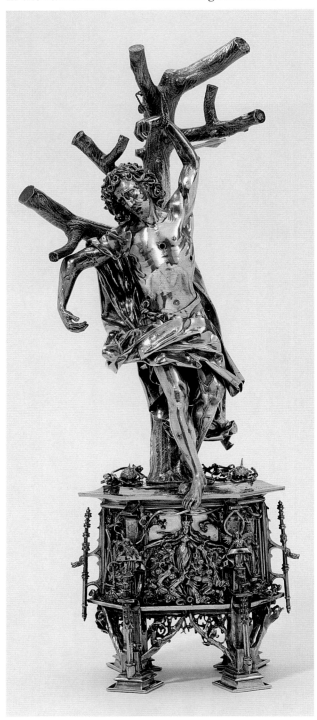

Plate 7.8 Unknown goldsmith, reliquary of Saint Sebastian, 1497, silver-gilt, base set with glass, pearls, sapphires and rubies, height 50 cm, Victoria and Albert Museum, London (M.27–2001). Photo: © V&A Images/ Victoria and Albert Museum.

Plate 7.7 Attributed to Hans Holbein the Elder, design for reliquary of Saint Sebastian, before 1497, metalpoint, 13 × 10 cm, British Museum, London. Photo: © The Trustees of The British Museum.

rather than carved and polychromed wood, the reliquary figure is convincingly lifelike by virtue of the carefully described musculature and pose of the figure.

Saints, their relics and their images were a powerful force in the Catholic Church. Protestant reformers abhorred the practice of interceding to saints and the traffic in their relics. Although Catholic churchmen were concerned to make a distinction between the veneration of saints represented through art and the unacceptable worship of representations of those saints, which would constitute idolatry, to the more extreme Protestant reformers like Zwingli and Karlstadt, all images invited idolatry and should be removed.

Location meant everything for the survival of art over the Reformation period. The central panel of the Heilspiegel altarpiece by Conrad Witz evidently perished along with so many other altarpieces in reformist Switzerland. That a number of panels have survived from the wings is surprising and suggests that as much of the altarpiece as possible was concealed from the iconoclasts. Although several cities in southern Germany, including Augsburg, suffered iconoclasm, the Kaisheim monastery apparently escaped for the altarpiece survived and instead fell victim to the vagaries of fashion. In 1673, a new Baroque altarpiece was acquired, but even then, the old altarpiece was dismantled and dispersed rather than discarded.[13] The reliquary probably stayed in the Kaisheim monastery until it was secularised by French troops in 1802. Fortunately, it was purchased and preserved by a well-known collector of late Gothic art. If location made all the difference to the preservation of works of art, equally it made all the difference to the fortunes of the artists who made them.

2 The case against images

Though critical of idolatry, the Wittenberg reformer Martin Luther (1483–1531) was opposed to the iconoclasm recommended by fellow reformer Andreas von Karlstadt (c.1480–1541) while Luther was in hiding. Karlstadt defended his views in a tract entitled *On the Abolition of Images* (1522); Luther refuted Karlstadt's arguments in *Against the Heavenly Prophets* (1525). Although certainly not an advocate of religious art, Luther was prepared to concede that some biblical images

might be acceptable: 'whether I will or not, when I hear of Christ, an image of a man hanging on a cross takes form in my heart, just as the reflection of my face naturally appears in the water when I look into it. If it is not a sin but good to have the image of Christ in my heart, why should it be a sin to have it in my eyes?'[14]

The standard defence of images – that the honour paid to an image is transferred to its prototype – was first made by Saint Basil in the fourth century, reiterated by the eighth-century Syrian saint, John of Damascus, in opposition to the iconoclasts of the Byzantine Empire, and reused in succeeding centuries.[15] Karlstadt rejected this argument out of hand. He considered all images as intrinsically idolatrous, and his solution was that recommended in the Old Testament book of Deuteronomy 7:5: 'You shall overturn and overthrow their altars. You shall break their images to pieces. You shall hew down their pillars and burn up their carved images.' What is more, he counselled against waiting for the Church to remove images itself 'for they will never begin to do it'.[16] Instead, magistrates should take matters into their own hands, and this is exactly what happened in the Swiss city of Zurich.

In Zurich the dominant reforming voice was that of Ulrich Zwingli, who used his appointment as preacher by the city council in 1522 to air increasingly radical views, including a stance on images. According to Zwingli, religious images were a substitution for the direct worship of God. In his *Answer to Valentin Compar* of 1524, he dismissed the visual tradition of the Catholic Church as a symptom of inadequate faith and the degeneration of spiritual life.[17] Although those who had donated images to churches in Zurich were initially given the opportunity to remove them, from July 1524 the remaining images were forcibly removed and destroyed on the instructions of the city magistrates.

In Basle, where Holbein lived, Erasmus gathered around him a group of supporters of moderate reform during his sojourn in the city from 1521 to 1529, but more extreme reforming views were being disseminated through the Basle printing presses. Iconoclasm hit Basle in 1528 largely as a popular movement initially resisted by the city magistrates.[18] On 10 April 1528 protesters stripped images from two Basle churches, which frightened the city authorities into agreeing to the

dismantling of images in the five city churches that had already espoused reform. Iconoclastic pressure continued, however, and on 8 February 1529 a crowd gathered at the town hall demanding the wholesale removal of images. The following day the storeroom was discovered where images from the cathedral had been placed for safekeeping. The crowd ransacked it, then ransacked the cathedral too. On Ash Wednesday the debris of the images was burnt in the public square. By the end of 1529, the images were gone, the Catholic Mass officially banned, the bishop dismissed and the cathedral chapter dissolved. Erasmus was among those who lamented the wanton destruction of the city's artistic treasures, and he left the city as a consequence, though he returned in 1535.

The only suggestion of Holbein's personal response to religious reform was his failure to attend the new communion service in 1530, of which he stated he needed a better explanation. His name later appeared among those conforming, but whether this was expediency or conviction is impossible to say.

3 Holbein and the reform of images in Basle

Holbein's activities in Basle up to his first visit to England in 1526 were extremely varied, and he quickly revealed himself to be a cosmopolitan artist, conversant with Netherlandish art, with the work of the famous painter and printmaker Dürer of Nuremberg, and with the Italian Renaissance. Holbein worked for conventional Catholic, humanist and Protestant patrons. His own allegiances are uncertain and, in the context of an artist responding to patronage opportunities, probably largely irrelevant. The most that may be said is that he cannot have felt it to be against his conscience to work for the range of patrons that he did; nor can his varied patrons have felt his religious views and activities to be an impediment to the placing of commissions, which was in any case a business arrangement.

A testimony to his rapidly increasing prestige is the 1521 commission for wall paintings for the council chamber of Basle town hall, which were designed to have an improving effect on council business.[19] Now known only through original drawings, copies and small fragments of some of the paintings, these didactic narratives were all taken from classical sources such as the fifth-century BCE Greek historian Herodotus, and Holbein drew on Italian Renaissance prints for his compositions. The scheme was completed only in 1530, when Holbein painted not classical narratives but two Old Testament subjects on the south wall of the chamber; it is tempting to wonder whether this represents a change of programme on the part of the city council, which had shifted in the interim from fashionable humanist interest in the classical past to Bible-conscious reform.

Like his father, Holbein painted large-scale altarpieces including the so-called Passion altarpiece (1520s, Öffentliche Kunstsammlung, Basle). With its two-tier structure and fictive carved and gilded scrolls separating the eight scenes, it is strongly reminiscent of his father's Kaisheim altarpiece, the outer shutters of which showed almost the same scenes, though Holbein's are not set within fictive carved frames.[20] Unusually, five out of Holbein's eight narratives are night scenes, but in all other respects this appears a conventional Catholic commission that, as a representation of the life of Christ, might not offend a Lutheran but would hardly have met with approval among the harder-line Zwingliists gaining influence in Basle.

By contrast with these respectable commissions, Holbein's skills were also in demand as a designer of woodcuts of reformist literature, which was printed in some quantities in the relatively liberal context of Basle. He designed the title page for the Basle edition of Luther's translation of the New Testament, first published in Wittenberg in 1522 (Plate 7.9). The woodcut itself stresses the biblical word so emphasised by the Protestant reformers. To either side are Saints Peter and Paul, both New Testament writers as well as heads of the early Christian Church, and in the corners are an angel, eagle, lion and winged bull, symbols of the four Gospel writers Matthew, John, Mark and Luke. Although not controversial in itself, this title page was done at a time when the translation of the Bible into the vernacular for the benefit of ordinary literate laypeople was still deeply contentious. In the same year, it may have been Holbein who designed a woodcut of Luther as Hercules trampling the philosophers underfoot. Sometimes interpreted as a criticism of Luther rather than a compliment, this may reflect humanist rather than Protestant reforming sensibilities.[21]

Plate 7.9 Hans Holbein the Younger, title page of Martin Luther's translation of the New Testament printed in Basle, 1523, woodcut, Zentralbibliothek, Zurich. Photo: Zentralbibliothek, Zurich.

Holbein seems also to have served as a hired designer for the block-cutter Hans Lützelburger (d.1526).[22] It was probably Lützelburger himself who commissioned designs for a series of woodcut *Pictures of Death* in 1523–5, in which death is represented as the constant companion to life, with the message that the moment of death is unpredictable. Around the same time, Lützelburger also cut, and perhaps commissioned, Holbein's designs for an alphabet of death, produced as one print with a biblical message inscribed underneath each letter. Although both sets of prints had anticlerical undertones, a degree of satire was inherent in the *danse macabre* with which Holbein's *Pictures of Death* most closely compare, and the programme does not necessarily

Plate 7.10 Design attributed to Hans Holbein the Younger, *Christ the True Light*, c.1522–3, woodcut, 9 × 28 cm, British Museum, London. Photo: © The Trustees of The British Museum.

imply reforming views.[23] Two woodcuts dating from around the early 1520s and again cut by Lützelburger have much more overt reforming themes that Oskar Bätschmann and Pascal Griener have identified as Lutheran.[24] The first depicts *Christ the True Light* showing the light to the faithful gathered to his left, while to his right the pope, a bishop, canons and monks together with ancient Greek philosophers Plato and Aristotle turn their backs on the light and, stumbling in darkness, fall into a ditch (Plate 7.10). The second, the *Selling of Indulgences*, shows the sale of remissions of sin by the pope and monks to the right contrasted with three true penitents to the left. It has been suggested that the designer of both these woodcuts was Holbein.

If Holbein's print designs served the cause of reform, he still worked for Catholic patrons as a portraitist and painter of altarpieces. On his election as burgomaster (or mayor) of Basle in 1516, the staunchly Catholic Jakob Meyer (1482–1530/1) and his wife Dorothea Kannengiesser sat for their portraits with Holbein, when the painter was only 19 years of age and not yet a member of the Basle guild (Plate 7.11). A shield with Holbein's initials and the date is included in the simulated frieze over the head of Jakob. The coin Meyer holds may allude to Basle's right to mint coins, granted in 1516. The portraits are somewhat reminiscent of those by Dürer in the informal, slightly dishevelled clothing of Jakob and the curious anatomy of the artificially broad and sloping shoulders of his wife. For the illusionistic architectural setting, Holbein could have taken inspiration from Augsburg printmaker Hans Burgkmair, whose work he must have known from his youth in the city: Burgkmair's 1512 portrait of Hans Paumgärtner has a similar

architectural background and oblique viewpoint.[25] The setting gives the illusion of continuity through Holbein's two portraits, and the coffered barrel vault, simulated marble columns and simulated gilded frieze are fashionably Italian Renaissance in character. Presumably plausible likenesses, the portraits were carefully rehearsed through detailed silverpoint drawings including colour notes (Plate 7.12), which Meyer seems to have purchased along with the picture. Except for his use of coloured chalks, Holbein's preparatory methods show little change since Jan van Eyck's portrait drawing of Cardinal Albergati, done some 80 years earlier.[26] Holbein continued to use detailed preparatory drawings to his death, though he was later to abandon the laborious silverpoint in favour of the swifter and perhaps more expressive medium of pen and ink and coloured chalks.

Meyer was evidently pleased with Holbein's services, for he gave him a second commission c.1525 for an altarpiece of the Virgin and Child with donors, the so-called *Darmstadt Madonna* (Plate 7.13). The Virgin of Mercy shelters the Meyer family beneath her cloak, as did the central statue of the Kaisheim altarpiece (Plate 7.5) for which Holbein's father had supplied painted shutters. The fig leaves in the background were thought to ward off disease and offer added protection. As befits the Queen of Heaven, the Virgin wears a lavish gold crown resembling that of the Holy Roman Emperor, decorated with figures of seated saints, pearls and rubies.[27] On the right, Meyer's deceased first wife, second wife and daughter carry rosaries with which to recite set prayers to the Virgin. Set within a classicising shell niche, with glimpses of plants and blue sky behind, the picture is also reminiscent of some

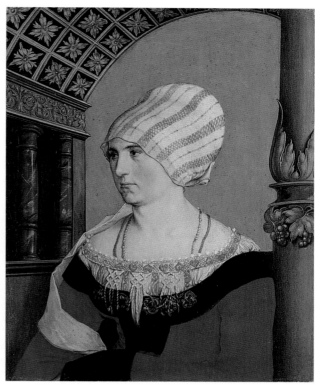

Plate 7.11 Hans Holbein the Younger, *Portraits of Jakob Meyer and Dorothea Kannengiesser*, 1516, oil on panel, 39 × 31 cm each, Öffentliche Kunstsammlung, Kunstmuseum, Basle. Photo: Kunstmuseum, Basle/Martin Bühler.

early Italian Renaissance *sacre conversazione* paintings, here adapted to include not saints but full-size donors.[28] The identity of the clothed young boy on the left remains uncertain; perhaps he was an undocumented son who died young.[29] The curious nudity of the foreground child may identify him as the young Saint John the Baptist, who was commonly included with the Christ Child by Leonardo da Vinci and a number of other Italian Renaissance artists, including Raphael and Michelangelo. It seems likely that Holbein knew Leonardo's work, and the cleverly foreshortened hand of Christ has been likened to that of Leonardo's famous Virgin in the *Virgin of the Rocks*.[30] Conversely, the rucked carpet in the foreground, painted in glorious *trompe l'oeil* detail, and the verissimilitude of the portraits are reminiscent of the Netherlandish tradition.

Although classed as an altarpiece, this work is also a memorial to the Meyer family, and it

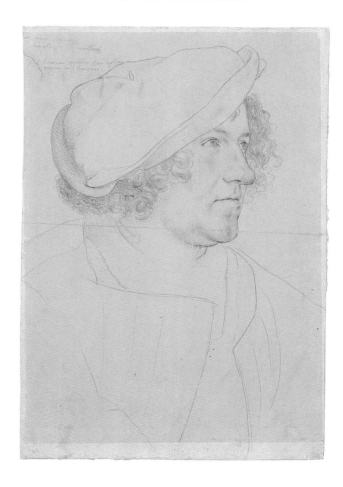

Plate 7.12 Hans Holbein the Younger, preparatory drawing of Jakob Meyer, 1516, silverpoint and chalk on paper with white priming, 28 × 19 cm, Kupferstichkabinett, Kunstmuseum, Basle. Photo: Kunstmuseum, Basle/Martin Bühler.

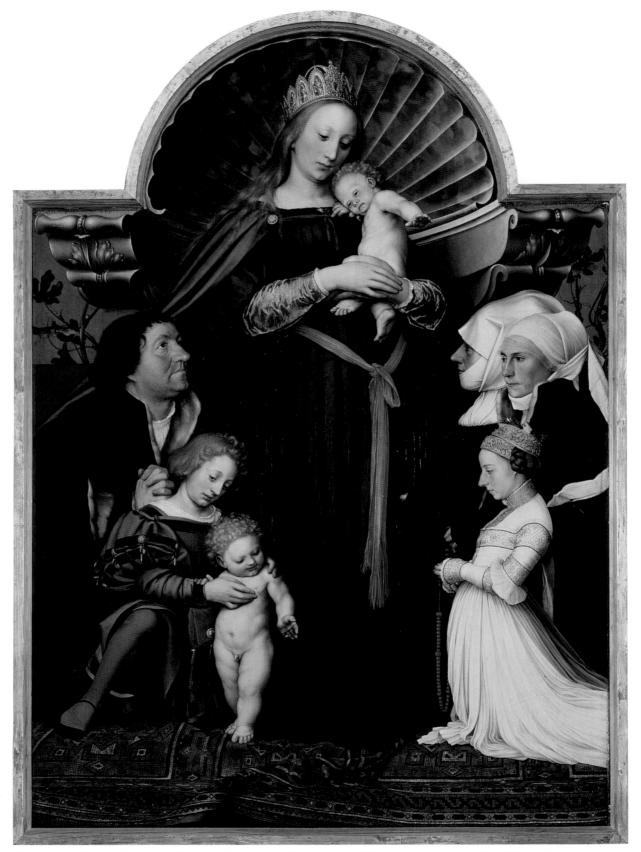

Plate 7.13 Hans Holbein the Younger, *Darmstadt Madonna*, *c*.1525–8, oil on panel, 147 × 102 cm, Schlossmuseum, Darmstadt. Photo: Bridgeman Art Library, London.

is perhaps significant that his daughter Anna wears rosemary and carnations in her hair, both symbols of remembrance. It is generally believed that the work was begun but perhaps not finished before Holbein first left for England in 1526. X-rays reveal significant changes to the female donors, particularly to Anna, whose long hair was originally loose in both the preparatory drawing and the initial painting, and to her mother, whose headdress was also altered. This is consistent with the artist and patron returning to and rethinking a work of art after some lapse of time, particularly since Anna was betrothed by 1528 and loose hair may no longer have been thought appropriate, but there is no proof.[31] What is certain is that it took some time and effort to finalise the composition, and that it must have been completed by *c.*1528–9, for it is most unlikely that anyone was still working on altarpieces in Basle after the iconoclasm. How this painting came to survive is uncertain, but it has been suggested that it might still have been

in the artist's studio during the image breaking.[32] Meyer himself remained a staunch Catholic, and evidently ensured the preservation of the painting thereafter. The *Darmstadt Madonna* is an unreformed image about the veneration of the Virgin and belief in the efficacy of her intercession on behalf of humanity. While no one could have objected to Holbein's portraits, the overall theme of the *Darmstadt Madonna* would have been most offensive to the reformers.

In addition to his conventional Catholic contacts, Holbein was also on good terms with leading Basle humanists. As early as 1519, he painted a small portrait of the scholar Bonifacius Amerbach (1495–1562), the son of one of Basle's most important printers and a friend and eventually heir of the famous humanist Erasmus (Plate 7.14). Many of the paintings that survive from Holbein's Swiss sojourn belonged to or were rescued by Amerbach or his son Basilius. To the left of the

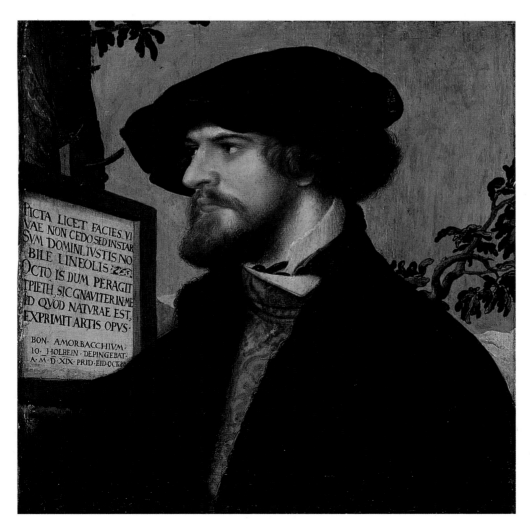

Plate 7.14 Hans Holbein the Younger, *Portrait of Bonifacius Amerbach*, 1519, oil on panel, 29 × 28 cm, Kunstmuseum, Basle. Photo: Kunstmuseum, Basle/Martin Bühler.

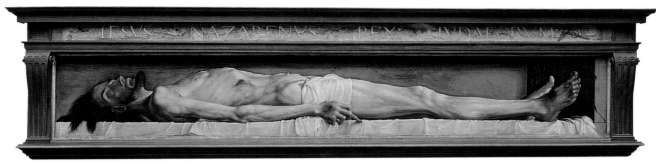

Plate 7.15 Hans Holbein the Younger, *Dead Christ*, 1521, oil on panel, 31 × 200 cm, Kunstmuseum, Basle. Photo: Bridgeman Art Library, London.

sitter, a fictive plaque is represented hanging from a tree, with a dated Latin inscription written by Amerbach himself, identifying the sitter and the artist and praising the artist's powers of lifelike representation: 'Although a painted face, I do not differ from the living visage, but I have the same value as my Master, drawn with the help of exact lines. At the time when he had completed eight cycles of three years, the work of art represents me, with all the exactitute that belongs to Nature.'[33] This plaque is reminiscent of the Latin inscription included in Dürer's engraved portrait of Albrecht of Brandenburg printed in the same year, which reads: 'Thus were his eyes, his cheeks, his features at the age of 29.'[34] The two portraits essentially serve the same purpose: to record for posterity an accurate likeness at a particular moment.

Amerbach is set against a blue sky, and on the horizon the tips of snow-covered mountains can just be glimpsed. Albrecht Dürer occasionally included a landscape background in his early portraits. The artist may also have made the short journey to Italy, and it is possible that this work reveals a knowledge of the portraits of leading Venetian painters Giovanni Bellini and Giorgione. Holbein's credentials, therefore, were of the most cosmopolitan kind.

Amerbach later owned, and it has been suggested perhaps even commissioned, a painting of the *Dead Christ* by Holbein in which the emaciated figure is lying on a rumpled cloth within the restricted space of a tomb, eyes wide open in death (Plate 7.15). A simulated inscription at Christ's feet, painted as if chiselled out of the end wall of the tomb, gives the date, 1521, and the artist's monogram. In its stark realism the *Dead Christ* recalls Matthias Grünewald, whose work Holbein's father probably encountered while working at

Isenheim, though Holbein himself is not known to have done so. The original framing of the panel is lost, though a Latin inscription on paper, 'Jesus of Nazareth, King of the Jews', interspersed with putti holding instruments of the Passion of Christ is incorporated into the present setting above the image of Christ, and according to John Rowlands could be contemporary with the painting.[35] Sometimes assumed to have been the predella of a lost altarpiece, it has also been suggested that this panel was an independent devotional work of art. Recently it was proposed that it was designed to form part of an epitaph planned by Bonifacius Amerbach for the family altar in the small cloister of the Carthusian monastery in Basle but never installed because of the Basle Reformation.[36] An engraved epitaph was finally placed in the chapel in 1544 that is very close in width to the *Dead Christ*, and Christ's pointing finger might well have been designed to draw attention to something below. The original setting and function remain uncertain, but what is certain is that from whatever ensemble the *Dead Christ* comes, it must inevitably have been an unconventional and disturbing image.

Carved Entombment groups were relatively common in northern Europe, but they usually included figures of the Virgin, Saint John and other mourners and bystanders. Very occasionally, a carved figure of Christ was 'entombed' within a recess in a church or chapel, as in the Jerusalem church erected by the Adornes family in Bruges in the fifteenth century. To represent Christ in such harrowing detail, enclosed within a claustrophobic tomb, was, so far as is known, unprecedented in painting. X-rays reveal that originally the roof of the tomb was curved, which might increase the sense of claustrophobia still more (and,

inexplicably, that the date was altered from 1522 to 1521). Whether it was patron or artist who devised this ground-breaking image, the picture suggests that Holbein's abilities as a painter of religious works of art were considerable. They were not, however, to be very much exercised. This was partly because of the pressures of the Reformation within Basle, but also because the contacts Holbein made and the sort of art his new patrons required did not necessarily favour religious art.

Amerbach was a close friend of Erasmus. Holbein designed the woodcut title page for Erasmus's *Enchiridion* in 1521, and enjoyed the patronage and friendship of Erasmus himself. Holbein had encountered Erasmus's writings much earlier, though, for shortly after their arrival in Basle he and his brother Ambrosius did pen and ink marginal drawings in a copy of Erasmus's *In Praise of Folly* owned by schoolmaster and theologian Oswald Myconius, who was perhaps teaching them Latin. The book survives and an inscription in the first page states that it gave Erasmus himself great pleasure.[37]

Erasmus took a critical attitude towards religious images, but he was interested in portraits, which he sent to his friends elsewhere in Europe as mementos to remember him by. In 1523 Holbein painted no fewer than three portraits of Erasmus, two of which were sent to England, the third to France. The most elaborate surviving version (Plate 7.16) is probably the portrait sent as a gift to Archbishop Warham, to whom Erasmus wrote: 'I presume that you have received by way of tribute a painted rendering of my features so that, should God summon me from here, you might have a bit of Erasmus.'[38] Holbein was later to paint Warham's own portrait in 1527 during his first trip to England (Louvre, Paris).[39]

Erasmus is represented in three-quarter view as a Renaissance scholar, his hands on a book inscribed on the edges in Greek and Latin: 'the Herculean labours of Erasmus of Rotterdam'. This portrait follows to a limited degree the tradition of the scholar in his study derived from the iconography of Saint Jerome, but the oblique viewpoint, the half-drawn curtain and the Renaissance-style column to the left are original touches. The capital of the column is taken from Book 4 of Cesare Cesariano's 1521 edition of the treatise on architecture by Vitruvius, showing off Erasmus's

(and Holbein's) Renaissance credentials.[40] The artist is acknowledged in a Latin inscription on the edge of one of the books on the shelf in the upper right: 'That I, Johannes Holbein, will less easily find an emulator than a denigrator.'[41] This, according to Bätschmann and Griener, is a reference to Pliny the Elder's life of Zeuxis, in which Zeuxis stated that carping was a great deal easier than imitating, and also to a similar saying of Plutarch. Hence, for those clever enough to be conversant with the references, Holbein is tacitly comparing himself with these great ancient Greeks, one a fellow artist. On the front of this book is the date, 1523.

The association between Erasmus and Holbein seems to have soured later, but in 1526 it was sufficiently strong for Erasmus to recommend Holbein to the service of his English humanist friend Sir Thomas More. In a letter of August 1526, Erasmus wrote of Holbein to a friend in Antwerp: 'Here the arts are freezing, [so Holbein] is on his way to England to pick up some angels [coins] there.'[42] Even before the dismantling of images began in Basle, it appears that the demand for art was in decline.

As already noted, the Protestant Reformation created problems for artists. In 1525, following the start of the destruction or removal of images the previous year, the painters and sculptors of Strasburg famously made an appeal to the civic authorities for employment:

> since the veneration of images has, through the word of God, now sharply fallen away and every day falls away still more, at which we are well content, inasmuch as they were indeed misused and still are misused; but as we have learned to do nothing else but paint, carve and the like, by which means we have until now fed our wives and children through our own labour, as is proper to good citizens, we will sorely lack even this scanty provision for us and ours, so that we await nothing more sure than final ruin and the beggar's staff.[43]

Since Holbein painted portraits and supplied designs for woodcuts, it would probably be an exaggeration to suppose that he faced the 'beggar's staff' in 1526 through the decline in religious commissions. But when he returned to Basle two years later, the situation was such that he left again for England in 1532, this time for good.

From the time of his arrival in Basle to his departure, portraiture was but one aspect of

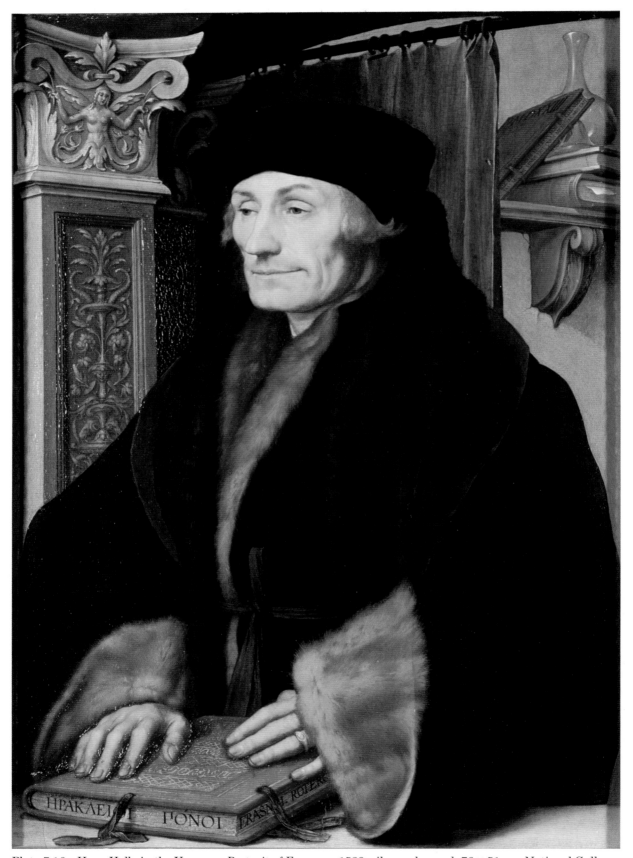

Plate 7.16 Hans Holbein the Younger, *Portrait of Erasmus*, 1523, oil on oak panel, 76 × 51 cm, National Gallery, London, on loan from a private collection. Photo: Bridgeman Art Library, London.

Plate 7.17 Hans Holbein the Younger, *Portrait of Jean, Duc de Berry*, 1524, black and coloured chalk on paper, 40 × 28 cm, Kupferstichkabinett, Kunstmuseum, Basle. Photo: Kunstmuseum, Basle/Martin Bühler.

Holbein's varied activity, and it cannot yet have been obvious that he would end up primarily a portrait painter. There is one indication that portraiture might have been more than an expedient for him. Holbein made a trip to France in 1524, apparently in the hope of finding work at the French court. In Bourges he sketched the carved portraits of Jean, Duc de Berry and his wife Jeanne de Boulogne attributed to Jean de Cambrai, now heavily restored and in the cathedral but at that time placed to either side of an altar in the Sainte-Chapelle, Bourges (see the map of key artistic sites in France, Plate 4.4). The figures are no more than pencilled in; it was the faces that interested Holbein, particularly the fleshy, elderly face of the duke (Plate 7.17), which in Holbein's drawing looks alive rather than carved of stone.[44] This drawing is also celebrated as the first time he used coloured chalk, which he could have learned in France and continued to use throughout his career in England.

4 Religious art in England on the eve of Holbein's arrival

The England that Holbein first visited in 1526 was in many ways a cosmopolitan country in which a foreign artist would by no means feel out of place. London, where he settled, was a major trading port, then still navigable via the River Thames, and foreign merchants and ships were an integral part of the life of the city. From the numbers of continental craftsmen working in England during the fifteenth and early sixteenth centuries, it is also clear that there was a demand for foreign skills, particularly Netherlandish, though from the second decade of the sixteenth century the demand for Italian Renaissance art and artists was growing. Many of these foreign craftsmen lived in Southwark in south London. Southwark was an area of liberty, which meant that residents were exempted from membership of the craft guilds, and since membership could prove problematic as well as expensive for foreigners, this was a huge advantage.

Continental craftsmen also worked beyond London, both for the royal family and for other wealthy patrons, and dynastic links between the Low Countries and England during the fifteenth century probably encouraged such artistic interchange. Edward IV's sister Margaret of York was married in 1468 to Charles the Bold, ruler of Burgundy and the Netherlands, and Edward himself took refuge in the Low Countries in 1470 during the ill-fated coup of the Duke of Clarence. Netherlandish craftsmen were employed on his behalf in the furnishing of Saint George's Chapel, Windsor. Documents reveal that in 1477–8 Flemish carvers Dirike van Grove and Giles van Castell produced statues of Christ on the Cross, the Virgin and Saint John, presumably for the rood screen, together with images of Saint George and the Dragon and Saint Edward. They were paid the fair sum of 11 pounds and 10 shillings at a rate of 5 shillings a foot. To warrant such a fee, these lost statues were probably over life-size, and the Saint George and the Dragon might even have been a monumental group along the lines of, for example, Bernt Notke's *Saint George* in Stockholm Cathedral, carved only about ten years later.[45]

Wall paintings of a very Netherlandish character were being painted at nearby Eton College Chapel at almost the same time as the Windsor statues.

Plate 7.18 Unknown artist, *The Woman Who Held an Image of the Christ Child as Hostage*, c.1480–7, oil on stone, north wall, second scene from the west, Eton College Chapel, Windsor. Reproduced by permission of the Provost and Fellows of Eton College. Photo: Malcolm Daisley, e-motif.

Although Henry VI's foundation dated from 1440, the chapel was built over a long period of time and its design much modified, so it was probably not until the early 1480s that work began on the wall paintings. The overseer of the project was Bishop William Waynflete (c.1394–1486), the executor of the will of Henry VI (ruled 1422–61, 1470–1). One William Baker was paid for pigments in 1486–7, and although it is not certain that he was also one of the artists, it is likely that the wall paintings, executed in semi-grisaille, were finished around this time, and hence during the reign of the new king, Henry VII (ruled 1485–1509).[46] What seems certain is that they were done either by

Netherlandish painters or by English painters trained in the Netherlands and working in the tradition of Rogier van der Weyden, Hugo van der Goes and Dieric Bouts. The Eton paintings are remarkable for their *trompe l'oeil* grisaille technique, their narrative flair and the fact that they are painted in oils directly onto the primed masonry rather than on plaster (Plate 7.18).

The wall paintings run along both north and south walls of what used to be the nave, or public part, of the chapel. The chapel was originally conceived as the chancel of a huge church that was drastically curtailed in the building, and it was subsequently divided in two to form a choir and a nave for parish

purposes. Scenes from the posthumous miracles of the Virgin Mary fill the lower tiers, the south wall being entirely devoted to one narrative of a wronged empress delivered by the intervention of the Virgin. Each scene has an explanatory text in Latin and is set within a continuous, fictive stone setting and divided by simulated statues set within fictive niches. A second tier of paintings of male saints, prophets and miracles – now lost – was set above to counterbalance the female programme. Clearly didactic in content, the story lines are taken from two popular medieval texts, the *Golden Legend* and the *Speculum historiale* of Vincent of Beauvais (part of his encyclopaedic work, the *Speculum maius*).

The narrative of the second scene on the north side offers an insight into the power of religious images (Plate 7.18). According to the *Golden Legend*, a widow, despairing of having her prayers for the release of her captive son answered, took the image of the Christ Child from a statue of the Virgin and Child, and held it hostage until the Virgin heard her prayers. The woman is reported to have said to the image of the Virgin: 'O Virgin blessed, I have often asked you for the liberation of my son, and so far you have not come to the aid of this pitiable mother. I have sought your patronage for my son and see no return for my prayers. Therefore, as my son has been taken away from me, I will take your son away from you and hold him in custody as a hostage for mine.'[47] Here the statue is clearly identified with the Virgin herself.

It goes without saying that the remarkable subject matter of the Eton paintings is based on legend rather than biblical text, and is somewhat like

manuscript illumination writ large for the general public. Indeed, perhaps the closest parallels in terms of subject matter and grisaille technique are the surviving manuscripts of *Les Miracles de Notre Dame* or *The Miracles of Our Lady* compiled by the Burgundian courtier Jean Miélot for Duke Philip the Good of Burgundy and the Netherlands. In both content and its didactic function, the Eton series reflects a pre-Reformation mindset, and like so many other church wall paintings, they were whitewashed over during the reign of Queen Elizabeth I in 1560.

Pre-Reformation England is sometimes depicted as culturally backward, in need of Continental artists because of the dearth of indigenous talent. In his book *The Governor* written in 1531, Thomas Eliot complained that 'if we will have anything well painted carved or embroidered', it was necessary to 'resort to strangers'.[48] In view of the dearth of surviving pre-Reformation art by British craftsmen, this judgement is difficult to verify. English patrons were evidently discriminating, with an eager eye for quality, and the little that is known about artistic projects around the end of the fifteenth and beginning of the sixteenth centuries, whether made by Continental or English craftsmen, suggests not the unimaginative conventions of a backward culture but a degree of innovation in terms of design and iconography. The Eton paintings were only one example of several. The combination of English patrons and Continental craftsmen appears to have been a particularly fertile one.

The Mercers' Christ (Plate 7.19) is made of English Chilmark stone and so was certainly carved

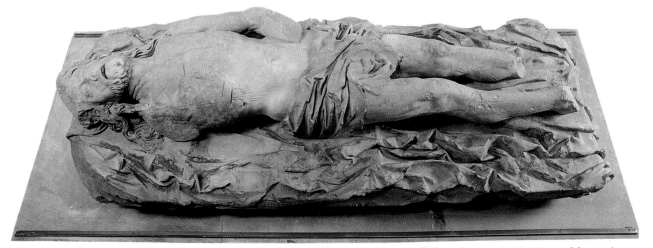

Plate 7.19 Unknown Netherlandish sculptor, *The Mercers' Christ*, c.1500–10, Chilmark stone, 197 × 69 cm, Mercers' Hall, London. Photo: reproduced by courtesy of the Mercers' Company.

in England, but stylistic comparisons strongly suggest that its carver is likely to have come from the north-eastern Netherlands, the area from which the majority of Netherlandish immigrants came.[49] Although very damaged, presumably by iconoclasts, it is still possible to tell that the figure originally lay with the right arm resting across the body, the left down by the side where traces of the fingertips still remain, and just below is carved a drop of blood as if fallen from the dead hand. This harrowing image shows thorns from the crown of thorns impaling both eyebrows, the head thrown back and without a pillow, the stone completely excavated beneath stiffened knees, the small of the back and the neck. The polychromy has now disappeared, but technical analysis revealed that the flesh tones were probably designed to simulate a deathly pallor.

Impressive in its affective power, the statue is still more impressive in its original iconography. The cloth on which Christ lies was not a white shroud but a rich purple cloth. The statue does not seem to have belonged to a multi-figure Entombment group like those common in France; nor is this strictly speaking an Entombment scene at all since Christ is placed on a sort of stretcher rather than in a tomb chest. Evidently commissioned at the beginning of the sixteenth century for the church of Saint Thomas of Acon on Cheapside in London, later the Mercers' Chapel, where it was uncovered in 1954, its original function is not known for certain. Inscriptions around the edge of the bier offer some clues, however. One inscription relates to the ceremonies of Good Friday, when a cross or a Eucharistic wafer representing the body of Christ was symbolically laid in a 'grave', a temporary Easter sepulchre usually erected to the north of the high altar. This sort of re-enactment of the dramatic incidents of Christ's life at major festivals of the late medieval Church was eventually outlawed by the Protestant reformers. A second inscription, taken from one of the New Testament letters from Saint Paul to the Philippians, suggests that the image might also have been related to specific and relatively new liturgies associated with the Holy Name of Jesus and the Five Wounds of Christ introduced to England during the fifteenth century. The power of *The Mercers' Christ*, therefore, should probably not be regarded as a stylistic matter attributable to the skills of a foreign craftsman; rather, it was an image

deliberately designed in a very innovative way to serve a particular, complex religious function. There was certainly nothing backward about this.[50]

Henry VII's chapel in Westminster Abbey was perhaps the most ambitious undertaking during the first decade of the sixteenth century. The first stones were laid in 1503, and the chapel was broadly complete by Henry's death in 1509, together with the 107 statues originally decorating the interior. Of these, 95 survive – partly, no doubt, because a royal chapel was out of bounds for iconoclasts. The statues reveal a heterogenous range of saints that certainly offered a vast array of potential protection for the deceased sovereign. The extent to which foreign craftsmen participated in their carving is much contested.[51] Enclosing the tomb of Henry VII is an elaborate bronze grate that was originally decorated with 32 bronze statues of saints, of which only six remain. All are known to have been cast by a Dutchman named Thomas as early as 1505–6, significantly earlier than the tomb itself (Plate 7.20).[52]

The chapel also included the bronze tomb of Henry VII's mother, Lady Margaret Beaufort, for which designs on cloth were produced by Netherlandish painter Maynard Vewicke in 1511, who was in the service of Henry VII from at least 1502. Henry VII's tastes appear to have been thoroughly late Gothic, and a Renaissance-style design for his tomb made by the Italian Guido Mazzoni in 1506 seems to have been rejected. His successor Henry VIII (ruled 1509–47) was more captivated by the Italian Renaissance. In 1512, the Florentine Pietro Torrigiano was employed to cast the tomb of Margaret Beaufort, and subsequently the double tomb of Henry VII and his wife Elizabeth of York as well. Torrigiano was also engaged to produce a Renaissance-style high altar for the chapel, with a terracotta statue of the dead Christ lying under the altar, reminiscent of the tradition of terracotta Entombment groups of Guido Mazzoni (?1450–1518) and Niccolò dell'Arca (d.1494) in northern Italy. Left unfinished when Torrigiano left the country, the altar was finally installed by the Italian sculptor Benedetto da Rovezzano (1474–c.1554) in 1526, the year that Holbein first arrived in England. The altar was destroyed in the seventeenth century.[53]

Despite a growing interest in the Italian Renaissance, the enthusiasm of the English court for craftsmen from northern Europe continued, for

Plate 7.21 Attributed to Lucas Horenbout, *Portrait of Hans Holbein the Younger*, 1543, vellum mounted on playing card, diameter 4 cm, Wallace Collection, London. Reproduced larger than life-size. Photo: reproduced by kind permission of the Trustees of the Wallace Collection, London.

1544. According to the biographer of Netherlandish artist Karel van Mander, it was Lucas who taught Holbein the art of miniature painting. A miniature version of the self-portrait Holbein made just before his death has sometimes been attributed to Lucas (Plate 7.21). Lucas's sister Susanna, whose abilities as an artist had surprised Dürer, also settled and married in England.[54]

Far from backward, the England in which Holbein arrived in 1526 was still offering considerable opportunities, whether in the royal works or for the large, wealthy merchant and aristocratic classes. The examples presented here show that craftsmen were not just producing conventional religious works of art by rote; rather, the specific demands of a project might entail a significant degree of innovation. Nor were opportunities restricted to craftsmen working in a particular tradition or style, for by the early sixteenth century the fashion for Netherlandish art, if such it was, had broadened to include Italian Renaissance styles.

Plate 7.20 Thomas the Dutchman, *Saint John the Evangelist*, 1505–6, bronze, grate of Henry VII's tomb, Westminster Abbey, London. Photo: © Dean and Chapter of Westminster.

Ghent painter and manuscript illuminator Gerard Horenbout was certainly in the service of Henry VIII between 1528 and 1531, and his son Lucas served Henry between 1525 and Lucas's death in

5 Holbein and the reform of images in England

Sir Thomas More (1477/8–1535), later Chancellor to Henry VIII, wrote to Erasmus at the end of 1526: 'I'm afraid [Holbein] won't find England as fruitful and lucrative as he had hoped. But I will do my best to ensure that it is not a complete waste of time.'[55] It was More himself who provided Holbein with his most important commission during his first visit to England from 1526 to 1528. In addition to a half-length portrait on panel in 1527 (Frick Collection, New York), More commissioned Holbein to produce a group portrait with his family, painted probably life-size in glue tempera on cloth. While group portraits of donors were found within altarpieces, independent secular group portraits were almost unheard of. Presumably the idea came from More himself, and as such was within the humanist penchant for portraits as mementos, like the ones Holbein had already painted for Erasmus.

The final portrait of the More family has perished, but a late sixteenth-century copy by Rowland

Lockey survives, along with a full-scale annotated drawing by Holbein (Plate 7.22) that was evidently sent to Erasmus in Basle and later belonged to Amerbach. Both copy and drawing show the extended More family within an extraordinarily illusionistic domestic interior, captured in attitudes of conversation and contemplation. Erasmus commented to More's daughter Margaret Roper in a letter of 6 September 1529, apparently in relation to the drawing that he had received, 'It is so successful that if I had been in person in your home I would not have seen more.'[56]

For this painting Holbein also produced detailed preparatory drawings in coloured chalks to capture the likeness of the individual family members. A drawing of Sir Thomas More is pricked for transfer and may conceivably have been used as a cartoon for the finished group portrait.[57] Cecily Heron, More's youngest daughter, is shown seated saying her rosary in the lower right quarter of the picture (third from the right in Plate 7.22). An individual study for this sitter also survives, in which her pose differs significantly (Plate 7.23). In the final

Plate 7.22 Hans Holbein the Younger, study for a portrait of Sir Thomas More and his family, 1527, pen and ink on paper, 39 × 52 cm, Kupferstichkabinett, Kunstmuseum, Basle. Photo: Kunstmuseum, Basle/Martin Bühler.

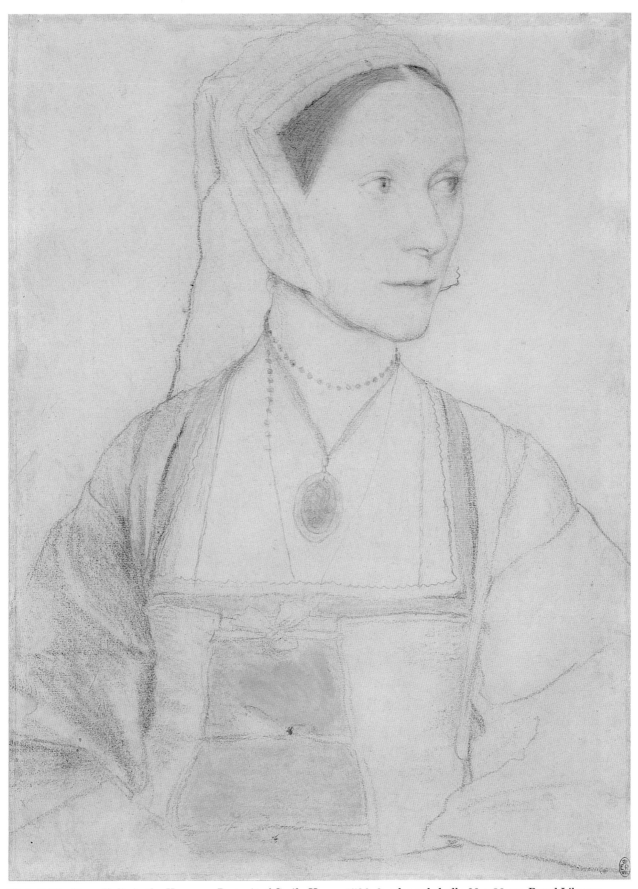

Plate 7.23 Hans Holbein the Younger, *Portrait of Cecily Heron*, 1526–8, coloured chalk, 39 × 28 cm, Royal Library, Windsor Castle. Photo: The Royal Collection © 2006, Her Majesty Queen Elizabeth II.

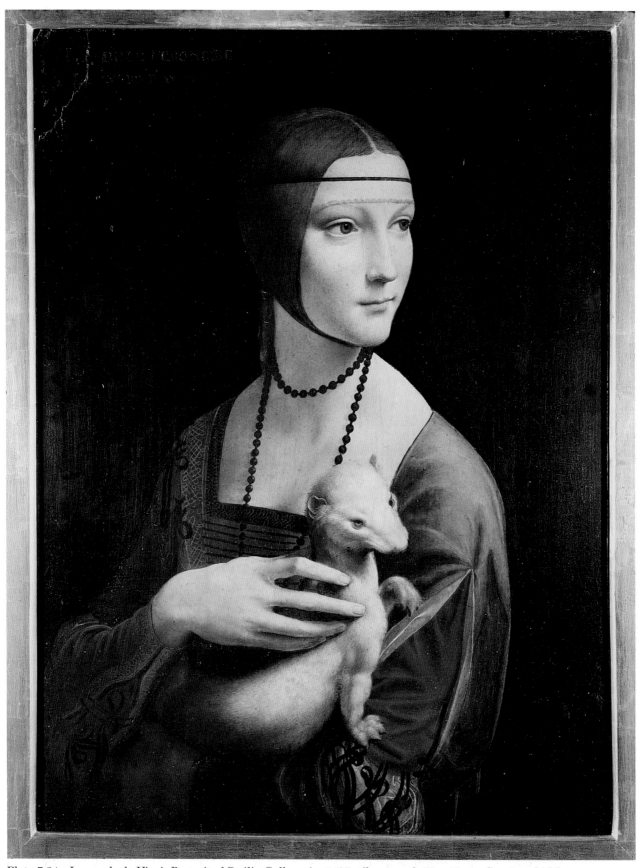

Plate 7.24 Leonardo da Vinci, *Portrait of Cecilia Gallerani*, *c*.1485, oil on panel, 55 × 40 cm, Czartoryski Museum, Kracow. Photo: Princes Czartoryski Foundation at the National Museum in Krakow.

painting, Holbein raised her right hand. The revised gesture, turn of her head, her direct gaze and even her costume recall the portrait of her namesake, Cecilia Gallerani, by Leonardo da Vinci (Plate 7.24). Leonardo's sitter holds an ermine, but the similarities of pose and watchful elegance are unmistakable, another indication of the esteem in which Holbein held Leonardo's work.

Among the other commissions Holbein succeeded in obtaining during his first visit was one for a double portrait of Sir Henry Guildford and his wife Mary Wotton (Plate 7.25). Here Holbein imported some of the motifs he had used earlier: the suggestion of sky and tendrils of plants in the background as in the *Darmstadt Madonna* (Plate 7.13) and the portrait of Amerbach (Plate 7.14); the Renaissance-style column found in a slightly different form in the portrait of Erasmus (Plate 7.16); the architectural setting framing the sitter found again in slightly different form in the portrait of Dorothea Kannengiesser (Plate 7.11). Conversely, Lady Guildford's clothes are represented in great detail, from her cloth-of-gold sleeves to the six gold chains adorning her bodice and the complicated architectural headdress that she wears. Holbein's full-length costume study in pen and ink now in the British Museum appears to relate to this portrait, suggesting that Lady Guildford's lady-in-waiting modelled the dress for Holbein.[58]

Somewhat forbidding in the portrait, Lady Guildford holds a rosary and a copy of a popular devotional text, the *Life of Christ* by Ludolph of Saxony (d.1378), stressing her orthodox piety, and the rosemary tucked into her bodice evokes remembrance. Nothing could be further from this pious severity than the informality of Holbein's preparatory drawing, in which she faces the viewer but casts an amused glance to her right, presumably towards her husband (Plate 7.26). Holbein used this drawing as a pattern, transferring the contours of the drawing to the underdrawing of the panel, which seems to have been his usual practice in the English portraits.[59] The difference between portrait and painting lies in the facial expression and pose, for the body has been shifted to three-quarter view. This shows the degree to which a painted image might be manipulated to create the desired impression for posterity. The piety injected into the finished painting of Lady Guildford may be no more than a convention of female respectability, but since such

religious trappings were by no means customary in Holbein's later English portraits, it is also possible that they reflected a real religious intention.

It is possible that Erasmus's acquaintance with Guildford effected the introduction, but Holbein may also have met Guildford at court, where the latter was master of the revels, or entertainment. In 1527, Holbein seems to have been employed by the court to decorate a temporary banqueting hall and theatre at Greenwich with two painted *trompe l'oeil* triumphal arches with Renaissance decoration and a painting of the defeat of the French at Thérouanne in 1513. A painting of the heavens on the ceiling was devised by the king's astronomer Nikolaus Kratzer, a friend of Sir Thomas More who also became Holbein's friend and commissioned a portrait by him in 1528. It was Kratzer who inscribed the identity of the various individuals in the drawing for the group portrait of the More family (Plate 7.22). Holbein was not yet typecast as a portraitist, it seems, and even on this first visit evidently had an introduction to the English court.[60]

Holbein could not be absent from Basle for more than two years without forfeiting his citizenship, and it may have been for this reason that he returned in 1528. By 1532, however, he was back in England. Initially, Holbein found employment among his fellow countrymen as a portrait painter. The community of traders from the Baltic area congregated in their headquarters, the so-called German Steelyard (the English equivalent of the Venetian Fondaco dei Tedeschi), which was situated on the north bank of the Thames west of Tower Bridge, where Cannon Street station now lies. With these men, Holbein had both language and culture in common, though oddly it does not seem to have been until his second trip that he won commissions there. For the dining room at the Steelyard, Holbein produced two Renaissance-style grisaille paintings in tempera on cloth representing the Triumph of Riches and the Triumph of Poverty, now known only through a cartoon and copies. He also produced several portraits of members of the Steelyard, possibly primarily as surrogate photographs to send home to their families.[61]

Danzig merchant Georg Gisze, whom Holbein painted in 1532, was a member of the Steelyard and is documented in England 1522–33 (Plate 7.27). In this portrait Holbein used an illusionistic setting that related to the sitter (like

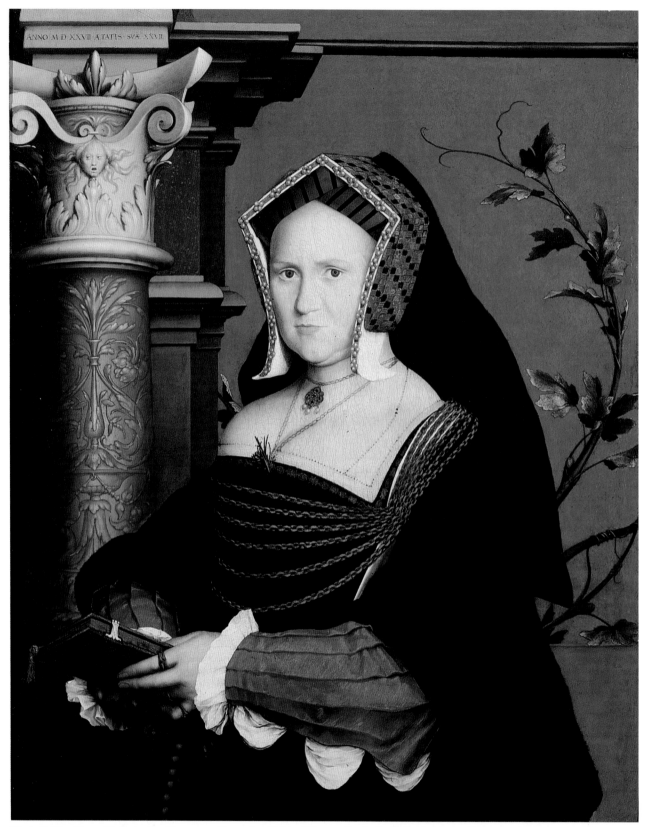

Plate 7.25 Hans Holbein the Younger, *Portrait of Mary Wotton, Lady Guildford,* 1527, oil on panel, 83 × 67 cm, Saint Louis Art Museum (museum purchase).

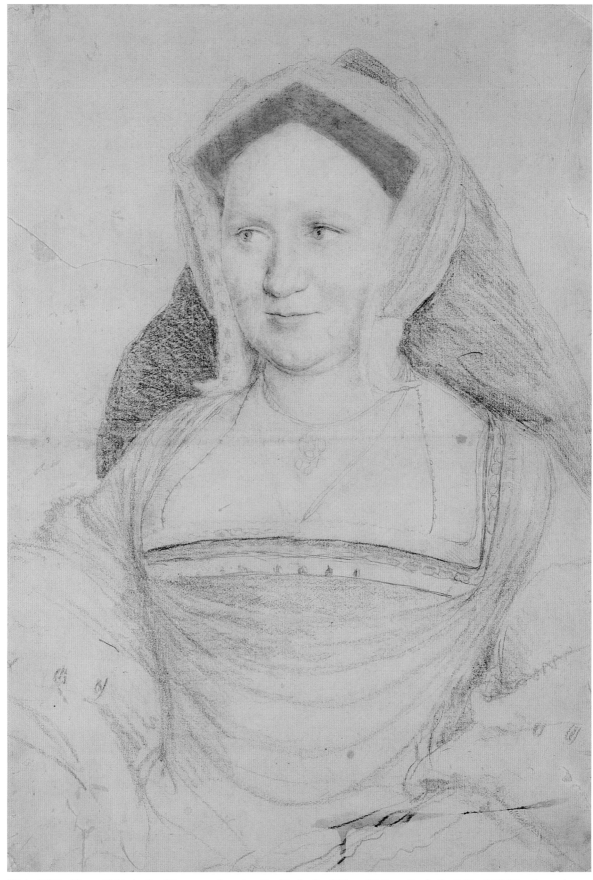

Plate 7.26 Hans Holbein the Younger, drawing for *Portrait of Mary Wotton, Lady Guildford*, 1527, coloured chalk on paper, 55 × 39 cm, Kupferstichkabinett, Kunstmuseum, Basle. Photo: Kunstmuseum, Basle/Martin Bühler.

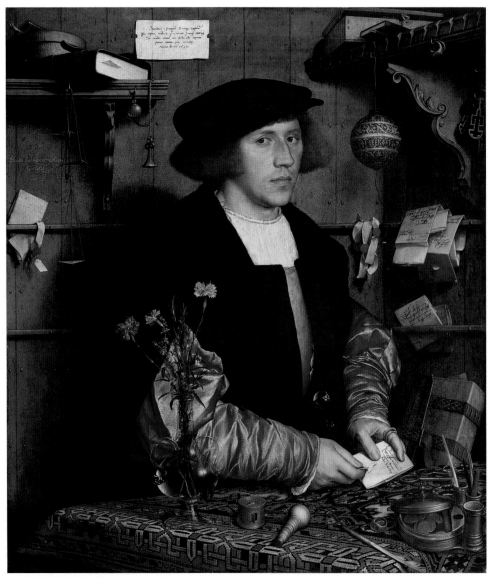

Plate 7.27 Hans Holbein the Younger, *Portrait of Georg Gisze*, 1532, oil on panel, 96 × 86 cm, Gemäldegalerie, Staatliche Museen, Berlin. Photo: © 2007 bpk/Gemäldegalerie, Staatliche Museen zu Berlin/Jörg P. Anders.

the setting for his 1523 portrait of Erasmus – see Plate 7.16), surrounding Gisze with the tools of his trade as a merchant. In Netherlandish painting there was a long tradition of using the setting as a way of commenting on the identity or activities of the sitter. As early as 1449 Petrus Christus of Bruges had painted a goldsmith in an interior surrounded by his wares and receiving clients (see Chapter 1, Plate 1.8).[62] In the *Portrait of a Man with a Coin* by Hans Memling (d.1494), details of the setting provide clues to the sitter's identity.[63] Holbein's portrait of Georg Gisze has been related to a portrait by Netherlandish painter Jan Gossaert of a banker thought to be

Jerome Sandelin of Zeeland, who is posed in the act of writing in a ledger in his office strewn with letters.[64]

Merchants were great letter writers, and letters bearing Gisze's name and merchant's mark are tucked behind a narrow wooden rail nailed onto the wall for the purpose, while Gisze himself is captured in the action of breaking the seal on another from one of his brothers. Gisze's identity is scribbled as if in chalk on the back wall, rather as a merchant might chalk up a list of figures later to be erased, together with his Latin motto, translated variously as 'no pleasure without regret' or 'no

joy without sorrow'.[65] Another Latin inscription is disguised as a note represented as if hastily stuck with sealing wax against the paneling at the top of the picture. This reads: 'This picture of Georg that you see records his features … in the year of his age 34, in the year of the Lord 1532.'[66] Holbein also includes a Latin inscription almost identical to the one found in Dürer's 1519 engraved portrait of Albrecht of Brandenburg cited above (p.264): 'He has in life such eyes, such cheeks.' While this suggests that Holbein or his patron knew Dürer's print, it also confirms a more generic function of portraiture as a memorial and reminder of mortality. Pens, an ink pot and a sand shaker to dry the ink all lie on the table before Gisze; scales presumably for weighing coins are suspended from the shelf behind, while a box of coins is half open in the lower right-hand corner. Yet this is no snapshot of a merchant at work but rather a careful construction full of meaning. The table is covered with an expensive oriental rug; the vase holds carnations, believed to offer protection from illness and evil, and together with the sprig of rosemary invoke remembrance. According to Sir Thomas More, Holbein's erstwhile patron, rosemary was 'the herb sacred to remembrance and therefore of friendship'.[67]

Portraiture remained a respectable and potentially lucrative option for an artist in England during the 1530s, whereas the possibility of undertaking any religious commissions receded markedly. In 1533, Henry VIII divorced his wife Catherine of Aragon in the face of the pope's refusal to annul the marriage, and he took for his second wife Anne Boleyn. In retaliation, the pope excommunicated the king, which led in 1534 to the Act of Supremacy, by which Henry declared himself head of the Church of England. Although probably himself no out-and-out reformer, he passed measures that strengthened the hand of the reformers in England and set in motion what was to become, under his son Edward VI, the English Reformation. In 1536 Henry's minister Thomas Cromwell began the Dissolution of the Monasteries, ostensibly on the grounds of corruption, and in the same year the Ten Articles were passed warning against the dangers of idolatry. Injunctions issued at the end of 1538 demanded the removal of idolatrous images from churches at the discretion of the local bishop and banned the burning of candles before images.

Very early on in his second period in England, Holbein appears to have entered the circle of Sir Thomas Cromwell (c.1485–1540), Protestant reformer and architect of much of the religious change of the 1530s. He became Chancellor of the Exchequer in 1533, oversaw the king's divorce and became vicegerent of the newly constituted English Church in 1535. Holbein's portrait of Cromwell (Plate 7.28) must date from 1532–3, the year that Cromwell was keeper of the royal jewel house, for the letter on the table refers to him in this office. This poorly preserved portrait shows him, like Gisze, as a man of affairs reading and writing letters, and even, perhaps, creates the illusion that he is about to respond to an applicant waiting just out of the painting to the viewer's left. Despite the sobriety of his black robe, his stern expression and the austerely geometric composition, Cromwell is subtly revealed as a man of wealth, with a ring and a robe with a lavish fur collar, a fine brocade cloth covering the wall behind, and an expensive rug on the table to the left.

Cromwell appears to have been the motivating force behind the first sanctioned translation of the Bible into English by Miles Coverdale in 1535. Just as Holbein had provided the design for the woodcut title page of Luther's 1523 New Testament in Basle (Plate 7.9), so he also was responsible for the title page of the Coverdale Bible (Plate 7.29). The finished woodcut has none of the finesse of those of Holbein's Basle collaborator Lützelburger, and the use to which the woodcut is put is little short of propaganda, for it shows Henry seated on a raised throne as head of the Church, handing over the book to a group of supplicant, kneeling bishops. Above to left and right are four scenes, each with biblical references, contrasting the Law of the Old Testament with the New Covenant of the New Testament – very like the old system of typology used by Conrad Witz in his Heilsspiegel altarpiece (Plates 7.2–7.3) but theologically worlds apart. Moses receives the Ten Commandments opposite Christ enjoining his disciples to go out into the world and preach the Gospel; all the disciples hold keys, apparently to avoid asserting the primacy of the usual keyholder, Saint Peter, who was the prototype of the despised papacy. Below Moses, the chief priest Esdras is reading the Law to the Israelites in Jerusalem; opposite is the scene of the Apostles preaching, after having received the Holy Spirit in 'tongues as of fire' at Pentecost (Acts 2).[68]

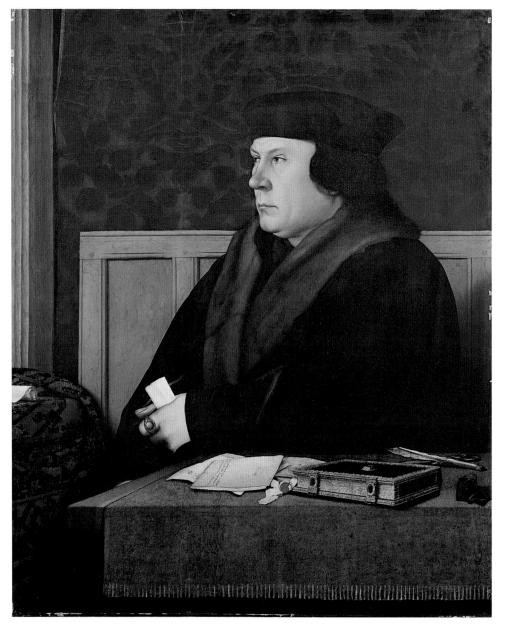

Plate 7.28 Hans Holbein the Younger, *Portrait of Thomas Cromwell*,
1532–3, oil on panel, 78 × 64 cm, Frick Collection, New York, Henry Clay Frick Bequest.
Photo: © The Frick Collection, New York.

At the top, the fallen Adam and Eve are contrasted with the risen Christ, victorious over sin and trampling the devil underfoot.

Although it is tempting to suppose that Holbein's connections with Thomas Cromwell account for his eventual employment as court painter, this is not necessarily so. Holbein had, after all, worked for Henry VIII during his first visit to England. He was made painter to the king by 1536 and perhaps earlier – incomplete documentation means that the exact date is unknown. In 1537, he completed

a group portrait perhaps rather less ambitious in artistic terms than that of the More family but one of immeasurably greater prestige: a wall painting of Henry VIII, Jane Seymour, Henry VII and Elizabeth of York for the palace of Whitehall in London.

This mural, now only known from copies and from part of the original cartoon used to transfer the design to the wall (Plate 7.30), was painted for the privy chamber, which Susan Foister describes as 'the most privileged space in which

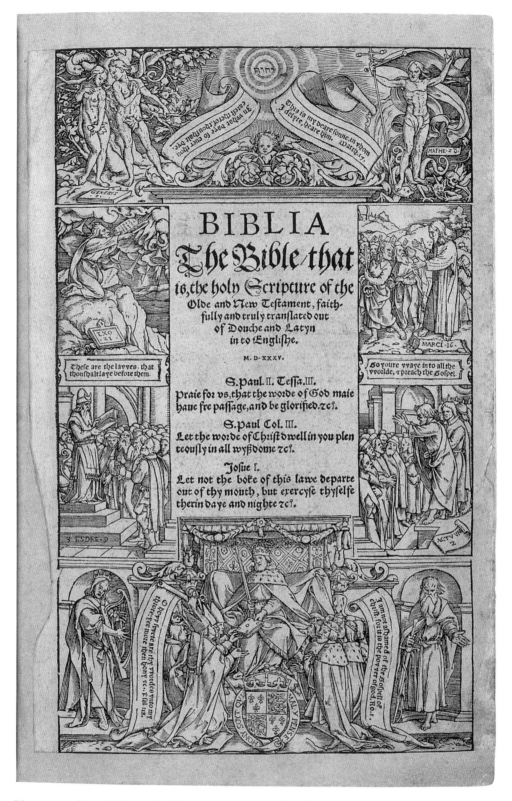

Plate 7.29 Hans Holbein the Younger, title page of the Coverdale Bible, 1535, woodcut, 32 × 18 cm, British Library, London (C.132.H46). Photo: by permission of the British Library, London.

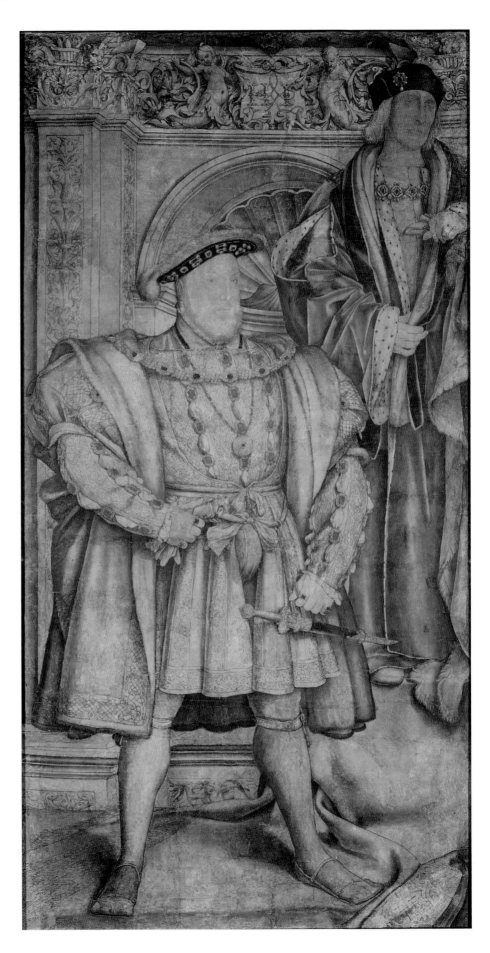

Plate 7.30 Hans Holbein the
Younger, cartoon for group
portrait of Henry VIII, Jane
Seymour, Henry VII and
Elizabeth of York, c.1536–7,
ink and watercolour on paper,
258 × 137 cm, National
Portrait Gallery, London.
Photo: © National Portrait
Gallery, London.

to meet the king'.[69] It is an ingenious statement of both power and fashion. The Renaissance-style frieze decorating the cornice and capitals of the architecture, the Italianate candelabra decoration of the pilaster, and the shell niche behind the two Henries testify to the cosmopolitan, up-to-date culture of the Tudor court and evoke the illusion of a real architectural setting. Conversely, the lavish costume of Henry VIII is described with the level of painstaking detail that characterized English portraiture. Beneath his feet, the rucked carpet, reminiscent of Holbein's *Darmstadt Madonna*, adds a sense of immediacy, as if the royal family had hurriedly assembled for a particular audience. This was merely an illusion, of course, since Henry's parents were dead and Jane Seymour died in 1537, the date the painting bears. Above all, the colossal bulk and ultra-confident pose of Henry VIII impart a sense of virility and authority that must be absolutely deliberate and designed to contrast with the other three, quieter figures. Although Henry's face is seen in three-quarter view in the cartoon, the copy of the Whitehall mural shows that in the final painting it was changed to full face, an indication of the degree of care with which this dynastic image was manipulated for effect.

On the altar in the centre of the picture is a Latin inscription in which Henry's royal image is inextricably bound up with his reforming religious policies as Supreme Governor of the Church of England, for which he claims greater fame even than his father, who brought peace to the country:

> If you enjoy seeing the illustrious figures of heroes,
> Look on these; no painting ever bore greater.
> The great debate, the competition, the great question is whether the father
> Or the son is the victor. For both indeed are supreme.
> The former often overcame his enemies, and the fires of his country,
> And finally gave peace to its citizens.
> The son, born indeed for greater tasks, from the altar
> Removed the unworthy, and put worthy men in their place.
> To unerring virtue, the presumption of the Popes has yielded
> And so long as Henry the Eighth carries the sceptre in his hand,
> Religion is renewed, and during his reign
> The doctrines of God have begun to be held in his honour.[70]

Those awaiting an audience with the king in the privy chamber might view his surrogate, a remarkably lifelike image conveying powerful dynastic propaganda. The irony is that here a secular artistic image is used to shore up religious policies that would eventually outlaw religious images altogether.

Holbein's portrait of Jane Seymour's son Edward, Prince of Wales, the future Edward VI, as a small child served a rather different function (Plate 7.31). Since it is probably the portrait Holbein is recorded to have given to Henry as a New Year's gift on 1 January 1539, it had no official propaganda purpose, and its flattering programme was presumably devised primarily by Holbein. Unlike the Steelyard portraits, this is no memento of the prince's precise appearance at a particular, tender age, for, as Susan Foister points out, the sickly Prince Edward is unlikely ever to have looked as robust as he is represented here.[71] The prince's pose and attire are incongruously regal but with a witty twist: he holds a rattle instead of a sceptre. The Latin inscription below, written by one of Cromwell's supporters Richard Morison, reads as follows:

> Little one, emulate thy father and be the heir of his virtue; the world contains nothing greater. Heaven and earth could scarcely produce a son whose glory would surpass that of such a father. Do thou but equal the deeds of thy parent and men can ask no more. Shouldst thou surpass him, thou has outstript all kings the world has revered in ages past.[72]

The contrived format of this portrait probably says more about Holbein (and Morison's) desire to curry favour and appeal to an exaggerated royal self-image than it does about the young prince himself.

As well as being useful as gifts and for propaganda purposes, royal portraits also retained their traditional function of allowing prospective brides and bridegrooms too geographically remote to meet a preview of their future spouse. Just as the Netherlandish painter Jan van Eyck had traveled to Portugal in 1428 to record the likeness of Isabella of Portugal, the future bride of his master Philip the Good, so Holbein was sent to Brussels in 1538 to the court of Mary of Hungary to paint the newly widowed Christina of Denmark, Duchess of Milan. Letters written back to England at the time reveal that Holbein was granted a sitting of three hours, during which he presumably made a drawing that he later used to produce the surviving

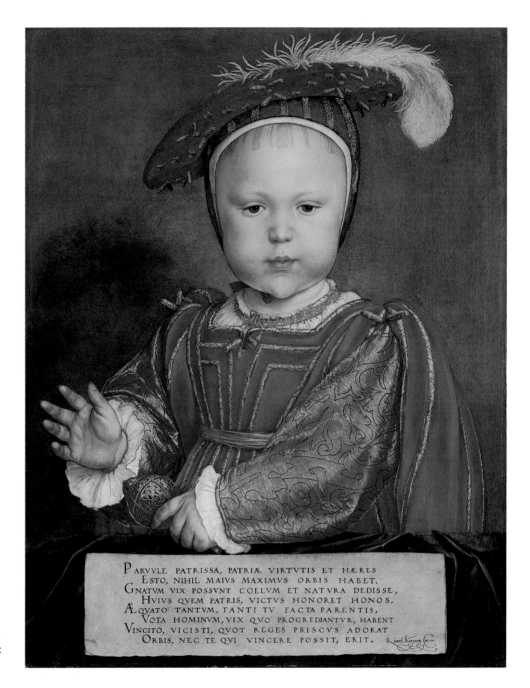

Plate 7.31 Hans Holbein the Younger, *Portrait of Edward, Prince of Wales*, c.1539, oil on panel, 57 × 44 cm, Andrew W. Mellon Collection, National Gallery of Art, Washington, DC. © Board of Trustees, National Gallery of Art, Washington, DC. Photo: Richard Carafelli.

painting (Plate 7.32). Only a few days earlier, another artist had taken Christina's portrait for Henry, but the dispatch of this painting was halted because it was deemed inadequate in comparison with Holbein's. In the earlier portrait Christina was shown out of mourning, so it is interesting that in Holbein's version the sitter reverted to her mourning clothes. In fact, the dramatic tonal contrasts between the black fabric and Christina's white face and elegant hands all serve to enhance her beauty. Though only 16 years old, the sobriety of her clothing also lends her a certain gravitas. While most of Holbein's other portraits, and most

marriage portraits by other artists, are half-length or head and shoulders only, the unusual full-length, erect pose and frontal gaze were presumably specified so that Henry could gain as full an impression of her as possible.

In Henry's quest for a new wife, Holbein was also sent to Düren in 1539 to paint Anne and Amelia of Cleves. English representatives had already been offered portraits of the sisters, one of which might be a painting of Anne now in Saint John's College, Oxford, but Holbein was sent nevertheless to provide a guaranteed likeness.[73] Although

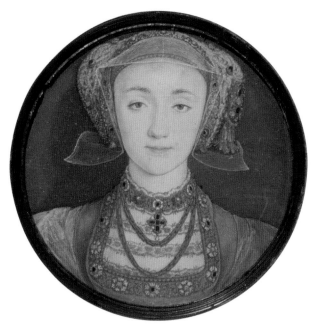

Plate 7.33 Hans Holbein the Younger, *Portrait of Anne of Cleves*, 1539, bodycolour on vellum, diameter 4.5 cm, Victoria and Albert Museum, London. Reproduced larger than life-size. Photo: © V&A Images/Victoria and Albert Museum.

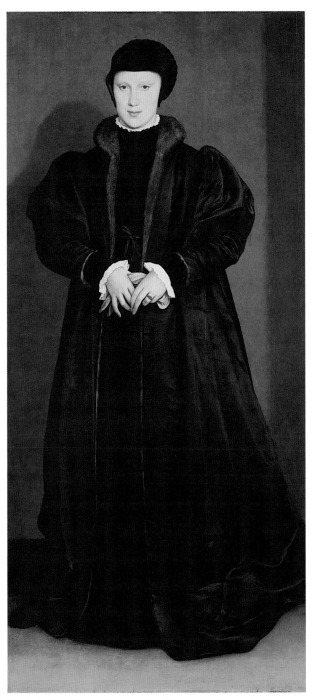

Plate 7.32 Hans Holbein the Younger, *Portrait of Christina of Denmark, Duchess of Milan*, 1538, oil on panel, 179 × 83 cm, National Gallery, London. Presented by the National Art Collections Fund with the aid of an anonymous donor. Photo: © National Gallery, London.

Henry went ahead with the marriage, it is well known that when Anne arrived in England he took a strong dislike to her, perhaps suggesting that Holbein erred on the side of flattery rather than

verisimilitude. One of the two surviving versions by Holbein is a portrait miniature (Plate 7.33), and exceptionally the ivory box in the form of a Tudor rose in which it was designed to be kept survives. Holbein's rare use of the expensive pigment ultramarine testifies to the preciousness of this tiny portrait, designed for private scrutiny. In Henry VIII's England, portrait miniatures offered an alternative format to conventional half-length or head and shoulders works, and Holbein produced many of them.

Holbein's skills as a portrait painter were clearly heavily in demand not only from his employer Henry VIII but from the many individuals connected with the court. In addition to his surviving paintings, there are some 50 portrait drawings for which no painted version survives and numerous versions after Holbein, some of which might have been done by members of his workshop.[74] It seems likely that the availability at court of such a gifted portraitist stimulated demand. Ultimately, it must have been this demand as much as the religious climate that decided the course Holbein's career in England finally took and on which his reputation was built.

6 Conclusion

There was considerable continuity between Holbein's activities in Basle and in London. In both cities he produced portraits, wall paintings and book illustrations of a reforming character. Conspicuously, however, there is no evidence that he produced conventional religious paintings during his time in England. While it might be true that English Protestant opposition during the late 1520s and 1530s was not necessarily so overwhelming as to preclude the production of religious works of art altogether, Holbein's artistic opportunities were governed by the requirements of his patrons and employers. Humanists, courtiers and merchants alike sought portraits, and it was evidently for his skills in portraiture that Holbein was renowned. Portraits were not necessarily devoid of moral or religious sentiment, and conventionally provided an important reminder of mortality as well as serving as surrogate family photographs,[75] but they did not incur the opposition of reformers. Hence they represented a safe option for both artist and patron during a turbulent reforming era. While such work was available, the absence of religious commissions might not have caused Holbein undue regret, particularly if, as has often been supposed, in time he began to adopt the reforming views of some of his employers.[76]

The fate of religious images in England was sealed at the accession of Edward VI in 1547. On 31 July, a new set of injunctions demanded that all images associated with pilgrimages, or any other form of abuse, be removed and destroyed. In December, chantry chapels were finally abolished, and with them religious guilds and their possessions. In January 1550, the act for the defacing of images was passed, which gave churches six months to destroy all religious images whether still in churches or already removed from them. In November 1550, an order was issued for altars to be completely dismantled. Religious art was never really viewed with approval in England again; indeed, virtually none survived to be viewed at all. This was Basle all over again, but Holbein was not there to see it. He had died, probably of the plague, in 1543.

Notes

Introduction

[1] Baxandall, 1972, ch.1.

[2] Ibid., ch.2, and Baxandall, 1980, ch.6.

[3] Goldthwaite, 1993.

[4] Labande-Mailfert, 1975, p.502.

[5] Aristotle, 2000, pp.65–7.

[6] Belozerskaya, 2002, pp.53–4.

[7] Barber, 1981, pp.140–1.

[8] Laborde, 1849–52, vol.2, pp.332–81.

[9] Vasari, 1996, vol.1, p.353.

[10] See Brewer, Gairdner and Brodie, 1869–1932, vol.1, pt 1, pp.141–2, for the design of this tomb.

[11] Marks and Williamson, 2003, cat.86–7, pp.223–5.

[12] Baldwin, 1926, quoted in Foister, 2004, pp.229–31.

[13] Goldthwaite, 1993, p.121.

[14] See Richardson, Woods and Franklin, 2007 (3.7.2).

[15] Vio, 1999, p.106.

Chapter 1

[1] See Frommel, 1961.

[2] On the *Galatea*, see Dussler, 1971, pp.99–100; Jones and Penny, 1983, pp.92–100.

[3] On Chigi, see Gilbert, 1980.

[4] See Frommel, 1961, p.9.

[5] On aspects of the history of the dresser, see Belozerskaya, 2002, pp.98–9.

[6] See Olsen, 1992.

[7] See Goldthwaite, 1993, pp.245–7; Holman, B., 1997, pp.61–7.

[8] See Joannides, 1983, p.205, cat. nos 288 and 290; Clayton, 1999, pp.80–5, cat. no. 20. A design for a silver water basin with Sea-Centaurs and Nereids after a drawing by Raphael can be found in the Ashmolean Museum in Oxford.

[9] Veblen, 1994, is an accessible modern edition.

[10] Vasari, 1996. For a discussion of the relative value of various types of artefacts, paintings and sculptures, see also Kemp, 1997; Duits, 1999.

[11] For a discussion, see Syson and Thornton, 2001, ch.IV.

[12] A seminal publication is Stephen Greenblatt's *Renaissance Self-Fashioning* (1980).

[13] For a recent example, see Kent, D., 2000.

[14] The classic study of art and its social messages is Michael Baxandall's *Painting and Experience in Fifteenth Century Italy* (1972).

[15] Spallanzani and Gaeta Bertelà, 1992. The price estimates listed in the 1492 inventory may have been added later (1512). See also Kemp, 1997.

[16] On the fresco cycle, see Roettgen, 1997, pp.350–83.

[17] See Thornton, 1991, pp.111–67.

[18] Martial, 1993, pp.196–7 (bk 2, epigram 90, verse 10).

[19] On Tuscan wages and prices during the fifteenth century, see Tognetti, 1995. On Florentine wages during the sixteenth century, see Goldthwaite, 1980. On Venetian wages and prices during the fifteenth century, see Mueller, 1997, pp.654–64. On wages and prices in Bruges, see Sosson, 1977, pp.296–309.

[20] Spallanzani and Gaeta Bertelà, 1992, p.28: 'Una vesta lunga di panno paghonazzo rosasecha foderata di martore.' See also Richardson, Woods and Franklin, 2007 (3.1.3).

[21] Spallanzani and Gaeta Bertelà, 1992, pp.63–4: '9 pezze di panno lino sottile [with a total length of 741 braccia] F120.-.-'; p.74: 'cinque braccia di panno sbiadato di Gharbo F2.-.-'. *Panno di Gharbo* was the cheaper quality wool woven in Florence. The price quoted for the *lino sottile* was more or less equivalent to 1 silver lira per braccio, slightly more than what a master mason earned in a day.

[22] See Herlihy and Klapisch-Zuber, 1978, p.251.

[23] On pilgrimage, see Webb, 1999.

[24] On pilgrims' badges, see van Beuningen and Koldeweij, 1993; Spencer, 1998; Koldeweij, 1999.

[25] Jacobowitz and Loeb Stepanek, 1983, pp.53–4 (cat. no. 7). On the artist, see also Lawton Smith, 1992.

[26] For prices of badges, see Spencer, 1998, p.15.

[27] On the Italian Renaissance workshop, see Thomas, A., 1995.

[28] On the painting and its contract, see Lightbown, 1978, vol.2, pp.56–7, cat. no. B42. For other fifteenth-century Florentine contracts, see Glasser, 1965, p.43; Thomas, A., 1995; O'Malley, 2005.

[29] Paviot, 1990. See also Laborde, 1849–52, vol.1, pp.255–6, for the rent of van Eyck's house.

[30] Edler de Roover, 1966, p.248.

[31] See van der Velden, 2000, pp.66–7.

[32] The erroneous identification of the sitter as Saint Eligius was based on the presence of a halo, which turned out to be a later addition when the painting was subjected to a thorough restoration. See Ainsworth and Martens, 1994, pp.96–101 (as Saint Eligius); van der Velden, 1998 (as Willem van Vlueten).

[33] On the painting, see Goddard, 1984, pp.129–31, cat. no. 2.

[34] Munro, 1983. See also Munro's internet paper at www. economics.utoronto.ca/ecipa/archive/UT-ECIPA-MUNRO-00–05.pdf (accessed 24 January 2006).

[35] On crimson, see Molà, 2000, pp.107–20.

[36] See above, n.20. The purple shade (*pagonazzo* or *pavonazzo*) of the Medici gown was made with crimson dye.

37 See Spallanzani and Gaeta Bertelà, 1992, p.33; Thomas, A., 1995, p.310. See also Richardson, Woods and Franklin, 2007 (3.1.3).

38 The floral ornament around the coat of arms consists of African violets as the Antwerp guild of Saint Luke had merged with the local *rederijkerskamer*, an association of poets, which bore the name *violieren*.

39 Pesenti, 1984, pp.133–4. On Baldassare Mattioli, see Bombe, 1912, pp.69–70.

40 See Pesenti, 1984, pp.112 and 120.

41 See Pesenti, 1984; Park, 1985, p.154.

42 On Bartolo di Tura, see *Dizionario Biografico degli Italiani* 5, pp.706–7 (under Bartolo Bandini).

43 Mazzi, 1900; see also Richardson, Woods and Franklin, 2007 (3.1.2).

44 See Lydecker, 1987, p.166; and Rubin and Wright, 1999, pp.312–45.

45 Mazzi, 1900, p.67: 'Una madonna col figluolo in collo e angioletti dal lato, in tavola'; and 'un quadretto piccolo con due figure di Sancti Cosma e Damiano'. See also Richardson, Woods and Franklin, 2007 (3.1.2).

46 Ibid., p.64: 'Una lettiera grande, dipenta ad drappo d'oro, chiusa da piei a la venetiana.' See also Richardson, Woods and Franklin, 2007 (3.1.2).

47 On Italian Renaissance beds, see Thornton, 1991.

48 On the chests, see Rubin and Wright, 1999, pp.316–19, cat. nos 78 and 79.

49 See Gargiolli, 1868, pp.99–100. On gold brocade prices, see also Duits, 1999, 2007.

50 Mazzi, 1900, p.92: 'Una fietta larga di brochato d'oro senza frange e la seta pavonaza'; and 'Un paio di maniche di brocato d'oro d'appicciollato alixandrino piano.' On Renaissance fashion, see Levi-Pisetsky, 1964–9, especially vol.2; Scott, 1980; Herald, 1981.

51 See, for instance, Shearman, 1975, p.26.

52 On the painting and the sitters, see Cortesi Bosco, 1980; Humfrey, 1997, p.66.

53 See Spallanzani and Gaeta Bertelà, 1992, pp.40–1. See also Richardson, Woods and Franklin, 2007 (3.1.3).

54 On book prices, see Fremmer, 2001, p.167.

55 On the medal, see *Renaissance Bronzes…*, 1951, p.200. On Ambrosius Jung, see Kranz, 2004, pp.68–303, cat. no. 27.

56 See above, n.37.

57 On portrait medals, see Scher, 1994, 2000; Syson and Gordon, 2001; Satzinger, 2004.

58 On Banchi, see Edler de Roover, 1966. On Banchi's income, see also Duits, 1999.

59 Goldthwaite, 1968, pp.194–206.

60 Duits, 2007.

61 See Lane, 1944; Mueller, 1997, p.649.

62 Herlihy and Klapisch-Zuber, 1978, p.251.

63 Sections from the inventory are reproduced in Shearman, 1975.

64 The problem with the *Primavera* is that its iconography does not go back to a single known textual source and does not correspond to any established allegorical conventions. For examples of recent interpretations, see Dempsey, 1992; La Malfa, 1999.

65 See Spallanzani and Gaeta Bertelà, 1992, p.11.

66 On the Sassetti Chapel, see Borsook and Offerhaus, 1981; Kecks, 1995, pp.119–26, cat. no. 14; Cassarino, 1996; Roettgen, 1997, pp.136–63; Cadogan, 2000, pp.230–6, cat. no. 16; Rohlmann, 2003, pp.165–244.

67 Some attribute the tombs to Bertoldo di Giovanni (c.1435–91) instead. See Cassarino, 1996, pp.109–19, for a discussion.

68 See Kecks, 1995, pp.126–44, cat. no. 15; Roettgen, 1997, pp.164–201; Cadogan, 2000, pp.236–42, cat. no. 17.

69 The sculptor Luca della Robbia (c.1399/1400–82) was paid 200 florins for the single but more elaborate marble wall tomb of Cardinal Federighi of Fiesole in 1455. See Pope-Hennessey, 1980, pp.242–4.

70 Rucellai, 1960, p.121.

71 The first to address this aspect of the cycle was Aby Warburg in his 1902 essay, 'The art of portraiture and the Florentine bourgeoisie'. See Warburg, 1999, pp.185–222.

72 I thank Caroline Elam for the comparison.

73 On this portrait, see Kecks, 1995, pp.151–2, cat. no. 22; Cadogan, 2000, pp.277–8, cat. no. 46.

74 'ARS UTINAM MORES ANIMUMQUE EFFINGERE POSSES PULCHRIOR IN TERRIS NULLA TABELLA FORET.' See Martial, 1993, p.327 (bk 10, epigram 32).

75 For examples, see Rucellai, 1960, pp.33–4; Frick, 1995, pp.15–29.

76 See Gargiolli, 1868, pp.99–100.

77 On female clothing, see Herald, 1981; Frick, 2002.

78 Two useful popular accounts of the history of the Medici family are Hibbert, 1974, and Hale, 1977. See also Roover, 1963; Rubinstein, 1966; Kent, D., 1978.

79 See Roover, 1963, pp.25 and 26; Duits, 1999, 2007.

80 See Gilbert, 1980, p.15. On the Vendramin estate, see Mueller, 1997, p.649.

81 The theoretical aspects of what distinguishes an 'art collection' from a mere ornate household are explored in Alsop, 1982. Useful observations on the formation of actual art collections in Renaissance Italy and the effect of this development on the art market can be found in Lydecker, 1987.

82 See Dacos *et al.*, 1973; Pollini, 1992; Acidini Luchinat, 1997.

83 Spallanzani and Gaeta Bertelà, 1992, p.36: 'Una schodella di sardonio e chalcidonio e aghata, entrovi più fighure et di fuori una testa di medusa, pesa lib. 2 once 6 f.10000.' See also Richardson, Woods and Franklin, 2007 (3.1.3).

84 The building costs of the Medici palace are unknown but can be estimated on the basis of a comparison with the slightly later Strozzi palace, which was of a similar size and cost around 40,000 florins to construct. See Goldthwaite, 1995.

85 See Spallanzani and Gaeta Bertelà, 1992. See also Richardson, Woods and Franklin, 2007 (3.1.3).

86 See Spallanzani and Gaeta Bertelà, 1992, pp.47–9 (Byzantine miniature mosaics) and p.52 (Flemish panels). See also Richardson, Woods and Franklin, 2007 (3.1.3).

87 See Vaughan, 1975.

88 On the ducal finances, see Vaughan, 1970, pp.259–60; see also Vaughan, 1975; Duits, 1999.

89 See van der Velden, 2000. On votive gifts, see also Kriss-Rettenbeck, 1972.

90 See Plate 2.27 in Woods, 2007.

91 On the price of the statuette, see van der Velden, 2000, pp.66 and 91. For the conversion, see Spufford, 1986, p.217. The amount of 1,200 pounds of 40 groat was equivalent to 25–30 times the annual income of a Bruges master mason. On the Bouts commission, see Schöne, 1938, pp.242–4; see also van Uytven, 1998; van der Velden, 2000, p.65; Duits, 2007. The sum of 500 guilders was equivalent to 600 pounds of 40 groat.

92 On votive paintings, see Kriss-Rettenbeck, 1972.

93 See Laborde, 1849–52, vol.2. See also Richardson, Woods and Franklin, 2007 (3.1.1).

94 See Letts, 1957, p.28. For a discussion, see Belozerskaya, 2002.

95 On the cross, see Bauer et al., 1987, pp.206–7; Kovacs, 2004, pp.83–91.

96 See Laborde, 1849–52, vol.2, p.3, no. 2022: 'Item une croix d'or pesant avec le pied II m. II o. V. estrelins, garnie de v balois, xx saffirs, iiii tronches de perles, chascune tronche de trois perles et … chacun bout iii perles. Et il a de la vraye croix au milieu et est armoye aux armes de MS le duc …' One mark corresponded to 8 ounces or 160 sterlings, and was the equivalent of 245 grams in modern weight. See also Richardson, Woods and Franklin, 2007 (3.1.1).

97 See Laborde, 1849–52, vol.2, p.241, nos 4082–6. On the icons, see also Ainsworth, 2004.

98 Laborde, 1849–52, vol.2, p.16, no. 2142: 'Item, une autre table pareillement de broudure, aussi en trois pièces, où il a en la pièce du milieu pareillement l'istoire des trois rois, en la seconde pièce l'istoire de roy David, assiz en ung tabernacle et autres plusieurs ymages lui faisant révérence, et en la tierce pièce l'istoire de Salmon assis en ung tabernacle et la royne Saba lui faisant révérence'. See also Laborde, 1849–52, vol.2, p.16, no. 2141; p.22, no. 2197; pp.243–4, nos 4092–5; Richardson, Woods and Franklin, 2007 (3.1.1). Embroidered tables d'autel could be found not only in the chapel of the Dukes of Burgundy, but also in other fifteenth-century princely households. See, for instance, Stratford, 1993, pp.188–9 (B 28; B 29) and 191 (B 47; B 48).

99 See Spallanzani and Gaeta Bertelà, 1992, pp.11 (panel paintings) and 68 (altar cloth).

100 On the tapestry, see Châtelet, 2001, p.67.

101 On the succession of the Netherlands to the Habsburgs, see Israel, 1995.

102 See Thümmel, 1980, who argues for a date of 1520 and a commission by the humanist scholar Johannes Cuspinian rather than the emperor himself.

103 See Brandi, 1965; Soly, 1999.

104 See Gargiolli, 1868, pp.99–100.

105 See Hackenbroch, 1979. A useful study for fifteenth-century jewels is Lightbown, 1992.

106 Newton, 1988, p.134.

107 The identification of the National Gallery portrait as Beatriz of Portugal is by Susan Haskins, who is currently preparing a publication on the subject. For examples of other women who had themselves portrayed as the Magdalene, see Haskins, 1993, pp.298–9.

108 See van der Velden, 2000, pp.82–3. On armour, see Blair, 1958; Pyhrr and Godoy, 1999.

109 Pyhrr and Godoy, 1999, pp.160–70.

110 The banner by Agnes van den Bossche has been reproduced in recent literature, but has not been the subject of an independent study. The most detailed information on it can be found in the online database of the Centre for the Study of Fifteenth-Century Painting in the Southern Netherlands and the Principality of Liège at http://www.kikirpa.be (accessed 24 January 2006).

111 See Hale, 1985.

112 See Conti, 1984, pp.27–8.

113 Mallett, 1974, pp.135–8; Hale, 1985, pp.109–18.

114 See Morall, 2002.

115 Conti, 1984, p.27.

116 On the palace, see Lutz, 1995.

117 See, for instance, Lowe, 2003.

118 On the painting, see Thomas, A., 1995, p. 310; and the online database of auctioned works of art, Artfact, at http://www.artfact.com/features/styleLot.cfm?iid=wUN12mQF (accessed 24 January 2006).

119 On Bishop Fox, see Marks and Williamson, 2003, pp.234–6; on the object, see ibid., p.241, cat. no. 104.

120 The bibliography on St Peter's is vast. See Francia, 1977; Spagnesi, 1997; Bredekamp, 2000; Pinelli, 2000.

121 Camesasca, 1994, p.175: 'questa è la più gran fabrica che sia mai vista … montarà più d'un millione d'oro, e sapiate che 'l Papa hà deputato di spendare sessanta mila ducati l'anno per questa fabrica'. Raphael's estimate was not far off the eventual cost, which amounted to around 1.5 million ducats by the time the building was finally finished around the middle of the seventeenth century. See Thoenes, 1997, pp.20–2.

122 For an account of the historical background, see Spufford, 1986 (see also the Spufford website at http://sccweb.scc-net.rutgers.edu/memdb/databasesSpecificFiles/SearchForm/SearchForm_Spuf.asp?provenance=databas

eList (accessed 24 January 2004) and the introduction to Goldthwaite and Mandich, 1994.

[123] For the exchange rates of Florentine gold and silver currencies and moneys of account, see Goldthwaite and Mandich, 1994. For the exchange rates of Venetian gold and silver currencies, see Mueller, 1997.

[124] The essential survey of European exchange rates is Spufford, 1986 (see also the Spufford website cited in n.122 above). The disadvantages of this colossal work of scholarship are that it ends in 1500, that many currencies are not included, and that the author has not made precise distinctions between actual gold coinage and moneys of account.

[125] See Laborde, 1849–52, particularly vol.1.

Chapter 2

[1] My translation from Vasari, 1986, pp.880–1.

[2] For a discussion of this attitude, which runs through the *Lives*, see Mitchell, 1975, especially pp.67–8, 75, 110, 119–21.

[3] For a good general discussion of Florentine workshop practice, see Rubin and Wright, 1999, pp.76–120.

[4] A passage from Bruni's *Panegyric* is translated in Baldassarri and Saiber, 2000, pp.39–43 (quotation p.40).

[5] The full passage is quoted ibid., pp.84–7.

[6] Ibid., p.210.

[7] Ludovico Carbone is quoted and discussed in Campbell, S.J., 2004, pp.138–9. For this excerpt from Pius II's diaries, see Elmer, Webb and Wood, 2000, p.234.

[8] See Rubin and Wright, 1999, p.8.

[9] Cantos 15–16 of Dante's *Inferno* contain many comments about the 'avaricious, envious and proud' Florentines. See Alighieri, 1939, vol.1, pp.192–211. For a history of the early development of the Florentine commune and Dante's opinions on it, see Brucker, 1969, pp.128–37.

[10] The Florentine major guilds consisted of the Arte di Calimala (cloth merchants), Arte della Lana (wool merchants), Arte dei Giudici e Notai (judges and notaries), Arte del Cambio (bankers), Arte della Seta (silk merchants), Arte dei Medici e Speziali (physicians and spice merchants), and Arte dei Vaiai e Pellicciai (furriers).

[11] Brucker, 1969, pp.133–7.

[12] For an overview of building in Florence from the thirteenth century, see Goldthwaite, 1980, pp.1–26.

[13] Rubinstein, 1995, pp.9–10.

[14] See Trachtenberg, 1997, pp.971–2, for quotation; see Rubinstein, 1995, pp.10–11, for a discussion of the size of the palace as 'demonstrating the supremacy of the common interest over private abuse of power'.

[15] For a full discussion of the dome, see Saalman, 1980.

[16] Baldassarri and Saiber, 2000, p.210.

[17] See Kent, D., 2000, p.125.

[18] Goldthwaite, 1980, pp.1–26.

[19] Translated and discussed in Burke, J., 2004, p.64.

[20] For a discussion and bibliography on individual *opere*, see Haines and Ricetti, 1995; Burke, J., 2004, p.69; Goldthwaite, 1980, pp.90–4.

[21] For a discussion of the wool merchants' guild and the cathedral *opera*, see Haines, 1989, and essays in Verdon, 2001, vol.1.

[22] Burke, J., 2004, pp.71–82, 125–7 and 138, for the Innocenti, Santo Spirito and a general discussion; for San Lorenzo see Ruda, 1978, pp.358–61.

[23] For the increasingly 'courtly and even obsequious' language used to Lorenzo, see Kent, F.W., 1994, p.50; for Medici political strategies, see Rubinstein, 1966.

[24] For the 'semi-public' nature of the Medici palace and its role in creating and maintaining patronage networks, see Kent, D., 2000, pp.230–5.

[25] For the stories of Judith and David, see the Old Testament books of Judith 10–13, and I Samuel 16–18. Blake McHam, 2001, p.33, discusses David as a symbol of the Florentine republic.

[26] For a discussion of the *Spinario* in the Renaissance, see Bober and Rubinstein, 1986, pp.235–7.

[27] Vespasiano de Bisticci, Cosimo de' Medici's later biographer, expressed this explicitly in reference to Cosimo's patronage of Donatello: see Gombrich, 1966, pp.40–1.

[28] Blake McHam, 2001, discusses the inscriptions and notes some of the extensive bibliography on these sculptures; see pp.32 and 36 for the inscriptions on the *David* and *Judith* respectively. For the fullest discussion of the sources for these inscriptions, see Caglioti, 2000, vol.1, pp.1–21.

[29] The importance of being an *operaio* in Lorenzo's artistic education is discussed in Kent, F.W., 2004, pp.21–8. For the political benefits of his involvement in Santo Spirito, see Burke, J., 2004, pp.72–3; for Lorenzo at the cathedral, see Kent, F.W., 2001, and at the Palazzo Vecchio, see Hegarty, 1996.

[30] Butterfield, 1997, pp.57–9.

[31] For fuller analyses of this extraordinarily innovative sculpture, see Butterfield, 1997, pp.62–80, and Shearman, 1992, pp.30–3.

[32] Quoted in Butterfield, 1997, p.77.

[33] The political implications of the iconography are discussed ibid., pp.61–2.

[34] See, for example, Hegarty, 1996, and Kent, F.W., 2004, pp.101–6.

[35] Herlihy and Klapisch-Zuber, 1985, p.100.

[36] Aristotle, 2000, pp.65–7 (bk IV, ch. 2).

[37] For discussions of magnificence, see Burke, J., 2004, pp.35–8; Syson and Thornton, 2001, pp.23–9; Fraser Jenkins, 1970, pp.162–70; Rubin, 1995, pp.37–49.

[38] Fraser Jenkins, 1970, pp.165–6.

[39] Translated in Herlihy and Klapisch-Zuber, 1985, p.111.

[40] See Rubin, 1995, p.37.

[41] Quoted in Elmer, Webb and Wood, 2000, p.221.

[42] My translation of Rucellai, 1960, pp.121–2. This passage is now translated in Richardson, Woods and Franklin, 2007 (3.2.1).

[43] An English translation of this contract can be found in Chambers, 1970, pp.173–5. This fresco is discussed extensively, with a full bibliography, in Cadogan, 2000, pp.67–90 and 236–43.

[44] 'AN(NO) MCCCCLXXXX QUO PULCHERRIMA CIVITAS OPIBUS VICTORIIS ARTIBUS AEDIFICIISQUE NOBILIS COPIA SALUBRITATE PACE PERFRUEBATUR.'

[45] Landucci, 1927, pp. 43–4. 'Messer' is an honorific title, more or less equivalent to the English 'Sir', but without the same implications of nobility.

[46] My translation from Masi, 1906, pp.16 and 122.

[47] Butterfield, 1997, p.60; Hirst, 2000, pp.487–8.

[48] A good example of reactions to these sometimes forced festivities can be seen in Bartolommeo Masi's account of San Giovanni in 1514, translated in Richardson, Woods and Franklin, 2007 (3.2.2).

[49] Translated and discussed in Trexler, 1980, pp.247–9.

[50] Machiavelli, 1988, p.361.

[51] The story of the Medici family's power in Florence is traced by Hale, 1977.

[52] Medici, 2004, p.3.

[53] Indeed, some scholars suggest that Lorenzo the Magnificent's relative lack of spending on lavish private buildings and art works was due to his awareness of the public resentment such spending could cause. See, for example, Kent, F.W., 2004, pp.44–8.

[54] Martines, 1979, pp.191–217 and especially 214–15.

[55] Baldassarri and Saiber, 2000, pp.70–1.

[56] Alamanno Rinuccini suggested that in the early 1460s patrician houses were displacing poor Florentines. For this, and other criticisms of palace builders, see Kent, F.W., 1987, pp.47 and 55–6, and Goldthwaite, 1980, pp.15–16.

[57] Goldthwaite, 1980, p.16; Saura, 1988, p.418.

[58] Landucci, 1927, pp.51–2.

[59] See Weinstein, 1970.

[60] My translation from Savonarola, 1962, pp.382–3.

[61] For translated extracts from this sermon, see Richardson, Woods and Franklin, 2007 (3.2.3).

[62] Savonarola, 1957, p.281.

[63] Ibid., pp.278–9.

[64] Savonarola, 1969, vol.1, p.189.

[65] For a bibliography of Savonarola's influence on the visual arts, as well as a contribution to that discussion, see Burke, J., 2004, pp.155–87.

[66] After being tricked into killing his wife and children by the goddess Hera, Hercules was sentenced to carry out 12 seemingly impossible tasks, which he accomplished with the aid of Hermes and Athena. Hercules' ability to win against overwhelming odds made him, like David, a favourite symbol of the Florentine republic.

[67] For a discussion of the fortunes of Donatello's *David* and *Judith* in 1495, see Caglioti, 2000, vol.1, pp.291–358.

[68] For the building of the hall, see Wilde, 1944, pp.65–72, though Wilde's reconstruction of the placement of the wall paintings has been questioned by recent scientific examinations, still underway; see also Rubinstein, 1995, pp.40–6, 70–8 and 114–15.

[69] Landucci, 1927, pp.264–5.

[70] The bibliography on the frescoes is vast, but the best discussion on the decoration of the hall as a whole remains Wilde, 1944, pp.75–81.

[71] Vasari, 1996, vol.2, pp.657–8.

[72] This document, first published in Milanesi, 1860, pp.68–9, is translated in Richardson, Woods and Franklin, 2007 (3.2.4). The most recent account of Rustici's career is Russo, 1998.

[73] Vasari, 1996, vol.2, pp.519–20.

[74] Loeser, 1928, p.260.

[75] Waldman, 1997, pp.870–1.

[76] This document is reproduced in Saalman, 1978, p.490. I disagree with Saalman's reading of this passage (p.485). Literally meaning 'shield', scudi is a currency that was used in several Italian states during the Renaissance.

[77] Vasari, 1996, vol.2, p.654.

[78] The document of commission is transcribed and translated in Seymour, 1967, pp.134–7.

[79] Ibid., pp.135–7.

[80] Ibid., pp.141–55. This document is reproduced in Richardson, Woods and Franklin, 2007 (3.2.5).

[81] See, for example, Landucci, 1927, pp.213–14; Parenti, *Storia Fiorentina*, quoted in Gotti, 1876, pp.29–30n; Cambi, 1785, vol.22, p.203.

[82] Caglioti, 2000, vol.1, pp.302–7.

[83] The golden decorations for the *David* are discussed in Ristori, 1986.

[84] Seymour, 1967, pp.3–17.

[85] Masi, 1906, pp.145–6.

[86] In this case, a tabernacle was a small winged devotional image made of wood, but this word could also refer to an external architectural niche with an image inside, as in the discussion below, pp.87–90. Neri di Bicci, 1976, pp.13, 75, 107–9, 117, 124–5, 127, 128, 167, 192, 239, 300, 273, 401, 408, 424 for Neri's artisan clients; pp.107–8 for the altarpiece for San Giorgio, and pp.124–5 for Giovanni the barber's Virgin Mary.

[87] Goldthwaite, 1980, pp.435–42.

[88] Neri di Bicci, 1976, p.424.

[89] 'BATJIC agrees wage settlement', at http://www.fmb.org.uk/press/fmbnews/160305.asp [accessed 15 June 2005].

[90] Note that the florin was worth 77 soldi in 1400, but 137 in 1499.

[91] Landau and Parshall, 1994, pp.295–6.

[92] For a discussion of woodcut technique, see Hind, 1935, vol.1, pp.1–28, and for colouring pp.23–4. For woodcut

technique see also Charles Harrison's chapter in the second volume of this series (Richardson, 2007).

[93] For an account of some very 'poor women' and their miraculous image (a sweating crucifix), see Burke, J., 2006.

[94] Henderson, 1994, pp.34–7.

[95] These rituals are discussed in detail by Weissman, 1982, pp.99–104.

[96] Translated and discussed ibid., pp.102–3.

[97] For a discussion of these plays, see Newbigin, 1996, vol.1.

[98] Wilson, 1992, pp.119–20.

[99] Eckstein, 1995, pp.1–17.

[100] Transcribed and translated in Newbigin, 1996, vol.1, pp.67–79.

[101] For a description by Abraham, the Russian Bishop of Souzdal, see ibid., pp.60–3.

[102] The fullest description of this altarpiece is Padoa Rizzo, 1991.

[103] For this confraternity and other groups of this kind, see Taddei, 1999.

[104] These unpublished statutes, kindly shared by David Rosenthal, are in the Archivio di Stato di Firenze, Compagnie Religiose Soppresse, Capitoli, 870 bis.

[105] A response to a line of the religious service.

[106] See Padoa Rizzo, 1991, pp.265–6.

[107] Archivio di Stato di Firenze, Compagnie Religiose Sopprese, Capitoli, 870 bis, fol.12v.

[108] Padoa Rizzo, 1991, pp.265–6.

[109] Rosenthal, D., 1999, 2006a and b. See also Trexler, 1980, pp.399–418 and 510–15. Rosenthal argues that these groups were more independent of Medici control than Trexler has allowed.

[110] Rosenthal, D., 2006a.

[111] 'SALVE VIRGO PARENS TERRARUM CUNTA REGENTIS / SALVE SPES HOMINUM GRATIA VITA SALUS.'

[112] 'QUESTO DEVOTO TABERNACHOLO ANNO FATTO FARE GLUOMINI DEL REAME DI BELIEMME POSTO IN VIA SANCTA CHATERINA MDXXII.'

[113] Rosenthal, D., 2006a, and Nuttall, 2004, pp.93–6, discuss the confraternities of northerners and their commissions.

[114] For these figures, see Marquand, 1920, pp.129–33. In comparison with the wages of skilled building workers in 2005, this altarpiece cost around £25,000.

[115] See Rosenthal, D., 2006a, for a broader discussion of the complex of motivations behind the commission of the tabernacle.

[116] Cerretani, 1993, p.413.

[117] Ibid., p.417; Cambi, 1785, vol.23, p.220.

[118] Cambi, 1785, vol.3, p.221, mentions that churches were closed to prevent festivities from around mid-November (Saint Stephen's day on the 18th) to late December (Saint Thomas's day on the 20th) 1522.

Chapter 3

[1] Meiss, 1974, pp.63–4.

[2] From the early Middle Ages, monks performed a cycle of daily prayers at fixed hours: Matins (about 2:30 am), Lauds (about 5 am), Prime (about 6 am), Terce (about 9 am), Sext (about noon), None (about 3 pm), Vespers (about 4:30 pm) and Compline (about 6 pm). Books of Hours developed as a lay adaptation of this monastic liturgy; by the end of the twelfth century, Hours of the Virgin often circulated as part of a Psalter (a type of book containing the book of Psalms and often other devotional material). In the thirteenth century, the Book of Hours emerged as a discrete volume.

[3] The Penitential Psalms (6, 31, 37, 50, 101,129 and 142) are especially expressive of regret for sin and penitence.

[4] A suffrage is an intercessory prayer directed to a saint. In Books of Hours, these prayers are usually organised hierarchically, beginning with the suffrages to the Trinity, the Virgin, Saint Michael and John the Baptist, and followed by the apostles, martyrs, confessors and female saints.

[5] The depiction of Apollo and his horse-drawn chariot was modelled on a medal showing the Byzantine Emperor Herakleios (ruled 610–41) acquired by the duke c.1402. Now lost, until the seventeenth century this medal was believed to be a Byzantine antique, but it is now recognised to have been a forgery; believing in its authenticity, the duke commissioned copies of it that may have been made by the Limbourgs. For the copies of this medal and their relationship to the *Très Riches Heures*, see Meiss, 1974, pp.184–5, and Scher, 1994, pp.32, 35–7.

[6] Meiss, 1974, pp.193–4.

[7] For a recent study, see Reynolds, 2005.

[8] King, M.L., 1994.

[9] Alexander, 1994, p.87.

[10] For a discussion of the manuscript's binding, see Hobson, 1989, pp.33–4.

[11] Hope and McGrath, 1996, p.161.

[12] Quoted in de la Mare, 1973, p.64.

[13] See Reynolds and Wilson, 1991.

[14] De la Mare, 1973, pp.62–84.

[15] Alexander and de la Mare, 1969, pp.xxii–xxxiii; Garzelli and de la Mare, 1985, pp.395–6; and Brown, M.P., 1990, pp.126–35 (also useful for discussions and plates of antique, Carolingian and twelfth-century scripts).

[16] Chambers, 1992, p.172, rejects the argument for Gonzaga patronage; Alexander, 1994, no. 71, pp.152–4; Alexander, 1970, pp.27–40; Watson, 2003, p.99.

[17] Ullman, 1960, pp.27–30, Figure 15.

[18] De la Mare, 1973, p.76; de la Mare, 1992, p.149.

[19] Vespasiano da Bisticci, 1997, p.213.

[20] De la Mare, 1992, pp.115–16.

[21] Ibid., p.133.

[22] Ibid.

[23] Ibid.; see also Ames-Lewis, 1984, pp.239–40, Plates 40–1.

[24] Alexander, 1994, no. 34, pp.95–8.

[25] Ibid., no. 35.

[26] Vespasiano da Bisticci, 1997, p.234.

[27] Quoted in Coleman, 1996, p.123.

[28] Ibid., p.120.

[29] Kren and McKendrick, 2003, no. 3, pp.91–2.

[30] Van den Bergen-Patens, 2000.

[31] Kren and McKendrick, 2003, p.117.

[32] Ibid., no. 80, p.290.

[33] Variations of this motto appear in other illuminations by the Master of the White Inscriptions, and it may be a form of signature: ibid., p.289.

[34] Royal MS 18 E iii (vol.1): 342 folios; Royal MS 18 E iv (vol.2): 326 folios.

[35] Alexander, Marrow and Sandler, 2005, no. 83, pp.359–61.

[36] Her status as a mistress is inscribed on fol.17r, which records 'the portrait of Pierre Sala, butler in the king's service … with the enigmas he composed for his mistress (*sa maîtresse*)': Backhouse and Giraud, 1994, pp.396–7.

[37] Giraud, 1994, p.308.

[38] This manuscript and its box have been reproduced in a facsimile edition accompanied by a commentary and translation: Backhouse and Giraud, 1994.

[39] Ibid., pp.364–79.

[40] Ibid., p.395; see also Backhouse, 1983, no. 22, p.174, n.7.

[41] Giraud, 1994, pp.316–17.

[42] The opening lines of *O intemerata* translate as 'O unsullied, an eternally blessed, singular and incomparable Virgin Mary mother of God'; *Obsecro te* begins 'I beseech thee, O Holy Lady Mary, mother of God'.

[43] Evans, M., 1983, pp.123–31.

[44] For the binding, see Hobson, 1989, pp.105–6.

[45] Evans, M., 1983, p.130.

[46] Ibid.

[47] This sketchbook of 1500–3, known as the Wolfegg Codex, is now in the British Museum: see Bober, 1957, especially pp.12, 45 and Figure 5.

[48] Barstow, 1992.

[49] Eichberger, 2005, no. 4, p.70.

[50] Kren and McKendrick, 2003, pp.215–16, no. 51.

[51] Blockmans, 1992, pp.33–9.

[52] Wieck, 1992, pp.119–98.

[53] Kren and Wieck, 1990, p.44.

[54] Ibid., p.53.

[55] Brieger, Meiss and Singleton, 1969.

[56] Pope-Hennessy, 1993b, p.17.

[57] The *Metamorphoses* of Ovid (43 BCE–?17 CE) is a series of tales about miraculous transformations. Ovid tells the story of Glaucus, the mythological Greek fisherman who placed a certain herb on a dead fish and saw it come back to life; he then ate the herb himself, leapt into the sea and became immortal.

[58] Quoted in Evans, M., 1992, pp.8–9. For this and other documents relating to the Sforza Hours, see Richardson, Woods and Franklin, 2007 (3.3.3).

[59] Evans, M., 1992, p.9.

[60] According to Christian doctrine, between Christ's Entombment and Resurrection he descended into limbo, a region on the border of hell, to liberate good souls who died before Christ's Incarnation. Adam and Eve and Old Testament prophets and patriarchs are among the souls he is believed to have liberated. The *Descent into Hell* is a major iconographic theme for the Greek Orthodox Church; see Chapter 5.

[61] See Kren and McKendrick, 2003, especially pp.427–37.

[62] Evans, M., 1995a, p.612, and Evans, M., 1995b, pp.546–8.

[63] Evans, M., 1992, p.28.

[64] Kren and McKendrick, 2003, no. 129, pp.428–31.

[65] For a reproduction of the *Arnolfini Portrait*, see Plate 2.24 in the second volume of this series (Richardson, 2007).

[66] Eichberger, 2005, p.291. Kren and McKendrick are more cautious, giving equal weight to the possibility that Charles inherited the manuscript after her death: Kren and McKendrick, 2003, p.429.

[67] For the inventory, see Debae, 1995.

[68] This letterform has been interpreted as a conjoint 'K' and 'I' for *Karolus Imperator* (Charles Emperor), and as a 'K' and an 'R' for *Karolus Rex*; it could simply be 'K' for *Karolus*.

[69] These vases could be related to a pair of crystal vases mentioned in the 1516 inventory of Margaret's library at Mechelen, described as 'deux grant potz de crestalins, couvertez, ayans les armes de Madame au millieu et dorez par les bords' (two large crystal pots, covered, carrying Madame's arms in the middle and with gilt edges) (inventory quoted in Eichberger, 2005, p.85). The Sforza Hours' vases do not have Margaret's arms, but otherwise they seem to match this description quite closely.

[70] 'James je ne seray contante / Sy ne me tenes pour votre humble tante / Marguerite' (Vienna, Österreichische Nationalbibliothek, cod. 1859, fol.21v), quoted in Eichberger, 2005, p.290.

[71] Eichberger has proposed another reading of this juxtaposition, suggesting that it was intended to serve as a caution to Charles to avoid the temptations of power and beauty to which King David succumbed: ibid., p.291.

[72] Eichberger and Beaven, 1995, p.226.

[73] Evans, M., 1992, p.37; for the Bernard van Orley portraits, see Eichberger, 2005, nos 18–19.

[74] Eichberger, 2005, no. 53, and Eichberger, 2002.

[75] Nothing is certain about the provenance of the Hours of Mary of Burgundy until it entered the collection of Emperor Matthias I (1557–1619): see Kren and McKendrick, 2003, no. 19, pp.137–41.

[76] Evans, M., 1992, p.33.

[77] Robinson, 1895, p.431.

[78] Ibid., p.433.

[79] Ibid.

[80] The miniature for May is London, British Library, Add. MS 62997; the October miniature is London, British Library, Add. MS 80800.

[81] Vespasiano da Bisticci, 1997, p.104, and Richardson, Woods and Franklin, 2007 (3.3.1).

Chapter 4

[1] *De artificiali perspectiva* was first published in Toul in 1505, but the list of artists was devised for the 1521 third edition. See Brion-Guerry, 1962, pp.428–43 (not all of Brion-Guerry's identifications are reliable).

[2] Zeuxis (fifth century BCE) and Apelles (fourth century BCE) were two of the most celebrated artists of antiquity, known from Pliny the Elder's *Natural History* (Book 35).

[3] See Evans, M., 1998; Avril, 2003, pp.50–63.

[4] See Avril, 2003, pp.18–28, 339–44.

[5] Grodecki, 1996, pp.329–42.

[6] Forsyth, 1970; Martin, 1997.

[7] See Avril and Reynaud, 1995, pp.58–69.

[8] See Hofmann, 2004, pp.72–191; Wieck, 2004. In earlier literature he is called Poyet.

[9] Jean Brèche of Tours, *De verborum significatione* (Lyons, 1556): see Hofmann, 2004, pp.69–70.

[10] See Thuillier, 1976.

[11] See Thuillier, 1983 and 1994.

[12] See Thiébaut, Lorentz and Martin, 2004. For a detailed historiographical study of how one particular pre-1500 painting attributable to a French 'primitive' has been manipulated by French scholars to advance notions of France's cultural history and standing, see Perkinson, 2005.

[13] See Réau and Fleury, 1994.

[14] Important examples include Henri Sauval and Roger de Gaignières: Sauval, 1724; Adhémar, 1974 and 1976; Vaivre, 1986; Coales, 1997.

[15] According to the account of Georges Chastellain, one of the leading Burgundian chroniclers: Chastellain, 1863–6, vol.4, pp.61–2, 85–6, 93–4. For comment, see Smith, 1989, p.125; Campbell, T.P., 2002, p.18.

[16] For a survey of the arts in Paris at the beginning of the fifteenth century and its distinction as an artistic centre, see Taburet-Delahaye, 2004.

[17] See Lecoq, 1987b, pp.149–68; Bamforth, 1997, pp.219–36.

[18] An administrative and judicial official for certain regions of France.

[19] See David, 1935, p.120; Müller, T., 1966, pp.136–7; Quarré, 1973, p.14.

[20] See Camp, 1990, Chapter VIII, and Chapter 3 in the first volume of this series (Woods, 2007).

[21] Avril, 2003, p.420; see also Richardson, Woods and Franklin, 2007 (3.4.1).

[22] Pradel, 1953, pp.20–1; Caffin de Mérouville, 1960, pp.190–1; Sterling, 1990, p.93. Bourré had much experience in commissioning works of art since he was a major patron himself. For a summary of the major aspects of his patronage, see Bricard, 1893, pp.327–74.

[23] Sterling, 1990, p.93.

[24] See Adhémar, 1976, p.10 (no. 1128), p.29 (no. 1243).

[25] Evans, J., 1969, p.217; Jarry, 1892, pp.96–7, 177.

[26] For documents and sources demonstrating René's practice as a painter, see Pächt, 1977, pp.78–83.

[27] BnF MS fr. 2695: Avril, 1986.

[28] See Coutagne, 1981, pp.131–82; Robin, 1985, pp.244–63.

[29] Lambron de Lignim, 1857, pp.2–3; Robin, 1985, pp.214–21; Elsig, 2004, p.38.

[30] MacGibbon, 1933, pp.136–7; Lapeyre, 1986, p.67; Durand and Laffite, 2001, p.122.

[31] Hale, 1979, p.131.

[32] MacGibbon, 1933, pp.136–7.

[33] Fiot, 1961, pp.106–16.

[34] See Avril, 2003, pp.375–81.

[35] Hale, 1979, pp.130–1.

[36] MacGibbon, 1933, pp.50–1, 146; see also Richardson, Woods and Franklin, 2007 (3.4.2).

[37] Kren and Evans, 2005.

[38] See Camus, 1894.

[39] Avril, Malandin and Lieutaghi, 1986, pp.269–72; Vornova and Sterligov, 1996, pp.192–7.

[40] The attraction such manuscripts held for patrons in royal circles can be shown from the survival of a close copy of this manuscript probably made in the 1520s: Paris, Bibliothèque nationale de France, MS fr. 12322: Avril, Malandin and Lieutaghi, 1986, pp.268–83.

[41] See Avril and Reynaud, 1995, pp.404–7, and Matthews, 1986, pp.4–18.

[42] See Filedt Kok, 1985, pp.201–2.

[43] Avril and Reynaud, 1995, pp.296–7.

[44] Cutolo, 1938; Denis, 1979. Cf. Antonovics, 1995.

[45] Seguin, 1961, pp.130–2.

[46] Translation adapted from Bridge, 1924, p.177.

[47] Filon, 1851; Lalanne, 1853; Leseur, 1929; Lesueur, 1929. For the château, see Grandmaison, 1873; Spont, 1894.

[48] Lesueur, 1904–6, pp.238–43; Lesueur, 1935.

[49] Verdon, 1978, pp.272–8.

[50] Verdon, 1990; König, 2001.

[51] Beaulieu, 1966.

[52] See Brown, C.M., 1981, pp.115–28.

[53] Its form is known from drawings and engravings: Vitry, 1901, p.169; Adhémar, 1976, p.45 (no. 1344).

[54] Cecchetti, 1980, pp.143–55.

[55] Polyclitus (fifth century BCE) and Euphranor (fourth century BCE) were celebrated sculptors in antiquity known through Pliny the Elder's *Natural History* (Books 34 and 35).

[56] By the reign of Charles VIII, the flame was probably understood to have special royal connotations: Labande-Mailfert, 1950.

[57] Scheller, 1983.

[58] 'ad sumptuositatem et decorem ecclesie': Neagley, 1998, p.94. The architect was Roulland Le Roux, working after a fire in 1514.

[59] Philibert de L'Orme, *Architecture*, 2nd edn, Paris, 1568, Book IV, Chapter VIII, p.107. Translation adapted from Frankl, 1960, p.296.

[60] Bos, 2003, pp.297–8.

[61] Deville, 1850, e.g. p.405.

[62] Chirol, 1952, pp.121–231. Much of the château of Gaillon was destroyed in the eighteenth and nineteenth centuries.

[63] Hale, 1979, p.113. For a useful account of the development of garden design in France during this period, see Lesueur, 1904–6.

[64] Hale, 1979, p.113.

[65] Weiss, 1953, p.7. The author of this description, Jacopo Probo d'Atri, was a secretary to the Marquis of Mantua, who was Mantegna's main patron. The reliefs he describes are lost.

[66] Chirol, 1959, pp.241–6. At least one major work actually by Mantegna's hand could be viewed in France by the time that the reliefs at Gaillon were executed: the *Saint Sebastian* (now in the Louvre). This was probably originally brought to Aigueperse by Chiara Gonzaga when she married Count Gilbert of Bourbon Montpensier in 1481.

[67] Martindale, 1979. Cf. Chirol, 1959, pp.240–7.

[68] Blanquart, 1898, pp.28–53.

[69] Block, 2003, pp.143–6, 380–3.

[70] Hale, 1979, p.55. Cf. Rosci and Chastel, 1963, pp.106–11.

[71] Hale, 1979, p.114; Weiss, 1953, p.6.

[72] For d'Estouteville's patronage in France, see Chirol, 1952, pp.31–5; Laporte, 1967, pp.211–34. For his patronage in Italy, see Callisen, 1936, pp.401–6; Gill, M.J., 1996, pp.498–522.

[73] Known as the *Puy Notre Dame*: Breuil and Rigollot, 1858; Durand, 1911; Lecoq, 1977; Pinson, 1987.

[74] Lecoq, 1977, and *ExtravagAnt*, 2005, pp.84–9.

[75] The artists responsible for carving the frame of the 1518 *puy* and those of subsequent years have been identified as those who worked on the choir stalls in Amiens Cathedral: Tracy and Harrison, 2004.

[76] Sterling, 1968; Reynaud, 1968; Avril and Reynaud, 1995, pp.350–1. For an alternative, less plausible, identification of the 'Moulins' painter with Jean Prévost, an artist from Lyons who worked in stained glass, see Châtelet, 2001.

[77] Only the Moulins altarpiece survives intact. Most of the remaining portraits attributable to Hey are fragments of larger compositions cut from their original contexts in later periods. They are usefully catalogued in Châtelet, 2001 (though mostly with attributions to Jean Prévost, not followed by the present author).

[78] Winkler, 1932; Bruyn, 1963; Châtelet, 2001, pp.45–54, 194–6.

[79] See Tolley, 1994, pp.225–6.

[80] See Sterling, 1968.

[81] See Labande-Mailfert, 1975, p.502.

[82] See Feydy, 1938.

[83] Sterling, Ainsworth *et al.*, 1998, pp.11–18.

[84] Stecher, 1891, III, p.5, IV, p.110.

[85] Jansen, 2004. Among the issues Anne of France touches on is the appropriate use of jewels.

[86] Pradel, 1953, pp.75–8; Baron, 1996, p.186.

[87] New York, Pierpont Morgan Library, MS M 50: Wieck and Hearne, 1999; Hofmann, 2004, pp.133–6.

[88] Cambridge, Fitzwilliam Museum, MS 159: Sheingorn, 1993, pp.76–7; König, 2001.

[89] Châtelet, 2001, p.189.

[90] The baggage primarily contained reliquaries, valuable for their devotional as well as their artistic and intrinsic significance: Labande-Mailfert, 1975, pp.412–13.

[91] BnF MS fr. 14363, fol.3: Avril and Reynaud, 1995, no. 194.

[92] Yabsley, 1932, pp.71–2; see also Richardson, Woods and Franklin, 2007 (3.4.5).

[93] Stecher, 1891, vol.4, pp.158–9; Duvenger and Duvenger-Van de Velde, 1967; see also Richardson, Woods and Franklin, 2007 (3.4.5).

[94] For an example, see Schaefer, 1985.

[95] Morphos, 1963; Wadsworth, 1959.

[96] Avril, 2003, pp.252–62.

[97] Zsuppán, 1970, pp.185–6; see also Richardson, Woods and Franklin, 2007 (3.4.3). Since Robertet refers in the poem to René of Anjou having died, it must date from after 1480.

[98] Zsuppán, 1970, pp.138–48, 179–84; cf. Delmarchel, 1989.

[99] Mayer and Bentley-Cranch, 1997, p.211.

[100] For the Hours of Louis of Laval (executed in two campaigns, datable c.1470–5 and 1480–5), see Avril and

Reynaud, 1995, pp.328–32; Avril, 2003, pp.388–94. For the iconography of sibyls in France during this period, see Mâle, 1986, pp.266–8; Zsuppán, 1970, pp.75–7; Schaefer, 1980, pp.42–4.

[101] BnF MS fr. 24461: Avril and Reynaud, 1995, pp.354–5 (with a summary of the dating problems and further bibliography).

[102] *Dictz moraulx pour faire tapisserie*: Lemaître, 1988. For commentary on this, see Vandenbroeck, 1988.

[103] Kendall, 1971, p.28.

[104] See further Bohat-Regond, 1979, pp.245–53; Lecoq, 1987a, pp.56–7; Vandenbroeck, 1988, p.81; Massing, 1995, p.22.

[105] For an assessment of collections of portrait drawings, see Jollet, 1997.

[106] Holban, 1986, pp.19–27.

[107] Part of an inscription by Robertet added on the final folio of BnF MS fr. 247. This statement is the basis of all attributions to Jean Fouquet, though recent scholarship considers the miniatures in the *Jewish Antiquities* more likely to be the work of one of Fouquet's sons: Avril, 2003, pp.310–27. For d'Armagnac's interests in illuminated books, see Avril and Reynaud, 1995, pp.164–7.

[108] Avril and Reynaud, 1995, pp.165–6. For Évrard's relations with Pierre of Bourbon, see Guibert, 1894, pp.451–6.

[109] See Thomas, M., 1971. For the accounts, see MacGibbon, 1933, p.17.

[110] Bloch, 1989, pp.317–28; Thibault, 1989, pp.20–48.

[111] Adhémar, 1975, pp.99–104.

[112] Leroux de Lincy, 1860, vol.4, pp.412–22. Louis XII gained an annulment from his marriage to Jeanne in 1498 to marry Charles's widow, Anne of Brittany.

[113] Winn, 1984, pp.603–4.

[114] BnF MS fr. 1686: ibid., pp.613–14.

[115] Beltran, 1986; Winn, 1994.

[116] See Sterling, 1990, pp.215–30; Avril and Reynaud, 1995, pp.256–62.

[117] This Book of Hours is Biblioteca Nazionale, Madrid, MS Vit. 24–1.

[118] Scheller, 1981–2, p.17.

[119] Wingfield Digby, 1980, pp.15–19.

[120] Asselberghs, 1972; McKendrick, 1991; Cavallo, 1993, pp.229–49; Campbell, T.P., 2002, pp.55–64.

[121] Jarry, 1892, p.79.

[122] Durrieu, 1913; Scheller, 1985, pp.26–30; Avril and Reynaud, 1995, no. 239. The patron was François de Rochechouart.

[123] For the theme of the Nine Worthies in art, see Wyss, 1957.

[124] Lecoq, 1987a, pp.229–43.

[125] Castiglione, 1967, p.88.

[126] For an account of Italian reactions to Charles VIII's supposed 'ugliness' and its consequences, see Kidwell, 1991, p.15.

[127] *Heptaméron, nouvelle* 32. During the two subsequent reigns, the portrayal of renowned beauties amounted to a preoccupation at the French court.

[128] Maulde de la Clavière, 1886, p.9.

[129] The *Complainte de nature á l'alchimiste errant*: Vernet, 1943; Sterling, 1963.

[130] Their identities are known through inscriptions: Reynaud, 1996.

[131] Hochstetler Meyer, 1975; Snow-Smith, 1982.

[132] Kemp, 1992, pp.9–14.

[133] This survives in several versions: Kemp, 1992 and 1994.

[134] Shell and Sironi, 1991; Jestaz, 1999; Knecht, 1994.

[135] Elsig, 2002.

[136] Durand, 1911; Duvenal, Leroy and Pinette, 1997.

Chapter 5

[1] Chatzidakis and Drakopoulou, 1997, pp.324–32.

[2] The works of Angelos were examined in the second volume of this series (Richardson, 2007, ch.5).

[3] Origo, 1963, pp.117–30; Ferguson, 1976, p.109.

[4] For the western-style image of the Resurrection, see Plate 2.10 in the first volume of this series (Woods, 2007, ch.2). It seems likely that this is the first appearance of the western-style Resurrection in Byzantine art: Paliouras, 1978, pp.395–7.

[5] Evans, H.C., 2004, p.485, no. 295. I would like to thank Caroline Elam for her suggestions in parts of the descriptions of the icon.

[6] It has been argued that the mendicant orders, and the Franciscans in particular, regarded Byzantine icons as sacred and, on occasions, adapted them within their context (e.g. churches): see Anne Derbes and Amy Neff in Evans, H.C., 2004, pp.459, 460.

[7] Acheimastou-Potamianou, 1989–90, p.117.

[8] Constantoudaki-Kitromilides, 1986, pp.254–5.

[9] Acheimastou-Potamianou, 1989–90, pp.110–12. An English translation of the relevant section of the will is available in Richardson, Woods and Franklin, 2007 (3.5.2).

[10] For an interesting approach on the 'failed experiment' of sculpture in Byzantium, see John Hanson's paper in Eastmond and James, 2003, pp.173–84.

[11] On iconoclasm, see Brubaker and Haldon, 2001. For a defence of images by Saint John of Damascus at this time, see Richardson, Woods and Franklin, 2007 (3.5.1).

[12] Kazhdan, *et al.*, 1991, vol.2, pp.975–8.

[13] Acheimastou-Potamianou, 1987, p.37. See also Maguire, 1996, p.138. The phrase was first used as a defence of icons by John of Damascus, whose writings held a prominent position in the Second Council of Nicaea in 787: see Evans, H.C., 2004, p.459 and n.83 (on p.605).

[14] Acheimastou-Potamianou, 1987, p.36.

[15] Nelson, 1989, p.150.

[16] Parry, 1989, p.181.

[17] Liz James in Eastmond and James, 2003, p.67 and n.43.

[18] See, for example, the narrative on a miraculous icon of Saint Michael, whose owner managed to escape the temptations of the devil because she was aware of the true form of the Archangel and was thus able to see through the devil's disguise: Lucy-Anne Hunt in Eastmond and James, 2003, pp.205–32, especially 214–17.

[19] Maguire, 1996, pp.5–7. It should be noted that the term 'Byzantine' was introduced years after the fall of Constantinople in 1453. As the 2004 exhibition in the Metropolitan Museum in New York, *Byzantium: Faith and Power (1261–1557)*, explained, it was in 1557 that the German scholar Hieronymus Wolf applied the term Byzantium to the conquered state for the first time in history. By using a variant of Byzantion, the name of the ancient Greek city near the site of Constantinople, Wolf acknowledged and paid tribute to the Greek heritage of the empire. Nevertheless, the people who actually lived during this era and in its territories would have found this term incomprehensible and would not have responded to it. See Lowden, 1997, pp.5–6.

[20] See Eastmond and James, 2003, p.xxx.

[21] Belting, 1994, p.1.

[22] Acheimastou-Potamianou, 1987, p.38.

[23] John Osborne in Eastmond and James, 2003, p.145.

[24] Vassilaki, 2000, pp.340–1, no. 32. See also Kotoula, 2006.

[25] These figures have been interpreted as members of the brotherhood who maintained the cult of the *Virgin Hodegetria* in Constantinople, with their wings as a device to raise them and the feast to a 'heavenly' level: Vassilaki, 2000, p.340.

[26] On the images of the Virgin painted by Saint Luke, see Michele Bacci in Vassilaki, 2005, pp.321–36. See also Georgopoulou, 1995, p.487.

[27] Tsamakda, 2002, pp.93–4, Figure 117 (miniature 118, fol.50r).

[28] Kazhdan, *et al.*, 1991, vol.1, p.196.

[29] Cavarnos, 1993, p.42. Sarah and Anna can also be depicted in the sanctuary: Sarah as part of the iconographic subject of the *Hospitality of Abraham*, a scene usually placed in the sanctuary, and Anna as the mother of the Virgin, mainly in medallions usually placed to the left and right of the sanctuary apse. (Anna usually is paired with her husband Joachim, the father of the Virgin.)

[30] Demus, 1948, p.12.

[31] Otto Demus in his study on *Byzantine Mosaic Decoration* chose this architectural type with a central cupola as the one that offered the best 'frame' for the Byzantine iconographic programme: see ibid., p.11.

[32] The Ascension celebrates the ascent of Jesus into heaven, and it is commemorated every year on the Thursday that comes 40 days after Easter. The Pentecost celebrates the descent of the Holy Spirit upon the Apostles and is named after the Greek word for 'fiftieth', because it took place 50 days after Christ's Resurrection.

[33] This is the Byzantine iconographic type equivalent to the Resurrection, which, as we have seen in Ritzos' work (Plate 5.2), shows Christ in hell pulling Adam by the hand out of his grave, the symbolic representation of the promise of the resurrection of the dead.

[34] In the Greek Orthodox Church, this feast is called the Dormition of the Virgin rather than the Death of the Virgin or the Assumption of the Virgin.

[35] For the establishment of the feasts, see Walter, 1993, pp.219–24; Walter is of the opinion that the notion of the 12 feasts or festival cycle did not originate in Byzantine church decoration.

[36] When the barrel-vaulted roof of the church is supported by transverse arches, then prophets could actually form part of the second zone. This allows their placement on the same level or even in the vicinity of the scenes to which they are connected; for example, King Solomon and David could be depicted close to the *Harrowing of Hell* scene, where they also have a place, while this arrangement could place Daniel, who is associated with the Incarnation, on the same level with the Annunciation and the Nativity.

[37] On the use of light and colour in Byzantine art, see James, 1996.

[38] For the templon see Epstein, 1981; Walter, 1993; Evans, H.C., 2004, pp.143–4, 645. See also Spieser, 1999. For the role of the *proskynetaria* icons in the development of the iconostasis, see Slobodan Ćurčić in Lidov, 2000, pp.134–60.

[39] Chatzidakis, M., 1986; Chatzidakis and Drakopoulou, 1997, pp.381–97.

[40] The type of the Virgin of the Passion depicts a half-length Virgin holding the Christ Child, who turns his head upwards in the direction of one of the two angels at the top right and left of the icon. These two angels hold the instruments of Christ's future Passion – hence the naming of the type. For the type, see the second volume of this series (Richardson, 2007, ch.5, pp.203–4).

[41] For a reproduction, see ibid., Plate 5.27.

[42] For a reproduction, see ibid., Plate 5.17. The representation of the Baptist with wings is based on the Gospels (Matthew 11:10; Mark 1:2), where Christ calls John 'messenger' (in Greek ἄγγελος, angel).

[43] Occasionally, the epistyle beam, when placed before the entrance to a chapel dedicated to a particular saint, can be decorated with scenes from the life of that saint: see Walter, 1993, p.215 and n.50. See also Spieser, 1999.

[44] This is a very interesting beam, belonging to a group of works that have come to be known as 'Crusader art'. It has been suggested, though not without objections, that it was made by a western artist, a Venetian to be more specific, who was apparently active in the eastern Mediterranean sometime in the thirteenth century, even possibly for a Latin-rite rather than an Orthodox church – although the use and adaptation of the Byzantine

templon within Latin-rite churches opens a different can of worms. For a detailed discussion see Barbara Zeitler in Lidov, 2000, pp.223–42.

[45] The Myrrh-bearers came to Christ's tomb to anoint his body with myrrh (as mentioned in the Gospels of Mark and Luke, hence the name), only to find it empty, and were informed by an angel that Christ had risen (Matthew 28:1–8; Mark 16:1–8; Luke 24:1–10; John 20:1–18).

[46] These are the words with which Christ addressed Mary Magdalene when he appeared to her (John 20:17).

[47] The frame of this particular icon is considered a later addition to the panel.

[48] Parry, 1989, p.181; Constantoudaki-Kitromilides, 1986, pp.253–4. During the sixteenth century the existence of private collections that included icons regarded by their owners as works of art for their own sake is documented. The appreciation of Byzantine miniature mosaics in the West is noted slightly earlier, by the late fifteenth century; I would like to thank Dr Rembrandt Duits for this information. See also Lymberopoulou 2007.

[49] Gerola, 1905–17, vol.2, p.312.

[50] Evans, H.C., 2004, p.152.

[51] For examples, see Tempestini, 1992, pp.61, 73; Goffen and Nepi Scirè, 2000, pp.37, 51, 59. The Virgin and Child against a gold background, which also seems to be the case in the Ursula painting, is a typical 'setting' in Byzantine art.

[52] Acheimastou-Potamianou, 1987, p.51.

[53] Constantoudaki, 1975, p.75 and n.305; Constantoudaki-Kitromilides, 1986, p.254.

[54] Cattapan, 1972, pp.211–13 (nos 6–8), 214–15. These contracts form part of Mario Cattapan's research in the Archivio di Stato di Venezia; they were found in the *Notai di Candia*, *busta* 31 (fol.191v). An English translation is available in Richardson, Woods and Franklin, 2007, 3.5.3.

[55] Cattapan, 1972, p.206, no. 73; Constantoudaki, 1973, p.317, no. 17; Chatzidakis and Drakopoulou, 1997, p.452.

[56] Cattapan, 1972, p.208, no. 117; Constantoudaki, 1973, pp.305–7, no. 6; Chatzidakis, M., 1987, pp.232–3.

[57] For bezzi, a billon (mixture of silver and copper) German coin, see Mueller, 1997, p.234. Apart from bezzi, marcelli – Venetian silver pieces of one-half lira – and hyperpyra – the Byzantine coin – are also mentioned as forms of payment in the contracts. For marcelli and lira, see ibid., pp.235, 703 and pp.610–25 respectively; for hyperpyra, see n.60 below. See also Rembrandt Duits's appendix in this volume (ch.1).

[58] I would like to thank Dr Rembrandt Duits for his assistance with this point.

[59] Cattapan, 1972, p.208, no. 128.

[60] The Byzantine currency, literally meaning 'highly refined', is spelled yperperi in the document. Hyperpyron (singular)/hyperpyra (plural) is the standardised spelling for modern scholarly usage. By the late fifteenth century (when the empire no longer existed), this monetary system, having ceased to be struck in gold by the fourteenth century, was a mere shadow of its former value; the contract informs us that, at the time, 117 hyperpyra equalled only 14 gold ducats. The devaluation of the hyperpyron is striking when we take into consideration that just over 100 years earlier, in 1395, 2 hyperpyra equalled 1 ducat: see Gasparis, 1989, p.87, n.2.

[61] Chatzidakis, M., 1977, p.688.

[62] For the painter and the type, see the second volume of this series (Richardson, 2007, ch.5, p.208). See also Lymberopoulou, 2003.

[63] See the second volume of this series (Richardson, 2007, ch.5, p.181) and Richardson, Woods and Franklin, 2007, 2.5.7.

[64] Chatzidakis, M., 1987, p.233; Chatzidakis and Drakopoulou, 1997, p.452.

[65] Constantoudaki, 1973, pp.360 (A), 367–68 (H). An English translation of the contracts published by Constantoudaki for arrangements between painters is available in Richardson, Woods and Franklin, 2007, 3.5.4–5.

[66] Constantoudaki, 1973, p.317, no. 17; Chatzidakis and Drakopoulou, 1997, p.452. The possibility that these houses were part of their inheritance – for example, her dowry – cannot be excluded.

[67] See, for example, Baltoyanni, 1994, pp.287–8, no. 74; p.288, no. 75; pp.290–1, no. 77. See also Plates 5.20–5.22 of this chapter.

[68] See the second volume of this series (Richardson, 2007, ch.5, pp.176–7).

[69] Constantoudaki-Kitromilides, 2002, p.571 and n.9.

[70] Chatzidakis, N.M., 1993, p.1.

[71] Constantoudaki, 1973, pp.295–359.

[72] An English translation of such commissions is available in Richardson, Woods and Franklin, 2007, 3.5.6.

[73] See the second volume of this series (Richardson, 2007, ch.5, p.208).

[74] See ibid., p.197.

[75] Vassilaki, 1990, pp.408–9, 417–19; Georgopoulou, 1995, pp.484–5.

[76] Georgopoulou, 1995, pp.484–5. See also the second volume of this series (Richardson, 2007, ch.5, p.196).

[77] Acheimastou-Potamianou, 1987, pp.176–7; Evans, H.C., 2004, pp.172–4, no. 94.

[78] For Saint Sebastian see Chapter 6, pp.223–4; for Saint Lawrence see Wimmer and Melzer, 1988, p.508.

[79] Chatzidakis, N.M., 1993, p.130.

[80] Ibid., p.128.

[81] Baltoyanni, 1994, p.290.

[82] See the second volume of this series (Richardson, 2007, ch.5, p.177).

[83] See Chatzidakis, N.M., 1993, p.40; M. Bianco Fiorin, who wrote the entry, is of the opinion that the icon came from the Adriatic and Ionian coasts rather than from Crete. In my opinion, this icon may well be Cretan. Whether or not we accept Bianco Fiorin's opinion,

however, it should be remembered that the Adriatic and Ionian coasts are an important part of the Greek–Venetian cultural sphere.

84 Chatzidakis and Drakopoulou, 1997, p.289. Although his origins are unknown, in the bibliography so far, it is implied that the painter came from Crete and probably Candia. See also Chatzidakis, N.M., 1993, pp.140, 144; Constantoudaki-Kitromilides, 1999, pp.1208–17; Constantoudaki-Kitromilides, 2002, p.573.

85 On the representation of camels, see also Paul Wood's chapter in the second volume of this series (Richardson, 2007).

86 See the second volume of this series (Richardson, 2007, ch.5, p.208).

87 Acheimastou-Potamianou, 1987, p.181.

88 For examples see Tempestini, 1992, pp.53, 113, 141, 145, 163, 283; Goffen and Nepi Scirè, 2000, pp.84–5, 117. On Bellini's popularity on Crete, see the second volume of this series (Richardson, 2007, ch.5, pp.205–6).

89 For Damaskinos see Chatzidakis, M., 1987, pp.241–54. See also Constantoudaki-Kitromilides, 2000.

90 This work has been used as a rule of thumb for the attribution of the work depicting Saints Peter, Francis and Dominic (Plate 5.26) to the Venetian-based Greek painter. For landscape examples by Bellini, see n.88 above; for Cima da Conegliano, see Humfrey, 1983, Plates 30, 62, 126.

91 Folda, 2002, p.127, who quotes Belting, 1994, p.374.

92 For examples, see Vassilaki, 2000, pp.29, 64, 93, 99, 99, 100, 106, 108, 109, 126, 127, 144, 168, 206, 247, 263, 303, 315, 343, 368, 381, 405, 433.

93 Duits, 2001, pp.234–42.

94 Chatzidakis, N.M., 1993, pp.134–6.

95 Ibid., p.136. Two icons by Permeniates, the *Virgin Hodegetria* and *Christ*, are kept in the Byzantine Museum in Kastoria: see Constantoudaki-Kitromilides, 2002, p.575, Figures 4a, 4b.

96 Evans, H.C., 2004, p.494.

97 See, for example, the works by Andreas Pavias and Andreas Ritzos in the second volume of this series (Richardson, 2007, ch.5, Plates 5.24 and 5.27).

98 See ibid., Chapter 4.

99 'Quasi alterum Byzantium', as Bessarion, a Greek scholar and theologian (*c.*1399/1400–1472) living in Italy, wrote to the doge in 1468: see Gouma Peterson, 1968, p.62; Evans, H.C., 2004, p.494. For Bessarion see Kazhdan, *et al.*, 1991, vol.1, p.285.

100 Constantoudaki, 1975, p.43 and n.23.

101 Chatzidakis, M., 1974b, p.117, rejects the existence of an 'Italo-Greek school of Venice'. See also Chatzidakis, M., 1974a, p.207.

102 Post-Byzantium, 2003, p.xiii.

103 It should be noted here that the supporting angels in Crivelli's work do not derive from Byzantine art. It is generally accepted that they first appear in a relief by Donatello: see Pope-Hennessy, 1993a, p.234, Figure 230.

104 See Plates 5.29 and 5.30 in the second volume of this series (Richardson, 2007, ch.5).

105 In the eyes of the Greek Orthodox faithful, the portraits of Catholic saints such as Francis and Dominic, who are not part of the Byzantine tradition and Greek Orthodox faith but are encountered, as we have seen, in many hybrid, post-Byzantine icons, also went back to a real-life portrait.

106 See Plate 5.17 in the second volume of this series (Richardson, 2007, ch.5).

107 See ibid., Plate 5.28.

108 See the first volume of this series (Woods, 2007, ch.7, pp.257–8).

109 See Chapter 6 in the second volume of this series (Richardson, 2007). An English text is available in Richardson, Woods and Franklin, 2007, 3.5.7.

110 Robert Maniura in Eastmond and James, 2003, p.99. See Plate 1.13 in the first volume of this series (Woods, 2007, ch.1).

111 Evans, H.C., 2004, pp.545–55.

Chapter 6

1 Piccolomini, 1936, p.9.

2 For a description and discussion of purgatory in the fifteenth century, particularly in England, see Duffy, 1992, pp.338–76.

3 This was what Matteo Palmieri did, for example, when he donated his clothes to the community of Benedictine nuns based at the church of San Pier Maggiore in Florence. His gift included Botticini's *Assumption of the Virgin* (1474–6), now in the National Gallery, London. See Bagemihl, 1996.

4 Duffy, 1992, p.330.

5 Johnson, 2000, pp.108–12.

6 Panofsky, 1992, p.67.

7 Duffy, 1992, p.330.

8 Ibid., p.302.

9 Quoted in Goodall, 2001, p.1.

10 Ibid.

11 Rosenthal, J.T., 1972, p.71.

12 See Goodall 2001, pp.223–55 for the statutes.

13 Binski, 2003, p.438.

14 Cook, 1947, p.177; Goodall, 2001, p.11.

15 *Guide to St Mary's Church, Ewelme*, 1967, p.13.

16 Alabaster is quite soft and therefore easy to carve into elaborate details and paint or gild, but it also breaks and marks easily so many such effigies have been lost or damaged. In England it was most commonly worked near to where it was mined, for example in the Midlands at quarries in Derbyshire and Nottinghamshire, although Alice's effigy was probably made in London, where some of the best workshops were based. See Gardner, 1940, pp.1–5.

17 Quoted and translated in Goodall, 2001, p.181.

18 Marks and Williamson, 2003, p.442.

19 Cohen, 1973, pp.21, 181.

20 King, P.M., 1984, p.45; King, P.M., 1990, pp.26–38.

21 King, P.M., 1984, p.47; Marks and Williamson, 2003, pp.206, 442.

22 On the tomb, see Goodall, 2001, pp.175–93.

23 Ibid., p.205.

24 Cust, 1898.

25 Clark, 1950; Mâle, 1986; Duffy, 1992, p.304.

26 Rouse, 1987, p.5.

27 Meadow, 1992, p.199.

28 Geiler von Kaisersperg's *Sermones: De arbore humana*, printed by Johann Gruninger, Strasburg, 1514.

29 Harrison, 1994, pp.25–9.

30 Bibliothèque nationale, MS fr. 995, fol.25v, quoted and translated in Harrison, 1994, p.54.

31 Ibid., fol.28r, quoted and translated ibid., p.64.

32 Ibid., fol.43v, quoted and translated ibid., p.128.

33 McDonald, 2004, vol.2, pp.199, 228. For a possible identification of the Master IAM of Zwolle, see Dubbe, 1970.

34 'Qui me concernent, quid erint videant mala spernent.'

35 See Meadow, 1992, for Dürer's *Promenade*.

36 Panofsky, 1955, p.151.

37 II Corinthians 10:3; Ephesians 6:10–17; Panofsky, 1955, p.152.

38 Anzelewsky, 1980, p.174; Bartrum, 2002, pp.186–7.

39 De Vos, 1999, pp.259–62.

40 Hayum, 1989, p.28.

41 Studies in English are rare. The best and most thorough is Hayum, 1989. The Antonite Order was founded in 1095 near Lyons and dedicated to Anthony Abbot, whose remains were transferred from Constantinople to France around 1070.

42 Hayum, 1989, pp.14–16.

43 Quoted ibid., p.21.

44 Huizinga, 1965, p.134, discussed in Duffy, 1992, p.301; Burke, P., 1984, p.59.

45 Lightbown, 1986, p.423.

46 Ibid., p.421.

47 On the commission and Mino da Fiesole's workshops in Florence and in Rome, see Zuraw, 2004.

48 For a summary of Forteguerri's career, see Butterfield, 1997, p.137.

49 Zuraw, 1998, p.462.

50 Zuraw, 2004, pp.78–9.

51 Zuraw, 1998, p.459.

52 Zuraw, 2004, p.85.

53 Butterfield, 1994, p.61.

54 On the Forteguerri monument in Pistoia Cathedral, see Butterfield, 1997, pp.137–57 and 223–8 (cat. 21 and 22). Wilder, Kennedy and Bacci, 1932, reproduce most of the original documents.

55 Butterfield, 1997, p.137.

56 Ibid.

57 Ibid., pp.224–5; Wright 2005, pp.312–13.

58 See Mancusi Ungaro, 1971, for the details of the Piccolomini altar; Richardson, 1998, pp.203–4.

59 The inscription reads: 'FRAN.CAR.SENEN.HOC. SEPULCHRUM.SIBI.VIVEN.PONI.CURAVIT'.

60 See Chapter 7 in the second volume of this series (Richardson, 2007).

61 Condivi, 1987, pp.26–7.

62 Hall, 2005, p.114; Kempers, 2000, p.40.

63 Vasari, 1996, vol.2, p.659.

64 Gill, M.J., 2005, p.91; Wright, 2005, pp.374–6.

65 Wright, 2005, p.360.

66 Ibid., pp.155, 374; Richardson, 2007, ch.1.

67 Wright, 2005, p.261.

68 Ibid., p.359.

69 Ibid., pp.361, 386–7.

70 Huntley, 1935, pp.57–64; Riegel, 1995, pp.201–8, 212–14.

71 Panofsky, 1992, pp.76–87.

72 Bustamante García, 2005.

73 Will of Isabella in Dormer, 1683, pp.323–4.

74 Wethey, 1936, p.16.

75 Ibid., p.4.

76 Diaz, 1968.

77 Isabella's will and appendices are in Dormer, 1683, pp.316–93. See pp.316–17 for the details of her tomb. Ferdinand's will is given on pp.393–472. His tomb is described on pp.397–400.

78 Liss, 1992, p.136.

79 In 1512 Fancelli wrote his will as he was about to make the journey to Spain; the will is in Andrei, 1871, pp.38–46.

80 Lenaghan, 1998, p.21.

81 Ibid., pp.19–20.

82 Roberts, A.M., 1989, pp.379–89.

83 Ibid., pp.392–5.

84 Morganstern, 2000, pp.81–4 and n.11.

85 See Egg, 1974; Oettinger, 1965.

86 Chipps Smith, 1994, pp.187, 192.

87 Silver, 1985, pp.7–21.

88 Quoted in Chipps Smith, 1994, p.127, from Appelbaum, 1964, p.v. See also Schultz, 1888, p.66, lines 33–6.

89 Bartrum, 2002, pp.194–7; Anzelewsky, 1980, pp.168–72.

90 Dürer's coloured drawing, *The Large Triumphal Chariot* (1518), is at the Albertina, Vienna. See Applebaum, 1964, for the whole project.

91 Silver 1985, p.18: the saints are Maximilian, Andrew (patron saint of Burgundy and the Order of the Golden Fleece), the Austrian Leopold, and three military saints

– George who was patron of the emperor's Order of Saint George, Sebastian patron of archers, and Barbara patron of artillery.

[92] Schmid, 1984, pp.757–9.

[93] Ibid., pp.765–6.

[94] Luther, *On the Misuse of the Mass*, 1521, quoted in Koslofsky, 2000, p.35.

[95] Koslofsky, 2000, p.36.

[96] John Frith, *Disputation of Purgatory*, 1531, quoted in Koslofsky, 2000, p.34. Frith was an associate of William Tyndale, who translated the Bible into English. Frith had fled to Antwerp from England in 1528 because of his support for Luther's Reformation; see Marshall, 2002, pp.48–51.

Chapter 7

[1] Gordon, 2002, p.39.

[2] All of the surviving panels from the altarpiece are in the Kunstmuseum in Basle except for Solomon and Sheba (Gemäldegalerie, Berlin) and Augustus and the Tiburtine sibyl and Saint Bartholomew (Musée des Beaux Arts, Dijon).

[3] The incident is repeated in 1 Chronicles 11:17–25. Sabothai is not named in either of these passages.

[4] Châtelet, 1987; document published in Roth, 1933–8, vol.3, pp.127–8.

[5] Gordon, 2002, pp.33, 35.

[6] 'Dis ist die engelwichi zu unser lieben frouwen zu den einsidlen ave gr[a]cia plenna.'

[7] Koerner, 2004, pp.146–7.

[8] The wooden statue of the Virgin in the monastery today is fifteenth century and far too late to have belonged to Saint Meinrad, however.

[9] Erasmus's 1526 colloquy, 'A pilgrimage for religion's sake', is in Erasmus, 1965, pp.287–91.

[10] See Eisler, 1970, and Richardson, Woods and Franklin (1.6.4).

[11] For an up-to-date English translation, see Voragine, 1993.

[12] Verdi, 2003, cat.216, p.271.

[13] Baxandall, 1980, p.292.

[14] See Richardson, Woods and Franklin, 2007, 3.7.5; for Karlstadt, see 3.7.1.

[15] For John of Damascus, see ibid. (3.5.1). See also Chapter 5.

[16] Lindberg, 2000, p.57.

[17] Garside, 1966, ch.8.

[18] For an account of events in Basle, see Eire, 1986, p.115, and Wandel, 1995, pp.152–89.

[19] See Müller, C., 1991, and Bätschmann and Griener, 1997, pp.77–81.

[20] It is now generally agreed that the panels served as the outer shutters of a carved altarpiece commissioned for the cloister of Basle Cathedral, and that there were relief carvings rather than paintings on the inner faces. See Müller, C. *et al.*, 2006, cat.104, pp.324–7.

[21] See Saxl, 1970.

[22] Rümelin, 1998, and Parshall, 2001.

[23] This is the argument of Zemon Davis, 1956. The series was not published until 1538, but prints from it were evidently circulating before Lützelburger's death.

[24] Bätschmann and Griener, 1997, pp.115–16.

[25] Ibid., p.36, and Landau and Parshall, 1994, p.201.

[26] See Plates 1.2–1.3 in the first volume of this series (Woods, 2007, pp.32–3).

[27] In the early sixteenth century the Holy Roman Emperor was overlord of what is now Germany, Belgium, Spain, Switzerland, Austria and much of central Europe.

[28] Frequently translated as a 'sacred conversation', the name probably derives from the Latin *sacra conversatio*, meaning a holy company or gathering.

[29] It has also been suggested that he represents the youthful Saint James, patron saint of Jakob Meyer, but this seems very much less likely. See Buck and Sander, 2003, p.45.

[30] There are two versions of this painting, one commissioned 1483, now Louvre, Paris, and the other *c*.1508, National Gallery, London, and probably originally from Milan. See Dunkerton *et al.*, 1991, pp.382–5. Holbein certainly visited France and probably also Milan; see Bätschmann and Griener, 1997, appendix, doc.3, p.211.

[31] Buck and Sander, 2003, p.38.

[32] Ibid., p.54.

[33] Quoted in Bätschmann and Griener, 1997, pp.27–9, except for the second line, where they have 'the work of art represents *in* me'. While a more accurate rendering of the Latin original, this translation is ungrammatical in English.

[34] Strauss, 1973, Plate 88, pp.186–7.

[35] Rowlands, 1985, Plates 19–24, pp.127–9.

[36] Müller, C., 2001, and Jenny, 2001.

[37] Rowlands, 1985, p.18.

[38] Winner, 2001, p.155.

[39] According to one source, a version of this portrait was sent to Erasmus by way of exchange for the portrait sent to him; see Rowlands, 1985, p.134.

[40] Ibid. See also the first volume of this series (Woods, 2007, ch.4) for a discussion of Cesariano's edition.

[41] Translation taken from Bätschmann and Griener, 1997, p.30.

[42] Translation taken from Roberts, J., 1979, p.5.

[43] Baxandall, 1980, p.75.

[44] See Plate 3.27 in the first volume of this series (Woods, 2007, p.133) for another likeness of the duke.

[45] Müller, T., 1966, Plate 137. See also Plate 3.30 in the first volume of this series (Woods, 2007, p.136).

46 For the history and analysis of the Eton paintings, see Martindale, 1995, and Gill, M., 2003.

47 Voragine, 1993, vol.2, p.155.

48 Foister, 2004, p.114.

49 For a full consideration of this statue, see Woods, 2006. For a seminal article written after the discovery of the statue in 1954, see Evans and Cook, 1955.

50 It is even possible that Holbein could indirectly have heard about this image, for Erasmus was in England around the time that it was probably carved, and certainly had contacts with Saint Thomas of Acon, not least through his friend Sir Thomas More, a member of the Mercers' Company, who also leased his house from the Mercers. Erasmus, it should be remembered, was also a great friend of Bonifacius Amerbach.

51 Lindley, 2003, takes the view that it is largely Continental, while Dow, 1992, sees the craftsmanship as essentially English.

52 Colvin, 1963–82, vol.3, pt2, p.219.

53 Darr, 1982, pp.293–4.

54 For the documentation of the Horenbouts' careers in England, see Campbell and Foister, 1986.

55 Translation from Latin in Buck and Sander, 2003, p.19.

56 Bätschmann and Griener, 1997, p.164; Foister, 2004, p.248 translates the Latin phrase slightly differently: 'I seem to see you all before me as if you were in my presence.'

57 Foister, 2004, p.59.

58 Ibid., p.55.

59 See Ainsworth, 1990, pp.178–9.

60 Foister, 2004, pp.121–8.

61 Holbein's portrait of Hermann von Wedigh seems to have been sent home to Cologne almost at once; see Markow, 1978, p.40.

62 Ainsworth and Martens, 1994, cat.6, pp.96–101.

63 See Plate 2.12 in the second volume of this series (Richardson, 2007, p.79).

64 See Holman, T.S., 1979. The Venetian painter Lorenzo Lotto (1480–1556/7) also portrayed collector Andrea Odoni (Royal Collection), for example, in a setting that commented on his own preoccupations in 1527, but it is perhaps less certain that Holbein could have been familiar with his work.

65 Rowlands, 1985, p.137, and Holman, T.S., 1979, p.142.

66 Holman, T.S., 1979, p.142.

67 Ibid., p.143.

68 The first scene is to be found in the Old Testament Apocrypha in 1 Esdras 9:39–55, and it follows an incident of obvious relevance to Henry VIII: the priests putting away their foreign wives. In the second scene, while it was conventional to represent the Apostles with tongues of flame on their heads as here, the stress on the subsequent preaching is distinctly Protestant and contrasts with the usual iconography of the Pentecost.

69 Foister, 2004, p.179.

70 Rowlands, 1985, p.225.

71 Foister, 2004, p.196.

72 Translation taken from Buck and Sander, 2003, p.130.

73 Hacker and Kuhl, 1992.

74 See Ainsworth, 1990.

75 Susan Foister stresses this point; see Foister, 2004, ch.5, especially p.237.

76 Susan Foister views his eventual attendance at Protestant services as a Protestant conversion, and raises the possibility that Holbein was a go-between supplying Thomas Cromwell with Protestant literature (Foister, 2004).

Bibliography

Acheimastou-Potamianou, M. (ed.) (1987) *From Byzantium to El Greco: Greek Frescoes and Icons*, London, Royal Academy of Arts/Athens, Byzantine Museum of Athens (exhibition catalogue).

Acheiamstou-Potamianou, M. (1989–90) Μ. Αχειμάστου-Ποταμιάνου, 'Δὺο εικὸνες του Αγγὲλου και του Ανδρὲα Ρὶτζου στο Βυζαντινὸ Μουσεὶο', *Δελτὶον της Χριστιανικῆς Αρχαιολογικῆς Εταιρεὶας*, vol.15, ser.4, pp.105–18.

Acidini Luchinat, C. (ed.) (1997) *Tesori dalle collezioni medicee*, Florence, Octavo (exhibition catalogue).

Adhémar, J. (1974 and 1976) 'Les tombeaux de la Collection Gaignières: dessins d'archéologie du XVIIe siècle', *Gazette des beaux-arts*, 84, pp.1–192; 88, pp.3–67.

Adhémar, J. (1975) '"Une galerie de portraits italiens à Amboise en 1500", *Gazette des beaux-arts*, 86, pp.99–105.

Ainsworth, M. (1990) '"Paternes for phiosioneamyes": Holbein's portraiture reconsidered', *Burlington Magazine*, CXXXII, pp.173–86.

Ainsworth, M. (2004) '"À la façon grèce": the encounter of northern Renaissance artists with Byzantine icons', in H.C. Evans (ed.) *Byzantium: Faith and Power (1261–1577)*, New York, Metropolitan Museum of Art/New Haven and London, Yale University Press, pp.545–55 (exhibition catalogue).

Ainsworth, M.W. and Martens, M.P. (1994) *Petrus Christus: Renaissance Master of Bruges*, New York, Metropolitan Museum of Art (exhibition catalogue).

Alexander, J.J.G. (1970) 'A manuscript of Petrarch's *Rime* and *Trionfi*', *Victoria and Albert Museum Yearbook*, 2, pp.27–40.

Alexander, J.J.G. (ed.) (1994) *The Painted Page: Italian Renaissance Book Illumination 1450–1550*, London, Royal Academy of Arts/New York, The Pierpont Morgan Library (exhibition catalogue).

Alexander, J.J.G. and de la Mare, A.C. (1969) *The Italian Manuscripts in the Library of Major J.R. Abbey*, London, Faber.

Alexander, J.J.G., Marrow, J.H. and Sandler, L.F. (2005) *The Splendor of the World: Medieval and Renaissance Illuminated Manuscripts at the New York Public Library*, New York Public Library/London and Turnhout, Harvey Miller (exhibition catalogue).

Alighieri, D. (1939) *The Divine Comedy*, trans. J.D. Sinclair, 3 vols, Oxford and New York, Oxford University Press.

Alsop, J. (1982) *The Rare Art Traditions: The History of Art Collecting and Its Linked Phenomena Wherever These Have Appeared*, London, Thames & Hudson.

Ames-Lewis, F. (1984) *The Library and Manuscripts of Piero di Cosimo de' Medici*, New York, Garland.

Andrei, P. (1871) *Sopra Domenico Fancelli fiorentino e Bartolomeo Ordognes spagnolo: Memorie estratte da documenti*, Massa, C. Frediani.

Antonovics, A.V. (1995) '"Il semble que ce soit là un vrai Paradis terrestre": Charles VIII's conquest of Naples and the French Renaissance', in D. Abulafia (ed.) *The French Descent into Renaissance Italy 1494–95*, Aldershot, Ashgate.

Anzelewsky, F. (1980) *Dürer: His Art and Life*, London, Alpine Fine Arts Collection Ltd.

Appelbaum, S. (ed.) (1964) *The Triumph of Maximilian I*, New York, Dover.

Aristotle (2000) *Nicomachean Ethics*, trans. and ed. R. Crisp, Cambridge and New York, Cambridge University Press.

Asselberghs, J.P. (1972) *Les Tapisseries tournaisiennes de la Guerre de Troie*, Brussels, Musées Royaux d'Art et d'Histoire.

Avril, F. (1986) *Le Livre des tournois du roi René de la Bibliothèque nationale (ms. fr. 2695)*, Paris, Herscher.

Avril, F. (ed.) (2003) *Jean Fouquet: Peintre et enlumineur du XVe siècle*, Paris, Hazan/Bibliothèque nationale de France.

Avril, F., Malandin, G. and Lieutaghi, P. (1986) *Mattaeus Platéarius: Le livre des simples medicines, d'après le manuscrit français 12322 de la Bibliothèque nationale de Paris*, Paris, Éditions Ozalid et Textes Cardinaux/Bibliothèque nationale de France.

Avril, F. and Reynaud, N. (1995) *Les Manuscripts à peintures en France, 1440–1520*, rev. edn, Paris, Flammarion/Bibliothèque nationale de France.

Backhouse, J. (1983) 'French manuscript illumination, 1450–1530', in T. Kren (ed.) *Renaissance Painting in Manuscripts: Treasures from the British Library*, New York, Hudson Hills Press, pp.145–50 (exhibition catalogue).

Backhouse, J. and Giraud, Y. (1994) *Pierre Sala: Petit Livre d'Amour. Stowe MS 955, British Library, London, Kommentar, Commentaire, Commentary*, Lucerne, Faksimile Verlag.

Bagemihl, R. (1996) 'Francesco Botticini's Palmieri altarpiece', *Burlington Magazine*, CXXXVIII, pp.304–14.

Baldassarri, S.U. and and Saiber, A. (eds) (2000) *Images of Quattrocento Florence: Selected Writings in Literature, History, and Art*, New Haven and London, Yale University Press.

Baldwin, F.E. (1926) *Sumptuary Legislation and Personal Regulation in England*, Baltimore, Johns Hopkins University Studies in History and Political Science.

Baltoyanni, C. (1994) Χ. Μπαλτογιάννη, *Εἰκόνες Μῆτηρ Θεοὺ Βρεφοκρατοὺσα στην Ενσάρκωση και στο Πάθος*, Athens, Αδὰμ (Adam).

Bamforth, S. (1997) 'Architecture and sculpture at the Field of the Cloth of Gold (1520) and the Bastille Festival (1518)', in P. Lindley and T. Frangenberg (eds) *Secular Sculpture 1300–1550*, Stamford, Shaun Tyas.

Barber, R. (ed.) (1981) *The Pastons: A Family in the Wars of the Roses*, London, Folio Society.

Baron, F. (1996) *Sculpture française: 1, Moyen âge*, Paris, Réunion des Musées Nationaux.

Barstow, K.A. (1992) 'The library of Margaret of York and some related books', in T. Kren (ed.) *Margaret of York, Simon Marmion, and 'The Visions of Tondal'*, Malibu, J. Paul Getty Museum, pp.257–63.

Bartrum, G. (2002) *Albrecht Dürer and his Legacy*, London, British Museum.

Bätschmann, O. and Griener, P. (1997) *Hans Holbein*, London, Reaktion Books.

Bauer, R. *et al.* (1987) *Kunsthistorisches Museum Wien: Weltliche und Geistliche Schatzkammer. Bildführer*, Salzburg and Vienna, Residenz Verlag.

Baxandall, M. (1972) *Painting and Experience in Fifteenth Century Italy*, Oxford, Clarendon Press.

Baxandall, M. (1980) *The Limewood Sculptors of Renaissance Germany*, New Haven and London, Yale University Press.

Beaulieu, M. (1966) 'Note sur la chapelle funéraire de Philippe de Commines au Couvent des Grands Augustins de Paris', *Revue du Louvre et des Musées de France*, 16, pp.65–75.

Belozerskaya, M. (2002) *Rethinking the Renaissance: Burgundian Arts across Europe*, Cambridge, Cambridge University Press.

Belting, H. (1994) *Likeness and Presence: A History of the Image before the Era of Art*, trans. E. Jephcott, Chicago and London, University of Chicago Press.

Beltran, E. (1986) 'L'humaniste Guillaume Tardif', *Bibliothèque d'Humanisme et Renaissance*, 48, pp.7–39.

Binski, P. (2003) 'The art of death', in R. Marks and P. Williamson (eds) *Gothic: Art for England 1400–1547*, London, V & A Publications, pp.436–55.

Blair, C. (1958) *European Armour, circa 1066 to circa 1700*, London, Batsford.

Blake McHam, S. (2001) 'Donatello's bronze David and Judith as metaphors of Medici rule in Florence', *The Art Bulletin,* 83, pp.32–47.

Blanquart, F. (1898) 'Le chapelle de Gaillon et les fresques d'Andrea Solario', *Société des Amis des Arts du Département de l'Eure*, 14, pp.28–53.

Bloch, D. (1989) 'La formation de la Bibliothèque du Roi', in A. Vernet (ed.) *Histoire des bibliothèques françaises*, vol.1: *Les Bibliothèques médiévales du VIe siècle à 1530*, Paris, Promodis, pp.311–31.

Block, E.C. (2003) *Corpus of Medieval Misericords in France, XIII–XVI Century*, Turnhout, Brepols.

Blockmans, W. (1992) 'The devotion of a lonely duchess', in T. Kren (ed.) *Margaret of York, Simon Marmion, and 'The Visions of Tondal'*, Malibu, J. Paul Getty Museum, pp.29–46.

Bober, P.P. (1957) *Drawings after the Antique: Sketchbooks in the British Museum*, London, Warburg Institute.

Bober, P.P. and Rubinstein, R. (1986) *Renaissance Artists and Antique Sculpture: A Handbook of Sources*, London, Harvey Miller/Oxford, Oxford University Press.

Bohat-Regond, A. (1979) 'Les peintures murales de la Renaissance au château de Busset (Allier)', *Bibliothèque d'Humanisme et Renaissance*, 41, pp.245–53.

Bombe, W. (1912) *Geschichte der Peruginer Malerei bis zu Perugino und Pinturicchio auf Grund des Nachlasses Adamo Rossis und eigener archivalischer Forschungen*, Berlin, Bruno Cassirer.

Borsook, E. and Offerhaus, J. (1981) *Francesco Sassetti and Ghirlandaio at Santa Trinita, Florence: History and Legend in a Renaissance Chapel*, Doornspijk, Davaco.

Bos, A. (2003) *Les Églises flamboyantes de Paris XVe–XVIe siècles*, Paris, Picard.

Brandi, K. (1965) *The Emperor Charles V: The Growth and Destiny of a Man and of a World Empire*, London, Jonathan Cape.

Bredekamp, H. (2000) *Sankt Peter in Rom und das Prinzip der produktiven Zerstörung: Bau und Abbau von Bramante bis Bernini*, Berlin, Wagenbach.

Breuil, A. and Rigollot, M.J. (1858) 'Les oeuvres d'art de la Confrérie Notre-Dame-du-Puy d'Amiens', *Mémoire de la Société des antiquaires de Picardie*, 5:2, pp.485–662.

Brewer, J.S., Gairdner, J. and Brodie, R.H. (eds) (1862–1932) *Letters and Papers, Foreign and Domestic, of the Reign of Henry VIII, 1509–1547*, 21 vols, London, Longman.

Bricard, G. (1893) *Jean Bourré, seigneur Du Plessis, 1424–1506: Un serviteur et compère de Louis XI*, Paris, A. Picard et fils.

Bridge, J.S.C. (1924) *A History of France from the Death of Louis XI*, vol.2: *The Reign of Charles VIII, 1493–1498*, Oxford, Clarendon Press.

Brieger, P., Meiss, M. and Singleton, C.S. (1969) *Illuminated Manuscripts of the Divine Comedy*, Princeton, Princeton University Press.

Brion-Guerry, L. (1962) *Jean Pélerin Viator: Sa place dans l'histoire de la perspective*, Paris, Les Belles Lettres.

Brown, C.M. (1981) 'Una imagine de Nostra Donna: Lorenzo Costa's Holy Family for Anne of Brittany', in *Cultura figurative ferrarese tra XVe e XVIe secolo: In memoria di Giacomo Bargellesi*, vol.1, Venice, Corbo e Fiore.

Brown, M.P. (1990) *A Guide to Western Historical Scripts from Antiquity to 1600*, London, British Library.

Brubaker, L. and Haldon, J. (2001) *Byzantium in the Iconoclast Era (ca. 680–850): The Sources, an Annotated Survey*, Birmingham Byzantine and Ottoman Monographs 7, Aldershot, Ashgate.

Brucker, G.A. (1969) *Renaissance Florence*, Berkeley, University of California Press.

Bruyn, J. (1963) 'The Master of Moulins and Hugo van der Goes', *Burlington Magazine*, CV, pp.370–1.

Buck, S. and Sander, J. (2003) *Hans Holbein the Younger: Painter at the Court of Henry VIII*, London, Thames & Hudson (exhibition catalogue).

Burke, J. (2004) *Changing Patrons: Social Identity and the Visual Arts in Renaissance Florence*, University Park, Pennsylvania State University Press.

Burke, J. (2006) 'Visualising neighbourhood in Renaissance Florence: Santo Spirito and Santa Maria del Carmine', *Journal of Urban History*, 32, pp.693–710.

Burke, P. (1984) 'Death in the Renaissance, 1347–1656', in J.H.M. Taylor (ed.) *Dies Illa: Death in the Middle Ages*, Proceedings of the 1983 Manchester Colloquium, Liverpool, Cairns, pp.59–66.

Bustamante García, A. (2005) 'Aragon, House of', Grove Art Online, Oxford University Press, http://www.groveart.com [accessed 28 April 2005].

Butterfield, A. (1994) 'Social structure and the typology of funerary monuments in early Renaissance Florence', *Res*, 26, pp.47–67.

Butterfield, A. (1997) *The Sculptures of Andrea del Verrocchio*, New Haven and London, Yale University Press.

Cadogan, J. (2000) *Domenico Ghirlandaio: Artist and Artisan*, New Haven and London, Yale University Press.

Caffin de Mérouville, M. (1960) 'À la recherche de tombeaux perdus', *Gazette des beaux-arts*, 56, pp.185–94.

Caglioti, F. (2000) *Donatello e i Medici: Storia del David e della Giuditta*, 2 vols, Florence, Olschki.

Callisen, S.A. (1936) 'A bust of a prelate in the Metropolitan Museum, New York', *The Art Bulletin*, 18, pp.401–6.

Cambi, G. (1785) *Istorie* (4 vols), in I. di San Luigi (ed.) *Delizie degli eruditi toscani*, vols 20–3, Florence, Gaetano Cambiagi.

Camesasca, E. (ed.) (1994) *Raffaello: Gli scritti: Lettere, firme, sonetti, saggi tecnici e teoretici*, Milan, Rizzoli.

Camp, P. (1990) *Les Imageurs bourguignons de la fin du Moyen Age*, Dijon, Les Cahiers du Vieux-Dijon.

Campbell, L. and Foister, S. (1986) 'Gerard, Lucas and Susanna Horenbout', *Burlington Magazine*, CXXVIII, pp.709–27.

Campbell, S.J. (2004) '"Our eagles always held fast to your lilies": the Este, the Medici, and the negotiation of cultural identity', in S.J. Campbell and S. Milner (eds) *Artistic Exchange and Cultural Translation in the Italian Renaissance City*, Cambridge and New York, Cambridge University Press, pp.138–61.

Campbell, T.P. (ed.) (2002) *Tapestry in the Renaissance: Art and Magnificence*, New York, Metropolitan Museum of Art.

Camus, J. (1894), 'Les noms des plantes du livre d'heures d'Anne de Bretagne', *Journal de botanique*, 8, pp.325–35, 345–52, 366–75, 396–401.

Cassarino, E. (1996) *La cappella Sassetti nella chiesa di Santa Trinita*, Lucca, Maria Pacini Fazzi.

Castiglione, B. (1967) *The Book of the Courtier*, trans. G. Bull, Harmondsworth, Penguin.

Cattapan, M. (1972) 'Nuovi elenchi e documenti dei pittori in Creta dal 1300 al 1500', Θησαυρίσματα, 9, pp.202–35.

Cavallo, A.S. (1993) *Medieval Tapestries in the Metropolitan Museum of Art*, New York, Metropolitan Museum of Art.

Cavarnos, C. (1993) *Guide to Byzantine Iconography*, Boston, MA, Holy Transfiguration Monastery.

Cecchetti, D. (1980) '"Florescere–Deflorescere": in margine ad alcuni temi del primo Umanesimo francese', in *Mélanges à la mémoire de Franco Simone: France et Italie dans la culture européenne*, Geneva, Slatkine, pp.143–55.

Cerretani, B. (1993) *Ricordi*, ed. G. Berti, Florence, Olschki.

Chambers, D.S. (1970) *Patrons and Artists in the Italian Renaissance*, London, Macmillan.

Chambers, D.S. (1992) *A Renaissance Cardinal and his Worldly Goods: The Will and Inventory of Francesco Gonzaga (1444–1483)*, Warburg Institute Surveys and Texts, 20, London, Warburg Institute, University of London.

Chastellain, G. (1863–6) *Oeuvres de Georges Chastellain*, ed. J.M.B. Constantin, baron Kervyn de Lettenhove, 8 vols, Brussels, F. Heussner.

Châtelet, A. (1987) 'Le retable du miroir du salut: quelques remarques sur sa composition', *Zeitschrift für Schweizische Archäologie und Kunstgeschichte*, 44:2, pp.105–16.

Châtelet, A. (2001) *Jean Prévost: Le Maître de Moulins*, Paris, Gallimard.

Chatzidakis, M. (1974a) 'Les débuts de l'école crétoise et la question de l'école dite italogrecque', in Μνημόσυνον Σ. Αντωνιάδη, Βιβλιοθήκη του Ελληνικού Ινστιτούτου Βενετίας Βυζαντινών και Μεταβυζαντινών Σπουδών 6, Venice, pp.169–211.

Chatzidakis, M. (1974b) 'Essai sur l'école dite "italogreque" précédé d'une note sur les rapports de l'art vénitien avec l'art crétois jusqu'à 1500', in A. Pertusi (ed.) *Venezia e il Levante fino al Secolo XV: Atti del Convegno Internazionale di Storia della Civiltà Veneziana Promosso e Organizzato dalla Fondazione Giorgio Cini (Venezia 1–5 giugno 1968)*, vol.2, Civiltà Veneziana Studi 27, Florence, Leo S. Olschki Editore, pp.69–124.

Chatzidakis, M. (1977) 'La peinture des "Madonneri" ou "vénéto-crétoise" et sa destination', in H.G. Beck, M. Manoussacas and A. Pertusi (eds) *Venezia Centro di Mediazione tra Oriente e Occidente (Secoli XV–XVI): Aspetti e Problemi*, Civiltà Veneziana Studi 32, Florence, Leo S. Olschki, pp.673–90.

Chatzidakis, M. (1986) *The Cretan Painter Theophanis: The Final Phase of his Art in the Wall-Paintings of the Holy Monastery of Stavronikita*, Mount Athos, Holy Monastery of Satvronikita.

Chatzidakis, M. (1987) M. Χατζηδάκης, Ἕλληνες Ζωγράφοι μετὰ τὴν Ἅλωση (1450–1830). Μὲ Εἰσαγωγὴ στὴν Ἱστορία τῆς Ζωγραφικῆς τῆς Ἐποχῆς, 1, Κέντρο Νεοελληνικῶν Ἐρευνῶν E.I.E. 33, Athens.

Chatzidakis, M. and Drakopoulou, E. (1997) M. Χατζηδάκης, Ε. Δρακοπούλου, Ἕλληνες Ζωγράφοι μετὰ τὴν Ἅλωση (1450–1830). Μὲ Εἰσαγωγὴ στὴν Ἱστορία τῆς Ζωγραφικῆς τῆς Ἐποχῆς, 1, Κέντρο Νεοελληνικῶν Ἐρευνῶν E.I.E. 62, Athens.

Chatzidakis, N.M. (1993) *From Candia to Venice: Greek Icons in Italy, 15th–16th Centuries. Museo Correr, Venice 17 September – 30 October 1993*, Athens, Foundation for Hellenic Culture (exhibition catalogue).

Chipps Smith, J. (1994) *German Sculpture of the Later Renaissance c.1520–1580: Art in an Age of Uncertainty*, Princeton, Princeton University Press.

Chirol, E. (1952) *Un premier foyer de la Renaissance en France: Le château de Gaillon*, Rouen, M. Lecerf.

Chirol, E. (1959) 'L'influence de Mantegna sur la Renaissance en Normandie', *Actes du XIXe Congrès International d'Histoire de l'Art*, 8–13 September 1958, Paris, pp.240–7.

Clark, J.M. (1950) *The Dance of Death in the Middle Ages and Renaissance*, Glasgow, Jackson Son & Co.

Clayton, M. (1999) *Raphael and his Circle: Drawings from Windsor Castle*, London, Merrell Holberton.

Coales, J. (1997) 'The drawings of Roger de Gaignières: loss and survival', *Church Monuments*, 12, pp.14–34.

Cohen, K. (1973) *Metamorphosis of a Death Symbol: The Transi Tomb in the Late Middle Ages and the Renaissance*, Berkeley, University of California Press.

Coleman, J. (1996) *Public Reading and the Reading Public in Late Medieval England and France*, Cambridge, Cambridge University Press.

Colvin, H.M. (1963–82) *The History of the King's Works*, 6 vols, London, HMSO.

Condivi, A. (1987) *Michelangelo: Life, Letters and Poetry*, ed. and trans. G. Bull, Oxford, Oxford University Press.

Constantoudaki, M. (1973) Μ.Γ. Κωνσταντουδάκη, 'Οἱ Ζωγράφοι του Χάνδακος κατὰ το πρῶτον ἥμισυ του 16ου αιῶνος οι μαρτυρούμενοι εκ των νοταριακῶν ἀρχεὶων', Θησαυρίσματα, 10, pp.291–380.

Constantoudaki, M. (1975) Μ.Γ. Κωνσταντουδάκη, 'Μαρτυρίες ζωγραφικῶν ἔργων στο Χάνδακα σε ἔγγραφα του 16ου και του 17ου αιῶνα', Θησαυρίσματα, 12, pp.35–136.

Constantoudaki-Kitromilides, M. (1986) Μ.Γ. Κωνσταντουδάκη-Κιτρομηλίδου, Οἱ Κρητικοὶ Ζωγράφοι και το Κοινὸ τους: Η Ἀντιμετώπιση της Τέχνης τους στη Βενετία', Κρητικὰ Χρονικὰ, 26, pp.246–61.

Constantoudaki-Kitromilides, M. (1999) 'L'arte dei pittori greci a Venezia nel Cinquecento', in M. Lucco (ed.) *La pittura nel Veneto: Il Cinquecento*, vol.3, Milan, Electa, pp.1203–61.

Constantoudaki-Kitromilides, M. (2000) 'Michael Damaskinos', in G. Speake (ed.) *Encyclopedia of Greece and the Hellenic Tradition*, vol.1, London, Fitzroy Dearborn, pp.443–5.

Constantoudaki-Kitromilides, M. (2002) 'Le Icone e l'arte dei pittori Greci a Venezia: Maestri in rapporto con la Confraternita Greca', in M.F. Tiepolo and E. Tonetti (eds) *I Greci a Venezia: Atti del Convegno Internazionale di Studio, Venezia, 5–7 Novembre 1998*, Venice, Istituto Veneto di Scienze, Lettere ed Arti, pp.569–641.

Conti, E. (1984) *L'imposta diretta a Firenze nel Quattrocento (1427–1494)*, Rome, Istituto storico italiano per il Medio Evo.

Cook, G.H. (1947) *Medieval Chantries and Chantry Chapels*, London, Phoenix House.

Cortesi Bosco, F. (1980) 'Il ritratto di Nicolò della Torre disegnato da Lorenzo Lotto', in P. Zampetti and V. Sgarbi (eds) *Lorenzo Lotto: Atti del convegno internazionale di studi per il V centenario della nascita*, Treviso, Comitato per le celebrazioni lottesche.

Coutagne, D. (ed.) (1981) *Le roi René en son temps 1382–1481*, Aix-en-Provence, Musée Granet.

Cust, L. (1898) *The Master E.S. and the 'Ars Moriendi': A Chapter in the History of Engraving during the XVth Century*, Oxford, Clarendon Press.

Cutolo, A. (1938) 'Nuovi documenti francesi sulla impresa di Carlo VIII', *Archivio sotrico per le province napoletane*, 63, pp.183–257.

Dacos, N. with Giuliano, A. and Pannuti, U. (eds) (1973) *Il tesoro di Lorenzo il Magnifico 1: Le gemme*, Florence, Sansoni.

Darr, A.P. (1982) 'From Westminster Abbey to the Wallace Collection: Torrigiano's head of Christ', *Apollo*, CXVI, pp.292–8.

David, H. (1935) 'Le tombeau de Philippe Pot', *Revue belge d'archéologie et d'histoire de l'art*, pp.119–33.

De la Mare, A.C. (1973) *The Handwriting of the Italian Humanists*, Paris, Oxford University Press for the Association Internationale de Bibliophilie.

De la Mare, A.C. (1992) 'Cosimo and his books', in F. Ames-Lewis (ed.) *Cosimo 'il Vecchio' de' Medici, 1389–1464: Essays in Commemoration of the 600th Anniversary of Cosimo de' Medici's Birth*, Oxford, Clarendon Press, pp.115–56.

De Vos, D. (1999) *Rogier van der Weyden: The Complete Works*, New York, Harry N. Abrams.

Debae, M. (1995) *La Bibliothèque de Marguerite d'Autriche: Essai de reconstitution d'après l'inventaire de 1523–1524*, Louvain, Éditions Peeters.

Delmarchel, G. (1989) 'Text and image: some notes on the tituli of Flemish Triumphs of Petrarch tapestries', *Textile History*, 20, pp.321–9.

Dempsey, C. (1992) *The Portrayal of Love: Botticelli's Primavera and Humanist Culture at the Time of Lorenzo the Magnificent*, Princeton, Princeton University Press.

Demus, O. (1948) *Byzantine Mosaic Decoration: Aspects of Monumental Art in Byzantium*, London, Kegan Paul Trench Trubner.

Denis, A. (1979) *Charles VIII et les Italiens: Histoire et mythe*, Geneva, Travaux d'Humanisme et Renaissance.

Deville, A. (1850) *Comptes des dépenses de la construction du Château de Gaillon publiés d'après les registres manuscrits des trésoriers du Cardinal d'Amboise*, Paris, Imprimerie Nationale.

Diaz, E.O. (1968) *La Capilla Real de Granada*, Granada, Albaicín/Sadea Editores.

Dizionario Biografico degli Italiani (1960–) Rome, Istituto della Enciclopedia Italiana.

Dormer, D.J. (1683) *Discursos varios de historia*, Saragossa.

Dow, H. (1992) *The Sculptural Decoration of the Henry VII Chapel, Westminster Abbey*, Edinburgh, Pentland.

Dubbe, B. (1970) 'Is Johan van den Mynnesten de "Meester van Zwolle"?', *Bulletin van het Rijksmuseum*, 18, pp.55–65.

Duffy, E. (1992) *The Stripping of the Altars: Traditional Religion in England c.1400–c.1580*, New Haven and London, Yale University Press.

Duits, R. (1999) 'Figured riches: the value of gold brocades in fifteenth-century Florentine painting', *Journal of the Warburg and Courtauld Institutes*, 62, pp.60–92.

Duits, R. (2001) 'Gold brocade in Renaissance painting: an iconography of riches', PhD thesis, University of Utrecht.

Duits, R. (2007) *Gold Brocade and Renaissance Painting: A Study in Material Culture*, London, Pindar Press.

Dunkerton, J. *et al.* (1991) *Giotto to Dürer: Early Renaissance Painting in the National Gallery*, New Haven and London, Yale University Press/London, National Gallery Publications.

Durand, G. (1911) *Tableaux et chants royaux de la Confrérie du Puy Notre Dasme d'Amiens, reproduits en 1517 pout Louise de Savoie, Duchesse d'Angoulême*, Amiens, Société d'Archéologie du Département de la Somme.

Durand, J. and Laffite, M.-P. (2001) *Le Trésor de la Sainte-Chapelle*, Paris, Réunion des Musées Nationaux (exhibition catalogue).

Durrieu, P. (1913) 'Un mystérieux dessinateur du début du XVIe siècle: le maître du "Monstrelet" de Rochechouart', *Revue de l'art ancient et moderne*, 33, pp.241, 321–6.

Dussler, L. (1971) *Raphael: A Critical Catalogue of his Pictures, Wall-Paintings and Tapestries*, London, Phaidon.

Duvenal, M., Leroy, P. and Pinette, M. (1997) *La Confrérie Notre-Dame du Puy d'Amiens*, Amiens, Pierre Mabire.

Duvenger, E. and Duvenger-Van de Velde, D. (1967) 'Jean Lemaire de Belges en de Schilderkunst: Een Bijdrage', *Jaarboek van het Koninklijk Museum voor Schone Kunsten Antwerpen*, pp.37–78.

Eastmond, A. and James, L. (eds) (2003) *Icon and Word: The Power of Images in Byzantium. Studies Presented to Robin Cormack*, Aldershot, Ashgate.

Eckstein, N.A. (1995) *The District of the Green Dragon: Neighbourhood Life and Social Change in Renaissance Florence*, Florence, Olschki.

Edler de Roover, F. (1966) 'Andrea Banchi: Florentine silk manufacturer and merchant in the fifteenth century', *Studies in Medieval and Renaissance History*, 3, pp.223–85.

Egg, E. (1974) *Die Hofkirche in Innsbruck: Das Grabdenkmal Kaiser Maximilians I. und die Silberne Kapelle*, Innsbruck, Tyrolia.

Eichberger, D. (2002) *Leben mit Kunst, Wirken durch Kunst: Sammelwesen und Hofkunst unter Margarete von Österreich, Regentin der Niederlande*, Turnhout, Brepols.

Eichberger, D. (ed.) (2005) *Women of Distinction: Margaret of York, Margaret of Austria*, Leuven, Davidsfonds (exhibition catalogue).

Eichberger, D. and Beaven, L. (1995) 'Family members and political allies: the portrait collection of Margaret of Austria', *The Art Bulletin*, 77, pp.225–48.

Eire, C. (1986) *War against the Idols: The Reformation of Worship from Erasmus to Calvin*, Cambridge, Cambridge University Press.

Eisler, C. (1970) 'Aspects of Hans Holbein the Elder's heritage', in H. Keller (ed.) *Festschrift für Gert von der Osten*, Cologne, Verlag M. Dumont Schauberg, pp.149–58.

Elmer, P., Webb, N. and Wood, R. (eds) (2000) *The Renaissance in Europe: An Anthology*, New Haven and London, Yale University Press.

Elsig, F. (2002) 'Un triptych de Jean Poyet', *Revue de l'art*, 135, pp.107–16.

Elsig, F. (2004) *Painting in France in the 15th Century*, Milan, 5 Continents Editions.

Epstein, A.W. (1981) 'The Middle Byzantine sanctuary barrier: templon or iconostasis?', *Journal of the British Archaeological Association*, 134, pp.1–28.

Erasmus, D. (1965) *The Colloquies of Erasmus*, trans. and ed. C.R. Thompson, Chicago and London, University of Chicago Press.

Evans, H.C. (ed.) (2004) *Byzantium: Faith and Power (1261–1557)*, New York, Metropolitan Museum of Art/New Haven and London, Yale University Press (exhibition catalogue).

Evans, J. (1969) *Art in Mediaeval France 987–1498*, rev. edn, Oxford, Oxford University Press.

Evans, J. and Cook, N. (1955) 'A statue of Christ from the ruins of Mercers' Hall', *The Archaeological Journal*, CXI, pp.168–80.

Evans, M. (1983) 'Italian manuscript illumination 1460–1560', in T. Kren (ed.) *Renaissance Painting in Manuscripts: Treasures from the British Library*, New York, Hudson Hills Press, pp.89–144 (exhibition catalogue).

Evans, M. (1992) *The Sforza Hours*, London, British Library.

Evans, M. (1995a) 'Commentary on the miniatures and borders', in M. Evans, B. Brinkman and H. Herkommer, *The Sforza Hours: Add. MS. 34294 of the British Library, London*, facsimile commentary, Lucerne, Faksimile Verlag, pp.603–734.

Evans, M. (1995b) 'The Italian miniatures and borders', in M. Evans, B. Brinkman and H. Herkommer, *The Sforza Hours: Add. MS. 34294 of the British Library, London*, facsimile commentary, Lucerne, Faksimile Verlag, pp.535–50.

Evans, M. (1998) 'Jean Fouquet and Italy: "… buono maestro, maxime a ritrarre del naturale"', in M.P. Brown and S. McKendrick (eds) *Illuminating the Book: Makers and Interpreters. Essays in Honour of Janet Backhouse*, London, British Library, pp.163–87.

Evans, M., Brinkmann, B. and Herkommer, H. (1995) *The Sforza Hours: Add. MS. 34294 of the British Library, London*, facsimile commentary, Lucerne, Faksimile Verlag.

ExtravagAnt: A Forgotten Chapter of Antwerp Painting 1500–1530 (2005) Antwerp, Koninklijk Museum voor schone Kunsten Antwerpen (exhibition catalogue).

Ferguson, G.W. (1976) *Signs and Symbols in Christian Art*, Oxford, Oxford University Press.

Feydy, J. (1938) 'Le Maître de Moulins et la Vierge des Bourbons', *L'Amour de l'art*, April, pp.111–18.

Filedt Kok, J.P. (1985) *Livelier than Life: The Master of the Amsterdam Cabinet or the Housebook Master c.1470–1500*, Amsterdam, Rijksmuseum (exhibition catalogue).

Filon, M. (1851) 'Ouvriers italiens employés par Charles VIII', *Archives de l'art français*, 1, pp.273–6.

Fiot, R. (1961) 'Jean Bourdichon et Saint François de Paule', *Mémoires de la Société archéologique de Touraine*, LV, pp.1–177.

Foister, S. (2004) *Holbein and England*, New Haven and London, Yale University Press.

Folda, J. (2002) 'Icon to altarpiece in the Frankish East: images of the Virgin and Child enthroned', in V.M. Schmidt (ed.) *Italian Panel Painting of the Duecento and Trecento*, Studies in the History of Art 61, Center for Advanced Study in the Visual Arts, Symposium Papers XXXVIII, Washington, DC, National Gallery of Art/New Haven and London, Yale University Press.

Forsyth, W. (1970) *The Entombment of Christ: French Sculptures of the Fifteenth and Sixteenth Centuries*, Boston, MA, Harvard University Press.

Francia, E. (1977) *1506–1606: Storia della costruzione del nuovo San Pietro*, Rome, De Luca.

Frankl, P. (1960) *The Gothic: Literary Sources and Interpretations through Eight Centuries*, Princeton, Princeton University Press.

Fraser Jenkins, A.D. (1970) 'Cosimo de' Medici's patronage of architecture and the theory of magnificence,' *Journal of the Warburg and Courtauld Institutes*, 33, pp.162–70.

Fremmer, A. (2001) *Venezianische Buchkultur: Bücher, Buchhändler und Leser in der Frührenaissance*, Cologne, Weimar and Vienna, Böhlau Verlag.

Frick, C.C. (1995) *Dressing a Renaissance City: Society, Economics and Gender in the Clothing of Fifteenth-Century Florence*, Ann Arbor, University Microfilms.

Frick, C.C. (2002) *Dressing Renaissance Florence: Families, Fortunes, and Fine Clothing*, Baltimore and London, Johns Hopkins University Press.

Frommel, C.L. (1961) *Die Farnesina und Peruzzis architektonisches Frühwerk*, Berlin, Walter de Gruyter.

Gardner, A. (1940) *Alabaster Tombs of the Pre-Reformation Period in England*, Cambridge, Cambridge University Press.

Gargiolli, G. (ed.) (1868) *L'Arte della seta in Firenze: Trattato del secolo XV*, Florence, G. Barbèra.

Garside, C. (1966) *Zwingli and the Arts*, New Haven and London, Yale University Press.

Garzelli, A. and de la Mare, A.C. (1985) *Miniatura fiorentina del Rinascimento, 1440–1525: Un primo censimento*, Florence, Giunta regionale toscana.

Gasparis, Ch. (1989) Χ. Γάσπαρης,'Οι Επαγγελματίες του Χάνδακα κατὰ τον 14ο αιώνα και οι Σχέσεις με τον Καταναλωτὴ και το Κράτος', *Σύμμεικτα*, 8, pp.83–133.

Georgopoulou, M. (1995) 'Late medieval Crete and Venice: an appropriation of Byzantine heritage', *The Art Bulletin*, 77, pp.479–96.

Gerola, G. (1905–17) *Monumenti Veneti nell' Isola di Creta*, 3 vols, Venice, Istituto Veneto di Scienze, Lettere ed Arti.

Gilbert, F. (1980) *The Pope, his Banker, and Venice*, Cambridge, MA and London, Harvard University Press.

Gill, M. (2003) 'The wall paintings in Eton College Chapel: the making of a late medieval Marian cycle', in P. Lindley (ed.) *Making Medieval Art*, Donnington, Paul Watkins, pp.173–201.

Gill, M.J. (1996) '"Where the danger was greatest": a Gallic legacy in Santa Maria Maggiore', *Zeitschrift für Kunstgeschichte*, 59, pp.498–522.

Gill, M.J. (2005) 'The fourteenth and fifteenth centuries', in M.B. Hall (ed.) *Artistic Centers of the Renaissance: Rome*, Cambridge and New York, Cambridge University Press, pp.27–106.

Giraud, Y. (1994) 'The *Petit Livre d'Amour* by Pierre Sala: a historical and literary review', in J. Backhouse and Y. Giraud, *Pierre Sala: Petit Livre d'Amour. Stowe MS 955, British Library, London, Kommentar, Commentaire, Commentary*, Lucerne, Faksimile Verlag, pp.301–58.

Glasser, H. (1965) *Artists' Contracts of the Early Renaissance*, Ann Arbor, University Microfilms.

Goddard, S.H. (1984) *The Master of Frankfurt and his Shop*, Brussels, Paleis der Academiën.

Goffen, R. and Nepi Scirè, G. (eds) (2000) *Il Colore Ritrovato: Bellini a Venezia*, Venice, Electa.

Goldthwaite, R.A. (1968*) Private Wealth in Renaissance Florence: A Study of Four Families*, Princeton, Princeton University Press.

Goldthwaite, R.A. (1980) *The Building of Renaissance Florence: An Economic and Social History*, Baltimore and London, Johns Hopkins University Press.

Goldthwaite, R.A. (1993) *Wealth and the Demand for Art in Italy, 1300–1600*, Baltimore and London, Johns Hopkins University Press.

Goldthwaite, R.A. (1995) 'The building of the Strozzi Palace: the construction industry in Renaissance Florence', in *Banks, Palaces and Entrepreneurs in Renaissance Florence*, Aldershot and Brookfield, Variorum (reprint from *Studies in Medieval and Renaissance History*, 10).

Goldthwaite, R.A. and Mandich, G. (1994) *Studi sulla moneta fiorentina (secoli XIII–XVI)*, Florence, Olschki.

Gombrich, E.H. (1966) 'The early Medici as patrons of art', in *Norm and Form*, London, Phaidon, pp.35–57.

Goodall, J.A.A. (2001) *God's House at Ewelme: Life, Devotion and Architecture in a Fifteenth-Century Almshouse*, Aldershot, Ashgate.

Gordon, B. (2002) *The Swiss Reformation*, Manchester and New York, Manchester University Press.

Gotti, A. (1876) *Vita di Michelangelo Buonarroti narrata con l'aiuto di nuovi documenti*, Florence, Tipografia della Gazzetta d'Italia.

Gouma Peterson, T. (1968) 'Crete, Venice, the "Madonneri" and a Creto-Venetian icon in the Allen Art Museum', *Allen Memorial Art Museum Bulletin*, 25:2, pp.52–86.

Grandmaison, C.L. (1873) 'Comptes du château d'Amboise', *Bulletin de la Société archéologique de Touraine*, 1, pp.253–304.

Greenblatt, S. (1980) *Renaissance Self-Fashioning: From More to Shakespeare*, Chicago, University of Chicago Press.

Grodecki, C. (1996) 'Le "maître Nicolas d'Amiens" et la mise au tombeau de Malesherbes', *Bulletin monumental*, 154, pp.329–42.

Guibert, L. (1894) 'Ce qu'on sait de l'enlumineur Evrard d'Espinques', *Mémoires de la Société des sciences naturelles et archéologiques de la Creuse*, 8, pp.447–68.

Guide to St Mary's Church, Ewelme, and to the Almshouse and the School (1967) Bath, Mendip Press.

Hackenbroch, Y. (1979) *Renaissance Jewellery*, London, Sotheby Parke Bernet.

Hacker, P. and Kuhl, C. (1992) 'A portrait of Anne of Cleves', *Burlington Magazine*, CXXXIV, pp.172–5.

Haines, M. (1989) 'Brunelleschi and bureaucracy: the tradition of public patronage at the Florentine Cathedral', *I Tatti Studies*, 3, pp.89–125.

Haines, M. and Riccetti, L. (eds) (1995) *Opera: Carattere e ruolo delle fabbriche cittadine fino all'inizio dell' Età Moderna*, Florence, Olschki.

Hale, J.R. (1977) *Florence and the Medici: The Pattern of Control*, London, Thames & Hudson.

Hale, J.R. (1985) *War and Society in Renaissance Europe 1450–1620*, London, Fontana Press.

Hale, J.R. (ed.) (1979) *The Travel Journal of Antonio de Beatis: Germany, Switzerland, The Low Countries, France and Italy, 1517–1518*, trans. J.R. Hale and J.M.A. Lindon, London, Hakluyt Society.

Hall, M.B. (2005) 'The High Renaissance 1503–1534', in M.B. Hall (ed.) *Artistic Centers of the Renaissance: Rome*, Cambridge and New York, Cambridge University Press, pp.107–83.

Harrison, A.T. (ed.) (1994) *The Danse Macabre of Women: Ms. Fr. 995 of the Bibliothèque Nationale*, Kent, OH and London, Kent State University Press.

Haskins, S. (1993) *Mary Magdalen: Myth and Metaphor*, New York, Harcourt, Brace & Company.

Hayum, A. (1989) *The Isenheim Altarpiece: God's Medicine and the Painter's Vision*, Princeton, Princeton University Press.

Hegarty, M. (1996) 'Laurentian patronage in the Palazzo Vecchio: the frescos of the Sala dei Gigli', *The Art Bulletin*, 78, pp.264–85.

Henderson, J.H. (1994) *Piety and Charity in Late Medieval Florence*, Oxford, Oxford University Press.

Herald, J. (1981) *History of Dress Series 2: Renaissance Dress in Italy 1400–1500*, London, Bell & Hyman/ Atlantic Highlands, Humanities Press.

Herlihy, D. and Klapisch-Zuber, C. (1978) *Les Toscans et leurs familles: Une étude du catasto florentin de 1427*, Paris, Presses de la fondation nationale des sciences politiques.

Herlihy, D. and Klapisch-Zuber, C. (1985) *Tuscans and their Families: A Study of the Florentine Catasto of 1427*, New Haven and London, Yale University Press.

Hibbert, C. (1974) *The Rise and Fall of the House of the Medici*, Harmondsworth, Penguin.

Hind, A.M. (1935) *An Introduction to a History of Woodcut: With a Detailed Survey of Work Done in the Fifteenth Century*, 2 vols, London, Constable.

Hirst, M. (2000) 'Michelangelo in Florence: "David" in 1503 and "Hercules" in 1506', *Burlington Magazine*, CXLII, pp.487–92.

Hobson, A. (1989) *Humanists and Bookbinders: The Origins and Diffusion of Humanistic Bookbinding 1459–1559*, Cambridge, Cambridge University Press.

Hochstetler Meyer, B. (1975) 'Louis XII, Leonardo and the Burlington House Cartoon (Six Letters, 1507)', *Gazette des beaux-arts*, 86, pp.105–9.

Hofmannn, M. (2004) *Jean Poyer: Das Gesamtwerk*, Turnhout, Brepols.

Holban, M. (1986) 'Nouveau apercus sur l'iconographie du ms.24461 de la Bibliothèque nationale: les portraits de François 1er et de sa famille', *Bulletin de la Société de l'histoire de l'art français*, pp.15–30.

Holman, B. (ed.) (1997) *Disegno: Italian Designs for the Decorative Arts*, Hanover and London, University Press of New England (exhibition catalogue).

Holman, T.S. (1979) 'Holbein's portraits of the Steelyard merchants: an investigation', *Metropolitan Museum of Art Journal*, XL, pp.139–58.

Hope, C. and McGrath, E. (1996) 'Artists and humanists', in J. Kraye (ed.) *The Cambridge Companion to Renaissance Humanism*, Cambridge, Cambridge University Press, pp.161–88.

Huizinga, J. (1965) *The Waning of the Middle Ages*, trans. F. Hopman, Harmondsworth, Penguin.

Humfrey, P. (1983) *Cima da Conegliano*, Cambridge, Cambridge University Press.

Humfrey, P. (1997) *Lorenzo Lotto*, New Haven and London, Yale University Press.

Huntley, G.H. (1935) *Andrea Sansovino: Sculptor and Architect of the Italian Renaissance*, Cambridge, MA, Harvard University Press.

Israel, J.I. (1995) *The Dutch Republic: Its Rise, Greatness, and Fall 1477–1806*, Oxford, Clarendon Press.

Jacobowitz, E. and Loeb Stepanek, S. (1983) *The Prints of Lucas van Leyden and his Contemporaries*, Washington, DC, National Gallery of Art (exhibition catalogue).

James, L. (1996) *Light and Colour in Byzantine Art*, Oxford, Clarendon Press.

Jansen, S.L. (ed.) (2004) *Anne of France: Lessons for my Daughter*, Cambridge, D.S. Brewer.

Jarry, L. (1892) 'Testaments, inventaire et compte des obsèques de Jean, Bâtard d'Orléans', *Mémoires de la Société archéologique et historique de l'Orléanais*, 23, pp.5–189.

Jenny, B.R. (2001) 'Die Beziehungen der Familie Amerbach zur Basler Kartause und die Amerbachsche Grabkapelle daselbst', *Zeitschrift für Schweizerische Archäologie und Kunstgeschichte*, 58, pp.267–78.

Jestaz, B. (1999) 'François Ier, Salaì et les tableaux de Léonard', *Revue de l'art*, 126, pp.68–72.

Joannides, P. (1983) *The Drawings of Raphael: With a Complete Catalogue*, Oxford, Phaidon.

Johnson, G.A. (2000) 'Activating the effigy: Donatello's Pecci tomb in Siena Cathedral', in E. Valdez del Alamo and C. Stamatis Pendergast (eds) *Memory and the Medieval Tomb*, Aldershot, Ashgate, pp.99–127.

Jollet, E. (1997) *Jean & François Clouet*, trans. D. Dusinberre, Paris, Lagune.

Jones, R. and Penny, N. (1983) *Raphael*, New Haven and London, Yale University Press.

Kazhdan, A.P. *et al.* (eds) (1991) *The Oxford Dictionary of Byzantium*, 3 vols, New York and Oxford, Oxford University Press.

Kecks, R.G. (1995) *Ghirlandaio: Catalogo completo*, Florence, Octavo.

Kemp, M. (ed.) (1992) *Leonardo da Vinci: The Mystery of the Madonna of the Yarnwinder*, Edinburgh, National Gallery of Scotland.

Kemp, M. (1994) 'From scientific examination to Renaissance market: the case of Leonardo da Vinci's Madonna of the Yarnwinder', *Journal of Medieval and Renaissance Studies*, 24, pp.259–74.

Kemp, M. (1997) *Behind the Picture: Art and Evidence in the Italian Renaissance*, New Haven and London, Yale University Press.

Kempers, B. (2000) '*Capella Iulia* and *Capella Sixtina*: two tombs, one patron and two churches', in F. Benzi (ed.) *Sisto IV: Le Arti a Roma nel Primo Rinascimento*, Rome, Edizione dell'Associazione Culturale Shakespeare and Company 2, pp.33–59.

Kendall, P.M. (1971) *Louis XI: '… the universal spider'*, London, George Allen and Unwin.

Kent, D. (1978) *The Rise of the Medici: Faction in Florence, 1426–1434*, Oxford and New York, Oxford University Press.

Kent, D. (2000) *Cosimo de' Medici and the Florentine Renaissance: The Patron's Oeuvre*, New Haven and London, Yale University Press.

Kent, F.W. (1987) 'Palaces, politics and society in fifteenth-century Florence', *I Tatti Studies*, 2, pp.41–70.

Kent, F.W. (1994) 'Lorenzo …, Amico degli Uomini da Bene: Lorenzo de' Medici and oligarchy', in G.C. Garfagnani (ed.) *Lorenzo il Magnifico e il suo mondo*, Florence, Olschki, pp.43–60.

Kent, F.W. (2001) 'Lorenzo de' Medici at the Duomo', in T. Verdon and A. Innocenti (eds) *La cattedrale e la città: Saggi sul Duomo di Firenze*, Atti del VII Centenario del Duomo di Firenze, 3 vols, Florence, Edifir, pp.340–68.

Kent, F.W. (2004) *Lorenzo de' Medici and the Art of Magnificence*, Baltimore and London, Johns Hopkins University Press.

Kidwell, C. (1991) *Pontano, Poet and Prime Minister*, London, Duckworth.

King, M.L. (1994) *The Death of the Child Valerio Marcello*, Chicago, University of Chicago Press.

King, P.M. (1984) 'The cadaver tomb in the fifteenth century: some indications of a Lancastrian connection', in J.H.M. Taylor (ed.) *Dies Illa: Death in the Middle Ages*, Proceedings of the 1983 Manchester Colloquium, Liverpool, Cairns, pp.45–57.

King, P.M. (1990) 'The cadaver tomb in England: novel manifestations of an old idea', *Church Monuments*, V, pp.26–38.

Knecht, R.J. (1994) *Renaissance Warrior and Patron: The Reign of Francis I*, Cambridge, Cambridge University Press.

Koerner, J.L. (2004) *The Reformation of the Image*, London, Reaktion Books.

Koldeweij, A.M. (1999) 'Lifting the veil on pilgrim badges', in J. Stoppard (ed.) *Pilgrimage Explored*, Woodbridge, York Medieval Press, pp.161–88.

König, E. (2001) *Das Guémadeuc-Stundenbuch*, Ramsden, Heribert Tenschert.

Koslofsky, C.M. (2000) *The Reformation of the Dead: Death and Ritual in Early Modern Germany 1450–1700*, Basingstoke, Palgrave.

Kotoula, D. (2006) 'The British Museum Triumph of Orthodoxy icon: iconography and meaning', in A. Louth (ed.) *Byzantine Orthodoxies? Papers from the Thirty-Sixth Spring Symposium of Byzantine Studies, Durham, March 2002*, Aldershot, Ashgate, pp.123–31.

Kovacs, E. (2004) *L'Âge d'or de l'orfèvrie parisienne au temps des princes de Valois*, Dijon, Éditions Faton.

Kranz, A. (2004) *Christoph Amberger: Bildnismaler zu Augsburg: Städtische Eliten im Spiegel ihrer Porträts*, Regensburg, Schnell & Steiner.

Krautheimer, R. (1986) *Early Christian and Byzantine Architecture*, rev. R. Krautheimer and S. Ćurčić, New Haven and London, Yale University Press.

Kren, T. and Evans, M. (eds) (2005) *A Masterpiece Reconstructed: The Hours of Louis XII*, Malibu, J. Paul

Getty Museum and the British Library in association with the Victoria and Albert Museum.

Kren, T. and McKendrick, S. (eds) (2003) *Illuminating the Renaissance: The Triumph of Flemish Manuscript Painting in Europe*, Malibu, J. Paul Getty Museum (exhibition catalogue).

Kren, T. and Wieck, R.S. (1990) *The 'Visions of Tondal' from the Library of Margaret of York*, Malibu, J. Paul Getty Museum.

Kriss-Rettenbeck, L. (1972) *Ex Voto: Zeichen, Bild und Abbild im christlichen Votivbrauchtum*, Zurich and Freiburg im Breisgau, Atlantis Verlag.

La Malfa, C. (1999) 'Firenze e l'allegoria dell'eloquenza: una nuova interpretazione della *Primavera* di Botticelli', *Storia dell'arte* 97, pp.249–93.

Labande-Mailfert, Y. (1950) 'L'épée dite "flamboyante" de Charles VIII', *Bulletin monumental*, 108, pp.91–101.

Labande-Mailfert, Y. (1975) *Charles VIII et son milieu (1470–1498): La jeunesse au pouvoir*, Paris, Klincksieck.

Laborde, L.E.S.J. de (1849–52) *Les Ducs de Bourgogne: Études sur les lettres, les arts et l'industrie pendant le XVe siècle et plus particulièrement dans les Pays-Bas et le duché de Bourgogne*, 3 vols, Paris, Plon Frères.

Lalanne, L. (1853) 'Transport d'oeuvres d'art de Naples au château d'Amboise en 1495', *Archives de l'art français*, 3, p.94.

Lambron de Lignim, H. (1857) 'Peintures murales executés à Saint-Martin de Tours par Coppin Delf, peintre du roi Louis XI', *Mémoires de la Société archéologique de Touraine*, XI, pp.17–27.

Landau, D. and Parshall, P. (1994) *The Renaissance Print 1470–1550*, New Haven and London, Yale University Press.

Landucci, L. (1927) *A Florentine Diary from 1450 to 1516 Continued by an Anonymous Writer till 1542 with Notes by Iodoco del Badia*, trans. A. de Rosen Jervis, London, Arno Press.

Lane, F.C. (1944) *Andrea Barbarigo: Merchant of Venice, 1418–1449*, Baltimore, Johns Hopkins University Press.

Lapeyre, A. (1986) *Louis XI mécène dans le domaine de l'orfèvrerie religieuse*, Nogent-le-Rotrou, Daupeley-Gouverneur.

Laporte, J. (1967) 'Le crépuscule de l'ancien monarchisme au Mont-Saint-Michel', in M. Nortier (ed.) *Millénaire du Mont-Saint-Michel*, Paris, P. Lethielleux, pp.211–34.

Lawton Smith, E. (1992) *The Paintings of Lucas van Leyden: A New Appraisal, with Catalogue Raisonné*, Columbia and London, University of Missouri Press.

Lecoq, A.-M. (1977) 'Le Puy d'Amiens de 1518', *Revue de l'art*, 38, pp.63–74.

Lecoq, A.-M. (1987a) *François Ier imaginaire: Symbolique et politique à l'aube de la Renaissance française*, Paris, Macula.

Lecoq, A.-M. (1987b) 'Une fête italienne à la Bastille en 1518', in *'Il se rendit en Italie': Études offertes à André Chastel*, Rome, Edizioni dell'Elefante/Paris, Flammarion.

Lemaître, J.-L. (1988) *Henri Baude: Dictz moraulx pout faire tapisserie. Dessins du Musée Condé et de la Bibliothèque nationale*, Paris, Musée du pays d'Ussel.

Lenaghan, P. (1998) 'Reinterpreting the Italian Renaissance in Spain: attribution and connoisseurship', *Sculpture Journal*, 2, pp.13–23.

Leroux de Lincy, A.J.V. (1860) *Vie de la reine Anne de Bretagne*, 4 vols, Paris, Curmer.

Leseur, F. (1929) 'Colin Biart, maître maçon de la Renaissance', *Gazette des beaux-arts*, pp.210–31.

Lesueur, P. (1904–6) 'Les jardins du château de Blois', *Mémoires de la Société des sciences et lettres de Loir-et-Cher*, 18, pp.235–305.

Lesueur, P. (1929) 'Les italiens à Amboise au début de la Reniassance', *Bulletin de la Société de l'histoire de l'art français*, pp.7–11.

Lesueur, P. (1935) 'Pacello da Mercogliano et les jardins d'Amboise, Blois et Gaillon', *Bulletin de la Société de l'histoire de l'art français*, pp.90–117.

Letts, M. (ed.) (1957) *The Travels of Leo of Rozmital through Germany, Flanders, England, France, Spain, Portugal and Italy 1465–1467*, Cambridge, Cambridge University Press.

Levi-Pisetsky, R. (1964–9) *Storia del costume in Italia*, 5 vols, Milan, Istituto Editoriale Italiano.

Lidov, A. (ed.) (2000) *The Iconostasis: Origins – Evolution – Symbolism*, Moscow, Progress-Tradition.

Lightbown, R.W. (1978) *Sandro Botticelli*, 2 vols, London, Paul Elek.

Lightbown, R.W. (1986) *Mantegna*, Oxford, Phaidon/Christie's.

Lightbown, R.W. (1992) *Mediaeval European Jewellery: With a Catalogue of the Collection in the Victoria & Albert Museum*, London, Victoria and Albert Museum.

Lindberg, C. (ed.) (2000) *The European Reformation Sourcebook*, Oxford, Blackwell.

Lindley, P. (2003) '"The singuler mediacions and praiers of al the holie companie of Heven": sculptural functions and forms in Henry VII's Chapel', in T. Tatton Brown and R. Mortimer (eds) *Westminster Abbey: The Lady Chapel of Henry VII*, Woodbridge, Boydell Press, pp.259–93.

Liss, P.K. (1992) *Isabel the Queen: Life and Times*, New York and Oxford, Oxford University Press.

Loeser, C. (1928) 'Gianfrancesco Rustici', *Burlington Magazine*, LII, pp.260–73.

Lowden, J. (1997) *Early Christian and Byzantine Art*, London, Phaidon.

Lowe, K.J.P. (2003) *Nuns' Chronicles and Convent Culture in Renaissance and Counter-Reformation Italy*, Cambridge and New York, Cambridge University Press.

Lutz, W. (1995) *Luciano Laurana und der Herzogpalast von Urbino*, Weimar, VDG.

Lydecker, J. K. (1987) *The Domestic Setting of the Arts in Renaissance Florence*, Ann Arbor, University Microfilms.

Lymberopoulou, A. (2003) 'The *Madre della Consolazione* icon in the British Museum: post-Byzantine painting, painters and society on Crete', *Jahrbuch der Österreichischen Byzantinistik*, 53, pp.239–55.

Lymberopoulou, A. (2007) '"*Pro animos mea*" but do not touch my icons: provisions for personal icons in wills in Venetian-dominated Crete', in D. Stathakopoulos (ed.) *The Kindness of Strangers: Charity in the Pre-Modern Mediterranean*, London, King's College.

MacGibbon, D. (1933) *Jean Bourdichon: A Court Painter of the Fifteenth Century*, Glasgow, privately printed.

Machiavelli, N. (1988) *Florentine Histories*, trans. L.F. Banfield and H.C. Mansfield, Jr, Princeton, Princeton University Press.

Maguire, H. (1996) *The Icons of their Bodies: Saints and their Images in Byzantium*, Princeton, Princeton University Press.

Mâle, É. (1986) *Religious Art in France: The Late Middle Ages, a Study of Medieval Iconography and its Sources*, ed. H. Bober, trans. M. Mathews, Princeton, Princeton University Press.

Mallett, M. (1974) *Mercenaries and their Masters: Warfare in Renaissance Italy*, London, The Bodley Head.

Mancusi Ungaro, H.R. (1971) *Michelangelo, the Bruges Madonna and the Piccolomini Altar*, New Haven and London, Yale University Press.

Markow, D. (1978) 'Hans Holbein's Steelyard portraits reconsidered', *Wallraf-Richartz Jahrbuch*, XL, pp.39–47.

Marks, R. and Williamson P. (eds) (2003) *Gothic: Art for England 1400–1547*, London, V & A Publications (exhibition catalogue).

Marquand, A. (1920) *Giovanni della Robbia*, Princeton, Princeton University Press.

Marshall, P. (2002) *Beliefs and the Dead in Reformation England*, Oxford, Oxford University Press.

Martial (1993) *Epigrams*, ed. D.R. Shackleton Bailey, Cambridge, MA and London, Harvard University Press.

Martin, M. (1997) *La Statuaire de la mise au tombeau du Christ: Des XVe et XVIe siècles en Europe occidentale*, Paris, Picard.

Martindale, A. (1979) *The Triumphs of Caesar by Andrea Mantegna in the Collection of Her Majesty the Queen at Hampton Court*, London, Harvey Miller.

Martindale, A. (1995) 'The wall-paintings in the Chapel of Eton College', in C. Barron and N. Saul (eds) *England and the Low Countries in the Late Middle Ages*, Stroud, Alan Sutton.

Martines, L. (1979) *Power and Imagination: City-States in Renaissance Italy*, London, Allen Lane.

Masi, B. (1906) *Ricordanze di Bartolommeo Masi: Calderaio fiorentino dal 1478 al 1526*, ed. O. Corazzini, Florence, G.C. Sansoni.

Massing, J.M. (1995) *Erasmian Wit and Proverbial Wisdom: An Illustrated Compendium for François I*, London, Warburg Institute.

Matthews, A. (1986) 'The use of prints in the *Hours of Charles d'Angoulême*', *Print Quarterly*, 3, pp.4–17.

Maulde de la Clavière, R.-A.-M. de (1886) 'Jean Perréal et Pierre de Fénin', *Nouvelles archives de l'art français*, 2, pp.1–9.

Mayer, C.A. and Bentley-Cranch, D. (1997) 'François Robertet: French sixteenth-century civil servant, poet and artist', *Renaissance Studies*, 11, pp.208–22.

Mazzi, C. (1900) *La casa di Maestro Bartalo di Tura*, Siena, L. Lazzeri (offprint from *Bulletino Senese di Storia Patria* 3).

McDonald, M.P. (2004) *The Print Collection of Ferdinand Columbus 1488–1539: A Renaissance Collector in Seville*, 2 vols, London, British Museum.

McKendrick, S. (1991) 'The Great History of Troy: a reassessment of the development of a secular theme in late medieval art', *Journal of the Warburg and Courtauld Institutes*, 54, pp.43–82.

Meadow, M.A. (1992) 'The observant pedestrian and Albrecht Durer's *Promenade*', *Art History*, 15:2, pp.197–222.

Medici, L. (2004) *Apology for a Murder*, trans. A. Brown, London, Hesperus Press.

Meiss, M. (1974) *French Painting in the Time of Jean de Berry: The Limbourgs and their Contemporaries*, London, Thames & Hudson.

Milanesi, G. (1860) 'Documenti riguardanti le statue in marmo e di bronzo fatte per le porte di San Giovanni di Firenze da Andrea del Monte San Savino e da Gio: Francesco Rustici, 1502–1524', *Giornale Storico degli Archivi Toscani*, 4, pp.63–75.

Mitchell, B. (1975) 'The patron of art in Giorgio Vasari's *Lives*', PhD Thesis, Indiana University.

Molà, L. (2000) *The Silk Industry of Renaissance Venice*, Baltimore and London, Johns Hopkins University Press.

Morall, A. (2002) 'Soldiers and gypsies: outsiders and their families in early sixteenth-century German art', in P. Cuneo (ed.) *Artful Armies, Beautiful Battles: Art and Warfare in Early Modern Europe*, Leiden, Boston and Cologne, Brill, pp. 159–80.

Morganstern, A.M. (2000) 'The tomb as prompter for the chantry: four examples from late medieval England', in E. Valdez del Alamo and C. Stamatis Pendergast (eds) *Memory and the Medieval Tomb*, Aldershot, Ashgate, pp.81–97.

Morphos, P.P. (1963) 'The pictorialism of Lemaire de Belges in *Le Temple d'Honneur et de Vertus*', in G.C. Rossi (ed.) *Annali*, vol.1, Naples, Istituto Universitario Orientale, pp.5–30.

Mueller, R.C. (1997) *The Venetian Money Market: Banks, Panics, and the Public Debt, 1200–1500*, Baltimore and London, Johns Hopkins University Press.

Müller, C. (1991) 'New evidence for Hans Holbein the Younger's wall paintings in Basel Town Hall', *Burlington Magazine*, CXXXIII, pp.21–6.

Müller, C. (2001) 'Holbeins Gemälde "der Leichnam Christi im Grabe" und die Grabkapelle der Familie Amerbach in der Basler Kartause', *Zeitschrift für Schweizerische Archäologie und Kunstgeschichte*, 58, pp.279–89.

Müller, C. *et al.* (2006) *Hans Holbein the Younger: The Basle Years 1515–1532*, Munich, Prestel (exhibition catalogue).

Müller, T. (1966) *Sculpture in the Netherlands, Germany, France and Spain, 1400–1500*, trans. E. and W.R. Scott, Pelican History of Art, Harmondsworth, Penguin.

Munro, J.H. (1983) 'The medieval scarlet and the economics of sartorial splendour', in N.B. Harte and K. Ponting (eds) *Cloth and Clothing in Medieval Europe*, London, Heinemann Educational Books/Edington, Pasold Research Fund, pp.13–70.

Neagley, L.E. (1998) *Disciplined Exuberance: The Parish Church of Saint-Maclou and Late Gothic Architecture in Rouen*, University Park, Pennsylvania State University Press.

Nelson, R.S. (1989) 'The discourse of icons, then and now', *Art History*, 12, pp.144–57.

Neri di Bicci (1976) *Le Ricordanze*, ed. B. Santi, Pisa, Marlin.

Newbigin, N. (1996) *Feste d'Oltrarno: Plays in Churches in Fifteenth-Century Florence*, 2 vols, Florence, Olschki.

Newton, S.M. (1988) *The Dress of the Venetians 1495–1525*, Aldershot and Brookfield, Scolar Press.

Nuttall, P. (2004) *From Flanders to Florence: The Impact of Netherlandish Painting, 1400–1500*, New Haven and London, Yale University Press.

O'Malley, M. (2005) *The Business of Art: Contracts and the Commissioning Process in Renaissance Italy*, New Haven and London, Yale University Press.

Oettinger, O. (1965) 'Die Grabmalkonzeption Kaiser Maximilians', *Zeitschrift des Deutschen Vereins für Kunstwissenschaft*, 19, pp.170–84.

Olsen, C. (1992) 'Gross expenditure: Botticelli's Nastagio degli Onesti panels', *Art History*, 15:2, pp.146–70.

Origo, I. (1963) *The World of San Bernardino*, London, Jonathan Cape.

Pächt, O. (1977) 'René d'Anjou Studien II', *Jahrbuch der kunsthistorischen Sammlungen in Wien*, 73, pp.7–106.

Padoa Rizzo, A. (1991) 'Cosimo e Bernardo Rosselli per la Compagnia di Sant'Andrea Dei Purgatori a Firenze', *Studi di Storia dell'Arte*, 2, pp.265–70.

Paliouras, A.D. (1978) Α.Δ. Παλιούρα, Ἡ Δυτικοῦ Τύπου Ἀνάσταση του Χριστοῦ καὶ ο Χρόνος Εισαγωγῆς της στην Ὀρθόδοξη Τὲχνη', *Δωδώνη*, 7, pp.385–408.

Panofsky, E. (1955) *The Life and Art of Albrecht Dürer*, Princeton, Princeton University Press.

Panofsky, E. (1992) *Tomb Sculpture: Four Lectures on its Changing Aspects from Ancient Egypt to Bernini*, London, Phaidon (first published 1964).

Park, K. (1985) *Doctors and Medicine in Early Renaissance Florence*, Princeton, Princeton University Press.

Parry, K. (1989) 'Theodore Studites and the Patriarch Nicephoros on image-making as a Christian imperative', *Byzantion*, 59, pp.164–83.

Parshall, P. (2001) 'Hans Holbein's pictures of death', in M. Roskill and J.O. Hand (eds) *Hans Holbein: Paintings, Prints and Reception*, Studies in the History of Art: 60, Symposium Papers 37, Washington, DC, National Gallery of Art/New Haven and London, Yale University Press, pp.83–95.

Paviot, J. (1990) 'La vie de Jan van Eyck selon les documents écrits', *Revue des archéologues et historiens d'art de Louvain*, 23, pp.83–93.

Perkinson, S. (2005) 'From "curious" to canonical: Jehan Roy de France and the origins of the French School', *The Art Bulletin*, 87, pp.508–32.

Pesenti, T. (1984) *Professori e promotori di medicina nello studio di Padova dal 1405 al 1509: Repertorio bio-bibliografico*, Padua, Lint.

Piccolomini, A.S. (Pius II) (1936, 1939, 1947, 1951, 1957) *The Commentaries of Pius II*, trans. F.A. Gragg, with introductions and historical notes by L.C. Gabel,

Smith College Studies in History, Northampton, MA, vol. XXII nos 1–2 1936, XXV nos 1–4 1939, XXX 1947, XXXV 1951, XLIII 1957. (Latin edition published as *Pii II Commentarii rerum memorabilium que temporibus suis contigerunt*, 2 vols, ed. A. van Heck, Vatican City, Biblioteca apostolica vaticana: *Studi e Testi*, vols 312–13.)

Pinelli, A. (2000) *The Basilica of St Peter in the Vatican*, 4 vols, Modena, Panini.

Pinson, Y. (1987) 'Les "Puy d'Amiens" 1518–1525: Problèmes d'attributions et d'évolution de la loi du genre', *Gazette des beaux-arts*, 109, pp.47–61.

Pollini, J. (1992) 'The *Tazza Farnese* reconsidered: Augusto Imperatore "Redeunt Saturnia Regna!"', *American Journal of Archaeology*, 96, pp.249–300.

Pope-Hennessey, J. (1980) *Luca della Robbia*, Oxford, Phaidon.

Pope-Hennessy, J. (1993a) *Donatello Sculptor*, New York, Abbeville Press.

Pope-Hennessy, J. (1993b) *Paradiso: The Illuminations to Dante's Divine Comedy by Giovanni di Paolo*, London, Thames & Hudson.

Post-Byzantium (2003) *Post-Byzantium: The Greek Renaissance. 15th–18th Century Treasures from the Byzantine and Christian Museum, Athens. Onassis Cultural Center, New York, November 7, 2002 – February 8, 2003*, Athens, Hellenic Ministry of Culture.

Pradel, M. (1953) *Michel Colombe: Le dernier imagier gothique*, Paris, Librairie Plon.

Pyhrr, S.W. and Godoy, J.-A. (1999) *Heroic Armour of the Italian Renaissance: Filippo Negroli and his Contemporaries*, New York, Metropolitan Museum of Art (exhibition catalogue).

Quarré, P. (1973) *Antoine le Moiturier: Le dernier des grands imagiers des ducs de Bourgogne*, Dijon, Musée de Dijon.

Réau, L. and Fleury, M. (1994) *Histoire du vandalisme: Les monuments détruits de l'art français*, Paris, Robert Laffont.

Renaissance Bronzes, Statuettes, Reliefs, and Plaquettes, from the Kress Collection (1951) Washington, DC, National Gallery of Art.

Reynaud, N. (1968) 'Jean Hey peintre de Moulins et son client Jean Cueillette', *Revue de l'art*, 1–2, pp.34–7.

Reynaud, N. (1996) 'Deux portraits inconnus par Jean Perréal au musée du Louvre', *Revue du Louvre et des musées de France*, 46, pp.36–46.

Reynolds, C. (2005) 'The "Très Riches Heures", the Bedford workshop and Barthélemy d'Eyck', *Burlington Magazine*, CXLVII, pp.526–33.

Reynolds, L.D. and Wilson, N.G. (1991) *Scribes and Scholars: A Guide to the Transmission of Greek and Latin Literature*, 3rd edn, Oxford, Clarendon Press.

Richardson, C.M. (1998) 'The lost will and testament of Cardinal Francesco Todeschini Piccolomini (1439–1503)', *Papers of the British School at Rome*, 66, pp.193–214.

Richardson, C.M. (ed.) (2007) *Locating Renaissance Art*, New Haven and London, Yale University Press in association with The Open University.

Richardson, C.M., Woods, K.W. and Franklin, M.W. (eds) (2007) *Renaissance Art Reconsidered: An Anthology of Primary Sources*, Oxford, Blackwell.

Riegel, N. (1995) 'Capella Ascanii-Coemiterium Julium: Zur Auftraggeberschaft des Chors von Santa Maria del Popolo in Rom', *Römisches Jahrbuch der Biblioteca Hertziana*, 30, pp.191–219.

Ristori, R. (1986) 'L'Aretino, il *David* di Michelangelo e la "modestia fiorentina"', *Rinascimento*, 26, pp.77–97.

Roberts, A.M. (1989) 'The chronology and political significance of the tomb of Mary of Burgundy', *The Art Bulletin*, 71, pp.376–400.

Roberts, J. (1979) *Holbein*, London, Oresko Books.

Robin, F. (1985) *La Cour d'Anjou-Provence: La vie artistique sous le règne de René*, Paris, Picard.

Robinson, J.C. (1895) 'The Sforza Book of Hours,' *Bibliographica: Papers on Books, their History and Art*, 1, pp.428–36.

Roettgen, S. (1997) *Italian Frescoes: The Flowering of the Renaissance 1470–1510*, New York, Abbeville Press.

Rohlmann, M. (ed.) (2003) *Domenico Ghirlandaio: Künstlerische Konstruktion von Identität im Florenz der Renaissance*, Weimar, VDG.

Roover, R. de (1963) *The Rise and Decline of the Medici Bank 1397–1494*, Cambridge, MA, Harvard University Press.

Rosci, M. and Chastel, A. (1963) 'Un château française en Italie: Un portrait de Gaillon à Gaglianico', *Art de France*, 3, pp.103–13.

Rosenthal, D. (1999) 'The genealogy of empires: ritual politics and state building in early modern Florence', *I Tatti Studies*, 8, pp.197–234.

Rosenthal, D. (2006a) 'The spaces of plebeian ritual and the boundaries of transgression', in J. Paoletti and R. Crum (eds) *Renaissance Florence: A Social History*, Cambridge and New York, Cambridge University Press.

Rosenthal, D. (2006b) 'Big Piero, the empire of the meadow and the parish of Santa Lucia: claiming neighbourhood in the early modern city', *Journal of Urban History*, 32, pp.677–92.

Rosenthal, J.T. (1972) *The Purchase of Paradise: Gift Giving and the Aristocracy, 1307–1485*, London, Routledge and Kegan Paul/Toronto, University of Toronto Press.

Roth, H. (1933–8) *Quellen und Forschungen zur Südwestdeutschen und Schweizerischen Kunstgeschichte im XV und XVI Jahrhundert*, 3 vols, Stuttgart, Strecker and Schröder.

Rouse, E.C. (1987) 'The dance of death painted panels on the Markham Chantry Chapel', unpublished pamphlet (BL X.208/8567).

Rowlands, J. (1985) *Holbein: The Paintings of Hans Holbein the Younger*, Oxford, Phaidon.

Rubin, P.L. (1995) 'Magnificence and the Medici', in F. Ames-Lewis (ed.) *The Early Medici and their Artists*, London, Department of History of Art, Birkbeck College, pp.37–49.

Rubin, P.L. and Wright, A. (1999) *Renaissance Florence: The Art of the 1470s*, London, National Gallery Publications (exhibition catalogue).

Rubinstein, N. (1966) *The Government of Florence under the Medici (1434 to 1494)*, Oxford, Clarendon Press.

Rubinstein, N. (1995) *The Palazzo Vecchio 1298–1532: Government, Architecture and Imagery in the Civic Palace of the Florentine Republic*, Oxford, Clarendon Press.

Rucellai, G. (1960) *Giovanni Rucellai ed il suo zibaldone*, vol.1: *Il Zibaldone quaresimale*, ed. A. Perosa, London, Warburg Institute.

Ruda, J. (1978) 'A 1434 building programme for San Lorenzo in Florence', *Burlington Magazine*, CXX, pp.358–61.

Rümelin, C. (1998) 'Holbeins Formschneider', *Zeitschrift für Schweizerische Archäologie und Kunstgeschichte*, 55, pp.305–22.

Russo, M. (1998) 'Giovan Francesco Rustici', in S. Valeri (ed.) *Scultori del Cinquecento*, Rome, Lithos, pp.7–20.

Saalman, H. (1978) 'Michelangelo at St. Peter's: the Arberino correspondence', *The Art Bulletin*, 60, pp. 483–93.

Saalman, H. (1980) *Filippo Brunelleschi: The Cupola of Santa Maria del Fiore*, London, Zwemmer.

Satzinger, G. (2004) *Die Renaissance-Medaille in Italien und Deutschland*, Münster, Rhema.

Saura, M. (1988) 'Architecture and the law in early Renaissance urban life: Leon Battista Alberti's *De Re Aedificatoria*', PhD thesis, University of California, Berkeley.

Sauval, H. (1724) *Histoire et recherches des antiquités de la ville de Paris*, 3 vols, Paris.

Savonarola, G. (1496) *Predica dell'arte del ben morire*, Florence, Bartolommeo de Libri.

Savonarola, G. (1957) *Prediche sopra Giobbe*, ed. R. Ridolfi, Rome, A. Berladetti.

Savonarola, G. (1962) *Prediche sopra Ruth e Michea*, ed. V. Romano, Rome, A. Berladetti.

Savonarola, G. (1969) *Prediche sopra i Salmi*, ed. V. Romano, 2 vols, Rome, A. Berladetti.

Saxl, F. (1970) 'Holbein and the Reformation', in H. Honour and J. Fleming (eds) *A Heritage of Images*, Harmondsworth, Penguin.

Schaefer, C. (1980) 'Nouvelles observations au sujet des Heures de Louis de Laval', *Arts de l'Ouest*, 1–2, pp.33–68.

Schaefer, C. (1985) 'Lemaire de Belges, Fouquet et maître Paoul Goybault: la peinture murale du Jugement Dernier de la Sainte-Chapelle de Châteaudun', *Bulletin de la Société nationale des antiquaries de France*, pp.249–64.

Scheller, R. (1981–2) 'Imperial themes in art and literature in early French Renaissance period: the period of Charles VIII', *Simiolus*, 12, pp.5–69.

Scheller, R. (1983) 'Ensigns of authority: French Renaissance symbolism in the age of Louis XII', *Simiolus*, 13, pp.75–141.

Scheller, R. (1985) 'Gallia Cisalpina: Louis XII and Italy 1499–1508', *Simiolus*, 15, pp.5–60.

Scher, S.K. (ed.) (1994) *The Currency of Fame: Portrait Medals of the Renaissance*, New York, Harry N. Abrams/London, Thames & Hudson in association with the Frick Collection (exhibition catalogue).

Scher, S.K. (ed.) (2000) *Perspectives on the Renaissance Medal*, New York and London, Garland in association with the American Numismatic Society.

Schmid, K. (1984) '"Andacht und Stift": Zur Grabmalplanung Kaiser Maximilians I', in K. Schmid and J. Wollasch (eds) *Memoria: Der geschichtliche Zeugniswert des liturgischen Gedenzens im Mittelalter*, Munich, Fink, pp.750–86.

Schöne, W. (1938) *Dieric Bouts und seine Schule*, Berlin, Verlag für Kunstwissenschaft.

Schultz, A. (ed.) (1888) *Der Weisskunig: Nach den Dictaten und eigenhändigen Aufzeichnungen Kaiser Maximilians I (Jahrbuch der kunsthistorischen Sammlungen des allerhöchsten Kaiserhauses, 6)*, Vienna, Holzhausen.

Scott, M. (1980) *History of Dress Series 1: Late Gothic Europe 1400–1500*, London, Mills & Boon/Atlantic Highlands, Humanities Press.

Seguin, J.-P. (1961) 'La découverte de l'Italie par les soldats de Charles VIII, 1494–1495', *Gazette des Beaux-Arts*, 57, pp.27–34.

Seymour, C. (1967) *Michelangelo's David: A Search for Identity*, Pittsburgh, University of Pittsburgh Press.

Shearman, J. (1975) 'The collection of the younger branch of the Medici', *Burlington Magazine*, CXVII, pp.12–27.

Shearman, J. (1992) *Only Connect ... Art and the Spectator in the Italian Renaissance*, Princeton, Princeton University Press.

Sheingorn, P. (1993) 'The wise mother: the image of St. Anne teaching the Virgin Mary', *Gesta*, 32, pp.69–80.

Shell, J. and Sironi, G. (1991) 'Salaì and Leonardo's legacy', *Burlington Magazine*, CXXXIII, pp.95–108.

Silver, L. (1985) 'Prints for a prince: Maximilian, Nuremberg, and the woodcut', in J. Chipps Smith (ed.) *New Perspectives on the Art of Renaissance Nuremberg*, Austin, Archer M. Huntington Art Gallery, College of Fine Arts, University of Texas at Austin, pp.7–21.

Smith, J.C. (1989) 'Portable propaganda: tapestries as princely metaphors at the courts of Philip the Good and Charles the Bold', *Art Journal*, 48, pp.123–9.

Snow-Smith, J. (1982) *The Salvator Mundi of Leonardo da Vinci*, Seattle, Henry Art Gallery, University of Washington.

Soly, H. (ed.) (1999) *Charles V 1500–1558 and his Time*, Antwerp, Mercatorfonds.

Sosson, J.-P. (1977) *Les Travaux publics de la ville de Bruges XIVe–XVe siècles: Les matériaux. Les hommes*, Brussels, Credit Communal, Collection Histoire Pro Civitate no.48.

Spagnesi, G. (ed.) (1997) *L'architettura della Basilica di San Pietro: Storia e costruzione*, Quaderni dell'Istituto di Storia dell'Architettura, new series 25–30 (1995–7), Rome, Bonsignori.

Spallanzani, M. and Gaeta Bertelà, G. (eds) (1992) *Libro d'inventario dei beni di Lorenzo il Magnifico*, Florence, Associazione 'Amici del Bargello'.

Spencer, B. (1998) *Pilgrim Souvenirs and Secular Badges*, London, Stationary Office.

Spieser, J.-M. (1999) 'Le développement du templon et les images des Douzes Fêtes', in J.-M. Sansterre and J.-C. Schmitt (eds) *Les Images dans les Sociétés médiévales: Pour une histoire comparée. Actes du colloque international organisé par l' Institute Belge de Rome en collaboration avec l' École Française de Rome et l' Université Libre de Bruxelles (Rome, Academia Belgica, 19–20 Juin 1998)*, Brussels and Rome, Bulletin de l' Institute Belge de Rome 69, pp.131–64.

Spont, A. de (1894) 'Documents relatifs à la reconstruction du château royale d'Amboise', *Correspondence historique et archéologique*, 1, pp.367–72.

Spufford, P. (1986) *Handbook of Medieval Exchange*, London, Boydell & Brewer.

Stecher, J.A. (ed.) (1891) *Oeuvres de Jean Lemaire de Belges*, 4 vols, Louvain, Lefever Frères et Soeur.

Sterling, C. (1963) 'Une peinture certaine de Perréal enfin retrouvée', *L'Oeil*, 103–4, pp.2–15, 64–5.

Sterling, C. (1968) 'Jean Hey le Maître de Moulins', *Revue de l'art*, 1–2, pp.26–33.

Sterling, C. (1990) *La Peinture médievale à Paris*, vol.2, Paris, Bibliothèque des Arts.

Sterling, C., Ainsworth M. *et al.* (1998) *The Robert Lehman Collection, II, Fifteenth- to Eighteenth-Century European Paintings, France, Central Europe, The Netherlands, Spain and Great Britain*, New York, Metropolitan Museum of Art/Princeton, Princeton University Press.

Stratford, J. (1993) *The Bedford Inventories: The Worldly Goods of John, Duke of Bedford, Regent of France (1389–1435)*, London, Society of Antiquaries of London.

Strauss, W.L. (ed.) (1973) *The Complete Engravings, Etchings and Drypoints of Albrecht Dürer*, New York, Dover.

Syson, L. and Gordon, D. (eds) (2001) *Pisanello: Painter to the Renaissance Court*, London, National Gallery Publications (exhibition catalogue).

Syson, L. and Thornton, D. (2001) *Objects of Virtue: Art in Renaissance Italy*, London, British Museum.

Taburet-Delahaye, E. (ed.) (2004) *Paris 1400: Les arts sous Charles VI*, Paris, Réunion des Musées Nationaux (exhibition catalogue).

Taddei, I. (1999) '"Per la salute dell'anima e del corpo": Artigiani e le loro confraternite', in F. Francsechi and G. Fossi (eds) *Arti fiorentine: La grande storia dell'artigianato. Volume secondo: Il Quattrocento*, Florence, Giunti, pp.29–66.

Tempestini, A. (1992) *Giovanni Bellini: Catalogo completo dei dipinti*, Florence, Cantini.

Thibault, P. (1989) *La Bibliothèque de Charles d'Orléans et de Louis XII au château de Blois*, Blois, Les Amis de la Bibliothèque de Blois.

Thiébaut, D., Lorentz, P. and Martin, F.-R. (2004) *Primitifs français: Découvertes et redécouvertes*, Paris, Réunion des Musées Nationaux/Musée du Louvre (exhibition catalogue).

Thoenes, C. (1997) 'S. Pietro: storia e ricerca', in G. Spagnesi (ed.) *L'architettura della Basilica di San Pietro: Storia e costruzione*, Quaderni dell'Istituto di Storia dell'Architettura, new series 25–30 (1995–7), Rome, Bonsignori, pp.17–30.

Thomas, A. (1995) *The Painter's Practice in Renaissance Tuscany*, Cambridge and New York, Cambridge University Press.

Thomas, M. (1971) *Les Grandes Heures de Jean de Berry*, London, Thames & Hudson.

Thornton, P. (1991) *The Italian Renaissance Interior 1400–1600*, London, Weidenfeld & Nicolson.

Thuillier, J. (1976) 'Les débuts de l'histoire de l'art en France et Vasari', *Il Vasari Storiogrfo e Artista: Atti del Congresso Internazionale nel IV Centenario della Morte*, Florence, Istituto Nazionale di Studi sul Rinascimento.

Thuillier, J. (1983) 'Pour André Félibien', *XVIIe siècle*, 35:1, pp.67–95.

Thuillier, J. (1994) 'André Félibien et les "anciens peintres"', in P. Rosenberg, C. Scalliérez and D. Thiébaut (eds) *Hommage à Michel Laclotte: Études sur la peinture du Moyen Age et de la Renaissance*, Milan, Electa/Paris, Réunion des Musées Nationaux.

Thümmel, H.G. (1980) 'Bernhard Strigels Diptychon für Cuspinian', *Jahrbuch der kunsthistorischen Sammlungen in Wien*, 76, pp.96–110.

Tognetti, S. (1995) 'Prezzi e salari nella Firenze tardomedievale: un profilo', *Archivio Storico Italiano*, new series vol.2, pp.263–333.

Tolley, T.S. (1994) 'Hugo van der Goes's altarpiece for Trinity College Church in Edinburgh and Mary of Guelders, Queen of Scotland', in J. Higgitt (ed.) *Medieval Art and Architecture in the Diocese of St Andrews*, Tring, British Archaeological Association, pp.213–31.

Trachtenberg, M. (1997) *Dominion of the Eye: Urbanism, Art, and Power in Early Modern Florence*, Cambridge and New York, Cambridge University Press.

Tracy, C. and Harrison, H. (2004) *The Choir-Stalls of Amiens Cathedral*, Reading, Spire Books.

Trexler, R. (1980) *Public Life in Renaissance Florence*, New York and London, Academic Press.

Tsamakda, V. (2002) *The Illustrated Chronicle of Ioannes Skylitzes in Madrid*, Leiden, Alexandros Press.

Ullman, B. (1960) *The Origin and Development of Humanistic Script*, Storia e letteratura, vol.79, Rome, Edizioni di Storia e letteratura.

Vaivre, J.-B. de (1986) 'Dessin inédites de tombes médiévales bourguignonnes de la Collection Gaignières', *Gazette des beaux-arts*, 108, pp.97–122, 141–82.

Van Beuningen, H.J.E. and Koldeweij, A.M. (1993) *Heilig en profaan: 1000 laatmiddeleeuwse insignes uit de collectie H.J.E. van Beuningen*, Cothen, Stichting Middeleeuwse Religieuze en Profane Insignes.

Van den Bergen-Patens, C. (ed.) (2000) *Les Chroniques de Hainaut ou les ambitions d'un prince bourguignon*, Turnhout, Brepols.

Van der Velden, H. (1998) 'Defrocking St Eloy: Petrus Christus' vocational portrait of a goldsmith', *Simiolus*, 26:4, pp.242–76.

Van der Velden, H. (2000) *The Donor's Image: Gerard Loyet and the Votive Portraits of Charles the Bold*, Turnhout, Brepols.

Van Uytven, R. (1998) 'De prijs van de schilderijen van Dirk Bouts', in *Dirk Bouts ca. 1410–1475: Een Vlaams primitief te Leuven*, Leuven, Peeters, pp.181–8 (exhibition catalogue).

Vandenbroeck, P. (1988) 'Dits illustrés et emblems moraux: contribution à l'étude de l'iconographie profane et de la pensée sociale vers 1500 (Paris, B.N., ms.fr.24461)', *Jaarboek: Koninklijke Museum voor Schone Kunsten*, pp.23–96.

Vasari, G. (1986) *Le vite de' più eccellenti architetti, pittori, et scultori italiani, da Cimebue insino a' tempi nostri: Nell'edizione per i tipi di Lorenzo Torrentino, Firenze 1550*, ed. L. Bellosi and A. Rossi, Turin, Einaudi.

Vasari, G. (1996) *Lives of the Painters, Sculptors and Architects*, trans. G. du C. de Vere, intro. and notes D. Ekserdjian, 2 vols, Everyman's Library, London, David Campbell (this edn first published 1927 by Dent).

Vassilaki, M. (1990) 'A Cretan icon in the Ashmolean: the embrace of Peter and Paul', *Jahrbuch der Österreichischen Byzantinistik*, 40, pp.405–22.

Vassilaki, M. (ed.) (2000) *Mother of God: Representations of the Virgin in Byzantine Art*, Athens, Benaki Museum (exhibition catalogue).

Vassilaki, M. (ed.) (2005) *Images of the Mother of God: Perceptions of the Theotokos in Byzantium*, Aldershot, Ashgate.

Vaughan, R. (1970) *Philip the Good: The Apogee of Burgundy*, London and Harlow, Longmans.

Vaughan, R. (1975) *Valois Burgundy*, London, Allen Lane.

Veblen, T. (1994) *The Theory of the Leisure Class*, ed. R. Lekachman, New York, Penguin.

Verdi, R. (2003) *Saved! 100 Years of the National Art Collection Fund*, London, Hayward Gallery (exhibition catalogue).

Verdon, T. (1978) *The Art of Guido Mazzoni*, New York, Garland.

Verdon, T. (1990) 'Guido Mazzoni in Francia: nuovi contributi', *Mitteilungen des Kunsthistorischen Institutes in Florenz*, 34, pp.139–64.

Verdon, T. (ed.) (2001) *La cattedrale e la città: Saggi sul Duomo di Firenze, atti del VII Centenario del Duomo di Firenze*, 3 vols, Florence, Edifir.

Vernet, A. (1943) 'Jean Perréal, poète et alchimiste', *Bibliothèque d'Humanisme et Renaissance*, 3, pp.214–52.

Vespasiano da Bisticci (1997) *The Vespasiano Memoirs: Lives of Illustrious Men of the XVth Century*, trans. W. George and E. Waters, Toronto, University of Toronto Press in association with the Renaissance Society of America (reprint of 1926 edn).

Vio, E. (1999) *The Basilica of St Mark in Venice*, Florence, Scala.

Vitry, P. (1901) *Michel Colombe et la sculpture française de son temps*, Paris, Librairie Centrale des Beaux-Arts.

Voragine, J. da (1993) *The Golden Legend*, 2 vols, trans. W.G. Ryan, Princeton, Princeton University Press.

Vornova, T. and Sterligov, A. (1996) *Western European Illuminated Manuscripts of the 8th to the 16th Centuries in the National Library of Russia, St Petersburg*, Bournemouth, Parkstone Press/Aurora.

Wadsworth, J.B. (1959) 'Jean Lemaire de Belges and the death of Pierre de Bourbon', *Romance Notes*, 1, pp.53–8.

Waldman, L.A. (1997) 'The date of Rustici's "Madonna" relief for the Florentine silk guild', *Burlington Magazine*, CXXXIX, pp.869–72.

Walter, C. (1993) 'A new look at the Byzantine sanctuary barrier', *Revue des études byzantines*, 51, pp.203–28.

Wandel, L.P. (1995) *Voracious Idols and Violent Hands: Iconoclasm in Reformation Zurich, Strasbourg and Basel*, Cambridge, Cambridge University Press.

Warburg, A. (1999) *The Renewal of Pagan Antiquity: Contributions to the Cultural History of the European Renaissance*, ed. K.W. Forster, trans. D. Britt, Los Angeles, Getty Research Institute for the History of Art and the Humanities.

Watson, R. (2003) *Illuminated Manuscripts and their Makers: An Account Based on the Collection of the Victoria and Albert Museum*, London, V & A Publications.

Webb, D. (1999) *Pilgrims and Pilgrimage in the Medieval West*, London and New York, I.B. Tauris.

Weinstein, D. (1970) *Savonarola and Florence: Prophecy and Patriotism in the Renaissance*, Princeton, Princeton University Press.

Weiss, R. (1953) 'The castle of Gaillon in 1509–10', *Journal of the Warburg and Courtauld Institutes*, 16, pp.1–12, 351.

Weissman, R. (1982) *Ritual Brotherhood in Renaissance Florence*, New York and London, Academic Press.

Wethey, H.E. (1936) *Gil de Siloé and his School: A Study of Late Gothic Sculpture in Burgos*, Cambridge, MA, Harvard-Radcliffe Fine Arts Series.

Wieck, R.S. (1992) 'Margaret of York's *Visions of Tondal*: relationship of the miniatures to a text transformed by translator and illuminator', in T. Kren (ed.) *Margaret of York, Simon Marmion, and 'The Visions of Tondal'*, Malibu, J. Paul Getty Museum, pp.119–28.

Wieck, R.S. (2004) 'Post-Poyet', in D.S Areford and N.A. Rowe (eds) *Excavating the Medieval Image: Manuscripts, Artists, Audiences. Essays in Honor of Sandra Hindman*, Aldershot, Ashgate, pp.247–64.

Wieck, R.S. and Hearne, K.M. (1999) *The Prayer Book of Anne de Bretagne: MS M. 50, The Pierpont Morgan Library, New York*, Lucerne, Faksimile Verlag.

Wilde, J. (1944) 'The hall of the great council of Florence', *Journal of the Warburg and Courtauld Institutes*, 7, pp.65–81.

Wilder, E., Kennedy, C. and Bacci, P. (1932) *The Unfinished Monument by Andrea del Verrocchio to the Cardinal Niccolò Forteguerri at Pistoia*, Northampton, MA, Smith College.

Wilson, B. (1992) *Music and Merchants: The Laudesi Companies of Renaissance Florence*, Oxford, Clarendon Press.

Wimmer, O and H. Melzer (1988) *Lexikon der Namen und Heiligen*, ed. J. Gelmi, Innsbruck and Vienna, Tyrolia Verlag.

Wingfield Digby, G. (1980) *The Victoria and Albert Museum Tapestries: Medieval and Renaissance*, London, V & A Publications.

Winkler, F. (1932) 'Der Meister von Moulins und Hugo van der Goes', *Pantheon*, 10, pp.241–8.

Winn, M.B. (1984) 'Books for a princess and her son: Louise de Savoie, François d'Angoulême and the Parisian libraire Antoine Vérard', *Bibliothèque d'Humanisme et Renaissance*, 46, pp.603–17.

Winn, M.B. (1994) 'Guillaume Tardif's Hours for Charles VIII and Anthoine Vérard's *Grandes Heures Royales*', *Bibliothèque d'Humanisme et Renaissance*, 56, pp.347–83.

Winner, M. (2001) 'Holbein's portrait of Erasmus with a Renaissance pilaster', in M. Roskill and J.O. Hand (eds) *Hans Holbein: Paintings, Prints and Reception*, Studies in the History of Art: 60, Symposium Papers 37, Washington, DC, National Gallery of Art/New Haven and London, Yale University Press, pp.155–73.

Woods, K.W. (2006) 'The Mercers' Christ re-examined', in R. Marks (ed.) *Late Gothic England: Art and Display*, Donnington, Paul Watkins Publishing.

Woods, K.W. (ed.) (2007) *Making Renaissance Art*, New Haven and London, Yale University Press in association with The Open University.

Wright, A. (2005) *The Pollaiuolo Brothers: The Arts of Florence and Rome*, New Haven and London, Yale University Press.

Wyss, R.L. (1957) 'Die Neun Helden', *Zeitschrift für Schweizerische Archäologie und Kunstgeschichte*, 17, pp.73–106.

Yabsley, D. (ed.) (1932) *Jean Lemaire de Belges: La plainte du désiré*, Paris, E. Droz.

Zemon Davis, N. (1956) 'Holbein's pictures of death and the Reformation in Lyon', *Studies in the Renaissance*, 3, pp.97–130.

Zsuppán, C.M. (ed.) (1970) *Jean Robertet: Oeuvres*, Geneva, Librairie Droz.

Zuraw, S.E. (1998) 'The public commemorative monument: Mino da Fiesole's tombs in the Florentine Badia', *The Art Bulletin*, 80, pp.452–77.

Zuraw, S.E. (2004) 'Mino da Fiesole's Forteguerri tomb: a "Florentine" monument in Rome', in S.J. Campbell and S.J. Milner (eds) *Artistic Exchange and Cultural Translation in the Italian Renaissance City*, Cambridge and New York, Cambridge University Press, pp.75–95.

Index

Page numbers in *italics* refer to illustrations.